The "Things of Greater Importance":
Bernard of Clairvaux's Apologia *and*
the Medieval Attitude Toward Art

Publication of this book has been aided by
a grant from the Millard Meiss Publication Fund
of the College Art Association

MM

The
"THINGS OF GREATER IMPORTANCE"

Bernard of Clairvaux's
Apologia *and the*
Medieval Attitude Toward Art

Conrad Rudolph

UNIVERSITY OF PENNSYLVANIA PRESS
Philadelphia

Permission is acknowledged to reprint the critical
Latin edition:

>Bernard of Clairvaux, *Apologia ad Guillelmum Abbatem.*
>*Sancti Bernardi Opera,* ed. Jean Leclercq and H. M. Rochais, vol. III:
>80–108. Rome: Edizioni Cistercensi, 1963.

Design: ADRIANNE ONDERDONK DUDDEN

Library of Congress Cataloging-in-Publication Data

Rudolph, Conrad, 1951–
 The "things of greater importance" : Bernard of Clairvaux's
Apologia and the medieval attitude toward art / Conrad Rudolph.
 p. cm.
 English and Latin.
 Includes bibliographical references.
 ISBN 0-8122-8181-0
 1. Christian art and symbolism—Medieval, 500–1500. 2. Bernard,
of Clairvaux, Saint, 1090 or 91–1153. Apologia ad Guillelmum
Abbatem. I. Title.
N7850.R8 1990
704.9'482'0940902—dc20 89-21480
 CIP

To Roberta
who has cheerfully shared the many, hard years

CONTENTS

PREFACE

Of all the human endeavors of the more than one thousand years of Western medieval culture, no single aspect looms so large in the modern mind as that of religious art. Yet despite the vast number of studies that have been undertaken to explain one aspect or another of medieval art, very few have attempted to explain in a non-aesthetic or non-theological way that issue which is so fundamental to a complete understanding of the artistic complexities of the Middle Ages—the medieval attitude toward art.

This is a study of the medieval attitude toward art primarily as expressed through Bernard of Clairvaux's *Apologia* and the early twelfth-century controversy over art, but also as expressed in the relation of the *Apologia* and that controversy to the historical constant of a non-iconoclastic resistance to art in the West. Indeed, the study of art in its controversial aspect often tells us more about its meaning than it does in its non-controversial aspect. For it is in periods of stress that strengths and weaknesses emerge, that issues arise. And so this is a study of some of the issues of medieval art, of some of its justifications and the challenges to those justifications, as they were seen by contemporaries.

However, this is not a comprehensive study of the medieval attitude toward art, nor is it a history of the early twelfth-century controversy over art. And as a non-aesthetic and non-theological study, it does not attempt to take up the legitimate artistic expression of religious concerns, concerns which are well-known and which are covered elsewhere: art was often made with sincere spiritual intent, but that is not the focus of study here. Also, it should be stated at the outset that the idealism that permeates this study is not an idealism imposed on an earlier age by a later writer. That is, it is not my idealism but theirs—but while it is their idealism, it was their claims that were idealistic, the reality was not.

Since this study takes the *Apologia* and the early twelfth-century controversy over art as its point of departure—both of which were inherently monastic—an attempt is made for the most part to cite sources which are related to monasticism in one way or another and which are known to have been accessible in Latin in the West during the Middle Ages. With a few exceptions, these are limited to the period before and during the life of Bernard, that is, from the early Christian writers to 1153.

I have come across many useful references to primary sources in the secondary literature; unfortunately, space does not allow me to cite all of the individual authors in whose works these have been found.

I use the Vulgate since most of the people referred to in this book used the Vulgate, and I generally make my own translations of it since there is no modern translation and in order to regularize vocabulary.

While the text proper deals with the medieval attitude toward art as seen through the concepts inherent in the *Apologia*, the commentary is more directly related to the *Apologia* as one document in the early twelfth-century controversy over monastic art—explaining elements of the structure, logic, meaning, and literary and social precedents of the various passages in a way that is typically not done in the text proper.

The hardest part of writing any academic work must surely be the acknowledgements. The author struggles with the frustrating problem of the necessity of expressing his gratitude for advice and support on the one side, and with the impossibility of his task on the other. In the end, he hopes that the mere mention of the names of those who so willingly and freely offered their aid will suffice as a sort of convention of the profession. And so I wish to make known my gratitude to Robert Benson, to Giles Constable, to Christopher Holdsworth, to Peter Klein, to Jean Leclercq, to Bengt Löfstedt, to Martin Powers, and to Karl Werckmeister, all of whose help and encouragement was help and encouragement indeed, and some of whose generous assistance was all the more generous as it was made to a stranger.

Advice on certain problems in the translation has been a burden borne by many; however, any shortcomings are my own. The Latin edition of the *Apologia* is reprinted here with the kind permission of Edizioni Cistercensi from the recent critical edition: Bernard of Clairvaux, *Apologia ad Guillelmum Abbatem*, edited by Jean Leclercq and H. M. Rochais, *Sancti Bernardi Opera* (Rome 1963) v.3:80–108.

Finally, I would like to thank the Getty Center for the History of Art and the Humanities for the Postdoctoral Fellowship in residence (1987–1988) which so facilitated the completion of this study, and the Department of Fine Arts at the University of Pittsburgh for the Andrew W. Mellon Postdoctoral Research Fellowship (1986–1987) during which part of the work was done. I would also like to thank the College Art Association for a grant from the Millard Meiss Publication Fund (1989) which aided in the publication of this study.

University of Notre Dame
Fall 1988

The "Things of Greater Importance":
Bernard of Clairvaux's Apologia *and*
the Medieval Attitude Toward Art

1
INTRODUCTION

When the rebuilding of the monastery of Saint Gall came to an end in the mid-ninth century, it was said of it—even with its abbey church truncated by one hundred feet as the result of a movement against excessive monastic art—that one could well see by such a nest what sort of bird lived in it.[1] This comment, entirely positive in nature, has been interpreted in modern times as a negative criticism of how things stood at that important center of art and literature. But to educated contemporaries, any ambiguity would have been quite absent, the author expecting his audience to instinctively recognize his position and to associate it with any number of particular attitudes toward art which had their own lineage of support and denial and which, if proper historical references were made, could often be put forth in an almost abbreviated form that nevertheless carried the full weight of that lineage.[2] Like the Saint Gall comment, many of the writings on art that have come down to us from the Middle Ages are often misunderstood or ignored by the modern reader because of an unawareness either of this form of reference, or of how such a reference applies to the artwork, person, or institution under discussion. Bernard of Clairvaux's *Apologia ad Guillelmum Abbatem* has been no exception to this phenomenon.

Sometime in 1125, an incompletely known set of circumstances compelled Bernard (1090–1153), abbot of the Cistercian monastery of Clairvaux, to write the *Apologia*, one of the best known monastic treatises of the Middle Ages and a document whose passage on art (*Apologia* 28–29) is the most important source we have today for an understanding of the actual medi-

1. Ermenricus, *Ad Grimaldum* 27, p.565, "Sed neque in edificiis construendis ex omni materia tam industrios viros vel raro usquam repperi, sicuti bene in nido apparet, quales volucres ibi inhabitent."
2. Cf. Gilson 1940:38.

eval attitude toward art as it functioned in society.[3] The time was one of profound social, political, economic, religious, and intellectual change on every side. Monasticism had re-established itself after the disintegration of the Carolingian Empire only to find that it was inextricably entangled in the social fabric it had been so instrumental in reconstructing. Indeed, it had become a victim of its own success, a success that has quite aptly been called a crisis of prosperity.[4] It had simply become too wealthy. It had gone too far in elaborating upon the *opus Dei*, the system of daily and yearly liturgical services, and it had played too active a role in opening itself up to the outside world.

The economic base of monasticism was traditionally agricultural. But it increasingly became the Office of the Dead and other services for the dead (called "the Cult of the Dead" here) that attracted the land donations that made this possible. The administration of these lands led to social entanglement and to the assumption of the pastoral duties which were theoretically the realm of the bishop. Also, many monasteries began to take an active part in the international pilgrimage ("the Cult of Relics"). This, too, involved pastoral care felt by many to be an infringement of the rights and duties of the episcopacy, as well as a dilution of monastic seclusion. All of this was seen as being in contradiction to the fundamental monastic principles of voluntary poverty, simplicity, and seclusion. Perhaps the most familiar instance of this situation is that of the abbey of Cluny in Burgundy, the leader of the most successful of the several different reform movements of the tenth and eleventh centuries, a monastery which was famous for its elaborate *opus Dei* and which had become almost legendarily wealthy, with corresponding expenses and social involvement.

Although it had lost none of its wealth and little real prestige, traditional monasticism's force of attraction was rapidly dissipating in favor of the new ascetic orders—monastic, collegial, and military—which more directly responded to the spiritual conceptions of the new society. The basis of this

3. The *Apologia* has been variously dated from 1123 to early 1127, with 1125 as the most commonly accepted date. 1125 is the date given by Van den Eynde (1969:398) in his chronology of Bernard's early writings. While Van den Eynde's reasoning is the most thoroughly worked out yet, his relative chronology seems to be more secure than his absolute chronology.

4. Leclercq 1971, esp. 222. On the crisis in general see both Leclercq, who approaches the subject in more purely spiritual terms without reference to politics or power groups, and Cantor (1960), who sees it in broad social and political terms. In the end, both agree that financial prosperity was the impetus to this crisis. Leclercq (1971:226, 228, 236) gives 1095–1145 as general limits to these events, at the end of which many of the ascetic foundations had become co-opted or had died out; Cantor (1960:47–48) suggests 1050–1130 as the significant years.

reform movement was a stricter observance of the regular life and, as far as many of the orders of the noneremitical monastic wing were concerned, a more literal interpretation of the Benedictine Rule.[5] Emphasizing a greater voluntary poverty and absence of social and economic ties than commonly found in the better known of the traditional Benedictine monasteries, the new ascetic orders began to outdistance the former in donations, choice recruits, new foundations, and public esteem. Gradually, envisioned threat and inferred insult on the one side and competition and assumed superiority on the other led to a more or less ongoing controversy between the traditional Benedictines and the new ascetic orders. Chief among these new ascetic orders were the Cistercians, with their main house at Cîteaux, also in Burgundy. First or second among the Cistercians at the time of the writing of the *Apologia*, and soon to become the most influential ecclesiastical politician in Europe, was Bernard of Clairvaux.[6] And it was Bernard's *Apologia* that was to become the central document in this controversy which, in its literary aspect, is one of the four or five great subjects of monastic history according to the well-known Benedictine scholar André Wilmart.[7]

The controversy has generally come to be known as the "Cluny-Cîteaux controversy" after its two most visible participants. But the strict polarization of monasticism into the two warring camps of "black monks" (traditional Benedictines, both Cluniac and non-Cluniac) and "white monks" (Cistercians) is more a question of historiography than of history. That is, terms, general events, and the actions of individual participants have been emphasized by some historians almost to the point of misrepresentation, with the result being an undesirably rigid and unrevealing view of this significant controversy. The vast majority of monastic opinion, it seems, lay

5. The vast majority of the monasteries of Western Europe at this time followed variations of the Rule of Saint Benedict of Nursia (c.480–c.550). Those that were constitutionally independent are often considered "non-Cluniac Benedictines," while those related in one way or another to the Congregation of Cluny are "Cluniac." Both are "traditional Benedictines." While the Cistercians are technically Benedictine, they are in practice not grouped among the Benedictines in discussions of the history of this time because they are not "traditional."

6. Bernard was born in 1090 in Burgundy. In 1113 he led thirty fellow noblemen into the novitiate of the fairly inconspicuous monastery of Cîteaux (on the probability of this date see Bredero 1961:60–62). The decision to make him abbot of Clairvaux (founded 1115) must have taken place soon thereafter. According to the *Vita Prima* (1:31, PL 185:246), a contemporary biography of Bernard, William of Champeaux had made Bernard known throughout all France before the former's death in 1121. The *Vita Prima* was begun by William of Saint-Thierry and continued by a variety of authors; see Vacandard 1902:v.1: XIX–XXV and Bredero 1961. See Vacandard 1902 for the modern biography; new studies are in preparation by Christopher Holdsworth and Jean Leclercq.

7. Wilmart 1934:296, 298.

on the various points of the spectrum between the intransigent proponents of both sides. As to the reaction of traditional Benedictine monasticism, its history was one of reform and many of its members were in varying degrees in natural sympathy with the new reformers. Among the more sympathetic of these was William of Saint-Thierry (c.1085–1148), a theologian and mystic who was professed as a monk at the non-Cluniac Benedictine monastery of Saint-Nicaise at Reims in 1113. Having made the acquaintance of Bernard around three to five years later, he very soon thereafter became a friend and political ally of Bernard's. By 1119 he was elected abbot of Saint-Thierry, near Reims, also non-Cluniac Benedictine. Although he later became a Cisterican—a move apparently deferred for many years at the personal urging of Bernard—he was actively engaged around the time of the *Apologia* in a rather pronounced reform movement within traditional Benedictine monasticism itself. It was along these lines that he turned (or so it is generally believed) to Bernard in 1125 for a defense and definition of the position of the new reform movement—and this he received in the form of the *Apologia*.[8]

While Bernard's treatise is universally recognized by such authors as Erwin Panofsky and Meyer Schapiro as crucial to our understanding of Romanesque and Gothic art—whose transition Bernard's life spanned—a combination of interpolations and preconceptions has led most scholars to see it as a simple indictment of art as it existed at the abbey of Cluny in particular, and at certain other Cluniac and Benedictine monasteries in general. The primary motivation for this has been seen—contradictorily enough—as either an unusually strong revulsion or an unusually strong attraction to art, depending on the scholar making the argument. However, the evidence suggests a situation at once more complex and more revealing. After an explanatory preface and sections defending his position in regard to William's "order" and rebuking the detractors of that "order," Bernard takes up the question of monastic excess, dividing his criticisms into two main categories, the "small things" and the "things of greater importance." Under the "small things" he included such clear infractions of external observance as excess in food, drink, and clothing. But what alarmed Bernard more were the "things of greater importance," things which until now have been seen as an almost total condemnation of monastic art.[9]

8. I believe that the evidence suggests a more complex immediate origin of the *Apologia*; see Appendix 1, "The Origin of the *Apologia*."

9. On the circumstances of the publication of the *Apologia*, including William's role, see Appendix 1. On its composition, which was twice revised by Bernard, see Appendix 1, esp. the section entitled "Bernard's Letter 84[bis] to William," the introduction to the Appendix 2, and throughout the section "Art Historical Commentary on the *Apologia*."

In fact, the "things of greater importance" did involve the almost total condemnation of *excessive* monastic art. "Excessive art" and the related "luxurious art" are inherently relative terms, and not susceptible to precise definition.

By "luxurious art" I mean that art which goes beyond the common, minimal expectations in material and craftsmanship of a particular social or religious group within a particular region at a particular time. These expectations could and did vary. For example, common minimal expectations for a copy of one of the writings of the Fathers at a traditional Benedictine monastery in early twelfth-century Burgundy did not demand the best parchment, exceptional calligraphy, elaborate illumination, a wide variety of high quality colors, or gilding. Any copy of the Fathers which went beyond the common, minimal expectations in these regards comprised—in varying degrees—luxurious art. Since a luxurious work of art can range from the moderately precious to the excessive, luxurious art could often be widely acceptable—as in the luxury manuscript believed to have been produced at Clairvaux during the abbacy of Bernard and known as the Great Bible of Clairvaux (Troyes, Bib. mun. 27).

By "excessive art" I mean that art which exceeds the norm of luxurious art of a particular social or religious group in the emphasis put on material, craftsmanship, size, and quantity, as well as in type of subject matter. For example, while a manuscript of one of the Fathers which had very high quality materials and craftsmanship—including a moderate number of illuminations whose subject matter was either neutral or overtly spiritual—would be luxurious but not necessarily excessive, if the same manuscript were pushed significantly further in either size, quantity of illuminations, a subject matter removed from that just described, or any combination of these, then such a manuscript would be excessive according to the standards of the time. Again, the concepts of luxurious art and excessive art are inherently relative and apply to all media.[10]

Bernard did not distinguish five specific "things of greater importance" as I have done in this study. In fact, despite his constant love of breaking down and enumerating the subject at hand, nothing could have been fur-

10. As to other terms used in this study, by "art program" I mean any artistic undertaking involving multiple works of art which is subject to some kind of overview—whether or not that overview involves thematic or aesthetic coordination. By "sacred economy" I mean the system of exchange of spiritual services or privileges for money or goods. While "secular" means just that, by "secular Church" I mean that part of the Church which was non-monastic, by "secular religious art" that art used by the secular Church, and so on. And the noun "religious" refers to those men and women who were bound by vows of poverty, chastity, and obedience and who led a communal life—that is, monks, canons regular, and nuns, as opposed to priests.

ther from his intent. Bernard was concerned with one thing and one thing only in his chapters on art: excessive art as inappropriate to the profession of the monk. In Bernard's view, everything discussed in this study would be subsumed under that heading. Furthermore, another historian could quite easily formulate his or her own "things of greater importance" based upon his or her own reading and approach to the text. Such a list, according to who devised it, could contain any number of primary headings including the acceptability of moderate art, art for the honor of God, the Judaic precedent, art to instruct the illiterate, the monastic infringement on the rights and duties of the bishop, the expense of art, and so on. One might expect Bernard himself to view his chapters along the lines of avarice, art as opposed to voluntary poverty, the dilution of monastic seclusion, materialism, the manipulation and sale of the holy, art as opposed to charity, art as opposed to spirituality, and so on. Also, Bernard did not present his "things of greater importance" in an analytical manner. There are no absolute categories. To be sure, several of the "things" are interwoven in such a way as to be virtually inseparable. Nevertheless, as long as one does recognize the author's approach, analysis can distinguish a number of factors seen by him as at play in the production and function of medieval art.

And that is the primary concern here. In one sense, this study is not an investigation of the *Apologia*, or even of Bernard's opinions on art. Far less is it a narrative of the early twelfth-century controversy over monastic art. What I hope it is, is a study of the issues active in that controversy, a study which may have application to the art of the rest of the Middle Ages and perhaps even to that of other periods.[11] That art was viewed as involving more than the question of affordability, more than the issue of "luxury" per se, more than some vague and unquestioned imperative to honor God would be a satisfactory outcome to this work. For art was seen as having a multiplicity of facets beyond the actual artwork itself. Not every medieval artwork, but certainly the great artistic undertakings commonly studied by art historians today, originated in a complex environment of perceived need, desired result, any number of active or passive resistant factors, and their corresponding justifications before the resultant artistic conclusion could become fact.

Bernard's two chapters on art do not cover all such facets of production. Indeed, this study only takes up those aspects of this process that appear or are referred to in the *Apologia* itself. The *Apologia* is not, and never was intended to be, a programmatic statement on art by the great monastic re-

11. The practicality of this study has been tested: for a direct application of some of its concepts to a crucial art historical moment, see Rudolph 1990.

former. But perhaps even more interesting and useful than that, it is a thoughtful and tempered exposition of his thoughts on the narrower question of monastic art. By being tempered, Bernard gives a far clearer idea of the issues involved in the period in which he was writing than if he were strictly putting forth his personal views, or those he thought ideal for the ideal monk—as in the early Cistercian legislation on art, for example. Instead, in the *Apologia* he offers a succession of intriguing observations not just on the way in which art was perceived, but rather on the way that it was acknowledged to be perceived differently by different orders of society, different wings within those orders, and different factions within those wings. Art was not just a static element in society, or even one which interacted with the various social groups. It was not simply something which was made to decorate or to instruct—or even to overawe and dominate. Rather, it was that and more. It was potentially controversial in ways both similar and dissimilar to its counterpart today. It was something which could by its force of attraction not only form the basis for the economy of a particular way of life, it could also come to change that way of life in ways counter to the original intent. Along with this and because of this, art carried a host of implications, both social and moral, which had to be justified. Indeed, it is from the two related and basic elements of justification and function—claim and reality—that Bernard approaches the question of art in the *Apologia*.

Finally, it was no accident that Panofsky was able to say that a modern art historian would thank God on his knees for the ability to write about art as Bernard had written about art.[12] In his treatise, Bernard rated art above the current monastic issues of his day in importance and took the care to make his position clear. However, centuries of scholarship have shown that it was clear only to his contemporaries who were deeply embroiled in the issues raised. Schapiro was quite right when he cautioned, "The whole of this letter calls for a careful study; every sentence is charged with meanings that open up perspectives of the Romanesque world."[13] Every sentence of *Apologia* 28–29 *is* charged with meanings that open up perspectives of the Romanesque world. And they are the perspectives which were seen by contemporaries as among the most important—the "things of greater importance."

12. Panofsky 1979:25.
13. Schapiro 1977:6.

Translation of Apologia 28–29

[On paintings and sculptures and silver and gold in monasteries]

XII. 28. But these are small things; I am coming to things of greater importance, but which seem smaller, because they are more common. I will overlook the immense heights of the places of prayer, their immoderate lengths, their superfluous widths, the costly refinements, and painstaking representations which deflect the attention while they are in them of those who pray and thus hinder their devotion. To me they somehow represent the ancient rite of the Jews. But so be it, let these things be made for the honor of God.

However, as a monk, I put to monks the same question that a pagan used to criticize other pagans: "Tell me, priests," he said, "what is gold doing in the holy place?" I, however, say, "Tell me, poor men"—for I am not concerned with the verse, but with the sense—I say, "Tell me, poor men, if indeed you are poor men, what is gold doing in the holy place?" For certainly bishops have one kind of business, and monks another. We know that since they are responsible for both the wise and the foolish, they stimulate the devotion of a carnal people with material ornaments because they cannot do so with spiritual ones. But we who have withdrawn from the people, we who have left behind all that is precious and beautiful in this world for the sake of Christ, we who regard as dung all things shining in beauty, soothing in sound, agreeable in fragrance, sweet in taste, pleasant in touch—in short, all material pleasures—in order that we may win Christ, whose devotion, I ask, do we strive to excite in all this? What interest do we seek from these things: the astonishment of fools or the offerings of the simple? Or is it that since we have been mingled with the gentiles, perhaps we have also adopted their ways and even serve their idols?

But so that I might speak plainly, does not avarice, which is the service of idols, cause all this, and do we seek not the interest, but the principal? If you ask, "In what way?" I say, "In an amazing way." Money is sown with such skill that it may be multiplied. It is expended so that it may be increased, and pouring it out produces abundance. The reason is that the very sight of these costly but wonderful illusions inflames men more to give

than to pray. In this way wealth is derived from wealth, in this way money attracts money, because by I know not what law, wherever the more riches are seen, there the more willingly are offerings made. Eyes are fixed on relics covered with gold and purses are opened. The thoroughly beautiful image of some male or female saint is exhibited and that saint is believed to be the more holy the more highly colored the image is. People rush to kiss it, they are invited to donate, and they admire the beautiful more than they venerate the sacred. Then jewelled, not crowns, but wheels are placed in the church, encircled with lights, but shining no less brightly with mounted precious stones. And instead of candlesticks we see set up what might be called trees, devised with a great amount of bronze in an extraordinary achievement of craftsmanship, and which gleam no more through their lights on top than through their gems. What do you think is being sought in all this? The compunction of penitents, or the astonishment of those who gaze at it? O vanity of vanities, but no more vain than insane! The Church is radiant in its walls and destitute in its poor. It dresses its stones in gold and it abandons its children naked. It serves the eyes of the rich at the expense of the poor. The curious find that which may delight them, but those in need do not find that which should sustain them.

Why is it that we do not at least show respect for the images of the saints, which the very pavement which one tramples underfoot gushes forth? Frequently people spit on the countenance of an angel. Often the face of one of the saints is pounded by the heels of those passing by. And if one does not spare the sacred images, why does one not at any rate spare the beautiful colors? Why do you decorate what is soon to be disfigured? Why do you depict what is inevitably to be trod upon? What good are these graceful forms there, where they are constantly marred by dirt? Finally, what are these things to poor men, to monks, to spiritual men? Unless perhaps at this point the words of the poet may be countered by the saying of the prophet, "Lord, I have loved the beauty of your house and the place where your glory dwells." I agree, let us put up with these things which are found in the church, since even if they are harmful to the shallow and avaricious, they are not to the simple and devout.

29. But apart from this, in the cloisters, before the eyes of the brothers while they read—what is that ridiculous monstrosity doing, an amazing kind of deformed beauty and yet a beautiful deformity? What are the filthy apes doing there? The fierce lions? The monstrous centaurs? The creatures, part man and part beast? The striped tigers? The fighting soldiers? The hunters blowing horns? You may see many bodies under one head, and conversely many heads on one body. On one side the tail of a serpent is seen on a quadruped, on the other side the head of a quadruped is on the

body of a fish. Over there an animal has a horse for the front half and a goat for the back; here a creature which is horned in front is equine behind. In short, everywhere so plentiful and astonishing a variety of contradictory forms is seen that one would rather read in the marble than in books, and spend the whole day wondering at every single one of them than in meditating on the law of God. Good God! If one is not ashamed of the absurdity, why is one not at least troubled at the expense?

Previous Scholarship on the Apologia

Despite the universal esteem in which the *Apologia* is held as our single most important source for an understanding of medieval art, and despite the mass of studies that to one degree or another have tried to come to terms with that treatise, there has been virtually no thorough attempt to analyze Bernard's chapters on art as a whole, especially in relation to his other writings, to the patristic literature, to the artistic evidence, and to the political and economic situation of eleventh- and twelfth-century monasticism. Instead, the tendency has been to isolate various passages of *Apologia* 28–29, to the detriment of an understanding of what Bernard was really saying. Largely because of this fragmentary approach, the treatment of the *Apologia* in the secondary literature has emerged in five major issues—or rather non-issues for the most part, because of the general absence of controversy and of progress of scholarship. These major issues are the audience to whom the *Apologia* was addressed, the *Apologia* as a description of Cluny, the artistic polarization of Cluny and Cîteaux, monastic versus secular religious art, and Bernard's personal attitude toward art. In general, it is fair to say that most of the issues are found in an incipient stage in the late seventeenth century in the work of the great monastic historian Mabillon, that they were politicized in the mid-nineteenth century, especially by Charles Montalembert, depoliticized later in that century by Elphège Vacandard (although without changing the received view of the *Apologia*), and so passed into contemporary scholarship. While the literature consulted in this analysis is too large to cite individual authors here, a thorough critique with bibliography has been made elsewhere.[14]

The initial problem for the study of the *Apologia* has been that it does not specifically name one monastery or monastic order (in the current sense of the word) as the subject of the criticisms contained in it. Although Bernard quite clearly and repeatedly addressed his admonitions to William of Saint-Thierry's "order," scholars have believed that, since William was a friend of Bernard, this address must have been a front for an indirect attack

14. For a more extensive critique of the scholarship on the *Apologia*, see Rudolph 1989, of which this section is a very brief summary.

elsewhere. Although the *Apologia* does use the term "Cluniacs" twice, it does so in a way that does not suggest that the treatise is specifically addressed to the Congregation of Cluny. To remedy this, Jean Mabillon prefixed on inconclusive evidence a certain letter of Bernard, Letter 84[bis], to the the first important edition of the *Apologia*. This letter, in recounting an earlier one of William's, did mention "Cluniacs." The result has been to give the appearance that the *Apologia* was specifically addressed to Cluny. It has been under this form that almost every author since Mabillon's revised edition of 1690 has had access to the treatise, until the appearance in 1963 of a new critical edition by Jean Leclercq and Henri Rochais which eliminated the use of Letter 84[bis] as a preface. Furthermore, when the text proper was quoted either extensively or without the aid of the spurious preface, writers from Mabillon to the *Apologia's* recent English translator have employed editing decisions and/or interpolations of some form of the word "Cluniac," as Bernard did not sufficiently use that word to accommodate their conception of the treatise. In response to the general nature of the work, some scholars have suggested that, while addressed to Cluny in particular, the *Apologia* was also addressed to certain other offending Cluniac and non-Cluniac Benedictine monasteries in general.

The confidence and unanimity with which the address of the *Apologia* has been ascribed to Cluny has resulted in profound repercussions for the art historical conception of that abbey. Many scholars have thought that if it were Cluny that Bernard complains about in his treatise, then it must also be Cluny that he describes in his chapters on art. Therefore, the *Apologia* was substituted for historical evidence in their reconstruction of the art program of that abbey. The use of Bernard's denunciation of the worst aspects of excessive art as a catalogue of the artworks as they were believed to have existed at Cluny in 1125 has led to an image of Cluny as a place sated with extravagant works of art and devoted to a conscious policy of excessive art production. This image was compounded by a somewhat misleading comparison with Cîteaux when Cîteaux was at its most impoverished level, yet with references to Cluny at its most affluent period. Such a polarization of the two most visible representatives of contemporary monasticism had its origin in the generation after Bernard and, in our own time, has contributed to a rather limited understanding of the monastic controversy of the early twelfth century, based on a refusal to see the one except in the light of the other. The political interests of the nineteenth-century Church revival, in portraying Cluny as the expression of ecclesiastical grandeur and Cîteaux as the embodiment of ascetic purity, found the polar extremes of the two appealing. The inflexibility of this view in combination with the previous two issues has as a consequence given the impression that excessive ornamenta-

tion was somehow distinctively Cluniac, and to be consistently found throughout the Cluniac Congregation. As a result, in limiting the complaints of the *Apologia* to Cluny or to a few major monasteries, it was only too easy to see those complaints as referring to specific infractions or works of art, rather than as the major flaws of the "things of greater importance."

The question of monastic versus secular religious art represents the only real effort to deal with the substance of *Apologia* 28–29. As such, it takes on an interest larger than the issue itself. The latter is fairly straightforward. Its components of a rejection of excessive monastic art, the characterization of art as a spiritual distraction within the monastery, and the acknowledgement of the usefulness of secular religious art were recognized early on. But the manner in which this issue has developed is quite revealing in regard to the literature's approach to the *Apologia*. Of the three components just mentioned, the one which has received the least attention has been Bernard's rejection of excessive monastic art. In contrast, the concession Bernard made in passing to nonmonastic religious art has at times been dealt with as if it were a major tenet of his monastic treatise. In other words, the tendency in the literature has been to show more concern with the two sentences in which Bernard gave lukewarm acquiescence to the use of art by bishops, than with the two chapters in which he thoroughly criticized its use within the monastery. This isolation of artistically positive aspects of the *Apologia* has detracted from Bernard's real question of whether or not a monastic art should even exist.

The same inclination is seen in efforts to explain the impetus behind *Apologia* 28–29. Ironically, the two main trends in this area are almost entirely contradictory. The premium set on medieval religious art by nineteenth-century Church enthusiasts and "passionate admirers of the ideal Middle Ages"[15] compelled them to denounce Bernard as having no aesthetic sense: in describing this Doctor of the Church as "dominated by violent prejudices against religious art," they thereby reduced Bernard's criticism of art to the personal level and limited the threat of any conflict between the artistic views of one of the most popular of all ecclesiastical figures of the time and the part art—the "most important manifestation of the Church"[16]—played in their plans for a Church revival. In stark contrast, modern methods of psychology have influenced some more recent art historians[17] to describe Bernard as having such a highly developed aesthetic

15. Vacandard ([1895] 1902:v.1:ii) deridingly uses this term in reference to historically selective activists such as Montalembert.

16. Montalembert 1861:8.

17. Most significantly Panofsky ([1946] 1979:25–26) and Schapiro ([1947] 1977:8–9).

sense that he was more susceptible to art than others and that he in fact had to struggle against it. This permitted one to recognize the undeniable position of Bernard against art as expressed in the *Apologia*, while simultaneously allowing him an appreciation of art, even one beyond the normal. But in the end, the image of Bernard as an "iconoclast" had only been replaced with one of him as "demanding" an end to the Romanesque style.

Very little opposition to these views has surfaced. The most notable exception has been Leclercq's warning that the *Apologia* should not be taken as a factual description of Cluniac observance. He cautions that it is a monastic treatise and that if the subject of art is raised, it is done so only in terms of monastic perfection, not from an artistic standpoint.[18] But ultimately there has been no thorough art historical analysis of the *Apologia*. The tendency has been to isolate various passages of *Apologia* 28–29, seeing the *Apologia* as the direct product of Bernard's personal attitude toward art and as a document which, in attempting to impose Cistercian standards on traditional monasticism, denounced virtually all art within the monastery, addressing its criticisms to the abbey of Cluny in particular—which it described and which was the artistic antithesis of Cîteaux—and to a few great Benedictine monasteries in general. In the process, the real value of the *Apologia* as our most important source on the medieval attitude toward art has been almost entirely overlooked.

18. Leclercq 1970b:21–22, 25; 1968:727.

2
THE "THINGS OF GREATER IMPORTANCE"

"I will overlook the immense heights of the places of prayer, their immoderate lengths, their superfluous widths, the costly refinements, and painstaking representations which deflect the attention while they are in them of those who pray and thus hinder their devotion." With these words, Bernard introduced the subject matter of perhaps the most famous work on art ever written in the Middle Ages, chapters 28 and 29 of the *Apologia*. It is also one of the most scathing indictments of religious art of all time. Indeed, these words, which come near the beginning of those two chapters, carry such rhetorical force and attraction that the sentence before it—which actually introduces the section on art—has been almost entirely ignored in the mass of studies which have attempted to come to terms with Bernard's artistic views. Yet this initial sentence is of central importance in any comprehensive analysis of the problem. It makes the transition from the rather long previous section which criticizes contemporary abuses of food, drink, and clothing in the monastery to the section on art: "These are small things; I am coming to things of greater importance, but which seem smaller, because they are more common." Thus, according to Bernard's own statement, he is dealing with excess in monastic life under two main headings, the "small things" and the "things of greater importance."[19] Under "small things," he included intemperance in matters which to one degree or another involve external observance, however significant in the history of monasticism and in the current controversy over the form of monastic life. But it was the "things of greater importance" which he found

19. On the source of these terms, see the commentary under 104:11−12 HAEC PARVA SUNT . . . QUIA USITATIORA. See Leclercq 1970b:14−15 for a more detailed literary outline of the *Apologia* which, however, does not take Bernard's own division of "small things" and "things of greater moment" into consideration.

more objectionable, things not covered in the Benedictine Rule, but things which he put above these particular infractions of the Rule in importance.

Within the "things of greater importance," a factor is at play which has never been fully recognized and whose expression scholars have had a great deal of trouble associating with the monastic nature of this treatise. Little attention has been paid to the fact that a dichotomy exists between Bernard's two chapters on art. In chapter 28, Bernard deals for the most part with the question of the relation between art and the layperson in the monastery. In chapter 29, he generally treats art which was ostensibly intended for the monk alone. That he intended such a distinction is apparent from the manner in which he begins each section. In *Apologia* 28, after a brief introduction to the subject of artistic excess in general in which he conveys the weight he gives to the matter and which sets the limits of his discussion, he takes up the subject of the relation between art and the layperson in the monastery in earnest with the expression "*quid facit*." The expression "*quid facit*" is paralleled in *Apologia* 29 where the subject of art which was ostensibly intended for the monk alone is dealt with. Likewise, in *Apologia* 28 the type of art under discussion is described as "*in sancto* (in the holy place)" and "*in ecclesia* (in the church)" several times—the holy place or church being the liturgical meeting ground of the layperson and the monk. But the transition to *Apologia* 29 makes a rhetorical show of excusing that art which is "*in ecclesia*," turning at this point to the question of that which was "*in claustris* (in the cloister)." Undoubtedly this was the meaning taken by Bernard's contemporaries, one of whom inserted a subtitle separating 28 from 29 which employs the term "*de claustris*," the two chapters being otherwise set apart from the rest of the text with a subtitle using the all-embracing expression "*in monasteriis* (in monasteries)" in the more common arrangement.[20]

Nevertheless, despite the general view of the literature, Bernard clearly indicates that in the case of *Apologia* 28 his main point of attack is directed toward the monk, not the layperson, in the sense of the former's reception of the latter in the monastery: "As a monk, I put to monks the same question that a pagan used to criticize other pagans: 'Tell me, priests,' he said, 'what is gold doing in the holy place?'" Bernard is speaking only to monks

20. The first redaction of the *Apologia* was without subtitles of any kind. These were only added in the second redaction, probably during the life of Bernard (Leclercq 1957:v.3:68, 75). Although Leclercq believes that there is at least a chance that some of the subtitles may have been by Bernard, it seems that he is referring only to the subtitle which begins the section against excess (*Apologia* 16). Bernard's authorship for the joint subtitle of *Apologia* 28–29 seems unlikely to me as that title lacks any significant understanding of the contents of the section and as the manuscripts from Clairvaux are without subtitle.

about artworks which they have had made only for laypeople, and whose purpose is only to attract donations. In other words, he is criticizing the use of pilgrimage art, but not just pilgrimage art in its broadest sense— although he might have liked to do this. Rather, he is criticizing pilgrimage art as it was used at pilgrimage monasteries alone. Furthermore, he is criticizing the use of art at monasteries only in excess. Bernard begins his chapters on art with the clear distinction between certain forms of art whose monastic use, even when admittedly somewhat excessive, he is willing to "overlook" on the one hand and the excesses of the "things of greater importance" on the other.

Finally, as mentioned earlier, my determination of the "things of greater importance" is a strictly art historical one and makes no pretense at reconstructing a definitive series of specific points enumerated by Bernard. As presented in this study, they follow a sequence from the economic base of monastic art production ("Art to Attract Donations: The Monastic Investment") to a discussion of the artistic means by which this was carried out ("Art to Attract Donations: The Liturgical Artwork"), to the reception of excessive art on the part of the general public ("Art to Attract Donations: The Equation Between Excessive Art and Holiness"), to external social objections ("Excessive Art as Opposed to the Care of the Poor"), and to the internal objections of monasticism ("Art as a Spiritual Distraction to the Monk").

What were these "things of greater importance"? Why were they placed above major infractions of the Benedictine Rule in importance, at a time when adherence to the Rule was all important? How was it that Bernard came to write a tract like this at a time when monastic art had achieved levels of density and intensity never before achieved? Clearly, more was at play on the part of the greatest ecclesiastical politician in Western Europe than personal prejudice or idiosyncrasy in these "things of greater importance."

Art to Attract Donations:
The Monastic Investment

"As a monk, I put to monks the same question that a pagan used to criticize other pagans: 'Tell me priests,' he said, 'what is gold doing in the holy place?'" (*Apologia* 28). The answer to this question comprises the heart of Bernard's chapter on the relation between art and the layperson in the monastery, and amounts to no less than a complete denunciation of the use of art to attract donations. And the core around which that argument is built, the basic premise of Bernard's critique of art to attract donations, is the conscious policy of investment in excessive art. But as he himself says concerning the "things of greater importance," they give the impression of being relatively inoffensive precisely because they were so common. The implication is, of course, that they were common among respectable monasteries, those who, even if they were conscious of engaging in such artistic overkill, were at the very least able to offer some sort of plausible explanation for doing so—an explanation which apparently found acceptance with a significant part of the public. Thus, as far as this "thing" was concerned, Bernard's task was twofold, to expose the process by which this took place and to take up as best he could the justifications through which it flourished.

The Process of the Monastic Investment in Art: Gauzlin of Fleury and Suger of Saint-Denis

The simple act of displaying an artwork—say, an image of the Virgin at an altar dedicated to her in a place accessible to the layperson in a monastic church—with the hope of realizing some return from the faithful who might visit that altar was, undoubtedly, objectionable to Bernard. But this is not what he is criticizing in *Apologia* 28. That is, it does not represent the phenomenon in the form in which he indicts it:

> But so that I might speak plainly, does not avarice, which is the service of idols, cause all this, and do we seek not the interest, but the principal? If you ask, "In what way?" I say, "In an amazing way." Money is sown with such skill that it may be multiplied. It is expended so that it may be increased, and pouring it out

produces abundance. The reason is that the very sight of these costly but wonderful illusions inflames men more to give than to pray. In this way wealth is derived from wealth, in this way money attracts money, because by I know not what law, wherever the more riches are seen, there the more willingly are offerings made. Eyes are fixed on relics covered with gold and purses are opened. The thoroughly beautiful image of some male or female saint is exhibited and that saint is believed to be the more holy the more highly colored the image is. People rush to kiss it [and] they are invited to donate (*Apologia* 28).

As presented by Bernard, the process of investing in art for the purpose of attracting donations involved a number of factors. It was induced by a desire for substantial, even exceptional income, not merely the usual offerings of altar or church. Toward this end, very large amounts of money were outlayed in an organized manner. The power of the liturgy was, at times, allied with the artwork. And the artistic focus—as Bernard portrays it in his criticism—was primarily, though not exclusively, bound with the showing of relics to the layperson by the monk.

What Bernard is describing was a very common occurrence among medieval monasteries: the development of lavish art programs in connection with the pilgrimage trade. Perhaps the most useful sources along these lines are Andrew of Fleury's *Vita Gauzlini* of c.1042–1044 and Suger of Saint-Denis' *De Administratione*, probably of 1150 (and to a lesser extent his *De Consecratione, Ordinatio,* and the *Vita Sugerii*).[21] One of the remarkable things of these two—I believe—related works, and of others like them such as the *Vita Richardi* and that part of book two of Hugh of Flavigny's *Chronicon* which deals with the life of Abbot Richard of Saint-Vanne at Verdun,[22] is that the biographical and autobiographical emphasis is on the administrative rather than the spiritual qualities of the protagonists. These protagonists are typically not saints. To see that there is more at work here than changing fashions in biography, one need only compare book one of the *Vita Prima*, a biography of Bernard which is contemporary with Suger's writings, where the absence of any facility at or even interest in administra-

21. Rodulfus Glaber also noticed a connection between building programs and relics, although one probably working under a different order of precedence than in the more sophisticated operations of Gauzlin and Suger; *Historia* 3:4:13, 3:6:19, p.62, 68. Cf. Jerome, *Vita S. Hilarionis* 31, PL 23:47.

My reasons for proposing the date of 1150 may be found in Rudolph 1990:20–24.

22. The very first thing mentioned in the *Vita Richardi* after Richard's becoming abbot is his systematic increase of the liturgical artworks of the monastery; *Vita Richardi* 7, p.283; cf. Hugh of Flavigny, *Chronicon* 2:7–10, p.373–377; and Dauphin 1946:103–127 for an account of Richard's art program and the relics involved. On Richard's reform movement and its ties to Cluny, see Sabbe 1928:551–570. On the renewal of the scriptorium by Richard, see Cahn 1982:109.

tion on the part of Bernard is consciously played down by William of Saint-Thierry.[23] Furthermore, the art programs which they detail and which receive such a truly remarkable amount of attention took shape during periods of reform: economic and supposedly consuetudinary in the case of Suger (and Richard) and, as Fleury stood in no need of consuetudinary reform by contemporary standards, largely just economic in the case of Gauzlin. This is in no way to say that economic and/or consuetudinary reforms were a prerequisite of significant artistic renewal, but the fact remains that they often did accompany a conscious policy of investment in art for financial return.[24]

In stark contrast to William's portrayal of Bernard, Andrew begins the *Vita Gauzlini* with open praise of Gauzlin as a great administrator and maintains this throughout his account with example after example of fiscal coups won by the abbot. It was not enough to praise the patron of the abbey's art program as another Moses or Solomon, the "patrons" of the art programs of the Tabernacle and the Temple.[25] Gauzlin's goal is quite clear: "in emulation of the deeds (*emulatusque monimenta*) of the famous Maccabeus who augmented his ancestral lands by force, he was conscious of his similar vow toward the amplification of his monastery (*sui loci*)."[26] It was no accident that this major statement concerning the administration of Gauzlin was made in preface to the first artistic renovation of Gauzlin's discussed by Andrew, the recovery of Germigny-des-Prés. This is not because Andrew's task was one of cataloguing the artistic acquisitions made under Gauzlin. It is because Gauzlin's task was one of economic expansion and glorification by whatever means were expedient. And art fit into this plan by being expedient to both. This certainly seems to be the point of Andrew's reference to Judas Maccabeus. For it was Judas Maccabeus who, after "augmenting his ancestral lands by force," restored the temple in Jerusalem (1 Macc 4:36–61). The phrase used by Andrew, *emulatusque*

23. Cf. the antithesis of Gauzlin and Suger in the two abbots excoriated by William of Malmesbury (*De Antiquitate* 66, p.134), the one for losing abbey lands, the other for dissipating church ornaments; and the criticism of another abbot as a "fool" by his own monks for preferring reading and writing in the cloister to administrative aggressiveness (Orderic Vitalis, *The Ecclesiastical History* 3, v.2:52).

24. However, it does seem that the most interesting art programs do come often from abbeys which underwent some form of reform, especially consuetudinary reform. Cf. Bernard's advice to a certain abbess that the care she showed in restoring the buildings of her convent be matched in "renovating (*renovandis*)" the way of life of her nuns; Letter 391, v.8:360.

25. Andrew of Fleury, *Vita Gauzlini* 22, 54, 66, p.62, 92, 136. The reference to Gauzlin as "a most pious Moses" occurs in connection with donations made to the "tabernacle of the Almighty" at Fleury. The allusions to him as Solomon were also in reference to artistic activities.

26. Andrew of Fleury, *Vita Gauzlini* 3, p.38.

monimenta, is exactly that used later by him in reference to the emulation of Gauzlin's artistic achievements by his successor, Arnaud.[27]

But more importantly, Andrew describes how, after the fame of Gauzlin himself had increased as a result of his efforts, King Robert came on the feast of Saint Benedict, normally a traditional day for showing relics at Fleury. No mention is made of his venerating the relics, however. Instead, he is made to be so consumed with the beauty of the church that he cried. After this fascinating reaction, he contributed heavily to the monastery.[28] What is most striking about Andrew's presentation of what it seems we should take as the ideal response of the ultimate pilgrim is not the surprisingly common effect that this art could have. Rather, it is that after so briefly mentioning the feast of the patron saint of the abbey, whose relics were among the most important of all France, the subject reverts to art—not to relics, not to the holiness of the saint, not to his miracles. This attitude is true throughout the *Vita*. In the midst of a litany of various triumphs of recovery and acquisition of land and rights, Andrew mentions a trip made to Rome by Gauzlin and the spoils he returned with. Andrew gives priority to two "quite amazing and almost inimitable" silver candelabra which Gauzlin "stumbled upon" (one almost expects to read, "that Gauzlin was lucky enough to stumble upon") and for which he paid sixty pounds. Andrew follows this with a description of the newly acquired relic of the burial cloth of Christ for which Gauzlin paid only one thousand *solidi* but which, he adds—perhaps a bit too defensively—was preferable to any kind of ornament. Once again, however unconsciously, relics and the spiritual phenomena of which they are the focal point are given a position of secondary importance relative to art.[29] And not only is the procurement of

27. Andrew of Fleury, *Vita Gauzlini* 64, p.128. It seems that the use of *monimenta* with respect to Judas Maccabeus was meant to give some implication of his restoration of the temple as well as the deeds leading up to it, and so to both types of activity on the part of Gauzlin. Indeed, after a detailed account of his embellishment of the abbey church, Andrew describes Gauzlin as a noble Solomon in reference to his renovation of Fleury; *Vita Gauzlini* 66, p.136. In ch.65 (p.134), Andrew relates how Gauzlin had the habit, when gazing upon his own artistic accomplishments, of paraphrasing Augustus, "I found a city of brick, and I will leave it of marble" (cf. Suetonius, *De Vita Caesarum*, Augustus 28:3, p.62). Cf. also Odilo of Cluny, who used to say that he found the monastery of Cluny of wood and left it of marble; Jotsaldus, *Vita S. Odilonis* 13, PL 142:908. The context of this reference is not merely one of simple aggrandizement, but rather one of correcting the previously unworthy architectural expression of the dignity of a particular place.

28. Andrew of Fleury, *Vita Gauzlini* 66, p.136.

29. Andrew of Fleury, *Vita Gauzlini* 20, p.60. Odo of Deuil displays the same habit, or describes people with the same habit, in his account of the Crusaders at Constantinople; *De Profectione* 4, p.64–66. While this attitude is more related to the aesthetics of holiness than to any question of holiness itself—as in the East—the *Libri Carolini* (3:24, p.153–155) did reject any attempt to equate art and relics.

artworks listed alongside that of relics, they are both listed alongside that of land and privileges, with the prices for all being given. Indeed, they are all listed with costs because they were all part of Gauzlin's economic reform of that great abbey.[30]

A microcosmic illustration of Gauzlin's economic reform is found in Andrew's account of Germigny-des-Prés. This church, which had once been owned by Fleury but was later lost, was recovered through a combination of guile, shrewd business sense, and an appeal to traditional rights. Once Fleury's power was reasserted over it, relics were supplied from various sources, as were the reliquaries and other liturgical artworks which, again, receive the greater part of Andrew's attention. Finally, the income of the new investment was assigned to the support of the monks of Fleury.[31] To this general reconstruction of the sacred economy were added a number of other economic stimuli, often with the consent of the community, such as the waiving of all tolls to foreigners with the exception of that on grain, which might adversely affect Fleury's own regional economy.[32] Aside from this encouragement of trade and pilgrimage, lost properties (including towns) and rights were recovered, new ones acquired, the bishop contended with, monks placed in high offices, and secular churches procured, built, and renovated.

But in the end, art was still the centerpiece of Gauzlin's plans, as Andrew's *Vita* shows. When Gauzlin ordered an Italian artist to make a crucifix of exceptional work (*insignis operis*), the first thing he did with the finished work was to display it in the most aggressive manner possible: he formed his monks up into a procession and carried the new artwork beyond the limits of the monastery—something apparently contrary to the rules of the house and so all the more forceful. The faithful of both sexes were allowed to join in the liturgical act, thus drawing even more attention to the work.[33] The reaction of the participants, again, was one of tears.[34] Despite

30. On this attitude, see Hugh of Saint-Victor, *De Sacramentis* 2:9:10, *PL* 176:476–478.

31. Andrew of Fleury, *Vita Gauzlini* 3, p.38–40.

32. Andrew of Fleury, *Vita Gauzlini* 71, p.142.

33. The exclusion of women at a particular liturgical level was so common that the specific mention of their participation apparently could at times imply some kind of special event. With Gauzlin, the reinforcement of the social bond seems also to have been a factor—in this case in conjunction with liturgical art. But it could also be financial, as in the case of the events related to the miracles which took place at the Cistercian abbey of Meaux (Yorkshire) immediately after the installation of a new carved crucifix there. The abbot petitioned the Chapter General to allow him to permit the entry of women into his abbey church (Cistercians excluded women from their churches by law). The reason given was that "if women had access to the previously mentioned crucifix, the general devotion would be increased and in this the advantage of our monastery would very much abound;" Thomas of Burton, *Chronica*, Hugo 10, p.35–36.

the veneer of spontaneity to this story, Gauzlin's awareness of the power of art was high: when he decided to build a new tower to the west of his church and was asked by the same King Robert what sort of work he was undertaking, he answered, "Such a work as to be an example to all of Gaul."[35] Andrew, who had already mentioned that the stone for the tower was to be imported ashlar, then goes on to list numerous accouterments for the church, many of which were from Byzantium or Spain or were exceptional in material or craftsmanship—showing the lengths to which Gauzlin went to ensure the desired effect.

To be sure, the themes of imported art and artists and superlative materials and craftsmanship run throughout the *Vita Gauzlini*.[36] But neither Gauzlin nor Andrew seem to have had much interest in projecting a justification for excessive art beyond the honor it gave to the monastery or its investment nature. Thus, when Gauzlin had the opportunity to buy an unusually magnificent golden alb, he did so not for the honor of God or for Saint Benedict in particular, but for the honor of "his" monastery (*ad sui loci honorem*). And when a mason fell while rebuilding the church, the monks zealously prayed for the restoration of his health, for, as Andrew himself drily notes in his *Miracula Sancti Benedicti*,

> Indeed, we were afraid that, if he should give up the spirit, the work would be interrupted by the broken morale of the entire common people, which seriously threatened the funding as well as the supply of labor for the completion of the work. For the common people are fickle and their instability of mind pushes them along in any direction whatsoever, like a reed blown about by the wind. They might perhaps have murmured that Father Benedict had no concern at all for his own [holy] place, and did not care if anything opposed to that work should occur.[37]

The monastery did not want to be cheated out of the income attracted by the building simply through the clumsiness of one of the workers.

Finally, just how large economic and artistic activities loomed in the mind of Gauzlin/Andrew is indicated by Gauzlin's talk of his own death in which he seemed to give those activities pre-eminence among his earthly duties: "Brothers and sons . . . just as by the grace of the Almighty I have built a suitable house of earthly habitation for you, so in the same way I will prepare your heavenly palace, going before you from here."[38] It is al-

34. Andrew of Fleury, *Vita Gauzlini* 65, p.132.

35. Andrew of Fleury, *Vita Gauzlini* 44, p.80.

36. On the general significance of imported labor and materials, see Warnke 1979:93–94.

37. *Miracula S. Benedicti* 8:30, p.328.

38. Andrew of Fleury, *Vita Gauzlini* 72, p.142.

most needless to add that Bernard would have argued that an abbot prepared the heavenly palace for his monks through his spiritual, not economic or artistic, guidance while on earth.

Suger, who was more sophisticated than Gauzlin/Andrew in both technique and theory, seems to have learned his lessons from Andrew's account. The startling similarity between the *Vita Gauzlini* and Suger's *De Administratione* (and to a lesser extent, his *De Consecratione*) is indicative, I believe, of both administrative and literary imitation on the part of Suger who, as so many have said, was fond of heroes. According to Panofsky, Suger probably spent 1104–c.1106 studying at Fleury.[39] As the *Vita Gauzlini* is known in no early copies outside the manuscript believed by Bautier to actually have been that which was dictated and personally corrected by Andrew,[40] it seems that the probability is good that not only did Suger study at Fleury, but that he studied Andrew's *Vita Gauzlini* while there—going through the archives of that monastery in the same way that he says he went through them at Saint-Denis.

The similarities are legion. The entire concept of an account of an abbot's administration as an essentially economic, non-spiritual reform[41] with a restructuring of abbey properties as the base for an expansive art program seems to have been taken by Suger from Gauzlin/Andrew, as does the general literary format of first listing the acquistion and recovery of land and rights, followed by what the profits from such undertakings came to be invested in, namely artworks. It should be noted that Suger gave as much attention to the economic aspect in his writing as Andrew did, with around 55 percent of *De Administratione* being devoted to fiscal matters and the rest, a very large amount indeed, to art. Like Andrew, Suger listed the prices paid for both land and art; however, his more organized account and Panofsky's readily accessible yet truncated edition tend to draw one's attention away from the fact. The underlying focus on art as an investment ostensibly to boost relics but in the end actually in conjunction with them

39. Panofsky 1979:225; cf. Cartellieri 1898:4, 127 (5). Waquet (1929:vi) suggests Fleury or Marmoutier; Benton (1986:4) tends toward Marmoutier. The place of Suger's studies is problematic. Toward the end of his life, he describes himself as having studied "in those parts (*in partibus illis*)" in relation to Fontevrault; Suger, Letter 14 (Lecoy 1867:264). Fleury is "in those parts" in relation to Fontevrault given the fact that Suger was writing in Paris, and that Fontevrault was down-river from Fleury. Fleury was also the most important school in those parts. In addition, there is a certain logic in Suger's not naming Fleury as the place of his schooling, if indeed he did study there, since Fleury was for the moment the main competitor with Saint-Denis as the burial place of the French monarchy—Philip I, Louis VI's father, having fairly recently been buried there.

40. Bautier 1969:23–25.

41. Suger claimed to have reformed his abbey, although to what degree this was the case is open to question. For the most complete account of Suger's reform, see Constable 1986:18–20; for my own views, see Rudolph 1990:8–11.

as the centerpiece of the monastery's economy not only has its parallels in both the *Vita Gauzlini* and *De Administratione*. There is also a striking similarity between the mutual tendencies in the *Vita Gauzlini* and in Suger's writings to record the inscriptions on works of art, inscriptions which linger fondly on the subjects of gold, precious stones, and the donor. The appearance of Gauzlin's aborted and Suger's successful wall mosaics, the latter though "contrary to modern custom," also suggests a relation. One even wonders whether Gauzlin's construction of the west tower at Fleury suggested to Suger that he begin his work on that aspect of the church which was most likely to attract attention and funding. Indeed, both were meant to serve "as an example," *in exemplum*, to those around them.[42] Finally, a host of other similarities are more or less characteristic of the time: the stress on imported art and artists; on the encouragement of trade; on the development of resources; references to Solomon or David; to community consent; to the desire to record so minutely so many artworks for posterity; the emphasis on material and craftsmanship; on cost; on speed of construction; on royal support and tears; on the artistic primacy of respective abbey churches. All these form a pattern which—when seen in conjunction with the more particular parallels mentioned above, with the overall conception, and with the general format—suggests an indirect source for the writings of Suger.

Yet, Suger seems to have gone beyond Gauzlin in his application of the concept of the mutually reinforcing investment of underdeveloped holdings and potential pilgrimage income—or at least the limitations of the sources lead us to believe this. For example, not only did Suger expand and renovate abbey lands along the same lines as did Gauzlin at Fleury but, when miraculous events, especially cures, were reported at an unused chapel on land held by Saint-Denis near Corbeil, he took the opportunity to cultivate the land, establish a priory, and develop a pilgrimage to the spot, with a share of the profits going to the mother house.[43] The rebuilding of the west end of Saint-Denis was itself something of an act of social compromise, with Suger relinquishing certain tax rights over the people of the village of Saint-Denis in return for 200 pounds toward its completion.[44] Two hundred pounds was a considerable sum; in fact, it was the amount fixed by Suger for the annual construction budget, a budget which encapsulates his program of artistic investment.[45] In other words, Suger's documented view of

42. Andrew of Fleury, *Vita Gauzlini* 44, p.80; Suger (Lecoy 1867:423).
43. Suger, *De Administratione* (Lecoy) 18–20, p.177–182.
44. Suger (Lecoy 1867:319–322).
45. Of the 200 pounds, 100 were to come from offerings at the fair of the Lendit and 50 from the fair on the feast day of Saint Denis, both important days for drawing pilgrims, many of whom were there for business as well as to venerate the relics. The other 50 were

the likely sources of funds applicable to the program was a combination of income either from people attracted to Saint-Denis by relics or art (in conjunction with trade), or from his economic reform. To what degree Suger's policy of expenditure on art was seen as a conscious means to attract donations may be guessed from his statement, "At first, expending little, we lacked much; afterwards, expending much, we lacked nothing at all and even confessed in our abundance."[46] Or as Bernard said, a great pouring out of money produces riches.

Art for the Honor of God and the Obligation to Spend

The justification of art for the honor of God has two primary components, the doctrinal and the traditional. The claim of the doctrinal component is that the veneration shown to an image passes on to its prototype.[47] The claim of the traditional component, really a debasement of the doctrinal, is that the honor shown to God and the saints through the ornamentation of the holy place or through the provision of images passes on to whoever is honored with the ornamentation and images—with all honor ultimately passing on to God. While the doctrinal component was rarely challenged by orthodox circles during the period under consideration,[48] the traditional component was questioned under certain circumstances. And it was just such a qualified questioning that Bernard put forth in the Apologia.

Despite a few references in the Vita Gauzlini to the display of art for the honor of God or the saints, neither that particular theme nor any other attempts to justify why the excessive art program of Gauzlin was developed. Certainly, the reason for this is not that such justifications were not current at the time, or even that Andrew was unaware of them, but rather that there simply was no need, in his view, to elaborate what everybody knew.

to come from a newly cultivated possession in Beauce whose annual yield was normally almost twice that; if for some reason it failed, the difference was to be made up from other holdings there whose recent renovations had doubled and trebled their annual output. To this was added the money from the collection box and anything specifically donated for the building. Suger, De Consecratione 4, p.103.

46. Suger, De Consecratione 2, p.90. The same phenomenon is expressed in a different way by Andrew of Fleury: with the rebuilding of Fleury, the fame of Gauzlin spread and the king came, bringing valuable donations; Vita Gauzlini 66, p.136.

47. This was expressed most authoritatively by the monk and bishop Basil the Great, De Spiritu Sancto 18:45, PG 32:149. Basil's definition was repeated in the important De Imaginibus (3:41, PG 94:1357) by the Eastern theologian John of Damascus, a number of whose works were known in the West during the Middle Ages. The adoration shown to the deity through an image passes on to the deity; the veneration shown to a saint through an image also passes on to the deity.

48. Cf. Libri Carolini 3:16, p.136–138.

That is, despite widespread and constant resistance to excessive art on many levels, it had never been challenged in such a way as to put its supporters truly on the defensive since the Early Christian period. The ground swell that had been forming long before Bernard and which was taking shape in the years previous to 1125 broke—as far as monasticism was concerned—with the appearance of the *Apologia*.

In the letter of Cardinal Matthew of Albano, the papal legate and former prior of Cluny and of the Cluniac monastery of Saint-Martin-des-Champs, to the traditional Benedictine abbots who had gathered at Reims in 1131 and who were about to meet again at Saint-Médard at Soissons in 1132, we are presented with an attitude toward monastic art which is not dissimilar to that of Andrew, but which at the same time was presented by someone who was familiar with the *Apologia*. When I say that his position is not dissimilar to Andrew's, I do not mean that it was out of date, but rather that it was presented more or less as an unchallenged justification, as a justification which did not conceptually respond to contemporary criticisms, but which could only repeat time-honored catchphrases in the belief that in themselves they carried sufficient authority to respond to the challenges to monastic art.

For example, just as Andrew referred to Gauzlin as another Moses, Solomon, and acting in emulation of Judas Maccabeus, so Matthew cited the same figures as a justification of religious art in his defense of traditional monasticism.[49] And Matthew's specific references to gold and silver in monasteries,[50] to 1 Maccabees 4:57 which mentions *coronae* (crowns used in one way or another as ornament), to Psalm 25:8 (whose significance is discussed below), and to the distinction between the episcopal and monastic use of art suggest that he was writing, if not in direct response to Bernard, at least with Bernard in mind. Furthermore, as in the *Apologia*, the importance of art is given expression by its placement at the end of the work, where it appears as the climax of the running argument. Yet, although Matthew was aware of what Bernard was getting at, he sidestepped the main issues raised by Bernard through a combination of repetition of traditional justifications and his own economic critique-of-a-sort hurled at the reforming Benedictines, charging that, while they had made the easy changes of reducing the accretions to the *opus Dei*, they were unwilling to cut their profitable ties with lay society in the form of the possession of secular churches, tithes, and estates.

49. Matthew of Albano, *Epistola* p.330–332.
50. Matthew of Albano, *Epistola* p.331, "vel auri vel argenti quippiam in monasteriis"; cf. the title of *Apologia* 28 as it appears in most manuscripts of the second recension, "De . . . auro et argento in monasteriis."

Matthew's primary position on art is that as far as monks are concerned, the purpose of art, which he links with the liturgy, is for the glory of God and Holy Mother Church. To detract from or to diminish the worship and reverence of the divine majesty is actually impious. In fact, one would have to be insane,[51] in Matthew's opinion, to attribute the use of art to another person's desire for his own pleasure and glory. To support the belief that art is commanded of man by God, he cites the examples of Moses and Solomon. But more to the point, he falls back on the simple argument of precedent as found in the actions of Christian emperors, kings, princes, holy and apostolic pontiffs, and, notably, venerable abbots. All these, he argues, have acted as prescribed in 1 Maccabees 4 : 57, "They adorned the facade of the temple with golden crowns (coronae)." This reference to the precedent of those who followed the example of the secular leader Judas Maccabeus, on whom Gauzlin modelled himself, and to Judaic religious practice, which Bernard disparaged in the Apologia, is symptomatic of Matthew's avoidance of the real issues involved in the acceptability of art within monasticism. Matthew fails to discriminate between areas of secular religious art and monastic art, apparently because of an unwillingness to publicly recognize that to many of his readers such a distinction did, in fact, exist. When he raises the objection of certain unnamed persons that religious art belongs to the episcopal sphere, he "answers" by resorting to other (non-artistic) areas of questionable monastic practice and in the end never confronts the issue at all. Such a refusal is tantamount to tacit recognition of the assumption of pastoral duties by monasticism. And his heavy reliance on the justification of monastic art on the grounds of the artistic gifts of "emperors, kings, and other princes" suggests an only slightly veiled appeal to the alliance between traditional monasticism and monarchy which did so much to further the Cult of the Dead, a practice currently somewhat out of fashion among such monastic groups as the Cistercians. He goes on to state that those Christian leaders, both secular and ecclesiastical, episcopal and monastic, who adorned the temple with coronis aureis, with golden crowns, can sing with the psalmist, "Lord, I have loved the beauty of your house and the place where your glory dwells" (Ps 25 : 8). Finally, he raises the specter of heresy, stating that those who would destroy religious art are worthy of eternal damnation.

Suger also takes the Apologia into consideration in his writings without attempting to answer it directly.[52] Like Matthew, he essentially avoids the less defensible issues of art to attract donations and art as opposed to the

51. Insanus; cf. Bernard's use of insanior in Apologia 28.

52. Panofsky (1979:15) feels that Suger's works were "largely directed against Cîteaux and Clairvaux," a position with which I disagree; see Rudolph 1990:12–18.

care of the poor. However, his relatively developed justifications of art for the honor of God and the saints and of art as a spiritual aid must be seen as intended to answer some of the issues raised by Bernard, although not necessarily in specific response to the *Apologia*.

The general pattern in Suger's writings is one of ever-increasing justification from the *Ordinatio* (1140 to early 1142) in which art for the honor of God is mentioned in only the most formulaic way, to *De Consecratione* (sometime soon after June 1144) in which the same subject is treated only superficially, and on to *De Administratione* (probably of 1150) in which the theme receives perhaps its most classic treatment in the Romanesque and Gothic periods.[53] Likewise, whereas *De Consecratione* shows only the vaguest traces of a theory of the justification of art as a spiritual aid, the more ambitious presentation of this justification found in the later *De Administratione* suggests that Suger's defense was in fact not planned in the original conception but only arose later.[54] Just why this happened could be because of any number of reasons. But in light of the reaction against Suger's administration after his death in January 1151 and of the distinct change in tone concerning artistic matters from the encyclical letter on the occasion of his death to the later *Vita Sugerii*, it seems that an important part of Suger's justifications may have been an awareness on his part to a rising resistance within Saint-Denis to his policies.[55]

In any event, Suger's concept of art for the honor of God is one which is wholeheartedly traditional on the one hand and inextricably linked to his policy of investment (artistic or otherwise) on the other. His writings are filled with commonplace references to art for the honor of God and the saints.[56] But beyond this, he presents an elaboration of the traditional justi-

53. Suger, *Ordinatio* p.131; *De Consecratione* esp. 2, 4, 5, p.90, 98, 106; *De Administratione* esp. 27, 30, 33, 34A, p.46, 52, 64f, 81. Suger's justifications are taken up in greater detail in Rudolph 1990:26–31, 48–63.

54. Suger, *De Consecratione* 5, 7, p.106, 120; *De Administratione* esp. 27, 33, 34, p.46–48, 62–64, 72–74.

55. It was no accident that the account of Suger's art program in the *Vita Sugerii* is immediately followed both by a reference to a letter of Bernard's which compares Suger to David and by Peter the Venerable's attestation that alone among his contemporaries Suger built not for himself but only for God; William of Saint-Denis, *Vita Sugerii* 2:10, p.392 (cf. Guibert de Nogent's accusation that Hélinand of Laon's art program was not for the honor of God, but rather for himself; *De Vita Sua* 3:2, p.270–272). It should be noted that Suger referred to himself in one way or another in his artworks at least thirteen times. In the preface of the *Vita Sugerii*, the author implies that the glories of Suger were being played down and later openly criticizes the fact that Suger's *Vita* had not yet been written—something which can only have been directed at Odo of Deuil, Suger's successor and an ally of Bernard.

56. A partial listing: *Ordinatio* p.130, 134; *De Consecratione* 4, p.98; *De Administratione* 31, 33, 33 A, 34 A, p.54, 66, 76. Suger's attitude of ascribing all to God and the saints is common enough; what is of interest is the way he uses it as a justification of excessive art.

fication based on Old Testament precedent—explicitly slighted by Bernard who cites Early Christian authority for his position. Presented in its most articulate form in the remarkable thirty-third chapter of *De Administratione* but also found elsewhere, this justification consists of a number of different elements. One of the most important and certainly the most widely recognized is his reference to the Old Testament Psalm 25:8, the same justification that Matthew of Albano fell back on in his letter to the Benedictine abbots: "Lord, I have loved the beauty of your house, and the place where your glory dwells."[57]

Previously seen as possessing only a strictly spiritual interpretation based on the authority of Augustine and Cassiodorus,[58] Psalm 25:8 was at the time of the *Apologia* taking on a literal interpretation as well in regard to art. Whereas the author of the *Libri Carolini* explicitly rejected the views of the Nicene Council of 787 which saw an artistic justification in this passage,[59] around 1110–1111, or immediately before the *Apologia* was written, the monk Rupert of Deutz stated his belief in a literal interpretation of the artworks mentioned in the Old Testament in general (not on the basis of Ps 25:8).[60] However, in Hildebert de Lavardin's *Vita S. Hugonis* of c.1121–1125, a definite, if tentative, application of Psalm 25:8 is made to specific artworks—the great abbey church of Cluny III and its ornamentation—by this important and influential author. More a justification of

Suger also uses a number of other traditional justifications of varying significance, such as rebuilding with the consent of the community, supernatural aid in finding building material and jewels as a sign of divine approbation, miraculous events during the building of the church, an uncommonly short building period, saving as much of the old building as possible, the necessity of rebuilding because of crowding and ruin, the unworthiness of the existing art program for the glory of the abbey, the continuation of previous traditions, and so on.

57. "Domini, dilexi decorem domus tuae, et locum habitationis gloriae tuae."

58. Augustine, *Enarrationes in Psalmos* 26:8, p.141; Cassiodorus, *Expositio Psalmorum* 25:8, p.232–233; Van Engen 1980:157–158. While the accepted interpretation of Ps 25:8 at this time was spiritual, the later literal interpretation shows up in imagery much earlier than it does in writing—although whether for simple narrative reasons or whether as an informal exegetical commentary on the psalm is uncertain. For example, see the illustration of Ps 25 in the Stuttgart Psalter (Stuttgart, Württembergische Landesbibliothek 23:31v) of c.820–830 where far more liturgical art, including textiles, is shown than is necessary either to convey the meaning of the psalm or to indicate a sanctuary by means of traditional artistic devices. Also, Pope Hilary (461–468) had Ps 25:8 inscribed above the door of the Oratory of John the Baptist, which he added to the Lateran Baptistry; Lauer 1911:467.

59. *Libri Carolini* 1:29, p.57–59.

60. Rupert of Deutz, *De Officiis* 2:23, p.56–58; Van Engen 1980:157. Rupert's attitude should be seen as indicative of a broader movement of which his work is an expression, not the impetus. It should also be pointed out that in his argument, Rupert was quite open about his disagreement with a number of the Fathers, including Jerome.

spending on art than a justification of excessive art itself, Hildebert's defense on the financial as opposed to the artistic front is indicative of attacks in that direction against Hugh of Cluny, the builder of Cluny III, and probably against excessive artistic expenditure in general.[61] A less stridently justificative tone is found in an anonymous *Vita* of Hugh of the 1120s where Psalm 25:8 is referred to twice. It appears the first time in the manner typical of most later occurrences, that is, as a simple justification of the idea of art for the honor of God. The second time, however, it is framed in such a way as to take into consideration both the old and the new exegeses of this passage.[62]

It is this latter manner of presentation that Suger first used in *De Consecratione* in a rather indirect reference to the new exegesis, but only in such a way that the artistic interpretation was given literal force and nothing more.[63] However, in his later use of the verse in *De Administratione*, it is central to perhaps the most important passage of all of his writings—his theory of the justification of art as a spiritual aid.[64] Here, Suger combines the increasingly popular interpretation of Psalm 25:8 as a straightforward justification of sacred art with the justification of art as a spiritual aid, and so the two mutually reinforce each other. Significantly, Psalm 25:8 was also used by Suger's biographer, William of Saint-Denis, in the encyclical letter circulated after Suger's death to sum up not just his art program at that monastery but both his artistic and economic endeavors

61. Hildebert de Lavardin, *Vita S. Hugonis* 10, col.420 (*PL* 159:867–868); see the section "Expenditure on Art as Similar to Almsgiving" for more on this passage.

62. *Miracula S. Hugonis*, col. 458, "Utriusque autem gloriae, gregis scilicet et loci, beatus Hugo sollicitus institit procurator coram Deo et eius angelis, pura dicturus conscientia, 'Domine, dilexi decorem domus tuae, et locum habitationis gloriae tuae.'" On the dating of both *Vitae* of Hugh, see Hunt 1968:15–17. Although I in no way wish to ascribe the origin of the use of Ps 25:8 as an artistic justification to either Hildebert or the anonymous author of the *Miracula*, it is interesting that these two early examples should be associated with Cluny. Cf. also the use of Ps 25:8 by Hugh of Saint-Victor which, although said specifically about an artwork, actually employs the traditional meaning of the verse; *De Arca Noe Mystica* 15, PL 172:702–703.

63. Suger, *De Consecratione* 5, p.104, "Jesus Christ himself being the chief cornerstone which joins one wall to the other; in whom all the building—whether spiritual or material—groweth unto one temple in the Lord. In whom we, too, are taught to be builded together for an habitation of God through the Holy Spirit by ourselves in a spiritual way, the more loftily and fitly we strive to build in a material way"; cf. Eph 2:19–22. It seems that the architectural allegory of Paul—and perhaps the role of the Holy Spirit which was an important element in the writing of Rupert and Theophilus—suggested the new exegesis of Ps 25:8 to Suger. Cassian, *Conlationes* 14:6, p.402, which mentions both the psalm and Paul, may have been influential in this.

64. Suger, *De Administratione* 33, p.62, "Thus, when—out of my delight in the beauty of the house of God—the loveliness of the many-colored gems has called me away from external cares. . . . "

together.[65] Finally, the confident manner of Suger's later use of Psalm 25:8 suggests that the alternate exegesis had by this time achieved a general recognition. In fact, it was a rapidly spreading, popular interpretation as both numerous other examples and Bernard's cautious handling of it show.[66]

But Suger also used the more traditional and time-honored justification of direct emulation of Old Testament practice.[67] More or less initiating his argument with the catchphrase so common in the writings of the contemporary monastic crisis, "Let every man abound in his own sense" (Rom 14:5),[68] he makes the argument that if golden vessels were used for the blood of animal sacrifices by the command of God, how much more appropriate is it to use such vessels for the blood of Christ in the form of the Eucharist. He quite agrees with the "detractors" who insisted that a saintly

65. William of Saint-Denis,*Vita Sugerii*, p.405, appended to the *Vita Sugerii*. William, too, was conscious of the novelty of the new exegesis of this passage as his emphasis on the validity of his interpretation shows: "[Suger] can therefore chant in all assurance with truth before the Lord, 'Lord, I have loved the beauty of your house, and the place where your glory dwells' (Unde veraciter et secure Domino decantere potest: Domine, dilexi decorem domus tuae et locum habitationis gloriae tuae)."

66. For example, Lehmann-Brockhaus 1955:14 (probably late twelfth century), 1524 (twelfth century), 2054 (after 1148), 4054 (William of Malmesbury, c.1125), 4706 (second half of the thirteenth century), 5472 (first half of the thirteenth century); Lehmann-Brockhaus 1971:98 (mid-twelfth century), 1875 (after 1158), 2023 (a very interesting example dealing with the abbey of Saint-Trond; 1169 according to Mortet 1929:12–13), 2763 (probably early twelfth century), 2859 (said in 1187 in reference to a particularly lavish *corona*). See also Theophilus, *De Diversis Artibus*, preface to bk.3, p.61–62 (Theophilus, who especially relates Ps 25:8 to liturgical artworks, takes both the old and the new exegeses into consideration; 1106–1150); Honorius Augustodunensis, *Gemma Animae* 1:32, *PL* 172:586 ("ut domus tali decore ornetur," c.1130); Odo of Deuil, *De Profectione* 3, p.54–56; and Mortet 1929:300 (in reference to a Premonstratensian abbey; 1274). It is interesting that the majority of these references are monastic or monastically related.

67. This tradition goes back to the earliest days and is too widespread to document. However, for an indication of its role in the current controversy, Gilbert Crispin offers an informative account of Old Testament precedent in his discussion between a Christian and a Jew over the question of the legitimacy of religious imagery; *Disputatio* 153–161, p.50–53. Honorius Augustodunensis justified sculpture and painting on the basis of their respective prototypes in the Ark of the Covenant and Solomon's Temple; *Gemma Animae* 1:133, 123, *PL* 172:586, 584. Rupert of Deutz likewise referred to the Old Testament precedent (Ex 25–27) and also to various of the Fathers; *De Officiis* 2:23, p.56–58; and *De Trinitate: In Exodum* 4:44, p.802. And even Bernard himself employed the Old Testament precedent of the Tabernacle in his account of the miraculous origins of the oratory of Saint Malachy; *Vita Malachiae* 63, v.3:368; cf. Heb 8:5 (and Ex 25:40 upon which the latter is based). For the opposition to the claim of justification by Old Testament precedent, see the section "Piety and Poverty for the Honor of God."

68. Suger, *De Administratione* 33, p.64. Peter the Venerable used this same authority in one of his apologetic letters to Bernard; Letter 111, p.279. The classic source for this in relation to art is Jerome, Letter 130:14, v.7:185–186, where it is used by Jerome in toleration, not defense, of excessive art.

mind, a pure heart, and a faithful intention are enough.[69] But he feels that it is necessary to do homage to God, who has not refused to provide "all things without exception," through the outward ornaments of sacred vessels.[70] To not repay God with the very gifts he has given and so proclaim his generosity might result in a diminution of divine benefactions.[71] In other words, Suger felt that the great prosperity which the abbey was undergoing as a result of his economic reform was the result of the favor of God and the saints and that it was his duty to reciprocate with the gifts that they had bestowed upon Saint-Denis.[72] Even so, one hardly had a choice, since the saints—whose generosity also had to be repaid—demanded the best, whether Suger wanted it or not.[73]

In short, there was an obligation to spend. Actually, this obligation was inherited from both Christian teaching and aristocratic self-image.[74] As far as monasticism was concerned, the issue was not whether or not one should spend, but rather what one should spend on. As to spending itself, perhaps the most straightforward monastic source is found, again, in Hildebert de Lavardin's *Vita* of Hugh of Cluny where it is said of Hugh, "He declared that they [silver and gold] shine more when they are spent than when they are retained."[75] However, in the same way that the Mosaic, Davidic, and

69. Suger, *De Administratione* 33, p.64–66. The reference to a pure heart is probably from Chrysostom, *Homiliae in Matthaeum* 50:3, PG 58:508. Cf. William of Malmesbury's statement that the early Cistercians preferred shining minds to vestments shining with cloth of gold; *Gesta Regum* 4:337, p.385 (PL 179:1290).

70. Suger, *De Administratione* 33, p.66. Although Suger puts great emphasis on the patron saints and relics of the abbey church throughout his texts, the attention here is entirely on the Eucharist, undoubtedly to justify the most primary liturgical vessels, but also probably with respect to the controversy over the relation between the eucharist and relics; see Geary 1978:28–29.

71. Suger, *De Consecratione* 1, p.84.

72. A similar but more strictly artistic position is taken by Rupert of Deutz (*De Trinitate: In Exodum* 4:44, p.802) and Theophilus (*De Diversis Artibus,* preface to bk.1, p.2–3) who see the employment of artistic skill in the worship of God as one aspect of this return of favors. On Suger's theory of reciprocity, see Maines 1986:80–81 and Rudolph 1990:26–28.

73. Suger, *De Consecratione* 5, p.106.

74. The Christian tradition was most clearly embodied in the responsibilities of the bishop for his people. On public building by the bishop as a measure of self-protection with aristocratic overtones, see Brown 1982:40.

75. "Ea melius impensa, quam servata rutilare praedicabat"; Hildebert de Lavardin, *Vita S. Hugonis* 5, col.417 (PL 159:864); Leclercq 1965:37. This statement, which was made in reference to the care of the needy, was entirely in keeping with Church doctrine and may have as its authority either Ambrose, *De Officiis* 2:137, p.260 (repeated in Ivo of Chartres and Gratian) or Jerome, Letter 130:14, v.7:185–186, where these two Doctors of the Church put the care of those in need over art. However, Hugh's idea of art, spending, and the poor cannot be said to be in true agreement with Ambrose and Jerome. See the section "Art as Opposed to the Care of the Poor" where the subject is taken up in greater detail.

Solomonic precedents of the secular or episcopal duty to embellish the house of God was absorbed by monasticism, so the obligation of monasticism to spend became deflected into art—as opposed to some other area, such as almsgiving. Furthermore, this attitude was reinforced by another concept, the relation between material and spiritual prosperity.

THE RELATION BETWEEN MATERIAL AND SPIRITUAL PROSPERITY

Paradoxically enough, reform seems to have been one of several underlying causes permitting the attitude which saw large-scale investment in art as legitimate for monks. This is by no means to say that art was necessarily part of any reform movement at this time. But it often did accompany the reform of individual houses, especially as the crowning achievement of the physical aspect of that renewal. Potentially part of the Cluniac reform, as for example at Saint-Martial at Limoges, it was also common with other reform movements. Consuetudinary reform, whether originating externally or internally, was often accompanied by an economic restructuring of the monastery's properties. The liturgical reorientation brought about through consuetudinary reform seems in many cases to have also involved an initial economic reform. This economic reform was typically undertaken in order to sustain the often increased number of monks and accouterments felt to be necessary for the proper staging of the *opus Dei*, the increased solemnity of which was the heart of the consuetudinary reform—the depleted economic condition of these monasteries in turn frequently inviting consuetudinary reform in the first place. This was especially true in the West following the disintegration of the Carolingian socio-economic structure. Initial support from local powers by outside influence was typically followed by a broader base of supporters eager to capitalize on a promising situation. Thus, when the Norman nobles saw the economic success of the ducally backed William of Volpiano, they flocked to offer further aid.[76]

Obviously, it was institutional successes like this which permitted the undertaking of ambitious art programs. Indeed, the relation between Benedict of Aniane and the Carolingian rulers, especially Charlemagne, suggests that such programs were even forced upon the occasionally hesitant monastic reformers. What is somewhat less obvious is the air of contemporaneity and achievement conferred in the process upon lavish monastic art programs by such reform, whether financed internally or externally. As far as I

76. Rodulfus Glaber, *Historia* 3:5:16, p.66, "Quodcumque denique monasterium proprio viduabatur pastore, statim compellebatur tam a regibus vel comitibus quam a pontificibus, ut meliorandi gratia illud ad regendum susciperet, quoniam ultra cetera divitiis et sanctitate ipsius patrocinio assumpta cernebantur excellere monasteria."

have been able to determine, this concept was never formally put forth as a theory of monastic life, but did in fact enjoy a very wide and acknowledged currency.[77] Rodulfus Glaber's reference to this idea merely mentions a relation between sanctity and riches, with William of Volpiano stating that when monks strictly observed the Rule they never lacked anything.[78] And Guibert de Nogent saw a "reverse" manifestation of this when he noted that the cooling of the love for holy life resulted in a reduction of material prosperity.[79] But by far the most characteristic expression of the relation between material and spiritual prosperity is that put forth by Abbot Odo of Saint-Jean d'Angély who in 1090 enlarged and "reformed" the *camera* of his monastery so that material need would in no way cool the monks' ardor.[80] And Gilo, in his *Vita* of Hugh of Cluny, discusses the topics of the artistic excellence of the abbey church of Cluny III and monastic life there together, specifically associating Hugh's rebuilding of Cluny with a wave of new recruits.[81] Put more directly, Ermenricus, Bishop of Passau, said in

77. The idea of the relation between material and spiritual prosperity is distinct from the widely recognized need for material security in order to maintain a normal spiritual life for a community. Cf., for example, *Pontificale* 36, v.1:122, where anyone wishing to build a church is required to show that various budgetary aspects have been provided for; and Lupus of Ferrières, Letter 71, p.75 where he refers to the beneficial effect of "imperial munificence" on the stability of religious life (*religio*). This is also what Suger is referring to when he describes material prosperity as necessary to spiritual matters, "to sustain them [his monks] with the necessities of life lest they break down on the road (labores et certaminum sudores quibuscumque seu spiritualium seu temporalium remediis alleviare, victualibus, ne deficiant in via, sustentare)"; *Ordinatio* p.123; Suger returns to the same idea a little further on. The passage is a clear reference to the story of the second miracle of the loaves and fishes of Mt 15:32 (cf. Mk 8:3), "ne deficiant in via"—and perhaps so an indirect and rather immodest reference to Suger's own multiplication of resources at Saint-Denis. See also *De Consecratione* 2, p.88. In *De Consecratione* 6, p.112, Suger draws a more figurative parallel between the material and the spiritual, "Their [certain bishops'] outward apparel and attire indicated the inward intention of their mind and body."

78. Rodulfus Glaber, *Historia* 3:5:16, p.66, "Ipse quoque firma testabatur assertione quia, si huius institutionis tenor quocumque loco a monachis custodiretur, nullam omnino indigentiam cuiuscumque rei paterentur." The previous sentence makes it clear that Rodulfus was speaking equally of both the material and the spiritual.

79. Guibert de Nogent, *De Vita Sua* 1:8, p.50, "decedente inter habenas iniquitatum seculo, sanctae conversationis refrixit caritas, et rerum opulentia, quasdam postmodum sensim deseruit ecclesias." Cf. *Vita Theoderici* 17, p.46, where a rather similar observation is made.

80. "Ego, Odo, indignus abba huius sancte Angeliacensis ecclesie, camerum huius domus in melius reformare et amplificare studui, ne forte, quod absit, fratribus in hac domo Deo sub regulari tramite militantibus, corporea adversetur necessitas, ac per hoc in eis sancti preposti tepescat spiritualis disciplina"; ed. G. Musset, *Cartulaire de Saint-Jean d'Angély*, Archives historiques de la Saintonge et de l'Aunis 30 (Paris 1901) v.1:46, no.20; cited by Constable 1971:306.

81. Gilo, *Vita S. Hugonis*, p.606. The same themes are taken up in the anonymous *Miracula S. Hugonis*, col.458. Although I do not wish to overemphasize the point, an influx of new recruits also means an influx of donations from those recruits; the distinguished

praise of the abbey of Saint Gall, "One can well see by this nest what sort of bird lives in it."[82]

The end result of this as far as art is concerned was that the belief in a relation between material and spiritual prosperity as a result of reform seems to have led to the specifically monastic acceptability of material wealth—as distinct from the corporate accumulation of wealth in the aristocratic milieu of medieval monasticism. This acceptable material wealth was used for the honor of God by embellishing his house and the liturgy that took place within it. But in many cases, this process came to be dealt with just as if it were another of the economic enterprises which financially permitted it. It was this to which Bernard objected.

The Response: Piety and Poverty

PIETY AND POVERTY FOR THE HONOR OF GOD

As far as medieval moral theology was concerned, there was no situation which vindicated the investment in excessive artworks for the purpose of attracting donations through the overawing of the faithful. Yet there was a justification which sanctioned art for the honor of God, and it was a small step to interpret this as sanctioning excessive art programs for the same reason, programs which, as the *Codex Calixtinus* shows, attracted attention and therefore donation-giving pilgrims for their own sake.[83] It is art for the honor of God that Bernard sees as the operative justification for the monastic investment in art and, in effect, for unrestrained avarice.

Bernard begins *Apologia* 28–29 by defining the limits of his critique of excessive art. He is willing to admit as acceptable a certain amount of artistic superfluity, and the rationale he gives for this is that it is made for the honor of God. Actually, he does this for several reasons, none of which constitute a real acceptance of that justification.

To begin with, Bernard tries to convey the impression of condonation, or even better, of compromise. But the areas he is willing to overlook despite their stated superfluity and ability to distract from spiritual endeavors are the basic artistic categories of architecture and religious imagery.[84] His

recruits mentioned by Gilo would in most cases have brought with them commensurately distinguished donations upon entering.

82. Ermenricus, *Ad Grimaldum*: 27, p.565.

83. On the *Codex Calixtinus*, see the next section, "Avarice and the Necessity of Pilgrimage Art."

84. "*Curiosas depictiones.*" See the commentary under 104:13–14 CURIOSAS DEPICTIONES, on why I believe this term refers to religious imagery.

grudging tolerance of immoderate architecture may be related in part to the demands of the expanding monastic populations, a problem to which he himself was forced to submit with the enlargement of Clairvaux around 1135–1145—his biographer being careful to evoke the traditional caution against excessive architectural undertakings, Luke 14:28, "This man began to build, but was not able to finish."[85] But the reference to religious imagery is little more than a statement of orthodoxy on Bernard's part, a necessity to a person like him, and here passed off as a concession. Although the Cistercians prohibited sculpture and nearly all painting in their churches, they did not do so in rejection of Gregory the Great's doctrine on the acceptability of art to educate the illiterate and as a spiritual aid—which would have been heretical—but only as an institutional decision to forego art as a distraction to themselves as monks.

No, Bernard is making the most of the situation, and trying to turn it to his own advantage rhetorically. Accepting the inevitable, at least as far as religious imagery goes, he steals his opponents' justification that such art is for the honor of God—a traditional justification which he could never hope to overcome—makes it his own, and in so doing gives the impression that he has accepted that justification and that anything that follows in his discussion goes beyond it. However, after his critique of what does go beyond it, he winds up *Apologia* 28 by returning to the subject of art for the honor of God. It is no coincidence that Bernard takes this up in its justificative form of Psalm 25:8, the same form used by Hugh/Hildebert, Matthew of Albano, Suger, Theophilus, and so many others: "Unless perhaps at this point the words of the poet may be countered by the saying of the prophet, 'Lord, I have loved the beauty of your house and the place where your glory dwells.'" In so doing, he implies that this is one of the justifications used for the excesses he has just deplored. Indeed, Bernard is not alone in his rejection—whether explicit or otherwise—of this new interpretation of Psalm 25:8.

In this Bernard was joined by his friend, William of Saint-Thierry, and his colleague, Aelred of Rievaulx, together the three most powerful and

85. Arnold of Bonneval, *Vita Prima* 2:29, *PL* 185:285. The complete Biblical passage is Lk 14:28–30. In recent times it has been cited by a member of the United States Senate in opposition to President Reagan's defense buildup; *Los Angeles Times*, Feb. 8, 1985, pt.1:6.

Bernard's apparent expression of grudging tolerance may also have been an open statement that he was not singling out the monastery of Cluny, whose third abbey church was then reaching an important stage of completion, for any more special attention than he may have just given it. For the question of the *Apologia* as addressed to and as a description of Cluny, see Rudolph 1988 and the section "Cluny, the Cluniacs, and the Non-Cluniac Traditional Benedictines."

influential Cistercian writers in the most important period of Cistercian literature. In agreement with Cassian's standard monastic work, the *Conlationes*, as well as with Augustine and Cassiodorus, they give a mystical interpretation to the psalmist's verse.[86] To Aelred, the beauty of God's house is in the "equity" of love and unity, not in gold, silver, and distractive works of art.[87] Furthermore, such things are completely out of agreement with monastic poverty.[88] Although not in response to Hildebert, William's argument against a literal rendering of Psalm 25:8 neatly fuses the issues of donations, excess, poverty, and the poor and could have been written as a direct rebuttal. The true beauty of the house of God is not material, but exists in reality in voluntary poverty and holy simplicity.[89] And the response of the Benedictine abbots to Matthew—believed by some to have been written by William—specifically repudiates the former's position on Psalm 25:8 saying, "As to the beauty of the house of God which was put forward as a justification (*praetenditur*) to us and which the prophet declares that he loves, it is interior."[90] As to Bernard, outside of the *Apologia* he consistently follows the mystical exegesis with the one exception of when he is writing to the "accursed" people of Rome.[91] Yet in the *Apologia* he simulates agreement, noting that even so, occasion is given for shallowness and avarice. It is just these two qualities, shallowness and avarice,

86. Cassian, *Conlationes* 14:6, p.402. Augustine, *Enarrationes in Psalmos* 26:8, p.141. Cassiodorus, *Expositio Psalmorum* 25:8, p.232–233. Cf. Van Engen 1980:157–158.

87. Aelred of Rievaulx *Sermones*, p.123–124, 127, "Furthermore, contemplating the heavenly temple, the prophet said, 'Your temple is holy and wondrous in its equity' (Ps 64:6). How is it wondrous? In gold and silver or in precious stones? Or floors covered with marble? Or do walls dressed in purple or violet, altars brilliant with gold and jewels make that temple wondrous? 'Your temple is holy and wondrous.' In what way? Undoubtedly in equity. O equity! Where is equity? What is equity? Where there is nothing uneven, nothing crooked, nothing misshapen, nothing distorted [cf. *Apologia* 29]: there is equity. This equity does not exist except in love and unity. O bright house, I have loved the beauty of your house, and the place where your glory dwells. . . . Peter said, 'I have no silver or gold, however, what I have I give to you' [Acts 3:6]. . . . Peter who first merited to enter that temple (*domus domini*), namely the Holy Church, by faith and the sacraments as it were, through the portal of grace, did not give riches of the eye."

88. Aelred of Rievaulx, *De Speculo Caritatis* 2:70, p.99; cf. also *De Institutione* 24, p.656–657.

89. William of Saint-Thierry, *Ad Fratres* 147–150, p.258–262.

90. *Responsio* p.348. The *Responsio* is attributed by Ceglar (1979:302) to William of Saint-Thierry.

91. Letter 243:4, v.8:132. Even here there is a fair amount of ambiguity. For the traditional use of Ps 25:8 by Bernard, see Letters 382:1, 510, v.8:346–347, 469; *Super Cantica* 27:4, 33:1, 38:3, 46 (in which the house is seen as both the Church and the individual soul), 58:3, v.1:184, v.1:234, v.2:16, v.2:56–61, v.2:128; *In Commemoratione S. Michaelis* 1:4, v.5:296; *In Festivitate S. Martini* 6, v.5:403; *De Consideratione* 5:9, v.3:473. *De Laude Novae Militiae* 9, v.3:222 seems, at least, to hint at Ps 25:8 in its use of Ps 92:5.

that Bernard sees as the real impetus for the exaggerated monastic concern with art for the honor of God.

According to Bernard, it is through diligent and sincere obedience that honor is shown to God, not through the example of the Judaic rites[92] that Suger and so many others claimed as precedent. In fact, the Judaic precedent as regards excessive art was one of empty formalism to Bernard.[93] And not only was the intention behind it wrong, but the deflection of monasticism's obligation to spend from areas of traditional institutional and social responsibility to that of art was little more than theft.[94] It was the Early Christian and especially the early monastic model to which Bernard appealed in his call for monastic piety and poverty.[95] Those who (like the

92. Bernard, *De Laude Novae Militiae* 9, v.3:222.

93. See the commentary under 104:15 ET MIHI QUODAMMODO . . . IUDAEORUM. Jerome, too, saw the Judaic precedent as a formalism to be rejected, and gold along with it as well; Jerome, Letter 52:10, v.2:185–186. The authority of Jerome on this subject was further disseminated in Gratian, *Decretum* causa 12:2:71 (col.710–711). Shortly after the death of Bernard, Idung of Prüfening referred to the authority of Jerome in relation to the excessive liturgical artwork, "Either we repudiate the gold along with the rest of the superstitions of the Jews, or if the gold is pleasing, the Jews are pleasing;" *Dialogus* 1:37, p.390. Claudius of Turin took an even more forceful position on the subject, see Russell 1965:16. Cf. also Jerome, *In Johannem*, p.517–518, where Jerome describes how Christ was not known when he was in the Temple, filled with liturgical art, but was proclaimed in the desert by the prototype of the monk, John the Baptist; and *De Nativitate*, p.524–525, where he straightforwardly rejects the use of gold and silver (with reference to the Old Testament precedent) for the honor of God. While not rejecting lavish art itself, the *Libri Carolini* did reject the justification of an Old Testament precedent for such art—although for reasons of external rather than internal policy; for example, *Libri Carolini* 1:18–20, 2:9, p.42–48, 70. Cf. the opposing position of Pope Hadrian I, Letter, *PL* 98:1267.

94. Cf. Letter 42:6–7, v.7:105–107. Odo of Cluny was equally as blunt as Bernard in his rejection of monastic art for the honor of God; see *Collationes* 3:13, *PL* 133:599–600. What Peter Damian thought of monasticism's obligation to honor God through art may be seen in his story of Abbot Richard of Saint-Vanne suffering in a Homeric hell, endlessly building, destroying, and building up again his works of art; Letter 8:2, *PL* 144:465. (But cf. his *De Institutis* 30, *PL* 145:362, where he distinguishes between anchorites and monks proper, associating excessive art with the latter.) Although not available in Latin during the Middle Ages, the use of art by monks as a means of honoring God was denounced by Pachomius, who actually destroyed a church which he had built because its beauty was such that honor went to it rather than to God; this passage is in the Syriac version of the *Paralipomena* 32, p.55.

95. Bernard called for a return to a model of poverty based on the Apostles, fishermen who cast their nets for the souls of men, rather than for gold and silver; Letter 238:6, v.8:118. The theme of the monastic life as being in imitation of the apostolic life is a constant in Bernard's writings; for example, *In Labore Messis* 3:7, v.6:pt.1:226; *De Diversis* 22:2, 27:3, v:6:pt.1:171, v.6:pt.1:200; *Vita S. Malachiae* 17, 44, v.3:326, v.3:349–350. The avoidance of wealth through voluntary poverty is a form of martyrdom; *In Festivitate Omnium Sanctorum* 1:15, v.5:341. Cf. Jerome, Letter 58:2–7, v.3:75–82 on monastic avarice and the Early Christian model.

Apostles) have left all to follow Christ do not seek gold, as Bernard said in his *De Consideratione*, nor do they seek the principal, but only the spiritual interest of their investment.[96]

To Bernard, piety is the worship of God, and it is in the heart that the monk honors him who has established himself in the heart.[97] The beauty of the soul consists in its intentions, and intentions are pure only if in all things one seeks the honor of God, the benefit of those around one, and a good conscience.[98] Since the intentions of those who embellish the church for temporal gain are not pure according to this definition, such actions are not effectively for the honor of God, nor should they be tolerated as such.

Indeed, in his view art for the honor of God is foreign to the monastic ideal of voluntary poverty, which is the proper way for a monk to show honor to God.[99] According to Bernard, the layperson offers to God not his or her body, but rather that which is necessary to the body. The prelate offers freely what has been given to him freely.[100] But since God would not ask from monks what they had left behind for love of him[101]—that is, the things of the world—it follows that the monk who offers excessive art for the honor of God could be seen as operating as a non-monk, as a secular churchman. The monk's duty is not to give to God what another has given to him, but to give himself—to do less would be ritualistic.

AVARICE AND THE NECESSITY OF PILGRIMAGE ART

In a memorable phrase, Bernard said, "The body of man will be sated with air before his heart is sated with gold."[102] He saw avarice as one of the basic characteristics of human nature, and it certainly must be one of the most recurrent topics in his writings. It is the root of all evil,[103] and this was nowhere more evident to him than in the display of excessive art: "Does not avarice, which is the service of idols, cause all this, and do we seek not the

96. *De Consideratione* 4:12, v.3:458. Cf. the similar passage in *Apologia* 28 which is based on Phil 4:17.

97. *De Diversis* 14:2, 125:3, v.6:pt.1:135, v.6:pt.1:406.

98. *De Diversis* 122, v.6:pt.1:399.

99. *De Laude Novae Militiae* 9, v.3:222. Cf. *In Vigilia Nativitatis* 1:5, 4:6, v.4:201, v.4:224, where he describes Christ's poverty as more glorious than gilded thrones and other treasures. Cf. also *In Festivitate Omnium Sanctorum* 1:15, v.5:341; and *In Psalmum 'Qui Habitat'* 3:4, v.4:395.

100. *In Ramis Palmarum* 1:4, v.5:45.

101. *In Psalmum 'Qui Habitat'* 3:4, v.4:395–396. Cf. *In Epiphania* 3:5, v.4:307.

102. *Ad Clericos de Conversione* 26, v.4:101, "Non ante satiatur cor hominis auro quam corpus aura satientur."

103. Bernard, *In Psalmum 'Qui Habitat'* 6:4, 15:9, v.4:407, v.4:474.

interest, but the principal?" (*Apologia* 28).[104] Far more than a misplaced conception of devotion, it is to the element of avarice in artistic investment that Bernard objects.

Accusing certain segments of monasticism of a lack of concern toward the spiritual interest accruing to their investment, he condemns them for caring only about recouping their financial outlay, their principal. According to the ideals of traditional monasticism as expressed in the Benedictine Rule, it is wrong for a monk to sell goods produced at the monastery even as high as the market price, with some monasteries, such as Cluny, extending this ideal to buying as well.[105] And Theophilus, following the Rule, admonishes his readers concerning profit made from the selling of artworks—as does Rupert of Deutz, on the grounds that their talent is not their own but God's.[106] To Bernard, and many monks would have disagreed with him, there was nothing inherently wrong with having gold or silver. The evil came with their abuse; their solicitation was even worse; but seeking a profit from them was the most disgraceful of all.[107] More reprehensible still was the profit sought from investment in religious art, for it amounted to profiteering from the sacred economy, or as Bernard put it, "selling the bride [of Christ]."[108] Indeed, to Bernard it was no less than a selling of the holy: "Do you ask whom I call impure? He who . . . rates piety as profit, he who seeks not the interest, but the principal."[109] But the selling of Masses, litanies, burials, and so on which was such an integral part of traditional monasticism's Cult of the Dead, and which the Cistercian monk Idung criticized around 1155, is never taken up with any real force by Bernard.[110] Instead, what Bernard criticizes is the tendency of some monks to

104. For this phrase, see the commentary under 105:9–10 ET UT APERTE . . . DATUM?

105. Benedict of Nursia, *Regula* 57. Hunt 1968:81–82. While Cluny received all pilgrims, the poor, and travellers, it refused—according to its written customs at least—admittance to the curious and to businessmen; Hunt 1968:65.

106. Theophilus, *De Diversis Artibus*, preface to bk.3, p.63. Rupert of Deutz, *De Trinitate: In Exodum* 4:44, p.802.

107. *De Consideratione* 2:10, v.3:417–418, "Ipsa quidem, quod ad animi bonum spectat, nec bona sunt, nec mala; usus tamen horum bonus, abusio mala, sollicitudo peior, quaestus turpior."

108. *Super Cantica* 77:2, v.2:262. Bernard apparently met resistance to his criticisms on this point.

109. *Super Cantica* 62:8, v.2:160; cf. *Apologia* 28 on this reference to Phil 4:17. See also *In Psalmum 'Qui Habitat'* 9:2, v.4:436, where Bernard criticizes the seeking of donations under the pretext of their having been made in the name of God. To Gregory the Great, impiety is always present in avarice; *Moralia* 14:63, p.737.

110. Idung, *Dialogus* 1:34–37, 3:31, p.389–390, 452–453. Idung makes only the vaguest association between the Cult of the Dead and art to attract donations. His criticism of excessive monastic art is largely based upon the *Apologia*, which he cites, attacking art

"immerse themselves again in worldly cupidity, erecting walls with great care, but neglecting morality."[111] This moral neglect did not arise with the erection of the walls, however, it arose with what went on within them—the manipulation of the Cult of Relics in conjunction with art as a source of income: "When people rush to kiss it [the image of a saint], they are invited to donate" (*Apologia* 28).

While the sources are more voluminous on the subject of the abuse of relics to attract donations than that of art, there was one contemporary of Bernard's who wrote on the relation between the two, Guibert de Nogent. A solid member of the establishment, Guibert was by no means opposed to the material prosperity of the monastery. In his autobiography of around 1115, he relates how at a time when there seemed to be no hope of the monastery of Nogent growing beyond the six monks that its domain could support, a very poorly planned attempt was made to rebuild the abbey church on a larger scale. It seems that this undertaking attracted donations from all of the local powers, including those involved in the consecration of the new church (as at Suger's consecration of Saint-Denis). A new abbot who was renowned neither for his learning nor for his birth but rather for his administrative abilities was elected—and the fortune of the monastery was made.[112] Nevertheless, in the area of the sacred economy proper, the area of the exchange of spiritual services or privileges, Guibert rivals Bernard in his denunciation of the manipulation of art and relics for gain. In his *Gesta Dei per Francos*, a copy of which was owned by Clairvaux in the twelfth century,[113] he wrote, "I do not dispute that it is from piety that the bodies of the saints are covered with gold and silver, but it is quite evident

from the angles of curiosity, excess, the poor (referring to the traditional passage of Ambrose discussed in the section, "Expenditure on Art as Similar to Almsgiving"), and Judaic precedent (citing Jerome's Letter 52, which Bernard follows in his tract). His only reference to art to attract donations is as follows, "Vester ordo, quia illa quinque sensuum oblectamenta, sicut noster ordo, non amputavit, plura accipit, quia pluribus indiget, non necessitate, sed sola voluntate."

Bernard did criticize the concept of the parish church as a commodity, especially in respect to monasticism. Concerning a controversy over altar rights in which Marmoutier was involved, he admonished that the sons of light and peace preferred darkness to light and temporalities to peace (Letter 397:3, v.8:375). And to the papal chancellor Gerard (later Pope Celestine II), "May your charity be amplified, rather than your chapels multiplied" (Letter 525, v.8:492). The issue of the use of secular churches as a funding source for excessive art programs brought about a break between Bernard of Tiron, the prior of Saint-Savin-sur-Gartempe, and his abbot over that abbey's famous art program; Gaufridus Grossus, *Vita B. Bernardi Tironiensis* 14, PL 172:1376–1377.

111. *In Laudibus Virginis Matris* 4:10, v.4:56. The reference to walls is from Sir 49:15 (Sir 49:13).

112. Guibert de Nogent, *De Vita Sua* 2:2, p.226–228.

113. Wilmart 1917:190.

that the exhibitions of relics and the tours of reliquaries are in the service of outrageous avarice for the collection of money."[114] Clearly, Guibert accepts both the veneration of relics and the use of religious art. But like Bernard, it is the application of both to avaricious ends to which he objects.

The traditional source of income of the old monasticism was extremely large grants of money and land from the aristocracy in return for special remembrances in the Office of the Dead and other spiritual services.[115] But

114. Guibert de Nogent, *Gesta Dei per Francos* 1:4, PL 156:695. The Carolingian administration was actually forced to write in 811 to the bishops and abbots of the realm concerning the abuse of relics and art; in this case the translation of relics "from place to place" in conjunction with the construction of new churches, apparently for the purpose of attracting donations; Charlemagne, *Capitularium* 72:7, p.163. Cf. Peter the Cantor's criticism (*Verbum Abbreviatum* 86, PL 205:257) of "the lies of preachers and mercenaries;" Walter of Châtillon (*Dilatatur Inpii*, p.107), "Many are rebuilding the walls of Babylon, / through which the house of the Lord is made a den of thieves." Reliquary tours and mercenary preachers seem to be more common during the Gothic period, which is, however, beyond the scope of this study.

115. While not taken up by Bernard in the *Apologia*, the issue of the use of ill-gotten gains in the financing of artistic undertakings is an important one. Many, such as Idung and Peter the Cantor (both of whom cite Bernard and Jerome for support in their overall arguments), believe that it is wrong to accept the donations of great sinners in return for prayers—arguably the basis of the Cult of the Dead of traditional monasticism; Idung, *Dialogus* 1:33–35, 3:31, p.388–389, 452–453 (Rupert of Deutz is said by Idung to agree with this position). Peter the Cantor goes even further than Idung in suggesting that monasteries only accept donations on Christmas, Easter, Pentecost, the feast of the patron of the church, and the burial and anniversary of the dead; *Verbum Abbreviatum* 29, 86, PL 205:106–107, 257–258. Also related to the Cult of the Dead, the Carthusian customary—written by Guigues de Châtel, who edited the letters of Jerome—specifically associates excessive liturgical art with donations, in particular with the donations of those who would most need intercession having accumulated their wealth immorally, usurers and excommunicants; Guigues de Châtel, *Consuetudines Carthusienses* 40:1–2, PL 153:717–719. And Odo of Cluny denies the acceptability of donated ornamentation which was paid for through improper means; *Collationes* 2:34, PL 133:580–581.

On a more general level, according to Chrysostom (*Homiliae in Matthaeum* 50:3, PG 58:508), the money paid for donated artworks is to have been honestly earned. This passage was apparently the one referred to by the emperor Louis the Pious in his instructions to Eigil upon the latter's assumption of the troubled abbacy at Fulda; Candidus, *Vita Eigilis* 10, p.228. Cf. Gregory the Great, *Moralia* 12:57, p.662–663, who denies the spiritual efficacy of alms from ill-gotten gain; cf. also *Moralia* 22:27–28, p.1112–1113, and *Dialogorum Libri* 3:26:5–6, p.368–370. Abelard criticizes excessive liturgical art in relation to the monastic Cult of the Dead; Letter 4, p.85–86. John of Salisbury tells how one Carthusian abbot refused the ill-gotten money offered by another Carthusian who had become a wealthy but venal legate; *Historia Pontificalis* 39, p.77. The customs of Grandmont enjoin the monks to not seek donations if they have enough for only one day more; Stephen of Muret, *Regula* 4, PL 204:1145. Cf. the model of one of the Desert Fathers who accepted nothing at all from others; Palladius, *Historia Lausiaca* 113, PL 73:1196. However, the principle of the incorrectness of accepting money from improper sources is by no means Christian in origin, having its literary precedent at least in the work traditionally but erroneously ascribed to Aristotle, *On Virtues and Vices* 5:4, p.494. See also Aristotle, *Politics* 1:10, p.28–29, where usury is rejected as unnatural.

after reaching a peak in the late eleventh century, this form of revenue seems to have begun to enter a relative decline for the great Benedictine monasteries. Peter the Venerable, abbot of Cluny at the time that the *Apologia* was written, complained bitterly of the great drop in this type of support.[116] There is no reason to believe that Cluny's faltering *opus Dei* was unique: the trend seems to have been shifting from the Cult of the Dead to the Cult of Relics.[117] Furthermore, there was great pressure on monasticism to divest itself of many sorts of income derived from properties which theoretically should have been controlled by episcopal or secular authorities.[118] This loss of income had to be made up from elsewhere. And the greater the existence of the emerging money economy, the greater the dependence on the cash offerings carried by increasingly free, mobile, and wealthy non-aristocratic pilgrims. And so the greater the need for art to stimulate these offerings.[119]

116. Peter complains that the kings of Europe are "equal to their predecessors in affection, but unequal in generosity (Pares sunt praedecessoribus suis in amando, sed dispares in largiendo)"; Letter 131, p.332. Cf. Guibert de Nogent, *De Vita Sua* 2:2, p.226, 228, where similar but less diplomatic reference is made to this drop in support, with Guibert complaining that the men of the previous generation were more generous with gifts of land and money than their sons are with kind words.

117. It is not a question of a lessening of concern over the soul after death, but rather very narrowly of how that concern manifests itself in the sacred economy. As usual, Suger had his finger on the economic pulse of twelfth century France when he saw the absence of pilgrims at Toury as one of the signs of its economic stagnation; *De Administratione* (Lecoy) 12, p.170.

The difficulty of the changing economic situation was compounded for traditional monasticism by the increasing pressure to give up tithes, the emerging money economy, and the economic competition placed on traditional monasteries by those of the new ascetic orders. Cf. Peter the Venerable's worry that in some places five to seven houses of the new ascetic orders surrounded one Cluniac monastery, making a reduction in the number of monks or even the closure of the Cluniac monastery certain if tithes from those houses were to be given up; Letter 33, p.108. While the gradual trend from the Cult of the Dead to the Cult of Relics cannot be denied, Cluny did continue to receive a number of generous gifts under Peter the Venerable. Those of Henry I of England were substantial enough for him to be considered, after Alphonso VI of Spain, as the builder of the new church of Cluny III; Bruel 1876:4095; Peter the Venerable, Letter 45, p.141–142. He also gave an annual rent of 100 marks in 1130 which was confirmed by his son Stephen in 1136 and by Geoffrey Plantagenet in 1144–1148 (Bruel 1876:4015, 4055, 4095). The count of Vermandois left 500 marks of silver and Eustace of Boulogne gave an annual rent of 20 pounds (Bruel 1876:4070, 3984). But in the end it was not enough, and Cluny was forced to pawn the golden plaques from its great crucifix, as well as other liturgical artworks; Peter the Venerable, Letter 56, p.177–178; Duby 1952:165, 165n.5, 169.

118. See Constable 1971.

119. Of course, art was only one means among several in eliciting gifts from pilgrims. For example, the liturgy of a great monastery such as Cluny must have been quite successful along these lines during its early period, and votive offerings also held strong appeal, as is mentioned below.

(For our purposes, the role of art in the Cult of the Dead and the Cult of Relics may be said to be illustrated, although in a way not intended by the artist, in a wonderful pair of miniatures from the *Vie de Saint Aubin*. In Figure 1, the tomb of the patron saint is portrayed as the focus of the Cult of the Dead, and alternatively, in Figure 2, as the focus of the Cult of Relics. Chased cross, candelabra, censer, crozier, and *corona*, all of gold; multi-colored and embroidered altar cloths, vestments, and tapestries, some with gold embroidery; elaborate pavement—all of this was apparently seen as more or less central to the identification of the action, contrary to the normally sparse detail of medieval narrative scenes. To be sure, these miniatures could almost serve as illustrations of the details mentioned in the *Apologia* or the Cistercian statutes dealing with art, Statutes 10 and 20, discussed below.)

Significantly, it was just around the time of the *Apologia* that the pilgrimage to Santiago was at its high point,[120] and the monasteries were an integral part of it. Of the twenty-six major sanctuaries mentioned as worthy of visiting in the fifth book of the *Codex Calixtinus*, half were monasteries, the rest being divided up between collegiate churches, cathedrals, and one lesser secular church. Of the ten sanctuaries in which the beauty of the church is praised or some work of art is mentioned, six were monasteries.[121] It was also around this time that a special liturgy for the pilgrim began to take shape, a distinctive set of clothing began to become standard, and some even considered the pilgrim to form a separate order of the Church.[122] In at least one case, that of the pilgrimage monastery Saint-Jouin-de-Marnes, all the saved of the Last Judgment sculpture of the facade are shown as pilgrims (Fig. 3).

Needless to say, there was quite a bit of money involved in the pilgrimage. In fact, some monasteries are known to have fought over the rights to give hospitality.[123] Aside from the income from hospice services, there was

120. Labande 1958:167. On the opposition to pilgrimages by monks, including opposition from Bernard, see Constable 1976, 1977, and Leclercq 1961.

121. *The Pilgrim's Guide* or bk.5 of the *Codex Calixtinus* was written sometime between 1139 and 1173; Bédier 1921:v.3:76; Vielliard 1963:xii. If the guide was written after 1152, the number of monasteries would be twelve rather than thirteen as the monastery of Saint-Samson at Orléans became a collegiate church in that year.

122. Vogel 1963:64–65, 86–90; Labande 1958:168–169; Sumption 1975:136–138, 171–173. Many also believe that it was around the time of the first crusade that the word *peregrinus* began to take on the sense of "pilgrim" as we know it; de Gaiffier (1963:14–15) feels that this happened somewhat earlier.

123. The monastery of Villafranca sought Hugh of Cluny's aid in 1088 (the year of the *fundatio* of the pilgrimage plan church of Cluny III) in a dispute with a rival who "unjustly usurped its right over the pilgrim (in peregrinus sua jura injuste usurpabat)"; Bruel 1876:4326. In 1122, the monastery of Oboña was granted a right which prohibited its rivals

the revenue from common feudal rights and monopolies, market items, the sale of pilgrim badges, the practice of legitimate medicine for those seeking miracle cures, and the direct sale of sacraments such as the Mass.[124] But the most lucrative area by the twelfth century seems to have been straightforward donations at the shrine of the relics of a miracle-working saint. If the monastery was under an obligation to spend, the pilgrim was under an obligation to give. Nowhere is this more dramatically put forth than in the sermon *Veneranda Dies*, in the first book of the *Codex Calixtinus*, which states that pilgrims who die with money in their pocket will suffer the eternal torments of hell.[125] In the mid-eleventh century the abbey of Saint-Trond required several men each night to carry away only the cash portion of gifts, Suger of Saint-Denis counted on pilgrim funding for three-fourths of the capital for the rebuilt west facade there, and at the cathedral-monastery of Canterbury in 1220—the year of the completion of the tomb of Thomas Becket—the donations of pilgrims accounted for nearly two-thirds of the total income.[126] What Bernard said concerning tithes applies equally well to this situation, "Our profession and the example of the monks of former times prescribe that we live from our own labors and not from the sanctuary of God."[127]

However, large-scale donations, especially in land, were still being made. But they were being made not so much to traditional monasticism as to the new ascetic orders. In fact, Peter the Venerable saw the old monasticism's recognition of the success of the new as the ultimate cause of the friction between both parties and chastised his own monks for their uncharitable behavior,

> Speak, O black monk . . . and lay bare what you have against your brother which lies hidden at the bottom of your heart. Who, you say, is able to tolerate that new men should be preferred to the old; that their works should be chosen over ours; that their work should appear more esteemed, and ours more common? Who can watch amicably as a great part of the world is turned from our

from "diverting its pilgrims elsewhere"; Sumption 1975:200. Cf. *Glossa Ordinaria* under Lk 28–29, *PL* 114:352, which describes pilgrims as being "called, or rather forced" to go to a particular hospice.

124. Cf. Sumption 1975:84, 161, 175.

125. *Codex Calixtinus* 1:17, v.1:157.

126. Sumption 1975:154, 160–161. Suger, *De Consecratione* 4, p.102. Large amounts of livestock and other gifts in kind were also common as donations at pilgrimage churches.

127. Bernard, Letter 397:2, v.8:374, "Clericorum est altari diservire et de altaro vivere. Nobis nostra professio et antiquorum monachorum exempla victum ex propriis praescribunt lavoribus, et non ex sanctuario Dei."

old order and is attracted to their new proposition? . . . Who can tolerate that new monks should be preferred to the old, juniors to seniors, white to black? [128]

Meanwhile, under the direction of Bernard, the Cistercians, the most financially successful of the new ascetic orders, actively avoided an economy in which "the very sight of these costly but wonderful illusions inflames men more to give than to pray" (*Apologia* 28). At least in the beginning, Cistercian monasteries rejected the sale of spiritual services as they did the use of most forms of art, although they later provided burial for bishops and great nobles and defied their own artistic sanctions. They preferred instead a technologically advanced agricultural system based on labor provided by either *conversi* (in the case of the Cistercians, lay monks) or paid workers. Whereas a traditional monastery such as Cluny acquired dependencies on the pilgrimage route, encouraged lay visitation by both sexes, and gave great hospitality to poor and pilgrims alike, the Cistercians in the beginning sought out remote sites for their monasteries, entirely refused entry to women, and appear to have been rather stingy in their care to the poor. [129]

Thus it seems that by attacking the pilgrimage art and general social involvement of the old monasticism, the agriculturally based new ascetic

128. Peter the Venerable, Letter 111, p.291. As stated before, "black" refers to the color of the habit of the traditional Benedictine monk and "white" to that of the Cistercian.

Although the Cistercians were the leading competition with traditional monasticism, the threat was perceived as coming from the new ascetic orders in general; Orderic Vitalis, *The Ecclesiastical History* 8:26, v.4:310, 326.

129. For Cluny's interest in the pilgrimage route, see Bédier 1921:v.3:75, 89–91 and Mâle 1928:292. Care of the poor is known to have caused financial difficulties for a number of Cluniac monasteries; de Valous 1970:v.1:162. The care of the poor at Cluny itself is too involved to go into here (see esp. de Valous 1970:v.1:161–166), but let it just be said that under Hugh the poor were said to have consumed 2,000 mule loads of grain a year and that in one year alone 17,000 poor were fed there; Ulrich, *Consuetudines* 3:11, PL 149:753. Duby (1952:160) believes that before 1080 the cash reserves of Cluny were used only for the care of the poor and the ransom of Mayeul. In addition to visiting poor, Cluny also took care of the poor and sick of the town of Cluny; de Valous 1970:v.1:163. It has been estimated that there were at least 400 pilgrims a day at Cluny; Duby 1952:163. They were well cared for while there, with no questions being asked before three days had passed. Women guests were received following the example of Pachomius, as de Valous points out. Upon leaving, all guests were given provisions and a cash gift; de Valous 1970:v.1:161–176; Duby 1952:158.

On the Cistercian reception of guests and the poor, see Vacandard 1902:v.1:452–453. Lekai has clearly shown that the gap between the Cistercian claims and reality is far wider than previously believed. In England alone, twenty-nine Cistercian monasteries moved from isolated sites to more populated and economically profitable areas. Even during the lifetime of Bernard, monasteries of the Cistercian Order accepted tithes from villages, churches, serfs, markets, mills, and so on; Lekai 1978:5–10.

orders, with Bernard at their head, actually struck at the sacred economy of mainstream monasticism.[130] In Bernard's view, not only had the monk in part negated the function of the monastery by opening it up to "the people," those whom he had left behind, but—which was far worse—he did so for avaricious gain, under the claim of honoring God. It is in this sense that he said, "Since we have been mingled with the gentiles, perhaps we have also adopted their ways and even serve their idols?" (*Apologia* 28). Or, as Odo of Cluny declared sometime before concerning the use of art by monks to stimulate pilgrim donations at Vézelay, "One sacrifices, but it is leavened. One offers something which God disdains."[131]

THE BUSINESS OF THE MONK

Bernard immediately followed up the question about gold in the holy place—or art as an investment—with the issue of the business of the monk. Of all the issues actually raised by Bernard, none has received greater attention than this one. In spite of this, its full implications have never been fully shown. On a purely artistic level, the major element of the issue of the business of the monk as put forth in the *Apologia* is that of the justification of art to educate the illiterate.

The value of art as an educational aid for the illiterate was recognized fairly early in the history of the Church, but it was only with Gregory the Great that it took on the force of doctrine. In two letters to Serenus, the bishop of Marseille, Gregory formulated what was to become the authoritative pronouncement on religious art in the West during the Middle Ages.[132] He distinguishes between the adoration of images and the teaching through images of what should be adored. The recipients of this teaching are explicitly stated to be the illiterate. In the process, Gregory appeals to both the justification of tradition and to the threat of disunity. He concludes in his second letter that art may be used to raise the spiritual awareness of the viewer, but that adoration of the artworks themselves is to be prohibited.

The authority of Gregory's statement was widespread, and—in keeping

130. On the use of my term "social involvement" or "social entanglement," cf. *Exordium Cistercii* 1:3, p.111, "*terrenis implicare negotiis.*"

131. Odo of Cluny, *Collationes* 2:34, *PL* 133:580–581.

132. Gregory the Great, *Registrum* 9:209, 11:10, p.768, 873–876. I use the *Corpus Christianorum* numbering here; in *PL* 77 the numbering is bk.9:105 and 11:13. Gregory's second letter is cited in Gratian's mid-twelfth century collection of canon law; Gratian, *Decretum* dist.3:27, col.1360. Cf. also the spurious letter now identified as Appendix 10 (*PL* 77, bk.9:52) which is concerned with art as a spiritual aid.

with Gregory's call for Church unity—Bernard as an orthodox churchman accepts it without question.[133] But if he accepts it without question, he does so to the letter of the law: it is the bishop whose duty it is to instruct the ignorant, not the monk; and the ones for whom art is thus considered an aid are those *qui litteras nesciunt* and the *idioti*—that is, the illiterate—the *litterati* or monks of Suger's theory of a specifically monastic art (discussed below) are not included.[134] As William of Saint-Thierry put it, signs are necessary for those who do not believe, not for those who do; they are for the foolish, not for the wise.[135] But having accepted Gregory's doctrine on the instructional value of art, Bernard refers to Jerome's statement on the clear distinction between the roles of bishop and monk.[136] Bernard's argument is not against art. He theoretically is in agreement with Gregory, Paulinus of Nola, Bede, Pope Hadrian I, the author of the *Libri Carolini*, the Council of Paris of 825, Walafrid Strabo, Honorius Augustodunensis, Theophilus, the author of the *Pictor in Carmine*, and the many others who support this particular function of art.[137] The subject of art to instruct the illiterate is an issue with Bernard only to the extent that he is denying its validity as a justification for monastic art. The key word is "monastic." He is not in the least concerned in the *Apologia* with the use of art by the secular Church to educate the layperson. The instruction of the layperson was the bishop's business. In reply to a letter from Oger which in all probability was the original request for the *Apologia*, Bernard stated in traditional terms what he felt the monk's business was. Referring to a passage from Jerome he wrote, "the function [of the monk] is not to teach, but rather to lament."[138]

133. Gilson 1940:19 states that Bernard was as much influenced by Gregory as he was by Augustine. Pope Hadrian, the *Libri Carolini*, and the Synod of Paris of 825 all defer to the authority of Gregory on the permissibility of art; see below.

134. Gregory the Great, *Registrum* 9:209, 11:10, p.768, 874 (*PL* 77, bk.9:105, 11:13). Suger, *De Administratione* 62, p.33, "opus quod solis patet litteratis." Suger's theory is taken up briefly in the section "Art as a Spiritual Aid" and in greater depth in Rudolph 1990:55–62.

135. *Ad Romanos*, bk.1:1:14, *PL* 180:556. Paul's verse on the foolish and the wise (Rom 1:14) was a favorite of Bernard's and is used in *Apologia* 28.

136. See the commentary under 104:21 ET QUIDEM . . . ALIA MONACHORUM.

137. Gregory the Great, *Registrum* 9:209, 11:10, p.768, 873–876 (*PL* 77, bk.9:105, 11:13). Paulinus of Nola, *Carmina* 27:580–595, p.288. Bede, *Vita Abbatum* 6, p.369–370. Hadrian I, *Epistola* 50, *PL* 98:1268–1269. *Libri Carolini* 2:23, p.81–82. Council of Paris of 825, *Concilium Parisiense* 11–12, p.487–489. The latter four all specifically refer to the authority of Gregory on images. Walafrid Strabo, *De Exordis* 8, p.483–484. Honorius Augustodunensis, *Gemma Animae* 1:132, *PL* 172:586. Theophilus (implied), *De Diversis Artibus*, preface to bk.3, p.63. *Pictor in Carmine*, p.142.

138. Bernard, Letter 89:2, v.7:236, "officium [monachi] non est docere, sed lugere." Bernard refers to Jerome, *Contra Vigilantium* 15, *PL* 23:352 (or 367 in the 1845 ed.), "The

In the end, Bernard's complaint about the monastic use of art as an instructional aid to the illiterate was really a complaint about the increased social involvement of the monastery. This meant different things to different people, and to the new ascetic reformers of the eleventh and twelfth centuries it meant, in large part, the dilution of monastic seclusion. In the process of partially assuming the duties of the episcopacy, monasticism had opened itself up to charges of undermining its own goals and ideals beyond the pastoral vacuum it filled. However, the interesting thing for this study is not the weakening of a religious principle, but rather its association with art. Suger is careful to draw attention to the increased benefit of seclusion for the monks of Saint-Denis as a result of his new artistic undertakings, although by his own evidence the opposite could easily be argued.[139] Speaking more realistically, Bernard associates art with the diminishment of monastic seclusion, explicitly citing the justification of art to instruct the illiterate in conjunction with monasticism's "mingling with the gentiles," and questioning the existence of monastic art since the monk had withdrawn from "carnal people" (*Apologia* 28).[140]

But to the bishops, the social involvement of monasticism represented less a threat to actual instructional responsiblilty or a dilution of monastic seclusion than it did an infringement on the rights and duties of the episcopacy and—in the end—an infringement on their financial resources. The author of the contemporary *Libellus de Diversis Ordinibus*, probably a canon regular, is quite clear without being negative about the relation between the opening up of the monastery and the financial aspects of the sacred economy.[141] It was this, and not teaching per se, that was the more volatile aspect of monasticism's relation with art and the layperson as far as the secular Church was concerned. But the subject of monasticism and pas-

monk does not have the function of a teacher, but rather of a mourner (Monachus autem non doctoris habet, sed plangentis officium)."

139. *De Administratione* 26, 28, p.44, 48. It should be noted that this appears in the later and more apologetic *De Administratione*. Cf. the violation of the cloister by women as the result of the earlier, unsatisfactory situation which Suger had taken care to change; *De Consecratione* 2, p.88. Unconnected with art, Bernard complained of the activity of laypeople at Saint-Denis (Letter 78:3, v.7:203), and Peter the Venerable made the same complaint concerning his own Cluny (Statute 23, p.60).

140. According to Hugue de Fouilloi, there was no need for art for those who sought seclusion from the layperson; *De Claustro Animae* 2:4, PL 176:1053. Abelard, Bernard's archenemy, condemned the opening up of the monastery to the layperson specifically in relation to the Cult of the Dead and excessive liturgical art; Letter 4, p.85–86.

141. *Libellus de Diversis Ordinibus* 2, p.2; Constable 1972:xv–xvii. In the *Libellus*, "those monks who live close to men" are characterized as being "Cluniacs and the like," while those who live away from men are described as "Cistercians and the like" (cf. the titles of chapters 2 and 3).

toral care is far too large to take up here.[142] Let it just be said that aside from the areas of monastic assumption of parish churches and tithes and the refusal of many monasteries (especially Cluniac monasteries) to submit to episcopal control, the mass reception of laypeople at the monastery also constituted an affront to priestly privilege. In much the same way that a serf belonged to the land, a parishioner "belonged" to his or her parish and was obliged to take the sacraments there. He or she was also obliged to pay for them there. This bond was so strong that, just around the time of the *Apologia*, Stephen of Muret was recorded as having insisted that the religious of his order, the Order of Grandmont, not usurp the local bishop's sacramental authority; and in 1263 Archbishop Peter of Bordeaux forbade under pain of excommunication the reception in the churches of his archdiocese of "strangers who have renounced their own churches."[143]

From the point of view of the layperson, the pilgrimage monastery could provide a means of breaking the often oppressive spiritual monopoly of the local ecclesiastical power. From that of the priest or bishop, it could be an uncanonical threat to their authority and income. To a reform-minded monk such as Bernard, it constituted a weakening of the Church hierarchy, a betrayal of the apostolic ideal of monasticism, and the institutionalization of one of the problematic as well as primary economic supports of traditional monasticism. Like Abbot John of Fécamp or Abbot Leo of Ravenna, Bernard criticized the blurring of distinction between the priest and the monk and denounced the wealth of the more worldly abbots as surpassing that of the bishops—a statement calculated to bring outside pressure to bear on the opposition.[144] He was well aware of the tension resulting from this situation, a situation which reached a high point in the period immediately preceding the writing of the *Apologia* at the Synod of Reims of 1119 and the First Lateran Council of 1123, both of which demanded an end to monastic infringement on the episcopal domain.[145] But unlike those earlier re-

142. Constable 1964, 1966, 1971; Duby 1980:140f. Ironically, Bernard's enemy, Abelard, was a strong voice against the monastic assumption of pastoral responsibility; Constable 1971:329.

143. Stephen of Muret, *Regula* 32, *PL* 204:1150–1151; the Rule was written soon after Stephen's death in 1124, supposedly in his own words. For the unedited statute of the archbishop of Bordeaux, see Dobiache-Rojdestvensky 1911:88n.1.

144. On John of Fécamp and Leo of Ravenna, see Leclercq 1964:180–181. Aside from the inherent potential for bringing outside pressure to bear in *Apologia* 28, see the commentary under 103:14–15 QUATENUS DUOBUS . . . SUFFICIAT MULTITUDO? This animosity seems to be the reason (along with general prestige) for Suger's constant references to the participation of friendly bishops in *De Consecratione*.

145. Bernard's most pronounced single text along these lines, aside from the *Apologia*, is *De Consideratione*; see esp. *De Consideratione* 3:14, 3:16, v.3:442–444; see also Letter 42:33, v.7:127–128.

formers, Bernard is unique in taking the analysis further, beyond the realm of the obvious sources of hard income to that of the relation between art and social involvement. The monastic possession of parish churches and tithes, if still quite alive, had already become openly questioned. Rather, Bernard chose to take up the subject of that source of income which was voluntarily given, and probably all the more lucrative by that very fact.

Again falling back on Jerome, Bernard wrote to no less than the abbot of Marmoutier, "It is [the business] of the clergy to serve the altar, and so to live from the altar. Our profession and the example of the monks of former times prescribe that we live from our own labors, and not from the sanctuary of God."[146] He goes on to state that if monks wished to live from the altar, then they must perform various pastoral duties including burying the dead and instructing the ignorant—two tasks that traditional monasticism profited from greatly. However, if the monk did this, then he would be opening his mouth in the middle of the Church when his duty was to sit inactive and be silent.[147] In other words, he would not be a true monk.

MATERIAL AND SPIRITUAL POVERTY

Finally, Bernard is quite aware in the *Apologia* of the currency of the popularly perceived idea that a cause and effect relation existed between material and spiritual prosperity—which permitted a material display in the monastery—and rejects it. Rather, he believes that material poverty was the necessary expression of spiritual poverty, or the state of being poor in spirit (Mt 5 : 3, Lk 6 : 20), and that material success was almost incompatible with spiritual success.[148] Although the subject of material and spiritual pros-

146. Bernard, Letter 397:2, v.8:374, "Clericorum est altari deservire et de altario vivere." Cf. Jerome, Letter 14:8, v.1:41, "Sed alia, ut ante praestruxi, monachi causa est, alia clericorum . . . illi de altario vivunt." Both are ultimately dependent on 1 Cor 9:13–14. Other authors of the period who criticized excessive art also took up this issue, citing both Jerome and Bernard, although not together; for example, Idung, *Dialogus* 3:42, p.463, and Peter the Cantor, *Verbum Abbreviatum* 29, PL 205:106–107. Although Bernard followed Pauline teaching on priestly support, he denied luxury to those who served the altar; see Bernard, Letter 2:11, v.7:21–22, which has much in common with both the *Apologia* and his Letter 42 in its criticism of excess, especially ornamentation of various sorts.

Bernard's Letter 397 is not specifically concerned with the opening up of the monastery itself, but rather deals with a fight over Marmoutier's claim to a local altar served strictly by priests, the revenue of which was granted to the abbey by the bishop.

147. On Bernard's rejection of monastic preaching as an infringement of the priestly order, see *De Diversis* 91:1, v.6:pt.1:341–342.

148. This incompatibility is given as the primary reason for the departure of the first Cistercians from Molesme in the *Exordium Cistercii* 1, p.111, a work possibly written at Clairvaux under Bernard's direction according to Leclercq 1963:89–90, 98–99. Robert de Torigny specifically saw the material prosperity of the old monasticism as the cause of its decline; *De Immutatione* 7, PL 202:1313.

perity is only indirectly referred to in *Apologia* 28–29, its implied negation is the major point the only other time he mentions art in the *Apologia*. In *Apologia* 16 Bernard says, "I am amazed that such intemperance in matters of . . . the construction of buildings is possible to grow among monks to the extent that wherever these things are the more diligently, joyfully, and even extravagantly done, there the better is order said to be kept, there the greater is religious life thought to be." This is what William of Saint-Thierry was getting at in his letter to the Carthusians at Mont-Dieu when he said concerning their new attentiveness to architecture, "Having cast aside holy rusticity . . . we create for ourselves a kind of religious respectability, as it were, in our dwellings."[149] Bernard believes material prosperity is one of the four general temptations for the Church and the faithful, one in fact which impedes observance of God's commandments.[150] However, he does not reject the material for, or even the proprietary rights of, those who dedicate themselves to God.[151] To do so would be to associate himself with heretical movements of reform.

Actually, Bernard was more moderate than most modern historians would have him. He was certainly more moderate than John Gualbert, who belonged to the same general ascetic movement as Bernard. Upon being handed the deed to a valuable piece of property which had been given to his monastery by a wealthy new monk, the founder of Vallombrosa tore it up, not even deigning to look back at the monastery which had caught fire just as he was leaving.[152] According to Bernard, temporal adversity is a stumbling block along with prosperity. But the situation with art within the monastery had gone so far that the Cistercian Hélinand de Froidmont could say only a few years after Bernard that the claim to voluntary poverty had not only been compromised by excessive art, but that it was in danger

149. William of Saint-Thierry, *Ad Fratres* 147, p.258–260, "Et abjecta sancta rusticitate . . . quasi religiosas quasdam nobis creamus habitationum honestates." William recommeded that monks build "tents" (Jer 35:9–10) for themselves; that is, they should consider their earthly existence as transitory, temporary; *Ad Fratres* 151, 155, p.262, 264. Cf. Thomas de Froidmont, whose intention is the same but whose terminology rejects even "tents;" *De Modo Vivendi* 18, *PL* 184:1211.

150. *Parabolae* 6, v.6pt.2:286 (cf. *De Laude Novae Militiae* 6, v.3:219); *In Septuagesima* 2:5, v.4:348.

151. *Super Cantica* 21:7, v.1:126. Cf. the rejection of material security for monks by Pseudo-Dionysius, *De Divinis Nominibus* 8, *PL* 122:1159.

152. Leclercq 1971:224–225. Jerome repeatedly singled out excessive architecture as incompatible with voluntary poverty; Letters 14:6, 46:11, 52:10, 58:7, 108:16, 128:5, 130:14, v.1:38–39, v.2:111, 185, v.3:81–82, v.5:179, v.7:153, 185–186. For similar early models of disdain which were specifically reserved for the labor and expense involved in the construction of monastic buildings: Cassian, *Conlationes* 23:5, p.646; Cassian, *Institutiones* 5:37, p.109; *Verba Seniorum* 6:4, *PL* 73:888–889; *Apophthegmata*, Agatho 6, Daniel 5, Zeno 1, *PG* 65:109–112, 156, 176; *Historia Monachorum* 23, *PL* 21:446–447. Later criticisms are too numerous to list.

of not even being believed at all.[153] Indeed, Bernard's friend, Aelred of Rievaulx, quite simply lists large-scale architecture, sculpture, and painting among the "delights of the world."[154] What Bernard felt was needed was moderation, the mean between temporal adversity and dangerous prosperity—the trick being to live with possessions as if one did not possess them.[155] In artistic terms and as applied to monasticism, this meant in large part the elimination of excessive gold from the holy place, gold which was used to stimulate donations, and especially as found in the subject of the next section, the liturgical artwork.

153. *In Festo Omnium Sanctorum* 23, *PL* 212:677–678.
154. *De Spiritali Amicitia* 3:77, p.333.
155. *Super Cantica* 21:7, v.1:126; *In Septuagesima* 2:5, v.4:348; *Parabolae* 6, v.6pt.2:286; cf. *Apologia* 18.

Art to Attract Donations:
The Liturgical Artwork

We know that Bernard saw excessive art as an investment. Yet we also know that, willingly or unwillingly, he accepted certain forms of art, such as architecture and specifically religious monumental painting and sculpture, as tolerable in monasteries—even when admittedly excessive.[156] The questions arise then, what did Bernard object to in excessive art, what exactly was the type of art that he denounced for its hold on those who came to the monastery from the outside, and how did this fit into his critique of art to attract donations?

Bernard's Categories of Excess

In *Apologia* 28, Bernard mentions five works of art as examples of immoderation. From these, a pattern of objection emerges which is fundamental to understanding his concept of excessive art. The works he mentions are gold covered relics, the image of a saint, *coronae* (crown-like chandeliers), candelabra, and images on decorated floors.[157] On a purely artistic level, these are objectionable to Bernard for a variety of reasons: the gold covered relics by virtue of their stated excess in material; the image of a saint by its material and craftsmanship; the *coronae* and candelabra by their material, craftsmanship, and size; and images on decorated floors by their material, craftsmanship, and quantity.[158]

Thus, what Bernard was objecting to in terms of artistic criteria was an excess in material, craftsmanship, size, and quantity.[159] And the reason

156. This subject was briefly dealt with in the previous section "Piety and Poverty for the Honor of God" and will be taken up in greater detail in this chapter and in the section "The Excesses and Limits of Art as a Distraction to the Monk."

157. On Bernard's criticism of the Church dressing its stones in gold, see below and the commentary under 105:25–106:2 FULGET ECCLESIA . . . QUO SUSTENTENTUR.

158. Excessive quantity carries here the implication of a resultant offense in disposition, that is, all fields of vision are invaded by artworks. For a positive and very evocative description of such a situation, see Theophilus, *De Diversis Artibus*, preface to bk.3, p.63–64.

159. On Bernard's use of the word "colored" as referring to precious materials (as opposed to pigments), see the commentary under 105:17–19 ET EO CREDITUR . . . SACRA.

that he opposed these qualities in artworks was the tendency to equate art-
works which possessed an excess of them with holiness, the tendency to ex-
pend funds on them rather than on the poor, their function as a spiritual
distraction—all of which will be taken up later—and their power to extract
donations from the faithful. But what concerns us here is what they com-
prised artistically.

Significantly, all of the artworks mentioned by Bernard are directly re-
lated in that they are liturgical artworks with the exception of the decorated
floors—and these too are indirectly related, as we shall see.[160] Bernard chose
to "overlook" certain excesses in architecture, painting, and sculpture in the
opening passage of *Apologia* 28, instead seeing liturgical artworks as the
major force of attraction on the viewer. But this is not simply a rejection of
excess in liturgical vessels along the lines of the very operative tradition of
such figures as Ambrose, Jerome, Chrysostom, Caesarius of Arles, Benedict
of Aniane, Odo of Cluny, the Carthusians, Odo of Tournai, the Cistercians,
Abelard, Aelred of Rievaulx, and others who repudiated excessive liturgical
artworks as opposed to the care of the poor or as a simple distraction.[161] Nor
is it limited to the straightforward rejection of gold found in the biographies
of the Fathers, such as the *Vita Antonii* by the "theologian of early monas-
ticism" Athanasius,[162] the *Vita Ambrosii*, the *Vitae Patrum*, the *Lausiac
History*, or Hilary of Arles' *Vita Honorati*, all of which spurned gold as
contrary to monastic propriety. Bernard is concerned with these issues, but
he is also concerned with more: namely the artistic effect of liturgical art on
the viewer and his or her manipulation.

It seems that what Bernard objects to in excessive liturgical art is the
force of attraction resulting from an unusually ostentatious display of pre-
cious metals and jewels, especially when presented in combination with
exceptional craftsmanship, size, and quantity. At the base of this was
the power of precious materials to visually impress. In a letter to Duke
Wladislaus of Bohemia concerning the Second Crusade and wrongly as-
cribed to Bernard, the author explains that the display of gold and silver
upon the knights and their horses had been prohibited in the course of the

160. Outside of the specific examples mentioned, Bernard also refers in a general way
to gold, material ornaments, costly but wonderful illusions (*sumptuosarum sed miran-
darum vanitatum*), and "riches" or expensive ornaments (*divitiarum*). All of these suggest
liturgical artworks as discussed in this section.

161. These authors are discussed below. The use of precious materials in liturgical art-
works was, obviously, quite acceptable even to those whose position on figural art was not
positive; for example, Augustine, *Enarrationes in Psalmos* 113:ser.2:6, p.1645. On some of
the issues involved in the material aspect of liturgical artworks, see Rudolph 1987:4–6.

162. Colombás 1964:75.

daily routine, but that it was allowed during battle so that when the sun shined upon them, they might strike terror into the enemy.[163] In the Life of Lanfranc, former abbot of Bec, it is told how on one of the relatively rare occasions that the English king wore his crown, one of those present exclaimed upon seeing the king, radiant in gold and jewels, "Behold, I see God. Behold, I see God."[164] It was the power of gold to impress the medieval viewer that Guibert de Nogent was getting at in his criticism of the use of gold and silver reliquaries to attract donations.[165] And, along with the element of voluntary poverty, this seems to be the reasoning behind chapter 17 of the *Exordium Parvum* and the early Cistercian Statutes 10 and 20 which proscribe gold and silver in most liturgical objects (*vasa non sacra*), but allow the painted image of Christ on the crucifix.[166] Thus, Suger, far from trying to defend the monumental painting and sculpture of his church, never even mentions them, devoting the greater part of his justification of excessive art to the liturgical artwork. In fact, in the opening of his *De Administratione*, he writes that the brothers of Saint-Denis had asked him to record "those increments . . . in the acquisition of new assets as well as in the recovery of lost ones, in the multiplication of improved possessions, in the construction of buildings, and in the accumulation of gold, silver, most precious gems, and very good textiles." This is essentially the breakdown of the book, with the phrase "gold, silver, most precious gems, and very good textiles" standing for the liturgical art he describes at such length.[167] And so Matthew of Albano, when discussing the controversy over monastic art, refers to the subject of that controversy only as things of "gold or silver," without any mention of painting and sculpture proper.[168]

Bernard poses the question of excess in material and craftsmanship in an

163. Letter 468 in the old edition of Bernard's works (*PL* 182:654). Cf. the account of the awe with which the Greek envoys to Charlemagne were said to have been struck upon seeing the sun shine on the gold and precious stones with which he was adorned; Notker the Stammerer, *Gesta Karoli* 2:6, p.750.

164. *Vita Lanfranci* 33, *PL* 150:53.

165. Guibert de Nogent, *Gesta Dei per Francos* 1:4, *PL* 156:695. Equally aware of the power of gold and silver in liturgical art, although not in a negative way, is Peter the Venerable's Statute 52, p.82.

166. Chapter 17 of the *Exordium Parvum* and Statutes 10 and 20 are discussed in the section "The Cistercians." On the distinction between *vasa sacra* and *vasa non sacra*, see Braun 1932:2.

167. Suger, *De Administratione* 1, p.40. It was especially for this type of art that he was remembered, as in the contemporary eulogy *De Nobilitate Domini Sugerii Abbatis et Operibus Eius* in Lecoy 1867:424; and William of Saint-Denis, *Vita Sugerii* 2:9, p.391–392.

168. Matthew of Albano, *Epistola* p.331.

original way—and one which both embraces and rejects the aesthetic conventions of the time. Suger and others might praise a particular work of art by referring to Ovid's phrase, "The craftsmanship surpassed the material."[169] However, in *Apologia* 28 Bernard, who refers to the phrase in a spiritual allegory elsewhere,[170] praises the craftsmanship highly but goes on to give such high praise to the material—most notably precious stones, which are crafted material in the same sense as bronze or refined gold—that it can, in fact, be seen as condemning. In the case of both the *corona* and the candelabra, Bernard noted that not even fire, that pure and immaterial primary element, could surpass in its brilliance the jewels with which these liturgical objects were encrusted. As in his criticism of hybrids in *Apologia* 29 and of food in *Apologia* 20, he is here objecting to a state where the natural has, in some way, been obviated. Not only has the material surpassed the craftsmanship, it has surpassed nature itself. Yet these jewels do not shine with their own light, but with borrowed light: something that Bernard describes elsewhere in an allegory involving a candelabrum as being hypocritical.[171]

169. "Materiam superabat opus," Ovid, *Metamorphoses* 2:5. Cf. Suger, *De Administratione* 27, 33, p.46, 60–62; *De Consecratione* 5, p.106. See Branner 1965:57–58 for references to a number of thirteenth-century uses of this citation. According to Branner, the first time it was used with respect to architecture was by Innocent IV in a bull of 1244 dealing with Sainte-Chapelle. However, while this as yet may be the case with Ovid, the concept is taken up by the author of the anonymous *Miracula S. Hugonis* (col.458) of after 1120, probably using Pliny as his authority, "it is difficult to judge whether it is more fitting in its size or more amazing in its craftsmanship (capaciorne sit magnitudine, an arte mirabilior, difficile iudicetur)." Cf. Pliny, "ut alibi ars, alibi materia esset in pretio," and "dubium aere mirabiliorem an pulchritudine," *Historia Naturalis* 33:6, 34:18; and Odo of Deuil, *De Profectione* 4, p.64, "nescio quid ei plus conferat pretii vel pulchritudinis, ars subtilis vel pretiosa materia." Ovid was used by other authors besides Suger and Bernard before the thirteenth century, most notably by the author of the *Actus Pontificum Cenomannis in Urbe Degentium* (Mortet 1911:166) in a discussion of stained glass windows, and by William of Malmesbury in his *Gesta Pontificum Anglorum* 1:43, p.69–70 in reference to liturgical artworks. Cf. also the inscription on the doors of the monastery of Monte Sant'Angelo cited in Panofsky 1979:164; Matthew of Paris in Lehmann-Brockhaus 1955:6015; and Henry of Blois' inscription on a lavish liturgical artwork which read "Art is above gold and gems," Gage 1982:50. And on a different note, see John of Salisbury's twelfth-century description of Roman cult statutes as "made by the gentiles in error more subtle and laborious than devoted"; *Historia Pontificalis* 40, p.78 (my translation differs from Chibnall's).

170. *In Festivitate S. Martini* 13, v.5:408, "quidni mirifica quaedam vasa dixerim divitis huius, auro gravia, gemmis micantia, pariterque materia et opere pretiosa?"

171. Letter 505, v.8:463. Cf. Alexander Neckam's similar criticism, but of architecture surpassing nature; *De Naturis Rerum*, p.179. On the traditional view of the craftsman as imitating nature, Hugh of Saint-Victor, *Didascalicon* 1:10, PL 176:747–748. For what is apparently a variation on Ovid, cf. William of Malmesbury, *Gesta Regum Anglorum* 2:169 [2:10], p.197, "naturam vincebat opus"; and Giraldus Cambrensis, "artificio longe materiam exsuperante" in Lehmann-Brockhaus 1955:4745.

It seems that Bernard's overt discussion of material and craftsmanship was meant to be understood as a reference to Ovid's phrase, whether directly or indirectly.[172] While the literal dependence is not strong, the concepts are certainly parallel, though extending in opposite directions. Ovid's influence was so great in the twelfth century that that period has been called the *aetas Ovidiana*.[173] And in the *aetas Ovidiana*, it was one of the works of William of Saint-Thierry—by whom the *Apologia* was formally requested and to whom it was nominally addressed—of around 1120 that was known as the *Anti-Naso*, Naso being the cognomen of Ovid.[174] Thus it may be that Bernard was taking up this subject less directly than he might in deference to his friend.

Furthermore, it seems that it is in reference to this passage of Bernard's that Suger directs at least one of his citations of Ovid and not, I believe, to some nameless group whose taste was more refined than Suger's, as Panofsky would have it. According to Panofsky, Suger employs Ovid in rebuttal to some of the "more sophisticated" monks at Saint-Denis who were not opposed to excessive art, but who merely felt that he rated the cost of the material of an artwork above its craftsmanship or form.[175] The artistic school of thought to which Suger belonged was forced to come to terms with stiffer opposition than that. Rather, it seems that in *De Administratione* the abbot of one of the most important monasteries of France was seeking the support of Ovid for something more pressing than the aesthetic delicacies of those under him. Always noting the pattern of increasing justification from *De Consecratione* to *De Administratione*, we see that in the former Suger's indirect reference to Ovid was meant as simple praise of both material and craftsmanship, and not as a justification in any sense.[176] However, the circumstances of its appearance alter significantly in *De Administratione*. In this later work, Suger cites Ovid twice, and both times it is in connection with his new (in relation to *De Consecratione*) theory of art as a spiritual aid. Its first occurrence is in one of the portal inscriptions of the new facade. Here, Suger paraphrases Ovid in his declaration that one should not be amazed at the gold and expense of the doors, but only at the craftsmanship.[177] However, the subject of craftsmanship is dropped, and in

172. And perhaps to Jer 10:1–4 and related texts as well.

173. For a brief bibliography on this, see Gilson 1940:200n.261.

174. *De Natura et Dignitate Amoris*; Gilson 1940:9, 200. Cf. William of Saint-Thierry's chastisement of the architecture of the monks of Mont-Dieu as *per manus artificium*, which may have been meant as a reference to Dt 27:15 (*opus manuum artificum*), Jer 10:3 (*opus manuum artificis*), and related texts.

175. Panofsky 1979:26–27, 164, 188.

176. Suger, *De Consecratione* 5, p.106.

177. Suger, *De Administratione* 27, p.46–48.

true Sugerian style he goes on to discuss how the "brightness"—on a literal level the gold plating of the doors, the material—leads one to the true light.[178] The situation is similar in the second example:

> But the rear panel, of marvelous craftsmanship and lavish sumptuousness (for the barbarian artists were even more lavish than ours), we ennobled with chased relief work equally admirable for its form (*forma*) as for its material, so that certain people might be able to say: "The craftsmanship surpassed the material." Much of what had been acquired and more of such ornaments of the church as we were afraid of losing, for instance, a golden chalice . . . we ordered to be fastened there. And because the diversity of the subject matter of the gold, gems, and pearls is not easily understood by the mute perception of the sight without a description. . . .[179]

While he does go on to mention the allegories which are an integral part of his theory of art as a spiritual aid, clearly the material is also a major part of it. Indeed, *forma*, which Panofsky translates as "form," might also be translated as "beauty," the overall beauty instilled in an artwork whether figural or non-figural by a skilled craftsman, and which can be, in fact, synonymous with craftsmanship. It is in this sense that Suger put forward his theory which included non-figural liturgical art, matching his direct reference to Ovid with Bernard's indirect one, defending or rather explaining the benefit of the marvelous craftsmanship (*miro opere*) of his altar panel to "certain people." These "certain people" were, I believe, Bernard and his circle of extreme reformers who opposed the use of marvelous craftsmanship (cf. *miro artificis opere* in *Apologia* 28) in monastic churches, and who had people at Saint-Denis who, it seems, were waiting to put an end to Suger's artistic policies. Suger had prepared the way for this justification in the chapter immediately preceding with a story about acquiring a very large amount of jewels from two unnamed Cistercian abbots and the abbot of the new ascetic order of Fontevrault. While this story was good natured on the surface, it was very much calculated to embarrass the previously mentioned circle—one of the Cistercian abbots almost certainly being Bernard.[180] But in the end, excess in craftsmanship was traditionally seen as no less inappropriate to the profession of the monk than excess in material.[181]

178. The passage is more involved than this; see Rudolph 1990:48–53.

179. Suger, *De Administratione* 33, p.60–62; I have altered Panofsky's translation somewhat.

180. Cf. Suger, *De Administratione* 32, p.58; Arnold of Bonneval, *Vita Prima* 2:55, *PL* 185:301–302; the Bernardine source of these jewels has also been suggested by the editor of the *Vita Prima*.

181. To cite only a few examples of the monastic rejection of excess in craftsmanship: Augustine, *Confessiones* 10:53, p.183; Chrysostom, *Homiliae in Matthaeum* 49:4, *PG*

The important thing about Bernard's passage is not that he mentions excessive material or that he mentions excessive craftsmanship, but that he mentions both together as does the Ovidian model. This, in conjunction with what appears to be a reference to it on the part of Suger and the following passage of the *Apologia* which interrogatively denies the function of liturgical art in the process of spiritual endeavors,[182] strongly suggest an awareness on Bernard's part of the use of this phrase as part of a justification of excessive material and craftsmanship, a justification which played down the expense of the artwork and consequently played up its craftsmanship. The craftsmanship—which included material beauty according to Suger—aided in spirituality and so circuitously justified the material.[183]

The Liturgical Artwork and the Sensory Saturation of the Holy Place

Bernard's criticism of excess in material and craftsmanship is one which might be applied to any artwork. Yet the examples of art he chose were for the most part quite specific: reliquaries,[184] *coronae*, candelabra, and decorated pavements. To be sure, there is more in the selection of artworks and their order of treatment than has been previously noticed. For it is not monumental painting and sculpture within the church that Bernard is condemning, it is something else. The conclusion is unavoidable that Bernard is criticizing artistic excess in regard to the layperson in the monastery, and more specifically in its aspect of liturgical art. The idea of major versus minor arts should never enter into the question. As Peter Lasko noted, whatever reason there may be for separating the two in some periods, none exists for doing so in the Middle Ages.[185] In fact, one could go further than this and say that at least among the sources so important to this study, liturgical art receives far more attention—both positive and negative—than do large-scale painting and sculpture. And when large-scale painting and sculpture are mentioned, it is more often than not the inscription which is of importance, not the artwork itself.

58:501; Caesarius of Arles, *Regula ad Virgines* 42, PL 67:1116; Aelred of Rievaulx, *De Speculo Caritatis* 2:70, p.99.

182. For a more detailed discussion of this see the commentary under 105:23–24 QUID PUTAS . . . ADMIRATIO.

183. If art could be admired for its craftsmanship, it could also be despised for the same reason; cf. Caesarius of Heisterbach, *Dialogus Miraculorum* 7:44, v.2:62–63.

184. For the reasons why I interpret the image of a saint as a reliquary, see the commentary under 105:16–17 AURO TECTIS . . . SANCTAE ALICUIUS.

185. Lasko 1972:2.

This is certainly the case with the *Vita Gauzlini*. Andrew's and un-
doubtedly Gauzlin's interests lay in the direction of that which was a part
of, assisted in, or embellished the liturgy. To be sure, Andrew does devote
some attention to wall painting at Fleury. But this largely consists of a list-
ing of the inscriptions which, while they serve as a record of the works, are
presented in such a way that gives no attention to the actual painting. The
situation with liturgical art is quite different. Here, an abundance of com-
ments extolling the beauty of the artwork or praising the material and
craftsmanship exists.[186] It is a work of liturgical art that receives the most
attention from the monk-artist Theophilus in his treatise written slightly
after the *Apologia*.[187] And, again, it is to the liturgical artwork that Suger
gives by far the most attention in his account of the art program at Saint-
Denis; and while he does record the inscriptions of certain figural works of
art, he never describes them for their own sake as he does the liturgical art.

Given the generic significance of the liturgical artwork, what is the sig-
nificance of the selection of individual artworks? To set aside reliquaries for
the moment, Bernard's concern in respect to art within the monastic church
focuses on excess in the material, craftsmanship, size, and quantity of litur-
gical art. But by singling out *coronae* and candelabra he both avoids the
more defensible area of those liturgical vessels which came into contact with
the Eucharist, *vasa sacra*,[188] and negatively refers again to the precedent of
the Temple in Jerusalem. In his description of the Temple in *De Laude
Novae Militiae*, Bernard uses the description of its restoration by Judas
Maccabeus (1 Macc 4 : 36–61) as his source, citing *coronae* and candelabra.[189]
If one can go so far as to suggest a source, however indirect, for this passage in
the *Apologia*, that source would be Judas' restoration with all the implica-
tions of a restoration of what Bernard would have characterized as Judaic
formalism on the part of contemporary monasticism. His selection of these
two items as representative of the Temple would have been clearly recog-
nizable to his contemporaries. Not only did the Lateran claim to possess the
original *menorah* from the Temple, but the justification of contemporary
large-scale candelabra was most commonly based on Old Testament prece-
dent.[190] Indeed, representations of the Jewish holy place often depend heav-

186. For example, *Vita Gauzlini* 3, 20, 38, 39, 44, 65.

187. Cf. Theophilus, *De Diversis Artibus* 3:24–43, 50–56, 61. p.75–94, 98–108,
113–119.

188. Cf. Suger's defense of the excessive liturgical artwork precisely for its eucharistic
function; *De Administratione* 33, p.64–66.

189. *De Laude Novae Militiae* 9, v.3:222. This same Biblical passage was cited in the
traditional, positive way by Matthew of Albano, *Epistola*, p.331.

190. The Lateran also possessed a great number of other relics related to Judaism; cf.
the *Liber de Ecclesia Lateranensi*, written only two years before the *Apologia*; Bloch

ily on the depiction of both *corona* and candelabra to convey its meaning.[191] In addition, Bernard characterizes the *coronae* and candelabra by their size, jewels, and lights: all aspects designed to overawe the viewer. Certainly, in mentioning not just once, but twice, the lure of blazing jewels and flickering lights, Bernard implicitly credits them with a special power over the lay audience. And that is just the point, in a positive way, of Peter the Venerable's Statute 52. In this statute, Peter restricts the use of lights on the great *corona* of Cluny precisely because of the *corona's* unusual power to overawe. For Peter was afraid that the effect of this "most elegantly composed *corona* of bronze, gold, and silver" would be weakened through habitual use, and so lessen the impact of the staging of the *opus Dei* at Cluny.[192]

Just how the images "which the very pavement gushes forth" fit into Bernard's complaint of liturgical art seems to be suggested by the order in which they occur within *Apologia* 28. The artform which he first takes up is the reliquary. It may be said to represent primary liturgical art in its role as the occasional focus of the liturgy. He next mentions *coronae* and candelabra, secondary liturgical art in that their assistance in the liturgy is more removed but still visually central. Size is a crucial category of excess in Bernard's criticisms of this type of art. It is size that distorts the original, unobjectionable forms of crown and candlestick into grotesque "wheels" and "trees." Having first raised the subject of what I have called primary liturgical art and then going on to secondary liturgical art, Bernard now discusses tertiary liturgical art, or art which neither is the focus of the liturgy nor less directly assists in it, but which acts as an indirect embellishment of it. Also criticizing the cost and impropriety of such art, he clearly objects to this type of decoration on the grounds of the ubiquitous disposition which is the result of excessive quantity.[193] In other words, he is complaining about the manipulation of the total artistic environment of the religious experience—what I call here the sensory saturation of the holy place.

It is in this sense that his mention of the Church dressing its stones in gold enters into the discussion. This criticism of Bernard's is too vague to be

1961:87. The identification of gold liturgical artworks with the perceived ritualism of Judaism could be very direct; see, Jerome, Letter 52:10, v.2:186; this in turn is cited by Idung, *Dialogus* 1:37, p.390.

191. For example, the representation of the Tabernacle from the Bible of Charles the Bald from S. Paolo fuori le Mura, f.21v; Bloch 1961:ill.58.

192. Statute 52, p.82; budgetary considerations also play a part in this statute. Fascination with gold and jewels is a constant in Suger's writings. See for example, *Ordinatio* p.132; *De Consecratione* 2, 4, 5, p.86, 100, 102, 104, 106; *De Administratione* 1, 31, 32, 33, 33A, p.40, 54, 56, 58, 60, 62, 64, 66, 68, 70, 76, 78.

193. Excess in itself was against monastic ideals; cf. Cassian, *Conlationes* 9:5, p.255–256.

seen as referring to a particular form of art or even a specific artistic technique. It is primarily used rhetorically and figuratively, under the authoritative form of a reference to Jerome's Letter 58:7 (and to a lesser extent to Letter 52:10 and the related 130:14). It is only secondarily a literal reference to the use of gold on church walls. But in its secondary, literal sense, the point of the passage is the same as that about the decorated floors: everywhere the visitor looks, the church is filled with distractive and even awe-inspiring artworks put there in order to overwhelm. Not only did Bernard see the sensory saturation of the holy place as a conscious effort, but so did some of those who promoted it in positive terms. In the preface to the third book of *De Diversis Artibus*, Theophilus noted what his mindful reader had learned and hopefully had done in the process of reading the first two books,

> You have given them [the viewers] cause to praise the creator in the creature and to proclaim him wonderful in his works. For the human eye is not able to consider on what work first to fix its gaze: if it looks at the ceilings, they glow like brocades; if it considers the walls, they are a likeness of paradise; if it regards the profusion of light from the windows, it marvels at the inestimable beauty of the glass and the variety of the most precious craftsmanship.[194]

Theophilus thus sees the properly decorated church as a place in which everywhere the eye looks it is confronted with works of art which in their multiplicity and artistic power affect the viewer profoundly, indeed, to the point of distraction so great that all he or she can do is to gaze from one artwork to another. And that primary and secondary liturgical art was also a part of this is shown (with a tinge of defensiveness) when he continues further on, "Prepare to execute what is still lacking in the vessels of the house of God, without which the divine mysteries and service of the offices cannot continue. These are chalices, candlesticks . . . reliquaries for holy relics. . . ."

The reliquary was the center of all this, financially, artistically, spiri-

194. *De Diversis Artibus*, preface to bk.3, p.63. I have changed Dodwell's translation somewhat. Cf. Bede, *Vita Abbatum* 6, p.369–370 where reference is also made to the disposition of art "wherever" the viewer turned; and Odo of Deuil, *De Profectione* 4, p.68, which offers a contemporary view from the successor of Suger at Saint-Denis of the sensory saturation of a Byzantine holy place. For a contemporary description of the opposite ideal, see Arnold of Bonneval's evocative and apparently realistic description of Clairvaux, *Vita Prima* 2:6, *PL* 185:272; and the apparently idealistic but no less significant description of Cîteaux in William of Malmesbury, *Gesta Regum Anglorum* 4:337, p.384–385. See also *Exordium Parvum* 17:5–8, p. 81, for an account of the elimination of liturgical artworks at Cîteaux.

tually, and often liturgically. As we have seen, it was the reliquary and the relics it contained that was so often the centerpiece of the monastic investment. It is the reliquary to which Bernard most directly attributes a remunerative power over the awestruck pilgrim. And, in fact, it is the reliquary that is the first specific type of artwork that he mentions in his list of artworks that were meant to stupefy their beholders. Bernard singles out the reliquary for a number of reasons. In many ways, the reliquary may be seen as the quintessential work of pilgrimage art. It was the earthly seat of power of the celestial patron, protector, hero, forgiver of sins, grantor of requests, and miraculous restorer of health. The amount of gold, silver, and jewels lavished upon it corresponded to the saint's importance. It was the ultimate goal of the pilgrim, and gradually became the artistic and liturgical focus of many pilgrimage churches.[195] Thus, it is no coincidence that in the twelfth-century *Pilgrim's Guide* which forms the fifth book of the *Codex Calixtinus*, the individual work of art which receives the single most attention should have been a reliquary—and a reliquary at a pilgrimage monastery at that.[196] Not only did the author obviously believe that it would be of great interest to his pilgrim readers, he himself was apparently attracted to it over the many other artworks he encountered on his trip. And Suger was at great pains to present the reliquary of Saint Dionysius "to the visitors' glances in a more glorious and conspicuous manner."[197]

Finally, the archetypal material of the reliquary was gold. In his description of the reliquaries assembled at the synod of Rodez in the early eleventh century, Bernard of Angers called them simply *capsis vel imaginibus aureis*, listing one after another: Saint Marius, *aurea majestas*, Saint Amans, *aurea majestas*, Saint Saturnin, *aurea capsa*, the Virgin, *aurea imago*, Saint Foi, *aurea majestas*.[198] This, more than any other artwork named in the *Apologia*, is the source of the gold in Bernard's rephrased question from Persius. But gold was a loaded word within monasticism, and especially so just at this time. With connotations that went far beyond the existence of the material object itself, gold implied an abandonment of apostolic poverty,

195. It was only after the eighth century that reliquaries were permitted to remain permanently on church altars. Before this they could be placed there only on feast days; Sumption 1975:158.

196. *Codex Calixtinus* 5[4]:8, v.1:362–364 covers the main reliquary at Saint-Gilles in detail.

197. *De Consecratione* 5, p.104.

198. *Liber Miraculorum* 1:28, p.72. The statement of Theofrid of Echternach (d.1110) that the saints should be honored on earth with riches suggests a response to some form of resistance to the excessive use of precious materials in reliquaries; *Flores* 2:6, *PL* 157:356–357; however, cf. *Flores* 2:4, *PL* 157:348–349 where Jerome's Letters 52:10 and 128:5 are invoked.

of the primitive simplicity of the Desert Fathers, and an acceptance of luxury.[199]

It was the reliquary which Theophilus' viewer would eventually come to rest his gaze upon, if he ever did rest it, and this is just the point of Bernard's critique. The works he criticizes are not criticized as isolated, if lavish, pieces. They were part of a much larger artistic unity of which the reliquary was often the centerpiece, but which in conjunction with the liturgy comprised a sensory saturation of the religious experience and which is probably forever beyond our imagination.[200] (A late fifteenth-century view of the high altar of Saint-Denis which had been restored by Suger, Figure 4, gives some sense, despite changes made after Suger, of how the accumulation of artworks could contribute to this sensory saturation. In this case, the artworks represent a continuous accumulation from the Merovingian, Carolingian, Romanesque, and Gothic periods. Suger was very conscious, both historically and aesthetically, of this accumulation.) How great an effect this sensory saturation had on the rustic visitor can only be guessed at from the Cistercian Aelred of Rievaulx's judgment of its effect upon the seasoned (and probably aristocratic) Cistercian monk in his sermon on the Feast of All Saints, "For, it seems to me, they do not celebrate the feasts well or reasonably who seek things of external glory and beauty, so that the external man is occupied with so much chanting, so many ornaments, so many lights, and other beautiful things of this sort that he is

199. The sources are far too numerous to cite here, many of which will be found throughout this work. But for the Desert Fathers, a few of the early Fathers, and Bernard, see the following. Athanasius, *Vita Antonii* 11–12, p.30–34. Ambrose, *De Officiis* 2:136–143, p.260–264. Paulinus, *Vita Ambrosii* 38, *PL* 14:40. Jerome, Letter 125:20, v.7:133; *In Johannem*, p.517–518; *De Nativitate*, p.524–525. Chrysostom, *Homiliae in Matthaeum* 50:3–4, *PG* 58:507–510. Palladius, *Historia Lausiaca* 10, *PL* 73:1102. *Verba Seniorum* 7:16, 10:15, *PL* 73:895, 914. *Apophthegmata*, Abraham 1, *PG* 65:129–132. Cassian, *Institutiones*, preface, p.3–4. Hilary of Arles, *Vita S. Honorati* 7, 32, *PL* 50:1253, 1267. And Bernard, Letter 113:6, v.7:291; *De Consideratione* 2:10, 4:6, 4:13, v.3:417–418, 453, 459; *De Laude Novae Militiae* 3, 8, 9, v.3:216, 220–221, 222; *Ad Clericos de Conversione* 26, v.4:101. Cf. also the apostolic ideal as expressed in Acts 3:6, "Peter said, 'I have no silver or gold, however, what I have I give to you,'" cited by Aelred of Rievaulx, *Sermones* 18, p.123–124, 127.

200. The stripped medieval church of today gives as much of an impression of what the medieval pilgrimage church at the height of its popularity was like as do the derelict walls of an abandoned house of the life that went on within it. Besides art, the churches were filled with an amazing variety of relics and votive offerings ranging from plows placed on altars to refectory tables hung from the rafters, and from scores of spears thrust into the ground to altar railings made from the chains of freed prisoners. Votive offerings, like artworks, were criticized as elements in a conscious program to attract donations (Labande 1966:286). In some cases, the enormous amount of votive offerings in the churches was actually criticized for impairing circulation (Labande 1966:286).

hardly able to think of anything else except that which he sees with his eyes, hears with his ears, or perceives through the other senses of the flesh."[201] And just as the reliquary was the centerpiece of an artistic unity, so were the relics it contained often the centerpiece of an economic unity, with taxes paid on the saint's feast day, markets held then, institutional authority projected through the saint's spiritual authority, gifts given in the saint's name, and, most importantly for our purposes, pilgrims attracted to the saint's shrine. To pilgrims, who were told that they would go to hell if they died on the road with money in their pockets,[202] the effect of all the gold, silver, and jewels, of the lavish material, craftsmanship, size, and quantity must have been profound. However, granted moderate art for the honor of God, and granted even moderate art for the instruction of the illiterate, the excess of sensory saturation—of which Bernard singles out the gold of the liturgical artwork as the focus of his attack because it was the main pillar and least defensible element—was in itself contrary to monastic practice.[203] But what was even more contradictory was the purpose to which this excess was put. The aim of this artistic overkill, of the aesthetics of excess, was no less than an answer to the revised question of the pagan, "Tell me, poor men, if indeed you are poor men, what is gold doing in the holy place?"

201. *Sermo* 22, PL 195:337. A similar opinion was expressed in more laconic fashion by Peter Damian, *De Institutis* 30, PL 145:362. For a conceptually antithetical position on the sensory saturation of the holy place, see Theophilus, *De Diversis Artibus*, preface to bk. 3, p.63–64, cited earlier.

202. *Codex Calixtinus* 1:17, v.1:157.

203. Elements of this will be taken up in the sections "Art as Opposed to the Care of the Poor" and "Art as a Spiritual Distraction to the Monk."

Art to Attract Donations:
The Equation Between Excessive
Art and Holiness

Bernard is also attacking pilgrimage art on a much more profound level than that of the simple greed described in the previous chapter. In his brief account of the power art held over medieval perception, he says, "The thoroughly beautiful image of some male or female saint is exhibited and that saint is believed to be the more holy the more highly colored the image is." By means of this sentence—interposed between those that draw the explicit relation between the investment in art and the financial return—Bernard brings up the logic of the reception of excessive art on the part of the layperson.

Hegel observed that, "The holy as a mere thing has the character of externality . . . the process of appropriating it is not one that takes place in the spirit."[204] And so it was that "the holy" came to be perceived as integrated into artworks in differing degrees by the medieval mind. Such a process neither increased nor decreased with time, but coexisted in all its aspects, and even in different aspects within the same work of liturgical art. Nevertheless, there is a logical progression from one stage to another, with corresponding negative stages which will not be discussed here.[205] To be sure, the relation between art and holiness in the Middle Ages was a complex and variable one, and certainly one which is worthy of study in depth. But for the purposes of this work, let its various aspects be simplified into the categories of ever-increasing power of holiness by association, by implication, and by transformation. The vagueness of Bernard's accusation takes all of these stages into its purview, without any damage to orthodoxy, and denounces not the phenomena, but rather how they are used.

Holy by association corresponds to the orthodox position which, I believe, may fairly be said to be represented by Bernard himself, who in all

204. *The Philosophy of History*; cited in Brown 1982:86.
205. Negative stages could be said to range from views associated with reformers to those of heretics.

matters strove for orthodoxy. In his "Fourth Sermon on the Dedication of the Church," he observed, "For although these walls may be called and have in truth been made holy by their consecration at the hands of bishops, by the daily reading of the Scriptures within them, by our constant prayer, by the relics of the saints, and by the angelic guardianship, nevertheless, we must not believe that even holy walls are worthy of honor for their own sake since it is certain that it is not for their own sake that they have been made holy."[206] Since all of the means of imposing sanctity related by Bernard in respect to the church apply equally well to many of the liturgical artworks within the church—especially consecration, prayer, and the presence of sacred relics—and since Bernard uses the term *sacer* in describing the images found within the church in the *Apologia* and elsewhere,[207] one may suppose his views on the former also apply to the latter. According to this moderate view, the object in question takes on a special character through its relation to some external source of holiness and is not considered to be holy in itself. As John of Damascus said concerning the pilgrimage places, "I venerate [them] . . . not on account of their nature, but because they are the receptacles of the divine operation of God, because through them and in them God is pleased to bring about our salvation."[208] But this attitude was taken a step further and by the most respectable authorities. In a letter accompanying a Latin translation he had made of Bishop Theophilus of Alexandria's broadside against Chrysostom's scant regard for liturgical art, Jerome praised Theophilus' effort, adding, "The sacred chalices, veils, and the other things which pertain to the veneration of the Passion of the Lord are not empty objects, not having holiness and lacking meaning, but from their association (*ex consortio*) with the body and blood of the Lord ought to be venerated with the same reverence as his body and blood."[209]

It is a short step from Jerome's extreme expression of holiness by asso-

206. Bernard, *In Dedicatione Ecclesiae* 4:4, v.5:385. Bernard's position was essentially that of Augustine (*Enarrationes in Psalmos* 113:2:6, p.1645) and is found in Hugh of Saint-Victor (*De Sacramentis* 2:9:10, *PL* 176:476–477) and Hélinand de Froidmont, *Sermo* 23, *PL* 212:678. Cf. William of Malmesbury, *De Antiquitate* 18, p.66, where the abundance of relics at Glastonbury is described as making that abbey a heavenly shrine on earth, a place so holy that hardly anyone dared to spit there.

207. *Apologia* 28, *sacris imaginibus*; Letter 243:4, v.8:132, *sacris imaginibus*.

208. *De Imaginibus* 3:34, *PG* 94:1353.

209. Jerome, Letter 114:2, v.6:45. An interesting example of this in daily life is the reluctance of the supporters of Anacletus II to break up liturgical artworks and their solicitation of non-Christians for this purpose (Arnold of Bonneval, *Vita Prima* 2:1, *PL* 185:269). The latter also explains the specific mention in the sources of Peter the Venerable's pawning of the great golden crucifix of Cluny to the Jewish merchants of Mâcon.

ciation to that of holiness by implication. By the latter I mean something which in itself implies holiness by the mere fact of its existence. This is, as Bernard sees it, the function of pilgrimage art in respect to the reception of the layperson in the monastic church. Nor was he alone in noticing this popular association. The following incident was recorded at the monastery of Prüm in the mid-ninth century soon after the arrival there of the new relics of Saints Chrysantus and Daria:

> Wishing to rend material assistance there to God and his servants the holy martyrs, a certain woman hurried to that place taking with her a wagon loaded with food, drink, and other goods. Actually, when she got near she ran ahead of the wagon. However, when she saw that their tomb did not shine with gold and silver, she looked down on the place and ridiculed it, as dull and irreligious minds are accustomed to do. Immediately turning around to meet her party, she ordered those who had come with her to return, saying that there was nothing holy contained there.[210]

In other words, not only could holiness be contained, its containment—which was repeatedly denied by various Church Fathers—was indicated by excessive art. And not only did the potential donor not tolerate any liturgical expression of voluntary poverty in the monastic church, but she even refused to engage in any transactions of the sacred economy because of the absence of excessive art. This awareness of the psychological and economic role played by the art of the time—indeed, one might even say of the psychology of economics—accounts to a large degree for programs of excessive art. There was actually a necessity of art, a financial necessity. As the Prüm chronicler noted: no art, no donations, at least as far as the pilgrimage aspect of the sanctuary's economy went.

The extreme view of holiness by transformation was apparently a constant in the medieval period—as opposed to the Early Christian period, when the threat of relapse into idolatry was ever present, as Augustine attests.[211] Carolingian references to artworks being seen as possessing divine power cannot be dismissed as reacting to the Eastern iconoclastic controversy alone. For example, Agobard of Lyon's complaint that some people are foolish enough to attribute sanctity to images devoid of soul is not only repeated by Bernard of Angers 200 years later, it is repeated 650 years later as a prelude to Protestant art reform.[212] The phenomenon both existed and

210. *Historia SS. Chrysanti et Dariae* 9, PL 121:676.

211. *De Moribus* 1:75, PL 32:1342, "I know many are worshippers of tombs and pictures."

212. Agobard of Lyon, *De Picturis* 16, p.165 (*De Picturis* was once thought to be the work of Claudius of Turin). See Baxandall 1980:53–54 for the anonymous *Der Spiegel des Sünders* of c.1475 from Augsburg.

was resisted in Western Europe on a continuing basis. As expressed by Bernard of Angers in an account of his reaction to the phenomenon of holiness by transformation before his "conversion" to the cult of Saint Foi and his acceptance of this phenomenon, such images as the reliquary-statue of Saint Gerald at Aurillac or that Saint Foi at Conques (Fig. 5) were not being employed along the doctrinal lines which permitted the use of art for purposes of teaching the illiterate or reminding the faithful of the deeds of the saints.[213] To Bernard of Angers, before his conversion, these reliquary statues were being worshipped as pagan idols—actually referring to Jupiter, Mars, Venus, and Diana in his evocative description of these reliquary statues' power over eleventh-century supplicants. He complained that images had such power over the "illiterate" that they actually imagined that the statues looked at them, and on occasion would by their countenance indicate if it were disposed toward a particular petitioner.[214] While such a phenomenon is extreme, it seems to have manifested itself in an even more pronounced manner in the occurrence of visions of saints appearing to the living not in human form, but in the form of the artworks in which they were supplicated. (Cf. Fig. 6. Is this a miniature of the real Virgin and Child that we see facing Bernward of Hildesheim or is it the sculpted image of the Virgin and Child that he is known to have commissioned? Or is it both, that is, is it a miniature of the real Virgin and Child's presence in the church as forcefully projected through that image?)

However, Bernard's concern, as is generally the case in the *Apologia*, is not with problems of the Church as a whole, but only with its monastic wing. It was not any "popular" misconception that warmed his pen. His position in *Apologia* 28 was an entirely untheoretical stand against the psychology of the economics of excessive art as practiced by certain pilgrimage monasteries. The problem was compounded for Bernard in that a very strong tradition independent of the pilgrimage existed which saw as legitimate the power of excessive art to create an effect which was directly related to an aura of holiness, and this tradition had strong roots in monasticism.

Perhaps its purest expression may be found in the writings of Suger and the author of the anonymous *Miracula Sancti Hugonis*. In *De Consecratione*, Suger singles out a particular chapel—that of Saint Romanus, the central chapel of the west end and apparently reserved for the spiritual devotions of the monastic community alone—as "most beautiful and worthy

213. Bernard of Angers, *Liber Miraculorum* 1:13, p.46–49.
214. Cf. Augustine, Letter 102:18–19, v.34:560, where Augustine describes as if it were a common phenomenon how pagan cult statues were perceived to be living beings, much as in Bernard of Angers' description. Interestingly enough, Augustine is careful to suggest a passage from Scripture (Ps 113b:5–6; RSV Ps 115:5–6). Along these lines cf. also the similar statement by Augustine in *Enarrationes in Psalmos* 113:2:7, p.1645.

to be the dwelling place of angels."[215] Several years later in his *De Administratione* he wrote, "How secluded this place is, how pious, how proper for those celebrating the divine rites has come to be known to those who serve God there as though they were already dwelling, in a degree, in heaven while they sacrifice."[216] It is apparently the beauty of the chapel that has caused Suger to distinguish it from the others of the west end by ascribing a celestial quality to it. But whereas in the earlier writing it was enough to discuss this celestial quality in laudatory terms, the more apologetic work speaks of the same phenomenon as it affected the monks who worshiped within that chapel, ascribing to it the power to induce a perception of the otherworldly while in that room.

What Suger describes was noticed and appreciated by others, most pertinently to this discussion by the author of the anonymous *Miracula Sancti Hugonis*. He is even more explicit than Suger in isolating the categories of excess criticized by Bernard in *Apologia* 28 as responsible for an aura of holiness imparted by religious art. After praising the craftsmanship and size of the third abbey church of Cluny he writes, "It is difficult to judge whether it is more fitting in its size or more amazing in its workmanship. So much so that you might even call the [house] of his beauty and the place of his glory [Ps 25 : 8] the walk of angels—if it were permissible to suppose that human abodes offered pleasure of this sort to heavenly inhabitants."[217] But the "walk of angels" was made for monks, and it was concerning these monks that the anonymous author observes, "Indeed, every day they celebrate as if it were Easter, for they have merited to cross over into a kind of Galilee."[218] Galilee apparently refers to Matthew 28 : 7 and Mark 16 : 7 which recount the meeting of the Apostles with Christ after his resurrec-

215. *De Consecratione* 4, p.96–98. Suger's use of *secretalis* to describe this chapel (*De Administratione* 26, p.44) refers to its removed and possibly reserved disposition. Cf. the statutes of Peter the Venerable where laypeople and priests are excluded without exception from the *secretaria* of Cluny (Statute 53, p.83); and Gregory of Tours' description of the arrangement and materials of a new church in which one feels a fear of God (*Historia Francorum* 2:16, p.82).

216. *De Administratione* 26, p.44. I have translated *devotus* and *habilis* as "pious" and "proper" rather than following Panofsky's "hallowed" and "convenient" which imply too much and too little, respectively.

217. *Miracula S. Hugonis*, col.458, "Capaciorne sit magnitudine, an arte mirabilior, difficile iudicetur. Haec eius decoris et gloriae eius, quam, si liceat credi coelestibus incolis in huiusmodi usus humana placere domicilia, quoddam deambulatorium dicas angelorum."

218. *Miracula S. Hugonis*, col.458; cf. Gilo, *Vita S. Hugonis*, p.606. For what one could call an antithetically opposed view of architecture which nevertheless evoked the same effect, see William of Saint-Thierry's account of his reaction to first seeing the hut in which Bernard lived when recovering from a serious illness, "I swear before God that the house itself instilled an awe of him [Bernard], as if I were approaching the altar of God;" *Vita Prima* 1:33, PL 185:246.

tion, thus conjuring up a state where one may physically feel oneself to be with the glorified Christ while one is still in this world, yet in a manner externally induced, and in a way not experienced in every church.[219] And so, like Suger, our author is struck first by the celestial quality of the totality of the artistic environment in which one prays, and then by the altered state of those praying in it.[220]

The references to the celestial used by Suger and the author of the *Miracula Sancti Hugonis* may be conventions, but if so, they are conventions which were deemed the most precise expression of a relatively common experience which was difficult to otherwise convey. There is no reason to suppose this phenomenon—which slightly overlaps but does not exactly coincide with the concept of art as a spiritual aid—to be merely high praise clothed in religious terms. The *Vita* of Benedict of Aniane by Ardo provides us with what must be the closest a medieval art historian can ever come to a controlled environment, an environment into which ever-increasing amounts of the subject under study have been introduced. In his account of Benedict of Aniane's two monasteries on his paternal estates, Ardo notes how with the first one, Benedict had

> resolved not to cover the buildings with decorated walls and red tiles, or to build them with painted panelled ceilings—but to cover them with straw and to build walls of the common sort.

However, despite Benedict's conscious effort to retain an atmosphere of simplicity and humility as the population of the monastery increased, an element of ever-increasing luxury in liturgical art was introduced— doubtless from external pressures on Benedict. This trend began already while still in the first church:

> He was unwilling that for themselves [i.e., for the monks] the vessels for the preparation of the body of Christ be of silver; if in fact in the beginning they

219. Mt 28:7, "'Then go quickly and tell his disciples that he has risen from the dead, and behold, he is going before you to Galilee; there you will see him.'" Mk 16:7, "'But go, tell his disciples and Peter that he is going before you to Galilee; there you will see him, as he told you.'" The use of the term "Galilee" here does not refer to the architectural entity known as a galilee.

220. The author of the *Vita S. Hugonis Episcopi Lincolniensis* actually speaks of the new church which Hugh of Lincoln had built "with amazing skill" as a bridge to paradise; Lehmann-Brockhaus 1955:2372. Theophilus also describes the walls of a properly decorated church as a "likeness of paradise (si consideret parietes, est paradysi species)"; *De Diversis Artibus*, preface to bk.3, p.63. It is apparently to this mentality that Aelred of Rievaulx refers but in a negative sense, characterizing one who does pray in such a place as Theophilus describes as being "expelled from paradise"; *De Speculo Caritatis* 2:70, p.99–100.

were of wood, [the material] rose in succession to glass, and so in the end to *stannum* [an alloy of lead and silver].[221]

But this tendency toward excess became programmatic in the second church at Aniane, constructed and furnished under the auspices of the emperor Charlemagne and with the aid of a number of dukes and counts:

> By the order of Charles . . . he began to build a very great church, but the claustral buildings (*claustra*) in the new undertaking [were] different, with as many marble columns as possible. . . . He did not cover the buildings with straw now, but with tiles. And that place is possessed of such great holiness that whoever may come to ask in faith for something—and does not doubt in his heart, but believes—will immediately be granted what he seeks. Therefore, since it shines forth with such amazing religiosity, we think it appropriate if we should make known something about the arrangement of that place for future readers.[222]

The "arrangement" of the new monastery consists, as one might by now expect, primarily of a detailed description of the liturgical artworks—now freely made of silver. Ardo clearly associates in his own mind the liturgical artworks—which were made with "inestimable labor" and based on Old Testament precedent and which included a large candelabrum of the type criticized by Bernard—with the amazing holiness and religiosity of the place. Indeed, this is the whole point of his description of the artworks, so that others might read and emulate, emulate this predecessor of and model for tenth-, eleventh-, and twelfth-century reform. The first monastery was admirable for its voluntary poverty, but the second—which was distinguished from the first only in its art and in absolutely no other stated way including the possession of pilgrim-attracting relics—was remarkable for a new aura of holiness which immediately became attached to it, which attracted outside visitors, and which effected numerous miraculous events. It is in just these miraculous events that Ardo's account differs from those of Suger and the *Miracula Sancti Hugonis*. Yet the one is only a more popular expression of the same concept dealt with by the others, and all enter into the equation between excessive art and holiness.

Furthermore, the equation between art and holiness seems to have been compounded in such a way as to increase even further the importance of art at pilgrimage churches. Fear of theft ostensibly brought about a rather common reluctance to actually display the relics that so many had come so far

221. Ardo, *Vita Benedicti Anianensis* 5, p.203–204.
222. Ardo, *Vita Benedicti Anianensis* 17, p.206.

to see and to be near. For example, the monastery of Conques refused to display its relics except at certain established times, thus leading to riots which required papal intervention. The famous pilgrimage monasteries of Saint-Martial and Charroux refused to show their relics more often than once every seven years. And within less than a century after the *Apologia*, some churches chose to never display their relics at all.[223] Yet the pilgrims expected to see something. The attitude of the woman who came to see relics at Prüm but subconsciously expected art was seen by the chronicler as widespread, even customary. Andrew of Fleury, after listing several recent and "almost inimitable" art acquisitions of Gauzlin, noted perhaps a bit too defensively that the new relic he had also brought back was of course preferable to any kind of ornament.[224] And Bernard himself said, "They admire the beautiful more than they venerate the sacred." Given the already widespread equation between excessive art and holiness, it seems that excessive art was at least in part used to meet the expectation of some great experience on the part of the crowd. That is, if that expectation was not to be fulfilled through holiness itself because of the "carnal" nature of the crowd, to use Bernard's term, then it could be fulfilled through aesthetics—and so the aesthetics of excess were in this case also the aesthetics of holiness.

On this level then, art functioned to create a sense of *praesentia* or the physical presence of the holy, as defined by Peter Brown.[225] The way in which this was effected was through excess in the categories criticized by Bernard, with the result being the creation of beauty. By beauty we should understand not merely the gracefulness of form, but more especially sensory stimulation through excessive material and craftsmanship as Bernard implies, "The thoroughly beautiful (*pulcherrima*) image of some male or female saint is exhibited and that saint is believed to be the more holy the more highly colored the image is." Or, from the point of view of the pilgrim, "How beautiful (*pulchrum*) it is to visit the tomb of Saint Giles."[226] The equation between art and holiness, or beauty and *praesentia*, was also recognized in the *Libri Carolini* which admonished those who considered artworks to be holy, "For if [it were the case that] the more beautiful (*pulchior*) any image is, the more holiness and power it has, it [would then be] inevitable that that which is more unsightly would have less holiness

223. Sumption 1975:215. On the threat of the theft of relics in general, see Geary 1978.

224. *Vita Gauzlini* 20, p.60, "pene imitabilis operis."

225. Brown 1982:88. The Christian prototype of this claim or sensation of *praesentia* may be found in 3 Kg 8:10–11.

226. *Codex Calixtinus* 5[4]:8, v.1:361.

and power. . . . [But] surely its holiness comes not from what one might call a sacred quality (*religione*), but from the labor of a master crafts-man."[227] The more excessively a sanctuary was decorated, the greater that saint's spiritual powers were believed to be and, consequently, the greater were the donations that poured in. As Bernard put it, "By I know not what law, wherever the more riches are seen, there the more willingly are offer-ings made" (*Apologia* 28). The important thing for Bernard is the conscious manipulation of art to create an overpowering sense of holiness. William of Malmesbury noticed both the phenomenon and the awareness of it when he said, "Certainly the more grandly constructed a church is, the more likely it is to entice the dullest minds to prayer and to bend the most stub-born to supplication."[228] Since all art originated in gifts to the saint, whether indirectly through gifts which generated money for the sanctuary such as land and feudal rights, or directly through gifts of cash or the artworks themselves, excessive art was seen as proof of the efficacy of that sanctu-ary's relics or patron saint.[229] Indeed, this was so much the case that what Bernard condemned in the manipulation of fine art, others condemned in the manipulation of that most immediate expression of folk art, the votive offering.[230]

Bernard saw the phenomenon of the equation between excessive art and holiness in the popular conception as the key to the power of excessive art to attract donations. A legitimate basis of attraction in the possession of relics on the part of the monastery and the corresponding religious fervor on the part of the pilgrim bring monastery and layperson into contact. An aware-ness of the remunerative power of excessive art leads to an exaggeration of the tradition of honoring the holy with artworks. The combination of ex-cess in material (especially gold) and craftsmanship instills a certain awe in the worshiper which compounds the religious fervor and at the same time confuses that which is holy (the relic) with that which instills awe (the ex-cessive artwork). When the worshiper approaches the holy, he is asked to donate at a time when art, liturgy, and the proximity of the sacred combine

227. *Libri Carolini* 4:27, p.226.
228. *De Antiquitate* 19, p.66–68.
229. This attitude is most commonly expressed in the opinion that a particular sanctu-ary is no longer in keeping with the growing prestige of its patron saint. Cf. Suger on the church of Saint-Denis, *De Consecratione* 2, p.86; Gregory of Tours on the church of Saint Martin of Tours, *Historia Francorum* 2:14, p.81; and, in a more worldly vein, Leo of Ostia, *Chronica* 3:26, p.717.
230. Around the time that the *Apologia* was written, a local knight accused the pilgrim-age monastery of Rocamadour of displaying counterfeit votive offerings in the church, ap-parently for the purpose of encouraging greater donations; *Les miracles de Roc-Amadour* 3:2, p.288–289.

to overwhelm him.[231] According to Bernard, the worshiper is distracted from his original purpose by the attraction of the art, the spiritual exercise is subverted by the deflection of spiritual goals, and the proprietor is tainted by the monetary transaction.[232] The result is that excessive art takes center stage to spirituality, and in fact becomes confused with it, translating the sensory saturation of the holy place into the *praesentia* of the saint.

231. For example, it is documented that at Santiago de Compostela, in the late thirteenth century, the ritual of the receiving of indulgence which took place next to the shrine of the saint was so arranged that at the moment when one priest bestowed the indulgence, another invited the pilgrim to donate, asking whether the gift was intended for the common fund or for the art program; source in López Ferreiro 1898:v.5:appendices p.65.

232. Hélinand de Froidmont opposed this process not only on the grounds just stated, but also in regard to the envy such excess attracted; *Sermo* 23, *PL* 212:678.

Art as Opposed to the Care of the Poor

Of all the "things of greater importance," it is that which is concerned with external social objections—art as opposed to the care of the poor—that has the most illustrious lineage in the patristic literature and that recurs most frequently in later times. Whether it was a purely moral and theoretical subordination or the praising of individual acts of selling liturgical art for famine relief and the ransoming of captives, a firm tradition existed for this alternative view of art. Thus, when Bernard gave his position on the subject in the *Apologia*, it must have been immediately understood as part of that tradition: "O vanity of vanities, but no more vain than insane! The Church is radiant in its walls and destitute in its poor. It dresses its stones in gold and it abandons its children naked. It serves the eyes of the rich at the expense of the poor. The curious find that which may delight them, but those in need do not find that which should sustain them" (*Apologia* 28).[233] Indeed, Bernard was himself an important part of that tradition. But his position was not identical with that of the traditional authorities who had written before him. Within the limitations of the treatise, his argument has two components. One is indicated by its literal content and follows the traditional position rather closely. The other is suggested by its context and, as with so much of Bernard's criticism of art in the *Apologia*, is more than a straightforward condemnation of the subject under discussion.

The Sale of Liturgical Art for the Relief of the Poor

Apparently from the period prior to the so-called Edict of Milan (313), a tradition existed in the Church which sanctioned the selling off of liturgical vessels, or liturgical art, for the care of those in need.[234] According to this

233. On the possible relation of this passage to recent events within the Cistercian Order, see the section "The Cistercians."

234. Although the distinction is not always as clear as one might like, I attempt to avoid cases of the selling of art only out of simple need and without the elements of famine, ransom, or a rejection of excess. An example of this simple need is that of Lupus of Ferrières (Lupus of Ferrières, Letter 32, p.42–43), whose actions find theoretical sanction in Burchard of Worms, *Decretum* 3:106, *PL* 140:694, who cites the Council of Auvergne as his authority.

tradition, which was most widely disseminated through the writings of Ambrose, the Roman deacon Laurence was approached following the martyrdom of Pope Sixtus in 258 by Roman officials who demanded that he hand over the treasure of his church. Laurence asked them to come back later so that he might gather this treasure together for them. When they returned, he showed them the assembled poor and sick of the city, explaining that they were the true treasure of the Church.[235] According to Ambrose, Laurence, who paid dearly for his reply, used the gold of the Church—previously sold liturgical artworks according to Ambrose—for the work of the Lord. But more significantly, this story was related during a period of exceptional institutional prosperity, in some ways not unlike the early twelfth century when so much liturgical art entered the Church.[236] It was also made in defense of Ambrose's own actions after he had broken up certain liturgical artworks to exchange for captives held by the barbarians in the wake of the disintegration of the *Pax Romana*. In this statement, Ambrose forcefully establishes the precedent and the ideal in respect to liturgical art that "the Church has gold not to keep, but to expend," and that "it [is] better to preserve intact living vessels than metal ones." But aside from this, he also, if incidentally, questions the place of gold in the liturgy, saying, "The sacraments do not demand gold, nor do they have an affinity with gold—these sacraments which are not acquired with gold."[237] And to reduce internal opposition as much as possible, he implies that the only resistance he encountered along these lines came from the quarter of the heretical Arians.

The story of Laurence was repeated by others, most notably by the late fourth- and early fifth-century Spanish poet Prudentius who, however,

235. Ambrose, *De Officiis* 2:136–143, p.260–265. A certain Macarius used quite similar terminology to that of Laurence in calling the sick of his hospital in Alexandria "hyacinths and emeralds"; Palladius, *Historia Lausiaca* 6, PL 73:1096–1097.

236. In merely one example in the *Liber Pontificalis*, that of the Constantinian gifts to the Lateran basilica (*Liber Pontificalis* 34:9–34:15, v.1:172–175), the amount of gold and silver is almost beyond belief.

237. *De Officiis* 2:137, 138, p.260, 262, "Aurum sacramenta non quaerunt, neque auro placent quae auro non emuntur." Cf. Paulinus, *Vita S. Ambrosii* 38, PL 14:43. That Bernard was familiar with Ambrose, whose importance as a source for Cistercian mysticism was very great (Gilson 1940:70), needs no proof. Let it just be said that Clairvaux possessed a copy of *De Officiis* in the twelfth century (Troyes, Bibl.mun.39; Wilmart 1917:152), and that he cites the death of Laurence in *Sententiae* ser.3:122, v.6pt.2:231. In the *Vita Prima* (2:55, PL 185:301–302) Arnold of Bonneval tells how in gratitude to political aid given to him by Bernard, Count Thibaut of Champagne broke up two of his favorite vessels which had been used at the coronation of his uncle, Henry II of England, in order to sell the gold and jewels to help those in need. Cf. the apostolic ideal concerning gold and silver as expressed in Acts 3:6.

makes no reference to the sale of liturgical art.[238] Rather, it was the version of Ambrose—which draws the explicit connection between liturgical art and the relief of the poor—that became the accepted version of Laurence's statement on the poor being the treasure of the Church. It was the precedent of Ambrose that the biographer of Augustine himself felt was necessary to invoke when relating how the monk and Bishop of Hippo was forced to break up liturgical artworks for the ransom of captives and the feeding of the poor.[239] It was Ambrose that Abbot Odo of Cluny referred to by name in his rejection of excessive liturgical art in his *Collationes*.[240] It was Ambrose's Laurence that two of Abbot Odilo of Cluny's monk-biographers, Jotsaldus and Peter Damian, had in mind when they wrote about how he sold so many liturgical artworks and *ornamenta insignia*, including the imperial crown bestowed on Cluny by Henry II only a few years before, in order to feed the poor during famine.[241] It was on the authority of Ambrose that Abbot Hugh of Cluny based his moral theology of almsgiving, as we shall soon see. And it was Ambrose to whom the Cistercian monk Idung refers in his rejection of the typically Sugerian belief that one should honor God with the most precious materials possible in those liturgical artworks which are directly involved in the sacrament of the Eucharist.[242] Finally, and there must be many, many more examples in the literature, it was Ambrose that appeared in the *Decretum* of the canon regular Ivo of Chartres (d.1115) and in the *Decretum* of the Camaldolese monk Gratian (c.1139), thus virtually serving to establish it as the standard authority on the subject.[243]

238. *Peristephanon* 2. Note the vague similarity between verses 299–300, "gemmas corusci luminis / ornatur hoc templum quibus," and *Apologia* 28, "nec magis coruscantes superpositis lucernis, quam suis gemmis."

239. Possidius, *Vita S. Augustini* 24, *PL* 32:54. As far as I have been able to determine within the limits of my current research, the example of Augustine was never used as a precedent for this phenomenon in the Middle Ages.

240. *Collationes* 2:34, *PL* 133:580. The *Collationes* of Odo were owned by Clairvaux (Troyes, Bibl.mun.239; Wilmart 1917:172).

241. Jotsaldus, *Vita S. Odilonis* 1:9, *PL* 142:904. That Jotsaldus saw Odilo's actions as based on Ambrose is indicated by the fact that he refers to Laurence by name, citing the poor as the *thesaurus Ecclesiae*, an expression used repeatedly by Ambrose but never by Prudentius. In a second account of this same event by Peter Damian (*Vita S. Odilonis*, *PL* 144:929), Leclercq (1965:35) has noticed a reminisence between the latter's passage and the Office of Saint Laurence.

242. *Dialogus* 1:37, p.390. In *Dialogus* 3:31, p.452–453, Idung again refers to Ambrose in his rejection of the role of monastic avarice in the sacred economy.

243. Ivo of Chartres, *Decretum* 3:180, *PL* 161:239–240; Gratian, *Decretum* causa 12:2:71 (col.710–711); my thanks to Steven Wight for bringing Gratian to my attention. A similar reference to Ambrose is found in a letter which was once attributed to Fulbert of Chartres, who reconstructed the cathedral in the eleventh century; Pseudo-Fulbert, Letter 2, p.271.

While Ambrose was the classic model for the sale of liturgical art to meet the needs of the poor, such a position was by no means dependent upon his authority. Sometime between 359 and 386 the city of Jerusalem was struck by famine. Cyril, bishop of Jerusalem, sold various liturgical artworks to buy food for the poor. As was the case with Ambrose, this act was reputed to have been held against him by the Arian opposition. His metropolitan, Acacius of Caesarea, ostensibly deposed him on the grounds that some of the ornaments had been bought by an actress and used as part of her costume.[244] Slightly later, the monk and bishop Paulinus of Nola was claimed by Gregory the Great not only to have sold all of the property pertaining to his episcopacy—implying but not explicitly stating the sale of the liturgical artworks of the cathedral—but also to have given his own person in exchange to ransom captives from the Vandals.[245] Jerome, in a famous letter on the monastic life, praised the actions of Bishop Exuperius of Toulouse, who between around 405 and 411 sold apparently all of the church ornaments to feed the poor of his city, content to use a simple wicker basket and glass chalice for the Eucharist.[246] It was undoubtedly this *Exuperius Tolosae episcopus* to whom Odo of Cluny referred when he praised *episcopus Eusebius Tolosanus* for a similar attitude toward liturgical art, citing Jerome's letter and crediting the latter with the merits of Exuperius.[247] Along with Exuperius, Odo also recalled the example of the monk Caesarius of Arles, who, as archbishop of that city (502–542), sold his thuribles, chalices, patens, and other liturgical artworks to redeem captives in the face of stiff opposition from his own clergy, whom he faced down.[248] In the *Verba Seniorum*—which has been called the most influential of all collections on monasticism in the West and which was probably translated into Latin as early as the middle of the sixth century[249]—the monk Evagrius Ponticus tells of another monk who owned nothing but a copy of the Gospels which he sold to feed the poor, thus selling the Word which commanded him to sell all and give to the poor.[250] It should be noted that the *Verba Seniorum* had special influence on the Cistercians as well as on Peter Damian, the Carthusians, and other new ascetic orders. Abbot

244. Sozomen, *Historia Ecclesiastica* 4:25, PG 67:1195. Cf. Burchard of Worms, *Decretum* 3:104, PL 140:694 who further cites Popes Stephen and Hilary.

245. Gregory the Great, *Dialogorum Libri* 3:1, p.256–258.

246. Jerome, Letter 125:20, v.7:133. A copy of the letters of Jerome were owned by Clairvaux in the twelfth century (Troyes, Bibl.mun.190 and 872; Wilmart 1917:155–156).

247. Odo of Cluny, *Collationes* 2:34, PL 133:580.

248. *Vita S. Caesarii* 1:23–24, PL 67:1012–1013.

249. Chadwick 1958:30, 34–35.

250. *Verba Seniorum* 6:5, PL 73:889. Owned by Clairvaux (Troyes, Bibl.mun.4; Wilmart 1917:168).

William of Volpiano sold the gold and silver relief work covering the baldachino over the tomb of Saint Bénigne at his church in Dijon to aid the poor during time of famine—probably in 1028 but possibly the same famine during which Odilo divested his monastery of much of its liturgical art.[251] And even Abbot Richard of Saint-Vanne, the ally of Odilo whom Peter Damian excoriated for his obsession with art, sold his "precious possessions" during famine to help the poor, in all probability liturgical art, given his previously mentioned interests.[252]

Resistance to Art as a Burden to the Poor

What all of the above authors from Ambrose to Gratian—with the exception of Hugh[253]—have in common is an explicit willingness to liquidate excessive liturgical artworks under pressing need to alleviate the suffering of the poor. While some of them rejected liturgical art outright, the basis of their actions was not necessarily one that was related to excess. But many others, while not rejecting art itself, objected to excessive art because of the arrogance of its lavishness in face of simple poverty, not because of any immediate threat of famine or the need to ransom captives. This more intensified form of criticism of the relation between art and the poor tends to focus not on art to attract alms, but on the expenditure of alms on art rather than on the poor. Certainly, the evidence suggests that men like Ambrose and Augustine must have been in complete agreement on this point, although documentary proof is lacking. But there is no lack of authoritative resistance to excessive art on this more strident level. Ironically, two of the

251. For William's actions, see *Chronicon S. Benigni*, p.99. Rodulfus Glaber (*Historia* 4:4:9, p.99) gives 1033 as the date of Odilo's actions; on Odilo, see also Jotsaldus, *Vita S. Odilonis* 9, PL 142:904. Schlink (1978:108n.315) notes that while the date of William's sale of the baldachino is associated with the famine of 1028, Rodulfus Glaber reported famines in 1005–1009 and 1033, and further that there were at least eight famines during William's abbacy. One wonders if the selling of so evocative a selection of liturgical art from the church might have been intended to mollify as well as feed the local poor in light of such an unusually ambitious building project during a famine period—as opposed to a more traditional selling off of liturgical art to aid in time of famine as recounted by Glaber in *Historia* 4:4:13, p.102.

252. Dauphin 1946:126.

253. I except Hugh not because he opposed this concept, but because he never actually advocated it. If one can believe the Cluniac sources, both Hugh and Cluny were renowned for their charity toward the poor. Hugh was remembered in the martyrology of Münchenwiler for his almsgiving: "In cenobio Cluniacensi depositio Sancti Hugonis ipsius loci abbatis et in elemosinarum largitate mirabilis"; Hunt 1968:81. The care of the poor by the monastery itself is too involved to go into here, however, with respect to the donations of pilgrims, it should be noted that Cluniac customs stipulated that a tenth of every gift should be given to the poor; Ulrich, *Consuetudines Cluniacenses* 24, PL 149:698.

most authoritative are Jerome and John Chrysostom. I say ironically be-
cause the friction between them regarding liturgical art was more narrowly
political than conceptual, with Jerome apparently unwittingly fabricating
disagreement in the area of liturgical art at the prompting of the unscrupu-
lous "lithomaniac," Bishop Theophilus of Alexandria.

The position of the monk Jerome, who was also cited in Gratian's *De-
cretum*,[254] is essentially an intensification of the previous attitude. Like Ber-
nard, Jerome does not object to art on iconoclastic grounds as did his friend
Epiphanius, a monk and the bishop of Salamis, whose letter concerning his
destruction of certain liturgical art was translated into Latin by Jerome
at Epiphanius' request.[255] Rather, Jerome objects to excessive art on the
grounds of its incompatibility with the humility of Christ and the offense it
gives to the poor. In Letters 52:10, 58:7, and 130:14, Jerome laid out his
views on art and the poor in what was to become the written authority for
Bernard in *Apologia* 28.[256] Never meant as anything more than a few well
chosen words on the subject, it is probably wrong to interpret the slightly
changing views expressed in these letters as an actual shift of position on the
part of Jerome. Instead, it seems that, like Bernard, he was quite unsystem-
atically advocating a different role for art according to the various orders of
the Church. In the earliest of them—a letter on the clerical life of 394—he
condemns excessive architectural decoration, especially in the use of gold,
and criticizes jeweled altars. He denies the Old Testament prototype, insist-
ing that the poverty of Christ has consecrated the poverty of his Church.[257]
In a treatise on the monastic life written one year later to the monk Paulinus
of Nola, Jerome harshly criticizes the practice of some monks who, under
the pretext of almsgiving, brood over their former riches. He goes on to say
that the soul of the believer is the true temple of Christ and that it is this

254. Gratian, *Decretum* causa 12:2:71 (col.710–711). It appears under the heading,
"The glory of the bishop is not to decorate the walls of his church, but to provide for the
poor."

255. Traditionally referred to as Jerome, Letter 51, see esp. 51:9. Epiphanius tore up a
door curtain with the image of Christ or some saint on it, afterwards telling the church-
keeper to give it to one of the poor to be used as a burial cloth. In his letter he asked Bishop
John of Jerusalem to prohibit the use of such curtains as a matter of permanent policy. See
Bevan 1940:117–118 for a short bibliograpy on the possibility that Epiphanius' statements
against art were ninth-century forgeries. His request concerning door curtains and the poor
is repeated in his letter to the Emperor Theodosius. In the sections of Odilo's biographies
which cover his selling of art for the maintenance of the poor, both Peter Damian and Jot-
saldus tell how Odilo, when coming upon two children who had died of hunger, buried
them himself, using his own clothing as a shroud; Jotsaldus, *Vita S. Odilonis* 1:9, *PL*
142:904; Peter Damian, *Vita S. Odilonis*, *PL* 144:929.

256. See the commentary under 105:25–106:2 FULGET . . . SUSTENTENTUR.

257. Letter 52:10, v.2:185, "cum paupertatem domus suae pauper Dominus dedicarit."

which should be decorated, for walls glowing with jewels are useless when Christ is dying of hunger in the poor. But even more to the point, he warns against giving that which belongs to the poor to those who are not poor.[258] In his letter of 405 on the life of a virgin, he tolerates the lavish decoration he condemned earlier but notes that such patronage is not appropriate to a virgin whose proper business is taking care of the sick and poor.[259]

Thus, Jerome made distinctions between the various orders of the Church, as he explicitly noted in his letter to Paulinus. With clerics, he basically warned against betraying the example of poverty set for the Church by Christ, the model of clerics. Ideally, this should extend to the fabric of the church itself. With monks, however, the burden of poverty is more extreme and the condemnation of excessive art is correspondingly more severe. The presence of excessive art is no less than a fraud which permits one to continue to own property in violation of the monastic vow of poverty, a formal vow not normally taken by clerics. Furthermore, care of the poor was a traditional and even mandatory aspect of monasticism.[260] The initial wrong is doubly compounded by the fact that not only is that art paid for with alms given to the monks for distribution to the poor, but that money which actually belongs to the poor is spent to please the rich who come to the church: "Somehow, those things which please the world more are those which displease Christ." The same theme is taken up in chapter 28 of the *Apologia*: in expending funds given to it either through land or cash donations on excessive artworks, the Church "serves the eyes of the rich at the expense of the poor. The curious find that which may delight them, but those in need do not find that which should sustain them." Finally, I do not believe that there is any real inconsistency between these letters and the one on the life of a virgin which tolerates certain forms of art in general, but not for the virgin. The previously unarticulated tolerance of art within the church was in all probability the result of the friction between Theophilus and Chrysostom in which Jerome was involved when he wrote the earlier letters, the later one being written a decade later.

Theophilus was the worst kind of early Christian bishop. Condemned as

258. Letter 58:2, 7, v.3:75, 81–82. Cited by Candidus, *Vita Eigilis* 10, p.228.

259. Letter 130:14, v.7:185–186. Jerome also denounced the practice of votive offerings, stating that it was better to give the money to the poor instead; Letter 108:30, v.5:199. See Letters 46:11 and 128:5, v.2:111, v.7:153 (cf. Letter 123:14, v.7:91) for apparent criticisms of excessively decorated civil architecture by Jerome.

260. See Benedict of Nursia, *Regula* 53, where Benedict admonishes the monk to receive the poor and pilgrims with great care, as fear of the wealthy exacts its own form of honor. For Cassian's view of the responsibility of the monk toward the poor, see *Conlationes* 3:9 and 18:7, p.81, 515.

a "lithomaniac" by Palladius in his monastic writings and as a "gold-maniac" and "litholater" by the monk Isidore of Pelusium, he was spurned by the Tall Brothers—also monks—for the extravagance of his art projects. Jealousy drove him to attack Chrysostom—monk and bishop of Constantinople—with false charges of Origenism, and to seize upon certain statements made by the latter concerning the proper attitude toward liturgical vessels, although he himself was thoroughly despised in his own city for his artistic excess (if one can completely believe Chrysostom's supporters).[261] Yet the evidence of Chrysostom's writings suggests that his position on excessive liturgical art was little different from that of Jerome, who had been asked by Theophilus to translate the bishop of Alexandria's attack against the bishop of Constantinople, and who takes the side of the gold-maniac against Chrysostom in a letter accompanying that translation.

Chrysostom states his position quite clearly in the Fiftieth Homily on the Gospel of Matthew, written as part of a series of sermons for the people of Antioch. In his opinion, honor is better paid to God through giving alms to the poor than through giving elaborate vessels and vestments to the

261. On Isidore of Pelusium's charge, see Moore 1921:51n.2. Much of the literature surrounding the Desert Fathers which was never translated into Latin during the Middle Ages contains extremely interesting passages on non-iconoclastic resistance to excessive art. Palladius, a strong supporter of Chrysostom, tells in his *Dialogus* how a rich widow of Alexandria gave Isidore, a priest of that city, a large amount of gold for the care of poor women only on the condition that the bishop, Theophilus, not be told. She feared that he would take the money and, ignoring the poor, spend it on stones—for like Pharaoh, he was possessed by a "lithomania" for stones for buildings which the Church did not need; Palladius, *Dialogus* 6, PG 47:22. In Sozomon's history, Isidore the Priest is recorded as saying that it is better to rebuild the bodies of the sick, which are more correctly the temples of God, than to build walls; Sozomen, *Historia Ecclesiastica* 8:12, PG 67:1546–1547. See Palladius, *Dialogus* 13, PG 47:46–47 for an unusually harsh invective against the spending practices of bishops as a means of curbing the "just hatred with which they are afflicted." The discussion largely centers around architectural excess. However, Palladius, like Jerome, does not condemn reasonable church architecture or the beautification of church property. Moore implies that Theophilus' part in the Anthropomorphic controversy had at least a partial impetus in his architectural excess. After Theophilus made Dioscorus, one of the Tall Brothers, bishop of Hermopolis, the latter fled back into the desert upon learning the true character and architectural extravagance of Theophilus. In revenge, Theophilus then stirred up the Anthropomorphic controversy against them; Moore 1921:54n.1.

The typically moderate view of the Desert Fathers as regards art and the layperson is expressed in the Pachomian literature (Codex Sahidique S21, p.397) as follows: "Timothy: Is it acceptable to make precious works with gold and silver for the sanctuary? Horsiesios: It profits the Lord less than if it were distributed to the poor. . . . Something modest can serve for the oblation and there are many sanctuaries where the sacrifice is performed without gold or silver. Timothy: Is it acceptable, Father, to build a church in the name of the Lord? Horsiesios: If those that exist are not sufficient for the people. If they are sufficient, it is better to give the money to the poor than to procure renown by building a church."

Church. It is not golden vessels that God desires but golden souls, a statement identical in concept to the position of Jerome.[262] He repeatedly states that he is in no way attempting to forbid the donation of liturgical art to churches, only that the act of giving alms is more beneficial than giving liturgical artworks, that the giving of artworks should be both accompanied and preceded by almsgiving, and that the money which paid for the art should be honestly earned.[263] Indeed, elsewhere he states that if someone is considering making a gift of liturgical art, he should be advised to give that money to the poor; but if the gift has already been made, then the artwork should not be sold, as such an act might dampen the enthusiasm of the giver.[264] What Jerome approaches from what he considers to be the proper position of the cleric, the monk, or the virgin, Chrysostom approaches from the aspect of the spiritual well-being of the lay donor. The question is not one of the use of alms, but rather of how alms are given and with what understanding of their purpose. It is not enough to simply give, for the giving of liturgical art is not a substitute for giving to the poor. Some need should be satisfied by that giving, and the needs of the members of the mystical body of Christ come before the embellishment of that which commemorates an originally humble act.

While both of these monks and Doctors of the Church agreed that moderate liturgical art was acceptable, those monks in the desert who spoke and wrote only for other monks had neither the need nor the inclination to take the layperson into consideration. The *Apophthegmata Patrum* or *Verba Seniorum* was the most important source of early monastic ideals for the various reform movements of the West. Collected from the late fourth to the mid-fifth centuries, this varied collection of sayings was probably translated from Greek into Latin in the mid-sixth century.[265] It is generally

262. Chrysostom and Jerome even parallel each other in their criticisms of specific examples of liturgical art: chalices, altars, cloths, vestments, hanging lamps, excessive ornamentation of columns, of column capitals, of walls, of pavements. Cf. Chrysostom, *Homiliae in Matthaeum* 50:3–4, 80:2, *PG* 58:508–509, 726; and Jerome, Letters 52:10, 58:7, 128:5, 130:14, v.2:185, v.3:81, v.7:153, v.7:185.

263. Chrysostom, *Homiliae in Matthaeum* 50:3, *PG* 58:508. It goes without saying that Clairvaux owned a copy of this important work (Troyes, Bibl.mun.38; Wilmart 1917:166). See also *Homiliae in Matthaeum* 50:4, *PG* 58:509 where Chrysostom is careful to repeat that he is not trying to forbid the giving of liturgical art to churches. He does, however, declare that admiration for excessive architecture is incompatible with personal moderation (*Homiliae in Matthaeum* 21:1, *PG* 57:296). However, on simple artistic excess in relation to the poor, both in wall painting and in the crafts involved in personal adornment, see *Homiliae in Matthaeum* 49:4–5, *PG* 58:501–502. On art and ill-gotten gains, see the section "Avarice and the Necessity of Pilgrimage Art."

264. Chrysostom, *Homiliae in Matthaeum* 80:2, *PG* 58:726.

265. It was printed as books 5 and 6 of Rosweyde's *Vitae Patrum* of 1617 (*PL* 73:851–1024). Clairvaux possessed at least two copies of this important work (Troyes, Bibl.mun.4; Wilmart 1917:168; Troyes, Bibl.mun.716; Chadwick 1958:35).

agreed that it is this work that Benedict of Nursia recommended in chapters 42 and 73 of his Rule. References to art in the desert communities (as distinct from those which refer to art in the cities) are very rare in any of the writings connected with the Desert Fathers, but the importance of the *Verba Seniorum* greatly increases the significance of the few that may be found there. An aversion to gold and silver was the natural result of an emphasis on voluntary poverty far more extreme than that found in mainstream Western monasticism, with the result that liturgical artworks of any value are never mentioned in those texts which reached the West. But the necessity of books, by the making of which many monks supported themselves, opened the door to possible excess. A certain resistance against the book as an object of personal possession and wealth seems to have existed, however slightly or theoretically, and it existed at the highest levels. Thus it was that the monk and later bishop of Thmuis, Serapion, told another monk that by owning books he had done no less than take the property of widows and orphans, which he then put on his window ledge.[266] The property of the widows and orphans which he had taken was, of course, the alms which he had been given by others or the alms which he should have given himself, but which he had spent on books instead. The chances are good that the books referred to by Serapion, who was well read and an accomplished author and theologian, were decorated since the only absolutely certain mention of art in the *Verba Seniorum* describes the Bible of a certain *abba* in a positive sense as both expensive and beautiful.[267] Elsewhere, the famous Macarius—actually named in the *Apologia* as a model of monastic behavior—advised upon request an *abba* of some stature to sell the three books he owned and to give the money to the poor, although the benefit he derived from them was good.[268]

The precedent of the East, whether in Jerome and Chrysostom or whether in the Desert Fathers, served as a source in the West for the position that the making or giving of excessive art consumed the funds of the poor and that it could act as a substitute for almsgiving.

266. *Verba Seniorum* 6:12, PL 73:890; cf. *Verba Seniorum* 6:5, 6:6, PL 73:889. See the section "Art as a Spiritual Distraction" for further references to this resistance.

267. *Verba Seniorum* 16:1, PL 73:969. Although the Latin version merely calls the book "good (*bonus*)," the Greek version describes it as *kalos*, meaning both "good" and "beautiful"; *Apophthegmata Patrum*, Gelasios 1, PG 65:145. It is interesting that Abbot Gelasios, who owned the beautiful Bible, is possibly the only one of the Desert Fathers noted for his lawsuits, although many were involved in polemics. The statement made by Epiphanius when he was still a monk in the desert that the sight alone of Christian books tended to make one sin less is probably no more than an allusion to the sacred character of the holy writings; *Apophthegmata Patrum*, Epiphanius 8, PG 65:165.

268. Both *Apologia* 23 and the *Verba Seniorum* seem to refer to Macarius the Great; *Verba Seniorum* 6:6, PL 73:889.

One of the most interesting of these occurrences involves the important monastery of Fulda. In 791 an ambitious rebuilding campaign was begun under the direction of the monk Ratgar who, as abbot from 802 to 817, pushed the resources of his abbey to the breaking point in an ill judged attempt to consummate his goal. Destined to ultimately bring about his downfall, the project was tolerated by the monastic community for over twenty years until, in 812, complaint was brought against him before the emperor Charlemagne by his own monks. Undeterred, Ratgar continued, apparently refusing to check either the pace or the scope of his project to a significant degree. Protests were again made by the community in 817, this time accompanied by the abandonment and therefore the negation of the function and efficacy of the abbey by the monks. The new emperor, Louis the Pious, deposed Ratgar, very likely with the counsel of his monastic advisor, Benedict of Aniane, whose personal tendency against excessive art was strongly enforced until outside pressures came to bear on him.[269] One year later, Louis confirmed Ratgar's successor, Eigil—in all probability making a speech similar to that recorded in Candidus' *Vita Eigilis* which served as both an admonishment to and a justification of Eigil. One year after that, Eigil dedicated the completed abbey church.

But just as interesting as the resistance itself to excessive art at Fulda is the language in which the affair is couched by Louis/Candidus.[270] Louis cautions the new abbot not to overtax either the abbey's monks or its retainers, a warning whose practicality and relation to the events surrounding the deposition of Ratgar is indicative of the active elements in that deposition.[271] However, Candidus then has Louis go on at great length about the potential conflict between the poor and expenditure on art, basing himself entirely on the writings of Chrysostom and Jerome who are referred to by name. The reference to Chrysostom has never been identified. However, the acceptability of gifts of artworks only if the poor receive sufficient alms, the condition that the money which paid for the artwork be honestly gained, the belief that honor is best paid to God through his poor, the insistence (made

269. On Benedict of Aniane's position on monastic art, see the section "Art to Attract Donations: The Equation Between Excessive Art and Holiness." To what degree Benedict enouraged the deposition of Ratgar is undocumented; however, the proximity of Benedict's monastery at Inden to the court at Aachen and his position as the official monastic advisor to Louis make it all but certain that he must have been consulted. Furthermore, it seems to be no coincidence that this action took place during the monastic synods held at Aachen in which friction surfaced between Benedict and the more conservative monastic leaders, something apparently related to the curtailment of the Saint Gall plan. On the latter, see Horn 1974:424–425.

270. Candidus, *Vita Eigilis* 10, p.227–228.

271. *Epistolae Variorum* 33, p.548–551; see esp. item 12.

in relation to art) that God lives in his poor, and the absurdity of glorifying a church building while the poor suffer—every one of these concepts is found in both the homily on Matthew and in Candidus' writing. The major tenets of Louis' speech so closely follow those put forth in Chrysostom's Fiftieth Homily on Matthew that it seems that Candidus was simply recalling this passage from memory and adapting it to meet the exigencies of the primarily architectural situation at Fulda. If this is in fact the case, then Candidus' paraphrase can only be seen as a very forceful intensification of Chrysostom in that it lays even greater stress on the suffering of the poor.

The paraphrase of Chrysostom is followed by the classic passage on the proper monastic attitude toward excessive art from Jerome's letter to Paulinus. Reference is then made to the Benedictine Rule: general in nature, it probably refers to chapter 53 where Benedict admonishes the monk to receive the poor and pilgrims with great care, as fear of the wealthy exacts its own form of honor. Whether or not Candidus is completely forthright in his attribution of the cause of the building controversy to the local level, it is no coincidence that Fulda was both the first monastic church to be of such great length[272] and the first to be criticized precisely for its great length.

The appeal to the Fathers found in Louis/Candidus is not present in all such cases. The monk Smaragdus in his *Via Regia* relies on Old Testament citations in his advice that a king should not construct his palaces on the tears of the poor and wretched, but rather that he should use his own money and that of the wealthy for this purpose.[273] And the monk Notker the Stammerer tells the tale of an abbot who, in supervising the building of the palace chapel at Aachen, let those corvée laborers who were able buy their way out while working the rest all the harder to make up for it. When a fire broke out in his house, he was compelled by greed to enter in order to

272. Horn 1979:v.1:187.

273. Smaragdus, *Via Regia* 27, PL 102:965–966. For a convenient overview of the situation of the poor in Carolingian times, see Fichtenau 1964:144–176. In an instance unrelated to either monasticism or religious art, Gregory of Tours puts his own views on the personal accumulation of gold and jewels by laypeople in the mouth of the otherwise quite ruthless Queen Fredegund after a very touching discussion of a certain disease which especially struck children. Seeing the cause of the disease as the just retribution of God on the wealthy for their abominable behavior, she is made to say, "Surely, it is the tears of the poor, the lamentations of the widows, the sighs of the orphans that kills our children! And though no hope remains for them, we keep on accumulating riches. We keep on gathering in treasures, not knowing for whom we gather them. . . . Were not our treasuries already crammed with gold, silver, precious stones, necklaces, and every other regal ornament? And now we are losing what we held most beautiful [i.e., their children]." Gregory of Tours, *Historia Francorum* 5:34, p.227.

save his money, losing his life in the process and so passing from transitory to eternal flames.[274]

Nevertheless, the tendency is one of seeking patristic justification. Just as Louis/Candidus seems to have adapted Chrysostom's passage to fit the circumstances of Fulda, so Theofrid, abbot of Echternach (d.1110), thoroughly adapted a number of Jerome's statements to fit the particular situation at that great center of manuscript illumination only a few years after its scriptorium reached its peak. Gradually shifting from the architectural to the codical, he writes,

> The saints do not long for gold, but rather to be religiously propitiated with the distribution of gold. They do not desire that oratories reach into heaven, that the capitals of columns be made of gold, that panelled ceilings be brilliant with riches, that altars be ornamented with blemishes of densely packed jewels, that pages of parchment should be dyed with purple color, that gold should be dissolved in letters, that books be covered with gems, that one has either little or no concern for the ministers of Christ, or that Christ should die naked before their doors.[275]

In this conceptual juxtaposition of one of the great German imperial Bibles in its liturgical setting with the social reality of the time, Theofrid has conflated at least two of Jerome's censures of artistic excess. The first immediately follows Jerome's famous *orbis terrarum ruit* passage: "Our walls shine with gold, our panelled ceilings shine with gold, the capitals of our columns shine with gold, and Christ in the poor dies naked and hungry before our doors."[276] The second is from the equally famous letter to Eustochium, a treatise on the ascetic life, "Parchment is dyed with purple color, gold is dissolved in letters, books are covered with gems, and Christ dies naked before their doors."[277] There are also reminiscences of Jerome's

274. Notker the Stammerer, *Gesta Karoli* 1:28, p.744. For a similar story concerning the palace chapel, *Gesta Karoli* 1:31, p.745–746.

275. *Flores* 2:4, PL 157:348–349, "Non quidem appetunt aurum sancti, sed propitiari religiose dispensantibus aurum. Non appetunt in altum extructa oratoriorum aedificia, non ex auro fabricata columnarum epistylia, non splendentia divitiis laquearia, non crebro maculis distincta smaragdo altaria; non ut membranae purpureo colore inficiantur; non ut aurum liquescat in litteras; non ut gemmis codices vestiantur; et ministrorum Christi aut minima, aut nulla diligentia habeatur, et nudus ante fores eorum Christus moriatur." However, cf. *Flores* 2:6, PL 157:356–357. Although Aubert sees the former passage as a probable source for *Apologia* 28, Theofrid and Bernard actually shared the same authority in Jerome's letters; Aubert 1947:140n.2. On the medieval use of *epistylium* to mean capital, see Mortet 1913:134–135.

276. Jerome, Letter 128:5, v.7:153, "Auro parietes, auro laquearia, auro fulgent capita columnarum, et nudus atque esuriens ante fores nostras in paupere Christus moritur."

277. Jerome, Letter 22:32, v.1:147, "Inficitur membrana colore purpureo, aurum liquescit in litteras, gemmis codices vestiuntur et nudus ante fores earum Christus

Letter 52:10.[278] Using an interpolated combination of Jerome's writings, Theofrid rejects the excess of material in liturgical art which contributes to the sensory saturation of the holy place as not contributing to proper worship. Rather, to Theofrid, the role of alms in proper worship consists primarily of the care of the poor, as both Jerome and Chrysostom have said.

Around the same time and not far from Echternach, there seems to have been a relatively strong local movement growing in Tournai against excessive art at the expense of the poor—Tournai being where Oger, a canon regular and the probable instigator of the *Apologia*, was sent in 1125. Certainly, the most well known member of this group was the monk Odo of Tournai, later bishop of Cambrai, who when abbot of Saint-Martin at Tournai refused to have the same liturgical art discussed earlier. For, "assiduously reading the institutes and teaching of the ancient Fathers . . . he did not want to make golden crosses. Rather, all the money which was given to him he spent on the poor and oppressed."[279] It was undoubtedly the same source of influence that caused Ailbert d'Antoing (d.1122), a canon regular of Tournai and later a co-founder and first abbot of Claire-Fontaine in the old diocese of Liège, to say that it was more acceptable to God to provide for the poor than to construct buildings since souls made in the image of God are immortal.[280] In fact, William of Saint-Thierry—who along with Oger was the impetus to Bernard's writing the *Apologia*—considered refined monastic architecture to be no less than a self-induced "reproach" on the grounds that it was paid for with the alms of the poor, also citing the example of the Desert Fathers.[281]

Ironically enough, one of the most outspoken condemnations of the spending on art of funds which should have gone to the care of the poor comes from Peter Abelard, whom Bernard described as "a monk without a rule" and who was denounced by Bernard at the instigation of William of Saint-Thierry.[282] In his *Regula Sanctimonialium*, written to Héloïse, Abelard follows the traditional teaching of the Fathers very closely. After

emoritur." Jerome and therefore Theofrid use *vestire*, meaning to dress or adorn, to describe how the covers of sacred books were decorated, contrasting the rich "clothing" of the holy although insensate objects with the life-threatening nakedness of impoverished human beings and members of the mystical body of Christ.

278. Jerome, Letter 52:10, v.2:185, "auro splendent lacunaria, gemmis altare distinguitur et ministrorum Christi nulla electio est."

279. Hermannus of Saint-Martin, *De Restauracione* 66–67, PL 180:90–91. This account is probably influenced by the *Apologia*, see the commentary under 104:16–18 ILLUD AUTEM . . . FACIT AURUM?

280. *Annales Rodenses*, p.10.

281. *Ad Fratres* 148–149, 158, p.260, 268; on the use of the word "reproach," cf. Ps 118:39. Cf. also his fellow Cistercian, Aelred of Rievaulx, *Sermones* 18, p.123–124, 127.

282. Bernard, Letter 193, v.8:44–45.

condemning excess in food and clothing, he moves to the subject of architecture, sculpture, and painting saying, "We do not build the dwelling places of poor men, we raise up the palaces of kings."[283] He then goes on to contrast the pride involved in this with the humility of Christ by citing a passage from another of Jerome's letters which censures excessive architecture,[284] finally raising the issue of alms and the poor: "For whatever we possess that goes beyond necessity, we possess as plunder (*in rapina*), and we are the cause of the death of so many of the poor whom we could have supported with it."[285]

Indeed, it was also in terms of plunder that the canon regular Hugue de Fouilloi saw artistic excess. In criticizing both the episcopacy and his fellow Augustinians around 1153, he put the greater blame on the bishops:

> Bishops build houses not unequal in size to their churches. They love to have painted bedrooms, with the images there dressed in extravagant clothing of [painted] colors. The poor man arrives without any clothes, and calls out at the gate with an empty stomach. O amazing but perverse pleasure! The painted wall wears Trojans dressed in purple and gold, and cast-off clothes are denied to Christians. Weapons are given to the Greek army, a shield shining with gold is given to Hector, but no bread is given to the poor man calling at the door. And, so that the truth be known, the poor are often plundered (*spoliantur*) while stones and wood are clothed. [The bishops'] palaces are adorned with columns and they put gates in front of their houses which I wish would admit the poor, not exclude them.[286]

283. *Regula*, p.282, "non habitacula pauperum aedificemus, sed palatia regum erigamus."

284. Jerome, Letter 14:6, v.1:39.

285. Abelard, *Regula*, p.282, "Quidquid enim necessitati superest, in rapina possidemus; et tot pauperum mortis rei sumus, quot inde sustentare potuimus."

286. *De Claustro Animae* 1:1, PL 176:1019–1020, "Episcopi domos non impares ecclesiis magnitudine construunt, pictos delectantur habere thalamos, vestiuntur ibi imagines pretiosis colorum indumentis. Pauper item sine vestibus incedit, et vacuo ventre clamat ad ostium. O mira, sed perversa delectatio! Trojanos gestat paries pictus purpura et auro vestitos, christianis panni negantur veteres. Graecorum exercitui dantur arma, Hectori clipeus datur auro splendens, pauperi vero ad januam clamanti non porrigitur panis, et ut verum fatear, pauperes spoliantur saepe et vestiuntur lapides et ligna. Ornant praetoria columnis, fores domibus anteponunt, quae utinam pauperes includerent, non excluderent!" There are possible reminiscences of Jerome in Hugue's description of the columns and the poor outside the door. On the reference to the bedroom, cf. Bernard, Letter 538, v.8:504–505.

Writing sometime from 1153 to 1174, the Cistercian monk Idung expanded the critique of expenditure on excessive art as theft of the poor to include the tactile and olfactory components of liturgical sensory saturation, namely vestments and incense. Idung was especially critical of the use of gold, citing both Jerome and Bernard as authorities; Idung, *Dialogus* 2:22–24, 3:23, p.417–418, 447–448. A modern parallel was made by none other than Dwight Eisenhower, president of the United States, in 1953, "Every gun that is made, every warship launched, every rocket fired signifies, in the final sense, a theft from those who hunger and are not fed, those who are cold and are not clothed."

Nor did he spare his own order, implicitly denouncing the money spent on "dressing" the images of Adam and Eve who decorate the church wall, and at the same time contrasting the compassion of God who gave clothes to the first naked with the lack of concern demonstrated by his fellow canons while "a multitude of brothers huddles together from the rigors of winter."[287]

Also around the time of Bernard's death or shortly thereafter, Peter the Cantor, an important theologian who became a Cistercian monk at the end of his life and who laid great stress on the practical in his study of ethics, took up the subject of art and the poor with reference to both "plunder" and Jerome. Writing as an ecclesiastic, his concerns were broader than monasticism but encompassed that segment of the Church as well: "The palaces of princes built from the tears and plundering (*rapinis*) of the poor execrate this passion for building (*libidinem aedificandi*). And monastic and ecclesiastical buildings erected from the loans and usury of the greedy, from the lies of deception and the deceptions of liars and hired preachers—these buildings often fall to pieces from the poor construction of their parts, for 'unclean plunder (*praeda*) does not have good results.'"[288] And, perhaps directed at the rich merchants who controlled the cities, "Because of the excess and expense of the houses and city walls, there is less piety and alms toward the poor today—for we give less alms with this sort of excessive expense."[289] Thus, Peter sees all facets of excessive building as essentially immoral, not on their own account, but for what they entail in respect to the gathering and dispersement of funds. In this discussion, he refers repeatedly to Jerome, both directly and indirectly. The most important among these are a citation of Jerome's Letter 108 : 16 where he praises the holy woman Paula's desire to spend her great fortune not on common stones, but on the living stones which make up the Heavenly Jerusalem

287. *De Claustro Animae* 2:4, PL 176:1053, "fratrum vero multitudo coarctatur hiemali molestia." The attribution of *De Claustro Animae* has been and continues to be disputed; cf. Grégoire 1962:193–195.

288. *Verbum Abbreviatum* 86, PL 205:257, "Hanc libidinem aedificandi destantur palatia principum constructa ex lacrimis et rapinis pauperum. Monastica autem vel ecclesiastica aedificia erecta ex fenoribus et usuris avarorum, mendaciis deceptionum et deceptionibus mendaciorum, praedicatorum mercenariorum, quae ex male partis constructa saepe dilabuntur, quia: 'Non habet eventus sordida praeda bonos [Ovid, *Eleg.*1].'" Cf. the similarity with Smaragdus, *Via Regia* 27, PL 102:966, "Cave ne pauperum lacrimis miserorumque impensis tibi domus aedificetur regalis." Cf. also Honorius Augustodunensis, *Elucidarium* 2:23, PL 172:1152; and Walter of Châtillon, *Dilatatur Inpii*, p.107. On the condemnation of the sacrifice to God of plunder (*rapinam*) from the sacred economy, see Odo of Cluny, *Collationes* 2:34, PL 133:581.

289. *Verbum Abbreviatum* 86, PL 205:256, "Sed etiam propter hanc superfluitatem et sumptuositatem domorum, murorum, minor est hodie pietas et erogatio in pauperes. Minus enim sufficimus alimoniae eorum, et huiusmodi sumptibus superfluis."

(cf. 1 Pet 2 : 5), and of Letter 46:11 in which he praises the poverty of the place of the birth of Christ entirely in terms of the absence of architectural excess.

Peter also refers to a story from Jerome's *Vita* of Paul the Hermit, interpolating (as far as I have been able to determine) into the famous conversation between Paul and Anthony an entirely apocryphal passage. Peter has Paul ask Anthony in the same breath if paganism and Judaism still endure and if the Christians imitate the customs of the pagans in the expense of their buildings. Anthony answers that they do, at which Paul sheds tears over their excess.[290] Peter also paraphrases Jerome's Letter 123 : 15 two or even three times without citation on the Megarians, who build as if they would never die and live as if they were to die tomorrow (this also occurs in Jerome Letter 128 : 4); and then goes on to do so again, this time citing Jerome directly. But one of the most interesting things about Peter is the similarity of the terms *libido aedificandi* and *morbus aedificandi* used to describe the building madness of laypeople and monks in the face of the needs of the poor, and the terms *litholater* and *lithomaniac* which Isidore of Pelusium and Palladius used to describe the same phenomenon.[291] He also recommends in words reminiscent of Ambrose that, rather than build excessive architectural works, the money be spent in support of the poor and on the ransoming of captives.[292] Thus, it is no longer a question of selling artworks to feed the poor and to ransom captives as before, but rather it is now a question of not making those artworks at all. In this connection, it is significant that Peter fixes on architecture. Whereas the focal point before had so often been the excessive material of liturgical art, it is now the fabu-

290. Peter the Cantor, *Verbum Abbreviatum* 86, PL 205:256. Cf. Jerome, *Vita S. Pauli* 10, PL 23:25.

291. Peter the Cantor, *Verbum Abbreviatum* 86, PL 205:257. Jerome is again referred to at the end of the chapter. Isidore of Pelusium and Palladius's *Dialogus* (Moore 1921:51n., and Palladius, *Dialogus* 6, PG 47:22) were not translated into Latin during the Middle Ages. Cf. Alexander Neckam's reference to excessive building activities as a *morbus inconstantiae*; *De Naturis Rerum*, p.179. It will be remembered that Bernard also described the excessive decoration of architecture (and of liturgical art) as "insane" (*Apologia* 28); the same condemnation being made by Hélinand de Froidmont of excessive palaces, *Sermo* 23, PL 212:676.

Although the question under discussion here is art, art was only one symptom of *lithomania* and *morbus aedificandi*. As a punishment for his excessive castle building, Bishop Alexander of Lincoln was given the penance of building a monastery for each castle he had built. However, to accomplish this he "plundered one altar to adorn the other," as Giraldus Cambrensis tells us; Lehmann-Brockhaus 1955:2345. The bishop of Salisbury was more directly criticized for building castles instead of aiding the poor. Sensing that this was a bad thing, he too made up for it by constructing monasteries and so on; Lehmann-Brockhaus 1955:1234; Warnke 1979:64.

292. *Verbum Abbreviatum* 86, PL 205:257–258.

lous amounts of wealth that have become "immobilized"[293] in stone: architecture has now replaced liturgical art as the pre-eminent art of excess.

Finally, the Cistercian monk Hélinand de Froidmont wrote a rather long passage on excessive art which was directed at his own order as well as others and which is similar to Peter the Cantor's work in many ways. Like Peter, Hélinand compares contemporary society to the Megarians of Jerome. And like Peter, he describes excessive art in terms of plunder (*ad tua rapiendum*).[294] Furthermore, he recommends—like Peter—that excessive architecture be given up, and that the money which would have been spent on it be given to the poor instead.[295] But what concerns us the most with Hélinand is his revealing discussion of the attitude toward the relation between art and almsgiving: art was not just a deflection of money from those in need, nor was it even a theft from those in need—rather it was actually being claimed by some to be morally similar to almsgiving.

Expenditure on Art as Similar to Almsgiving

Around the same time Bernard was writing "O vanity of vanities, but no more vain than insane!" to describe his feelings on the relation between expenditure on art and the poor, Honorius Augustodunensis was writing,

> Since it is necessary to leave behind your riches to others, hurry and send your treasure ahead to heaven now through the hands of the poor. . . . Provide the churches with books, vestments, and ornaments, renew destroyed or abandoned churches. . . . You should build bridges and roads and through this provide for yourself in heaven. Offer the necessities of food and clothing to the poor and needy and hospitality to pilgrims, and by this obtain eternal riches for yourself.[296]

It was precisely this view that Hélinand de Froidmont was referring to when, after criticizing the justification that excessive architecture was not just for oneself but also for those who would come after, he said,

> Let us not demand that we carry the burden of future generations, but only of those who are here now and living among us—and I hope that we can manage

293. The term is from Lopez 1952.

294. Hélinand de Froidmont, *Sermo 23, PL* 212:676, 677, 678.

295. Hélinand de Froidmont, *Sermo 23, PL* 212:676, "Quid illi proderunt facta in corpore sumptuosa aedificia, quando ipsum corpus relinquet anima? Ut quid perditio haec? Potuerunt et debuerant ista relinqui, et impensae dari pauperibus."

296. *Sermo Generalis, PL* 172:864. A chronicle contemporary with the *Apologia* records the 1049 description of the cathedral of Cambrai by the bishop as "a shelter and refuge of the poor"; Lehmann-Brockhaus 1971:1661.

that. Certainly he who would do this satisfies the law as the Apostle testifies [Gal 6 : 2–5]. For what kind of charity is it to not listen to the call of the poor man who is right now at the gate and to construct a building for one who will be calling in the future? To give nothing to one who is hungry right now and to withhold alms for one who does not yet exist?[297]

There can be no question of reconciling the two attitudes toward art presented by Honorius and Hélinand. They coexisted, were opposed, and, in the most general terms, may be said to represent the positions on art of the old and new monastic reform movements respectively.

The ease with which Honorius mixes almsgiving and expenditure on art is characteristic of the mainstream view of which we have seen only the opponents up until now. Indeed, that view was so widespread and ingrained that it is probably easier to find clear-cut resistance to it than it is to find any programmatic explication of it from among the so many who took it for granted. However, there exist elements of such an explication attributed to Abbot Hugh of Cluny which amount to no less than a moral theology of art production. Given Hugh's unofficial stature as the *abbas abbatum*, the abbot of abbots,[298] within Western monasticism, this moral theology of art production has an authority which is by definition mainstream establishment.

The position attributed to Hugh was put forth by Hildebert de Lavardin, then bishop of Le Mans and soon to be archbishop of Tours, in his *Vita Sancti Hugonis.* Hildebert was no common monastic biographer, but one of the more respected writers of his day and an eminent churchman. One of his better known works is a poem praising the lost glories of Rome and the beauty of its sculpted gods who were worshipped more for the skill of their craftsmanship than for any divinity they might have been thought to possess.[299] Writing one year after the consecration of his own rebuilt cathedral, Hildebert relates how Hugh—who had begun and almost completed construction of one of the largest buildings in Western Europe—gave much to the poor, to lepers, to the sick, and to indigent monasteries. And

By these activities and practices of the spirit, he consecrated both silver and gold. He declared that they shine more when they are expended than when

297. *Sermo* 23, *PL* 212:677, "Non ergo futurorum onera jubemur portare, sed solum praesentium, et nobiscum viventium: et utinam vel ista faceremus. Certe qui hoc faceret, teste Apostolo, legem impleret. Quaenam autem est charitas, non exaudire pauperem jam clamantem ad ostium, et exstruere aedificium clamaturo: nihil dare jam esurienti, et reservare eleemosynam nondum existenti."

298. Mabillon 1739:v.5:463.

299. Hildebert de Lavardin, *Par Tibi, Roma* 31–36, p.302.

they are retained. And in conformity with the testimony of Ambrose, when a chalice redeems from either famine or an enemy those whom the blood of the chalice has liberated from death, then it is truly a vessel of the Church.[300]

But Hugh/Hildebert goes further. Having already claimed Ambrose as his undisputed authority, Hildebert says of Hugh further on,

> No one could consider the man of God to be desirous of money, whether in seeking gifts or in keeping riches. His abundance of wealth was used not for avarice but for mercy, and not for himself but for the poor. And so he said with the prophet, "Lord, I have loved the beauty of your house and the place where your glory dwells [Ps 25 : 8]." Whatever the piety of the faithful brought to him, he consecrated it all, whether on the embellishment of the church or whether on expenditure for the poor.[301]

Thus, according to Hugh/Hildebert, money is consecrated by almsgiving, and to spend money on art is the same as almsgiving; therefore, to spend money on art is a consecrated act. It is no accident that Ambrose, the quintessential authority for the disbursement of artworks to aid the poor, has been cited here. Whether consciously or unconsciously, his authority was co-opted into the logic of this syllogism, although its tenets were considered self-evident and needed no logical justification to the vast majority of Hildebert's oligarchic contempories. Yet Hildebert was quite aware of the issue of art and the poor—its escalation from the level of a constant to that of a polemic had apparently begun now, and this is precisely why he paired expenditure on art and the poor as equals in this passage which was prob-

300. *Vita S. Hugonis* 5, col.417 (*PL* 159:864), "His animum studiis, his usibus, et argentum consecrabat et aurum. Ea melius impensa, quam servata rutilare praedicabat, et juxta Ambrosii testimonium, tunc vere calicem Ecclesiae, cum calix a fame vel ab hoste redimit, quos sanguis calicis a morte liberavit." Cf. Ambrose, *De Officiis* 2:138, p.262, "Vere illa sunt vasa pretiosa, quae redimunt animas a morte . . . ut calix ab hoste redimat, quos sanguis a peccato redimit."

301. *Vita S. Hugonis* 10, col.420 (*PL* 159:867–868), "Nemo autem putet virum Dei tamquam pecuniae cupidum, vel quaesisse, vel oblatas suscepisse divitias. Earum copia non avaritiae servivit, sed misericordiae, non ipsi, sed egenis. Ille cum propheta dicens, 'Domine dilexi decorem domus tuae, et locum habitationis gloriae tuae.' Quicquid ei fidelium devotio contulit, totum vel ornamentis ecclesiae, vel expensis pauperum consecravit." As mentioned earlier, in this treatment of gifts Hugh was following the Cluniac stipulation that a tenth of every gift should be given to the poor; Hugh was also remembered in a Cluniac necrology for his almsgiving.

Hildebert's description of Hugh has apparently formulaic elements: cf. the descriptions of Odo of Tournai (Hermannus of Saint-Martin, *De Restauracione* 66, *PL* 180:90) and Stephen Harding (William of Malmesbury, *Gesta Regum* 337, v.2:384–385) which take the same form but are expressed in strictly ascetic terms.

ably read during the office of the canonized Hugh throughout the Cluniac Congregation and its milieu.[302]

However, the minor premise of Hugh/Hildebert's syllogism concerning art and almsgiving is weak. The idea that spending on art is the same as almsgiving is dependent on the assumed rectitude of a justification which has nothing to do with the poor—the justification of art for the honor of God. And so the emphasis given to Psalm 25:8 by Hugh/Hildebert. Indeed, it was with a neutralization of this very passage that Bernard closed *Apologia* 28. While the opponents of excessive art could forcefully claim the authority of a number of the early Fathers, someone with Hugh/Hildebert's attitude was more secure with the vague but popular belief that art for the honor of God was a virtue which was the equivalent of any. Even so, he was careful to fulfill Chrysostom's admonition that such art be accompanied by almsgiving.

Actually, the pairing of both as virtues by Hugh/Hildebert may stem more directly from Hugh's highly respected predecessor who, along with Hugh himself, is praised by Bernard in *Apologia* 23. In his life of Odilo—fittingly entitled *De Vita et Virtutibus Sancti Odilonis Abbatis*—Jotsaldus quite interestingly integrates the subjects of art and the poor under the overall scheme of the four Cardinal Virtues: Prudence, Justice, Fortitude, and Temperance. Under the virtue of Justice, Jotsaldus includes those qualities of Odilo which we today would call charity, taking up his generosity to the poor and in particular how he sold much of the liturgical art of Cluny to feed the poor in time of famine. It is here that the authority of Ambrose on Laurence is cited. Indeed, it is the modern day virtue of charity which seems to receive the greatest attention in this *Vita*, a virtue for which Hugh was especially famous. And it is under Temperance that Jotsaldus brings up Odilo's artistic renovation of Cluny and other monasteries, initiating this passage with, "aside from these interior [virtues], there was in him externally glorious acts of devotion in constructing and renovating the buildings of the holy places, and in acquiring ornaments from wherever he could."[303] Thus, Hildebert follows the same general pattern as Jotsaldus, emphasizing almsgiving as a virtue while citing Ambrose and further on describing artis-

302. Hunt suggests that the reason that Hildebert had been asked to write this *Vita* when at least two others already existed was a desire to profit from his superior literary style in the lessons for Hugh's office after he was canonized in 1120; Hunt 1968:15.

303. *Vita S. Odilonis* 13, *PL* 142:908, "Et praeter haec interiora, fuerunt in eo extrinsecus gloriosa studia in aedificiis sanctorum construendis, renovandis, et ornamentis undecunque acquirendis." Far from seeing art as in any way related to "good works," Idung described the monastic practice of manuscript illumination as "useless and idle work," *Dialogus* 2:51, p.432.

tic endeavors as a virtue while associating it with temperance. Furthermore, Hugh was also following the precedent of Odilo in a sort of division of alms between art and the poor. On one occasion when Christian knights brought back a huge amount of gold and silver plunder to Cluny taken from the personal adornment of their Saracen opponents and their horses' harness, Odilo ordered that the best of it be made into a ciborium for the high altar. The rest he distributed among the poor, to the last coin.[304]

Although Bernard was in agreement with Hugh/Hildebert on alms-giving proper, his objection to expenditure on art as somehow similar to almsgiving has a basis on both the spiritual and the social levels. "O vanity of vanities, but no more vain than insane" (*Apologia* 28), is actually the transition between the passage on art to attract donations and the passage on art as opposed to the care of the poor. It carries the implication that excessive art is no more futile than it is extravagant. The word "vain" (*vanus*), when juxtaposed to "vanity of vanities" (Ec 1:2) implies futility, in this case the spiritual futility of both parties involved in the pseudo-spiritual transaction of the previous passage in which excessive art acts as the middleman. "Insane" (*insanus*) refers to the following passage, indicating both madness and extravagance, the madness of a rationalization that permitted overexpenditure on a building while those within starved, and the extravagance that brought that situation about. But the church Bernard has in mind is more than a simple building. Attention is lavished upon the walls of the church as a structure, but the members of the Church as an institution are ignored.[305] As we have seen, according to the tradition of which Ambrose is the classic expression, the real treasure of the Church is its poor. Bernard denounces the expenditure of the material treasure of the Church on the inanimate while the animate spiritual treasure is left in need. To consider such an act as consecrated is insanity in Bernard's view. Not only is it wrong, but the money that should have gone to the maintenance

304. Rodulfus Glaber, *Historia* 4:7:22, p.110. A similiar attitude of linked distribution between art and the poor may be observed in the *Vita Sugerii* where in the course of praising Suger's generosity to the poor and sick, strangers and neighbors alike, William concludes, "Is it not a clear proof of his extreme generosity that he gave those superb windows to the church of Paris?" William of Saint-Denis, *Vita Sugerii* 2, p.386–387. Linked distribution may also be the point of the vague connection between William of Malmesbury's account of Lanfranc's care of the poor and his lavish art program; *Gesta Pontificum* 1:43, p.69–70. Rupert of Deutz discusses this issue on a more theoretical level in his defense of liturgical art; *De Officiis* 2:23, p.57. For the historical context of this passage from *De Officiis*, see Van Engen 1983:306–307.

305. Cf. 1 Pet 2:5; Apoc 21:18–21; and Jerome, Letter 108:16, v.5:179 on living stones. Honorius Augustodunensis described the material church as a symbol of the living church in his defense of religious art; *De Gemma Animae* 29, PL 172:586.

of the poor is instead invested in art to stupefy pilgrims for the purpose of attracting further donations. "It serves the eyes of the rich at the expense of the poor. The curious find that which may delight them, but those in need do not find that which should sustain them." Who are the curious? They are the same curious pilgrims criticized by Rodulfus Glaber a century earlier. Or those who go on pilgrimage only to see "charming places or beautiful buildings," as condemned by Honorius Augustodunensis around the time of the *Apologia*.[306] They are the wealthy guests who arrived "by horse"—that is, not "by foot"—and whose provision, including unlimited wine, was in some cases subsidized by the alms and offerings made to the monastery.[307]

Bernard undoubtedly was truly concerned with the well-being of the poor. Indeed, some of his most fiery language was aimed at the injustice inflicted upon the poor.[308] But the approach here is again largely from a mo-

306. Rodulfus Glaber, *Historia* 4:6:18, p.107. Honorius Augustodunensis, *Elucidarium* 2:77 (2:23), p.435, "Indeed, if some people because of curiosity or human praise run around to the holy places, they undertake this in detriment—because they will have seen charming places or beautiful buildings or they will have heard praise rather than loved [these places]."

307. De Valous, 1970:v.1:163–164, 173. Aside from the traditional Benedictine injunction to care for poor visitors (Benedict of Nursia, *Regula* 53), there seems to have been a certain stimulus to receiving large numbers of poor at one's pilgrimage place in that such large crowds of poor suggested an efficacy of the place's spiritual powers and so was likely to attract the richer sort of pilgrims. As Rodulfus Glaber noted, the poor were usually the first to lead the way to whatever was to become the current ultimate on the pilgrimage route: the peak of the popularity of the pilgrimage to Jerusalem began with the poor, was taken up by those of middle station, followed by the greatest kings, counts, and other members of the ruling strata, and finally by women of all degrees—the latter being something which had never happened before; *Historia* 4:6:18, p.106.

The question of the proportion of the poor to the self-sustaining is not at all clear. Voluntary poverty was traditionally associated with the pilgrimage; Labande 1958:168. As to a simple breakdown by social group, Sumption states that of the 655 pilgrims mentioned in miracle stories at Canterbury from 1171 to 1177, 8 percent were from the higher aristocracy and 26 percent were knights. He cautions that it is likely that the wealthier element received attention greater than their numbers; Sumption 1975:122–123. It should also be mentioned that while the traditional Benedictines could use the claim of their pastoral care of the poor as a justification to build churches, Giraldus Cambrensis used the similar defense of the physical care of the poor as a justification for the insatiable "greed" of the Cistercians; *Itinerarium Kambriae* 1:3, p.43.

308. This can be very fiery indeed: Letter 42:6–7, v.7:105–107, "What if someone bolder than myself were to lash out at them not with the words of the Apostle, not of the Evangelist, not of the Prophet—in short, not of any ecclesiastical authority—but only in the words of a pagan, 'Tell me, priests, what is gold doing, not even in the holy place, but on the bridles of your horses?' [cf. *Apologia* 28] . . . Even if public opinion may keep silence, hunger will not. . . . We, too, have been made in the image of God; we, too, have been redeemed by the blood of Christ; we, too, are your brothers [cf. Hélinand de Froidmont, *Sermo* 23, PL 212:677]. Consider what sort of thing it is to feed your eyes from your

nastic standpoint. It is not just a question of art or the care of the poor. It is also a question of debunking the traditional social justification of excessive art—that it was somehow similar to almsgiving. Bernard places this passage after the section on art to attract donations so that the glaring contradictions of the claim may act as a foil to the situation which it attempts to justify. Not only is this justification a false one to Bernard, the whole question of monks and alms is problematic. In the same way that art for the honor of God is not the business of the monk since the monk has already offered the most precious gift one can to God, so there is no need for a rationale which sees these lesser gifts as a worthy form of honor for a monk to convey, a form of honor which as a spiritual undertaking is ultimately contradictory to the dictates of charity.[309]

brother's portion [cf. *Apologia* 28]. Our life is changed by you into superfluous abundance. . . . Two evil things come forth from the one root of cupidity: you lose yourselves in your vanity, and you kill us in your plundering. . . . Rings, chains, bells, studded reins, and many other such things as beautiful with colors as they are heavy with precious materials hang from the necks of your mules; but you do not give even miserable rags [to cover] the bodies of your brothers [cf. *Apologia* 28; and Ovid, *Metamorphoses* 2:5]. Add to this that you have siphoned off all these things for yourselves neither by a taste for business dealings nor by your own labor. . . . These things the poor say, but only before God, to whom hearts speak. For they do not dare to dispute openly against you, to whom they inevitably have to beg meanwhile for their lives. Yet in the future 'they will stand up in great firmness against those who distress them' with the father of orphans and the protector of widows standing for them." Letter 152, v.7:358, "The clergy are enriched by the labor of, of course, others. They consume the fruit of the earth without paying for it." *De Consideratione* 1:13, 4:5, v.3:408, 452, "Everywhere those who are more powerful oppress those who are more poor. We cannot desert the oppressed. . . . The lives of the poor are sown in the streets of the rich [i.e., where they are trampled as a matter of course]."

309. See the conclusion to the section "Piety and Poverty for the Honor of God" for the logic and sources on this statement.

Art as a Spiritual Distraction to the Monk

As has been stated, a dichotomy exists between Bernard's two chapters on art.[310] In chapter 28, he is primarily concerned with the relation between excessive art and the layperson in the monastery. However much this chapter revolves around the visiting layperson, its subject is still essentially the moral and spiritual position of the monk in regard to art. In chapter 29, he turns to the question of art which is ostensibly intended for the monk alone. Here, he takes up one of the most interesting and also one of the most misunderstood "things of greater importance"—excessive art as a spiritual distraction to the monk. Rhetorically sighted on the cloister and so away from any overt culpability involving avarice and the lay public, the issue of art as a spiritual distraction to the monk most clearly defines Bernard's "non-moral" objections to art (non-moral to us by today's common religious standards, but to him certainly involving the greatest questions of morality) and as such may be of the most interest to the modern art historian. Certainly, this issue was the one which most elicited an explicit written response from Bernard's contemporaries, as we shall soon see.

Like most of the other "things of greater importance," art as a spiritual distraction had a relatively long literary tradition, although it seems to have mushroomed as a direct result of the controversy of which the *Apologia* was the central document. To begin with, art as a distraction is only a subset of the larger problem of distraction proper. While this is a subject in itself, several of the most basic monastic sources on the subject should at least be noted. The venerable *Longer* and *Shorter Rules* of Basil—translated early on into Latin by Rufinus and recommended for reading in the Benedictine Rule—both have sections dealing with distraction from spiritual pursuits.[311] So do the *Institutes* of Pachomius, translated by Jerome, which like the *Apologia* cautions the monk against excess in food, drink, clothing, and

310. For a discussion of this dichotomy, see the general introduction to this chapter.

311. Basil the Great, *Regulae Fusius* 5, PG 31:919–923; *Regulae Brevius* 201–202, PG 31:1215. Owned by Clairvaux; Wilmart 1917:166; Troyes, Bibl. mun. 1422. Benedict of Nursia, *Regula* 73.

bedding.[312] Spiritual distraction as it occurred both inside and outside of church was a popular subject with the monks of the *Verba Seniorum*.[313] Augustine considered curiosity to be one of the more dangerous temptations, more complex than simple temptations of the senses.[314] And the subject is taken up in the important monastic biographies of Honoratus, the founder of the great abbey of Lérins, and of no less a figure than Benedict of Nursia by Gregory the Great.[315]

Art as a Spiritual Distraction

The narrower topic of art as a spiritual distraction was taken up at an even earlier date than the monastic Fathers in the *Contra Celsum* of Origen, an influential author in regard to the Cistercians in general and Bernard in particular, and in whose work art is described as drawing one's eyes away from God and down to the earth.[316] Certainly, the authority that most impressed Bernard along these lines was Cassian. It was from a passage criticizing the distractive powers of art in Cassian's *Conferences* that Bernard took his terms—and a major concept in the argument of the *Apologia*—the "small things" and the "things of greater importance." It is the "things of greater importance" that prevent the monk from fixing his attention on God.[317]

312. Pachomius, *Instituta* 18, p.58–61. The monastic rules of Basil and Pachomius were well known in the West and were consulted in Benedict of Aniane's *Concordia Regularum*.

313. *Verba Seniorum* 11:9, 11:28, 12:2, 15:10, *PL* 73:934, 937, 941, 955.

314. *Confessiones* 10:54, p.184; *De Diversis Quaestionibus* 78, p.223–224.

315. Hilary of Arles, *Vita S. Honorati* 1:7, *PL* 50:1252–1253; Gregory the Great, *Dialogorum Libri* 2:4, p.150–152. The *Dialogues* were owned by Clairvaux; Wilmart 1917:168; Troyes, Bibl.mun.4.

316. Origen, *Contra Celsum* 4:31, *PG* 11:1074–1075. Although not included in the Latin *Vita* of Pachomius owned by both Cluny and Clairvaux (Van Cranenburgh 1969:50, 52), not only did Pachomius warn against distraction in general terms, he also specifically cautioned his monks against beautiful architecture and manuscripts; *The First Greek Life of Pachomius* 63, p.341. On a possible general movement among the monks of the desert against decorated books, see the section "Resistance to Art as a Burden to the Poor." Pachomius is not alone in his concern over the distraction of paintings. While he is probably not referring to religious art, one poor wretch was distracted by paintings of women as well as their memory; *Verba Seniorum* 5:6, *PL* 73:875; cf. also *Verba Seniorum* 10:94, *PL* 73:929–930. The monk Nilus of Sinai (actually of Ancyra) denounced contemporary church decorations of martyrs, animals, plants, and hunting and fishing scenes as infantile distractions; Nilus of Sinai, Letter bk.4:61, *PG* 79:577–580.

317. Cassian, *Conlationes* 9:6, p.256–257, "Et re vera non minus haec, quae parva videntur et minima quaeque ab his qui nostrae professionis sunt cernimus indifferenter admitti, pro qualitate sua adgravant mentem, quam illa maiora quae secundum suum statum saecularium sensus inebriare consuerunt." See the commentary under 104:11–12 HAEC

Augustine—surprisingly for someone who wrote about music, "Thus I float between the danger of sensual pleasure and the experience of its beneficial effects"—lacks any real force in his references to art in general as a distraction. He does, however, mention painting and "other types of representation" as distracting, along with vessels, clothes, and even shoes.[318] Caesarius of Arles is both harsh and detailed in his wide-ranging proscription of art and art forms in the *Regula ad Virgines*, a proscription quite reminiscent of Early Cistercian legislation on the subject.[319] Under the direction of Boniface, the Council of Clovesho of 747 denounced the introduction into the cloister of the excessive ornamention of vestments which contributed to a lack of attention to reading and prayer.[320] And Odo of Cluny—who was called *fossorius*, the "digger," because of his practice of keeping his eyes down to avoid distraction—criticized the disturbance of the mysteries caused by the costly splendor of liturgical art.[321]

After the *Apologia* the pace of criticisms of art as a spiritual distraction, as well as a spiritual aid, increased. There was Cistercian legislation itself and statements by Cistercians such as Aelred of Rievaulx in 1142–1143 and William of Saint-Thierry in his famous *Epistola ad Fratres de Monte Dei* of just a few years later.[322] Others, too, criticized this aspect of religious art—both Christian and Judaic—from Peter the Chanter to the Reformation and so up to the present day.[323]

PARVA SUNT . . . QUIA USITATIORA for an explication of this passage. Cf. Chrysostom, *Homiliae in Matthaeum* 49:4, PG 58:501.

318. *Confessiones* 10:50–53, p.181–184. Augustine sees most art as superfluous (*De Doctrina Christiana* 2:39, p.61), ultimately distrusting it along Neoplatonic lines (*Soliloquia* 2:18, PL 32:893).

319. *Regula ad Virgines* 42, PL 67:1116; cf. also Letter 2, PL 67:1133.

320. Montalembert 1868:v.5:214. The Fourth Council of Tours condemned the religious use of animal imagery; Vacandard 1884:233n.39.

321. *Collationes* 2:34, PL 133:580. Pachomius is mentioned in the passage that follows Odo's criticism of art, but without any relation to art. On the epithet, "the digger," John of Salerno, *Vita S. Odonis* 2:9, PL 133:66.

322. For Cistercian regulations concerning art see Rudolph 1987. Aelred of Rievaulx, *De Speculo Caritatis* 2:70–73, p.99–101; *De Institutione* 25, p.657. *De Speculo Caritatis* was written at the request of Bernard and its passage on art shows many parallels to *Apologia* 28–29. Aelred also refers to Anthony and Macarius and virtually cites part of Augustine's *Confessiones* 10:53, p.183–184 (as well as 10:50 on music in the previous chapter). Aelred makes another strong statement against the distraction of liturgical art in *Sermo* 22, PL 195:337; see the section "The Liturgical Artwork." William of Saint-Thierry, *Ad Fratres* 148, 154, p.260, 264.

Aelred, William, and Nilus of Sinai all refer to the absence of art as somehow masculine. According to Gregory the Great, strength of mind is associated with the masculine, and weakness of mind with the feminine; *Moralia* 11:65, p.623.

323. Peter the Cantor, *Verbum Abbreviatum* 86, PL 205:256. On distraction related sources for the Franciscans, see Mortet 1929:236 (1225–1233), 286 (1260); the Carthusians, Mortet 1929:265 (1261); the Dominicans, Mortet 1929:247 (1298); for a short bibli-

Art as a Spiritual Aid

Art as a distraction was different from most of the other "things of greater importance" in that its opponents were able to establish a defensible counter-position, largely in response to the *Apologia* but also in response to the con-stitutional statutes of some of the new ascetic orders and above all to the unrecorded discussions of the monks and canons of all orders. They were able to do this, in part, because of the subjective character of the charge and because of its relatively weak patristic foundation. This does not mean, however, that art as a spiritual aid had a strong patristic foundation. Quite the opposite.

While Augustine's theories on the meditative function of beauty and number may have been used by others to support such claims, it is prob-lematic to see the abstract level on which his discussion was made as apply-ing to an actual meditative function for real architecture—as has been claimed. Although one may get the impression that he in fact might have thought along these lines and was not as inimical to painting and sculpture as a literal reading of his writings may suggest, the theoretical character of his writings seem to consciously disallow such a position to be argued for him.[324] Likewise, Paulinus of Nola's reference to his artistic undertakings as a *materiam orandi* is ambiguous at best.[325] Only in a spurious letter at-tributed to Gregory the Great is a significant reference made to the use of art as a spiritual aid. In this eighth-century forgery, Gregory is portrayed as having been solicited by a certain solitary, Secundinus, for images. Gregory

ography, Fracheboud 1953:124n.33. My thanks to Shalom Sabar for bringing to my attention Rabbi Meir ben Baruch of Rothenburg (c.1215–1293) who denounced art as a distraction from spiritual excercises, not as an offense against the Second Commandment. He did, however, make a distinction between painting and sculpture; Agus 1947:v.1:266. For an overview of sources leading up to the fifteenth century, see Ringbom 1984:11–22. Gage (1982:36–37) gives a number of interesting references to light (as well as art) as a spiritual distraction ranging from the early fourteenth-century *Roman de Perceforest* to Thomas More's *Utopia*. Hélinand de Froidmont discusses art as a distraction to those who would like to steal it; *Sermo* 23, PL 212:678.

324. On the claim that Augustine saw architecture as a spiritual aid, see Augustine, *De Ordine* 2:39–43, p.129–131, and von Simson 1974:21–25. However, distinct from any theoretical position on the use of art—including architecture—as a spiritual aid, Augustine certainly followed the sapiential tradition of a belief in the ability of visible things to lead to invisible things. See, for example, *De Trinitate* 12:4, 15:3, 15:49, p.358, 462, 531; Au-gustine, *De Doctrina Christiana* 1:4, p.8; *De Diversis Quaestionibus* 45:1, p.67; Letter 102:5, v.34:549; *In Joannis Evangelium* 24:1, p.244. In this, Augustine is in accord with Paul, Rom 1:20, "The invisible things of God's . . . are understood through those things which have been made," whom he often cites.

325. Paulinus of Nola, *Carmina* 27:596–598, p.288, "Quod superest ex his, quae facta et picta videmus, / materiam orandi pro me tibi suggero poscens, / rem Felicis agens ut pro me sedulus ores."

responds, defending the use of visible things to lead to invisible things (*per visibilia invisibilia*).[326] However, whether because of a less broad distribution or whether because its origin was suspect, this spurious letter of Gregory does not seem to have been cited with the same authority as the two letters to the bishop of Marseille, although it does seem to have been the source of a reference of Bede's to the use of art as a spiritual aid.[327]

In Suger of Saint-Denis, on the other hand, we have an author who enthusiastically if apologetically approaches the subject of art as a spiritual aid. According to Suger, the basis of this claim is the ability of material things to lead the viewer to immaterial things. Whatever may have been his personal opinion on the subject, his theory as put forth in *De Administratione* is one of a monastic art that claimed to be "accessible only to the *litterati*." That is, it was accessible only to the monk who was educated in Scriptural study—*litteratus* meaning in current Cluniac usage the standard choir monk who could read and so who could perform the textually based *opus Dei*, as opposed to the *idiota* or illiterate monk.[328] More advanced than the spurious letter of Gregory the Great which likened certain artworks to Scripture, Suger claims that certain artworks in his program functioned in a way similiar to the exegetical study of Scripture. However, there was a contradiction in this claim in that Suger's art program was in reality also quite accessible to the layperson, something which seems to have been consciously the case: that which was not intellectually accessible to the layperson was visually so, forcefully taking part in an unusually intense sensory saturation of the holy place.[329]

326. Gregory the Great, *Registrum*, appendix 10, p.1110–1111 (*PL* 77, bk.9:52). There is a reference to the use of art to arouse compunction in *Registrum* 11:10, p.875 (*PL* 77, bk.11:13) but it is made only in passing, the main subject being art to educate the illiterate—the latter being distinct from the former. Gregory makes no reference at all to art as a spiritual aid in *Registrum* 9:209, p.768 (*PL* 77, bk.9:105), where only art to educate the illiterate is discussed.

327. Bede, *Vita Abbatum* 6, p.369–370. The spurious letter of Gregory's was also recognized as authentic by the Council of Paris of 825; *Concilium Parisiense* 14, p.489.

Cf. also the reference in Cassian's *Conlationes* (10:2–5, p.286–291) to an anthropomorphist monk's dependence in prayer upon an image of God which is, in all probability, only to a mental image. Also, Clotilde, the wife of Clovis, used art to arouse her nonspiritual husband, but hardly in the way Suger claimed many centuries later: she decorated her church with various hangings and curtains to attract the attention of the still pagan Clovis and so to obtain his permission for the baptism of their son; Gregory of Tours, *Historia Francorum* 2:29, 90–91.

328. *De Administratione* 33, p.62. On the use of the term "*litterati*," see *Constitutiones Hirsaugienses* 2:11, p.484–485; Constable 1973:334–335. Suger's term "*litterati*" should not be confused with the modern word "literati."

329. For a more complete development of this subject, see Rudolph 1990:48–68. Bernard's question, "Whose piety, I ask, do we strive to excite in all this?" (*Apologia* 28) is a

It is along these latter lines that Theophilus and William of Malmesbury refer to the subject. Actually, Theophilus even uses the same word, *meditatio*, to describe the contemplation of art that Bernard uses to describe the spiritual contemplation which the contemplation of art interrupts.[330]

But perhaps the most significant support for the position which saw art as a spiritual aid to the *litterati* came from Hugh of St-Victor, a canon regular who lived in Paris and who is generally considered to be the most important theologian in Europe during the time that Suger planned his art program. According to Hugh,

> In the same way that an illiterate who may look at an open book sees figures [but] does not understand the letters, so the foolish and carnal man who does not perceive those things which are of God [1 Cor 2 : 14] sees the external beauty in certain visible created things but does not understand the interior reason. However, he who is spiritual and is able to discern all things, in that he has considered the external beauty of the work, comprehends interiorly how wondrous the wisdom of the Creator is. . . . The foolish man wonders at only the beauty in those things; but the wise man sees through that which is external, laying open the profound thought of divine wisdom. Just as in the same passage of Scripture the one will commend the color or the form of the figures, so the other will praise the sense and the signification.[331]

To be sure, Hugh seems to have acted as a principal advisor to Suger both with regard to the actual program and, clearly, to the justification of that program as a spritual aid to the *litterati*. But what Suger put forth so defensively, Hugh states with the confidence of one who knows the va-

tacit but disapproving recognition of the monastic justification of art as a spiritual aid for the layperson. A positive antithesis of Suger's claim to a strictly monastic art is exemplified in the reaction of both the monks and the townspeople to the newly made cross of Gauzlin's; Andrew of Fleury, *Vita Gauzlini* 65, p.132.

330. See Theophilus, *De Diversis Artibus*, prefaces to bks.1, 2, and 3, p.1, 36, and esp. 63–64, for reference to both the figural and the non-figural as aids in spiritual devotion. On the use of the word *meditatio* to refer to monastic contemplation, see Leclercq 1974:18–22, 91. William of Malmesbury, *De Antiquitate* 19, p.66–68, "Certainly the more grandly constructed a church is, the more likely it is to entice the dullest minds to prayer and to bend the most stubborn to supplication." However, cf. the more characteristic description of ecclesiastical splendor which "seized the spirit" and "tempted the eyes to the ceiling," not to prayer; *Gesta Pontificum* 1:43, p.69–70.

331. *Didascalicon* 7:4, *PL* 176:814; Hugh's passage is based on Augustine, *In Ioannis Evangelium* 24:2, p.244–245. For an explicit expression of visible things leading to invisible things by Hugh, see *In Hierarchiam* 2, *PL* 175:949–950. The degree to which the writings of Pseudo-Dionysius were directly applied to art at this time—Suger aside—is still unclear. However, for instances of his presentation of the claim of visible things leading to invisible things, see, for example, Pseudo-Dionysius, *De Caelesti Hierarchia* 1, *PL* 122:1038–1039; *De Divinis Nominibus* 4, *PL* 122:1131 (with reference to Rom 1:20). Cf. also Erigena, *De Divisione Naturae* 3:17, *PL* 122:678.

lidity of the historical tradition of his position—and also with the confidence of one whose credentials within the new ascetic reform movement were beyond question, with Hugh and Bernard having written treatises to each other.[332]

Indeed, in the period after Bernard's death, it is the Cistercians who take up this very theme. It was probably the Cistercian Adam of Dore who wrote the *Pictor in Carmine* around 1200, a collection of types and antitypes not unlike Suger's altar and windows which is heavily influenced by the *Apologia*. The ostensible purpose of this work is to provide the material for worthy subjects both to educate the unlearned and to stimulate the "*litterati.*"[333] And the Cistercian author of the so-called Pontigny *Vita* of Edmund of Abingdon (d. 1240), archbishop of Canterbury, wrote in approving terms that when the bishop did his religious reading, he did so with an extremely beautiful image of the Virgin before him, the image making the reading more, not less, "accessible."[334] It is more than just a coincidence that this process, which is described by the Cistercian monk using the word *contemplatio*, took place at a monastery which, although having far fewer monks than Cluny, had a church that was approximately 80 percent the length of the latter's church proper.[335]

Bernard's Concept of Artistic Distraction

BERNARD AND CURIOSITY

While Suger's and Bernard's concepts of art within the monastery are diametrically opposed, both take—in different ways—reading as their point of departure. The reason for this is not only that reading was traditionally recognized as the basis of monastic culture, but also that it was one of the

332. For a more detailed account of the relation between Suger and Hugh, see Rudolph 1990:32–47, 48–50, 59–60, 64. Hugh was also an artist to one degree or another and personally provided a complex and now lost miniature to elucidate the text of his mystical treatise, *De Arca Noe Morali*—a writing clearly intended for the highly educated religious. His related work, *De Arca Noe Mystica*, is a detailed set of directions for reproducing this miniature; cf. *De Arca Noe Morali* 1:2, PL 176:622.

333. "Literatos ad amorem excitent scripturarum," *Pictor in Carmine*, p.142. Cf. the author's use of *excitent* with *excitant* in *Apologia* 28. There is some question about the authorship of this text, with the best explanations in favor of James's ratification of Adam of Dore. Bernard of Cluny has also been suggested; James 1951:144.

334. Lehmann-Brockhaus 1955:5878; cf. the use of *patefecit* here with that of *patet* in Suger, *De Administratione* 33, p.62. Peter the Venerable is also recorded as having used art as a spiritual aid; Letter 86, p.224. Bernard Silvestre, who believed that communication with God was more direct through light than through the word, probably aimed his defense of religious ornament at Bernard of Clairvaux according to Duby (1976:116).

335. Conant (1968:141) gives 135.34m for the length of Cluny III proper, Aubert (1947:v.1:187) 108m for Pontigny.

acknowledged means of spiritual exercise which lead to various stages of spiritual awareness and ultimately to ecstasy. Bernard is afraid that art may distract the monk not only from his reading, but also from meditating (*meditando*) on the law of God (*Apologia* 29). The two are associated in such a way as to make it plain that Bernard is referring to reading as a means of spiritual exercise in the tradition of Gregory the Great, Cassiodorus, and so on. Indeed, to a Benedictine—which Bernard was despite terminology—*meditatio* refers to a form of contemplation of which reading was the basis.[336] In this sense, it is significant that both Suger and Theophilus should co-opt the term *meditatio* in their promotion of art to aid spirituality when it was exactly that function that Bernard felt would be impaired by art.[337]

Interestingly, it is to Adam that Theophilus traces the wisdom and skill which rationality permits man to use in the making of art; while it is to the origin of all sin that Bernard traces the curiosity which led to Adam's Fall.[338] The importance of the vice of curiosity cannot be exaggerated in Bernard's opinion. To him, curiosity is "drunkenness"; it corrupts the eyes; to overcome it is the goal of the "first struggle" of the fear of God; it is the natural enemy of piety and can destroy piety if one is negligent.[339] Curiosity receives far more attention than any of the other vices in his *De Gradibus Humilitatis et Superbiae*; he rates it as one of the seven deadly sins, even as one of the four major sins; the soul is forcibly dragged off by curiosity, and Bernard feels that the harshest curse he could impose on a person who spurns spiritual repose in favor of curiosity is that that person should have what he is curious about.[340] Curiosity is not simply a means to sin, it is a sin in itself, binding its victims to its own insatiability, and compromising that undiluted, powerful, and pure force of the soul which is man's principal sense—his sight.[341] It is a love of the world which leads the soul astray and in so doing denies human rationality by substituting curiosity about the world for curiosity about the things of God.[342] It is no less than an abandonment of the fear of God and a rejection of the divine voice which the "pil-

336. On reading and meditation see Leclercq 1974:18–23.

337. Suger, *De Administratione* 33, p.62; Theophilus, *De Diversis Artibus*, preface to bk.1, p.1.

338. Theophilus, *De Diversis Artibus*, preface to bk.1, p.1; Bernard, *De Gradibus Humilitatis* 38, v.3:45.

339. *De Diversis* 14:2, 54, 74, 125:3, v.6pt.1:135, 279, 313, 406 (and so piety checks curiosity, cf. *III Sententiae* 19, 20, 21, 98, v.6pt.2:76, 77, 164).

340. *De Gradibus Humilitatis* 28–38, v.3:38–46; *III Sententiae* 98, v.6pt.2:160 (cf. *III Sententiae* 89, v.6pt.2:136); *III Sententiae* 9, 89, 98, v.6pt.2:69–70, 137, 162; *De Conversione* 14, v.4:88.

341. *III Sententiae* 7, v.6pt.2:68; Letter 385:3, v.8:352; *III Sententiae* 73, v.6pt.2:110–111.

342. *III Sententiae* 20, 83, v.6pt.2:76, 120. Curiosity belongs to the animals; *In Circumcisione* 3:7, v.4:288.

grim," or spiritual person, avoids, swerving neither to the right nor to the left on the journey to the homeland.[343] Finally, it is a vice which Bernard very much, although by no means exclusively, applies to art.[344]

One of the greatest weaknesses in the scholarship dealing with the *Apologia* is the tendency to ascribe the public statements of this accomplished writer and successful politician to personal quirks. While virtually no attention has been paid to the many examples of Bernard's development of the traditional monastic theme of the suppression of curiosity as part of an overall program for the spiritual life,[345] great emphasis has been put on two misunderstood passages from the *Vita Prima* which recount—or rather, seem to recount—Bernard's personal absence of awareness or absence of curiosity about the art and natural beauty which surrounded him.

The most important of these passages is by William of Saint-Thierry, the first of several authors of this extended biography of Bernard and the person to whom the *Apologia* was nominally addressed. It tells how after an entire year in the novitiate at Cîteaux, Bernard was oblivious to whether its ceiling was vaulted or not. It goes on to mention how after having prayed many times in the abbey church, he thought that there was only one window in the main apse, whereas there were three.[346] In the second passage, by Geoffrey of Clairvaux, the third author of the *Vita Prima*, Bernard is described as having ridden all day along the shores of Lake Geneva. When several of his companions were talking about the lake that evening, Bernard tried to join in the discussion in a forced attempt at companionable light conversation. However, he had been so unaware of his surroundings that the best he could do was to ask them what lake they were speaking about.[347] Quite mistakenly, these hagiographical devices have been interpreted in terms of the personal psychology of Bernard, rather than recognized for the traditional, edifying function of *Vita* events that they were intended to serve. Actually, the meaning of these stories is conveyed on two literary levels entirely removed from that of personal psychology. On one level, the point of the stories is traditionally didactic and is accompanied by other similar tales and discussion: the stories of Bernard's unawareness are

343. *In Annuntiatione* 3:9, v.5:41; *De Conversione* 10, v.4:82; *In Quadragesima* 6:1, v.4:377.

344. Aside from the *Apologia* and Letter 42, cf. *De Diligendo Deo* 18, v.3:134 where Bernard, using Is 5:8 and Horace, criticizes unnecessary residential construction, ascribing the cause to curiosity; and *Super Cantica* 27:10, v.1:189 where he implies that art (*curiosa specatandi*) detracts from the ability to receive the divine presence.

345. Only a small fraction of the applicable citations have been mentioned here. Schapiro (1977:25n.6) tangentially mentions the weight given to curiosity by Bernard.

346. *Vita Prima* 1:20, PL 185:238.

347. *Vita Prima* 3:4, PL 185:305–306.

only a few of many dealing with his complete suppression of the senses, beginning with the welcome he gave to horrified novices that they were to leave their bodies outside upon entering the monastery. On the other level, these stories are written in such a way as to be universally recognized by contemporary audiences as drawing an overt parallel between Bernard and the early Fathers, particularly the Desert Fathers.

In writing the first book of the *Vita Prima*, William sought not to merely demonstrate Bernard's emulation of the Fathers, but also to show that Bernard had actually restored the fervor of the Egyptian monks, and that he and his monks were making fresh tracks in the path that the monks of the desert had walked so long ago.[348] Thus it is no surprise to find that the story about the ceiling of the novitiate and the windows of the church corresponds to a story of Abba Helladius in the *Verba Seniorum*, in which Helladius is said to have lived twenty years in the same cell without ever raising his eyes to look at the ceiling.[349] But this means of historical reference, if most pronounced in William, is common to at least the first three authors of the *Vita Prima*. Geoffrey's story of Bernard and Lake Geneva is almost identical in concept to another story in the *Verba Seniorum* about an Egyptian ascetic who lived on a river bank for sixty years, never once glancing at the water.[350] Furthermore, the second author of the *Vita Prima*, Arnold of Bonneval, seems to have co-opted a story in the *Verba Seniorum* about the abandonment by Abba Agatho and his monks of their quarters and applied it to the moving of the site of the monastery of Clairvaux during the building of Clairvaux II.[351] In fact, perhaps the most venerated of all the stories about Bernard—the so-called *in imbre sine imbre* incident in which Bernard was caught in the rain while dictating his famous Letter 1, one of the great documents of the Cluny-Cîteaux controversy, with the

348. *Vita Prima* 1:34, 42, *PL* 185:247, 251. The way of life, the architecture, and the solitude of Bernard and his monks were also similar to that of Benedict; *Vita Prima* 1:35, *PL* 185:248.

349. *Verba Seniorum* 4:16, *PL* 73:866. The Greek version describes Helladius as living in Cellia without ever raising his eyes to look at the ceiling of his church; *Apophthegmata*, Helladius 1, *PG* 65:173.

350. Abbatissa Sara to be exact; *Verba Seniorum* 7:19, *PL* 73:896–897.

351. *Vita Prima* 2:29, *PL* 185:285; *Verba Seniorum* 6:4, *PL* 73:889. For a similar case of co-opting of literary passages, cf. William's magnificent comparison of the ascetic Bernard to a bow put in tension by an archer in *Vita Prima* 1:38, *PL* 185:249 and *Verba Seniorum* 10:2, *PL* 73:912.

Although not directly related to this exact process, Bernard's famous comparison of himself and those who give up secular pursuits as "jesters and acrobats" of God may very well have come from Jerome's praise of Eustochium's training of her companions to be "lute and lyre players" of God; Bernard, Letter 87:12, v.7:231; Jerome, Letter 54:13, v.3:36.

parchment remaining miraculously dry—has an extremely long pedigree, one which involves no fewer than three of the abbots of Cluny itself.[352]

The point of all this is that these stories, and others like them,[353] serve the dual function of being both palatable indicators of Bernard's own thought and writings and immediately recognizable historical references which acted to establish a specific, claimed spiritual lineage put forth for him on the part of his faction. This purpose is distinct from any possible secondary biographical intent which, after all, had no crucial spiritual purpose in hagiographical writing.[354] Yet, it would be misleading to say that the stories about the monastery and the lake were totally fabricated. Rather, they are traditional means of conveying traditional monastic values which were strongly specific to Bernard. In regard to art and the question of Bernard's personal awareness, there was no ambiguity or need for his contemporaries to resort to psychological complexities to understand his position: it was like that of the early monks. As William explains in some detail immediately following the story of the novitiate and the abbey church, Bernard had a great natural capacity and a good mind.[355] Bernard's attitude toward art was a spiritual one, not an aesthetic one. When one goes beyond the boundaries of the *Apologia* itself, one finds that Bernard possessed a completely normal awareness of—as distinguished from an inclina-

352. William of Saint-Thierry, *Vita Prima* 1:50, PL 185:255. A large number of *"in imbre sine imbre"* (or *"in pluvia sine pluvia"*) stories exist, none of which I believe are the original model (aside from Gideon's fleece, Jg 6:36–40). Cf. Gregory the Great, *Dialogorum Libri* 3:11, 3:12, p.292–298. In reference to Odo of Cluny, see John of Salerno, *Vita S. Odonis* 2:22, PL 133:73. For Odilo of Cluny, see Jotsaldus, *Vita S. Odilonis* 2:16, PL 142:929–930 (with a conceptual dependency on Gregory the Great, *Dialogorum* 3:18, p.344–346), and again in 2:18, PL 142:931. Smith (1930:232) mentions an occurrence involving Hugh of Cluny but gives no reference. For other examples of this device, see William of Malmesbury, *Gesta Pontificum* 3:134, p.275; cf. *Historica Narratio* 3, AA SS, March, v.3:141; in the *Codex Calixtinus* prologue, v.1:1, Calixtus is made to recount that similar events happened to him quite often in the course of the writing of that book; Gregory of Tours, *Historia Francorum* 3:28, 4:34, 10:29, p.132–133, 169, 441; and Bernard the Monk, *Itinerarium* 12, PL 121:572–573 for an example at the tomb of Mary in Jerusalem c.870.

353. Russell 1981:116n.3 has noted a direct parallel between *Historia Monachorum* 25:2 and another story about Bernard in Conrad of Eberbach, *Exordium Magnum* 2:3, p.100–101. This type of historical reference was not always in the protagonist's interest as can be seen in Walter Map's unkind story of Bernard (*De Nugis Curialium* 1:24, p.80) based on Elisha's revival of the Shunammite's dead son (4 Kg 4:32–37), which shares certain similarities with Boccaccio's tale about one of the less accomplished of the Desert Fathers (*Decameron* 3:10).

354. As William of Saint-Thierry himself put quite bluntly: *Ad Fratres* 172, p.280.

355. William of Saint-Thierry, *Vita Prima* 1:21, PL 185:239.

tion toward—all forms of beauty: artistic, human, natural, literary, and musical.[356]

THE DANGER OF MATERIALITY

Aside from the risks of curiosity which accompany the excessive artwork, there is a very real danger to the monk inherent in any artwork—excessive or otherwise—in the simple fact of that object's unavoidable materiality. As Bernard and other new ascetic reformers, such as Peter Damian, who opposed excessive art were fond of saying, "The Most High does not live in things made by the hands of men."[357] On the spiritual level, materiality is the point of the near constant refrain that runs throughout *Apologia* 28–29, "Tell me, priests, what is gold doing in the holy place? . . . Tell me, poor men, if indeed you are poor men, what is gold doing in the holy place? . . . What are these things to poor men, to monks, to spiritual men? . . . What is that ridiculous monstrosity doing? . . . What are filthy apes doing there?" and so on. To Bernard, the spirit of man is from above and has nothing to do with the things from below, the things of this world.[358] It is in this sense that the embrace of voluntary poverty means more than the sacrifice of what one desires, more than the rejection of pride and the adoption of humility. It is, as Bernard says in *Apologia* 28, a renunciation of "all things shining in beauty, soothing in sound, agreeable in fragrance, sweet in taste, pleasant in touch—in short, all material pleasures." The monastic life is a life of withdrawal from the world, a cultivation of that which is interior. Given Bernard's definition of the sense faculty as exter-

356. Artistic: aside from the *Apologia*, see Bernard, *Super Cantica* 25:3, 26:7, 28:1, v.1:164, 175, 192; *De Laude Novae Militiae* 9, v.3:222; *Vita S. Malachiae* 14, 63, v.3:323, 367–368; Letter 243:4, v.8:132.

Human: *Super Cantica* 25:3, v.1:164; and cf. *De Diversis* 12:2, 122, v.6pt.1:128, 399.

Natural: for a very sensitive evocation of the beauty of nature, see *Super Cantica* 27:2, 27:4, v.1:183, 184; but cf. *Super Cantica* 25:7, v.1:167, where his public view is given: nature is beautiful, but true glory is interior, not exterior.

Literary: *In Laudibus Virginis* 3:1, v.4:35; and throughout his letters where he praises numerous correspondents on their Latin style.

Musical: Letter 398:2, v.8:378.

357. Cf. Bernard, *In Dedicatione Ecclesiae* 2:2, v.5:376, "neque enim Altissimus in manufactis inhabitat"; and Peter Damian, *De Institutis* 30, PL 145:362, "Altissimus non in manufactis habitat"; and the Vulgate, Acts 17:24, "Deus . . . Dominus, non in manufactis templis habitat." In *Apologia* 12, Bernard also refers to the same Biblical citation (1 Tim 4:8) used by Peter which immediately follows the passage from Acts. See also Bernard, *In Dedicatione Ecclesiae* 1:6, v.5:374 (based on 2 Cor 5:1).

358. *In Vigilia Nativitatis* 2:3, v.4:206.

nally alert, it is clear that the function of the senses in the perception of excessive art is fundamentally opposed to monastic spirituality.[359] Since the senses are opposed to the spirit, that which is from below must be suppressed in order to achieve that which is from above.[360] And, going a step further, since to Bernard sight is the principal sense,[361] it is in this area that materiality has most to be overcome.

However, Bernard's rejection of materiality and the senses is not all-inclusive. In his *De Consideratione* he presents a position on the senses that may be interpreted as not inimical—theoretically—to a theory of art to aid in spirituality such as Suger proposes, but which does not consider one who uses such an excercise as a spiritual adept.[362] Although not specifically applied to art, such an application is both safe and fair to make given the nature of his discussion, his generally superb grasp of the issues involved, and the importance he gives to sight. According to Bernard, there are three methods of spiritual ascent. The first is called "directive (*dispensativa*)," in the sense of managing that which is to be sensually perceived in the same way that a modern motion picture director "directs" the various elements at his disposal. It usefully and bravely employs the senses to achieve salvation for oneself and others, and the person who uses it is great. No less great is the person who uses the second method, the "estimative (*aestimativa*)." This pleasant and fertile method uses the senses, but in a philosophical way, to investigate everything so that it might take one a step further toward God. This would be the method claimed by Suger.[363] The third method, the "speculative (*speculativa*)" method for the person who is spiritually greatest of all, rejects objects and the senses as much as is humanly possible in its flying in contemplation to the sublime—not by stages, but by unexpected departures. The first is powerful, the second free, and the last pure. The first two methods of spiritual ascent must function as preliminary stages for the latter, or "they are not what they are said to be." The first would sow much but reap nothing, and the second would make some progress but not

359. Bernard, *De Gratia* 3, v.3:167. Cf. Idung's rejection of art which is strongly oriented toward the senses but which lacks Bernard's profundity; *Dialogus* 1:36, p.389–390.

360. Bernard, *De Consideratione* 5:2, v.3:468.

361. *De Diversis* 10:3–4, v.6pt.1:123–124; *III Sententiae* 73, v.6pt.2:110–111.

362. Bernard, *De Consideratione* 5:3–4, v.3:468–469. On the acceptance of the senses, Bernard follows Augustine, *De Vera Religione* 56, p.223–224. For an educated, contemporary expression of this position by one who was not opposed to the monastic use of art, see Hugh of Saint-Victor, *In Hierarchiam* 2, PL 175:950.

363. Bk.5 of *De Consideratione* was finished in 1152–1153, and an earlier part was made known to Peter the Venerable, friend of Suger, in 1149 (Leclercq 1957:v.3:381). It is possible, although there is no direct evidence, that Bernard was aware of Suger's attempts to justify monastic art.

rise. Thus, even on an abstract level, Bernard is reserved in his recommendation of these methods for the unaccomplished and sees them as transitory, not permanent, means of spiritual ascent.

Bernard's moderate views were expressed near the end of his life and in a treatise to a former Cistercian monk who had now become the religious leader of the entire Christian West, Pope Eugenius III. Since the monk's life is contemplative and the speculative method is contemplative, it may be assumed that it was this method that Bernard felt was proper to the monk. This view is upheld by William of Saint-Thierry's writings, and so indicates the probability of a consensus on the subject among the leaders of the new ascetic reform movement. To be sure, William, too, acquiesced in the admission of art for the spiritual novice.[364] But, as with Bernard, it was a different story for the spiritually advanced. William's complete rejection of the image extends even to mental imagery, recognizing only a rudimentary level of spiritual development in which the soul that is not advanced is allowed to imagine the Passion of Christ.[365] If one wishes to advance, one avoids all conceptions of the divine which involve physical localization or even quality and quantity.[366]

Such a conception of the basis of monastic contemplation agrees well with that presented by Cassian in the passage from his *Conlationes* which I believe was the source for Bernard's adoption of the terms, "small things" and "things of greater importance." In this passage, Cassian discusses how the things which seem small oppress the soul by their nature more than the larger things which some monks allow indiscriminately.[367] It also coincides strongly with Cassian's passage on Anthropomorphism and the rejection of any mental images of God in the spiritual excercises of the monk.[368] Indeed, William believes that the mind is diffused in carnal images, blinded.[369] To the truly spiritual person, not only is there not even a question of images, words alone can impede the mind in its search for divine realities.[370]

But the ultimate danger of the materiality of art lay elsewhere to William. According to him, every sense experience changes the person

364. *Ad Fratres* 174, p.282–284.

365. *Meditativae Orationes* 10:4, p.160.

366. William of Saint-Thierry, *Speculum Fidei* 32, PL 180:394.

367. *Conlationes* 9:5, p.254–256. According to William, the spiritual man (the monk) avoids excessive architecture, and in so doing emulates the monks of the desert; *Ad Fratres* 156–157, p.266.

368. *Conlationes* 10:2–5, p.286–291.

369. *Ad Romanos* 8:26, PL 180:637, "Sed mens nostra . . . in carnalibus imaginibus fuerit sparsa . . . caecatur."

370. William of Saint-Thierry, *Speculum Fidei* 32, PL 180:395.

experiencing it in some way into that which is sensed.[371] The implications of this as regards *Apologia* 29 are significant, even if one cannot impute them to Bernard himself. One is what one experiences. Thus, following William's position, the monk who indulges in idle curiosity in viewing the hybrids of the cloister capitals or of his book takes on some of the conflict of nature inherent in them and so is proscribed from the harmony of union with God. While Bernard does not explicitly go so far as his close friend William, the important question with him is also union with God. If this is achieved by contemplation and if contemplation comes about through the condescension of the Word of God to human nature through grace and the raising up of human nature to the Word through divine love,[372] then human nature cannot possibly rise to the Word since it resists the divine voice through the bodily senses.[373] Any distraction from contemplation necessarily involves a certain rejection of grace and Christ himself, and to cut oneself off from contemplation is to cut oneself off from various ineffable mysteries.[374] For he who concerns himself with proper meditation can have no temporal curiosty but will say, "How I have loved your law, Lord, it is my meditation all the day,"[375] as opposed to the monk that Bernard describes in *Apologia* 29 who "would rather read in the marble than in books,

371. This idea is probably based on Gregory the Great, *Moralia in Job* 1:33, p.43, where Gregory states, "For we ought to transform what we read into ourselves. . . . " It may ultimately be dependent on Plato, *Republic* 6:13. v.2:68, where Plato writes that the person who has his mind fixed on divine realitites and associates himself with divine order will himself become orderly and divine.

372. Bernard, *De Diversis* 87:3, v.6pt.1:331.

373. Bernard, *De Conversione* 10, v.4:82. Other writers against excessive art shared the same view; cf. Aelred of Rievaulx, *De Speculo Caritatis* 2:70–73, p.99–101; and Augustine, *Confessiones* 10:51–53, p.182–184 (although in a much more qualified way). Bernard's rejection of the material world is not complete, however; see *De Diversis* 9:1, v.6pt.1:118.

So we see that to Bernard it meant little more than a loss of physical labor when the people of Le Mans forgot their work and had their "understanding" taken away while contemplating (*intuentium*) a particular work of art some time around Bernard's last years (Mortet 1911:v.1:166). These were the "animal men" the monk had left behind (*Apologia* 28); and the "animal man"—whose senses are his primary characteristic—does not understand the things of the spirit of God; Bernard, *Super Cantica* 1:3, v.1:4; and *In Vigilia Nativitatis* 3:3, v.4:259. The term "animal man" (*animalis homo* or *carnalis homo*, also translated "sensual man" or "unspiritual man") is a favorite of William's and for our purposes is most notably found in his *Ad Fratres* 140–141, 146–147, 155, p.254, 258–260, 264; it is based on 1 Cor 2:14. To Bernard, the senses are characteristic of animals, rationality of man; *In Vigilia Nativitatis* 3:8, v.4:217. The labor of the people of Le Mans was manual, and "manual labor is of value to a degree, but piety is of value in every way"; *Apologia* 12, (based on 1 Tim 4:8).

374. Cf. Bernard, *III Sententiae* 30, v.6pt.2:84; *Super Cantica* 41:3, v.2:30.

375. Bernard, *De Diversis* 29:4, v.6pt.1:213; the citation is from Ps 118:97, which may be the source for the parallel in *Apologia* 29.

and spend the whole day wondering at every single one of [the distractive works of art in front of him] than in meditating on the law of God."

The basis, then, of Bernard's objection to art as a distraction to the monk is not rooted in any personal idiosyncrasy, but is the vigorous projection of traditional monastic values. Yet, in *Apologia* 28 he explicitly sanctions certain types of art in the monastery. This being the case, what exactly constituted artistic spiritual distraction to Bernard, and what were the limits of this criticism?

In *Apologia* 28 the "things of greater importance" are each discussed in terms of their own criteria for artistic excess, centering variously on material, craftsmanship, size, and quantity—or some combination of them all. In chapter 29 Bernard turns to the question of art which is ostensibly intended for the monk alone. Here, too, this "thing of greater importance," art as a spiritual distraction to the monk, assumes its own criteria for artistic excess.

In his criticism of art as a spiritual distraction to the monk, Bernard mentions fourteen examples of excessive art by way of illustration. These are a ridiculous monstrosity which nevertheless exhibits an amazing kind of deformed beauty which is at the same time a beautiful deformity, filthy apes, fierce lions, monstrous centaurs, creatures which are part man and part beast, striped tigers, fighting soldiers, hunters blowing horns, creatures with many bodies under one head, creatures with many heads on one body, a quadruped with the tail of a serpent, the head of a quadruped on the body of a fish, a creature consisting of a horse in front and a goat behind, and finally a creature which is horned in front and equine behind.

Some scholars see this attack as a straightforward rejection of figural capital sculpture, others primarily as a censure of the use of monstrous forms, and still others as a general condemnation of all art as a spiritual distraction. But Bernard's reproach is, actually, none of these things. It seems that it is the apparently random nature of Bernard's examples which has been so misleading, but that randomness *is* only apparent. To be sure, Bernard is criticizing certain forms of art under certain conditions as a spiritual distraction to the monk. But his precision of description, which is so highly praised by Panofsky, is matched by an equal precision of criticism which carefully delineates his field of argument and, in so doing, partially defines the limits of the controversy over monastic art in the early twelfth century.

Far from being random, Bernard uses his examples generically—and to great rhetorical advantage—to indicate three categories of iconographical types which he feels lend themselves to spiritual distraction: monstrous and hybrid forms, animals, and men engaged in worldly pursuits.

MONSTROUS AND HYBRID FORMS

Of the fourteen examples cited, nine come under the heading of monstrous and hybrid forms. Clearly this is the group to which Bernard most vehemently objects and therefore, one may assume, feels is potentially the most distractive. And of those nine, at least eight are portrayed as hybrid.[376] Again, one may assume that Bernard sees hybrids as the most distractive of monstrous forms. The reason for this attitude will not be found in the question of whether or not these creatures held any symbolic meaning to Bernard. This former point of contention should once and for all be characterized as a non-issue. Bernard recognized the full spectrum of medieval symbolism in monstrous and animal forms: traditional non-religious, traditional religious, and non-traditional religious interpretations of his own devising are all amply represented in his writings—not to mention his non-traditional non-religious description of himself in hybrid terms.[377] Rather, the answer may be found in the concept of a contradiction of nature which underlies the entire chapter.[378]

To begin with, hybrid forms are by definition a contradiction of nature.[379] But that this constitutes their outstanding property of distraction to

376. Bernard's first example of a monstrous form ("What is that ridiculous monstrosity . . . ?") gives no indication of its type despite the antithetical phrasing. His avoidance of such monsters as the basilisk, griffin, and dragon is probably for tactical reasons: on the one hand, they carry much of the distractive force of the less standard hybrids; yet on the other hand, they have an undeniable pedigree in the Bible and in bestiaries. To confront these types adds nothing to his argument, to sidestep them is to his advantage.

377. Traditional non-religious: *In Psalmum "Qui Habitat"* 14:7–8, v.4:473. Traditional religious: *In Psalmum "Qui Habitat"* 14:8, v.4:473–474. Non-traditional religious: *In Quadragesima* 1:2, v.4:354. Non-traditional non-religious: his famous description of himself as the chimera of his times, Letter 250:4, v.8:147; for a similar but negative description of Arnold of Brescia, Letter 196:1, v.8:51; and Letter 78:11, v.7:208. Cf. Peter the Venerable, Letter 111, p.297, where a hybrid reference from Horace is used.

378. On a far less profound level, Vitruvius criticized the illogic—and the excess of materials—of the Third Style of Roman painting in *De Architectura* 7:5:3–7, p.332–336. Bernard also brought up the subject of the contradiction of nature in relation to the adulteration of food in his famous chapter on excess in monastic eating habits; *Apologia* 20.

379. Cf. Bernard's Letter 78:11, v.7:208, where he asks, "What kind of monster is this, I ask, that while it wishes to be seen as a cleric and a soldier at the same time, is neither one?" and Letter 250:4, v.8:147, "I am what one might call the chimera of my time, I function as neither a cleric nor a layman." Jerome also described a man in terms of this

Bernard is brought out in his decision to emphasize this contradiction by detailing forms which are invariably invested with an element of contradiction which goes beyond the mere joining of disparate forms in the offense it gives to the natural order. And so it is that each of Bernard's carefully chosen, specific examples conveys the idea of an essential debasement of nature in that far from just signifying the animals named, they represent the major zoological classes and sub-species according to medieval science. Thus a reptile is incongruously joined to a mammal, a mammal to a fish, a solid-hoofed animal to a cloven-hoofed one, and the integrity of the physical being itself is corrupted when its two most fundamental units—head and body—are joined together in grotesque mismatch, defying the most elementary laws of physiology.[380] This concept of contradiction is repeatedly driven home even in the oppositions present in the structure of his descriptions of those hybrids for which a particular name does not exist: " . . . under . . . on; . . . on one side . . . on the other side; . . . over there . . . the front . . . the back; . . . here . . . in front . . . behind. . . ." Indeed, immediately following his list of examples which culminates in the attentive description of the hybrids, he characterizes the entire lot of examples as a plentiful and astonishing variety of "contradictory forms (*diversarum formarum*)"[381] which the monk was tempted to gaze upon instead of fulfilling the important obligation of spiritual reading. So, to Bernard, it was the concept of a contradiction of nature rather than the symbolic conjunction of opposing forms that constituted the quintessential aspect of the hybrid and therefore also comprised one of his major objections to certain forms of art as distractive.

Even the acknowledged beauty of the figures was put forth in contradictory terms. In introducing the subject of art as a spiritual distraction as it appears in *Apologia* 29, Bernard writes, "What is that ridiculous monstrosity doing, an amazing kind of deformed beauty and yet a beautiful deformity?" Apparently, Bernard sees the contradiction of nature inherent in the physical cause as producing a contradiction in the aesthetic effect: the

same monstrous hybrid, the chimera, as being "of contrary and diverse natures (ex contrariis diversisque naturis)"; Letter 125:18, v.7:130. When Abelard was castrated, he was "denatured" and so described himself as "monstrous;" *Historia*, p.80. Even the union of a horse and an ass to conceive a mule was regarded in medieval bestiaries as against nature in this sense; cf. *Bestiary*, p.89, 205.

380. The zoological classes of reptiles, mammals (beasts), and fish were recognized in medieval bestiaries; *Bestiary*, p.7, 165, 195. The distinction between the sub-orders of solid-hoofed animals (solidungulates) and cloven-hoofed ones (artiodactyl ungulates) has a pre-Physiologus literary tradition in Lev 11:3–8.

381. See the commentary under 106:21–22 TAM MULTA . . . UBIQUE VARIETAS for the reason why *diversarum* is translated here as "contradictory."

nature of beauty has been deformed, but its force of attraction remains unnaturally the same through the artist's reconciliation of the disparity of the parts. Indeed, the attraction caused by beauty is now supplemented with the attraction caused by contradiction. This too is a subversion of nature and, as such, potentially holds a shocking fascination of its own in Bernard's view.[382]

ANIMALS

As to the categories of animals and men engaged in worldly pursuits, Bernard gives far less textual indication of his objections. The animals he names and their attributes—filthy apes, fierce lions, striped tigers—establish no forceful pattern of specific disapproval outside of the fact that they are not indigenous. At the most, the three examples share a common trait of ferocity as they are described in medieval bestiaries.[383] However, this quality is brought out in the *Apologia* for the lion only, for whom ferocity was traditionally the distinguishing trait. To be sure, the epithets applied to the other two animals also state features for which those particular animals were especially known in the writings of the time. And so it seems that by the inclusion of these animals, Bernard intends nothing which may be interpreted as anything more than a rejection of the representation of non-mythical animals as catering to curiosity—both in terms of simple distraction and of knowledge for knowledge's sake, which he defines and condemns in one of his *Sententiae* as curiosity.[384]

WORLDLY PURSUITS OF MEN

Likewise, with the two examples of men engaged in worldly pursuits—fighting soldiers and hunters blowing horns—there is a mutual element of violence or potential violence. We know that Bernard strongly disapproved of both war and hunting.[385] It may even be argued that the reason these

382. According to Hugh of Saint-Victor, it is improper to join the deformed to the beautiful; *De Arrha Animae*, PL 176:954, "Ineptum est deformia pulchris conjungere."

383. According to a mid-twelfth century bestiary which may be from the Cistercian monastery of Revesby, apes, lions, and tigers are specifically named among those animals which should be called "beasts" because they "rage about with tooth and claw"; *Bestiary*, p.7.

384. *III Sententiae* 108, v.6pt.2:180; cf. *III Sententiae* 19, v.6pt.2:76. But Bernard is careful to make clear that he does not reject all knowledge; *Super Cantica* 36:2, v.2:4. Cf. Bernard's condemnation of the pagan philosophers as curious and vain; *In Die Pentecostes* 3:3, v.5:173. Cf. Hugh of Saint-Victor, *De Sacramentis* 1:6:3, PL 176:265.

385. Bernard (*De Laude Novae Militiae* 2, v.3:215) rejects any fighting which is not in the interests of Christendom. He also believes that the Christian knight should abhor hunt-

examples of men are mixed with those of beasts is that in Bernard's opinion, the violent man has given up that which is characteristic of man—his rationality. Like the others of his time, Bernard sees man's power of reason as that trait which distinguishes him from the irrational animals. It is rationality which enables him to discern between good and evil, truth and untruth.[386] The examples of violent pursuits chosen by Bernard show man in his aspect as a slave to his passions, not discerning what is good and true, and therefore irrational as the beasts are irrational and so incapable of worshipping his creator. Indeed, cruelty stems from the "stolidity of corporality which is found particularly in animals."[387]

Yet this violence, while undeniable, is not the common denominator of Bernard's two examples of man. The vast majority of the monks to whom Bernard addressed his treatise came from the aristocracy. Fighting was their profession, and hunting was one of their major recreations: these actions are in a sense as descriptive of medieval aristocracy as ferocity is of the lion or stripes are of the tiger. Equally or even more important than the element of violence is the fact that that violence was being performed by those very people from whom the monk had withdrawn himself, as Bernard reminds us in the previous chapter (*Apologia* 28). In other words, Bernard's mention of these examples implies a rejection of the invasion of secular imagery unrelated to spiritual concerns into the monastic environment.

We see now that Bernard is by no means objecting to all forms of art as a spiritual distraction to the monk in the *Apologia*. He finds monsters the most distractive iconographical category and hybrids the most distractive type of monster. This is because of a contradiction of nature inherent in them, a contradiction which even affected the nature of the beauty they possessed by transforming it into a hybrid itself of beauty and ugliness, and thus capable of the distractive powers of both beauty and contradiction. He rejects the representation of non-mythical animals as catering to idle curiosity. And he opposes the use of secular imagery in monastic art to convey non-spiritual concerns, especially in its violent aspect. Bernard describes

ing and hawking; *De Laude Novae Militiae* 7, v.3:220. As with monsters and animals, Bernard is aware of the allegorical use of violence to indicate spiritual struggle: one need look no further than the *Apologia* itself (*Apologia* 22) for one of his many examples of the genre.

386. Bernard, *In Vigilia Nativitatis* 2:3, 3:8, v.4:206, 217. The Christian authorities for this view are too numerous to list and cover every period previous to and contemporary with Bernard; for example, Augustine, *De Doctrina Christiana* 1:20, p.16, and *In Joannis Evangelium* 1:18, p.10; Gregory the Great, *Moralia* 24:15, p.1198; Erigena, *De Divisione Naturae* 4:5, *PL* 122:757; and for a contemporary view, Hugh of Saint-Victor, *Didascalicon* 1:4 (citing Boethius), 5, 10, *PL* 176:743–744, 747–748.

387. Bernard, *III Sententiae* 9, v.6pt.2:69–70.

these types of art as "absurd" (*Apologia* 29), absurd for the spiritual person and so going beyond the acceptable limits in respect to the monk. In Bernard's view, that limit was the line which demarcated the spiritual from the non-spiritual. In fact, the distinction is not always so clear-cut, as was the case with the art of Cîteaux itself.

Bernard never mentions images of Christ, the Virgin, Biblical scenes, and so on in *Apologia* 28–29—images which would have been considered distractive according to Cistercian legislation. Rather, he takes a position on art in the monastery which rises above the bounds of any organizational policies or personal feelings to define a conception of restrictive art which could encompass all of traditional monasticism. Monumental sculpture and painting which took as their subjects overtly religious themes were by no means necessarily included in his criticism of that which went beyond the limits of an acceptable monastic art. Bernard is not complaining about the fact of the representation of hybrids and so on in stone, he is complaining about the function of their distraction: "One would rather read in the marble than in books, and spend the whole day wondering at every single one of them than in meditating on the law of God." Having previously condoned monumental religious art and condemned certain aspects of the relationship between art and the layperson in the monastery, he now criticizes that art which was ostensibly meant for the monk alone. Bernard apparently felt that this type of art was most forcefully exemplified in the monstrous, animal, and secular imagery of the cloister, but the reasons for this should not be seen as limiting his criticisms to the cloister. By choosing the cloister, he makes clear that his complaints are strictly monastic, fixes those complaints to spiritual excercises, and avoids the traditional justifications for art elsewhere in the monastery, including in manuscripts—the latter being covered in eloquent silence. With this in mind, the traditionally recognized limit of his critique of monastic art to the medium of capital sculpture alone is untenable, and must be seen as extending to other forms of art within the monastery.

3

THE *APOLOGIA* AND THE ART OF THE ORDERS OF CLUNY AND CÎTEAUX

In the previous section we have seen that Bernard is in no way opposed to all forms of imagery, and in studying those categories of images that he does oppose, we have seen that his complaints are quite independent of the artistic medium of cloister sculpture. It is art as a spiritual distraction to the monk—not the medium of cloister sculpture—that he objects to with such force and style, and theoretically, his criticisms could apply equally well to the art of manuscript painting or any other artistic medium for that matter. Nevertheless, the traditional view that Bernard is specifically denouncing the presence of excessive forms in the capital sculpture of monastic cloisters puts the burden of proof on this study to carry its arguments a step further—a pragmatic step this time.[388] In determining where the most explicit occurrences of Bernard's examples and categories of distractive art are most readily found, I hope to show without question the broader application of the *Apologia* to other forms of monastic art and, in the process, see if perhaps a little light can also be shed on the address of that treatise.

For these purposes, I have chosen four major works of monastic art whose imagery will be examined in terms of Bernard's artistic criteria of distraction. On the Cluniac side, these artworks come from Moissac and Saint-Martial at Limoges, two major Cluniac dependencies whose respective art programs of cloister sculpture and book painting are excessive. That is, they should not be taken for typical Cluniac monasteries.[389] I have also

388. Pragmatic, not aesthetic, because my concern is distraction and not beauty, and because it does not deal with theoretical or philosophical traditions.

389. On the idea that Moissac should no longer be seen as "typically Cluniac," see Stratford 1984:171n.47 and Forsyth 1986:459.

selected for study two early illuminated manuscripts from Cîteaux, manu-
scripts whose colophons dated 1109 and 1111 indicate that they were begun
and probably finished before Bernard's arrival there in 1113. It is hoped that
a comparison of these Cistercian manuscripts with their Cluniac counterpart
will be revealing as to the broader intent of the *Apologia*.

The Capitals of the Cloister of Moissac

It was no accident that Bernard chose cloister sculpture rather than some other form of art as his means of discussing excessive art as a spiritual distraction to the monk. To Bernard, the physical cloister was inextricably bound with the concept of monasticism itself, as indicated in his characterization of monastic life as the "claustral paradise (*paradisus claustralis*)."[390] Indeed, the cloister was the true social center of that segment of society which Bernard—and many others before him—saw as central to society.[391] By describing excessive art as a distraction to the monk in terms of cloister sculpture, Bernard was doing more than developing a brilliant rhetorical device or even the most likely example. In using the cloister as the primary medium for this particular "thing of greater importance," he was not only underscoring what he felt to be the corrupting influence of excessive art in the physical heart of monasticism—more importantly, he was also driving home with special force his denouncement of the corruption of its moral heart. When the various excesses described by Bernard were allowed to exercise their disruptive powers here, it was monasticism itself that was being disrupted.

On a less significant but more practical level, the cloister was also the place where the monk normally did his prescribed religious reading. It was often where the novices and *pueri* (in non-Cistercian monasteries) received their instruction. And it was a holy place in its own right on the basis of the liturgical acts that took place in it, the churches, chapels, and semi-liturgical buildings that opened onto it, and the graves that occasionally occupied it. The cloister of Moissac was even sanctified by the presence of relics imbedded in a sculpted capital. Furthermore, in theory at least, the cloister was

390. See esp. *De Diversis* 42:4, v.6pt.1:258; *III Sententiae* 29, v.6pt.2:84 (*paradisus claustralis*); *III Sententiae* 91, v.6pt.2:140 (the cloister is both *paradisus* and *eremus*, and the place of *sancta avaritia*). And cf. *In Laudibus Virginis* 4:10, v.4:55; *In Ramis Palmarum* 2:5, v.5:49; *I Sententiae* 18, 26, v.6pt.2:13, 16; Letter 78:4–5, v.7:203–205. Cf. Honorius Augustodunensis, *Gemma Animae* 1:149 on the cloister as paradise.

391. For the theoretical and social expressions of this by Theodulf of Orléans, Dudo of Saint-Quentin, Abbo of Fleury, and Helgaud of Fleury, see Duby 1980:83, 85–87, 88–91, 183, cf. 142, 177–178, 185–187, 195–196. On the development of the cloister, see Horn 1973.

a place for monks alone.[392] Bernard referred to this practice in his transition from *Apologia* 28 to *Apologia* 29, but on the level of spirituality rather than of social hierarchy.

Thus, Bernard's choice of cloister sculpture as a means of discussing spiritual distraction carries a significance which is greater than might be apparent at first glance. To what degree it was applicable to contemporary monastic cloisters is of real importance in trying to determine the scope and intent of Bernard's passage. Many scholars have seen this passage as a specific description of the cloister at the monastery of Cluny at the time the *Apologia* was written. In the absence of any historical evidence that would support such a claim, I will match the examples of Bernard's chapter 29 with the seventy-six column capitals and eight pier reliefs of the cloister sculpture of Moissac, the pre-eminent, extant Cluniac sculpted cloister of the period just preceeding the *Apologia*.

Since it is my belief that Bernard never openly condemned the representation of Biblical scenes or saints' lives in the *Apologia*, these types of scenes will not be referred to unless specifically noted.

Instances of Bernard's Fourteen Examples

I have already suggested that Bernard's fourteen examples of excessive capital sculpture were meant generically, not specifically. Perhaps nothing could better illustrate this than their comparison with the cloister sculpture of Moissac. His first example—an amazing kind of deformed beauty which is at the same time a beautiful deformity—describes the archetypal monster of his concept of the contradiction of nature inherent in certain artistic forms, most notably hybrids. It cannot be identified with any one sculpture. But with respect to many of Bernard's other examples, the tally is little different: there are no apes in the cloister of Moissac, no centaurs, no quadrupeds with the tail of a serpent. Nor are there any creatures with the head of a quadruped on the body of a fish, any consisting of a horse in front and a goat behind, or any which are horned in front and equine behind.

In fact, there are only a very few instances of most of Bernard's other

392. According to Ekkehard IV of Saint Gall (c.980–1060), "not even the most powerful canon or layperson of the secular world was permitted to enter the monks' enclosure or even to glance into it" at Saint Gall at this time; Horn 1962:118n.50. This contrasts strongly, however, with the situation at other places and at other times. Cf. Bernard's objection to the invasion of secular business into the cloister of Saint-Denis (Letter 78:4–5, v.7:203–205) and Peter the Venerable's complaint that the intrusion of so many clerics, laypeople, and especially *famuli* had turned the cloister of Cluny "almost into a public street" (*Statuta* 23, p.60).

examples. Two cases of *semihomines* appear, but in the imposts only. In the first, the impost of a capital probably portraying the Triumph of the Cross has eight avian figures, the heads of six of which have been destroyed (impost 58, Fig. 7).[393] While traces suggest that the heads of all eight were not necessarily the same, the two complete ones represent traditional harpies. In the second case, intertwined birds decorating the impost of a capital of the Vision of Saint John hold heavily mutilated, horned human heads at the centers and corners (impost 15, Fig. 8). There are only two instances of non-human hybrid figures on the Moissac imposts, one multi-bodied and one multi-headed creature. The impost of a decorative bird capital (impost 60, Fig. 9) has four leonine figures with two bodies each, stretching along the sides of the impost joining in a single head at the corner and creating the illusion of being two different animals when seen straight on from the face of the capital, rather than from the angle.[394] Conversely, another impost (impost 2, Fig. 11) has a series of creatures with two heads on one body—in this case, double-headed eagles regularly spaced along the length of the circuit of the impost, with one positioned at each corner, a head facing in either direction in antithesis to the previous impost.

Of all Bernard's examples, it is in the depiction of the traditional lion that Moissac excels. Two capitals (capitals 69 and 72) and six imposts (imposts 7, 11, 24, 33, 41, 48; Fig. 12) display a relatively large number of lions, usually though not always combined with some other beings such as monsters, animals, men, or some combination thereof. Whether any of these felines were originally meant to portray tigers is impossible to say, now that their paint has worn off.

As to soldiers fighting and hunters blowing horns, both cases are problematic, but for different reasons. One capital portrays armed crusaders at Jerusalem (capital 49, Fig. 13). Is this or is this not covered in Bernard's criticism of distractive art? While Bernard himself was one of the major figures in the promotion of the Second Crusade, he was strongly opposed to the participation of monks in it. Therefore, despite the ostensibly religious basis of this capital, it seems that Bernard would probably have objected to it on the basis of its depiction of an activity he found suitable for laymen, but unsuitable for monks.

393. The numbering system found in Schapiro 1977b is followed here.

394. A number of other imposts and capitals border on ambiguity in their representation of animals and monsters whose heads almost join at the corners, but in fact do not. See esp. impost 11 which is quite similar to impost 60 except for the fact that the lions' heads do not merge, capital 60 whose birds' heads almost merge in contrast to the lion impost above, and capital 28 (Fig. 10) where the regular, incised parallel lines describing the body surface of the dragons add to the near-ambiguity.

The case with possible representations of hunting is different. One capital shows a number of figures with weapons and blowing horns (capital 63, Fig. 14) which, however, seems to fall short of a true parallel to Bernard's examples. Two anthropomorphic—but decidedly not human—figures stand on bows on opposite sides of the capital, pulling at the bow-strings with their hands. Arrows held in their mouths accentuate their monstrous faces. Two disembodied monstrous heads on the adjacent sides blow large horns, as do four other figures on the corners of the capital. The latter are headless, mutilated beyond recognition except for their anthropomorphic bodies, bodies which quite likely carried monstrous heads similar to their archer companions. Finally, there are no indications that hunting is in any way the subject of this scene. And although there are indications of hunting in the impost decoration of another capital (impost 45, Fig. 15), there are no hunters and apparently no conception of a hunt properly speaking. Two sides of this impost show an affronted stag and a riderless, but saddled, horse. Iconographically, it derives from an Islamic hunting scene.[395] The elimination of the hunter, however, removes the impost from the level of Bernard's criticism of the representation of the worldly pursuits of men and places it pictorially in the realm of seemingly irrational conflict.

Thus, a strict matching of excessive art as characterized in *Apologia* 29 with the cloister sculpture of Moissac finds very few points of contact. Of the fourteen examples, only five can be said to have any direct resemblance to the seventy-six capitals and eight pier reliefs. Three of the five examples are represented in only one instance each, a very slight showing. And of these three, one scene has an overt if disallowable religious basis, while the other two—hybrids—are relegated to secondary areas of imagery and are quite conventional (and so less distracting) in form. Also conventional are the other two instances of Bernard's example of *semihomines*, which are likewise assigned to the impost area. Only the example of the lion is found in any real quantity at Moissac, but it too is primarily, although not exclusively, an inhabitant of the imposts.

Instances of Bernard's Three Iconographical Categories

But since Bernard did not mean his fourteen examples as independent criticisms in themselves, a fair picture of how the *Apologia* relates pictorially to the sculptural program of the cloister of Moissac can only be reached

395. Capelle 1981:89–90.

through the broader application of his larger iconographical categories: monstrous and hybrid forms, animals, and the worldly pursuits of men.

Whereas only four instances of monstrous impost sculpture correspond to three of Bernard's specific examples, five capitals and fourteen imposts apply to the broader category of monstrous and hybrid forms. Indeed, while the figure must be used with extreme caution because of the high incidence of monstrous sculpture in the impost area, almost 25 percent of all capital and impost ensembles contain some form of monstrous creatures. Furthermore, no less than eleven of the fourteen monstrous imposts contain hybrids—that type of excessive art most severely criticized by Bernard. And while it is true that all of these are conventional hybrids (griffins and basilisks in addition to those already mentioned) and that all of them are confined to the impost area, most of them occur in relation to capitals of overtly religious content, thus functioning as a distraction from the spiritual. As to the five capitals which are devoted to monstrous forms, three of them have eight full-length dragons decorating them, and another has eight large monstrous heads, thus contributing to distraction through size, quantity, and position.

The category of animals is represented even more fully at Moissac in instances in seven capitals and nineteen imposts (including the impost of the eastern central pier, that of Abbot Durandus of Moissac). However, variety in their representation is rather lacking. Five of the seven capitals and twelve of the nineteen imposts consist to one degree or another—very often exclusively—of birds (especially aquiline figures). Aside from those animals already referred to, the only other identifiable animals in the capitals and imposts of Moissac consist of a pair of goats and the zodiacal sign of pisces, both in imposts. But, despite the great absence of variety, the curiosity catering aspect of the bestiaries is strikingly apparent in the inscription "aves" above the heads of a pair of corner birds (capital 60, Fig. 9), an inscription which one cannot help but compare to the inscriptions which appear in some of the religious capitals, such as the very next capital (capital 61, Fig. 16) which not only captions the shepherds of Bethlehem (*pastores*), but also their ass (abbreviated as *asi*) and cattle (*boves*).

Finally, the representation of the worldly pursuits of men in the cloister of Moissac must be said to be almost negligible: besides four capitals and two imposts which show men being dominated by or struggling with monsters and animals, there is only a capital of the Apotheosis of Alexander, an impost with enigmatic circular faces, and the religiously based capital of the crusaders at Jerusalem. None of these scenes really fits the spirit of Bernard's criticisms of the secular pursuits of men with the possible exception of the Jerusalem capital. Furthermore, the character of all the capitals of

men with monsters or animals, except the Apotheosis of Alexander, is such that they are primarily monster or animal scenes—not human scenes. Humans play only a secondary role in them. And in the impost depictions, humans are for the most part elements of ornamental pattern.

In the end, the overwhelming character of the cloister sculpture of Moissac is religious. The eight large pier reliefs of the Apostles and Abbot Durandus are entirely religious in their pictorial aspect. Forty-six of the seventy-six column capitals depict overtly religious scenes. Thirty-seven of these are from the Old and New Testaments, while another nine depict saints' lives, the Eight Beatitudes, the Triumph of the Cross, and so on. Seventeen capitals are wholly vegetal, leaving only thirteen to portray monsters, animals, and men. Even so, these few capitals mesh poorly with either Bernard's specific criticisms or with his broader criticisms of the depiction for monks of hybridity and the worldly pursuits of men. While there is a fair showing of monstrous forms at Moissac, the fact remains that absolutely all of that type of monstrous form most criticized by Bernard— the hybrid—are restricted to the impost area. Furthermore, not one of these depict the more distractive non-traditional hybrid type given such attention in the *Apologia*. As to the worldly pursuits of men, there is nothing that can be wholeheartedly described as illustrating that category as implied by Bernard in *Apologia* 29. Only in the area of animals can the situation be said to agree straightforwardly with the criticisms of *Apologia* 29, yet these animals are for the most part no more exotic than birds rather than the non-indigenous, ferocious beasts described by Bernard. And, as with the monstrous forms, it is in the impost area that the better part of the animal types are found at Moissac. It is interesting that their appearance in a secondary field of attention should have its counterpart in the canon tables of illuminated manuscripts, as we shall see. For, ultimately, Bernard's choice of the cloister was a rhetorical and conceptual decision, not a sumptuary or artistic one in the sense of emphasizing one medium over another. To be sure, the evidence suggests that far from representing a typical "Cluniac" cloister, the cloister of Moissac was atypical in its excess. And that is just the point. The poor correspondance between the excessively sculpted cloister of Moissac and *Apologia* 29 is indicative on the one hand of the generic nature of Bernard's criticisms, and on the other of its broader application to all media of medieval art.

The Second Bible of Saint-Martial, and the Bible of Stephen Harding and the Moralia in Job of Cîteaux

As has been mentioned, each of the "things of greater importance" was discussed by Bernard in terms of its own criteria for artistic excess. In *Apologia* 29, Bernard concludes that excessive art acts as a distraction from spiritual reading and contemplation. It was this that Bernard objected to, not any particular offense specific to capital sculpture. An examination of manuscripts representative of both Cluniac and Cistercian monasticism of the period just before the *Apologia* was written will make clear to what degree distractive qualities were common, as well as indicate the address of the *Apologia* in as far as the excesses condemned in it are present. For this purpose I will use the Second Bible of Saint-Martial (Paris, Bib. nat. lat. 8) of c.1100 from the Cluniac abbey of Saint-Martial, and the early Cistercian Bible of Stephen Harding of c.1109 (Dijon, Bib. publ. 12–15) and *Moralia in Job* of c.1111 (Dijon, Bib. publ. 168–170, 173), both from the mother house of Cîteaux.

However, while Bernard's criticisms were put forth strictly in terms of content, elements other than content also contribute to the distractive qualities of art. Therefore, when applying Bernard's critique of art as a distraction to actual artworks, both the content of the miniatures (as suggested by his three iconographical categories and as far as possible by his fourteen examples) and those elements which are used to convey the content will be investigated for their distractive qualities.

Instances of Bernard's Fourteen Examples

Bernard's condemnations were generic, not specific. His fourteen examples were meant to illustrate his criticism of excessive art, they were not categories of excess in themselves. As such, some of his examples—most notably his series of six of the eight hybrids—were written more with a certain concept in mind than as descriptions of particular artworks he had seen or knew existed. Nevertheless, a matching of the illustrations in our manuscripts with the examples listed by Bernard yields surprising results.

As with the cloister sculpture of Moissac, no reference to illustrations of Biblical scenes or saints' lives will be made unless specifically mentioned.

1. *A ridiculous monstrosity which nevertheless exhibits an amazing kind of deformed beauty which is at the same time a beautiful deformity.* Bernard here describes the archetypal monster of his concept of the contradiction of nature inherent in certain artistic forms. It may also apply to his categories of animals and the worldly pursuits of men. As such it is the ideal form, so to speak, and cannot be defined as a particular miniature.

2. *Filthy apes.* The Second Bible of Saint-Martial has two miniatures of apes. The first (8:2:166v) sits on an object which may represent a ball, decorating the column base of one of the canon tables. It should be noted that the canon tables of the the Second Bible are an area of far more intense imagery relative to the rest of the Bible both in the quantity of figures represented and in their more unconventional subject matter. The second ape appears in the last figural illustration of the book (8:2:259v), sitting in a hoop which is held by a trainer.

There are no apes in the Bible of Stephen Harding, but the *Moralia in Job* has one ape, standing on the head of a human as part of an obscure allegory (173:66).

3. *Fierce lions.* The Second Bible has seven scenes with a total of thirteen lions (8:1:41, 91, 149, 183, 184; 8:2:169, 232).[396] In six of the seven scenes, the lions appear in pairs, a problem in reference to distraction which will be taken up later. It also has numerous unidentifiable clawed quadrupeds which give the appearance of being predatory.

The Bible of Stephen Harding has six separate scenes with a total of six lions (12:3v, 54v; 13:3v; 14:44v; 15:7 head only in canon table, 56v),[397] and the *Moralia* has four scenes with a total of five lions (169:36v; 173:7, 103v, 111v).

4. *Monstrous centaurs.*[398] Second Bible: none.

The Bible of Stephen Harding has three scenes with a total of four cen-

396. Two are non-textual embellishments in Biblical illustrations; another is being trodden by an author. None of them illustrate any textual passages.

397. Two of these appear in Biblical or textual scenes but are narratively and physically unrelated to the former.

398. I have not insisted on solid hoofs in my determination of centaurs because of the conviction that those without solid hoofs were in fact meant as "hybrid" centaurs and that the overall impression of these figures still reads as "centaur."

taurs (14:14; 15:5v, 68), one of which is from the canon tables. The *Moralia* has one scene with two centaurs (173:56v).

5. *Creatures which are part man and part beast.* Second Bible: none.
The Bible of Stephen Harding has four scenes with five such creatures (12:3v; 14:128v; 15:56v, 108v), and the *Moralia* has three scenes with no fewer than nine *semihomines* (173:7, 56v, 103v). It should be added that the variety among them is very great, with only a few being able to be called faun types.

6. *Striped tigers.* The word "striped (*maculosae*)" which Bernard used to modify "tigers" can also mean "spotted." In the Second Bible there are six scenes with a total of ten spotted, clawed, and apparently predatory quadrupeds (8:1:213v; 8:2:167v, 170, 170v, 171, 192v). It is impossible to say more than this in regard to whether the artist felt he was portraying tigers or some other animals such as pards, leopards, or panthers, all of which are credited with variegated markings by the writer of a twelfth-century Cistercian bestiary.[399] Half of these animals appear in the canon tables. Another appears in the form of a hybrid with two bodies and one head (8:2:170v), also in the canon tables.
I have been unable to find any animals which might be interpreted as tigers in the two Cistercian manuscripts.

7. *Fighting soldiers.* The Second Bible has no examples of miniatures of men who are clearly soldiers, outside of one Biblical narrative scene. There are, however a number of scenes of armed men struggling with monsters, animals, and each other which in all probability do not represent actual soldiers (8:1:208v; 2:67v, 136v; Fig. 17). This is because of the absence of characteristically military clothing—either armor or the luxurious clothing of knights criticized by Bernard in his *De Laude Novae Militiae*—or because of the choice of weapons used. Weapons such as a small knife, stave, or even a rock which suggest that the user is not a soldier or knight are predominant. None of the figures uses a sword or shield, though spears are used in one scene.
Likewise, the Bible of Stephen Harding has only one probable non-Biblical scene of a soldier (14:128v), although it puts far greater emphasis on warfare in its Old Testament narrative illustrations than does the Second Bible, another subject which will be taken up soon. In contrast, non-Biblical representations of soldiers abound in the slightly later *Moralia* where there

399. *Bestiary*, p.12–14.

are six scenes with a total of nine soldiers (168:4v, 52v; 169:88v; 173:20, 111v, 133v). All the soldiers either are prepared to fight, are fighting, or have just finished fighting.

8. *Hunters blowing horns.* There are no hunters or horn blowers in the Second Bible.

The Bible of Stephen Harding has one hunting scene with man, dog, falcon, and prey (14:90v), and another which shows a dog with collar on the scent of various game which are portrayed throughout the canon table in which they appear (15:9). It also has a faun type blowing a horn with a live game bird at his feet (15:56v), although whether or not this was meant to represent a hunt is problematic. Two hunting scenes appear in the *Moralia*, one with man and dogs and the other with a falconer (169:62v; 173:174; Fig. 18).[400]

9. *Creatures with many bodies under one head.* There are two scenes with three examples of this type of creature in the Second Bible (8:1:170v; 2:170v). One of the scenes is in the canon tables.

Neither the Bible of Stephen Harding nor the *Moralia* has any creatures which fit this description.

10. *Creatures with many heads on one body.* The Second Bible has three scenes with four of these hybrids (8:1:191v; 2:166v, 170). Three of the four appear in the canon tables.

In the Bible of Stephen Harding, only one chimera type exists (15:3v). The *Moralia* also has only one of these monsters, a radical hybrid but one whose bicephalism is relatively subdued as a result of its rather innocuous snake-like tail which comprises the second head (173:103v, Fig. 19).

11. *A quadruped with the tail of a serpent.* Second Bible: none.

Bible of Stephen Harding: none. The *Moralia* has a creature which could be said to fit this description, although I believe its bicephalism disqualifies it from matching exactly what Bernard had in mind: the previously mentioned snake-tailed monster also has quadruped features such as a bovine head and canine paws on its forefeet (173:103v).[401]

400. A copy of Jerome's letters from Cîteaux (Dijon, Bib. publ. 135:102) has a miniature of a man blowing a horn while standing on a dragon.

401. Precisely the hybrid described in *Apologia* 29 appears in the Letters of Jerome from Cîteaux, being a goat in front with a serpent tail behind (Dijon, Bib. publ. 135:82).

12. *The head of a quadruped on the body of a fish.* None of the manuscripts has a hybrid answering this description.

13. *A creature consisting of a horse in front and a goat behind.* None of the manuscripts has a hybrid answering this description.

14. *A creature which is horned in front and equine behind.* Second Bible: none.
Bible of Stephen Harding: none. The *Moralia* has a creature which is horned in front and equine behind (173:103v); however, it is also human in between and so not really what Bernard was describing.

Thus, a literal matching of the fourteen examples of Bernard's in *Apologia* 29 with the miniatures of the Second Bible of Saint-Martial and of the Bible of Stephen Harding and *Moralia in Job* from Cîteaux reveals certain definite patterns.

On the one hand, the Second Bible far exceeds the Cistercian works in the number of its more conventional animals such as the lion and tiger (spotted, clawed quadruped). Even its hybrids—the only type it has are those having multiple bodies or heads—are among the more conventional in medieval art. Even so, it is in the canon tables that the vast majority of those creatures fitting Bernard's descriptions appear. While the tiger is plentiful in the text, it nevertheless figures importantly in the bases and capitals of the canon tables where it is the most numerous specifically identifiable species of animal, if we may interpret spotted, clawed quadrupeds as tigers. Indeed, the majority of the few hybrids also appear here as does one of the two apes. In short, the Second Bible of Saint-Martial is strong in the area of Bernard's examples of animals, having several depictions of each. But it is weak in the area of hybrids, having only a few conventional forms, and it makes no showing at all in that of his examples of soldiers fighting and men hunting.

On the other hand, the Bible of Stephen Harding and the *Moralia in Job* present a quite different picture. Between the two of them there are no illustrations of animals that can be called tigers, and the only ape to be seen is part of a complex allegory. Even the normally ubiquitous lion is found only six times in the Bible of Stephen Harding as compared to thirteen in the Second Bible. But it is in the area of Bernard's examples of hybrids that these two books excel. Given the fact that many of his examples of hybrid forms were meant for rhetorical force and to convey his concept of their inherent contradiction of nature, the sheer quantity and variety—two ex-

cesses condemned by Bernard in regard to art as a distraction to the monk—
is startling. While there seems to have been a clear resistance to portraying
monsters with multiple heads and bodies in these manuscripts, the repre-
sentation of animal-human hybrid combinations is pronounced. And it is
all the more significant that the *Moralia*, strictly speaking a non-liturgical
book meant solely for the spiritual reading of the monks, should have re-
ceived the largest share of these creatures which are part man and part
beast. As to soldiers, both books have non-Biblical miniatures of this ex-
ample of Bernard's. But once again, it is the *Moralia* which presents by far
the most of them. Hunting is portrayed equally by the two, and in such a
way as to present the most interesting narrative quality. So, while these
Cistercian manuscripts show only the slightest interest in the conventional
depiction of animals, they are exceptional in the quantity and variety of
their monstrous hybrids and the narrative quality of their scenes of men
fighting and hunting.

Instances of Bernard's Three Iconographical Categories

Aside from a literal matching with Bernard's fourteen examples, how do
these manuscripts fare with the more general iconographical categories of
monsters, animals, and the worldly pursuits of men? The Second Bible of
Saint-Martial has a total of eighty-three monsters compared with only
fifty-four in the Bible of Stephen Harding and just thirty-four in the *Moralia
in Job*. It has one hundred and twenty-nine animals as compared to forty-one
in the Bible of Stephen Harding and twenty-six in the *Moralia*. And in
regard to illustrations of men which neither explicitly illustrate the text nor
present an author portrait, the Second Bible has seventy-two as compared
with the Bible of Stephen Harding's twelve and the *Moralia*'s forty-six.

Frequency, Effect, and the Distractive Quality of Art

While the above statistics tend to agree with those of the previous section's
on animals, they disagree—or rather seem to disagree—with those on
monsters and men. However, close study of the miniatures of all three
works shows that a strictly statistical analysis can be very deceptive when it
comes to the question of artistic distraction. Other means of determining
the distractive quality of art, means not discussed by Bernard in his monas-
tic treatise, are necessary to put the relation between the frequency and
effect of these figures in proper perspective. A large number of elements
which can add to or detract from this quality are at play in our three manu-
scripts. This section deals with a few of the more important of them, first in

reference to the excesses of quantity, variety, and narrative and then to other elements which help reinforce these excesses.

QUANTITY: FINIAL HEADS AND FULL BODIES

By far the majority of the monsters that appear in our three manuscripts do not literally match the descriptions of *Apologia* 29. Most of them offer no specific points of identification, and may only be said to take the general form of a dragon. As briefly mentioned, the Second Bible appears at first glance to have a considerably greater distractive potential in its larger quantity of these monstrous forms. The total count of monsters in the Second Bible of Saint-Martial is eighty-three as compared with fifty-four in the Bible of Stephen Harding and only thirty-four in the *Moralia in Job*.

However, of the Second Bible's eighty-three monsters no less than sixty-seven consist of heads only. That is, of a total of eighty-three monsters, only eighteen are full-bodied. And of these eighteen, six appear in the canon tables, leaving just twelve full-bodied monsters throughout the text. Of the twelve, two pairs are symmetrically arranged (this subject is taken up in the next section), and so only eight full-bodied, non-paired monsters are found throughout the Bible.

In sharp contrast are the Cistercian books. Of the total of fifty-four monsters in the Bible of Stephen Harding, thirty-four are full-bodied and only two are in the canon tables. Of the thirty-two full-bodied monsters appearing throughout the text, absolutely none are paired. The general tendency to do away with finial heads was taken even further in the *Moralia*, where there are only three such heads compared with thirty-one full-bodied monsters. One pair of the latter are symmetrically arranged.

A striking feature of this phenomenon of disembodied heads is that they are particularly associated with monsters: while sixty-seven such monstrous heads exist in the Second Bible, there are just six disembodied animal heads and only one human.[402] In general, the disembodied head of a monster appears most often as a finial at the termination of letter forms. The simple absence of an independent body limits their dramatic and narrative potential, and thus their distractive force. Their subordination to the letter form also diminishes their distractive force. They are primarily decorative, not narrative. In fact, they often tend to take on the designs of those purely decorative forms around them. For example, in the Second Bible a number of heads take on the surrounding decoration to varying degrees, occasion-

402. The Bible of Stephen Harding has three animal and four human heads. The *Moralia* has no examples of either type.

ally merging to a point of absolute ambiguity (8:2:231, see Fig. 20 for the most notable examples).

And in those cases when disembodied heads do take on a narrative aspect, their participation is constrained. This effect comes about not only because of the absence of a body, but also because of the common use of a convention whose format is static, with whatever amount of activity desired being simply added within the given bounds. This practice is clearly exemplified by a series of initial *A*s in the Second Bible. The first consists simply of an *A* with two symmetrical, curving arms coming off the top and an identical monstrous head at the end of each turning back toward the letter (8:2:91, Fig. 21). In the second example, symmetrical and identical griffins who are made to fight with the finial heads were added to the basic form in the free space between each monstrous head and the body of the *A* (8:1:171, Fig. 22). Finally, in the third example, a pair of fighting men have been placed in the same space in place of each griffin, although now in slightly asymmetrical compositions (8:2:136v, Fig. 17). This additive principle of narration, when seen in combination with the many other *A*s of the text, is read not as a striking example of variety (i.e., an "original creation"), but as only the most elaborate form of the first static *A*. The basically independent initial remains, and the added figures and their actions are just as subordinated to it and dominated by it as the earlier monstrous heads. The narrative is dependent on the letter, not vice versa.

The distractive potential of full-bodied monsters (as well as of animals and men) is significantly different from that of finial heads. First, the very nature of the full body lends itself to a wider range of opportunities for distraction. The basic opportunity is the extended field of detail, color, and dramatic impact offered by the larger and often unusually shaped body. But the claws, tail, arms, and so on of the full body also permit more complex forms of interaction and therefore more distracting narrative than the typical finial head. Furthermore, it is only through the possibilities of the full body that hybridity—that aspect of distraction given the most attention by Bernard—could be developed to the degree he describes. And while the question of the monster's relation to the letter largely remains a choice of the artist, the full-bodied monster of the Cistercian manuscripts often tends to be less subordinated to it. This is so much the case that the distractive force of letter forms is taken up in its own section.

So what at first glance seemed to indicate a greater tendency toward distraction in the Second Bible actually suggests the same for the Cistercian manuscripts. The power of distraction may indeed fluctuate according to quantity, but the distractive force of the individual miniatures is a crucial factor in any question of numbers. Full-bodied monsters offer far greater

potential for distraction than disembodied heads. This is not only because of their own actual appearance—including hybridity—but also because of their relation to the other figures around them and to the letter in which they are portrayed.

VARIETY: SYMMETRICAL PAIRS AND HYBRIDITY

At one hundred and twenty-nine, there is no question but that the number of animals decorating the Second Bible far surpasses the forty-one of the Bible of Stephen Harding and the only twenty-six of the *Moralia*.[403] Yet, the impression conveyed by this large number of animals is not equal to the absorbing attraction one encounters with the Cistercian manuscripts. Very many factors are at play here, but as far as the animals proper are concerned, perhaps the most important is that of their pairing.

Of the one hundred and twenty-nine, fully one hundred and two animals are paired with each other in the Second Bible. Of the remaining twenty-seven, only five are formally paired with another monster or human, and two are the central figures in sets of other pairs. Only twenty of the original one hundred and twenty-nine are depicted without strict pairing at all—and even four of these appear paired but without any attempt at symmetry with men (mostly in scenes of struggle), and eight decorate the bases and capitals of the canon tables. In effect, this leaves only eight animals (one of which is a finial head) in the text proper of the Second Bible which are in absolutely no way paired or related to pairs. In sharp contrast, absolutely none of the Cistercian animals are composed in conventional pairs, although a very small number of monstrous and human finial heads are symmetrically paired, as is one pair of slightly mismatched, slightly asymmetrical monsters in the *Moralia* (173:103v, Fig. 19).

Most of the one hundred and two paired animals in the Second Bible appear in what might be called heraldic compositions, the majority of these being arranged in matched, symmetrical, affronted pairs or matched, symmetrical, addorsed pairs. The others generally take the form of mismatched, symmetrical, affronted pairs; mismatched, symmetrical, addorsed pairs; mismatched, slightly asymmetrical pairs; vertical pairs; and pairs which make up patterns such as crosses and circles.

Although repetition is an element in the weak distractive force of

403. Just as the discussion of the previous section was not limited to monsters but was also applicable to animals and men, so this section deals with principles which primarily are found in connection with animals in these books but which also occasionally occur with monsters and men.

matched, symmetrical pairs, even more important is their tendency to not be involved in narrative.[404] Instead, the animals exist as essentially immobile decorative devices which—especially after a large number of them as in the Second Bible—come to be read as simply "convention," "pattern," "symbol," and so on (for example, Fig. 23). Their symmetry often dictates their arrangement according to the structure of the letter, in the most extreme cases seeming to become a part of that structure itself. Instead, not only do these miniatures bear no relation to the text, but by adding nothing which engages the attention as do scenes of spiritual struggle, allegory, and even enigmatic images, the viewer anticipates the totality of the composition after having concentrated his or her attention on only part of it, and is far less likely to devote reading time to it than to a more involved narrative composed of unusual creatures.

The counterpart in our manuscripts to the conventional, regularized, and repeated symmetrical pair is epitomized by the Cistercian hybrid. The characteristics of the Cistercian hybrid are variety, narrative, and relative quantity. This can be amply demonstrated simply by describing one miniature in the *Moralia*, ironically, the only miniature in our two Cistercian manuscripts which has a symmetrical pair of full-bodied creatures.

The miniature (173:103v, Fig. 19) is an inhabited initial *P*, the only non-figural part of which is the upright. At the base of this upright a bald, bearded midget with severely atrophied legs rides a saddled, harnessed, and naked human on all fours as if he were a horse. The saddle and harness are rendered in such detail as to include breeching, bellybands, breastband, saddle cloth, facepiece, cheekpiece, and reins. These two amble off to the right, discreetly ignoring the mayhem which goes on above them. This begins with a bright red hybrid with human legs and feet, and a leonine body and head—the latter being ocher. Walking upright to the left and turning around and above to the right, the hybrid claws and bites at a smaller, green lion who tears with his teeth at the red lion's face. He does this as he himself is apparently in danger of being carried aloft any minute by a large bird of prey who sinks both beak and talons into him. The bird of prey in turn is about to be bitten by a long-eared snake who, on closer inspection, is found to be the tail of a quadripartite hybrid. With snake tail and canine paws, this human-bodied and taurine-headed monstrosity holds a shield with his left hand and runs a long and very sharply pointed spear completely through the body of a figure who forms the top half of the circular part of the *P*, causing much blood to flow. This creature has a human torso and legs with cloven-hoofed (artiodactyl ungulate) forelegs and a goat head which he

404. There are exceptions, such as 8:2:67v and 136v, but these are rare.

butts against that of a similar creature who forms the bottom half of the *P*. This creature, too, has a goat head and human torso, but unlike the former hybrid he has equine legs (solidungulate) and tail, and human arms which appear to grab at a "hybrid" dragon with canine paws which has its tail wrapped around the former hybird's legs.[405] The hybrid dragon wrenches the long, pointed ear of another hybrid between his teeth. This latest monster is composed of the body of a wild boar, the long, pointed ears already mentioned, and the bearded face of a human. He stands on the back of a very awkward looking hybrid which has the hind parts of a quadruped such as a lion (as suggested by the comparison of its croup to other lions), canine paws (no lion claws), and a human torso, arms, and head. He runs a spear completely through the earlier taurine hybrid, the blood running down his side. This brings the chain of violent action full circle, with the taurine hybrid's snake tail lunging at the bird of prey who is about to carry off the green lion who mauls the bright red hybrid lion who straddles the human equestrian pair.

These, then, are the types to which Bernard most vehemently objected. They are portrayed in complex variety, both among the various creatures to decorate any particular miniature and within the composition of the individual hybrids themselves. This variety, indeed, is such that of the six "centaurs" and fourteen *semihomines* only two may be said with any certainty to belong to exactly the same "hybrid species."[406] Furthermore, there are virtually no regularized groupings (the only exception being one pair in the initial just described). The absence of regularized groupings tends to give more weight to the distractive power—relative to the symmetrical pairs of the Second Bible—of the already considerable quantity of figures in the Cistercian books. Finally, the narrative potential of this kind of book decoration is far more powerful than that of strictly symmetrical pairs, as is shown in the following section.

NARRATIVE: INCOHERENT VIOLENCE AND SPIRITUAL STRUGGLE

Perhaps the most important element of figural art as a distraction is the interaction between figures, or their narrative quality. While both the Saint-Martial and Cistercian manuscripts have interaction between figures

405. That this is a deliberate attempt at hybridization is indicated by the fact that only one other dragon-type monster in both of the Cistercian manuscripts has canine paws, and this is in the Bible of Stephen Harding (15:99v).

406. These are centaurs, the most conventional of the Cistercian hybrids, of the classical equine type (15:68, 173:56v). The hoofs, an important indicator of animal type, cannot be seen on one of the centaurs (14:14).

in those miniatures of theirs which do not directly and literally illustrate the text, it is carried out with such different approaches as to often suggest different respective purposes.

As with monsters and animals, the Second Bible has a far larger number of human figures: seventy-two as compared with twelve in the Bible of Stephen Harding and forty-six in the *Moralia*. And, as with monsters and animals, the illustrations with humans in the Second Bible have a less distracting impact than the Cistercian books, especially the *Moralia*. At least part of the reason for this is the manner in which the humans are portrayed in the Cistercian manuscripts. Both the book from Saint-Martial and those from Cîteaux have a number of scenes which show relatively unrestrained violence involving monsters, animals, and men. Some of them offer little clue as to any specific purpose beyond the most general explanations of the violence inherent in Nature, or perhaps even the adoption of iconographic forms which had lost their meaning and so may only be seen as decorative—setting aside what the demand for and function of that decoration may imply. However, other scenes clearly have a more specific level of meaning, a meaning which is not directly—although it may be indirectly—related to the text. The discussion here can in no way be a comprehensive analysis of the question of spiritual struggle in these manuscripts, but only an introduction to the issue and some of the complexities involved. Breaking with the practice of the previous sections in which I discussed major problems in terms of that category of creature with which they were most often associated, in this section I take up the subject of spiritual struggle in terms of not only the human figure, but also those creatures with which humans are made to fight. Indeed, all three types are intimately connected in the subject of spiritual struggle. But it is the *semihomines*, because of their unique position between monster, animal, and human that provide the link between those scenes of recognizable spiritual struggle and those of seemingly incoherent violence.

Most of the scenes of the Second Bible involving men fighting with monsters or animals offer no readily identifiable theme of spiritual struggle. Already discussed in reference to regularized, identical pairs and the limited potential of the additive principle of narration is an initial *A* in which one man spears a monster-headed finial of the letter on each side while at the same time being attacked by another man who apparently defends the monster (8:2:136v, Fig. 17). There is nothing in facial appearance, bodily form, gesture, clothing, or attributes that would suggest a spiritual superiority of either the attacking or the defending pair of men. While both attacking men have spears, one also uses the less exclusively knightly—and therefore, one may assume, less noble—knife that his comrade's opponent

uses. And while one of the defenders is so reduced as to use a large rock for a weapon, both attackers are noticeably balding—sometimes a sign of moral questionableness. Only the fact of the attackers' combat with monsters allows one to suppose that the attacking men might have been intended to be seen as superior. Even so, if the similarity of this initial with the other *A*, which has the same general composition but with monstrous griffins instead of men (8:1:171, Fig. 22), is any indication of the artist's own intention, then one is left only with ambiguity.

Equally ambiguous is the initial *O* with two similar men, similarly dressed, sitting on similar bovines, each holding a stave, and pulling the other's hair (8:2:67v, Fig. 24). The only distinguishing attribute between them is the smooth face of the man on the left and the contracted face of the man on the right. Coming at the beginning of the Book of Wisdom this miniature may have been meant to indirectly illustrate some of the teachings of that book, but ambiguity still outweighs certainty.

And what of such miniatures as the incipit initial *A* to the First Book of Chronicles? Enclosed in narrow strips of decoration within the body of the letter, four vicious bovines close in from the uprights on the almost painfully claustrophobic figure of a nude man in the crossbar (8:2:91, Fig. 21). Actually, the nightmarish quality of this miniature suggests an intensity of feeling stronger than that found in the less ambiguous examples. But any clear, or even probable, spiritual connotations are as yet unrecognizable.

The least ambiguous of all the scenes of violence in the Second Bible is the incipit initial *D* of the prologue to the Book of Daniel (8:1:170v, Fig. 25), one of the few miniatures in this book that has men fighting with full-bodied monsters rather than animals or finial monstrous heads. Inside the *D* two scenes of struggle go on which are similar in general composition, but significantly different in detail. The first shows a creature with two bodies and one head devouring a man who has been swallowed up to the chest. The man has been thrown face down, his hair flying up in the process. Lying with arms outstretched and in no way attempting to resist the beast, he is the object of despair. The other man is likewise being swallowed up to the chest by a creature with two bodies and one head. He, however, is pictured face up, valiantly gripping one of the forepaws of the creature with each of his hands. He is muscularly built, and his hair lies flat on his forehead implying a relative calm in regard to the other man. Indeed, when seen in relation to the previous figure and to its position in the text, it does seem that the painter intentionally tried to convey an image of fortitude. As to the hybrids, it seems that their traditional form of hybridity was meant to suggest nothing more than that it should be understood as a sign of their evil nature. Despite the interpretation of this scene in light of spiritual

struggle, it must be emphasized that this is the exception in the Second Bible, the rule being one of either incoherent violence or inexplicable ambiguity.

The Cistercian manuscripts, too, have their share of seemingly aimless violence and spiritual ambiguity—the miniature of monstrous combat discussed in the previous section being a case in point (173:103v, Fig. 19). But they also have a large number of scenes of violence with a more specific content. A gradual progression of images from the clear to the less clear will illustrate the extent to which spiritual struggle is a part of the violence of the Cistercian miniatures.

Certainly, no one would dispute the element of spiritual struggle in the incipit initial of the Apocalypse in the Bible of Stephen Harding depicting the battle between the archangel Michael and the great dragon (15:125, Fig. 26). Michael, armed with sword and shield, slashes at the throat of his enemy in this wonderfully drawn but essentially traditional illustration of Apoc 12:7.

Nor is the intent of the painter obscure in the initial Q at the beginning of the tenth book of the *Moralia in Job* (169:88v, Fig. 27). In this miniature Christ stands on the head of an image of the devil as the monster Behemoth.[407] In his left hand he holds the balance of justice; his right hand is placed on the head of a kneeling figure with contemporary dress and hair style who holds a sword at arms inscribed with the word "Job." Since Job earlier appears in this book in Old Testament dress with long hair and beard (168:7), one may assume with a good amount of certainty that the figure shown here represents not Job, but one who armed with the weapon of Job's example has conquered worldly afflictions.

With clear examples of, first, a traditional scene of spiritual struggle involving an angel and dragon/devil and, then, an original scene with a human and monster/devil, it is a small step to see the frontispiece of the *Moralia*, which portrays two armed humans and two dragons, as an unambiguous scene of spiritual struggle (168:4v, Fig. 28). The upright of the initial R is composed of a slighty ascetic looking knight standing on the back of a hierarchically smaller, crouching squire. A large dragon forms the diagonal leg of the R, the circular part being made up of a smaller dragon which clings to the neck of the former. The knight is proportionally tall. He stands with his weight on his right leg, his left leg bent. Spine straight, head erect, eyes level, with beard and hair finely detailed, he raises a large sword aloft—but poised, not striking: it is ready to strike, but is perfectly at rest, like the rest of his body. In contrast to the largely blue tunic of the squire which visually blends with the many other blues of the miniature and

407. The word *"bemoth"* is inscribed underneath the creature. Cf. Job 40:10.

whose folds suggest forward motion, the bright orange folds and volumi-
nous sleeves of the knight's robe stand out as they hang motionless, em-
phasizing his state of power at rest.[408] He looks forward, seeing nothing,
over the heads of both the smaller dragon, whose tail laps about his finely
drawn head, and of the larger dragon, who howls in pain as the knight's
squire plunges a long spear entirely through his body. The knight is obliv-
ious to the danger of the teeth of the smaller dragon which grip his shield—
a shield with which he in no way attempts to defend himself—and to the
danger of the claws of the larger dragon which tear at his poised leg. Follow-
ing the logic of the previous examples, this initial also represents a scene of
spiritual struggle, but without being a textual illustration and without being
inscribed with names. To be sure, it is even more powerful than the others
despite these differences and despite the unreal elements of the knight's re-
fusal to defend himself or even to look at his enemy—or perhaps I should
say because of them.

In any event, the certainty of the *Moralia* frontispiece is an important
link in understanding a more obscure form of scenes of struggle, those in-
volving hybrids. The incipit initial *D* of the Book of Wisdom in the Bible of
Stephen Harding (14:128v, Fig. 29) actually follows the frontispiece of the
Moralia quite closely in form. An erect, bearded knight with flowing robe
and hanging sleeves holds a shield in his left hand and sword in his right,
forming the upright of the *D*. He strikes at a dragon which makes up the
circular part of the letter. However, instead of tearing at the leg of the
knight as in the previous miniature, the dragon now clutches at a hybrid
consisting of part man and part dragon who tries to defend himself from the
monster's claws. The action here is clearly one of rescue: when viewed in
relation to the other more certain images of spiritual struggle, it seems that
this must be one of spiritual aid. The fully human nature of the rescuer and
the partially human, partially bestial nature of the creature being saved re-
inforces the idea of potential salvation from a morally superior being. The
implication for an understanding of hybrids in scenes of violence in the Cis-
tercian manuscripts is one of the visual expression of the fallen nature of
man, who is at once composed of the spiritual and the material.

That this need not be seen as a wholly negative commentary on man's
nature, but one of hope through struggle with the evil things of this world,
is irrefutably shown in the initial at the beginning of book twenty-three of
the *Moralia* (173:56v, Fig. 30). Without going into all the detail of this
almost nocturnal vision, let it just be said that the circular part of the *P* is
formed by an extremely large, bright red dragon. It is curving down, grip-

408. The effect of motion and wind are readily shown by the artist of the *Moralia*. Cf.
173:20, 47, 133v, 174 (Fig. 18).

ping the entire torso of a shod, equine centaur in his mouth, while another smaller dragon swallows one of the centaur's back legs. The centaur firmly holds the first dragon's neck with a strong left arm while he raises a sword over his head with his right. As in the *Moralia* frontispiece, the centaur, almost inexplicably, looks above and beyond the dragon. But what makes this hybrid different than the rest, what makes him a probable link between scenes of recognizable spiritual struggle and seemingly incoherent violence is one particular feature that the monk-artist chose to bestow on his part human, part bestial hybrid: a tonsure. Here we have, painted by a monk, at a monastery of documented spiritual fervor, the depiction of unrestrained violence in which one of the principal monstrous forms is signified as a monk. Leaving aside the other strange creatures that inhabit this initial, the combat between the monk-centaur and the two dragons is unquestionably an image of spiritual combat—and one put forth in explicitly monastic terms.

While both the Saint-Martial and the Cistercian books are filled with scenes of violence, the majority of those in the Second Bible are either inexplicable or ambiguous at best. This is true to such a degree as to suggest that many of the miniatures showing violence have no definite spiritual meaning. The Bible of Stephen Harding and the *Moralia* also have their share of irrational images of violence. However, these manuscripts—especially the *Moralia*—have a far greater tendency toward clarity in regard to spiritual struggle. One reason for this is the unequivocal portrayal of human figures in combat with monstrous ones. But the introduction of the hybrid into these battles adds a third party who, when identified as a depiction of the soul in its human imperfection, becomes a potential link to those scenes of violence whose spiritual imagery is unclear. It is the unconventionality of some of the Cistercian hybrids, that is, the *semihomines*, that ties together monster, animal, and man in one nature and removes so many of those miniatures which do not directly and literally illustrate the text from the realm of incoherent violence to that of spiritual struggle. In the end, it is the *semihomines*, not the humans and not the conventional monsters or hybrids, who positively and directly relate the images of struggle to monastic concerns.

OTHER ARTISTIC FACTORS

A great many other factors at play in the question of the distractive powers of our manuscripts have not yet been touched upon. Only the most important of these—quite a few of which are interrelated—will now be listed as briefly as possible.

WORK SCENES

Certainly one of the most famous—and distracting—types of miniatures in early Cistercian art is the work scene. There is nothing like it in the Second Bible. Aside from the appealing facets of humor, letter design, and detail which are such an important part of their success, the work scene also depends upon the representation of social activity for interest.

Of the two Cistercian manuscripts dealt with here, work scenes are found only in the *Moralia*.[409] It has eight, possibly nine, scenes showing manual labor; a large amount when one considers that there are only twenty-seven miniatures with humans in this book besides portraits of Gregory, Leander, and Job. A relatively wide variety of labor is shown: the grain and grape harvests (170:32, 75v; 173:148),[410] forest clearance (168:2; 170:59; 173:41),[411] cloth production (173:92v),[412] and probably a scene of monks drying themselves before a fire after getting caught in the rain in the fields (173:167, mutilated).[413] A ninth miniature shows what could very well be two monks folding cloth (170:20).[414] But what is of most interest for our purposes is the break with common usage in the representation—with so much uniqueness and variety—of labor in a book of Biblical exegesis.

KNIGHTLY PREDILECTION

The *Exordium Parvum* describes Cistercian monasticism as a "spiritual knighthood (*militia spiritualis*)" and Cistercian monks as the "new knights

409. Work scenes in other Cistercian books are rare, but do exist. See for example, Dijon, Bib. publ. 135:114v and 141:75. The latter is based on 170:32 from the *Moralia*. Both lack the exuberance of the *Moralia* miniatures.

410. Bread and wine as monastic staples are specifically mentioned in Cistercian Statute 14, p.16 in such a way as to refer to the Cistercian ideal of following the primitive observance of the Rule of Saint Benedict on these matters (ch.39, 40). See *Exordium Parvum* 17, p.77 on the increase in vineyards at the time of the making of the *Moralia*.

411. The ideal of separation from society by physical removal to "desert places" was such an important part in the Cistercian ideal that it was given priority of place in the early statutes: Statute 1, p.121, "In civitatibus castellis, villis nulla nostra construenda sunt coenobia." Cf. *Exordium Parvum* 15, p.78 "suscepturos quoque terras ab habitatione hominum remotas." The large number of scenes of various stages of land clearance would seem to refer to and reinforce this claim. For other factors at play in the choice of labor scenes, see below.

412. On the importance of Cistercian cloth production, Lekai 1953:214–216.

413. It may also be that this was meant to represent a scene of swamp drainage, something for which the Cistercians were well known.

414. The blessing gesture of the left monk and the depiction of the right hand of the right monk are problematic to this interpretation.

of Christ (*novi milites Christi*)."[415] While the use of such epithets is as old as Christian monasticism itself and is in fact the result to a great extent of the use of early monasticism as a model for the spiritual life, Cistercian appropriation of the idea also seems to have incorporated a strong measure of reference to real knighthood as part of its appeal and direction.

Actually, even in the Old Testament illustrations the emphasis on blood, torture, and dismemberment seems excessive (14:158, 191), as does the amount of soldiers and the obvious delight in portraying their weapons (14:13, 13v, 173, 191). And some of the images of spiritual struggle already discussed are put forth in the most overtly knightly terms (especially 168:4v, Fig. 28; 173:20). But even those whose spirituality is questionable (173:133v) or perhaps even negative (173:174, Fig. 18) are shown with sword, spears, helmet, coat of mail, and caparisoned horse, leading one to believe that the use of knightly imagery—or at least its extent—was intended to appeal to the aristocratic background of the vast majority of Cistercian monks in a way that was not entirely spiritual metaphor.

DETAIL

Certainly an important part of the distractive force of many of the different types of miniatures in the Cistercian manuscripts including monstrous, spiritual struggle, work, and knightly scenes is the strong attention to detail. Whereas detail in the Second Bible tends for the most part to take on a patterned or metal work effect (as in the birds in 8:2:4, Fig. 23), detail in the Cistercian miniatures is approached from an entirely different angle. For example, the monk in one work scene (173:41, Fig. 31) is shown with ragged robe and work apron, bunched hose, and with a knife dangling from his belt.[416] In general, the tools of the work scenes are pictured with a high degree of accuracy as is seen in the hardware of the flail which holds swiple to handle in the threshing scene (173:48) or in the distinction made between a woodsman's hatchet (168:2; 173:41) and a battle ax (14:13v; 168:52v). The more fashionable detail focuses on striped sleeves, spiral patterns on hose, the red outline of a knight's shoes, elegant robes, checkered capes, luxuriously decorated cushions and pillows, pointed shoes, heraldic shields, hawking glove and jesses, musical instruments, military weapons and equipment, hair fashions, elegant servants, and equestrian trappings

415. *Exordium Parvum* 16, 15, p.80, 77.
416. Cf. Benedict of Nursia, *Regula* 53, where robe, hose, and knife are listed along with a few other things that a monk might keep, although not possess—anything else being inimical to a life of voluntary poverty

such as spurs, harness, and bells hanging from the harness (for example, Fig. 18, 19, 28). In short, there is a great attention to detail which cannot be explained either by textual reference or identifying need and which can only have been intended to appeal to the curiosity of the viewer.

LETTER FORMS

In contrast to the Second Bible where the conventional knotted and floriated initial with the possible addition of finial heads and a non-integral figure or two compressed in decorative strips within the letter form is the rule, one of the most imaginative artistic aspects of the early Cistercian manuscripts is the composition of letter forms.

Their most striking instance of imaginative letter forms is the use of figures and objects alone to create the letter shape. These range from the compositionally simple initial *A* formed by the dragon and the Archangel Michael (15:125, Fig. 26), to the more complex *R* of the frontispiece of the *Moralia* (168:4v, Fig. 28), to the ingenious *H* of Jerome handing his translation of the New Testament to Pope Damasus (15:3v). Indeed, there is no shortage of ingenuity in the Cistercian initials, as the work scenes of the *Moralia* especially show: a reaper bending over his task forms one side of a *Q*, the other side being made up of stalks of grain, with a tied bushel of cut grain for the cross bar (170:75v); a thresher swinging his flail high above his head serves as an *S* (173:148). This finally reaches a high point with the quite startling initial *I* of a tree being cut down which is so little bent to the letter shape, so large (around one half the size of a column of text), and so far out in the margin that it is almost abstract in reference to its function as a letter (173:41, Fig. 31). Certain letters may be said to have become abstract in another sense, that of their abstraction from the two-dimensional written word to the "three-dimensional" letter-object which is climbed upon (169:36v), harvested from (170:32), hunted in (169:62v), and so on. Initials also take the form of identifiable scenery in which human figures appear: the *A* in which Judith kills Holophernes is the tent in which the action takes place (14:158); the tower in which three armed soldiers stand guard acts as the initial *I* (173:133v). It seems that, loosely speaking, it is those scenes in which humans are an integral part and not just an addition—especially the work scenes—which make up the majority of the more imaginative of this type of initial.

Another common type of Cistercian initial is that in which a largely outlined letter is filled with fighting, mostly hybrid, figures (for example 15:68; 173:7, 56v; Fig. 30). While maintaining the overall structure of the letter, within those bounds the figures constitute a visual cacophony of

violence, free movement, asymmetry, variety, and irrationality. Only the most general shape of the letter is indicated by outline and colored background.

Even those Cistercian initials which are primarily vegetal are more flowing, more organic, make greater use of modeling and relatively natural colors (14:14; 168:39v) than the geometric, angular, and patterned vegetal initials of the Second Bible. And, like the previous examples, logical activity often takes place within them (14:76, 90v; 168:2). And whereas the profuse, conventional vegetation of the Saint-Martial initials often tends to become homogeneous, the logical activity—or illogical hybrids (14:14)—functions as a disruptive feature to any possible harmony.

In short, while animals and men are treated as additions and almost decorative afterthoughts in the Second Bible, in the Cistercian manuscripts they are not just an addition, but such an integral part of work that they often form the entire letter themselves or are the focus of attention in an initial which otherwise acts as an identifiable backdrop to their activity.

AUTHOR PORTRAITS

Author portraits in the Second Bible often take the conventional form of the author being portrayed in architectural space, which is essentially the same as that of the textual illustrations (cf. 8:1:91 and 41). In fact, the major compositional difference between the portraits of Jerome and Damasus in our Cluniac and Cistercian Bibles is the elimination of absoutely all architectural framework in the latter (8:1:1; 15:3v; Fig. 32, 33). But they also serve as purely figural initials in the Cistercian work, thus becoming at once both miniature and the text itself.

In addition, a number of the Cistercian author portraits, and other figures as well, are larger relative to the page and have taller, thinner proportions which also help add to their distractive qualities (cf. the James portraits, 8:2:228; 15:83v, the latter being another purely figural initial).

Finally, some Cistercian author portraits have adjunct scenes of monstrous combat, as in the initial to Acts (15:68) where Paul writes in the loop of the *P* and Theophilus ponders in the upright while a group of centaurs and a flying dragon frantically destroy one another below. The extremity of the loop is formed by a large dragon which is vomited forth from a finial monster head at the right top of the upright and upon which Paul rests his feet. Another finial monster head decorates the left top of the upright, clutching a writhing snake in its beak. In contrast, the initial *P* to the second book of Timothy in the Saint-Martial Bible (8:2:258) simply has a bust of

Paul making a gesture of blessing in the loop, with the figure of Timothy standing next to the letter.

While the Cistercian works do have many traditional elements in their author portraits, in general they make use of all the artistic devices common in the other miniatures, such as striking letter forms and monstrous creatures. To this can be added elongated proportions not found to such a noticeable extent in the other paintings of humans. Likewise, the author portraits of the Second Bible follow the conventions found throughout the manuscript of non-integration of the figure into the letter form, use of architectural frames, and traditional means of representing the human figure.

THE MINIATURE AND THE PAGE

While all of the manuscripts being studied here adhere to the common practice of general alignment of the miniature with the text format of the page, the Cistercian miniatures seem to be even more closely related to the format of the text than those of the Second Bible.

The most classic example of this is the illustration of the three young Hebrews in the furnace at the beginning of Daniel (14:64, Fig. 34). The large, bright red area of the flames has its counterpart in the large, bright red *D* of Jerome's preface on the facing page. The vertically long and narrow visible part of Nebuchadnezzar's tunic is paralleled by the similarly proportioned orange *I* directly above it. This orange *I* is matched by another also on the facing page and on almost exactly the same level, as is the green *E* above it.[417] And aside from the use of color or the general alignment of the miniature with the text, even the courses of the masonry are related to the text, being the very lines which had been ruled for the words on that page.

A more typical example involves a color relationship between the red in the wings of an angel forming the right side of the initial *A* (*Anno*) and the continuation of the rest of the word "*nno*," the top line of the text of Daniel (14:64v). Lower down, the blue in the angel's robe is paralleled in the blue of the second word, "*tertio*," which forms the second line. The ornamental brown band around knee level on the angel's robe is taken up in the word nearest it, "*Ioachim*," the final line of the text adjoined to the illustrated initial *A*. Many other examples of varying complexity of color relationships between figures and the text exist.[418]

417. Only the *I* of *Incipit* and the *E* of *Explicit* are singled out with distinctive coloring.
418. To name just a few, 14:56, 76; 15:11v, 29v; 168:4v.

COLOR

Although the basic range of colors in all our manuscripts is virtually the same—red, green, blue, and yellow—the effects are at times quite different. Red is actually used rather sparingly in the Second Bible. The bright blue is especially common as a background color. Orange, pink, and a variant tone of green appear. And purple is a standard ground in the initials, particularly surrounding them. The sometimes clumsy use of gold and silver is, according to Gaborit-Chopin, probably a later addition.[419] The Cistercian book paintings show the basic colors mentioned plus some purple, while making heavy use of orange, ocher, and brown (the text script is sepia). Gold is not uncommon although its application is often somewhat reserved. While the colors of the Second Bible are by no means dull, the Cistercian colors generally surpass them in intensity.

It is the use of color within the miniatures of the two scriptoria that is at odds. In the work from Saint-Martial, a colored figure against a colored ground is the rule. In the Cistercian works the rule is variety, having colored figures against colored grounds, sometimes generally uncolored figures against colored grounds (14:191; 169:62v), colored figures against uncolored grounds (14:13v, 91), and uncolored figures against uncolored grounds (169:62v). Sometimes the figures are partially colored (170:32), sometimes only very lightly colored (14:158), and sometimes not at all (14:122v; 169:62v). The variety is increased by various combinations of these practices within the same miniature. But variety aside, one of the most effective of the restricted color techniques is that which tends to limit most of the color to the central scene of action: Judith cutting off Holophernes' head (14:158), or two deer alertly poised, listening for the distant hunter and his approaching pack of dogs (169:62v). The painter also excels in the use of large areas of colors startling in their intensity which, for example, help make one creature stand out from the anarchy of many others and which then is used to establish a strong color contrast with the juxtaposed figures—such as the red lion of the *Moralia* (173:7) whose brilliancy could not be reproduced in the color photographs of Oursel's book.[420]

Other color devices found in the Cistercian miniatures include the establishment of a unifying color relationship between the central figure of a scene and its secondary elements, such as that between the bright orange of David's robe and throne and the dominant orange of the lateral towers (14:3v), or between the orange and blue of God's drapery and the sur-

419. Gaborit-Chopin 1969:93.
420. Oursel 1960:pl.XXX.

rounding foliage (14:76). And the use of a "rainbow" color spectrum in the wings of supernatural beings is impressive both in itself and often in its relation to the surrounding colors (especially 14:64v, 15:11v, 125).[421] The Cistercian miniatures never use the striped backgrounds sometimes found in the Second Bible. Nor is the imaginative use of color restricted to miniatures alone. Chapter "rubrics" vary from one intense color to four, very often setting up color relationships with the miniatures, and also festive patterns among themselves such as the bright red and blue alternating initials of the Epistle to the Romans or the red and green alternating initials of some parts of the Book of Psalms.

THE CANON TABLES

The difference between the canon tables of the Bible of Stephen Harding and those of the Second Bible of Saint-Martial is that in the former the canon tables are relatively lightly decorated and then largely with animals, and in the latter they are heavily decorated, containing most of the hybrids and more than half of the human figures in the manuscript. Only four of the eight Cistercian canon tables have figural decoration (twenty-three figures), including all of the Bible's paired figures. Ten of the Second Bible's canon tables are figural, carrying as many as eighty-nine monsters, animals, and men. These include acrobats, wrestlers, men playing ball games, and most of the less common animals of the book. In general, the canon tables of the more conventional Second Bible are a place for the painter's imagination to indulge in quantity, variety, and the unusual. In the Cistercian Bible these characteristics are more rightly said to be found amid the actual text.

HUMOR

Finally, the last major element of distraction in our manuscripts to be discussed here is that of humor. Given the enigmatic quality of certain miniatures in the Second Bible, one can only describe this work as entirely serious outside of the decoration of the canon tables, and these are actually entertaining rather than humorous.

The same certainly cannot be said of either the Bible of Stephen Harding or the *Moralia*. A undeniable strain of conscious humor can be traced from the less pronounced form in the earlier work where humor is conveyed through comical dress, gesture, and a somewhat nonsensical physical rela-

421. On 15:125, cf. Apoc 10:1 and 12:7–9.

tionship between characters (15:99v, Fig. 35), to the more explicit type in the *Moralia* which depends on narrative and facial expression. In one initial (169:36v, Fig. 36) a watchful lion at the bottom of the upright vigorously twitches his tail while his companion climbs the letter, gripping a—if I may say so—humorously terrified man by the leg as he frantically tries to climb up out of reach. His streaming hair and popping eyes are in comical contrast to another man, with prominent nose and noticeably balding, who clutches the top of the initial with a concerned but relieved look and who makes no effort at all to aid the other man, who is the only thing between him and the lions. Other miniatures show hunting dogs biting themselves while their prey hides safely in the vegetation (169:62v), a monk chopping down a tree while a hired hand is still high up in its branches (173:41, Fig. 31), and a slight looking monk making an expression of weary exhaustion while a larger brother who is doing all the heavy work gives him a quizzical look (170:59). These, and other lesser examples, in appealing to both man's sense of humor (which according to medieval science was one of the distinguishing factors between man and the animals) and man's interest in himself surely offer an element of distraction as compelling—although not as fascinating—as the monsters Bernard so vehemently denounced.

Of all the works of art studied here in relation to the criticisms in *Apologia* 29, it is the heavily sculpted cloister of Cluniac Moissac that least matches Bernard's fourteen examples. Even where there are points of contact, they typically remain restricted to a secondary field of attention—the impost. The case is the same for the most part for his three categories of monstrous and hybrid forms, animals, and the worldly pursuits of men. When instances do occur, they are inevitably traditional and so more common and less distractive to the viewer, and also generally limited to the impost area as well.

Granted that Bernard's criticisms were not meant to be seen as referring to capital sculpture alone, the lavishly illuminated Second Bible of the Cluniac monastery of Saint-Martial is greatly outdistanced with respect to the fourteen examples by the early Cistercian Bible of Stephen Harding and *Moralia in Job* in all cases but those of animals, notably the traditional lion. As with Moissac, however, most of the examples are, again, relegated to an area of secondary visual importance—in this case, the canon tables. Rather, it is in the books coming from the scriptorium of the monastery where Bernard made his novitiate, Cîteaux, that the greatest correspondence is to be found. Even more to the point, of Bernard's three categories it is in the category which he found most distractive, the hybrid, that the art of early Cîteaux finds its greatest expression. And while the large number of mon-

strous, animal, and human miniatures in the Second Bible cannot be denied, the tendency toward the presentation of disembodied, repetitive, or incoherent figures downplays the distractive potential of quantity, variety, and narrative.

It is at Cîteaux, not Cluniac Moissac, that one finds the centaurs deprecated by Bernard. It is at Cîteaux, not Cluniac Saint-Martial, that the *semihomines* of his critique abound. It was an inconsequential fraction of Bernard's non-Cistercian reading public that would have been aware of this disparity, and his critique toward the excessive art of establishment Benedictine monasticism was in no way lessened. But his own Order was aware of the limits of its well-known artistic legislation, as it was of its collection of magnificently illuminated manuscripts. The position taken in regard to artistic excess by Bernard in the *Apologia* was not Cistercian. It does not represent the artistic reality of the Cistercian Order in 1125, nor does it represent the ideal. It is the expression of Bernard's own position with regard to monastic art both without and within the Order. If a Cluniac reader of the *Apologia* might feel some twinge of conscience as he sat in the cloister of Moissac, reading his Cassian beneath a regularized, traditional capital of some familiar animal, how much more must the conscience of his Cistercian counterpart have been tried as he opened his copy of the *Moralia in Job* to book twenty-eight, only to be confronted with the visual cacophony of color and imagery presented there (Fig. 19). In the end, whether publicly or privately, it was the art of the Order of Cîteaux, no less than that of the Congregation of Cluny, that was the subject of Bernard's denunciation of art as a spiritual distraction to the monk.

4

TO WHOM THE *APOLOGIA* WAS ADDRESSED

Both historians and art historians have traditionally seen the criticisms of art in Bernard's treatise as an indictment of the art of the abbey of Cluny in particular and of certain offending Cluniac and non-Cluniac traditional Benedictine monasteries in general. But scholarly opinion has been formed for the most part on the deceptive and rare use of the word "Cluniac" in the *Apologia* and on an overly polarized view of the monastic controversy of the early twelfth century. According to the more strident expressions of this polarization, which was very much formed on the basis of the *Apologia* itself and which refuses to see the one segment of monasticism except in light of the other, Cluny was a place absolutely devoted to the aesthetics of excess in all of its manifestations, and this attitude was to be consistently found throughout the Cluniac "Order." "Cîteaux" was equally devoted to the opposite, an extreme and virtually monolithic artistic asceticism.

However, such a position is inconsistent with the historical evidence regarding not only Cluny and its congregation but also the artistic situation among the early Cistercians. Furthermore, the polarized view of these two most visible representatives of twelfth-century monasticism ignores entirely the vast middle ground, both with respect to the large part of traditional monasticism that was not inimical to the new reform and to the less strident of the new ascetic orders which either were monastic or had strong ties to reform monasticism. For Bernard's reform activity extended to more than just the establishment of new Cistercian houses. He was deeply involved in the reform of middle ground Benedictine monasteries, to some degree of the episcopacy, and in a sense even of the papacy, not to mention that of the Cistercians themselves as in, for example, their chant. He was also very active in the organization of many of the new ascetic orders—monastic, military, and collegial. As a formal statement of position on middle ground monastic reform by that reformer who was most involved in

every facet of Church reform, the *Apologia* is best understood in relation to Bernard's larger, contemporary concern of Church-wide reform rather than the misleading polarization of later times. In this endeavor, he was primarily concerned with the cause of promoting his view of the ecclesiastical order, not with imposing specifically Cistercian standards—and it is this same attitude that is found in the passage on art in the *Apologia*. Along these lines, Bernard dealt with the subject of artistic reform in the *Apologia* on the moral and spiritual levels, not the constitutional. That is, he dealt with the subject of artistic reform on a widely applicable, middle ground basis, not on a narrow, specific, polemical basis. The question is, then, to whom was this moral and spiritual artistic reform directed?

Cluny, the Cluniacs, and the Non-Cluniac Traditional Benedictines

As previously stated, the predominant view of the *Apologia* has been that its criticisms of art were directed at the abbey of Cluny in particular and at certain offending Cluniac and non-Cluniac traditional Benedictine monasteries in general—such as Moissac, Saint-Denis, and Vézelay. An important factor in this has been a polarized view of the early twelfth-century monastic controversy, the process of which had already begun in the generation after Bernard[422] and was greatly encouraged in modern times with the study of the *Apologia* itself.

For centuries, the standard edition of the *Apologia* mistakenly presented Bernard's Letter 84[bis] as the preface mentioned in his Letters 88:3 and 85:4.[423] In Letter 84[bis], Bernard repeats William of Saint-Thierry's request that he defend himself and his party against charges that they had been slandering the "Cluniac Order."[424] This was naturally seen to correspond to Bernard's use of the term "Cluniacs" twice in his treatise. Furthermore, in Letter 18:5, Bernard refers to an *"apologia"* written to a certain friend in which he discussed "Cluniac observances and ours, that is, Cistercian."[425] Finally, the great similarities between the *Apologia* and Bernard's Letter 1 to his cousin, Robert of Châtillon, who had run away from Clairvaux to Cluny, have reinforced the view of the treatise as directly referring to Cluny almost to the point of no return.

However, the problem with this straightforward reading of the word

422. Bredero 1971:156. An example of this process of polarization may be found in the interpolation of criticism of Cluny by later Cistercians into a letter of 1132 by Archbishop Thurstan of York on the foundation of Fountains Abbey; Constable 1975b:23n.7; see also Constable 1975:135.

423. See Appendix 1, "The Origin of the *Apologia*." It is quite possible that Mabillon understood the use of *Cluniacensis Ordinis* in Letter 84[bis] to mean "traditional Benedictines" and intended his unqualified statement in the introduction that the document had been published against the "Cluniacs" to mean the same thing.

424. Bernard Letter 84[bis], v.7:219, "intellexi quidem te velle ut illis, qui de nobis tamquam detractoribus Cluniacensis Ordinis conqueruntur."

425. Bernard, Letter 18:5, v.7:69, "apologiam ad quemdam amicum nostrum, ubi aliqua disserui de Cluniacensibus et nostris, id est Cisterciensibus, observantiis."

"Cluniac" is that after the rise of the Cistercians that term was applied to all traditional Benedictines, regardless of their actual affiliation.[426] Since this has never been taken into consideration in regard to the *Apologia*, the question of just what Bernard meant by "Cluniac"—whether those who lived at the mother house of Cluny, those who were actual members of the Congregation of Cluny, those who lived within the Cluniac milieu, or those who were simply non-Cluniac traditional Benedictines—is still open to question.

Bernard never implies in the *Apologia* that his observations are directed at the "Cluniacs" as we understand the term today in the narrow sense of an "Order of Cluny." He begins by referring in *Apologia* 1 to the "order" of William (*Ordini vestro*), who at that time was a non-Cluniac traditional Benedictine, and continues along the same line in *Apologia* 5 where he mentions several non-Cluniac traditional Benedictines as "of the same order." It is only in *Apologia* 6 and 7 that he uses the word "*Cluniacenses*," and then strictly in company with and in opposition to "*Cistercienses*."[427]

426. A wide range of scholars attest to this; Berlière 1900:469; Constable 1974:35; 1980:ii (who further cites Hallinger and David); Wollasch 1971:180 (who further cites Hallinger, Semmler, and Jakobs). The term "Cluniacs" meaning "black monks" was so widespread as to be used in no less than papal documents of the twelfth century; Hunt 1968:1. Even contemporaries were in doubt as to who was a "Cluniac"; Constable 1976c:18. According to Mabillon, the term "Benedictine" was not used before the fifteenth or sixteenth century (Constable 1974:34). Before the Cistercians, Orderic Vitalis has the monks whom Robert of Molesme left behind at Molesme divide Western monasticism into two groups, the Cluniacs and the monks of Tours; Orderic Vitalis, *The Ecclesiastical History* 8:26, v.4:320. After the appearance of the Cistercians, Bernard himself divides monasticism into three groups, the Cluniacs, the monks of Tours, and the Cistercians; Bernard, *De Praecepto* 48, v.3:286. See also Rodulfus Glaber, *Historia* 3:5:17–18, p.66–67, where the implication is that Cluny was the direct successor of Benedict, and that it somehow represented (pre-Cistercian) monasticism as a whole. In his *Dialogus*, Idung has the Cluniac describe William of Saint-Thierry to the Cistercian as "of our order [i.e., Cluniac]," while the Cistercian characterizes Robert of Molesme to the Cluniac as "of your order [i.e., Cluniac]"; Idung, *Dialogus* 1:14, 1:52, p.382, 400. Part of the reason for this was the ubiquity of Cluniac houses, and the even greater coverage of Cluniac or Cluniac-influenced customs.

Aside from this, there was also a general attitude which saw Cluny as the moral leader of monasticism. On this see Peter the Venerable (Letter 161, p.390–391) who thought of Odo of Cluny as the pre-eminent restorer of monasticism in France after Benedict and Maurus; according to Mabillon, some even believed that Odo had written the Benedictine Rule (Mabillon 1739:v.3:361, bk.42:ann.927). The abbot of Cluny was associated with the archangel Michael (Duby 1980:203); see also the discussion of the title "abbot of abbots" in Appendix 1, "The Origin of Bernard's Letter to Robert of Châtillon (Letter 1)." Conversely, according to King (1954:208), members of the Cistercian Order were sometimes referred to as *Clarevallenses*, and so on.

427. *Apologia* 6, "sive Cluniacenses, sive Cistercienses, sive clerici regulares, sive etiam laici fideles, omnis denique Ordo"; *Apologia* 7, "Cisterciensis sum: damno igitur Cluniacenses? Absit!" I capitalize "order" in the complete translation of the *Apologia* in order to

In the one case, the sense is that of complementing each other in regard to the monastic wing of the orders of the Church: Cluniacs, Cistercians, canons regular, and faithful laypeople. In the other, it is a question of simple opposition within that wing: one is either a Cluniac or a Cistercian. In both cases, Cluniacs and Cistercians are implied to comprise together the monastic wing. After these occurrences, the word is never seen again in the whole of the *Apologia* and any reference to the address of the treatise continues to be put in terms of "your order," "that order," or "the order," as before. Indeed, it was apparently precisely because of this absence of a strongly defined address in the *Apologia* that Mabillon chose to attach Letter 84[bis] to it as a preface in the first place.

But while Bernard readily repeated William's informal reference to the "Cluniacs" in his equally informal reply in Letter 84[bis], he tends by comparison to avoid the word in his formal treatise. This agrees with his personal letter to Peter the Cardinal Deacon in Letter 18:5 where he again reverts to the term *Cluniacenses*. Clearly, Bernard is using the term in its commonly accepted use as meaning traditional Benedictines (Cluniac and non-Cluniac) in both his private and public writings,[428] but he tends to avoid its use in his critical public writing whether out of deference to Cluny or for greater precision or a combination of the two.[429]

Aside from all this, there plainly was no reason why Bernard would have been so urgently asked to criticize the excess of Cluny in the *Apologia*, when he had just done so probably only a few months earlier in his Letter 1. In Letter 1, he attacks the monastery of Cluny by name, raising all the criticisms that appear as the "small things" in the *Apologia*.[430] To be sure, the strong similarities between it and the *Apologia* have suggested to most a common target. But their proximity suggests rather that they do not serve the same purpose. And the striking similarities of the two works

make clear Bernard's play on words; however, he is referring to the traditional Benedictines in general as explained in the previous note, not to a specific, institutionalized order.

428. In Letter 83:2, v.7:217, Bernard refers to monks of the non-Cluniac Benedictine monastery of Saint-Nicolas-aux-Bois as "in ordine illo Cluniacensi."

429. Bernard shows a certain refusal to get involved in the affairs of Cluny as seen in his avoidance of Cardinal Deacon Peter during his investigation of the invasion of Cluny by Pons (Letter 17, v.7:65). He later, though perhaps with a good deal of formality, expresses an unwillingness to oppose Peter in any way (Letter 149, v.7:353). In his *De Consideratione* 3:18, v.3:445–446, he criticizes monastic exemption, but then seems to excuse the privilege as extended to Cluny. This reticence may account for his avoidance of making an issue out of excessive architecture.

430. Bernard raised all the points with the exception of the section on healthy monks who pretend to be sick in order to enjoy the less stringent regulations regarding the sick. This section was added only in the second redaction and was not part of Bernard's original scheme.

make the dissimilarities all the more important, becoming the significant point of departure. Whereas in the *Apologia* the heart of the criticism, the "things of greater importance," deals with artistic excess, Letter 1 is primarily concerned with stability and the monastic vow under conditions of loose observance of the Rule and makes no mention at all of art. Nor does the schedule in Peter the Venerable's Letter 28 which responded to unidentified Cistercian criticism of Cluniac practice, nor does any of Bernard's continuing correspondence with Peter which occasionally takes up criticisms of Cluny.[431] In other words, the only documents that can irrefutably be proven to represent either the charges directed specifically at Cluny by Bernard or Cluny's authoritative defence contain not a single word on artistic excess. Furthermore, in *Apologia* 4 Bernard states that he had never spoken against "that [William's] order" before. Given the undoubted circulation of Letter 1, this implies that he was then referring in the *Apologia* to what we today would call traditional Benedictine monasticism (Cluniac and non-Cluniac), since he had already publicly and explicitly criticized the abbey of Cluny in his letter to Robert.

This corresponds to what we know of the art program at Cluny. Of the four specific types of artworks mentioned in *Apologia* 28–29, only a *corona* can with any certainty be shown to have been at Cluny at the time of the *Apologia*.[432] Besides, the study of the "things of greater importance" shows

431. For example, Bernard's Letter 277, v.8:190 to Pope Eugenius III on Peter's behalf mentions his reforms in fasting, silence, and expensive and curious clothing, a set of points which corresponds well to the complaints of Letter 1 but not well to the *Apologia*. The reference in *Apologia* 28 to Phil 4:17 which sees the use of art as an exorbitant source of income is used in Letter 1:8, v.7:7, along the entirely different lines of recruitment as income.

432. Peter ordered the use of this *corona* to be curtailed for financial reasons and so as to not weaken its power to overawe; Peter the Venerable, Statute 52, p.82; nevertheless, *coronae* of large size were relatively common as a cursory glance at Lehmann-Brockhaus shows. It is a subject of debate whether or not the great candelabrum of Cluny was given before or after 1125; Evans (1931:123n.2; 1950:25) suggests that it was the gift of Matilda, wife of Henry I of England. According to Conant (1968:82) it was from her daughter, also Matilda, and was not presented until 1136–1142, that is, not until after the *Apologia* had been written. Both arguments remain inconclusive. Cf. Bloch 1961:134, 183. An eighteenth-century eyewitness reported that the pavement of the sanctuary consisted of a mosaic of roses, stars, and checks—not of figural decoration; for Philibert Bouché's account (1787–1817), which was dependent on that of Benoît Dumolin (1749–1778), see Conant 1968:35; for illustrations of the fragments, Conant 1968:ill.182, 183. Remains have been found of the cloister as it existed at the time of the *Apologia*, none of the extant capitals being historiated, only floriated; Conant 1968:65–66, 87, ill.224–226.

The other charges are either so general as to apply to almost any major traditional Benedictine monastery or to be not applicable to Cluny at all according to our evidence. It should be noted that at the time of the writing of the *Apologia*, Cluny was not—according to Conant and contrary to popular belief—the largest church in Western Christendom.

that Bernard was not condemning specific forms of art, but rather specific functions of art. Actually, to contemporaries, excess at the monastery of Cluny seems to have been typified in the concern over the vestments used in the elaborate liturgy there.[433] Furthermore, in general, life at Cluny was little different from other respectable monasteries, and, with a few exceptions, the relations between Cluny and the Cistercians were good if competitive.[434] Indeed, if Bernard is almost commanding, even threatening, in

Aside from Saint Peter's, that distinction belonged to the cathedral of Canterbury; Conant gives the length of the church proper of Cluny III (all that is believed to have been completed by the time of the *Apologia*) as 135.34m (Conant 1968:141); he gives 143.86m as the length of Canterbury by 1130 (Conant 1972:7). There even may be an element of deferential treatment on the part of Bernard toward Cluny in regard to his "overlooking" of the size of Cluny III, although the negative example of heretics who denounced church buildings is certainly a prime factor. It should also be remembered that Clairvaux II itself, at over 100m, was not so small in comparison to Cluny III that it can be described as modest.

433. Cf. the *Vita Amedaei* (p.92–93) of c.1160, the story of a Cistercian monk who fled his monastery to Cluny in order to obtain a better education for his young son who was with him. He soon returned because of the lack of poverty and simplicity he found there. The criticism centers around the elaborate liturgy of Cluny, especially the vestments, although brief mention is made of liturgical objects. The dichotomy is one of learning and liturgical splendor in contrast to simplicity and voluntary poverty. The subject of excessive monumental art is conspicuous by its absence. While Bernard diplomatically avoided repeating the implicit criticism of excessive liturgical vestments made in the early Cistercian documents, Idung was not so generous, describing them as an out and out theft from the poor; Idung, *Dialogus* 2:22–23, p.417–418.

434. On the normalcy of life at Cluny, see Constable 1975:135; Hallinger 1971; Leclercq 1965:41–42. As to the relations between Cluny and the Cistercians, there was no line separating old from new. On the similarities between spiritual traditions, see Morghen 1971:28. The old reform monasticism was quite respectable, though outdated in some ways; Berlière 1900:255f., 264, 259f. (on Cluniac expansion around this time); Constable 1975:136–137 (on praise by leaders of some of the new ascetic orders), 1977b:217, 165–166, 202–203, 216–217 (on expansion throughout the twelfth century in the Low Countries), 1980:ii–iv; Leclercq 1970:124; and see Bernard Letter 364, v.8:318–319 on the high prestige of Cluny. Not only was much direct co-operation and support common but many traditional Benedictine monasteries including Cluny undertook internal reform. The relations between Cluny and the Cistercians more closely approached intense sibling rivalry which might occasionally break out in dispute than it did open warfare between enemies—this point cannot be overemphasized. William of Saint-Thierry dealt with the issue (perhaps for complex reasons) strictly as an internal problem resulting from the too high standards of Bernard at Clairvaux; *Vita Prima* 1:50, *PL* 185:255. On Bernard's relations with Cluny, see Bouton 1953. Cluny under Pons had actually given financial support to Clairvaux in the form of a gift of—no less—parish tithes which the Cistercians were not legally allowed to accept; Cowdrey 1978:259n.4. According to Orderic Vitalis, the reforms of Peter rivalled those of the Cistercians; Orderic Vitalis, *The Ecclesiastical History* 13:13, v.6:426. Peter the Venerable was a reformer in his own right (Constable 1975:119–120) and was recognized as such by Bernard (Letter 277, v.8:190). The Cistercian Chapter General of 1149 passed a resolution commemorating Peter as special lord, father, and dearest friend; this also included all of Peter's people, living and dead (Bernard Letter 389, v.8:357). And Bernard praised the generosity of Peter toward indigent Cistercians (Letter 277,

tone in some of his writing to Suger, he is consistently respectful to Peter the Venerable—even when he is angry. No, Bernard was not singling out Cluny for attack in the *Apologia*. For the study of the *Apologia*, the significant thing about Letter 1 is not just that Bernard did not mention excessive art, but that he did not hesitate to chastise Cluny publicly by name when he felt that the situation warranted it.[435] And Peter's Letter 28 shows that Peter was ready to respond to any public challenge directed toward Cluny and probably would have done so with regard to the *Apologia* if he had thought that it was so directed.

This is not to say that the monastery of Cluny should not be considered as a nondistinctive part of the stated target of the *Apologia*, "William's order"—which, as Idung writes, was "Cluniac."[436] It certainly was, as were the many Cluniac dependencies. However, just what was a Cluniac dependency and what wasn't was only a little less vague to contemporaries than it is to us today. Whereas a monastery either was Cistercian or wasn't, no such clear-cut distinction could be made for "Cluniac" monasteries. Estimates of their number range from thirty-four to 2000.[437] All the members of the Congregation of Cluny were bound to the mother house on an entirely individual and varying basis which changed over time and according to those in power at each end.[438] The vast majority of "Cluniacs," it seems, were bound in spirit only. Cluniac customs could vary greatly from house

v.8:189). Significantly, Peter's family supported at least one Cistercian monastery (Constable 1967:v.2:180–181) and Bernard is known to have supported Cluniac monks (Letter 58:2, v.7:151). Bernard and Peter maintained an extensive correspondence and personal contact as well, including visits to Cluny (Bernard, Letters 147:2, 148, v.7:351–352). Bernard's writings are known to have been read at Cluny (Bouton 1953:211) and the Cistercians are known to have disseminated some of Peter's works (Constable 1980:iii; Leclercq 1970b:21). See Peter's Letter 111, p.291, for an extremely telling comment on the economic and social source of friction between the Cluniacs and Cistercians. The idea of wealthy Cluniacs opposed to impoverished Cistercians should become a thing of the past; cf. Peter the Venerable, Letter 34, p.109–113.

435. Cf. Bernard's Letter 149, v.7:353, where he is quick to make suggestions to Peter which are not in the interests of Cluny's political power.

436. Idung, *Dialogus* 1:14, p.98.

437. Constable 1976c:18. The number 2000 includes cells and monasteries influenced by Cluny. Papal bulls list the number at 131 and 140. Hunt (1968:77) mentions a list from the twelfth century that gives the names of only thirty-four monasteries actually paying a tax to Cluny; how complete this list is is uncertain. The reference to 200 priors—and so 200 dependent priories—at the 1132 Chapter General at Cluny by Orderic Vitalis probably gives the most realistic estimate; to this would be added sixteen dependent abbeys around the time of the *Apologia* (Constable 1976c:20; Cowdrey 1978:206–207). But as with the Cistercian system, the real test of unity is the ability to mobilize political unity and so power.

438. Constable (1976b:153, 160–161) describes this as a nonjuridical union with greater or lesser degrees of adherence. Hunt (1968:6, 8, 38) gives a similar description.

to house, new priors and abbots often brought changes of policy, and the installation of a Cluniac as abbot in a non-Cluniac house could be made without even the intention of a change in customs or association.[439] During the last twenty years of Hugh's life, he only visited those monasteries in the immediate vicinity of Cluny, leading to even less control than the conditions would normally have warranted.[440] And while Hugh was willing to use force on occasion to impose his claims, Peter rejected such a practice.[441] The result was the near impossibility of any attempt at control over many of the dependencies on the one side, and a widespread opposition to being controlled on the other.[442]

Thus, it is potentially misleading to equate Cluny with the Cluniacs. The Congregation of Cluny was not a monolithic institution, it was not an order in the modern sense. It was composed of various factions whose support and opposition on both internal and external affairs shifted according to the specific requirements of the moment.[443] "Cluny" was essentially a reform movement, and the majority of dependencies in at least France and Italy were founded previous to Cluniac control—that is, almost every one had a tradition of what passed for independence. In contrast, the Cistercians at the time of the *Apologia* tended to establish new foundations—with the clearly stated constitutional ideal being one of filiation.[444] So while Cluny was obliged to consider previous traditions, existing factions, the established desires of local aristocratic families, and the precedent of regional artistic customs,[445] the Cistercians at this time could impose their own standards entirely on new foundations made with new monks sent from the founding abbey.[446]

439. Constable 1976b:152, 160; 1976c:25. This mutability of customs was criticized by Idung, *Dialogus* 1:39, p.390–391, and was undoubtedly on the minds of the framers of the *Carta Caritatis.*

440. Bredero 1971:159; Constable 1976c:17. Cowdrey (1978:253) suggests that this loss of control may have been the real cause of Pons's downfall.

441. Compare Hugh's actions at Saint-Cyprian, Saint-Martial in Limoges, and Saint-Sernin in Toulouse with Peter's words, "I strongly wish that all such things might everywhere be corrected among us if it could be done with peace. But since, as I see it, this is not able to be done . . . "; Peter the Venerable, Statute 61, p.93.

442. This was complained of by Peter; Constable 1975:124, 130, 1976b:160, 1976c:18–19; see also Hunt 1968:184.

443. For Cluny, see esp. Tellenbach 1964; cf. also Bredero 1971 and White 1958.

444. This would change later with a certain easing of regulations. When former Benedictine abbeys were admitted into the Cistercian Order, allowance was made for both previous artistic and economic realities, to the point of attracting papal censure under Alexander III in 1169; see d'Arbois de Jubainville 1858:28 and Lekai 1978:8–10.

445. Saint-Martial at Limoges is a good example of this last consideration.

446. This is in no way to say that the Cistercians ignored regional family power or artistic practice.

Whatever may have been the case at the mother abbey of Cluny, Cluniac dependencies such as Moissac, Vézelay, and Saint-Gilles were lavish producers of excessive art—and all were mentioned for it in the twelfth-century *Pilgrim's Guide* in the *Codex Calixtinus*. Whatever the situation at Cluny, the idea that excessive monastic art is somehow distinctively Cluniac is in large part based upon that monastery's dependencies. And while there is no question but that these monasteries were exactly the type of pilgrimage monastery so harshly criticized by Bernard, the fact remains that the vast majority of Cluniac dependencies did not have excessive art programs. When considering the motives of Bernard in writing *Apologia* 28–29, it is crucial to also take into consideration such Cluniac monasteries as that of Malay which was built with great care, but with great moderation as well in the years immediately preceding the *Apologia*.[447] Much of the economy of a monastery such as Moissac depended on the pilgrimage trade, and it was hardly about to dismantle its art program in response to Bernard's call. It has been assumed that if Bernard was directing his complaints toward the "Cluniacs," then they must necessarily have justified those complaints. But the marginal monasteries, those like Malay, could and did come under the influence of Bernard, of whom the Cluniac author of the *Riposte* said he was always eager to read his writings,[448] and one may assume that it was these marginal monasteries rather than a committed pilgrimage monastery that were more likely to act upon what Bernard had to say.

The situation was much the same with non-Cluniac traditional Benedictines. The relations between the Cistercians and the traditional Benedictines were, on the whole, good.[449] And while monasteries whose economies were heavily dependent on the pilgrimage, such as Sainte-Foi, Saint Martin at Tours, and Saint-Genès at Aliscamps outside of Arles (all of which are also mentioned for their art in the *Pilgrim's Guide*), were not likely to do away

447. Oursel 1929:87–88.
448. *Riposte*, p.309.
449. On Bernard's relations with non-Cluniac Benedictines, see Bouton 1953b; Vacandard 1902:v.1:172–201. For numerous other examples of co-operation and respect between the new and old movements in general, see Berlière 1900. The Benedictine monasteries of Saint-Bénigne and Gilly gave gifts of land and pasturage to Cîteaux (Müller 1957:v.1:39), and Bernard supported Saint-Bénigne before the pope around the time of the *Apologia*; Letters 14–16, v.7:63–64. He also aided Molesme in its struggles over a certain secular church; Letters 43, 44, v.7:131–132. Orderic Vitalis gives a rather balanced view of the Cistercians and the monastic controversy in general; Orderic Vitalis, *The Ecclesiastical History* 8:26, 8:27, v.4:p.310–326, 332–334. Von Simson (1974:46) suggests that the good relations that Bernard enjoyed with such Benedictine houses as Liessiés which were active artistic producers may have accounted for the fierce tone of the *Apologia*.

with their art programs, even a monastery with such an excessive art program as Saint-Denis underwent what at least Suger called a reform, an undertaking in which Bernard himself was somehow involved.[450] Many more monasteries which are not famous today also eagerly instituted self-imposed reforms. The most interesting example of self-imposed reform on the part of traditional Benedictines which specifically involved art is probably that of the reform synods of the Benedictine abbots of the ecclesiastical province of Reims. In reaction to one such synod held in the fall of 1131, Cardinal Matthew of Albano, papal legate in France, wrote a letter to the abbots in which he tried to challenge their efforts at liturgical reform. At the end of this letter, he brings up the question of artistic asceticism, condemning in the strongest possible terms those who would run counter to tradition: in fact he suggests that such action would merit "eternal punishment." For their part, the abbots rejected his traditional arguments in a *Responsio* prepared for the succeeding synod of 1132 which was held at the Benedictine monastery of Saint-Médard at Soissons and to which Bernard had been invited.[451] It is no coincidence that the *Apologia* itself was formally requested by and dedicated to the abbot of a traditional Benedictine monastery which was not affiliated to Cluny, William of Saint-Thierry, a signatory of the acts of the synod of 1131 and attributed to be the author of the *Responsio* to Matthew of Albano.[452] Nor is it that when William died, the official *Vita* of Bernard which he had begun was taken up at the insistence of the monks of Clairvaux by another non-Cluniac Benedictine abbot, Arnold of Bonneval.[453]

Furthermore, it is always so easy to overlook the obvious, that the *Apologia* was formally dedicated to William. Regardless of the impetus to that treatise's writing or Bernard's friendship, this must have carried a certain message of its own. As I have said, it is absurd to think that Bernard would have expected a monastery such as Moissac to dismantle its art program. The evidence suggests that he very much had in mind those marginal monasteries which were not deeply involved in excessive art at the time but which could become so. In *Apologia* 3, Bernard says to William, "I write to

450. On the logic of Suger's reform and of the relationship between Suger and Bernard, see Rudolph 1990:8–18.

451. Matthew of Albano, *Epistola*, p.331–332; *Responsio*, p.348. Bernard, Letter 91, v.7:239–241.

452. The individual authorship of the *Responsio* is attributed by Ceglar to William of Saint-Thierry. Both William of Saint-Thierry and Simon of Saint-Nicolas-aux-Bois were signatories to the acts of the synod of 1131, and both were referred to in *Apologia* 4; Ceglar 1979:301–302, 305, 316. Bernard supported Simon in the reform of his monastery; Letter 83, v.7:216–218.

453. Vacandard 1902:v.1:xxii.

you what you have often heard so that—since I am unable to go to each person and explain myself to him individually—you may have something which you know is without any doubt from me with which you may persuade them for me." Bernard says that he has written the *Apologia* to be circulated by William on his behalf. But he certainly means more by this figure of speech. The idea of an unspecified coalition comes up in absolutely all of the letters preparatory to the final publication of the *Apologia*. In Letter 84bis Bernard repeats William's request that he defend a certain group of which they were both members. In Letter 88:3 he writes to Oger, "I for my part actually sent to you that other [short work]—which you indicate that you have copied—to be read, not to be copied. You yourself must know to what or for whose advantage you have copied it."[454] Going on, he raises the question of whether the *Apologia* should be shown indiscriminately, dropped entirely, or allowed to be read by only a select few. And to William this time, "May he who has caused you to wish also cause you to accomplish whatever you wish for yourself or for your friends by virtue of your intentions."[455] Bernard is referring to more than just Oger or William. And he is not describing the behind-the-scenes workings of a squabble between Cîteaux and Cluny. Bernard is being dragged into—or giving the appearance of being dragged into—a much broader non-denominational effort.[456] So despite his outrage at what he sees as certain abusive functions of excessive art, he approaches the subject unquestionably from a position which does not attempt to impose a set of Cistercian standards, but one which makes a certain degree of concession to both a different tradition and a different economy. The reduction of liturgical vestments which was so prominent in Cistercian legislation (Statute 10) and which typified Cluniac and Cluniac influenced liturgical ceremony is nowhere seen in the *Apologia*, although other aspects of the sacred economy are severely criticized. And the Cistercian proscription of all sculpture and painting except for painted crucifixes (Statute 20) is not even hinted at in this broader tract—despite the fact that he suggests the complete elimination of certain forms. Clearly, Bernard's treatise was not aimed at imposing Cistercian artistic standards, and in this sense was not adamantly opposed to the practical existence of monastic art within certain limits and so was not anti-Cluniac or anti-Benedictine as has been claimed.

454. Letter 88:3, v.7:234, "Nam illum alium quem te transcripsisse significas, ego quidem legendum tibi miseram, non transcribendum: videris tu qua vel quorum utilitate transcripseris."

455. Letter 85:4, v.7:223, "Quidquid vel tibi, vel amicis tuis recte vis, qui dedit velle, det et perficere pro bona voluntate."

456. He probably refers to some of these people in his letter to William's brother, Simon of Saint-Nicolas-aux-Bois, when he defers to "the counsel of those who are wiser."

Thus, Bernard's use of the word "Cluniac" must be taken in the broadest possible sense of "traditional Benedictines." The reputation of Cluny as a self-indulgent place bent on a program of excessive art production is—aside from the third abbey church—largely based upon its liturgy, the art of its dependencies, and the *Apologia* itself. We have seen that it is impossible to describe that work as singling out the monastery of Cluny for any special attention. It is even more fruitless to try to localize Bernard's censures within the Congregation of Cluny. And yet, to describe those censures as directed at the offending parties alone as has so often been done is to miss the point. Not all traditional Benedictines saw excessive art in such mandatory terms, as the residue of nineteenth-century ecclesiastical politics has taught us to believe.[457] Just as the method of address generally changes from a heavy use of the second person in the section of the *Apologia* on detractors to an equally heavy and largely consistent use of the first person plural in the section on excesses—most particularly in that on art[458]—so Bernard's point of view in the *Apologia* was not really that of a Cistercian but of a broad coalition of activist reformers, many of whom were themselves Benedictines. In defining this position he presented a body of argument which touched upon previous Cistercian statements on art, such as the disruption of monastic meditation and the focus on the liturgical artwork, but ignored others, like those regulating the liturgical vestments so favored by Cluny and those prohibiting sculpture and painting entirely except for painted crucifixes. More interesting still is the introduction of those issues which are new relative to Cistercian legislation, such as art to attract donations and art as opposed to the care of the poor. Certainly the greater part of Bernard's criticism was directed toward excessive art in the great pilgrimage monasteries, but he also set his sights on the marginal monasteries which did not as yet subscribe to excessive art programs. Yet even for these his topics remained the same: the sacred economy, the poor, distraction. But it is just this point—that the *Apologia* was meant as much for those without excessive art as it was for those with it—that suggests another direction of address to that treatise, the new ascetic orders and the Cistercians.

457. This is true even for those who actively promoted art for the honor of God; cf. Theophilus (*De Diversis Artibus*, preface to bk. 1, p. 3) who cautions against the attitude that one must employ costly and imported materials. There also certainly must have been many who took a public stance against excessive art but whose names are not recorded, such as the clerk and prelate of Reims from whom no writings survive but who was mentioned by Peter the Cantor; *Verbum Abbreviatum* 81, PL 205:256, 257.

458. There are exceptions for rhetorical effect, but the general trend is certain. Those sections which were added only in the second recension, such as the one on monks who pretend to be sick, are discounted.

The New Ascetic Orders
and the Cistercians

The period before and during which the *Apologia* was written was one of enormous monastic and collegial expansion and experimentation. The common denominator for most of this, aside from the question of accretions to the regular life,[459] was a desire to live that life according to the principles of a strict voluntary poverty. It was this element of voluntary poverty that tended to lead to the general reticence toward excessive art which seems to have accompanied the earliest stages of so many of these monastic and collegial reforms. But the inclination in most reforms was toward backsliding, and evidence of these early propensities toward artistic asceticism often survived only in the *vitae* of charismatic forefathers.

Contemporaries were quite aware of the pattern of the abandonment of primitive rigor that came with formal establishment. William of Malmesbury described this regrettable but inevitable relapse as a *perpetua lex*.[460] The difference between the Cistercians and the other new ascetic orders in regard to artistic asceticism was not any ability to resist the slackening which so often came with success, but rather the transition from unwritten tradition to that of written, unchanging, mandatory legislation. It was Bernard personally, I believe, who was responsible for this difference.[461] Given his decided bent toward ecclesiastical affairs outside his own monastery, it seems that the circumstances surrounding the writing of the *Apologia* would suggest a broader direction to that treatise than has previously been thought to be the case.

The New Ascetic Orders

An excellent example of the syndrome of the "lost" reform just mentioned is that of the movement begun by Odo of Tournai. Having begun a collegial

459. The regular life is that life led according to a formal religious rule (*regula*), whether monastic or collegial.

460. William of Malmesbury (*Gesta Regum* 4:337, v.2:385, PL 179:1290) raises the subject of relapse in a positive way in his discussion of the Cistercians, Walter Map somewhat later in an extremely negative way (*De Nugis Curialium* 1:16–1:18, 1:23–28, p.50–58, 68–116).

461. My reasons for saying this are given in Rudolph 1987.

reform in Tournai in 1092 based upon the strictest principles of asceticism, voluntary poverty, and care of the poor, Odo refused to accept certain gifts or accumulate wealth.[462] This attitude encompassed a rejection of liturgical art even more radical than that of the Cistercians, one that would not even permit the use of silver in chalices.[463] Despite his great popularity, outside forces which objected to what they saw as Odo's immoderate expenditure on the poor gradually compelled him to adopt Cluniac customs, and with no provision for his earlier way of life, the primitive austerity became compromised. This tendency to avoid putting religious practice into written law— apparently the result of a theoretical resistance[464]—may have been seen by Bernard as an internal weakness of the new movement, and a major portion of the so-called Cluny-Cîteaux controversy seems to have had as it purpose the gaining of influence over just such movements as Odo's in order to ensure compatibility of purpose.

It is impossible to give a full account here of the rise of the new ascetic orders, but a list of some of the foundations establishing themselves at this time would include Afflighem, Arrouaise, Cadouin, the Carthusians, Fontevrault, the Gilbertines, Grandmont, Obazine, Oigny, the Premonstratensians, Savigny, the Templars, Tiron, the Victorines, and many others. Of these, a good many not only had not formalized their customs in writing by the time of the *Apologia*, but a significant number of the original leaders of these movements were dying and leaving their charges at a sort of crossroads of translating charisma into legislation. In 1117 Bernard of Tiron, a friend of Robert d'Arbrissel and a great figure of resistance to Cluniac domination under the regime of Hugh, died, after which his congregation of Tiron gradually adopted the Cluniac customs he had fought so hard to avoid. Robert himself, the founder of Fontevrault and a major leader among the new ascetic orders, died the same year, writing the rule for his house only in the last year of his life. The founder of Cadouin, Gerard de Salles, followed him in 1120 with Cadouin being taken over by the Cistercians also in the year before his death. It was in 1120 that the Premonstratensian Order was founded amid a good amount of constitutional confusion, with some members failing in an attempt to affiliate with Cîteaux and with its leader Norbert leaving the order in 1126. In 1122 Conon, the founder, but no longer a member, of Arrouaise died leaving its third abbot free to change

462. Dereine 1948:138–146.

463. Hermannus of Saint-Martin, *De Restauracione* 66–67, PL 180:90–91.

464. It was only after many years that even Cluny wrote down a relatively complete codification of its customs, and even then at outside prompting. It has been said that only a monk oblated at Cluny at a very young age could master all of the detail of its practice required for the office of precentor, and that even the abbot of Cluny could not question the precentor on such practice; de Valous 1970:v.1:157–158.

directions of the order toward the Cistercians. In that same year Vitalis de Mortain who founded Savigny and who was another follower of Robert d'Arbrissel, died, as did Fulgence, the first abbot of Afflighem. Stephen de Muret, the founder of the Congregation of Grandmont, died in 1124. And in 1127 the Carthusians formalized their customs in writing after forty-three years of existence.

The hypothetical date of 1123–1124 for the compostion of the Bernardine directed *Summa Cartae Caritatis*, a document apparently composed as a legislative aid for the new ascetic orders, seems far from a coincidence in light of all this.[465] The period around the writing of the *Apologia* was one of extreme activity, and one from which Bernard emerged as the pre-eminent leader of the new movements. Exactly to what degree his efforts corresponded to results has never been fully worked out. But in general terms we do know that the influence of Bernard and the Cistercians was great. A number of Cistercian successes have already been mentioned, but Bernard was also instrumental in the inception of quite a few Premonstratensian foundations, apparently even to the point of donating the land for Prémontré itself.[466] It was around the time of the *Apologia* that he wrote his Letter 11 to the Carthusians. Oigny directly copied a number of passages from the *Summa Cartae Caritatis* into its customs probably sometime between 1125 and 1134, Arrouaise doing the same between 1127 and 1135.[467] In 1128 Bernard was called upon to help write the Rule of the Temple, composing his *De Laude Novae Militiae* for the Templars shortly thereafter. The usages of Prémontré which were begun around 1128 and finished in their first form between 1135 and 1138 also show the direct influence of the *Summa Cartae Caritatis*.[468] And it was sometime around this that the institutes of the Victorines were written—this too showing the mark of Bernard and the *Summa Cartae Caritatis*.[469] The 1143 rule of Grandmont was formulated with some Cistercian influence, and in 1147 the entire congregations of Savigny and Obazine merged with the Cistercians: Obazine with

465. Grill 1959, esp. p.54–56. Grill believes that the *Exordium Cistercii* and *Summa Cartae Caritatis* were written by Bernard on the occasion of the Chapter General of February 1125. Leclercq, the editor of the critical edition of Bernard's works, does not think that Bernard himself wrote the documents but agrees that the two works are by the same author, stating that it is "extremely probable—a probability which borders on certainty—that our texts had been composed at Clairvaux with the agreement of Bernard" (Leclercq 1963:89–90, 98–99).

466. Bernard, Letter 253:1, v.8:150.

467. Van Damme 1972:6–14, 26–33, 34f.; the dates for Oigny are not fixed with absolute certainty; Milis 1970:XLIII–XLVI, LII.

468. Van Damme 1972:14–25, 32–33, 34f.

469. Milis 1970:XLIII.

its two dependencies being put under the authority of Cîteaux, while that of Savigny with no less than twenty-nine went to Clairvaux. The Gilbertines sought admission at the same time but were rejected on the grounds of their largely female membership. However, their leader, Gilbert of Sempringham, is said in his *Vita* to have had close ties with Bernard, the two of them being described in a papal bull as the founders of that order.[470] Undoubtedly, a wealth of other connections have yet to come to light.

The interesting thing for us is that, despite all this activity, not a single house or order that remained outside Cistercian filiation adopted artistic legislation at this time which could be said to be of explicitly Cistercian influence, with the exception of the Gilbertines (probably 1147–1148).[471] While a very few foundations around the time of the *Apologia* had at least some statutory restrictions on liturgical art, such as the Carthusians, most did not, and absolutely none had written restrictions on representational art at this time.[472] Even among those that borrowed certain Cistercian articles word for word, the restrictions of both Statutes 10 and 20 are notable by their absence. This is not to say that there may not have been traditions of varying strengths among the different foundations which in practice would have restricted excessive or even all art, as the later legislation of the Car-

470. *Liber S. Gileberti* 13–14, p.40–44; Graham 1901:13; Foreville 1987:xli. Graham states that Gilbert drew up the customs for his order at Clairvaux with the help of Bernard himself; Graham 1901:13, 48. However, the account in the *Vita* about Gilbert's visiting the Cistercian Chapter General is not universally credited.

471. On the Gilbertines in general, see Graham 1901, esp. p.12–14, 33, 48–49. These customs provide an interesting line of artistic-ascetic acceptability. While an almost word-for-word borrowing of the Cistercian Statute 20 was in effect for the canons of the order (the words *sculpturae* and *picturae* are qualified by the modifier *superfluae*; however, there is no critical edition of the customs), the nuns were allowed to employ "icons and other sculptures" of the Virgin and the saints on either their or the visitors' altar or some other appropriate place—but only if these artworks were gifts, not if money were expended in procuring them. This allowance for women appears in the institutes of the lay brothers where the buying of silks and various other "vanities" for the latter are prohibited; cf. *Capitula de Canonicis* 9, 15, p.*xxviii, *xxxi; *Scripta de Fratribus* 13, p.*xl; and also *Institutiones ad Moniales* 1, 19, 28, p.*xliv, *xlviii, *l. Nothing approaching the later Cistercian Statute 80 appears in the Gilbertine customs, the closest concept being *Capitula de Canonicis* 9, "Qui vero scripturus est literas, simpliciter scribat, et omnino caveat vanitatem profundi vel pomposi dictaminis."

472. The Carthusian customary of 1127 contains a brief chapter prohibiting gold and silver liturgical artworks with the exception of the chalice and *calamus* or *fistula*, as well as decorated textiles; Guigues de Châtel, *Consuetudines Carthusienses* 40, PL 153:717–719. This is definitely independent of any Cistercian influence in its impetus if not in its detail. Cf. Guibert de Nogent's earlier account which mentions only a silver chalice; Guibert de Nogent, *De Sua Vita* 11, PL 156:854–855. Van Damme 1966:116 notes restrictions on liturgical art for Afflighem but gives no further information. It is one of the ironies of this subject that Bernard's archenemy, Abelard, should have been among the earliest monastic authors to attempt to put artistic restrictions in a rule; Abelard, *Regula*, p.263, 282.

thusians and Grandmontines implies.[473] But the evidence shows that, while far from excessive in the twelfth century, the artistic tendencies among many of the other new ascetic orders were less strict than those proposed by the Cistercians in their full vigor.[474] And other congregations, such as the

473. In 1240 the Grandmontines ordered, among other things, the removal of all useless and superfluous painting and sculpture from their churches and buildings ("Omnis pictura et omnis sculptura inutilis et superflua a nostris penitus absit aedificiis"). The statute makes no distinction as to those artworks which were neither useless nor superfluous. This was presumably to be decided by individual case. The Carthusian injunctions of 1261 basically repeat part of the early prohibition, with the addition of an admonition to remove decorated textiles from cells and to abolish at least those paintings which were unusually distractive from churches and guest houses ("Picturae curiosae de ecclesiis et hospitiis deleantur"); for both, see Mortet 1929:265. These later statutes imply earlier traditions or very broad interpretations of earlier laws as does the Carthusians' custom of reading Chrysostom's *Homiliae in Matthaeum* 69, which refers to the pointlessness of excessive architecture, on the feast of their founder, Bruno (see esp. Hom 69:3, *PG* 58:652). The inclusion of the passage by Ambrose on art and the poor by Gratian, a Camaldolese, may reflect a strong Camaldolese tradition; *Decretum* causa 12:2:71 (col.710–711). Peter Damian, who also opposed excessive art as mentioned above, was also a leading Camaldolese.

474. Very little systematic work has been done on the artistic practices of the new ascetic orders aside from the Cistercians. It has been suggested that Premonstratensian abbeys rivalled the "Cluniacs" in richness of ornamentation and that a study would reveal an unsuspected amount of art; R.P. Borchmans cited by Armand 1944:13n.1. A certain amount of Premonstratensian illustrated manuscripts exist. Mâle (1928:ill.18) has an example of one twelfth-century illustration. Petit (1947:216) notes that the Premonstratensians generally practiced manuscript illumination, the abbey of Cuissy particularly distinguishing itself. Lehmann (1918:409, 412) mentions a heavily illustrated passional with a large number of monstrous figures which he believes is probably a twelfth-century work from the Premonstratensian house of Saint Peter of Weissenau. My thanks to Solange Michon for the latter reference and for her opinion that the illuminated Commentary of the Psalms of Peter Lombard in the Lilly Library (Ricketts 20) in Indianapolis is a related work from Weissenau. One Premonstratensian, Adam of Dryburgh, may have imitated Hugh of Saint-Victor in the use of artworks to illustrate mystical writings. Premonstratensian statutes of the mid-twelfth century permit the controlled presence of artisans in the *claustrum*, but don't specify exactly what sort of artisans they mean (*Statuts de Prémontré XIIe siècle* 4:12, p.49–50). Their thirteenth-century revision clarifies this with "artifices preciosorum operum" (*Statuts de Prémontré XIIIe siècle* 1:10, p.20). They did restrict liturgical vestments (*Statuts de Prémontré XIIe siècle* 4:16, p.51–52) but, as with the Grandmontines and Carthusians, the Premonstratensians felt the need to legislate against excessive art later, including architecture and liturgical artworks (*Statuts de Prémontré XIIIe siècle* 4:4, 9, p.95–97, 109).

It seems that Grandmont had a rather lavish art program including luxurious vestments, liturgical artworks, and a systematic style of architecture, although this may have only begun after the death of Stephen of Muret (see Graham 1926:164, 166–168, 189–192, 207–210). Gaborit-Chopin (1969:146–147, 179) notes and gives illustrations of a lavish Grandmontine manuscript of the mid-twelfth century complete with gold, silver, and acrobats. Mortet (1913:107) notices a tendency in the early twelfth century among the Carthusians toward at least some artistic interests. Carthusian statutes may—they are unclear—refer to practicing illuminators among the monks (Mortet 1911:358). The nave capitals of Fontevrault employ scenes of animal combat. Many of the new ascetic orders later became known for their art, including the Camaldolese, Carthusians, Vallombrosans, and the Cistercians themselves.

Tironian and that of Chaise-Dieu, the French forerunner of the new ascetic orders, seem to have actively promoted art production.[475] And Hugh of Saint-Victor, one of the leading non-Cistercian thinkers of the new ascetic orders, seems to have actively supported Suger in both the iconographical and justificative aspects of his new art program at Saint-Denis as well as having used art as an integral part of one of his major mystical writings.[476] Furthermore, the question of relations between orders was not static. If the Cistercians could enjoy cordial relations with the other new ascetic orders when the Cluniacs under Hugh and perhaps Pons were dominant, the tables could be turned when the Cistercians were dominant and the Cluniacs could—and did—enjoy an improvement of relations with that wing of the Church under Peter the Venerable.[477] In fact, the relations with that order

475. Bernard of Tiron greatly encouraged craft skills, including "joiners . . . sculptors, goldsmiths, painters, and masons"; Orderic Vitalis, *The Ecclesiastical History* 8:27, v.4:328–330. As prior of Saint-Savin-sur-Gartempe, Bernard of Tiron's dispute with his abbot over the famous art program seems to have been largely on the basis of the means of funding—through the acquisition of secular churches—rather than the program itself; Gaufridus Grossus, *Vita B. Bernardi Tironiensis* 14, PL 172:1376–1377. The tomb of Saint-Front at Périgueux, described in the *Codex Calixtinus* 5[4]:8, v.1:368, as surpassing all other pilgrimage tombs in beauty, was made in 1077 by Guinamand, a monk of Chaise-Dieu who was skilled as a sculptor and goldsmith—and some say as an architect as well (Mortet 1911:242–243); the decoration of this tomb included images of animals, monsters, and figures from antiquity (Vielliard 1963:59n.2). Mâle (1928:32–34, ill.33) notes the murals in the chapter house of Lavaudieu, a dependency of Chaise-Dieu, and de Warren (1953:516) mentions the multiplication of statues of the Virgin by the monks of Chaise-Dieu.

476. Rudolph 1990:32–47, 60, 64. Richard of Saint-Victor followed him in this (Cahn 1984:151, Fig.6.8–6.10) and at least one Premonstratensian, Adam of Dryburgh, may have done so as well.

477. The histories of many of the new ascetic orders involve some sort of resistance to Cluny or Cluniac customs, sometimes very directly as in the case of Bernard of Tiron. But under Peter the Venerable, conditions improved dramatically. A large number of statements on the part of Peter attest, above all, to his respect for the Carthusian Order (see Letters 24, 132, 170, 186). The most revealing is Letter 158, p.377–379, to the Cistercian pope, Eugenius III, in which he declares that he prefers the Carthusian Order to any of all the other Latin orders, for they do not strain out the gnat and swallow the camel—an accusation he made against the Cistercians in his famous Letter 28, p.66; see Appendix 1, "Peter the Venerable's Letter 28 to Bernard." The affection and praise was mutual (see Constable 1975:136–137; 1976c:25; 1977b:165n.17), resulting in a liturgical commemoration of Peter (Constable 1967:v.2:111; PL 153:1127–1128). This stands in stark contrast to the pact between the Cistercians and the Carthusians in which they both agreed to put an end to the acceptance of questionable transfers from the other's order; PL 153:1130. This attitude of collegiality on the part of Cluny—which seems to have been common enough before Hugh, or at least before Odilo—was not restricted to the Carthusians. The Cluniacs and the Premonstratensians also formed a spiritual association in 1140 (Constable 1967:v.2:173–174), around the same time that the Cistercians and Premonstratensians, this time, signed a peace in which they agreed to not receive each other's questionable transfers (Canivez 1933:v.1:35–37). Numerous other instances of cooperation between Cluny and the new ascetic orders certainly exist.

with which the Cistercians seem to have been on the best terms around the time of the *Apologia*, the Premonstratensians, soured, eventually resulting in a dispute between the former allies which seems to have been more bitter than that between the Cluniacs and the Cistercians and which ended up with the breaking off of relations over art—in particular over the Cistercian attempt to dictate standards of artistic asceticism to the Premonstratensians.[478] But perhaps the most crucial element for Bernard was that of the relationship between the other new ascetic orders and the pilgrimage.[479] Current scholarly opinion holds that it was not Cluny which was responsible for the writing of the twelfth-century *Pilgrim's Guide*, but probably a secular clerk. According to Lambert, the author who has advanced this view, the *Pilgrim's Guide* was written around the time that the canons regular were expanding along the pilgrimage route, assuming a major responsibility for the care of pilgrims, the poor, and the sick.[480] To some of the new orders hospitality was a major ideal. Grandmont in particular owed its success to its proximity to the pilgrimage route. The Templars, like the older Hospitallers, were dedicated to the protection of pilgrims in the Holy Land. And Norbert, the founder of the Premonstratensians, recommended the care of pilgrims as one of the three principal elements of their life.[481]

Thus, the situation was one of a mass of new ascetic orders rapidly becoming wealthy and spreading throughout Europe and the Middle East, es-

478. The actual dispute took place in 1211–1229. But the tension had been building up for some time, as our source indicates, and in fact friction can be traced to the lifetime—and actions according to Hugh of Fosse, the abbot of Prémontré—of Bernard (Letter 253, v.8:149–155). It should be said that the Cistercians themselves were hardly free at this later time of the same accusations that they levied against the Premonstratensians; see Mortet 1911:214. Shortly after Bernard's death, the Cistercian Idung criticized the Premonstratensians strongly; *Dialogus* 2:39–46, p.425–429.

479. The objections of many of the monastic leaders of this time, such as Stephen of Muret, Guigues de Châtel, Peter the Venerable, and Bernard himself to pilgrimages by monks should not be confused with the lay pilgrimage; Constable 1976:136–140; Constable 1977:20–24. Many of these leaders had been pilgrims themselves, for example Adalemus of Chaise-Dieu, Robert d'Arbrissel, Norbert of Xanten, and Stephen of Obazine; Constable 1977:12.

480. Lambert 1959:22–23, refuting Bédier; and Lambert 1959:22–29 on the expansion of the canons regular. Some of the more important collegial churches were Saint-Sernin at Toulouse, Saint-Léonard in Limousin, Saint-Front at Périgueux, Saint-Martin at Tours, Saint-Hilaire at Poitiers, and San Isidoro at León. Many lesser known collegial churches were established around the time of the *Apologia*. The canons regular were especially active in promoting the Roland legend, Roncevaux being collegial. Various hospitallers were also involved (see Lambert 1959:26–29; Mâle 1928:253). The older Chaise-Dieu was involved in the pilgrimage trade as well; Starkie 1965:34.

481. Along with the cult and correction at chapter. It was the great work of mercy of the canons, the hospice at Prémontré being richly endowed for the purpose; Petit 1947:39–40.

pecially along the pilgrimage routes, often with ideals of hospitality and preaching but just as often without written rules regulating their position in regard to art and the layperson in their houses. The years immediately before the *Apologia* were characterized by a rash of deaths among the leaders of these foundations, generally followed by a period of regulation writing. According to some scholars, the *Summa Cartae Caritatis* was written under the direction of Bernard, and must have served as an attempted means of bringing some of these orders in line with his own vision of monastic and collegial life. But the artistic statutes were virtually ignored, whatever the actual practice may have been: there were a very few vague statutes governing liturgical artworks and absolutely none controlling sculpture and painting. And the tendency was one of backsliding, particularly when no written rules existed. An examination of the tenets of *Apologia* 28 and 29 show that despite its strong plea against pilgrimage art, it was not in the least incompatible with the artistic customs of most of the new ascetic orders, either written or unwritten: it made no attempt to impose a Cistercian-style regulation of liturgical art as in Statute 10, nor a Cistercian-style proscription of monumental art as in Statute 20. It did take as one of its principal points the relation between art and the layperson in the monastery, and in this sense—although I do not wish to overemphasize the point—was theoretically as applicable to the expanding new ascetic orders which were almost all building at this time as it was to the established traditional Benedictines.

By concentrating on existing excess only, one neglects an important facet in the overall art historical context of the *Apologia*: each new house required all the same potentially excessive artworks that a wealthy Cluniac or traditional non-Cluniac Benedictine house would need, such as a church building, liturgical vessels and other liturgical objects (such as reliquaries, chandeliers, and candleabra), vestments, liturgical books, a cloister, and a library. It should not be overlooked that Bernard mentions canons regular twice in his treatise (*Apologia* 5 and 6)—as many times as he mentions the "Cluniacs." If Bernard addresses this work to William, the abbot of a traditional non-Cluniac Benedictine monastery, he makes an uncommonly pointed effort to bring the name of Oger, a canon regular, into it. Given Oger's role as the probable initiator, would-be preface writer, editor, and a principal disseminator of the *Apologia*, it seems safe to say that Bernard's tract was written with the new ascetic orders in mind.[482] All modern histo-

482. On Oger's role in the origin of the *Apologia*, see Appendix 1. Oger was a canon regular of Mont-Saint-Eloi in the region of Arras, whose abbot he had arranged for Bernard to meet on some business, possibly in November of 1124. Probably before the next year was out, the year in which the *Apologia* was written, Oger was made abbot of Saint-

rians agree that the *Apologia* was an open letter. Together with William, the two act as indicators to the reader of the support—that undefined, non-denominational group mentioned in all of the letters preparatory to the final publication of the *Apologia*—within the monastic and collegial wings for the position elucidated in that work. Bernard was trying to advance his policy of reformed life in all elements of the Church, not just with the Cistercians.[483] Indeed, if one examines Leclercq's list of manuscripts from the first redaction of the *Apologia*, one finds that, of the five extant copies, two formerly belonged to Benedictine abbeys and two to collegial churches, while only one of the extant manuscripts originates from a Cistercian monastery.[484] The role of non-Cluniac Benedictines and canons regular in the instigation and dissemination of the *Apologia* and the corresponding absence of direct Cistercian participation in at least the immediate writing suggest that the *Apologia* was the central document in a controversy not between Cluniacs and Cistercians, but rather between establishment religious and an active faction of a coalition which covered a broad spectrum of ecclesiastical reformers.

The Cistercians

According to Giraldus Cambrensis, Bernard eventually became disgusted with the grasping and avaricious behavior of the Cistercian abbots, and both the Cistercian Pope Eugenius III in the lifetime of Bernard and Alexander III only a few years later were compelled to caution the Cistercians on the almost total transformation of the Order.[485] It was only a matter of time before Walter Map would lampoon their insatiable greed and the Cistercian

Médard in Tournai with the assignment of establishing canons regular there; Leclercq 1957:v.3:63; Van den Eynde (1969:379) gives September 1126 as the *terminus ante quem*. Oger was later largely responsible for founding Saint-Nicolas-des-Prés, an Augustinian house in the diocese of Tournai. Flanders at this time was rife with religious discontent. Norbert of Xanten's opinion that the time of the Antichrist was near and that the Church faced severe persecution (Bernard, Letter 56, v.7:148) may have been the result of his experiences in Flanders.

483. William of Saint-Thierry (*Vita Prima* 1:26, PL 185:242) says that Bernard's highest concern was the salvation of all, from the first day of his conversion. The new reform of monasticism was associated with that of the collegial orders, with Bernard being identified as the leading monastic reformer and Norbert of Xanten as the leading collegial reformer; Abelard, *Historia*, p.97 and *Censura Doctorum*, PL 178:109).

484. Leclercq 1957:v.3:80.

485. Eugenius gave his warning in 1143, Alexander in 1169; Leclercq 1970:119, 126; 1971:231–232, 237. By 1145 all the new ascetic orders, including the Cistercians, owned *spiritualia*; Constable 1971c:330. Cf. also the comment of the Cistercian Abbot Gilbert of Hoyland on Cistercian materialism, not long after the death of Bernard, *Tractatus* 7:5, PL 184:279.

Hélinand de Froidmont would publicly warn the Order on its artistic excess. When a late twelfth-century mystic noted for his revelations was requested by the abbot of Cîteaux to ask God what was most opposed to the purity of religious life in the Cistercian Order, he was answered with three offenses, one of which was the vanity of Cistercian buildings.[486] According to the soon-to-be Cistercian Peter the Cantor, Bernard himself cried upon seeing the move within his order away from architectural simplicity toward excess.[487] Indeed, given the later Cistercian legislation against excessive art, it seems that the passage on art which mentions stained glass in the Cistercian Idung's *Dialogus* may have been aimed as much at his own order as at the traditional Benedictines.[488] And even as Bernard lay dying, a general reaction against his policies set in among the Cistercians, pointed up by the placement of a former monk from Cîteaux as abbot of the mother house for the first time since Bernard entered the Order.[489]

Until now, Bernard's personal authority had been enough to hold in check the artistic tendencies of an order spurred on by ever-increasing wealth. But what the moral leadership of Bernard could impose when the Order was small and economically struggling, legislation could only deal with in concessional terms when the Order was large and wealthy. The most telling of these compromises essentially permitted the legal possession of gold- and silver-plated crucifixes of modest size as part of an arrangement for doing away with larger ones and those of solid gold: this took place only four years after the death of Bernard, and it is no accident that that very year the strict lay burial policy of the early Cistercians gave way to one which in permitting the burial of certain lay benefactors approached the practices of traditional Benedictine monasticism.[490] After that, the story of Cistercian artistic asceticism is one of constant inroads which are too numerous to be detailed here. They include everything from the legal retention of certain forms of figural art by already established monasteries entering the Order to unwritten concessions on such art forms as windows

486. Conrad of Eberbach, *Exordium Magnum* 5:20, p.334–336.
487. Peter the Cantor, *Verbum Abbreviatum* 86, *PL* 205:257.
488. Idung, *Dialogus* 1:36, p.389–390.
489. Bernard offered lackluster support for this monk, Goswin, as an afterthought in a letter to Eugenius III, also a monk of Clairvaux; Letter 270:3, v.8:180.
490. Statutes 15, 63 from 1157; Canivez 1933:v.1:61, 68. It is possible that these compromises were part of a regrouping of the expansionist party which seems to have made a temporary comeback around this time. In the same year the Chapter General gave permission to paint the "portas vel ostia ecclesiae" white (Statute 12, Canivez 1933:v.1:61). One wonders if this involved more than a simple painting, perhaps something along the lines of the designs found on Cistercian tile pavements and windows. For what is probably a very schematic example of polychrome doors, see the miniature of Saint-Martin-des-Champs in London, British Library, ms add. 11662:4, reproduced in Bony 1986:ill.9.

and pavements, often with the result in dialectical fashion of the concession becoming the new restrictive standard.[491] Indebtedness as a result of over-expenditure on building programs even became almost common.[492] The ideal of artistic asceticism had nowhere near the force it had in the early years, and the art of the Cistercian Order came to rival that of the most excessive Benedictine monasteries.

But what was the reality of that ideal? The artistic asceticism of the early Cistercians is almost legendary and their later artistic indulgence is histori-cal fact. Did the early ideals simply give way gradually, or has the element of artistic asceticism been misrepresented? And if it has been misrepre-sented, what role may the Apologia have played in regard to the Cistercian Order itself? Emphasis on the personality of Bernard has tended to merge his views with those of the rest of the entire Cistercian Order, but the his-torical evidence suggests that this was not exactly the case.

Bernard did not limit his political activities to outside the Cistercian Order. Upon entering Cîteaux as a novice, he was already the acknowledged leader of a group of men, very many of them relatives, who were to form the nucleus of the Cistercian Order's extraordinary expansion. While their in-stitutional loyalties may have been to Cîteaux, their personal loyalties were to Bernard—as his meteoric rise in power within the Order shows. He must have been marked as a future abbot even before his advancement from the novitiate, having entered in 1113 and been made an abbot already in 1115.[493] He seems to have taken the lead from Stephen Harding on legis-

491. Norton (1983:101) writes of the attempt by the Burgundian proto-abbeys to offer a "normative" style of tile pavement and its failure to take hold throughout the Order. It is my belief that even these "normative" pavements were excessive according to the standards previous to Bernard's death, and the mere fact that an entire book could be written on Cis-tercian grisaille windows (Zakin 1979) says the same for the latter. For the most complete collection of Cistercian regulations on art, see Norton 1986:318–393; it supercedes d'Arbois de Jubainville 1858:28–35; Mortet 1929:30–38; Aubert 1947:v.1:135–149; and Dimier 1947:267–273 which should be seen as a supplement to Aubert.

Also see Norton 1983:71–76, 98–101 for coverage primarily on tiled pavements but also other subjects as well. For studies which include or are devoted to twelfth- and thir-teenth-century Cistercian art made after the probable mid-twelfth century date of Statute 80, see throughout Aubert 1947 on numerous subjects, from sculpture and painting to fig-ural funerary art (esp. v.1:307–349); Cahn 1984 on manuscripts; Cothren 1982 on tile pavements in Yorkshire; Norton 1983 on tile pavements in France; Stratford 1981:226–230 on a possible new dating of some of the early illuminated manuscripts from Cîteaux; Walliser 1969 on the scriptorium of Heiligenkreuz; Zakin 1979 on grisaille win-dows in France.

492. The subject comes up in the Chapters General of 1188, 1202, 1213, and 1220.

493. If Bernard was made abbot in 1115, the decision would have to have been made already in 1114 since he was made founding abbot of a monastery whose planning was

lative matters early on in a number of different issues. The mere fact of the great emphasis put on the arrival of his group at Cîteaux in 1113 in the *Exordium Parvum* is proof of their political importance at the time of its writing in 1119, especially since Cîteaux had already grown enough before that arrival to legislate on new foundations and to plan that of La Ferté. His probable role in the writing of the *Exordium Cistercii, Summa Cartae Caritatis,* and *Capitula* is a significant indicator of power. His leadership in the Morimond affair of 1124 amounts to his being the unoffical head of the Order. And his placement of friends and relatives as abbots within the Order (and without, his sister was made abbess of Jully in 1128) is, perhaps, the clearest expression of his position. It was this placement of friends which allowed Bernard to institute policies which were often in conflict with the desires of the first generation Cistercians, policies whose most widely recognized manifestation was the promotion of the rapid expansion of the Order by the second generation, something the first opposed.[494] However, it is wrong to see Bernard's views on art as necessarily identical with that of the entire Order.

For our purposes, Bernard's most significant political move is the one responsible for the changes which occurred in the official Cistercian position on art sometime from 1115 to 1119, a move which can be seen as an important part of a major assumption of moral leadership from the first generation by the second with Bernard at its head. According to the testimony of *Exordium Parvum* 17, an official Cistercian history of c.1119, when Bernard and his party of converts entered Cîteaux in 1113 the monastery under Harding and the older monks from the Benedictine Molesme was following a thoroughly undistinguished policy toward art.[495] Traditional use of luxurious liturgical artworks and vestments was allowed, although there is no mention of monumental sculpture and painting. That is, Cistercian practice in regard to art either was no different than other traditional Bene-

under consideration for at least a year prior to its actual foundation. Also, according to William of Saint-Thierry, he took the initiative in founding the convent of Jully for the wives and sisters of his companions even as a novice; William of Saint-Thierry, *Vita Prima* 1:19, *PL* 185:237. Bernard apparently did not act alone in this, and the foundation was made through Molesme, an act typical of the early Cistercian aversion to incorporating women; cf. the foundation charter of Jully, *Cartulaires de Molesme* charter 241, v.2:225–226.

494. The first generation had experienced the problems accompanying rapid expansion at Molesme before they founded Cîteaux, one of which was that the newcomers came to outnumber the founders (Lekai 1953:17). This was something which they apparently wished to avoid a repetition of at Cîteaux, but which was destined to happen again.

495. *Exordium Parvum* 17:5–8, p.81. For a more thorough account of the early Cistercian legislation on art, see Rudolph 1987.

dictine monasteries with similar financial resources or was at least less restrictive than that of other of the new ascetic orders.[496] And yet by 1125 William of Malmesbury could describe the artistic asceticism of the Cistercians as one of their most distinctive features.[497] While the *Apologia* did much to spread the reputation of Cistercian artistic asceticism, it itself was not an explicit expression of that asceticism. The statutory basis of Cistercian artistic asceticism—and to some degree of the institutional claim that gave Bernard the moral right to take up the "things of greater importance" in the *Apologia*—may be found in Statutes 10 and 20, two important statutes regulating the use of art in Cistercian monasteries and enacted sometime from 1115 to 1119.[498]

Of these two, the one given precedence of place in the early compilation of statutes (1115–1119), as well as the vast majority of attention in *Exordium Parvum* 17, is Statute 10:

10. What is permissible or non-permissible for us to have of gold, silver, jewels, and silk

Altar cloths and the garments of those ministering are to be without silk, except the stole and maniple. No chasuble is to be had, unless of one color. All ornaments, vessels, and utensils of the monastery are to be without gold, silver, or jewels, except the chalice and the fistula which two alone we are allowed to have when of silver and gilded, but by no means when golden.[499]

496. See above on the strict artistic asceticism of some of the new orders and the laxity of others.

497. Although William's primary topic was Stephen Harding, it is clear from his tone as much as from his reference to Persius (*Satires* 2:69) that his account of Cistercian art policy is based upon *Apologia* 28 as well as the statutes; *Gesta Regum* 4:337, v.2:385 (*PL* 179:1289–1290).

498. The reasons for my dating of Statutes 10 and 20 are given in Rudolph 1987. The early Cistercian documents are perhaps most famous for their Gordian complexity. The two most vocal authors on the early Cistercian documents in general are J.A. Lefèvre and J.B. Van Damme; also prominent are Bouton, Winady, Dereine, Zakar, Waddell, de Waha, and Holdsworth. For the bibliography up to 1974 see Van Damme 1974:43–46; for a more complete bibliography of Lefèvre see Zakar 1964:103–104; for useful posings of the question, see Zakar 1964 and Holdsworth 1986 (with later bibliography), both of which have been used here. For a very brief summary of my position, see Rudolph 1987:32–33.

499. Statute 10, p.15, "Altarium linteamina, ministrorum indumenta, sine serico sint, praeter stolam et manipulum. Casula vero nonnisi unicolor habeatur. Omnia monasterii ornamenta, vasa, utensilia, sine auro et argento et gemmis, praeter calicem et fistulam: quae quidem duo sola argentea et deaurata, sed aurea nequaquam habere permittimur." The counterpart of Statute 10 in the *Capitula, cap* 25, is virtually a word-for-word copy, with only a few "*et*"s dropped and the final verb changed from passive to active. The fistula is a pipe through which the element of the wine was taken by the communicant. On textiles, cf. Caesarius of Arles, *Regula ad Virgines* 42, *PL* 67:1116, which is, however, wholly different in concept.

Statute 13, p.16, also forbade the use of gold in book clasps and brocade in book covers,

Statute 10 consists of two main parts, one dealing with altar cloths and liturgical vestments, the other with liturgical objects. While touching upon the question of color, the primary concern is with material. Luxurious materials such as gold, silver, and jewels—perhaps those words which come up most often in Suger's writings on art—and silk are proscribed with certain exceptions.[500] Excepted are the use of silk in the stole and maniple, and the use of silver and gilding for the chalice and fistula. While silver gilt is not required, it is nevertheless implied as a standard, a standard which should be seen a maximum standard in light of the minimum standard of ungilt silver as implied in the contemporary interpretation of Statute 10 found in *Exordium Parvum* 17.

At first glance, the overall impression of this statute would seem to be one of relative moderation, of limiting rather than totally proscribing ornament in divine worship. But the dominating principle is that of the minimum. By the twelfth century, silk had become all but canonically required for the stole and maniple, and the minimal requirement of silver, with gold being preferable, for *vasa sacra* had finally become standard after centuries of promulgation by Church reformers who wanted to prohibit such materials as wood, horn, bronze, and glass.[501] This is not a concession to mere tradition, but rather the minimal compliance with the reformist position on this subject. By allowing, or rather tolerating, their use, the Cistericans avoided branding themselves as among those extreme reformers who were beyond the pale of orthodoxy.

Whereas Statute 10 deals with the necessary, Statute 20 deals with the unnecessary:

20. Concerning sculptures, paintings, and the wooden cross

> We forbid sculptures or paintings in either our churches or in any of the
> rooms of the monastery, because when attention is turned to such things the

"XIII. DE FIRMACULIS LIBRORUM. Interdicimus ne in ecclesiarum nostrarum libris aurea, vel argentea sive deargentata vel deaurata habeantur retinacula, quae usu firmacula vocantur, et ne aliquis codex pallio tegatur." This statute does not appear to be directly related to Statutes 10 and 20 as part of an overall policy, but seems to be in response to a particular situation.

500. The restriction on color is the first example of what was to become one of the most constant themes in Cistercian art legislation.

501. Braun 1907:591, 535. Cf. Regino of Prüm, *De Synodalibus* 1:68, p.55; and Braun 1932:38–40, 259–260 who gives a complete account of sources on the subject. *Stannum*, an alloy of silver and lead, was permitted in cases of extreme indigence. *Vasa sacra* are those vessels which come into direct contact with the consecrated elements of the Eucharist and which are themselves either consecrated or blessed. *Vasa non sacra* are those vessels used for secondary liturgical functions, such as candlesticks; Braun 1932:2. Abelard, *Regula*, p.263, was stongly influenced by Statute 10.

advantage of good meditation or the discipline of religious gravity is often neglected. However, we do have painted crosses which are of wood.[502]

Statute 20 proscribes all sculpture and painting in the entire monastery, excepting only the painted wooden cross.[503] Like Statute 10, it is concerned with material, legislating use of the readily accessible and modest medium of wood.[504] But Statute 20 differs from Statute 10 in that it finds it necessary to justify its restrictions: art may act as a spiritual distraction. However, it is not just that art is a spiritual distraction pure and simple, rather art is a spiritual distraction to the monk in particular. While on the surface Statute 20's restrictions concerning monumental art are simply the counterpart to Statute 10's liturgical art, Statute 20 is, in fact, more daring. Where Statute 10 can in no way be seen as in opposition to Church practice, Statute 20 comes very close to defying Church doctrine on the educational value of imagery as expressed by Gregory the Great in his two letters to Bishop Serenus of Marseille.[505] And so the necessity of justification and of the painted wooden cross. On the one hand, the justification explains that it is not the use of art to educate the illiterate that the Cistercians oppose; and on the other, the allowance of the painted wooden cross attempts to convince with practice, as if theory is not enough.

However, such a literal reading of the Cistercian statutes regulating art within the monastery does not present the entire picture. The Cistercians were not alone in their artistic asceticism, and on the literal level Statutes 10 and 20 are less severe than the restrictions practiced by other of the new ascetic orders. And yet, contemporaries saw in those statutes something which set the Cistercians apart. Put as briefly as possible, the two major sources of income of traditional monasticism at this time were the Cult of the Dead and the Cult of Relics. The sensation which the Cistercian legislation on art caused was the result of the recognition that Statute 10 severely restricted the visual appeal of the liturgical aesthetics of the Cult of the

502. Statute 20, p.17, "xx. DE SCULPTURIS ET PICTURIS, ET CRUCE LIGNEA. Sculpturae vel picturae in ecclesiis nostris seu in officinis aliquibus monasterii ne fiant interdicimus, quia dum talibus intenditur, utilitas bonae meditationis vel disciplina religiosae gravitatis saepe negligitur. Cruces tamen pictas quae sunt ligneae habemus." Abelard, *Regula*, p.282 followed the Cistercian precedent and even tried to go beyond it.

503. *Cap* 26, p.125, of around five years later confirms the implication of Statute 20 that these crosses are to be non-sculptural.

504. Cf. Theophilus, *De Diversis Artibus*, preface to bk.1, p.3, on the use of local materials.

505. Gregory the Great, *Registrum* 9:209, 11:10, p.768, 873–875 (Letters 9:105, 11:13 in *PL* 77). The letter now identified as appendix 10, p.1110–1111 (Letter 9:148 in *PL* 77) is spurious.

Dead, while Statute 20 essentially proscribed the use of art to encourage a pilgrimage economy—and that the resultant rejection of social entanglement was seen to have been made mandatory through unchanging legislation and so to break the perpetual law (*perpetua lex*) of inevitable relapse of those who sought to leave the world behind and to return to the primitive simplicity of the Rule or of the apostolic life.

Within the Order, the situation looked somewhat different. As I have said, when Bernard entered Cîteaux in 1113, the Cistercians seem to have been hardly distinct artistically from other monasteries with similar financial resources. Both their liturgical art and their manuscripts were of such a degree of lavishness as to be excessive by later legislative standards.[506] What does not seem to have been appreciated about the early Cistercian legislation on art is that it did not simply prohibit the acquisition of most religious art, it was also the active instrument of the removal of the existing— and now legally excessive—art of the first generation Cistercians. The official and contemporary Cistercian history in the *Exordium Parvum* is quite clear:

> Afterwards, so that nothing in the house of God . . . should remain which smacked of pride or excess, or which would eventually corrupt poverty, . . . they established that they would not retain gold or silver crosses . . . and that they would not retain [gold] candelabra However, they did retain silver chalices—not gold, but gilded if it could be done, and they retained a silver fistula, gilded if possible.[507]

The wording is unmistakable: "So that nothing should remain . . . they established that they would not retain . . . and that they would not retain . . . however, they did retain . . . and they retained." There had been an artistic overturn of one element of the Order by another, with real changes having been made. One can not say with absolute certainty what the reaction of the first generation was to this, but the evidence cited already suggests that they had little choice but to go along. Bernard and his faction had the power in terms of chapter general votes,[508] in terms of the majority of

506. It is known that the founder of Cîteaux, Robert of Molesme, owned a finely worked golden cross (now in the Musée des Beaux-Arts, Dijon; Norton 1983:74n.33) and that his private chapel was significant enough to have been negotiated over in correspondence with the papal legate (*Exordium Parvum* 7:11, p.65).

507. *Exordium Parvum* 17:5–8, p. 81.

508. While enough information does not exist to document how votes went in the early chapters general, the abbots of Pontigny and Morimond at this time were associated with Bernard, the former definitely entering Cîteaux with Bernard, and the latter probably doing so. The votes of these three abbots of the second generation had a majority over those of Cîteaux and La Ferté which at this time represented the first generation. It has, to my

the general monastic population, and in terms of some form of moral credentials in that they had made the Cistercian Order what it was.[509] Nevertheless, while literally prohibiting all imagery from the monastery with the exception of the painted wooden crucifix, it seems that illuminated manuscripts continued to be made at a number of Cistercian monasteries, including Cîteaux, after the enactment of Statute 20—something which eventually led to the passage of Statute 80 which explicity forbade the use of depictive initials within the Order.[510] In short, despite the passage of the first restrictive artistic legislation in the West, there was resistance within the Order and compliance was irregular.

Furthermore, the initial writing of the *Apologia* is believed to have taken place sometime around the spring or summer of 1125. In the winter of 1124–1125, Stephen Harding, abbot of Cîteaux, was forced to make a trip to Flanders to secure additional food supplies in order to blunt the effects of a famine that made itself felt at least as early as the harvest of 1124.[511] The famine seems to have continued through to 1126, the result of rigorous winters and poor harvests. It was the winter of 1124–1125 that provided the most severe blow and, following the ghastly cycle of famines, the period just before the winter wheat harvest—that is, right around the

knowledge, never been noted before how Bernard replaced the abbots of these monasteries with men of his own choosing at the first available opportunity, just as he did with certain strategic bishoprics, such as Langres. When that opportunity came at Cîteaux, one of Bernard's former monks from Troisfontaines was given the abbacy, and when he immediately proved to be unacceptable (the reasons are not known) a monk from Clairvaux was made abbot. At La Ferté, the original abbot was probably replaced by his own prior (also of the first generation) possibly in 1117; but when he died in 1124, yet another monk of Clairvaux became a proto-abbot. Thus, at the time of the *Apologia*, Bernard's block may be said to have included all proto-abbots with the exception of that of Cîteaux, and eventually came to include Cîteaux as well. When the abbot of Morimond died in 1125, it was the prior of—the pattern is clearly established now—Clairvaux who took his place. And so it comes as no surprise that on the approach of the death of Bernard, the abbacy of Cîteaux finally reverted to a monk of Cîteaux who immediately instituted a reaction against some of Bernard's most important policies. For references to the sources for these facts, see King 1954:22, 108–111, 149–150, 332, 335.

509. Documents of a later date describe the Cistercians as *Clarevallenses, de ordine Clarevallensium,* and the *Ordo S. Bernardi;* for references to the sources for these facts, see King 1954:208. The total absence of any correspondence between the prolific Bernard and Harding is hardly conducive to the idea that they were on intimate terms.

510. It should be noted that the highly illuminated Bible of Stephen Harding was by law the literary model for other Cistercian monasteries in the early days; Statutes 2 and 3, p.13. On Statute 80, see Rudolph 1987:21–28.

511. On the dating of the famine, see Vacandard 1902:v.1:453n.3; Van Damme 1966:151. Vacandard dates the beginning of the famine to the winter of 1124–1125, overlooking Harding's trip to Flanders as an indicator that the signs were clear at least by the harvest of 1124. On the purpose of Harding's trip to Flanders, see Van Damme 1966:152.

time that the rough draft of the *Apologia* was being written—was the most desperate period. According to one account, Bernard decided in council with his chapter that the best thing to do was to adopt a certain number of poor to whom a living diet was given. The remaining poor were given something, but less than was considered necessary by the monks to support life.[512] Bernard, for whom the suffering of the poor was a theme that is found first in the *Apologia* but which would appear again and again in his later writings, was thus forced into a position of literally bestowing life on some, death on others. While Harding's exact itinerary is not known, it is known that he was not in Burgundy in the beginning of the winter of 1124–1125[513] and that the Morimond affair which stretched into February of 1125 was put entirely in Bernard's hands rather than Harding's as one would expect.[514] It is also known that during this winter of doom Harding made arrangements for the acquisition of a relatively luxuriously illustrated manuscript, complete with gilding and monstrous forms, from a monk of Saint-Vaast in Flanders whose work he admired.

Now, the colophons of the most striking of the illuminated manuscripts from Cîteaux are dated 1109 and 1111, that is, just prior to Bernard's arrival there in 1113. But the evidence suggests that illuminated manuscripts continued to be made there for sometime after his arrival and very probably after the enactment of Statute 20.[515] Given that Harding's actions before Bernard's artistic overturn were inconsistent with the tenets of Statute 10, Statute 20, the *Apologia*, and Statute 80—indeed, some even believe that Harding actually painted many of the early Cistercian illuminated manuscripts himself—and that his artistic activity during the deadly winter of 1124–1125 is wholly out of character with the spirit of the *Apologia* and

512. John the Hermit, *Vita Quarta* 2:6, PL 185:543. Vacandard questions the figure of 2000 poor fed daily, believing it instead to be the result of a rivalry with the Premonstratensians, who had fed 500, and to represent the recording of names in a register (*matricula*) of poor maintained; Vacandard 1902:v.1:453n.3. The general insufficiency of the harvests of Clairvaux around this time is substantiated by William of Saint-Thierry (*Vita Prima* 1:49, PL 185:255). Bernard's contemporary, Hugh of Saint-Victor, notes that distribution to the poor from Church property may not be made to the point of threatening those who hold Church office; *De Sacramentis* 2:9:10, PL 176:478.

513. Bernard, Letter 4:1, v.7:24. Letter 4 is dated to December 1124 by Van den Eynde 1969:389–393.

514. It should be noted that one of Bernard's complaints against art was its sheer expense. A major part of Morimond's problem was its insolvency.

515. The chronology of early Cistercian manuscript illumination as produced after the *Moralia in Job* of c.1111 has not yet been satisfactorily worked out; see esp. Oursel 1926 and 1960 who sees the force of the *Apologia* as a *terminus ante quem* for the later works, and Stratford's observations (1981:227–230) which provisionally suggest a date of c.1130 for the miniatures of the Jesse Master. To this list of post-1111 manuscripts should be added the illuminated Breviary discussed in Koch 1946:146–147.

Statute 80, it is reasonable to assume that it was public knowledge within the Cistercian Order that Bernard and Harding did not see eye to eye on the subject of art within the monastery.[516] As with the other passages in *Apologia* 28–29, the passage on the poor is above all of general application and is unquestionably more suitable to the great pilgrimage monasteries than to any Cistercian works of art. However, to those within the Order who knew of this longstanding disagreement, the passage, "It serves the eyes of the rich at the expense of the poor. The curious find that which may delight them, but those in need do not find that which should sustain them" could have been seen as no less than a judgment of Harding's new acquisition, written by Bernard as the starving gathered outside the gates of Clairvaux and Cîteaux.[517]

The tendency was to backslide, to fulfill the *perpetua lex* of William of Malmesbury. Contemporary writers were well aware that economic success often led to laxity among monastic orders and Bernard was no less aware than the others, as his legislation on art shows. We have already seen the high degree to which the art of Cîteaux previous to Bernard's arrival— manuscripts which in all probability Bernard himself had read as a novice— answered the examples of excess so graphically described in *Apologia* 29. In light of continued artistic acquisition and production among the Cistercian monasteries, it seems that they too, like the other new ascetic orders, were within the purview of the *Apologia* as much for what they were doing as for what Bernard wished to prevent them from doing.[518] Here, then, is an

516. Bernard certainly knew from his experience with Letter 1 to his cousin Robert that the *Apologia* would attract much attention within his own order. It is interesting that the reason Letter 1 was written "in imbre sine imbre" was that Bernard felt it was necessary to leave the monastery in order to secure greater secrecy outside ("ad dictandum quippe secretius septa monasterii egressi fuerant"); William of Saint-Thierry, *Vita Prima* 1:50, PL 185:255. Bernard, it seems, was trying to keep his fellow monks from learning of his actions. In light of this, it is significant that absolutely no Cistercians were involved with the publication of the *Apologia*, but only friends outside the Order.

The manuscript commissioned by Harding still exists, Dijon, Bib. mun.30. It seems that Harding especially admired this monk's calligraphy; Oursel 1926:7, 55–56, 79–80, pl.LI. There are a number of incomplete miniatures, at least one of which—a monstrous initial (30:2)—is certain to belong to the original Saint-Vaast manuscript. One wonders if the publication of the *Apologia* had anything to do with this unfinished initial. On the belief that Harding himself was an artist, see Porcher 1959:19–20.

517. This is precisely the situation abstractly referred to by Jerome, Letter 22:32, v.1:147–148. The early Cistercian ideal of the Desert Fathers in its most austere form dictated that books were to be sold to feed the poor; *Verba Seniorum* 6:5, PL 73:889. Ardo, *Vita Benedicti Anianensis* 7, p.204 gives a detailed description of how in a similar situation, the poor actually built huts outside the monastery in which to live until the next harvest.

518. It is categorically wrong to write off Bernard's explicit criticisms of the Cistercian detractors in the *Apologia* as purely rhetorical. Bernard had faced similar issues with his own monks, such as the question of the relation between the spiritual and physical in mo-

example of the art Bernard rails against, not in the cloister of Cluny as some would have us believe, but—among other places—in the very books he was afraid the monks would be distracted from reading.

nastic excercises; cf. *Apologia* 13–14 and William of Saint-Thierry, *Vita Prima* 1:36–37, *PL* 185:248–249. And as the haphazard pattern of many of the statutes which do not appear in the *Capitula* (and a good number of which were probably enacted after the *Apologia*) suggest that they were written in reaction to specific events, it seems that even the Cistercians were potentially not wholly free of the charges made in the "small things"— although I do not suggest in any way that Bernard aimed those directly at his own order. Nevertheless, note that Statute 41 vaguely touches upon the question of bedding raised in *Apologia* 16 and 24; Statutes 42 and 54 cover much the same issues of equipage as *Apologia* 16 and 27; Statute 56 implies problems with food and drink, perhaps not entirely dissimilar to the general problem raised in *Apologia* 16 and 20–21 (see Van Damme 1966:162–163 on the controversy over excessive food and clothing for the *conversi* which occurred around the time of the *Apologia*); Statute 81 takes up excessive clothing in language quite similar to *Apologia* 16 and 24–26 (*ysembruno, walembruno*; and *isembrunum, galabrunum*); Statute 85 and *Apologia* 19 both touch upon the question of silence during various activities; furthermore, Statutes 31 and 36 deal with illegal constructions, and Statute 37 with excess in furniture. The Statutes were armed with a general provision for punishment of those who were negligent; Statute 35, p.21.

5
CONCLUSION

During the early twelfth century, the greatest artistic controversy to occur in the West previous to the Reformation took place—a controversy which through its documents laid bare many of the concerns of medieval society in regard to its attitude toward art in a way which would never have been possible had that controversy not come to a peak. The most important document from that controversy, indeed, the most important source for medieval art, is Bernard of Clairvaux's *Apologia ad Guillelmum Abbatem*. In the beginning of this study, I evoked Schapiro's admonition concerning the *Apologia*, "The whole of this letter calls for a careful study; every sentence is charged with meanings that open up perspectives of the Romanesque world." And we have seen that these perspectives, the "things of greater importance," are not the personal idiosyncracies of a mind either repulsed by or attracted to art. Nor are they the simple condemnations of a particular monastery or group of monasteries that they were once thought to be.

Above all, Bernard was a monk. His treatise is a monastic treatise, and it deals with monastic subjects. When he takes up the subject of art, he takes up art which is in the monastery and in the monastery only. Everything else is extraneous. He is not concerned with establishing a new aesthetic, nor is he with destroying an old one. He is, however, concerned with art as inappropriate to the profession of the monk, and this he approaches from the two related and basic elements of justification and function—claim and reality. Even so, he is not involved in a theoretical debate over the validity of those justifications but rather with the questions raised by the functions that they support.

A dichotomy exists within Bernard's chapters on art which conceptually distinguishes two major areas of artistic excess: the relation between art and the layperson in the monastery, and art which was ostensibly intended for the monk alone. But both take the monk as their primary rationale. The

layperson enters into Bernard's discussions only as he pertains to the monk, not for his own sake.

Nevertheless, the layperson plays a central role in Bernard's major complaint, "What is gold doing in the holy place?" The answer is that gold is there to attract more gold. But Bernard is relatively methodical in his critique of art to attract donations, exposing the economic base of monastic art production, describing the artistic means by which it takes place, and the public reception which makes it possible. The basis of art to attract donations is the process of the conscious monastic investment in art and its various justifications. As exemplified by two of the art historically most important pilgrimage monasteries of the Romanesque and Gothic periods, Fleury and Saint-Denis, this process is typically but not exclusively one that makes the artistic embellishment of the holy place and its relics the centerpiece of a larger economic reform and reorganization of abbey properties and rights. Often associated with consuetudinary reform, accounts of how this takes place characteristically list relics, churches, land, privileges, and art together because they were—in this sense—all viewed as investments. Heavy expenditure on art was justified in the monastery in a number of ways, including the justifications of art for the honor of God, the relation between material and spiritual prosperity, and art to instruct the illiterate. Most notably embodied in Psalm 25:8, "Lord, I have loved the beauty of your house, and the place where your glory dwells," art for the honor of God was predicated on the obligation to embellish the house of God in return for his many favors. Prosperity not only permitted this, it also justified it according to one view current around the time that the *Apologia* was written. Probably as a result of a perceived association between both moral and physical decline in the wake of the break-up of Carolingian society, the later economic reform which often accompanied the spiritual reform of so many monasteries came to be seen as related. Material prosperity came to be interpreted both as a concomitant of and necessary to spiritual prosperity. And so with this new, specifically monastic (although not necessarily universal) acceptance of material wealth (as opposed to the acceptance of wealth by monasteries as aristocratic institutions), the excessive display of art potentially and theoretically lost the pejorative overtones of its materiality. Finally, the instruction of the illiterate came to be seen by some as a legitimate duty of monasticism, and thus a justification of the artworks which were a part of that instruction.

These justifications, however, were not put forth without opposition. The beauty of the house of God, it was argued, is internal, not external. According to Bernard, it is through piety and poverty that the monk shows honor to God. In fact, to do so in material terms is a non-monastic act since

the monk has left the things of the senses behind in order to follow Christ. Far from being indicative of spiritual prosperity, material prosperity is virtually incompatible with the spiritual life. On the contrary, according to this line of reasoning it is material poverty that is the physical expression of the poor in spirit. Written during a period of unparalleled material prosperity, it was just that very prosperity which was seen as most compromising monasticism. This was so much the case that this "crisis of prosperity" led to a successful challenge by the new ascetic orders, with the result of a certain loss of customary funding sources for traditional monasticism. As to the use of art to educate the illiterate, opponents responded that the duty of the monk was to mourn, not to teach. Without rejecting traditional Church doctrine on the matter, Bernard and others denounced the dilution of monastic seclusion brought about through lucrative social involvement under the guise of parochial duty. It is no accident that this happened during the high point of monastic artistic activity along the pilgrimage routes and during the widespread acceptance of a money economy. Careful not to overtly criticize the traditional source of income of the old monasticism—the *opus Dei* and the Cult of the Dead—Bernard does take up artistic aspects of the Cult of Relics at a time when the financial profitability of the former was beginning to dry up and the latter was to some degree taking its place. While the large land donations from the nobility continued to be important, there was a diversification of the monastic investment in art which now also sought to attract the smaller cash offerings of the more free, mobile, and wealthy non-aristocratic social groups. But if the pilgrimage provided a convenient substitute for this loss, it was one which carried with it its own set of problems. The evidence suggests that pilgrimage art became something of a necessity for those monasteries which wished to maintain a high level of income, and it was the resultant manipulation of art in conjunction with the sacred economy by the predatory monk that Bernard condemned as avarice.

Having discussed the process of the monastic investment in art, Bernard takes up the means through which it is implemented. To begin with, he specifies a number of different artistic criteria as contributing to what he finds objectionable in monastic art: namely, excess in material, craftsmanship, size, and quantity. However, while these categories of excess may apply to any artwork, he also mentions five works of art as particularly embodying that excess and these can be shown to represent various degrees of liturgical art as distinguished from monumental sculpture and painting. More than a simple rejection of gold in the liturgy, Bernard's censure shrewdly avoids those vessels which come in direct contact with the Eucharist, instead concentrating its forces on those other liturgical artworks which allied with the liturgy to form an artistic unity leading to a sensory satura-

tion of the holy place and of the religious experience. Directly related to the pattern of art as an investment, the financial, artistic, spiritual, and often liturgical center of this sensory saturation was the reliquary. And it is the reliquary—whose archetypal material was the gold he criticizes in the opening of *Apologia* 28—that Bernard credits with the greatest remunerative powers.

Bernard's critique of art to attract donations is complete only with the logic of the reception of the excessive artwork on the part of the public, that crucial element of pilgrimage art, the equation between excessive art and holiness. According to the individual artwork and according to the individual experiencing it, art was seen as possessing a variable relationship to the holy. Ranging from simple respect for its association with the holy, to awe from its implication of another object's holiness (as found in the *Apologia*), to the transformation in the viewer's perception of the artwork into the embodiment of holiness itself, Bernard objects to the equation between art and holiness on the grounds of its manipulation. While a strong tradition existed which saw as legitimate the use of excessive art to create an effect which was interpreted as an aura of holiness, Bernard's resistance to the psychology of the economics of excessive art was based on the conscious investment in excessive material, craftsmanship, size, and quantity to bring about a sensory saturation of the holy place which would instill a sense of *praesentia* for the purpose of inordinate gain.

Of all the "things of greater importance," it is that which is concerned with external social objections—art as opposed to the care of the poor—that has the most distinguished tradition in the patristic literature. On the literal level, Bernard follows the tradition most authoritatively represented by the writings of those two Doctors of the Church, Ambrose and Jerome. It is the writings of Ambrose which are responsible for the dissemination of the tradition which sanctions the selling off of liturgical artworks under pressing circumstances for the care of those in need. The tradition represented by Jerome takes this a step further, objecting to excessive art on the grounds of the offense it gives the poor and its diversion of funds from the poor: in other words, expenditure on art rather than on the poor. But Bernard's position on the issue goes further still. Not content with criticizing the action itself, he takes up the current justification which attempted to rationalize expenditure on art as somehow similar to almsgiving. Found in its most strident form in what amounts to a moral theology of art production, this justification claimed that money is consecrated by almsgiving, that to spend money on art is the same as almsgiving, and that therefore to spend money on art is a consecrated act. Dependent on the unstated co-premise of another justification which had nothing to do with the poor, art for the honor

of God, Bernard approaches the former as he did the latter—from a monastic standpoint which dismisses both as incompatible with the profession of the monk.

But Bernard is equally concerned with internal monastic objections to excessive art, namely art as a spiritual distraction to the monk. In contrast to the other "things of greater importance," Bernard's opponents on this issue were able to actively put forth an effective counter-position. As expressed by Suger of Saint-Denis, a specifically monastic art is justifiable on the basis of the claim that it can function in a way similar to the exegetical study of Scripture. This is an art which claims not to be for the education of the illiterate, but rather to be accessible only to the *litteratus* or educated choir monk. In reality it served both, being intellectually accessible to the monk and visually accessible to the layperson in its role in the sensory saturation of the holy place. For his part, Bernard objects to the tenets of this justification on the grounds of the monastic vice of curiosity and the danger of materiality, both of which threaten the spiritual communion of the monk with the divine. Wholeheartedly the expression of traditional monastic values, Bernard "overlooks" the use of monumental sculpture and painting in the monastery and, in so doing, adds greater moral force to the excesses he denounces and the limits he defines. He is not criticizing capital sculpture per se in his famous description of the medieval cloister. Rather, he uses the vehicle of capital sculpture to illustrate a number of iconographical categories characteristic of art in general that he finds most distractive. Thus, in monstrous and hybrid forms, he objects to the distractive power of contradiction and beauty—especially as inherent in that most characteristic monster, the hybrid. In non-mythical animals, it is the gratification of idle curiosity—something particularly common artistically in representations of non-indigenous beasts. And in the worldly pursuits of men, he sees the introduction into monastic art of secular imagery divorced from spiritual concerns as a very real danger to monastic contemplation—most notably in their violent and narrative aspects. And so, the monk who indulges in idle curiosity in viewing the hybrids of the capitals of a "Cluniac" cloister partakes of the same excess as the monk who yields to that temptation in the pages of a Cistercian illuminated manuscript. However, it would be wrong to interpret Bernard's criticism of art as a spiritual distraction to the monk as something which was meant to be seen as a straightforward standard for all monks in all monasteries. If Bernard expects an almost total artistic asceticism from his own Cistercian monks, it is because they like many among the traditional Benedictines have chosen higher spiritual/ascetic standards. Less spiritually advanced monks—whether individuals or groups— while always subject to the moral expectations expressed in the *Apologia*,

were not automatically condemned by Bernard for the moderate use of art as a spiritual aid.

Indeed, while the tenets of the *Apologia* were undoubtedly more applicable to the "Cluniac" side, it would be falsely limiting the intent of that treatise to see Bernard as concerned with offenders alone. Not only should Bernard's use of the term "Cluniac" in the *Apologia* be interpreted according to the common twelfth-century meaning of "traditional Benedictines," but the scope of that treatise should be understood to include those elements of the monastic and collegial wings of the Church which were marginal in regard to artistic asceticism, and even those who were themselves committed to it by written law or unwritten custom. The current view of the monastic crisis of the early twelfth century is far too polarized. It has long been held that if Bernard had addressed his treatise to the "Cluniacs," then they must be guilty "Cluniacs." But the idea that excessive monastic art is somehow distinctively "Cluniac" is largely based on that monastery's liturgical practices, the art of its dependencies, and the *Apologia* itself. Very many traditional Benedictine monasteries in no way indulged in programs of excessive art, and many more were not at all hostile to the new reform movement. It was to these marginal monasteries—which could go either way in their artistic undertakings—as well as to the great pilgrimage monasteries that Bernard directed his critique of monastic art.

And just as the nominal address of the *Apologia* to William of Saint-Thierry was meant as an indicator of the more traditional direction of that work, so was the inclusion of the canon regular Oger meant to convey intent toward the new ascetic orders. To be sure, just around the time that the *Apologia* was being written the new ascetic orders—some of which seem to have had oral customs against excessive art but no written laws—were experiencing a spate of deaths among their founders, leaving them leaderless charismatically and without written restrictions pertaining to art. The tenets of *Apologia* 28–29 were in no way incompatible with the practices of this segment of the regular life, a segment which was expanding at a far, far greater rate than the traditional Benedictines and so potentially that segment where artistic asceticism was most being tested. Nor are the Cistercians themselves to be considered as entirely free of all of the implications found in Bernard's chapters on art. The historical evidence suggests that extreme artistic asceticism was not deemed to be of interest to the first generation Cistercians, that the art historically important Statutes 10 and 20 were only instituted as part of an artistic overturn on the part of the second generation led by Bernard. In fact, there was resistance within the Order to extreme artistic asceticism; and probably at the very moment that Bernard was writing his scathing indictment of the relation between excessive mo-

nastic art and the poor, an excessively illuminated manuscript was being produced for the abbot of Cîteaux—and the starving were gathering outside the gates of both Cîteaux and Clairvaux, many of them begging for food which the monks were forced to refuse them for lack of sufficient supplies. Furthermore, a comparison of both the explicit and the implicit criteria of artistic excess in Bernard's treatise with the capital sculpture of the cloister of Cluniac Moissac and the illuminated manuscripts from Cluniac Saint-Martial at Limoges on the one hand, and illuminated manuscripts from Cîteaux on the other, shows that the elements of distraction most strongly denounced by Bernard are more readily found in the latter than in the former—and in the very books that he was afraid the monks would be distracted from reading, rather than in the cloister sculpture. Bernard's treatise was pan-monastic in character, and just as the rejection of art implied in Cistercian art legislation was within the bounds of Church doctrine and so avoided any possible association with heretical teaching, so in the *Apologia* Bernard held his criticisms within the bounds of his pan-monastic and collegial audience.

But Bernard's treatise tells us more than simply what he was telling his contemporaries. The question of whether or not to have art involved more than the mere ability to acquire and pay craftsmen, the good luck to get hold of the proper materials, and the decision concerning in what manner the work was to be undertaken. Art was a complex product: it was one thing to the monk, another to the priest, another to the layperson, and different things still to the various factions within those social groups. Material, craftsmanship, size, content, quantity, variety, and a number of other elements not covered in this study had to be taken into consideration. And the greater the physical ambition of the project, the greater either the social compromise or its opposite. In this process, the justification of art was of prime importance to those who made it, and still is to those who wish to understand it. Only those justifications directly taken up by Bernard have been covered here, but other justifications, such as building miracles, divine commands to build, visions, miraculous supplies of materials, the finding of hidden treasures for funding, the supernatural provision of completed works of art, and many more were used in various ways and for various reasons.

And not only could the determination of the artwork involve the question of different degrees of art, there could also be a significant distinction in its physical location as referred to by Bernard in his transition from *Apologia* 28 to *Apologia* 29. Thus, the profusion of sculpted capitals found in many Romanesque churches tends to be absent from the interior of many Gothic churches, only to reappear on the exterior, now characteristically

and more consistently fulfilling the overt function of instruction—this new sensitivity toward interior capital sculpture very probably being largely, although not wholly, the result of the early twelfth-century controversy over art. Nevertheless, while the use of art to create an aura expressive of spiritual prosperity and immanent holiness (according to the sensibilities of a certain monastic spirituality in a Romanesque church) may give way to the visual claim of an at least sculpturally "stripped" or "bare" interior in the Gothic church (according to the sensibilities of a certain secular spirituality which borrowed heavily from the monastic), this claim is typically contradicted by the use of liturgical art and especially the newly exploited medium of the stained glass window in the continued sensory saturation of the interior.

Bernard was not "blind" to art, nor was he expressing his personal view. If one insists on an architectural aesthetic for Bernard, it may be found on the personal level in the miserable hut he lived in when recuperating from an illness in the early days of his abbacy that so filled William of Saint-Thierry with awe, and on the institutional level in the description of Clairvaux I on the occasion of Innocent II's visit after the Council of Etampes: there were no painted windows, no decorated pavements, no high quality masonry, mystical proportions, or efforts at light symbolism—in fact "the Roman saw nothing in that church which he might desire, no liturgical furnishings disturbed [the pope and his court's] attention there, they saw nothing in the church but bare walls."[519] Bernard was stating his official position for all monasticism and for the collegial orders as well in the *Apologia*. The limits of his artistic critique stop well short of any attempt to impose Cistercian standards, there is even a certain degree of concession for different traditions and economies as regards liturgical vestments. Yet, in regard to the use—or rather the misuse—of art, he is quite systematic in his criticisms: from the economic base of monastic art production, to the artistic means by which this was carried out, to the reception of excessive art on the part of the general public, to external social objections, and finally to internal spiritual objections.

Nevertheless, criticism of religious art within the bounds of Church doctrine was a constant throughout the Middle Ages, especially in monastic circles, and if Bernard represents a high point in this, he is only the most distinctive of a tradition which included many of the greatest religious

519. Arnold of Bonneval, *Vita Prima* 2:6, PL 185:272. It is interesting that Arnold's use of *aspectum* is identical to that in *Apologia* 28. It is also interesting that his description of the pope as a Roman potentially coveting the wealth in liturgical artworks is the same as used by Suger in his *Vita Lodovici* 9, p.32–33.

leaders of Western Christendom. Bernard is not proscribing monumental sculpture and painting in their traditional format of images of Christ, the Virgin, Biblical scenes, and so on in the *Apologia*. Rather, he is condemning the monastic manipulation of excessive art as part of an overall sensory saturation in regard to the reception of the layperson in the monastery, the precedence given to this process and art in general over the well-being of the poor, and the monastic use of distractive, non-religious imagery. It was in this sense that he could place the "things of greater importance" above major infractions of the Benedictine Rule in consequence. The "things of greater importance" were not artworks. They comprised an excess, a moral excess, which in threatening the poverty, seclusion, and spirituality of monastic life, threatened its very foundations.

APPENDIX 1:
THE ORIGIN OF
THE *APOLOGIA*

Public Letters Prior to the Apologia

THE ORIGIN OF BERNARD'S LETTER TO ROBERT OF CHÂTILLON (EP. 1)

Although the precise conditions surrounding the writing of the *Apologia* are and probably will forever remain unclear, its origin is polemically very closely related to both Bernard's *Ep.* 1 to Robert of Châtillon—a public attack on Cluny addressed to his cousin—and to Peter the Venerable's Letter 28 to Bernard—a public refutation of charges against Cluniac monasticism which is generally believed to bear no direct relation to any of Bernard's writings.[520] The relationship of these three works is not at all easy to decipher. However, all authors believe that Bernard's *Ep.* 1 was written first, with most recent scholars agreeing that it was followed a very short time later by both Peter's Letter 28 and the *Apologia*. And so it is with the conditions leading up to the publication of Bernard's letter to Robert that I will begin.

Bernard's correspondence and the biography by William, which must provide a very sparse indication of his activity indeed, indicate that in the

520. Robert is sometimes wrongly called Bernard's nephew. On the so-called Cluny-Cîteaux controversy—of which this study is not an account and cannot cover all the events and documents involved—see esp. Bredero 1956, 1971; Bouton 1953; Cabrol 1929; Constable 1956b, 1956c:94, 1957, 1960, 1975, 1975b; Cowdrey 1978; Dimier 1956; Holdsworth 1986; Knowles 1955, 1956; Leclercq 1957b, 1970b, 1974; Tellenbach 1964; White 1958; Wilmart 1934; Zerbi 1972. The controversy between Cluny and Cîteaux was only part of a larger exchange within monasticism and in no way should be seen as distinct.

In general, I follow Van den Eynde's dating of the *Apologia* and of all of Bernard's letters that I have used here. The only exception is the precedence of Bernard's *Ep.* 1 over *Ep.* 89, concerning which Van den Eynde's datings are general and not insistent. While Bernard's *Ep.* 18:3 is important as a *terminus ante quem* for the *Apologia*, it is not treated as one of the sources for the impetus of that treatise here.

years preceding the writing of the *Apologia*, Bernard was not exactly the recluse living in the "valley of absinthe," the "place of awe and of enormous solitude," that he is programmatically projected as being in the *Vita Prima*.[521] From these sources, especially from Bernard's correspondence, it is known that he travelled much, that he received many visitors, that he maintained a flattering correspondence with high Church dignitaries, that he had a very high personal reputation based on his speaking and writing, that he had established strong contacts with officials of several of the new ascetic collegial orders, and that he not only took part in theological debates, but was considered a bit of an authority. In fact, William of Saint-Thierry tells us that through the efforts of William of Champeaux, bishop of Châlons, Bernard had become greatly respected in the province of Reims and even throughout all France by 1121.[522] And, although still speculative, perhaps Reims is a good place to look for the more specific events which led up to the writing of the *Apologia*.

At the Council of Reims of 1119, presided over by Pope Calixtus II, Pons of Cluny was vigorously attacked by the archbishop of Lyon and the bishop of Mâcon who objected to Cluny's insistence on its papal exemption from episcopal authority and its assumption of secular churches and tithes. Archbishop Humbert of Lyon, who led the attack, was thereupon joined by a combined party of "bishops, monks, and other clergy." While not explicitly mentioned as taking part in this affair, Bernard's two good friends, bishops William of Champeaux and Geoffrey of Chartres, are ambiguously tied to it by Orderic Vitalis and mentioned as having led discussions at the council with thunderous eloquence.[523]

Unfortunately, there seems to be no definitive evidence as to who the monks were that took part in the episcopal attack. However, less than eight weeks later (December 23, 1119), Calixtus formally approved the Cistercian constitution, the *Carta Caritatis*, which insisted in its very opening sentence upon monastic recognition of episcopal jurisdiction, and even gave

521. William of Saint-Thierry, *Vita Prima* 1:25, PL 185:241; the same phrase, "loco horroris et vastae solitudinis" (Dt 32:10), is used by Bernard in a letter of 1118 or 1119 (*Ep.* 118, v.7:298), his famous letter to Robert (Bernard, *Ep.* 1:3, v.7:4), and it also appears in the *Exordium Cistercii*, believed by Grill (1959:54–56) to have been written at Clairvaux, possibly by Bernard, in the period just before the *Apologia*.

522. By 1121 since the bishop of Châlons died in 1121. William of Saint-Thierry, *Vita Prima* 1:31, PL 185:246, "Quinetiam et Remensis provincia, et Gallia tota per eum [William of Champeaux] in devotionem excitata est ad reverentiam viri Dei."

523. Orderic Vitalis, *The Ecclesiastical History* bk.12:21, v.6:268–274. Pons had previously petitioned for, and received over some resistance, the right to wear episcopal regalia; Hunt 1968:51.

bishops a certain role in a number of disciplinary matters.[524] This constitution was accompanied by a historical introduction, the *Exordium Parvum*, which tended to emphasize the episcopal role in the founding of Cîteaux—especially that of Archbishop Humbert's predecessor, Hugh—rejected monastic possession of secular churches and tithes, proclaimed that a fourth of all tithes rightfully belonged to the bishop, insisted upon some degree of episcopal approbation for the taking on of *conversi*, and generally discussed provisions for a monastic life based on an economy essentially and pointedly different from that of the Cluniacs and the Cluniac milieu.[525]

It was also around this time, 1120 or a little earlier, that Bernard is first documented as openly accepting at Clairvaux those who had fled their own religious houses contrary to a literal interpretation of the Benedictine Rule, something for which he became quite well known. In this case, the transfers were canons regular. References to this type of transfer coming to him continue, but probably reflect only a small fraction of this activity. A little after 1121 he publicly declared his sympathies for the unsuccessful reform of a Benedictine monastery, Saint-Nicolas-aux-Bois, whose abbot Simon is believed to be the brother of William of Saint-Thierry. Later, in September of 1123 or 1124, he sent back an illegal transfer, a monk probably of his political ally Simon, although a little before November 1124 he is again on record as keeping questionable transfers from a more traditional Benedictine monastery—such distinctions undoubtedly only aggravating the situation.[526] By November 1124 he was considered to be enough of an authority on the subject that he was solicited for his advice by another Cistercian abbot. In fact, he even speaks of himself during the period before the *Apologia* (December 1124) as receiving questionable monastic and collegial transfers as a matter of principle even as he complained that a certain Cistercian

524. *Carta Caritatis*, prologue, ch.9, p.89, 97–98. Some scholars believe that the hypothetical first attack on Cluny by Cîteaux was based on the *Carta Caritatis*; Bredero 1956; Williams 1938:344; Knowles 1955:13 disagrees. It is possible that at the time of the Council of Reims, Bernard was convalescing just outside the monastery of Clairvaux under the direct orders of William of Champeaux (with the authority of the Cistercian Chapter General). However, it is known that Bernard's monks were very active and outspoken.

525. *Exordium Parvum* 15, p.77–78; the strain of the recognition of episcopal jurisdiction runs throughout the *Exordium Parvum* despite some historical discrepancies. On the latter see Van Damme 1982:318–320. The legal basis for the monastic life presented in the *Exordium Parvum* may be found in the statutes of the Cistercian Chapters General up to the time of the former's writing. Cluny must have been aware of all this, as the first Cistercian daughter house of La Ferté was founded in 1113 about twenty miles from Cluny—a distance probably within the proscribed radius of economic competition as laid down in Statute 6, appended to the so-called statutes of 1134; Canivez 1933:v.1:32–33.

526. For example, see *Ep.* 84, 406, v.7:218, v.8:387.

monk had been publicly making him odious in this regard to "thousands of holy men." Yet again, probably in spring of 1125, he once more sent back a monk of his ally, William's brother. And very probably during the actual writing of the *Apologia*, just before May 1125 or perhaps 1126, Bernard is again documented as being involved in another case of questionable transfers.[527] Finally, some time before the appearance of the *Apologia*, the *Exordium Cistercii*, *Summa Cartae Caritatis*, and *Capitula* were apparently produced at Clairvaux under Bernard's supervision. This work contains summaries of those statutes which give the *Exordium Parvum* it polemical edge. Furthermore, it was apparently intended for monastic and collegial reform, a reform which was a silent condemnation of traditional monasticism.

Now, at some indeterminate time between 1116 and "several years"[528] before Bernard wrote his *Ep.* 1 (which was probably in the spring of 1125), Robert, who had been promised to Cluny as a child but who as an adult was professed at Cîteaux and lived under his cousin Bernard at Clairvaux, was induced to transfer to Cluny without Bernard's permission by Cluny's major prior when the latter was at Clairvaux during an absence of Bernard.[529] If Van den Eynde's dating of the letter is correct, it seems that the

527. The significance of this activity for this study is not whether or not Bernard acted within the limits of the law: sometimes he did, and sometimes he rose to what he felt was a higher law; sometimes he kept the monk or canon, and sometimes he sent the person back. For our purposes, what matters is that his actions, whether perceived or real, created resentment. The most important sources are: Bernard, *Ep.* 3, 83 (Van den Eynde 1969:365), 406, 86, 32, 33, 34, v.7:18–19, 84, 67, 68. According to Benedict of Nursia, *Regula* 61, an abbot may not accept the monk of a known monastery without the consent of that monk's abbot. Monks from unknown monasteries could, however, be admitted upon their request. The subject often comes up in Bernard's writings, being covered in greatest detail in the *Liber de Praecepto et Dispensatione* (before 1143 or 1144). On the general question of Bernard and the "*transitus*," see Dimier 1953b. The Cistercians had a papal confirmation of the protection provided by the Benedictine Rule against this very same action in the Roman Privilege of 1100, contained in the *Exordium Parvum* 14, p.74; for a discussion of this document, see Waddell 1982:293–296. Cluny itself was hardly innocent in this matter, see Peter the Venerable, Letter 28, v.1:55, 78–79; Constable 1967:v.2:119, and Cowdrey 1978:260–261.

528. 1116 since Bernard says that Robert's monastic admission was put off for two years (probably from 1113, the time when Bernard and so many of Robert's brothers and relatives entered Cîteaux), after which he served one year in the novitiate; Bernard, *Ep.* 1:8, v.7:7. The expression "several years" was used by Geoffrey of Clairvaux who personally placed the letter at the head of Bernard's collected lettters; Geoffrey of Clairvaux, *Fragmenta ex Tertia Vita* 6, PL 185:526, "Cum enim in alio ordine jam per aliquot annos demoraretur, scripsit ad eum epistolam;" see also William of Saint-Thierry, *Vita Prima* 1:50, PL 185:255. Geoffrey and Robert, both eventually Cistercian abbots, had ample opportunity to meet at the annual Chapters General.

529. Bernard, *Ep.* 1:4, v.7:4. It seems that he was not the only relative of Bernard's who had transferred to the Cluniacs and later returned; see Peter the Venerable, Letter 181, p.424, and Constable 1967:v.2:219.

use of the term "several years" by Geoffrey of Clairvaux, Bernard's personal secretary and later abbot of Clairvaux, refers to the abbacy of Pons which ended only two and one-half years previously. This is corroborated by Bernard's sarcastic description of the abbot of Cluny as the *"princeps priorum,"* prince of priors, apparently a reference to allegations made by critics that Pons had attempted to assume the title of *abbas abbatum,* abbot of abbots, a title which was never claimed by Peter the Venerable.[530] But why was Robert taken in the first place, and why did Bernard then wait "several years" before responding to Cluny?

As to the first question, it seems that Bernard saw the staging of Robert's transfer as a direct blow at himself, in retaliation for actions he had committed against Cluny. In *Ep.* 1:11, he says, "For what advantage to you, for what necessity to you did our friends whose hands are covered with blood, whose sword has pierced my soul, whose teeth are spears and arrows, and whose tongue is a sharp sword do this? If I have at any time or in any way offended them—which I am not aware of—they have certainly repaid me with full reciprocation. It would be surprising if I have not received a greater retaliation in kind."[531] Thus, it seems that Robert was taken—whether by forethought or as a target of opportunity—as an explicit punishment to Bernard in regard to Bernard's activities involving questionable transfers, that he was quite aware of why it was done, that it was what he had been doing to those who took Robert, and that there was some kind of verbal campaign going on against him at the time of the writing of *Ep.* 1.[532]

530. According to the Chronicle of Monte Cassino, Pons fought with the abbot of that monastery at the Lateran Council of 1116 over the right to the title. The *Simonis Gesta Abbatum S. Bertini* asserts that Pons had boasted that he would impose his authority as *abbas abbatum;* see Cowdrey (1978:208) who suggests that it was only detractors of Cluny who used this term. If so, *princeps priorum* would be even more derogatory, since in referring to *abbas abbatum* it sarcastically corrects the latter in light of the fact that the heads of most houses of the Cluniac Congregation were only priors, not abbots. According to Hunt (1968:51) this title of *abbas abbatum* was never claimed by any of Pons' predecessors. However, according to Mabillon (1739:v.5:463, v.5:bk.71:17), Hugh of Cluny was accused in 1106 of assuming the previously unknown title *archiabbas* in his takeover of Saint-Cyprian—a takeover which eventually resulted in the founding of the Congregation of Tiron by Robert d'Arbrissel one year after Bernard had entered the Cistercian Order. Cf. Adalbero of Laon's also sarcastic reference to the association between the abbot of Cluny and the archangel Michael by describing the former as *princeps militiae* (cited in Duby 1980:203).

531. *Ep.* 1:11, v.7:8–9 "Verumtamen quo tuo commodo, qua tui necessitate hoc nobis moliti sunt amici nostri, quorum manus sanguine plenae sunt, quorum animam meam pertransivit gladius, quorum dentes arma et sagittae et lingua eorum gladius acutus [Ps 56:5]? Nam utique mihi, si in aliquo umquam eos offenderam—quod utique conscius mihi non sum—plenam prorsus rependere vicem. Mirum vero si non plus talione recepi."

532. The implied disparagement of traditional monasticism through his general efforts

As to why Bernard waited several years to write his letter to Robert, to answer this is to begin to show the impetus of the *Apologia* itself.

It is easy enough to explain why Bernard did not write at first. William tells us that in the early days of Clairvaux, this being the time that Robert was a monk there, Bernard was about as capable of coming to terms with the human frailties of his monks as light is capable of coming to terms with darkness. To be sure, he believed that those who fell to the graver sort of temptation were not really monks at all.[533] He himself admits as much in his letter to Robert. However, it is another matter to explain why he wrote this letter at the time that he did. The evidence mentioned above suggests that Bernard was under intense pressure for his open policy of accepting questionable transfers and of reforming Benedictine monasteries. This agrees with the message of *Ep.* 1, which is not Bernard's request for Robert to return—the entire central portion of the letter is not even nominally directed to Robert, but to the general public. The explicit message of *Ep.* 1 is concerned with the issue of the meaning of the monastic vow: whether the vows made by a person's parents when that person was chronologically immature are more binding than those made by the person himself as an adult, which leads to the implicit message of whether that person's monastic vow is kept at all when one stays at a monastery at which vows were made when that person was spiritually immature and so no more bound to be held to them than the former case was. Despite the necessity of dealing with the specifications of a real life situation, the undercurrent of Bernard's argument is theoretical: whether one is justified in leaving a place of stricter observance for one of less strict observance such as Cluny, and so the converse, leaving a place of less strict observance for one of stricter observance such as Clairvaux. In the course of this rhetorically quite shrewdly structured exposition, Bernard justifies his own position on accepting questionable transfers while masterfully showing that not only is he not alone in this practice, but that the very ones who complain of his doing so do so

at monastic and collegial reform was probably also a factor in this. The suggestion of a verbal campaign against Bernard is substantiated by his letter of a little after 1121 in support of William's brother whose monastery he was helping to reform (*Ep.* 83, v.7:216–218). In this he noted that he too was suffering from the plots and violence of worldly (i.e., not otherworldly, not reform minded) malice. As already mentioned, in December of 1124 Bernard felt he was being impugned before thousands of fellow monks (*Ep.* 7:19, v.7:45). And a few months after that in his letter to Robert he wrote that word had come to to him that Robert had been denouncing him recently at Cluny (*Ep.* 1:2, v.7:2). In *Ep.* 84[bis], v.7:219, probably written in the spring or summer of 1125, he repeats William's request for a defense of his position so that whatever ill those who believe that he is criticizing the Cluniac Order might have or "have wished others to have" would be known to be untrue.

533. William of Saint-Thierry, *Vita Prima* 1:28, PL 185:243.

themselves. To accomplish this he was obliged to show that the monastic vow was not being perfectly kept at certain traditional Benedictine monasteries. This argument took the form of a series of relatively unprogrammatic criticisms of practices involving food, clothing, manual labor, silence, bedding, vigils, fasts, travel, and the novitiate—criticisms which are secondary to the issue of stability and the fulfillment of the monastic vow. The pressure concerning questionable transfers appears to have built up on Bernard to the point that he felt himself forced to explain his position publicly. This is why Bernard waited several years to write to Robert. And this is why a letter written to a close relative about their personal relations should have had a public character. The case of Robert probably suggested itself because of general Cluniac leadership in the verbal campaign against Bernard, of which Robert's complaints against Bernard were said by the latter to be a part. Robert provided Bernard with the opportunity to publicly express his position in a way that could claim to be private while actually being public, and to be provoked rather than provoking. It was a way which both explained his position on questionable transfers and showed that his accusers were guilty of the same offense.

PETER THE VENERABLE'S LETTER 28 TO BERNARD

Despite the fact that many of the points raised in Bernard's letter from the spring of 1125 to Robert appear in Peter the Venerable's Letter 28, there is no evidence that Peter had seen Bernard's letter to Robert by the time his Letter 28 was written. Whether this is because the two were written concurrently, because it was an affair under the administration of Pons whose laxity Peter claimed he was now trying to correct,[534] or because Peter opted not to answer it directly as a result of its nominally personal character, the fact remains that Peter's letter is addressed to Bernard but answers a long schedule of complaints against Cluny not contained in either Bernard's *Ep.* 1 or the *Apologia*. Giles Constable believes that the schedule is an authentic recounting of certain criticisms and that these criticisms were made by unidentified monks of Bernard's from Clairvaux because of Peter's use of such expressions identifying the detractors as *quidam vestri*.[535] While

534. Peter the Venerable, *De Miraculis* 2:11, col.1309–1310, *PL* 189:921–922. However, one must be careful against ascribing any real moral degeneration at Cluny to Pons; see esp. Cowdrey 1978:200, 203–204, 244–245, 248. Reform in this period was not necessarily prompted by degeneration, but rather by accretions to the Rule. According to Bernard (*Ep.* 277, v.8:190), Peter began reforming his order almost immediately after his 1122 assumption of office.

535. Constable 1967:v.2:270–271.

this certainly seems to be the case, it also seems that by confronting the entire body of current debate as embodied in the schedule Peter made the Cistercians look quite petty for the most part, something he could not have done if he had publicly answered Bernard's letter—if indeed he saw that letter before writing his own. Whatever the timing of the two letters may be, the relationship between them and the *Apologia* is complex.[536] As neither Peter's Letter 28 nor the *Apologia* have been seen as containing any evident reference to the other, general opinion has assumed that they were written concurrently. Certainly, there is no overt correlation between Peter's Letter 28 and Bernard's writings, but it may be that there is a definite indirect one, as we shall soon see. For now, let us simply assume the precedence of Peter's Letter 28.

Constable suggests that the schedule may have been the report of an oral debate. Given that at least some of Bernard's monks traveled frequently and probably took part in monastic discussions in their travels,[537] something of the sort is likely. Furthermore, the schedule represents a position which was often too strident for Bernard, yet strident in a way which tended to focus on a totally rigid application of certain monastic principles. This attitude is entirely in keeping with that displayed by a group of novices attracted to Clairvaux sometime before 1121 who in their radical rejection of the most innocuous pleasures in monastic life actually opposed Bernard in his own monastery to the point of "murmuring"—a traditional term covering any complaints short of open rebellion—and soliciting outside opinion.[538] This would explain why Peter, even if he never saw or chose to ignore *Ep.* 1, addressed Letter 28 to Bernard.

Peter placed the schedule of Letter 28 immediately after his opening remarks, later refuting the points individually in detail. It consists of twenty criticisms of Cluniac monasticism which may very loosely be said to consist of the three broad categories of daily life, fine points of the Rule, and ad-

536. On the relationship between *Ep.* 1 and the *Apologia,* see the section "Cluny, the Cluniacs, and the Non-Cluniac Traditional Benedictines;" see also Van den Eynde 1969:395–396.

537. William of Saint-Thierry tells us that not just the residence of the bishop but the entire city of Châlons was like a home for the monks of Clairvaux (*Vita Prima* 1:31, PL 185:246). It is to be expected that Bernard's monks took part in the same discussions on their travels that Bernard himself admits to having in *Apologia* 4.

538. William of Saint-Thierry, *Vita Prima* 1:36–37, PL 185:248–249. William of Champeaux was asked to be the arbiter in this disagreement. If these murmurers were novices at Clairvaux before or during 1121, by the time of Peter's Letter 28 they could have been at Clairvaux, Troisfontaines (the closest of the Clairvaux filiations to Reims at the time of the 1119 Council), Fontenay (the closest of the Clairvaux filiations to Cluny at the time of the writing of the *Apologia*), or Foigny and could loosely be considered to be monks of Bernard's, having professed under him.

ministrative and economic policy.[539] Of these three categories, Bernard to-
tally ignores the fine points of the Rule in both *Ep.* 1 and the *Apologia*,
undoubtedly as being too petty; interestingly, he also avoids the specific
criticisms of Cluniac administrative and economic policy that appear in the
schedule, such as Cluny's insistence on papal exemption from episcopal au-
thority, the holding of secular churches, first fruits, and tithes, and the
holding of secular sources of income, all of which had come up at the 1119
Council of Reims. It is only on the questions of daily life that he takes a
stance, a compromise stance relative to the schedule.[540] The significance of
this is not that Peter and Bernard should cover certain of the same general
points, but that their arguments concerning those points, whether they
agree or disagree, should have a number of striking, specific parallels. But
first the immediate origin of the *Apologia* must be discussed.

The Immediate Origin of the Apologia

BERNARD'S EP. 89 TO OGER

The traditional view of the origin of the *Apologia* has been that at some
point after writing his letter to Robert, Bernard was asked by William of
Saint-Thierry to write the treatise that would become the *Apologia*.[541] Ber-
nard complied, addressing the treatise to William. But historians are sur-
prised as to why he then sent his preliminary draft to Oger, a canon regular
of Mont-Saint-Eloi near Arras. William, in fact, was the immediate cause of

539. Daily life: 2) the use of furs and leather garments, 3) the use of some sort of
garment underneath the habit, 4) excessive bedding, 5) the number and types of dishes,
7) neglect of regular fasts, 8) non-observance of manual labor.
 Fine points of the Rule: 9) non-observance of prostration before and foot-washing of all
guests, 10) neglect by the abbot of keeping a complete list of all monastery property, 11)
neglect of divine office when away from the church, 12) abbatial neglect of dining with
guests, 13) neglect of the practice of junior monks asking a blessing from senior monks
upon meeting, 14) neglect in assigning a wise old man as porter, 15) neglect of the porter in
calling out "deo gratias" or of giving a blessing when someone knocks at the door, 16) the
practice of repeating vows of stability, conversion of manners, and obedience at another
monastery.
 Administration: 1) the absence of a one-year novitiate, 6) repeated reception of one's
own monks after they had illegally left the monastery, 17) the practice of keeping question-
able transfers from other monasteries, 18) absence of traditional compliance with the rights
of the diocesan bishop, 19) the holding of secular churches, first fruits, and tithes, 20) the
holding of secular sources of income.
 540. The details and implications of this are discussed in the section "Cluny, the Clun-
iacs, and the Non-Cluniac Traditional Benedictines."
 541. The origins of the *Apologia* have been traced by a number of different authors, the
standard study being Leclercq's introduction to the critical edition.

Bernard's writing the *Apologia*. However, the evidence suggests that he did not initiate either the idea or the request.

Sometime in Lent of 1125 (February 11 to March 28), just around the time that Bernard's *Ep.* 1 was written and shortly before Bernard's *Ep.* 84^bis which repeats William's request that Bernard write a defense of his position, Oger wrote a letter to Bernard which is no longer extant.[542] In his reply, Bernard declined a request from him to undertake a written work of some sort, exactly what being unstated except for the fact that it was to involve a discourse by Bernard to others on virtue. It seems Bernard felt that not only would this detract from the interior silence required for his Lenten exercises but, more importantly for us, that "not only is the work which you desire to bring about concerning this affair not proper to my profession, what you wish me to perform is not within my ability The duty of the monk is not to teach, but to mourn But so that I may not seem to completely refuse what you have asked, I invite and challenge you and those who, like you, desire to advance in the virtues to cultivate [silence] . . . and if not orally by my teaching, then silently by my example so that perhaps I will teach you by silence to be silent, you who by speaking compel me to teach of what I am incapable."[543]

Bernard felt that Oger's request required an effort of instruction on his part and that—although a certain amount of humor is involved—by offering the example of a typically monastic virtue (silence), he had in however small a way partially fulfilled Oger's request. Only slightly less certain than two of our other three direct sources on the origin of the *Apologia*,[544] I believe that the instruction asked for by Oger and answered by Bernard with a reference to a monastic virtue was meant to be a monastic treatise along the lines of the *Apologia*. And the inclusion of others as recipients of Bernard's proposed teaching of monastic virtue suggests a larger audience, such as that to which Bernard referred in all of his later letters on the *Apologia*. Also, Bernard's reaction to both William's and Oger's requests was extremely similar: *huiusmodi operam dare iubes* (*Ep.* 84^bis); *huic rei operam dare quam postulas* (*Ep.* 89:2). Likewise, in both these letters he complains that he has neither the ability nor the leisure for such an undertaking. And in both the *Apologia* and his letter to Oger his reason for not wanting to

542. Although Van den Eynde (1969:395–396) dates Bernard's *Ep.* 1 to "1125, probably in the spring," his chronology is actually based on the opinion that it was written after *Ep.* 32 (1124, a little before November) and before the *Apologia*. There is absolutely no evidence to suggest that *Ep.* 1 was not written before *Ep.* 89, and Van den Eynde himself is quite clear about the necessarily general dating of many of Bernard's letters.

543. *Ep.* 89:2, v.7:236.

544. Bernard's *Ep.* 88:3 and *Ep.* 85:4 are to be taken up directly.

write are virtually identical: *praesumerem quod nesciebam* (*Apologia* 1); *praesumat docere quod nescit* (*Ep.* 89:2).[545] Nor is it any coincidence that in *Ep.* 89:1 Bernard complains of the difficulties involved in writing, the difficulties of determining exactly "what is more logical to the purpose, what is clearer to the understanding, what is more suitable to the sense, and what is to be placed where." These happen to be exactly the areas of concern discussed by William in the letter to which *Ep.* 84[bis] was the response and in *Ep.* 84[bis] itself.

From all this, I would suggest that, probably as a result of reading *Ep.* 1, Oger had been the first to contact Bernard concerning a treatise dealing with the regular life; that Bernard chose at the time not to take up the project; and that Oger (who we know from Bernard's letters was in contact with William) then got in touch with William, since William was a closer friend of Bernard's and a mutual sympathizer in the cause at hand, and asked him to put the request to Bernard. Bernard's statement in *Apologia* 1 that under other circumstances he might not have agreed at all to take up William's proposal may even be a reference to his refusal to Oger. The opening line of *Ep.* 84[bis] seems to imply that it was only the fact that it was specifically William who was the one making the request that caused Bernard to give in: "Since you ask me to apply myself to matters of this kind . . . I willingly accept."[546] In any event, Bernard complied with William, addressing the treatise to him. But the crucial role played by Oger earlier in this matter explains why Bernard sent the preliminary draft to him rather than to William, even though Oger was twice the distance from Clairvaux than William. This is why Oger was included in the power over certain editorial decisions that Bernard had bestowed on William, including the power to determine whether it would be publicly released, privately circulated, or set aside. This is why Oger took the initiative to send the draft of the *Apologia* to William without asking Bernard's permission. This is why when he did send the copy to William, Bernard dismissed his actions by saying that he had never intended that Oger should do so, but that he did not mind because of his affection for William—not, as one might expect, because William was the instigator of the treatise. This is why Oger was bold enough to compose a preface for the treatise from other letters of Ber-

545. Along the same lines he cites Jerome in both *Ep.* 89:2, v.7:236 and *Apologia* 1 as a support for his not writing on the grounds that he is a monk—both citations being from works of Jerome's which also were polemical.

546. "Quod me huiusmodi operam dare iubes . . . libenter accipio." Oger had originally asked for a rather long letter (*longiorem epistolam*; Bernard, *Ep.* 89:1, v.7:235), and Bernard himself describes the *Apologia* as a long letter in *Apologia* 15.

nard.[547] And, finally, this is why Oger is addressed in *Apologia* 30, an address which amounts to a public statement of his participation in the writing and dissemination of the *Apologia*.

BERNARD'S EP. 84[bis] TO WILLIAM

It was probably in the spring or summer of 1125 that William wrote to Bernard—in all likelihood at Oger's request, as I have said—asking him to defend an unspecified group, of which they were both members, from charges that they were detractors of the "Cluniac Order." While this letter is no longer extant, a large portion of Bernard's *Ep.* 84[bis] repeats the essential ideas expressed in William's letter. William's request was really for more than a defense, it was actually for a definition of position of that unspecified group, for in the same breath that he asked Bernard to proclaim that they were not slandering the "Cluniac Order," he also called for criticisms of certain excesses of that order. William also asked that this be done in a particular manner ("in the way you ask me to; *quemadmodum iniungis*"), a manner which I suspect may account for the pleasure Bernard said that he took in repeated readings of William's letter and which quite probably occurred to William, as it seems to have to Oger, from their reading of Bernard's *Ep.* 1 which had only just been written.

In *Ep.* 84[bis], Bernard reiterated William's proposed structure of the *Apologia*. William had suggested:

1. that Bernard refute the accusations that an undefined group which included Bernard and William were slandering the "Cluniac Order," and
2. that he criticize the excess of the "Cluniac Order" in food, clothing, and certain "other things."

Bernard responded that it might be best if he:

1. first praised the "Order,"
2. then declared that it was the detractors of the "Order" who were open to censure, and
3. finally took up the question of excess.

Keeping strictly along these narrow lines of thought, the actual structure of the *Apologia* may be said to be as follows:

547. Perhaps *Ep.* 1, 2, 7, and/or 11.

1. an introductory section, in which Bernard addressed William, laid out the problem, made some observations on the fruitlessness of ascetic practice stimulated by worldly pride rather than by a sincere desire to follow the example of Christ, and stated that the writing was addressed to William not because he was unfamiliar with Bernard's views on the subject but, quite the contrary, so that William might have an authoritative statement on the subject with which to counter their mutual critics,

2. a section in which Bernard combined both William's desire for a denial of detraction and his own device of praise of the "Order,"

3. a section devoted to Bernard's conviction that the detractors themselves were open to censure,

4. criticism of excess in the "small things," the condemnation of which is attributed in *Ep.* 84[bis] to William's impetus and which fall under the headings of food, clothing, and some "other things" mentioned by William and agreed to by Bernard,

5. criticism of the "things of greater importance," i.e., various problems arising from excessive art in the monastery, and

6. a concluding section which brought up, among other topics, the subject of monks from other communities and observances who had tried to transfer to the Cistercian Order.

This overview reveals a number of interesting facts concerning both the actual writing of the *Apologia* and the concepts behind it. To begin with, neither William's nor Bernard's structures include the ideas found in *Apologia* 1–3. This will be taken up in the following section. Next, aside from the *Apologia* 1–3, the actual structure of the *Apologia* follows a logical combination of William's and Bernard's tentative outlines up to the point of the "things of greater importance" (*Apologia* 28–29).[548] That is, Bernard followed William's suggestions and the order in which they were suggested, only inserting his own section against detractors between William's two sections. Lastly, and this is critical for our understanding of the *Apologia*, the evidence suggests that the section on the "things of greater importance" was not initiated by William.

William's list of excesses as related by Bernard in *Ep.* 84[bis] comprises "food and clothing and the other things which you add." This matches the list given in *Apologia* 16 which heads the section on excess, "food, drink, clothing, bedding, retinue, and the construction of buildings," to the degree that food (with drink subsumed under this heading) and clothing are specifically covered, leaving the possibility that bedding, equipage, and the con-

548. *Apologia* 30–31 essentially comprises concluding statements. On the issue of questionable transfers, see below.

struction of buildings were the "other things" mentioned by William. Yet, while the list of problem areas in *Apologia* 16 corresponds exactly with the actual outcome of the excesses raised in the *Apologia* in content and order of presentation up to the point of *Apologia* 28,[549] it does not correspond in key elements either to the information in *Ep.* 84bis or to the *Apologia's* two chapters on art. Bernard never really discusses the "construction of buildings" in the *Apologia*—at most he raises the subject only to drop it. He does, however, take up various other aspects of excessive art which can in no way be seen as synonymous with the "construction of buildings." This leads to the conclusion that if the list in *Apologia* 16 does indeed represent William's original request with the "other things" detailed, then it is highly unlikely that at the time of the writing of either *Ep.* 84bis or *Apologia* 16 Bernard interpreted the "construction of buildings" in the same way that he approached the subject of excessive monastic art in *Apologia* 28–29. Nor does it seem probable that Bernard would have enumerated the "small things" in *Ep.* 84bis while lumping the far more crucial "things of greater importance" with bedding and equipage under the "other things."

Did William actually suggest a section on excessive architecture, a section that Bernard never really took up?[550] William's writings show a notable tendency to strongly associate simplicity in architecture with the humility of spirit proper to a monk. Indeed, according to his own admission, it was the simplicity of the hut in which Bernard was living at the time of their first meeting that so profoundly impressed him concerning Bernard even before he actually saw him. And upon entering the hut he writes, "I swear before God that the house itself instilled an awe of him [Bernard], as if I were approaching the altar of God."[551] William ascribed a similar reaction to all who saw the monastery of Clairvaux for the first time, comparing the simplicity of its architecture to no less than the cave of Benedict at Subiaco.[552] In his definitive statement on excessive architecture in his famous *Golden Epistle*, William goes so far as to brand it as a quickly corrosive

549. The section on healthy monks who feign sickness in order to enjoy the less stringent dining regulations of the infirmary was not included in the first recension and is not considered here.

550. There is absolutely no information on Oger and the specific criticisms of the *Apologia*. In light of the mass of sources concerning William and Bernard, there seems to be no reason to ascribe any influence in the matter to him.

551. William of Saint-Thierry, *Vita Prima* 1:33, PL 185:246, "Deum testor, domus ipsa incutiebat reverentiam sui, ac si ingrederer ad altare Dei."

552. William of Saint-Thierry, *Vita Prima* 1:35, PL 185:247–248. William was also the source for the misunderstanding that Bernard was "insensitive" to architecture (*Vita Prima* 1:22, PL 185:239–240), see the section "Bernard and Curiosity."

influence on the spiritual life.[553] Yet despite the evidence of William's attitude toward architecture, he never mentions art in his writings before 1125, and even from his later writings nothing would suggest that he initiated Bernard's economic critique of monastic art.[554] Thus it seems that William suggested the topic of the "construction of buildings" to Bernard and that this was probably among the "other things" of *Ep.* 84[bis]. It also seems that by the time of the writing of *Apologia* 16, Bernard probably still envisaged his discussion on art in the same light as William—that is, as a simple attack against excessive architecture and nothing more. But some time after writing *Apologia* 16, Bernard significantly changed his course. Whether this was the result of pondering the moral issues involved in the excesses he was criticizing or whether it was from research he had apparently undertaken on the Fathers in preparation of his writing, Bernard virtually set aside the subject of architecture after the opening sentence of *Apologia* 28 in order to take up the "things of greater importance."

BERNARD'S EP. 88 TO OGER AND EP. 85 TO WILLIAM

The remaining two sources dealing with the origin of the *Apologia, Ep.* 88:3 (summer 1125) and *Ep.* 85:4 (summer or autumn 1125), have as their subjects the revision of an already written draft. Leclercq has determined that this is a non-extant preliminary draft.[555] From *Ep.* 88:3, we know that Bernard had sent a booklet (*libellus, opusculum*) to Oger who had it copied without Bernard's permission and who then sent a copy of it to William. In giving Oger and William certain joint editorial powers over the work, Bernard submitted to both of them whether a certain preface (*praefatiuncula*)

553. William of Saint-Thierry, *Ad Fratres* 147–158, p.258–268. For other comments on architecture see *Vita Prima* 1:36, *PL* 185:248; *Super Cantica* 194, p.384.

554. Later writings of William show a resolute stance against excessive art at the expense of the poor (*Ad Fratres* 148, 158, p.260, 268) and against art as a distraction (see the section "Bernard's Concept of Artistic Distraction")—the latter despite the fact that as a Cistercian he could recommend art as a spiritual aid for spiritual novices (*Ad Fratres* 173–174, p.282–284). William also showed a normal respect for art; *De Natura Corporis* 2:14, *PL* 180:723. However, the closest William comes to even hinting at an economic critique of art is his statement that art and architecture are used by the good and misused by the bad (*Ad Fratres* 58–59, p.190). For separate similes which compare creation with the acts of painting and stone sculpture, see *Ad Romanos* bk.5:8:19, *PL* 180:634, and *De Natura Corporis* 2:2, *PL* 180:710. For the use of repoussé in a divine simile, see *Ad Romanos* bk.2:3:27, *PL* 180:579. In *De Natura Corporis* 2:5, *PL* 180:715 he follows the venerable Platonic tradition of likening God to an artist (on this tradition see Leclercq 1984:70–71; Schapiro 1977:8n.10). His account of a vision related to the site of Clairvaux II (*Vita Prima* 1:34, *PL* 185:247) is notably similar to Bernard's *Vita Sancti Malachiae* 63, v.3:367–368.

555. Leclercq 1957:v.3:65–66.

already put together by Oger from an earlier letter of Bernard's was acceptable (which he evidently did not think was the case but which he was trying to put softly) or whether it might not be better to write a new one.[556] Although nothing proves with absolute certainty that Bernard was speaking about the *Apologia*, it has been the convincing circumstantial evidence of the connection of this booklet with the names of William and Oger—both of whom are linked in the *Apologia* to its instigation or dissemination— and the very real caution with which he treats its publication that has led to its universal acceptance as referring to the *Apologia*.[557]

Likewise, *Ep.* 85:4 to William cannot be seen as infallibly referring to the *Apologia*, although scholars have also believed this to be so.[558] Having given Oger and William control over the preface in his letter to Oger, Bernard now discusses the subject with William, stating that the preface which William had asked to be sent to him was not yet ready, that he had not yet composed it because he didn't think it was necessary.

Thus it seems that Bernard's preliminary draft was without a preface. Yet, as Leclercq has noted, the *Apologia* as it stands in the first and second redactions is in no need of one.[559] If, as the documents suggest, a preface is contained in the *Apologia* which was imposed by William and Oger and which Bernard was resistant to adding, then it is of some interest to determine where Bernard originally started the tract in order to more clearly comprehend his original tone and intention, as well as to follow his original enunciation of to whom exactly he felt he had to justify himself.

In my discussion of *Ep.* 84^bis, I showed that there exist three patterns of structure proposed for the *Apologia*: two general ones in *Ep.* 84^bis and one dealing with only the area of excess in *Apologia* 16. I also showed that all of these correspond perfectly to *Apologia* 4–27 and that *Apologia* 28–29 originated with Bernard, with *Apologia* 30–31 more or less comprising concluding statements. Now, the first proposition of the general structures as outlined by William and Bernard distinctly and forcefully begins with *Apologia* 4. It is only with *Apologia* 4 that Bernard took up in earnest his denial of any calumny: it is here that his justification proper begins. The relatively amorphous first three chapters unquestionably build up at the

556. Leclercq (1957:v.3:68–69) feels that nothing in the beginning of the *Apologia* justifies the belief that this effort of Oger's is contained there.

557. Leclercq 1957:v.3:63–65.

558. His closing statement, "May he who has caused you to wish also cause you to accomplish whatever you wish for yourself or for your friends by virtue of your intentions," is certainly in line with the undercurrent in *Ep.* 84^bis that Bernard is defending a particular group of individuals at the request of William.

559. Leclercq 1957:v.3:65.

end of *Apologia* 3 to a presentation of what follows, yet the tone of what follows gives the impression of being independent of what precedes. And *Apologia* 4 begins with a clarification of one of the immediate reasons for writing, the accusation that Bernard had been denigrating the "Order" in public and/or in private, a clarification which needed no restatement as it had already been alluded to twice in the previous chapters. *Apologia* 4 also takes up the question of questionable monastic transfers, a question to which Bernard returns in the concluding section of his treatise as he briefly does to several other subjects, such as his criticism of detractors, of those who practice excess, and of praise of the "Order," all of which are taken up only after the first three chapters. Furthermore, while the first three chapters are written in a method of address which is ostensibly a semi-personal conversation between Bernard and William for rhetorical purposes, *Apologia* 4 introduces a general tone which may better be described as directed toward the monastic public using William as the rhetorical vehicle.

The evidence suggests that the no longer extant preliminary draft of the *Apologia* was without what William and Oger considered to be a suitable preface, that that preface had been added before the completion of the first redaction, that *Apologia* 1–3 constitutes that preface, and that Bernard's preliminary draft must have begun with *Apologia* 4. In its rhetorical self-chastisement, this added preface toned down, however slightly, the unyielding—yet equanimous—defense of Bernard's denial of any detraction on his part. It must have been the absence of any rhetorical remorse, any presence of a disarming or even softening concession before the almost challenging tone of the opening of *Apologia* 4 burst forth that made William and Oger so insistent that chapters 1 to 3 be added.

THE *APOLOGIA* AND THE "PRESSING NEW SITUATION"

After Bernard gave in to the urging of William and Oger concerning the preface, he made the extant first redaction available to them for revision. It is the result of this revision, the second redaction, which is translated here.[560] Aside from softening the opening of the *Apologia*, the preface insisted upon by Bernard's friends also offers a previously overlooked clue in the actual address as to at least part of the "pressing new situation" mentioned in *Apologia* 1.

560. For a complete account of the technical aspects of the writing of the *Apologia*, see Leclercq 1957:v.3:63–79. Leclercq also details the revisions between the first and second redactions which, however, have no bearing on the subject at hand; for translations of those passages as they stood in the first redaction, see the commentary.

Even before the reader is presented with Bernard's views on monastic unity, detraction, and excess, even before he reads the first word of *Apologia* 1, he is confronted in the *intitulatio* with Bernard's self-bestowed epithet, "the unworthy servant of the brothers who are at Clairvaux." This reference to Luke 17:10 appears in absolutely none of the *intitulationes* of Bernard's other treatises and in less than 1 percent of his 547 extant personal letters.[561] If it is not an epithet often used by him, why should he have chosen it to head a treatise so sensitive that he was unsure whether it should ever be shown to anyone at all?

Interestingly, Luke 17:10 also received prominence in Peter the Venerable's Letter 28. Immediately following the schedule of charges with which he opened, Peter fires a short but powerful blast at those who were behind the schedule before he takes up its points one by one. Among other things, he answers the schedule's accusation that the Cluniacs were not fulfilling their vow to observe the Rule of Saint Benedict by turning it back on its authors, charging that it was they who left their vows unfulfilled. Citing the seventh step of humility from chapter 7 of the Benedictine Rule, Peter chastises his accusers for their pride in their supposed observation of the Rule, declaring that in reality it is they who do not observe its commandment that the monk is not only to say that he is lower and meaner than all others, but that he is to believe it in his heart as well. He then asks if they have fulfilled this requirement in their extolling of themselves and their condemnation of the Cluniacs when Luke 17:10 prescribes that "when you have done all that is required of you, say, 'We are worthless servants.'"[562] It is no coincidence that both authors should have cited the same Biblical passage, nor is it that Peter should have described Bernard as learned in divine literature in the beginning of Letter 28.[563] Only a very short time before Bernard's *Ep.* 89 and *Ep.* 88 to Oger were written, Bernard had published his *De Gradibus Humilitatis et Superbiae*, based on chapter 7 of the Rule of Saint Benedict, a work which was deeply concerned with the cultivation of the monastic virtue of humility. In this work, Bernard himself discusses the seventh step of humility referred to by Peter, and in a different passage puts forth the example of those who do all that is required and then call themselves unworthy servants, citing Luke 17:10.[564] Bernard must have been quite sensitive to the position he was in, not only in relation to

561. See *Ep.* 37, 399, 400, 408, 498. Two of these appear in letters to Benedictine abbots and are conflated with Gregory the Great's popular variation of Gen 9:25, *servus servorum Dei*.

562. Peter the Venerable, Letter 28, v.1:57.

563. Peter the Venerable, Letter 28, v.1:53.

564. Bernard, *De Gradibus Humilitatis* 43, 18, v.3:49–50, 29.

that particular treatise but also to the subject of vows raised in his letter to Robert, saying in *Apologia* 3, "For who is more impious, the one who professes impiety or the one who feigns sanctity? . . . What can I say? I am afraid that I may be held in suspicion." Peter apparently gave Bernard the benefit of the doubt in an attempt to defend his party without needlessly escalating the situation. Bernard recognized this and made public concession in an equally discreet yet undeniable manner, making his very *intitulatio* a statement of disassociation with the position of the detractors William had asked him to deny and which he himself was about to attack with force in *Apologia* 10–14. It was, given the circumstances of his recent publications, a very clear profession of humility.[565]

In the same key passage of Peter's Letter 28, Peter calls his opponents "pharisees," a term Bernard also applies to detractors in *Apologia* 1 and returns to in *Apologia* 10 and 11. Peter associates this term with the Cistercian proclivity to distinguish themselves from the rest of monasticism by their dress and other practices, and this too is its association in *Apologia* 1. One of the modifiers used by Peter, *singulares*, relates not only to the very passage referred to in the discussion of chapter 7 of the Rule of Saint Benedict in *De Gradibus Humilitatis* mentioned above, it also corresponds to the chapter before it where Bernard himself cited the example of the pharisee, and to *De Gradibus Humilitatis* 17—perhaps the source of Peter's inspiration—where the theme of the pharisee comes up in association with that particular modifier.[566] Reference to the pharisee comes up indirectly as well elsewhere in Letter 28 and the *Apologia* in the phrase from that Biblical passage, "one ought to do the former, and not neglect the latter"—an important point in both Peter's and Bernard's criticisms of detractors and an apparent recognition of and reference to Peter's letter by Bernard for those who were current with the debate.[567]

The idea that Bernard's section against detractors was simply a rhetorical device intended to throw the Cluniacs off their guard should be put away

565. Bernard's awareness of his precarious position probably also accounts for the very close parallel between his passage on the monk who desires singularity in *De Gradibus Humilitatis* 42, v.3:48–49 ("Nec tamen melior esse studet, sed videri") and the similar description applied to himself in *Apologia* 2 ("studeo non esse vel potius non videri sicut ceteri hominum").

566. Peter the Venerable, Letter 28, v.1:57, see also v.1:94; Bernard, *De Gradibus Humilitatis* 42, 43, 17, v.3:48–50, 29. Cf. Bredero 1956:58n.15, but also the later Bredero 1971, esp. p.148.

567. Peter the Venerable, Letter 28, v.1:73; *Apologia* 13. There is a possibility that the discussion of the different paths (*semitae*) to heaven in *Apologia* 8 and 9 took as its impetus the opening line of the schedule (Peter the Venerable, Letter 28, v.1:53) which states that the Cluniacs were following unknown paths (*ignotas semitas*).

once and for all. Any rhetorical advantages Bernard reaped from it must be seen along with the facts that he chose to ignore many of the detractors' propositions as too petty in the schedule, that he openly disagreed with others, and that their brand of superiority was at odds with Bernard's other writings, such as *De Gradibus Humilitatis*. In fact, it seems to be specifically the "certain of your people (*quidam vestrorum*)" mentioned by Peter as authors of the schedule that Bernard is referring to in the opening sentence of his section against detractors saying, "Certain members of our Order (*quidam de Ordine nostro*) have been complained of to me."[568] And just as Peter went on to sarcastically describe these detractors as true observers of the Rule, the only truly holy monks in the world, who branded the others as transgressors, so Bernard chastised them for describing themselves as the only monks who live regularly, for considering themselves as holier than all others, and for calling all others transgressors.[569] But these instances of parallelism are only isolated elements. On a more general level, it is to Peter's discussion of humility and love (*caritas*) in Letter 28 that one may look for the direct stimulus to Bernard's response on the same subject, a subject which was never suggested by William.

After this initial disassociation, Bernard made a number of other positive references to Peter's Letter 28 before taking up the question of excess. The relation between Bernard's expression "If this were the case then the Rule would not be a rule, since it would not be right," and Peter's "For if the rightness of the Rule ceased, it would not be able to remain a rule" seems clear.[570] And so it is with a number of points in the schedule which Bernard disagrees with, such as furs, food, drink, and manual labor, al-

568. Peter the Venerable, Letter 28, v.1:53; *Apologia* 10.

569. Peter the Venerable, Letter 28, v.1:57–58, "veri observatores regulae . . . vos sancti, vos singulares, vos in universo orbe vere monachi . . . voti nostri nos nitimini ostendere transgressores." *Apologia* 10, "Dicitis, ut dicitur, solos vos hominum esse . . . omnibus sanctiores, solos vos monachorum regulariter vivere, ceteros vero Regulae potius existere transgressores." Peter and Bernard bring up these and similar points elsewhere. Bernard's "Tu ergo cum de horum observatione elatus, aliis eadem non observantibus derogas, nonne te magis transgressorem Regulae indicas?" (*Apologia* 13) may correspond directly to the closing statement of the schedule, "In his omnibus professionis et voti vestri transgressores vos esse apertissime ostendimus. . . . Nos vero haec omnia uti praecipiuntur observamus, et ex integro quicquid in regula tenenda Deo promisimus custodimus." See also Bernard's discussion of his sixth step of pride (which corresponds to Benedict's seventh step of humility mentioned above) in which he condemns the prideful monk who believes in his heart that he is holier than all others; *De Gradibus Humilitatis* 43, v.3:49–50. Also cf. Peter the Venerable, Letter 28, v.1:57, "aliorum facta deprimere, sua extollere"; and *Apologia* 13, "temetipsum extollis . . . alios deprimis."

570. "Alioquin Regula iam non est regula, quia non recta," *Apologia* 11; "Si enim rectitudo regulae desit, regula iam constare non poterit," Peter the Venerable, Letter 28, v.1:90.

though he later cites some of them from a different angle.[571] On the question of furs or leather garments, Bernard seems to have taken up two of Peter's excusatory examples; on manual labor his prototype of Mary and Martha; in general discussion his borrowed allegory of the gnat and the camel; and as a recurrent theme in this section, Paul's dictum that manual labor is of value to a degree, but piety is of value in every way.[572] Again, these individual elements are only symptomatic of a larger parallel, that of the question of dispensation of the Rule, an issue on which Bernard agrees with Peter.[573] Bernard is not borrowing these citations from Peter, but is agreeing with him for all to see.

It is quite another case in the section on excess. Having just agreed that mutation of the Rule is acceptable, Bernard begins his section on excess with a second recognition of the possibility of change, going on to describe a host of abuses. The reason these are tolerated is love (*caritas*), but this, he says, is contrary to logic, for "that kind of love destroys love." The argument that the Rule may be altered on the grounds of love happens to be precisely Peter's primary rationale on this subject.[574] Likewise, Bernard's *vera caritas* of *Apologia* 19 seems to directly refer to Peter's discussion of love.[575] These are not attacks on Peter, but rather indirect responses to Peter made by Bernard in order to make a clear distinction as to where Peter's position lets off and his begins on this key issue. Thus when Peter compares love to the *materfamilias*, later referred to as a *domina*, we understand the meaning of Bernard's otherwise inexplicable comment in his initial rejection of the love-rationale in *Apologia* 16 that that sort of mercy is "to feed the maid and to kill the mistress (*dominam*)."[576]

Although Bernard is careful to make known his acceptance of "Cluniac"

571. See *Apologia* 12 for his disassociation from the schedule on these points.

572. *Apologia* 12; Peter the Venerable, Letter 28, v.1:62–63 (furs; Bernard repeats the examples of John the Baptist and Benedict, the two monastic prototypes par excellence for the West; it is possible that Peter's long list of prototypes in this section spurred Bernard on in his numerous prototypes for food, drink, and manual labor), 70–71 (manual labor; see also *Apologia* 5, 13), 66 (gnat and camel), 92 (1 Tim 4:8 also comes up twice in *Apologia* 13).

573. There seems to be a specific parallel along these lines on the one hand with Peter's references to the Cistercian claim that one either harms the Rule by changing it or one adheres to it in complete obedience, and if one thing is lacking, all the rest are worthless and on the other hand with Bernard's more direct citation of Jas 2:10, he who offends in one thing is guilty of all (Peter the Venerable, Letter 28, v.1:98; *Apologia* 14). On this in general, see *Apologia* 14 and Peter the Venerable, Letter 28, v.1:66–68, 89–101.

574. *Apologia* 16; Peter the Venerable, Letter 28, v.1:91, 97–100.

575. Peter the Venerable, Letter 28, v.1:88–93, 97–100.

576. Peter the Venerable, Letter 28, v.1:96. There is no parallel between Bernard's expression and any of the medieval proverbs and sayings found in Walther 1963.

customs as instituted by the Fathers in contradiction to the authors of the schedule—indeed, this is one of the first points made in the original prefaceless draft—he refuses to recognize certain excesses that have accrued as having originated with the Fathers in his section on excess.[577] One of the major questions along these lines is excess in clothing. And one of Bernard's major arguments against excess in clothing—referred to four times in one chapter alone—was the example of the Apostles who made distribution to each according to his need (Acts 4:35). As we by now might expect, this was also one of Peter's prime defenses, being resorted to no less than five times, two of which appear in his defense of Cluniac practices regarding clothing.[578] Peter's use of this Biblical passage as a justification for excess is taken up and corrected by Bernard, who gives what amounts to an exegesis on the verse as it pertains to monastic life, concluding contrary to Peter that the apostolic model proscribes excess. Bernard also answers Peter indirectly over the question of pride and the monastic habit. Peter criticizes the Cistercian adoption of the unusual color of their habit as a means of setting themselves apart from other monks, noting that the traditional habit had been adopted by the Fathers through humility. Bernard, in his turn, bemoans the sartorial vanity of contemporary monasticism, saying that the habit "used to be a symbol of humility, [but] is worn by the monks of our time as a sign of pride."[579]

In the end, it cannot be proven beyond the shadow of a doubt that Peter's Letter 28 appeared before the *Apologia* and that the *Apologia* indirectly refers to it. However, given the previous evidence and Vacandard's argument that internal evidence in Peter's Letter 28 indicates Bernard had

577. *Apologia* 4, 16, 23; cf. Peter the Venerable, Letter 28, v.1:53, 93.

578. *Apologia* 24; Peter the Venerable, Letter 28, v.1:59, 62, 64, 67, 68. It is used three times in conjunction with Benedict of Nursia, *Regula* 34; cf. Acts 2:45. Acts 4:35 is also cited in *Regula* 55 on clothing, and Bernard undoubtedly is referring to this. But his citation of Acts 4:32 shows that he also has the apostolic model prominently in mind.

579. *Apologia* 25; Peter the Venerable, Letter 28, v.1:57. Bernard's repeated referrals to the authority of the Rule on the subject of monastic clothing also seem to be in response to Peter's discussion of the Cistercian habit. In his statement following the schedule, Peter criticizes the Cistercian preoccupation with the color of their clothing (i.e., uncolored or "white"), citing the Rule which admonishes the monk to be indifferent to the color and texture of their clothes (Benedict of Nursia, *Regula* 55). Bernard seems to have answered Peter on this point by substituting that part of the passage which Peter neglected to quote: that the monk should obtain whatever is locally available and inexpensive; Peter the Venerable, Letter 28, v.1:57; *Apologia* 24, 25, 26. A slight possibility also exists that Bernard's references to the "Cluniac" justification for excess in clothing, horses, and bedding as due to *honestas* and *cultus munditia* (*Apologia* 16) comes from Peter's defense of *femoralia* about which he said, "mundiciae et honestatis nobis defendimus."

not yet entered the debate,[580] it seems probable that on the one hand Bernard felt the need to publicly define the position of himself and his group, and on the other to avoid an escalation of the conflict by publicly refering to Peter's letter—something which would have been at odds with the aims of the *Apologia* anyway.

For ultimately, the "pressing new situation" that forced Bernard to write seems to have been a general threat of division within monasticism. That traditional monasticism should have been under attack from the episcopacy was nothing new. And that it should have been criticized by influential monks and hermits was not surprising in itself. But these combined with a broad and highly successful reform movement within monasticism which both implicitly and explicitly challenged a major wing of the Church—a wing which was too firmly established to simply disappear. While very sound in terms of discipline, traditional monasticism was an open target to charges involving the economic basis of social entanglement and its consequences. Peter's letter tells us that Bernard's people were involved. The *Apologia* tells us that Bernard himself saw his policy of accepting questionable transfers as a significant factor. This situation was apparently aggravated by a verbal campaign against Bernard, as well as by statements made by Bernard himself in public and private.[581] This, and undoubtedly Bernard's letter to Robert, induced Peter to address his Letter 28 to Bernard without, however, referring directly to that letter. It seems that Peter's letter may have been one of the factors that convinced Bernard, and William, that the situation in God's kingdom had reached the point of scandal.[582] The scandal Bernard refers to was not the prosperity of traditional monasticism but rather the crisis of disagreement brought about by that prosperity, and so the general themes of humility, love, and Church unity found in the *Apologia*. But for a number of reasons, Bernard chose not to respond directly to Peter. Indeed, the *Apologia* is in no way addressed to either Cluny or traditional Benedictine monasticism alone, as we have seen. At least one of these reasons was that Bernard was not in total agreement with the schedule of Letter 28, despite certain remarks made by him in *Ep. 1*. But Bernard's analysis of the crisis of prosperity went far beyond

580. Vacandard 1902:v.1:103n.1; cf. Peter the Venerable, Letter 28, p.101, "Haec tibi . . . scripsi. . . . Erit amodo tuum si aliter senseris, et hoc quoque michi tuo per omnia revelare."

581. *Apologia* 3, 4, and perhaps 1 and 31. See also Bernard, *Ep.* 17, v.7:65. "Private" refers to the semi-public conditions of the rooms off the cloister; see Horn 1979:v.2:337, 345–347.

582. Bernard, *Ep.* 84[bis], v.7:219.

the limits of either Cluny or the "Cluniacs," as it went beyond William's and Peter's conceptions of that crisis. Having agreed to William's request for a treatise on the subject—essentially a definition of position—Bernard came to the realization that the crisis went far deeper than the "small things" enumerated by William or even the legal questions of the holding of episcopal rights and secular properties mentioned in the schedule, which he shrewdly avoided. In the course of analyzing the crisis of twelfth-century monasticism, Bernard gradually saw the major problem largely in terms of the economic basis of social entanglement, but not in the sense that it was condemned at Reims and in the schedule. To Bernard, the "things of greater importance" played a significant role in this socially based monastic crisis, gravely undermining the monastic position in general.

APPENDIX 2:
THE TEXT AND TRANSLATION OF THE *APOLOGIA* WITH ART HISTORICAL COMMENTARY

Schapiro was referring only to *Apologia* 28–29 when he said that every sentence of Bernard's "letter" opens up perspectives of the Romanesque world.[583] Indeed, one would be hard-pressed to find a sentence in these two remarkable chapters which does not warrant the closest attention. The primary purpose of this art historical commentary is to elucidate those elements in Bernard's chapters on art which do not lend themselves to treatment in the discussion of the "things of greater importance." However, an art historical understanding of Bernard's treatise is dependent on those historical factors taken up previously in this study, and so at least some attempt has been made to gloss the entire work, but only as it pertains to the basic issues already raised. Thus, this commentary aims at a number of different things in its presentation: the structure of the *Apologia*, Bernard's flow of argument, the literary tradition in which Bernard stood, the literary sources upon which he depended, the significance of the elements of his artistic discussion, and the various indications throughout the text of its intention, address, and limits.

I have taken up Bernard's literary tradition and his relation to patristic authority only as they apply to an understanding of the "things of greater importance" and not as an aspect of Bernardine literary criticism. In terms of his literary tradition, my goal has been to show that while the *Apologia* may be a very unique document indeed, its general themes were for the

583. Schapiro 1977:6.

most part traditional and were seen as such by his contemporaries; and so the many literary references given in this study. Precedent and tradition, of course, only increased the legitimacy of Bernard's arguments and therefore the potential for applicability to works of art. It has been said that as an author, Bernard was "hopelessly unoriginal," but that without copying he took his subjects from the patristic tradition and presented them in such a way that they appeared new.[584] While the first characterization may be a little strong, the general idea is quite succinct.

Bernard's handling of a particular reference to Jerome in *Apologia* 1 is an excellent example of this attitude toward sources in the *Apologia* at its best. The original expression of Jerome is, "de cavernis cellularum damnamus orbem, si in sacco et cinere," from which Bernard gave, "in pannis et semicinctiis, de cavernis, ut ille ait, dicimur iudicare mundum."[585] Paying only the most cursory attention to Jerome's vocabulary, Bernard rephrased the expression, retaining the literal meaning and significance of the citation, while at the same time making it more applicable to the contemporay situation. In the most narrow terms, Jerome both protested his innocence against false charges in a local monastic controversy and condemned the phenomenon of monks criticizing those around them. He claimed that his letter was occasioned by the request of one who was already quite familiar with his views on the subject, despite his resistance to entering the dispute. Thus, Bernard used the literal meaning of the impropriety of monks passing judgment on others while at the same time taking advantage of the broader context of the letter—not exactly drawing a parallel between himself and the saint, but not denying it either if the better-read among his readers chose to recognize the similarity of positions. Finally, his choice of vocabulary reflects contemporary usage.[586] In general, this method may be said to apply to much of Bernard's literary references in the *Apologia* including those from Scripture, in the study of which Bernard was described by a contemporary non-friend as the most distinguished person since Gregory the Great.[587]

584. Waddell 1979:xvi, xviii.

585. Jerome, Letter 17:2, v.1:52, "from the holes of our cells we condemn the world, in sackcloth and ashes"; Bernard, *Apologia* 1, "[we who] in rags and tatters and from [our] holes, as he [Jerome] says, are alleged to pass judgment on the world."

586. See Casey 1970:34:n.2 on the possible meaning of *semicinctium*; see Bernard, Letter 237:2, v.8:114, and the *Usus Conversorum* ch.16, p.241, for contemporary uses of *pannus*. Jerome was an established model for letter writing and especially for monastic asceticism; Leclercq 1974:123.

587. John of Salisbury, *Historia Pontificalis* 12, p.26–27, "The abbot [Bernard] for his part, as his works show, was so distinguished a preacher that I can think of no one after

But there is more to Bernard's dependence on the Fathers than that. The reason for Bernard's heavy reliance upon authority is, actually, of more importance than the fact of its existence and is crucial to an understanding of his position on art. Not only did Bernard subscribe to the view that he and his generation were intrinsically inferior to the Fathers,[588] he was adamant in his self-insistence on orthodoxy to the point of publicly declaring that if anything he said in the belief that it was orthodox should ever be shown not to be so, then in advance he retracted his views in order to remain in conformity with the Roman Church.[589] In short, he believed that only those views which were authentic and traditional and which bore the mark of orthodoxy were worthy of dissemination,[590] and to anything else he was reluctant to agree.[591] Furthermore, he saw his writing as the words of Scripture or of the Fathers rephrased and somehow made his own.[592] What all this means in regard to art history is that Bernard was not expressing his personal opinion, but rather his public position—which is of far more interest and importance—and that this position was attuned to a relative constant throughout the Middle Ages which was based on the patristic literary tradition.

TECHNICAL ASPECTS OF THE *APOLOGIA*

The edition of the *Apologia ad Guillelmum Abbatem* used and translated in this study is that which appears in the critical edition of Jean Leclercq and Henri Rochais' *Sancti Bernardi Opera*,[593] which has replaced the centuries-old standard of Mabillon with its misleading "preface" consisting of Bernard's Letter 84^bis.[594] The basic textual studies on the *Apologia* are Leclercq's introductions to the Latin text and to the first complete English translation of 1970.[595] For the purposes of this commentary, it is enough to say that it is

Saint Gregory comparable to him: he surpassed all in the elegance of his style and was so saturated in the Holy Scriptures that he could fully expound every subject in the words of the prophets and apostles. For he had made their speech his own, and could hardly converse or preach or write a letter except in the language of Scripture."

588. Bernard, Letter 174:1, v.7:388.

589. Bernard, Letter 174:9, v.7:392. Cf. Augustine, *De Trinitate* 1:2:4, 1:3:6, 5:1:1, p.32, 34, 208.

590. Bernard, Letters 174:2, 398:2, v.7:389, v.8:378.

591. Bernard, Letter 174:2, v.7:389.

592. Bernard, *De Gratia* 46, v.3:199; *In Laudibus Virginis Matris* 2:14, 3:1, v.4:31, 35–36. See Gilson 1940:20–21, 46.

593. Bernard, v.3:80–108.

594. *PL* 182:893–918.

595. Leclercq 1957:v.3:63–79; 1970b:3–30. A number of other studies, some of which have been superseded by the later works, may be found in Leclercq 1962, particularly

known that there were three drafts of the *Apologia:* a rough draft (no longer extant), a first redaction (extant), and a second redaction (translated here with major differences between it and the first redaction noted).[596] As to the title of the treatise, Bernard himself called it an *epistola* (*Apologia* 15), a *libellus* (Letter 88:3), an *opusculum* (Letter 88:3, *Apologia* 30), and an *apologia* (Letter 18:5), although the most common usage in early manuscripts is *Apologeticus.* A number of variations exists.[597] There were no divisions or chapter titles in the first redaction, and those in the second redaction often vary considerably. Leclercq thinks that they may have been worked up during the lifetime of Bernard and that a few of them may even be by Bernard.[598] This is the only technical point on which I dare to disagree with the editor of Bernard's works, ignoring chapter titles completely in the commentary as being by someone other than Bernard.

As to the structure of the *Apologia*, it is the outcome of a gradual process:

The structure proposed by William[599]

1. *Apologia* 4–9: a justification to those who complained of Bernard and his group as detractors of the Cluniac Order: the apologia proper.
2. *Apologia* 20: criticism of excess in food.
3. *Apologia* 24–26: criticism of excess in clothing.
4. *Apologia* 21 and 27: probably the criticism referred to as "the other things which you add."

The structure proposed by Bernard[600]

1. *Apologia* 4: praise of the "order."
2. *Apologia* 10–14: criticism of detractors.
3. *Apologia* 16–27?: criticism of excesses.

v.1:243–244 (successive forms of the *Apologia*), v.2:123–126 (the early question of whether the *Apologia* was composed of two of Bernard's letters), v.3:18f. (on the "prologue" of the *Apologia*), 81–84 (models of Bernard's), 110f. (the composition of the *Apologia*), 274f. (Bernard and the Benedictine Rule), and 296f. (Bernard in the literary tradition).

596. Leclercq 1957:v.3:63–68, 74–76.

597. Leclercq 1957:v.3:74–75. The wording of these variations often tends to express a pan-monastic conception of the tract rather than the narrower "Cluny-Cîteaux controversy" idea current today.

598. Leclercq 1957:v.3:68, 75–76. Leclercq does not state which titles he believes Bernard may have written.

599. As repeated by Bernard in Letter 84[bis], v.7:219.

600. Bernard, Letter 84[bis], v.7:219.

The actual structure of the Apologia

1. *Apologia* 1–3: preface.
2. *Apologia* 4–9: the apologia proper.
3. *Apologia* 10–15: criticism of detractors (*Apologia* 15 constitutes the transition to the following section).
4. *Apologia* 16–27: the "small things."
5. *Apologia* 28–29: the "things of greater importance."
6. *Apologia* 30–31: conclusion.

Thus, the eventual structure of the *Apologia* was the logical combination of William's suggestions and Bernard's reactions to them (comprising an apologia proper, a section against detractors, and the "small things"), along with the solicited preface, the addition of the "things of greater importance" only after *Apologia* 16 had been written, and a conclusion.[601]

Finally, this translation was not made for literary enjoyment or spiritual edification, but rather for historical purposes. I have tried to make it as literal as possible, following Bernard's grammar, syntax, and vocabulary as closely as could be done without becoming awkward. I have not hesitated to borrow frequently from earlier English translations when I have found their choice of wording to be closest to my reading of the original.[602]

References in the Commentary section designate page and line numbers as they appear in Leclercq and Rochais' critical edition, whose pagination and lineation have been followed here with their pagination appearing in brackets at the bottom of each page of Latin text.

601. See Leclercq 1970b:14 for a more detailed literary outline of the *Apologia* which, however, does not take Bernard's own division of "small things" and "things of greater importance" into consideration.

602. Cf. the Cistercian Fathers translation by Michael Casey, whose intent is literary and spiritual; Casey 1970:3–69; on Casey's translation see Norton 1983:71n.8. Cf. also Coulton 1910:70–72 for a translation of *Apologia* 28–29; and Panofsky 1979:25 for a translation of *Apologia* 29. It should be noted that almost every translation of any length of the *Apologia* in any language suffers from misleading interpolations.

APOLOGIA AD GUILLELMUM ABBATEM

Venerabili Patri GUILLELMO, frater Bernardus,
fratrum qui in Claravalle sunt inutilis
servus:

salutem in Domino.

I. 1. USQUE modo si qua me scriptitare iussistis, aut invitus, aut nullate-
nus acquievi: non quia negligerem quod iubebar, sed ne prae-
sumerem quod nesciebam. Nunc vero, nova urgente causa, pristina fugatur
verecundia, et vel perite, vel imperite, dolori meo satisfacere cogor, fiduciam
dante ipsa necessitate. Quomodo namque silenter audire possum vestram
huiuscemodi de nobis querimoniam, qua scilicet miserrimi hominum, in pan-
nis et semicinctiis, de cavernis, ut ille ait, dicimur iudicare mundum, quod-
que inter cetera intolerabilius est, etiam gloriosissimo Ordini vestro deroga-
re, sanctis, qui in eo laudabiliter vivunt, impudenter detrahere, et de umbra
nostrae ignobilitatis mundi luminaribus insultare? Itane sub vestimentis ovi-
um, non quidem lupi rapaces, sed pulices mordaces, immo tineae demolien-
tes, bonorum vitam, quia palam non audemus, in occulto corrodimus, nec
saltem clamorem invectionis, sed susurrium detractionis emittimus? Si hoc
ita est, ut quid sine causa mortificamur tota die, aestimati sicut oves occisio-
nis? Si ita, inquam, pharisaica iactantia ceteros homines et, quod est super-
bius, nobis meliores despicimus, quid nobis prodest tanta in nostro victu

[3]Lc 17, 10 [11]ille ait: S. Hieronymus, Epist. 17, 2 [14]Mt 7, 15 [15]Mt 6,19
[16]Cor 10, 9–12 [18]Ps 43, 22 [19]Lc 18, 11 [20]Gen 37, 26; Iob 21, 15

[2]Patri: presbytero *FL* Guillelmo: Guilelmo *Sgpc*, W. *FLSt* frater: *om St*
[5]qua: quid P [6]quia: ut P [7]nova: *om FL* [12]gloriosissimo: glorioso *FL*
[14]mundi: huius *add* C [15]pulices: culices *F* mordaces: mordentes *FL*
[15]immo: seu P [16]in occulto corrodimus: *om SgTd* [18]aestimati: sumus
add FL Sgac [19]iactantia: damnamus *add L* homines: damnamus *add F*
[19-20]superbius: superius *Sgac Td* [20]despicimus: *om FL*

A JUSTIFICATION TO ABBOT WILLIAM

To the venerable Father William,
From Brother Bernard, the unworthy servant of the
brothers who are at Clairvaux,

Greetings in the Lord,

I. 1. U NTIL now, if you asked me to write anything, I agreed either reluctantly or not at all—not because I was indifferent to your request, but so that I would not undertake something of which I was incapable. Now, however, as a result of the pressing new situation my former diffidence is dispelled, and whether it is done skillfully or clumsily, necessity itself gives me confidence and compels me—much to my distress—to agree. For how can I listen silently to your complaint concerning us, the most miserable of men who, in rags and tatters and from [our] holes, as he [Jerome] says, are alleged to pass judgment on the world and what is, among other things, more intolerable even to disparage your most glorious Order, to detract impudently from the holy men who live commendably in it, and to insult the luminaries of the world from the shelter of our low position?

But if this is so, then must it not be that we are not really rapacious wolves in sheep's clothing, but nibbling fleas, or rather maggots destroying the way of life of good men, gnawing in secret since we dare not openly, not even uttering a cry of invective but only a whisper of slander? Yet, why then should we be slain all the day long, accounted as sheep for the slaughter? If we with pharisaic boasting despise the rest of men—and what is more arrogant, those better than us—what good to us is such great moderation and coarseness in our food, the conspicuous and well-known cheapness and difference of our clothing, the daily exertion of manual labor,

parcitas et asperitas, in vestitu notabilis illa vilitas ac diversitas, in opere manuum quotidiana desudatio, in ieiuniis et vigiliis iugis exercitatio, totius denique vitae nostrae singularis quaedam atque austerior conversatio, nisi forte omnia opera nostra facimus ut videamur ab hominibus? Sed dicit

5 Christus: Amen dico vobis, receperunt mercedem suam. Nonne si in hac vita tantum in Christo sperantes sumus, miserabiliores sumus omnibus hominibus? An vero non in hac vita tantum in Christo speramus, si de Christi servitio temporalem tantum gloriam quaerimus?

2. Miser ego homuncio, qui tanto labore et industria studeo non esse

10 vel potius non videri sicut ceteri hominum, minus tamen accepturus, immo gravius puniendus, quam quilibet hominum. Siccine ergo non inveniebatur nobis via, ut ita dicam, utcumque tolerabilior ad infernum? Si ita necesse erat, ut illo descenderemus, cur saltem illam, qua multi incedunt, viam scilicet latam, quae ducit ad mortem, non elegimus, quatenus vel de gaudio, et

15 non de luctu, ad luctum transiremus? O quam felicius est illis, quorum non est respectus morti eorum et firmamentum in plaga eorum, qui in labore hominum non sunt et cum hominibus non flagellantur, qui, etsi peccatores ac pro gaudiis temporalibus perpetuis cruciatibus addicti, saltem abundantes in saeculo obtinuerunt divitias! Vae portantibus crucem, non sicut Salvator

20 suam, sed sicut ille Cyrenaeus alienam! Vae citharoedis citharizantibus, non ut illi de Apocalypsi, in citharis suis, sed vere, ut hypocritae, in alienis! Vae semel, et vae iterum pauperibus superbis! Vae, inquam, semel, et vae iterum, portantibus crucem Christi et non sequentibus Christum: qui nimirum cuius passionibus participantur, humilitatem sectari negligunt.

25 3. Duplici quippe contritione conteruntur qui huiusmodi sunt, quando et hic pro temporali gloria temporaliter se affligunt, et in futuro pro interna

[1-2] 2 Cor 11, 27–28 [4-5] Mt 6, 5 [5-7] 1 Cor 15, 19 [10] Lc 18, 11
[13] Mt 7, 13 Ps 72, 4–5 [18] Ps 72, 12 [19] Lc 14, 27 [20] Lc 23, 26
[30] Apoc 14, 2 [23] Mt 16, 24 [24] 1 Pet 4, 13 [25] Ier 17, 18

[1] diversitas: adversitas *Clac* [4] facimus: faciamus *FL* videamur: videantur P [5] Nonne: Numquid non P (non *om LSt*) [7] An vero: Aut P [9] studeo: studui *FLSt* [10] vel: immo *F* [11] puniendus: cruciandus P, *M*, vel cruciendus *add int lin CtM* [17] flagellantur: flagellabuntur *L, C* [18] cruciatibus: supliciis *A*
[25] huiusmodi: huiuscemodi *SgTd*

the constant practice of fasts and vigils? In short, what good to us is the singular and even rather austere conduct of our entire way of life, unless we do all our works so that we are seen by men? But as Christ said, "I tell you solemnly, they have had their reward." And is it not so that "If we hope in Christ for this life only, we are the most wretched of all men"? Do we not in fact hope in Christ for this life only, if from the service of Christ we seek temporal glory only?

2. Miserable wretch that I am, I try with so much toil and effort not to be—or rather not to seem to be—like other men, yet I will receive less and be punished more harshly than anyone else. Cannot a somewhat more, if I may say so, tolerable way to hell be found for us? If it is inevitable that we should go down there, why do we not at least choose the road which leads to death which many march along, namely that broad road of joy and not sorrow, as we pass over to that sorrow? Oh, how much happier it is for those who are unconcerned with death and are constant in their misfortune, who are not subject to the suffering and affliction of other men, and who although sinners and slaves to temporal pleasure—for which they will undergo perpetual agony—at least have had so many good things in this life! How unfortunate it is for those who do not carry their own cross like the Savior, but carry another's like the Cyrenian! How unfortunate it is for those who do not play their own harps like the men of the Apocalypse, but play another's like hypocrites! How unfortunate it is once, and how unfortunate a second time for proud paupers! How unfortunate, I say, once, and how unfortunate a second time for those carrying the cross of Christ but not following Christ, for they share in his Passion but neglect to follow his humility!

3. People of this sort suffer a double affliction when they torture themselves in this world for temporal glory, and in the next when they are dragged off to eternal

superbia ad aeterna suplicia petrahuntur. Laborant cum Christo, sed cum Christo non regnant; sequuntur Christum in paupertate sua, sed in gloria non consequuntur; de torrente in via bibunt, sed non exaltabunt caput in patria; lugent nunc, sed tunc non consolabuntur. Et merito: quid enim facit superbia sub pannis humilitatis Iesu? Numquid non habet quo se palliet humana malitia, nisi unde involuta est infantia Salvatoris? Et quomodo intra praesepium Domini simulatrix arrogantia se coarctat, ac pro vagitibus innocentiae malum inibi detractionis immurmurat? Annon illi superbissimi de Psalmo, quorum prodiit ex adipe iniquitas eorum, multo tutius operti sunt iniquitate et impietate sua, quam nos latemus sub sanctitate aliena? Quis enim magis impius, an profitens impietatem, an mentiens sanctitatem? Nonne is qui, etiam mendacium addens, geminat impietatem? Et quid dicam? Vereor ne forte et ego suspectus habear, non quidem vobis, Pater, non vobis, cui utique notum me novi, quantum in hac caligine homo homini innotescere potest,—et specialiter de hac re scio vos non ignorare quid sentiam. Sed propter illos qui me nec ita ut vos cognoverunt, nec sicut vobis hinc loqui soleo, loquentem audierunt, scribo vobis quod et frequenter audistis, ut, quoniam ego per singulos ire et singulis satisfacere nequeo, ex me habeatis, unde quod de me certissime scitis, eis pro me verissime persuadeatis. Neque enim timeo omnium oculis scribere quidquid de hac re vobis in aure locutus sum.

II. 4. Quis umquam me adversus Ordinem illum vel coram audivit disputantem, vel clam susurrantem? Quem umquam de Ordine illo nisi cum gaudio vidi, nisi cum honore suscepi, nisi cum reverentia allocutus, nisi cum humilitate adhortatus sum? Dixi, et dico: modus quidam vitae est sanctus, honestus, castitate decorus, discretione praecipuus, a Patribus institutus, a

[1]Mt 25, 46 Apoc 20, 4 [3]Ps 109, 7 [4]Mt 5, 5; Lc 6, 21 [7]Lc 2, 7
[9]Ps 72, 7 et 6 [12]Io 12, 27, [21]Lc 12, 3

[1]pertrahuntur: rapiuntur *St* [2]gloria: sua *add St* [3]consequuntur: sequuntur *FL Sgac ut vid* [5]habet: sub *add FL* [8]detractionis: nocentiae *K ubi add int lin* vel detractionis [9]ex adipe: *om Sgac Td* multo: *om FL* [10]latemus: latentes *FL* [12]etiam: omne *Sgpc Td* impietatem: inquitatem *F* [17]quod: quae *SgTd* [18]quoniam: quomodo *St* nequeo: non queo *FStTd, ABD* [23]umquam: *Td in ras*, vel inquam *add int lin Ct M* [24]allocutus: sum *add P* [25]sum: *om FL*

torment for internal pride. They labor with Christ, but they do not reign with Christ. They follow Christ in his poverty, but they do not attain his glory. They drink from the stream along the way, but they will not lift up their heads in the homeland. They are sorrowful now, but they will not be comforted later. And deservedly, for what is Pride doing in the swaddling clothes of Christ's humility? Does not human malice have anything with which to cover itself except that with which the infant Savior was wrapped? How does the impostor, Arrogance, squeeze herself into the manger of the Lord, and utter malicious detractions there in the place of the cries of Innocence? Are not those exceedingly proud men of the Psalm, whose iniquity has come forth from fatness, much more safely protected in their iniquity and impiety than we who take refuge under a sanctity which is alien to us? For who is more impious, the one who professes impiety or the one who feigns sanctity? Does not the latter compound impiety by adding a lie?

What can I say? I am afraid that I may be held in suspicion, although not by you, Father, not by you, to whom I know that I am known as well as any man can be known to another in the darkness of this world, and I know that you are not at all unaware of how I feel concerning this affair in particular. But on account of those who have heard me speak but who neither know me as you do, nor with whom I normally speak of these things, I write to you what you have often heard so that— since I am unable to go to each person and explain myself to him individually—you may have something which you know is without any doubt from me with which you may persuade them for me. For I am not afraid to write for all to see whatever I have said to you in private concerning this affair.

II. 4. Who has ever heard me either speaking out in public or whispering in private against that Order? What member of that Order have I ever seen without joy, received without honor, spoken to without respect, or exhorted without humility? I have said and I continue to say that this way of life is holy, honorable, becoming in chastity, pre-eminent in discretion, instituted by the Fathers, preordained by

Spiritu Sancto praeordinatus, animabus salvandis non mediocriter idoneus.
Egone vel damno, vel despicio, quem sic praedico? Memini me aliquando
in aliquibus eiusdem Ordinis monasteriis hospitio susceptum fuisse: reddat
Dominus servis suis humanitatem quam infirmanti mihi, ultra etiam quam
5 necesse fuit, exhibuerunt, et honorem quo me, plus quoque quam dignus
fui, dignati sunt! Ipsorum me commendavi orationibus, interfui collationi-
bus; saepe de Scripturis et salute animarum habui sermonem cum multis, et
publicum in capitulis, et privatum in cameris. Quem umquam vel clam, vel
palam, aut ab illo Ordine dissuadere, aut ad nostrum ut veniret persuadere
10 tentavi? Annon potius multos cupientes venire repressi, venientes et pulsan-
tes repuli? Annon fratrem Nicolaum ad Sanctum Nicolaum, et vobis duos
de vestris, vobis teste, remisi? Sed et duobus quibusdam eiusdem Ordinis
abbatibus, quorum ne nomina prodam,—ipse eos optime nostis, et nihilo-
minus quam amica mihi familiaritate iungantur, scitis—, numquid non tamen
15 ad alium Ordinem, quod et vos non latuit, migrare desiderantibus, iam iam-
que deliberantibus, nostrum eis dissuasorium consilium obviavit, ac ne suas
desererent cathedras effecit? Cur igitur Ordinem damnare putor vel dicor, cui ami-
cos meos deservire suadeo, cui suos ad nos venientes monachos red-
do, de quo et mihi orationes tam sollicite requiro, tam devote suscipio?
20 III. 5. An forte quia iuxta alium Ordinem conversari videor, propterea
suspectus hine habeor? Sed eadem ratione et vos nostro derogatis, quicum-
que aliter vivitis. Ergo et continentes, et coniuges invicem se damnare pu-
tentur, quod suis quique legibus in Ecclesia conversentur. Monachi quoque
ac regulares clerici sibi invicem derogare dicantur, quia propriis ab invicem
25 observantiis separantur. Sed et Noe, et Danielem, et Iob in uno se regno
pati non posse suspicemur, ad quod utique non uno eos tramite iustitiae

[1]Act 10, 41 [3]1 Reg 24, 20 [11]Sanctum Nicolaum: monasterium Sancti
Nicolai de Bosco dioecesi Laudunensi; ad Nicolaum, huius coenobii monachum, referri
videtur S. Bernardi epistola 84.

[2]Egone vel: Ego nec *FL, T* vel[1]: *om St, AT* [3]Ordinis: *om SgTd*
[4]etiam quam: ~ *P* [8]privatum: privatim *FL* [9]dissuadere: dissuasi *FL*
[10]Annon potius: An potius non *P, AB* [16]consilium: *om FLST* [17]effecit:
consilium *add FLSt* [17]igitur: ergo *SgTd* vel: *om Sgac, et Td* [19]tam . . .
suscipio: *om KSc* [26]tramite iustitate: ~ *P*

the Holy Spirit, and exceedingly suited to the salvation of souls. Would I then condemn or look down on what I thus proclaim? I remember how at various times I received hospitality in a number of monasteries of the same Order, and may the Lord repay his servants for the extraordinary kindness which they showed to me when I was sick, as well as for the honor in which they held me and which was more than I was worthy. I have commended myself to their prayers and have taken part in their discussions. I have often had conversations concerning the Scriptures and the salvation of souls with many of them, both publicly in chapter and privately in their chambers.

Whom have I ever tried to influence either privately or publicly to leave that Order or to persuade him to come to ours? On the contrary, haven't I stopped many who wished to come and sent back many others who did come knocking? With you as my witness, didn't I send Brother Nicholas back to Saint Nicholas, and two of your own people back to you? And what about those two abbots of the same Order whose names I won't mention? You are very well acquainted with them and know how they are bound to me in friendly intimacy. When they not only wished to change to another Order—as you know—and actually already planned to do so, didn't my advice to the contrary prevent them and ensure that they not resign their offices? So why then am I thought or said to condemn the Order to which I urge my friends to devote themselves, whose monks I return when they come to us, and from which I so anxiously seek and so devoutly receive prayers for myself?

III. 5. Is it that since I am seen to be a member of another Order, I am held suspect? But by the same rationale, you disparage ours, whoever of you live according to a different way. And so celibates and married people might be considered to mutually condemn each other, in that each one lives within the Church according to his own laws. Monks and canons regular could also be said to criticize each other because they are distinguished from each other by their own observances. We may suppose that Noah, Daniel, and Job are not able to tolerate each other in the same

[84]

pervenisse cognovimus. Mariam denique et Martham necesse sit aut utramque, aut alteram Salvatori displicere, cui nimirum tam dissimili studio devotionis contendunt ambae placere. Et hac ratione in tota Ecclesia,—quae utique tam pluribus tamque dissimilibus variatur ordinibus, utpote regina
5 quae in Psalmo legitur circumamicta varietatibus—, nulla pax, nulla prorsus concordia esse putabitur. Quae etenim secura quies, quis tutus in ea status invenietur, si unus quilibet homo, unum quemlibet Ordinem eligens, alios aliter viventes aut ipse aspernetur, aut se ab ipsis sperni suspicetur, praesertim cum tenere impossibile sit vel unum hominem omnes Ordines, vel unum
10 Ordinem omnes homines? Non sum tam hebes, ut non agnoscam tunicam Ioseph, non illius qui liberavit Aegyptum, sed qui salvavit mundum, et hoc non a fame corporis, sed a morte simul animae et corporis. Notissima quippe est, quia polymita, id est pulcherrima varietate distincta; sed et sanguine apparet intincta, non quidem haedi, qui peccatum significat, sed agni, qui
15 designat innocentiam, hoc est suo ipsius, non alieno. Ipse profecto est Agnus mansuetissimus, qui coram non quidem tondente, sed occidente se, obmutuit, qui peccatum non fect, sed abstulit peccata mundi. Miserunt, ait, ad Iacob qui dicerent: Hanc invenimus; vide utrum tunica filii tui sit, an non. Vide et tu, Domine, utrum haec sit tunica Filii tui dilecti. Recogno
20 sce, omnipotens Pater, eam quam fecisti Christo tuo polymitam, dando quidem quosdam apostolos, quosdam autem prophetas, alios vero evangelistas, alios pastores et doctores, et cetera quae in eius ornatu mirifico decenter apposuisti, ad consummationem utique sanctorum, occurrentium in virum perfectum, in mensuram aetatis plenitudinis Christi. Dignare etiam, Deus,

[1]Le 10, 38 ss [4]Ps 44, 15 [10-13]Gen 37, 23 [13]Gen 37, 31 [14]Ex 12, 5
[15]Io 1, 29 Ier 11, 19 [16]Is 53, 7 [17]1 Pet 2, 22 Io 1, 29 [18]Gen 37, 32
[20]1 Cor 12, 28 [23]Eph 4, 12–13

[3]Et: de *add FLSt* [8]sperni: spretum *Sgpc Td* [9-10]hominem . . . homines:
Ordinem omnes homines, vel unum hominem omnes Ordines P [12]simul animae: ~ P
(simul *om St*) [13]distincta: contexta *St* [17]ait: *om FL* [17-18]ad Iacob
qui dicerent: qui dic. ad Iac. P (ad *om St*) [19]Vide et tu . . . tui dilecti: *om FL*
[20]Christo: filio *add BDK* tuo: tunicam *add FL* [20-21]dando quidem quosdam:
quosd. quid. d. *FSt*, quosd. d. quid. *L*, d. quosd. quid. *Sg in ras Td* [22]eius: eis *FL*
[24]aetatis: aeternam *St*

kingdom which we know they reached but not by a single way of life. And, of course, it would be unavoidable that either Mary or Martha or both displeased the Savior, whom they both strove to please with different efforts of devotion. And by this rationale neither peace nor harmony will be considered to exist in the Church—which is given variety with so many and so dissimilar Orders, like the queen in the Psalm who was clothed in diversity. What untroubled rest, what security will be found in such a state of affairs if any one man, choosing any one Order, either himself shows disdain for others living differently, or imagines himself to be disdained by them, especially since it is impossible to hold either one man to all Orders or one Order to all men?

I am not so dull that I do not recognize Joseph's robe. Not the Joseph who saved Egypt, but the Joseph who saved the world; and not from hunger of the body, but from death of both the soul and the body. His robe is famous because of its many colors, and it is extremely beautiful in its distinct variety. But it is dipped in the blood—not of a goat, which signifies sin—but of a lamb (that is, in his own, not in another's) which denotes innocence. It is the gentle lamb who was silent in the face of not its shearing, but its death; who did not sin, but rather took away the sins of the world. The prophet tells us that they sent someone to Jacob who said, "We found this, see whether it is your son's robe or not." You also, Lord, see whether this is the robe of your beloved son. Examine, almighty Father, this many-colored robe which you have made for your son, Christ, by appointing some apostles or prophets, others evangelists, pastors, or teachers, and the rest whom you have rightly furnished for his wonderous garment in preparation for the consummation of the saints and the attainment of the perfection of man, in the measure of the fullness of Christ. Also deign, God, to recognize the crimson of his most precious

pretiosissimi purpuram sanguinis, quo aspersa est, recognoscere, et in purpura praeclarum insigne ac victoriosissimum indicium oboedientiae. QUARE ERGO, inquit, RUBRUM EST VESTIMENTUM TUUM? TORCULAR, ait, CALCAVI SOLUS, ET DE GENTIBUS NON EST VIR MECUM.

5 6. Itaque quandoquidem factus est oboediens Patri usque ad torcular crucis, quod utique solus calcavit: solum quippe brachium suum auxiliatum est ei, iuxta illud in alio loco: SINGULARITER SUM EGO, DONEC TRANSEAM. Iam ergo exalta eum, Deus, et da ei nomen quod est super omne nomen, ut in nomine Iesu omne genu flectatur caelestium, terrestrium, et infernorum.
10 Ascendat in altum, captivam ducat captivitatem, donet dona hominibus. Quae dona? Relinquat videlicet sponsae suae Ecclesia pignus hereditatis, ipsam tunicam suam: tunicam scilicet polymitam, eamdemque inconsutilem, et desuper contextam per totum; sed polymitam ob multorum Ordinum, qui in ea sunt, multimodam distinctionem, inconsutilem vero propter indis-
15 solubilis caritatis individuam unitatem: QUIS ME, inquit, SEPARABIT A CARITATE CHRISTI? Audi quomodo polymitam: DIVISIONES, ait, GRATIARUM SUNT, IDEM AUTEM SPIRITUS; ET DIVISIONES OPERATIONUM SUNT, IDEM VERO DOMINUS. Deinde diversis enumeratis charismatibus, tamquam variis tunicae coloribus, quibus constet eam esse polymitam, ut ostendat etiam inconsutilem et desuper
20 contextam per totum, adiungit: HAEC AUTEM OPERATUR UNUS ATQUE IDEM SPIRITUS, DIVIDENS SINGULIS PROUT VULT. CARITAS QUIPPE DIFFUSA EST IN CORDIBUS NOSTRIS PER SPIRITUM SANCTUM QUI DATUS EST NOBIS. Non ergo dividatur, sed totam et integram hereditario iure sortiatur Ecclesia, quia et de illa scriptum est: ASTITIT REGINA A DEXTRIS TUIS IN VESTITU DEAURATO, CIRCUMDATA VARIE-
25 TATE. Itaque diversi diversa accipientes dona, alius quidem sic, alius vero sic,

[1]Apoc 19, 13 [2]Is 63, 2–3 (Vg: rubrum est indumentum tuum et vestimenta tua. . . torcular calcavi) [5]Phil 2, 8 Is 63, 3 [6]Ps 88, 22 [7]Ps 140, 10
[8]Phil 2, 9–10 [10]Eph 4, 8 [11]Eph 1, 14 [12]Gen 37, 23 Io 19, 23
[15]Rom 8, 35 (Vg: Quis ergo nos sep.) [16]1 Cor 12, 4–6 (Vg: Divisiones vero, Spiritus et divis. ministrationum sunt idem autem Dominus. Et divis. oper. sunt idem vero Deus) [19]Io 19, 23 [20]1 Cor 12, 11 (Vg: autem omnia operatur) [21]Rom 5, 5 (Vg: caritas Dei) [24]Ps 44, 10 [25]1 Cor 7, 7

[3]vestimentum: indumentum *SgStTd* eamdem C [15]caritatis: unitatis *FL* circumamicta *FL* [25]dona: *om FL* [7]loco: Psalmo *T* [19]etiam: esse *add D* [12]eamdemque: [19] [24]circumdata:

blood with which his robe is sprinkled, and deign to see in that crimson a magnificent symbol and victorious sign of obedience. "Why," he asked, "is your clothing red?" And he was answered, "I have trodden the wine-press alone and not a man from the gentiles is with me."

6. And so he became obedient to the Father, all the way to the wine press of the cross, which he trod alone. His arm alone helped him, and as is said in another place, "I am alone until I go." Therefore, exalt him, God, and give to him that name which is above every name, so that by the name of Jesus every knee may be bent in heaven, on earth, and in hell. May he ascend on high, may he make captivity captive, may he give gifts to men. What gifts? May he leave behind to his bride, the Church, his own robe as a token of her inheritance—a many-colored robe, both seamless and woven from top to bottom, many-colored because of the many distinct ways of life of her many Orders, seamless because of the indivisible unity of her indestructible love. "Who," he asked, "will separate me from the love of Christ?" Hear in what way she is many-colored: "There are varieties of gifts, but the same spirit; and there are varieties of service, but the same Lord." Then, having enumerated the different gifts of grace as the various colors by which the robe is known to be many-colored, in order to show that it is seamless and woven from top to bottom the Apostle adds, "These are inspired by one and the same Spirit, apportioning to each one individually as he wills. Love has been poured into our hearts through the Holy Spirit, who has been given to us."

Therefore, do not let the robe be divided, but let the Church be allotted it whole and complete by hereditary right, as was written concerning her, "The queen stands on your right in golden clothing, encircled with diversity." And so different people receive different gifts, one this, another that—whether Cluniacs, Cistercians, or

sive Cluniacenses, sive Cistercienses, sive clerici regulares, sive etiam laici fideles, omnis denique Ordo, omnis lingua, omnis sexus, omnis aetas, omnis conditio, in omni loco, per omne tempus, a primo homine usque ad novissimum. Nam et propter hoc talaris dicta est, quod ad finem usque pertingat,

5 dicente Propheta: ET NON EST QUI SE ABSCONDAT A CALORE EIUS, nimirum congruens ei cui et facta est, qui, perhibente videlicet alia Scriptura, et ipse ATTINGIT A FINE USQUE AD FINEM FORTITER, ET DISPONIT OMNIA SUAVITER.

IV. 7. Omnes ergo pariter occurramus in unam tunicam, et ex omnibus constet una. Ex omnibus, inquam, una: nam etsi ex pluribus et diversis,

10 una est tamen columba mea, formosa mea, perfecta mea. Alioquin nec ego solus, nec tu sine me, nec ille absque utroque, sed simul omnes sumus illa una, si tamen solliciti sumus servare unitatem spiritus in vinculo pacis. Non, inquam, tantum Ordo noster, aut solus vester, ad illam pertinet unam, sed noster simul et vester, nisi forte, quod absit, invicem invidentes, invicem

15 provocantes, invicem mordeamus et ab invicem consumamur, et sic non possit Apostolus uni nos illi viro, cui et despondit, virginem castam exhibere Christo. Verumtamen illa una dicit in Canticis: ORDINATE IN ME CARITATEM, ut etsi una in caritate, divisa tamen sit in ordinatione. Quid ergo? Cisterciensis sum: damno igitur Cluniacenses? Absit! Sed diligo, sed praedico,

20 sed magnifico. «Cur ergo», inquis, «Ordinem illum non tenes, si sic laudas?» Audi: propter hoc quod Apostolus ait: UNUSQUISQUE IN EA VOCATIONE, IN QUA VOCATUS EST, PERMANEAT. Quod si quaeris, cur et a principio non elegerim, si talem sciebam, respondeo: propter id quod rursus ait Apostolus: OMNIA LICENT, SED NON OMNIA EXPEDIUNT. Non quod scilicet Ordo sanc-

25 tus et iustus non sit; sed quia ego carnalis eram, venumdatus sub peccato, et talem animae meae languorem sentiebam, cui fortior esset potio necessaria.

[4] Gen 37, 23 [5] Ps 18, 7 (Vg: nec est) [7] Sap 8, 1 (Vg: Attingit ergo a fine) [8] Eph 4, 13 [10] Cant 2, 10; 6, 8 [12] Eph 4, 3 [14] Gal 5, 26 [15] Gal 5, 15 [16] 2 Cor 11, 2 [17] Cant 2, 4 (Vg: Ordinavit in me) [21] 1 Cor 7, 20 (Vg: in qua vocatione vocatus est in ea) [24] 1 Cor 10, 22 (Vg: Omnia mihi licent) [25] Rom 7, 14

[8] occurramus: curramus *FL*, concurramus *StTdSg in ras, AKT* [9] etsi: si *FStTd* [10] formosa mea: *om FL* [12] spiritus: *om SgTd, Sc* [15] ab: *om C* [15-16] non possit Apost. uni nos: nos non possit Apost. uni P [20] si: quem *St* [22] in: *om P, AB* [23] talem: esse *add* P rursus: rursum *C, T* [25] ego: *om FLTd*

canons regular, or even faithful laypeople: in short every Order, language, sex, age, and condition; in every place, for every time, from the first man to the last. Because of this it is said to be ankle-length, since it reaches to the farthest extent. The prophet says, "Nothing is concealed from its warmth," suiting him for whom it was made, who—as another Scriptural passage asserts—"Reaches mightily from one end to the other, and orders all things well."

IV. 7. Therefore, let us all come together in the one robe, and from all let there be one. From all, I say, let there be one. For although from many and different parts, my dove, my beauty, my perfect one is still one. Neither I alone, nor you without me, nor the one without the other, but all of us together form that one robe if we really are anxious to maintain the unity of the Spirit in the bond of peace. Not only our Order or only yours belongs to that one robe, but ours and yours at the same time, unless perhaps—may it never happen—mutually envious and provoking we gnaw at each other in turn and in turn we are devoured. And so the Apostle would not be able to present us to that one husband, Christ—to whom he betrothed us—as a chaste virgin. The prophet said about that one robe in the Song of Songs, "Arrange your love about me," so that if one in love, it is nevertheless divisible in arrangement.

And so? I am a Cistercian. Do I therefore condemn the Cluniacs? Far from it. Rather I love them, I praise them, I extol them. "Why then," you ask, "do you not belong to that Order, if you praise it so?" Listen, because this is what the Apostle says, "Everyone should remain in the state in which he was called." If you ask why I didn't choose it in the beginning if I knew it to be so exceptional, I answer, again, because of what the Apostle says, "All things are lawful, but not all are expedient." Not because the Order is not holy and just but because I myself was carnal, sold under sin, I recognized the weakness of my soul to be such for which a stronger dose was necessary. Different illnesses call for different remedies, stronger illnesses

Et diversis morbis diversa conveniunt medicamenta, et fortioribus fortiora. Fac duos homines febribus anxiari, quartanis unum, alterum tertianis. Commendet autem, qui quartanis laborat, tertiano aquam, pira et frigida quaeque sumenda, cum tamen ipse ab his abstineat, vinumque et cetera calida, utpote sibi congruentia, sumat. Quis, rogo, hinc eum recte reprehendat? Si diceret ille: «Cur tu aquam non bibis, quam ita laudas?», annon recte responderet: «Et tibi eam fideliter tribuo, et mihi salubriter subtraho?»

8. Denique requiratur etiam a me cur, cum omnes Ordines laudem, omnes non teneo? Laudo enim omnes et diligo, ubicumque pie et iuste vivitur in Ecclesia. Unum opere teneo, ceteros caritate. Faciet autem caritas, —fidenter loquor—, ut ne illorum quidem fructu frauder, quorum instituta non sequor. Plus aliquid dicam. Tu tibi caute age: potest namque fieri, quia tu frustra laboraveris; ut autem ego frustra diligam bonum quod operaris, fieri omnino non potest. O quanta fiducia caritatis! Alius operatur non amans, et alius amat nihil operans. Ille quidem suum opus perdit, illius vero caritas numquam excidit. Et quid mirum, si in hoc exsilio, peregrinante adhuc Ecclesia, quaedam huiuscemodi sit pluralis, ut ita dixerim, unitas unaque pluralitas, cum in illa quoque patria, quando iam ipsa regnabit, nihilominus forte talis aliqua dispar quodammodo aequalitas futura sit? Inde etenim scriptum est: IN DOMO PATRIS MEI MANSIONES MULTAE SUNT. Sicut itaque illic multae mansiones in una domo, ita hic multi ordines sunt in una Ecclesia; et quomodo hic divisiones gratiarum sunt, idem autem Spiritus, ita tibi distinctiones quidem gloriarum, sed una domus. Porro unitas tam hic quam ibi una consistit in una caritate, diversitas autem hic quidem in ordinum vel operationum multifaria divisione, illic vero in quadam meritorum notissima, sed ordinatissima distinctione. Intelligens denique Ecclesia hanc suam quodammodo discordem concordiam concordemve discordiam: DEDUXIT ME, inquit, SUPER SEMITAS IUSTITIAE PROPTER NOMEN SUUM. Ponens quippe semitas

[9]Tit 2, 12 [13]Iob 39, 16 [16]1 Cor 13, 8 [20]Io 14, 2 [22]1 Cor 12, 4
[25]1 Cor 12, 6 [27]Ps 22, 3

[1]medicamenta: medicamina P [6]Si: *om FL* recte: *om FL* [7]subtraho: *om St*, subtraham *FL* [8]laudem: collaudem *Td* [12]quia: ut *FL* [13]tu: *om FLTd* [15]nihil: non *St*, nil *FL* quidem: vero *Td* [16]excidit: excidet *St* [17]ut ita dix: *om FL* [20-21]itaque illic: illic utique *FL* [21]sunt: *om FLSt* [24]una[1]: *om A* [26]sed: et *add Mac Sc* [27]concordemve: et concordem *SgStTd* concordemve discordiam: *om FL*

for stronger remedies. Take two men suffering with fevers, one with quartan and the other with tertian. The one who is sick with quartan might recommend that the one with tertian take water, pears, and cold foods while he abstains from these, taking wine and hot foods as appropriate for himself. Who could rightly criticize him for this? If the man with tertian said, "Why don't you drink the water which you recommend so?" couldn't the other justly answer, "I both prescribe it to you in good faith and beneficially avoid it myself"?

8. It may be asked of me, why—since I praise all Orders—don't I join all? I love all Orders and praise them wherever life is led piously and justly in the Church. I belong to one in necessity, I belong to the others in love. I am confident that love will not let me be deprived of the benefits of those institutes which I do not follow. But I have more to say. Be cautious, for it could happen that you have labored in vain, yet it absolutely cannot happen that I should love the good you do in vain. How great is the confidence of love! One man works without loving, another loves without working. The former wastes his work, but the love of the other is never lost.

Why is it strange if, in this exile and with the Church still on pilgrimage, there should be a certain plurality of this kind—a unity and plurality in one—when even in the homeland, when she herself will reign, there may well be a somehow unequal equality? For thus it is written, "In my Father's house there are many rooms." Just as there are many rooms in one house there, so there are many Orders in one Church here. And just as there are varieties of gifts but the same Spirit here, so there are different types of glory but one house there. Furthermore, the unity here as much as there consists in the one love, while here the diversity consists in the various divisions of Orders or activities, and there it consists in a certain well-known and well-ordered division of merit. The Church understands this discordant concord or concordant discord of hers when she says, "He led me along the paths of righteousness for his name's sake." Putting paths in the plural

pluraliter, et iustitia singulariter, nec diversitatem praetermisit operationum, nec unitatem operantium. Praevidens quoque et illam in caelestibus discretam unitatem futuram, devotissime laeta decantat: Plateae tuae, Ierusalem, sternentur auro mundo, et per omnes vicos tuos Alleluia cantabitur.

5 Audiens enim plateas et vicos, coronas et glorias diversas intellige. In auro, quo uno metallo illa civitas ornata describitur, et in uno Alleluia, quod cantandum perhibetur, dissimilium specierum similem pulchritudinem, et multarum mentium unam devotionem attende.

9. Non igitur una tantum semita inceditur, quia nec una est mansio quo

10 tenditur. Viderit autem quisque quacumque incedat, ne pro diversitate semitarum ab una iustitia recedat, quoniam ad quamlibet mansionum sua quisque semita pervenerit, ab una domo Patris exsors non erit. Verumtamen stella ab stella differt in claritate: sic erit, ait, et resurrectio mortuorum. Nam etsi fulgebunt iusti sicut sol in regno Patris eorum, alii tamen aliis

15 amplius, pro diversitate meritorum. Quae sane merita sciendum non sic in hoc saeculo, ut in illo, facile ab homine posse discerni: quippe cum hic tantum opera videantur, illic etiam corda nihil impediat intueri. Siquidem radiante ubique Sole iustitiae, tunc manifesta erunt abscondita cordium; et sicut non est nunc qui se abscondat a calore eius, ita tunc non erit qui se

20 occultet a splendore ipsius. Et de operibus quidem saepe incerta, et ob hoc periculosa sententia fertur, cum multoties minus iustitiae habeant, qui magis operantur. Hactenus mei excusatio.

[1] 1 Cor 12, 6 [3] Tob 13, 22 (Vg: Ex lapide candido et mundo omnes plateae eius sternentur et per vicos eius) [9] Io 14, 2 [11] Ps 22, 3 [12] Io 14, 2 1 Cor 15, 41–42 (Vg: stella enim a stella, sic et resurrectio) [14] Mt 13, 43 [18] Mal 4, 2
[18] 1 Cor 4, 5 [19] Ps 18, 7

[1] iustitia: iustitiae *KBD Mac Sc* [2] unitatem: unanimitatem P [4] vicos tuos: vias tuas *FL* [5] enim: *om* P vicos: vel vias *add F int lin* [6] et: *om FL*
[8] attende: intende *Stac* [12] una: in *add FL* [13] et: *om FL* mortuorum: iustorum *Sg* [14] sicut sol.: *om Td* [21] magis: maius *FL* [22] Hactenus . . . excusatio: *om* P, C, Explicit *Sc*

and righteousness in the singular, the prophet disregarded neither the diversity of work, nor the unity of those who work. And foreseeing that future differentiated unity in heaven, the Church most devoutly chants the joyful words, "Your streets, Jerusalem, will be paved with pure gold, and Alleluia will be sung throughout all your houses." For streets and houses you should understand different crowns and glories. In the gold—the one metal by which that magnificent city is described—and in the one Alleluia—which is presented in song—you should consider the similar beauty of dissimilar types and the one devotion of many minds.

9. Therefore, not just one way is to be taken, because there is not just one room which is aimed for. Let everyone take whatever way he may have seen, but let him not depart from the one righteousness because of the diversity of ways, since at whichever one of the rooms he may have arrived on his particular way, he will not be deprived of the one true house of the Father. Nevertheless, "Star differs from star in glory, and so it will be at the resurrection of the dead." Although the righteous will shine like the sun in the kingdom of their Father, some will shine more than others because of the diversity of merit. In this world, what kind of merit is certainly not to be known, while in the other world it will easily be able to be discerned by man. For if here only the works may be seen, there nothing impedes looking into hearts. The hidden things of the heart will then be revealed with the Sun of Righteousness shining everywhere. And just as there is no one now who can hide from his warmth, so there will be no one then who can hide from his splendor. To pass judgment on works is often uncertain and for this reason hazardous, since those who work more often have less righteousness. [Up to this point has been my excuse.]

Incipit adversus detractores

V. 10. Unde nunc mihi conveniendi sunt quidam de Ordine nostro, qui contra illam sententiam: Nolite ante tempus iudicare, quoadusque veniat Dominus, qui et illuminabit abscondita tenebrarum et manifestabit
5 consilia cordium, aliis Ordinibus derogare dicuntur, et suam iustitiam solam volentes constituere, iustitiae Dei non sunt subiecti: quos profecto, si qui tamen huiusmodi sunt, nec nostri, nec cuiuspiam esse Ordinis verius dixerim; quippe qui etsi ordinate viventes, superbe tamen loquentes, cives se faciunt Babylonis, id est confusionis, immo filios tenebrarum ipsiusque gehen-
10 nae, ubi nullus ordo, et sempiternus horror inhabitat. Vobis ergo inquam, fratres, qui etiam post auditam illam Domini de Pharisaeo et Publicano parabolam, de vestra iustitia praesumentes, ceteros aspernamini: Dicitis, ut dicitur, solos vos hominum esse iustos aut omnibus sanctiores, solos vos monachorum regulariter vivere, ceteros vero Regulae potius exsistere trans-
15 gressores.

11. Primo quid ad vos de alienis servis? Suo domino stant, aut cadunt. Quis vos constituit iudices super eos? Deinde si ita, ut dicitur, de Ordine vestro praesumitis, qualis ordo est, ut antequam de suo quisque trabem eiciat, in fratrum oculis tam curiose festucas perquiratis? Qui in Regula glo-
20 riamini, cur contra Regulam detrahitis? Cur contra Evangelium ante tempus, et contra Apostolum alienos servos iudicatis? An Regula non concordat Evangelio vel Apostolo? Alioquin Regula iam non est regula, quia non recta. Audite, et discite ordinem, qui contra ordinem aliis Ordinibus derogatis: Hypocrita, inquit, eice primum trabem de oculo tuo, et sic videbis

[3] 1 Cor 4, 5 [6] Rom 10, 3 [9] Iob 10, 22 [11] Lc 18, 9–14 [16] Rom 14, 4
[17] Lc 12, 14 [18] Mt 7, 3–4 [19] Rom 2, 23 [20] 1 Cor 4, 5 [21] Rom 14, 4
[22] Rom 11, 6 [24] Mt 7, 5 (Vg: et tunc videbis)

[1] INCIPIT. . . DETRACTORES: *om* P, C, ADVERSUS DETRACTORES: DE CISTERCIENSIBUS CLUNIACENSIUM BLASPHEMANTIBUS *Sc (ubi* blasphemantibus *dein erasum)* [2] Unde: Inde *T*
[4–5] et manif. cons. cord.: *om* P [8] qui: *om FLSt, AB* [10] et: sed *AB* Vobis ergo inquam: Vos ergo, inquam, convenio P, *A* [15] iustos: sanctos P [16] aut: vel P
[19] perquiratis: inquiratis *FLSt* [19] Regula: Lege *FL* [21] et contra . . . servos: *om FL*
[22] quia: quoniam *Sg in ras St*

[Against detractors]

V. 10. Certain members of our Order have been complained of to me who are said to detract from other Orders contrary to the maxim, "Do not judge before the time, before the Lord comes, who will illuminate the things hidden in the darkness and will disclose the purposes of his heart" and, wanting to establish their own righteousness alone, do not submit to the righteousness of God. Indeed, if they are like this, I would say that they are neither of our Order, nor of any other Order. This is because although living in an orderly way, they nevertheless speak proudly— making themselves citizens of Babylon, that is, of confusion, or rather sons of darkness and hell itself, where there is no order and perpetual horror dwells. I am speaking to you brothers, who even after having heard the Lord's parable on the pharisee and the publican take your own righteousness for granted and scorn others. It is alleged that you say you are the only righteous men, holier than all others, that you alone of all monks live regularly, and that the rest are, rather, transgressors of the Rule.

11. First, what are another's servants to you? They stand or fall before their own master. Who made you judges over them? Second, if, as is said, you thus take your own Order for granted, what sort of order is there that you so carefully search for the splinter in your brother's eye before every one of you have removed the plank from your own? You who glory in the Rule, why do you disparage others, contrary to the Rule? Why, contrary to the Gospel, do you judge before the time and, contrary to the Apostle, do you judge another's servants? Can it really be that the Rule does not agree with the Gospel and the Apostle? If this were the case then the Rule would not be a rule, since it would not be right.

Listen and learn order, you who contrary to order detract from other Orders: "Hypocrite, remove the plank from your own eye, then you will see clearly enough

EICERE FESTUCAM DE OCULO FRATRIS TUI. Quaeris quam trabem? Annon gran-
dis et grossa trabes est superbia, qua te putans esse aliquid, cum nihil sis,
insanissime tibi tamquam sanus exsultas, et aliis vanissime, trabem portans,
de festucis insultas? GRATIAS, inquis, AGO TIBI, DEUS, QUIA NON SUM SICUT
5 CETERI HOMINUM, INIUSTI, RAPTORES, ADULTERI. Sequere ergo, et dic: detracto-
res. Neque enim minima est festuca inter ceteras. Quare, cum tam diligen-
ter alias enumeres, istam taces? Si pro nulla vel minima habes, audi Aposto-
lum: NEQUE MALEDICI, ait, REGNUM DEI POSSIDEBUNT. Audi et Deum in Psalmo
comminantem: ARGUAM TE, inquit, ET STATUAM CONTRA FACIEM TUAM. Quod
10 quia detractori loquatur, certum est ex praecedentibus. Et quidem iuste ad
se retorquendus, et se compellendus est intueri, qui avertens faciem suam a
se, aliena potius mala quam sua solet curiosius perscrutari.

 VI. 12. «At», inquiunt, «quomodo Regulam tenent, qui pelliciis indu-
untur, sani carnibus seu carnium pinguedine vescuntur, tria vel quatuor
15 pulmentaria una die, quod Regula prohibet, admittunt, opus manuum, quod
iubet, non faciunt, multa denique pro libitu suo vel mutant, vel augent, vel
minuunt?» Recte: non possunt haec negari; sed attendite in regulam Dei,
cui utique non dissonat institutio sancti Benedicti. REGNUM, inquit, DEI INTRA
VOS EST, hoc est non exterius in vestimentis aut alimentis corporis, sed in
20 virtutibus interioris hominis. Unde Apostolus: REGNUM DEI NON EST ESCA
ET POTUS, SED IUSTITIA, ET PAX, ET GAUDIUM IN SPIRITU SANCTO; et rursus:
REGNUM DEI NON EST IN SERMONE, SED IN VIRTUTE. De corporalibus itaque
observantiis patribus calumniam struitis, et quae maiora sunt Regulae, spiri-
tualia scilicet instituta, relinquitis, camelumque glutientes, culicem liquatis.
25 Magna abusio! Maxima cura est, ut corpus regulariter induatur, et contra
Regulam suis vestibus anima nuda deseritur. Cum tanto studio tunica et

[2]Gal 6, 3 [3]Mt 7, 5 [4]Lc 18, 11 (Vg: Deus gratias ago tibi quia, raptores
iniusti adulteri) [5]Rom 1, 30 [8]1 Cor 6, 10 (Vg: maledici . . . regnum) [9]Ps 49, 21
[11]Ps 12, 1 [15]prohibet: Reg. s. Bened., c. 55, c. 36, c. 39 [16]iubet: Ibid., c. 48
[19]Lc 17, 21 [20]Rom 7, 22 [20]Rom 14, 17 (Vg: Non est enim regnum Dei)
[22]1 Cor 4, 20 (Vg: Non enim in sermone est regnum Dei) [24]Mt 23, 24

[2]esse aliquid: ~ P, *AK* [3]exsultas: insultas *FL* [7]alias: ceteras *SgTd, K*
[7]vel: pro *add FL* [10]iuste: *om FLSt* [12]curiosius: curiosus C [13]inquiunt:
inquit *St* [17]regulam: regula P [21]gaudium in Sp. S.: pax et misericordia *SgTd,*
iustitia et misericordia *FL*

to remove the splinter from your brother's eye." What plank, you ask? Isn't pride the long and thick plank by which, thinking yourself to be something when you are nothing, you most insanely exult as if sane and carrying a plank yourself you quite conceitedly insult others for their splinters? You say, "I thank you, God, that I am not like other men: unjust, extortioners, and adulterers." But go on—say "detractors." For it is not the least of the splinters. Why do you omit that one when you so diligently enumerate the others? If you regard it as of little or no consequence, listen to the Apostle, "Slanderers will not inherit the kingdom of God." And listen to God threaten in the psalm, "I will rebuke you and lay the charge before you." It is certain that he is speaking to the detractor by what preceded it. He who turns his face from himself and makes a habit of examining another's faults more thoroughly than his own should rightfully be turned around and forced to look at himself.

VI. 12. "But," you ask, "how do those who dress in furs keep the Rule? How do those who are healthy keep it when they eat meat or animal fat or allow three and four dishes a day which the Rule prohibits while not performing the manual labor which it enjoins? And how do they keep it when they change, increase, or reduce many things according to their inclination?" You are quite right, these things cannot be denied. But listen carefully to the rule of God, with which the Rule of Saint Benedict does not conflict: "The kingdom of God is within you." It is not external, in the clothing and food of the body, but in the virtues of the inner man. As the Apostle says, "The kingdom of God is not food and drink, but righteousness, peace, and joy in the Holy Spirit." And, "The kingdom of God is not in words, but in power."

Thus, you make up false accusations concerning the physical observances of the Fathers, and depart from the spiritual regulations which are the more important things of the Rule. You strain out the gnat while gulping down the camel. How wrong! The greatest concern is that the body is dressed according to the Rule, yet the naked soul is deprived of its clothing contrary to the Rule. Since the robe and a

cuculla corpori procurentur, quatenus cui deerunt, monachus non putetur, cur similiter spiritui pietas et humilitas, quae profecto spiritualia indumenta sunt, non providentur? Tunicati et elati abhorremus pellicias, tamquam melior non sit pellibus involuta humilitas, quam tunicata superbia, praesertim
5 cum et Deus tunicas pelliceas primis hominibus fecerit, et Ioannes in eremo zona pellicea lumbos accinxerit, et ipse tunicarum institutor in solitudine, non tunicis, sed pellibus sese induerit. Repleti deinde ventrem faba, mentem superbia, cibos damnamus saginatos, quasi non melius sit exiguo sagimine ad usum vesci, quam ventoso legumine usque ad ructum exsaturari, praecipue
10 cum et Esau non de carne, sed de lente sit reprehensus, et de ligno Adam, non de carne damnatus, et Ionathas ex gustu mellis, non carnis, morti adiudicatus, econtra vero Elias innoxie carnem comederit, Abraham angelos gratissime carnibus paverit, et de ipsis sua fieri sacrificia Deus praeceperit. Sed et satius est modico vino uti propter infirmitatem, quam multa aqua ingurgi-
15 tari per aviditatem, quia et Paulus Timotheo modico vino utendum consuluit, et Dominus ipse bibit, ita ut vini potator appellatus sit, Apostolis quoque bibendum dedit, insuper et ex eo sacramenta sui sanguinis condidit, cum e contrario aquam ad nuptias bibi non passus sit, et ad aquas contradictionis populi murmur terribiliter castigaverit, David quoque aquam, quia
20 desideraverat, potare timuerit, virique illi Gedeonis, qui prae aviditate toto corpore prostrato de flumine biberunt, digni ad praelium ire non fuerint. Iam vero de labore manuum quid gloriamini, cum et Martha laborans increpata, et Maria quiescens laudata sit, et Paulus aperte dicat: LABOR CORPORIS AD MODICUM VALET, PIETAS AUTEM AD OMNIA? Optimus labor, de quo Pro-
25 pheta dicebat: LABORAVI IN GEMITU MEO, et de quo alibi: MEMOR FUI DEI,

[5]Gen 3, 21 Mt 3, 4; Mc 1, 6 [10]Hebr 12, 16 Gen 3, 17
[11]1 Reg 14, 29 [12]3 Reg 17, 6 Gen 18, 8 [13]Ex 20, 24 [14]1 Tim 5, 23
[16]Mt 11, 19; Lc 7, 34 Mt 26, 27 [18]Io 2, 1–11 Num 20, 6; Ps 77, 15–21;
1 Cor 10, 5 [19]2 Reg 23, 16 [20]Iudic 7, 5 [22]Lc 10, 41–42 [23]1 Tim 4, 8
(Vg: corporalis exercitatio ad modicum utilis est) [25]Ps 6, 7 Ps 76, 4

[1]deerunt: deerit *FL* putetur: *ab binc deest textus in Sg* [2]profecto: *om* P
[5]tunicas . . . hominibus: primis hom. tun. pell. P [9]exsaturari: saturari P [16]bibit: biberit *FL* [16-17]quoque: ad *add St* [17]dedit: dederit *FL* condidit: condiderit *FL* [19]aquam: aqua F quia: quam *KM*

cowl for the body are attended to with such great effort—for as long as he lacks them, a man is not considered a monk—why then are piety and humility, which are spiritual clothing, not similarly provided for the soul? Robed and proud, we abhor furs. Yet isn't it better when humility is concealed in furs than when pride is concealed in robes, especially since God made garments of skin for the first people, John girded his loins with a leather belt in the desert, and even the originator of our robe dressed himself not in a robe in the wilderness but in skins?

With our stomachs filled with beans and our minds with pride, we condemn meals with fat as if it were not better to use a little fat in eating than to be sated with windy beans to the point of belching. Esau was rebuked not for meat, but for lentils; Adam was condemned not for meat, but for eating from a tree; and Jonathan was sentenced to die for tasting honey, not meat. On the contrary, Elijah ate meat without blame; Abraham graciously served meat to the angels; and God ordered his own sacrifices to be made with the same.

And it is better to take a little wine for illness than to gulp down a lot of water through greed, seeing that Paul advised Timothy to take a little wine; that the Lord himself drank in such a way that he was called a wine-drinker; that he gave wine to the Apostles; and that, moreover, he instituted the sacrament of his own blood with it? On the contrary, he would not let water be drunk at the marriage [of Cana] and he terribly chastised the complaints of the people at the waters [of Meribah]. David was afraid to drink the water that he had desired, and those men of Gideon's who from greed drank from the river with the entire body prone were not worthy to go to battle.

Why do we glory in manual labor when Martha was chided for working and Mary was praised for being still? Paul plainly said, "Manual labor is of value to a degree, but piety is of value in every way." The best labor is that concerning which

[92]

ET DELECTATUS SUM, ET EXERCITATUS SUM; ac ne corporale intelligas exerciti-
um: ET DEFECIT, inquit, SPIRITUS MEUS. Unde autem non corpus, sed spiritus
fatigatur, spiritualis procul dubio labor intelligitur.

VII. 13. «Quid ergo», inquis? «Siccine illa spiritualia persuades, ut etiam
5 haec, quae ex Regula habemus, corporalia damnes?» Nequaquam; sed illa
oportet agere, et ista non omittere. Alioquin, cum aut ista omitti necesse
est aut illa, ista potius omittenda sunt quam illa. Quanto enim spiritus cor-
pore melior est, tanto spiritualis quam corporalis exercitatio fructuosior. Tu
ergo cum de horum observatione elatus, aliis eadem non observantibus de-
10 rogas, nonne te magis transgressorem Regulae indicas, cuius licet minima
quaedam tenens, meliora devitas, de quibus Paulus: AEMULAMINI, ait, CHARIS-
MATA MELIORA? Detrahendo quippe fratribus, in quo temetipsum extollis,
perdis humilitatem; in quo alios deprimis, caritatem: quae sunt procul du-
bio charismata meliora. Tu tuum corpus multis nimiisque laboribus atteris,
15 ac regularibus asperitatibus mortificas membra tua, quae sunt super terram.
Bene facis. Sed quid si ille quem similiter non laborantem diiudicas, modi-
cum quidem habeat de hac, quae ad modicum utilis est, corporali videlicet
exercitatione, amplius autem quam tu de illa, quae ad omnia valet, id est
pietate? Quis, quaeso, vestrum Regulam melius tenet? Annon melius qui
20 melior? Quis vero melior, humilior an fatigatior? Annon is qui a Domino
didicit mitis esse et humilis corde, qui et cum Maria optimam partem elegit,
quae non auferetur ab eo?

14. Quod si Regulam ab omnibus, qui eam professi sunt, sic ad litteram
tenendam censes, ut nullam omnino dispensationem admitti patiaris, audacter
25 dico, nec tu eam, nec ille tenetis. Nam etsi ille, quantum quidem pertinet
ad observationes corporeas, in pluribus offendit, impossibile est tamen te
quoque vel in uno non transgredi. Scis autem quia qui in uno offendit,

[2] Ps 76, 4 [5] Mt 23, 23; Lc 11, 42 [8] 1 Tim 4, 8 [10] Iac 2, 11
[11] 1 Cor 12, 31 (Vg: Aemulamini autem) [14] 1 Cor 12, 31 [15] Col 3, 5
[16] Iac 2, 19 [18] 1 Tim 4, 8 [20] Mt 11, 29 Lc 10, 42 [27] Iac 2, 10

[2] autem: *om St*, cum *FL* [2-3] sed sp. fatigatur: defecisse dicitur *St* [3] procul
dubio: *om P* [4] etiam: *om P* [10] nonne: numquid P (numquid non *FL*) indicas:
iudicas *FL, ACt,* C [10] cuius: utique *add FLTd* [11] ait: inquit *FL, ASc* [14] nimiis-
que: et nimiis, P, *KT* [16] diiudicas: iudicas *FL* [19] Regulam melius: ~ P, *DT*
[22] eo: ea *FTd* [26] corporeas: corporales *St*

the prophet says, "I have labored at my sorrow," and elsewhere, "I thought of God, and I was both delighted and exhausted." And so that you do not think of the exhaustion as physical, he says, "And my spirit grew weary." Thus, let the spirit rather than the body be exhausted, for it is doubtlessly the labor of the spirit that is understood here.

VII. 13. "What," you say, "do you so recommend the spiritual that you condemn even these physical things which we have from the Rule?" Not at all. But one ought to do the former and not neglect the latter. When it is necessary to neglect either the one or the other, the latter is to be neglected rather than the former. For as much as the spirit is better than the body, just as much is spiritual work more fruitful than physical work. Therefore, when you are puffed up concerning your observance of these things and you detract from others who do not observe them, do you not show that you, rather, are the transgressor of the Rule? Although holding to what might be called its least important parts, you avoid its better parts concerning which Paul said, "Desire better gifts." By detracting from your brothers, you lose humility in that you exalt yourself; in that you deprecate others, you lose love. These are the better gifts. You wear down your body with many excessive labors and mortify that which is earthly in you with regular severities. Well done. But what if the man whom you condemn for not working may have only a small degree of that which is useful to a small degree, namely physical work? He may have more than you of that which is of value in every way, that is, piety. Who, I ask, follows your Rule better? Isn't it the one who is better? And who is better, the more humble man or the more exhausted man? Isn't it the one who has learned from the Lord to be gentle and humble at heart, and the one who with Mary has chosen the better part which will not be taken from him?

14. If you think that the Rule is to be followed to the letter by all who are professed to it so that you allow absolutely no dispensation, then I confidently say that neither you nor he follow it. For even if he errs in many things as far as physical observances are concerned, it is nevertheless impossible that you not transgress, if only in one thing. And you know that he who offends in one thing is guilty of all.

[93]

omnium est reus. Sin vero concedis aliqua posse mutari dispensatorie, procul dubio et tu illam tenes, et ille, quamquam dissimiliter: nam tu quidem districtius, at ille fortasse discretius. Neque hoc dico, quia haec exteriora negligenda sint, aut qui se in illis non exercuerit, mox ideo spiritualis efficiatur,

5 cum potius spiritualia, quamquam meliora, nisi per ista, aut vix, aut nullatenus vel acquirantur, vel obtineantur, sicut scriptum est: NON PRIUS QUOD SPIRITUALE, SED QUOD ANIMALE, DEINDE QUOD SPIRITUALE. Sicut nec Iacob, nisi prius cognita Lia, desideratos amplexus Rachel meruit obtinere. Unde rursus in Psalmo: SUMITE PSALMUM, ET DATE TYMPANUM, quod est dicere: Sumi-

10 te spiritualia, sed prius date corporalia. Optimus autem ille, qui discrete et congrue et haec operatur, et illa.

15. Iam vero, ut epistola remaneat, epistola finienda erat, quandoquidem et nostros, de quibus, Pater, conquestus estis, quod Ordini vestro detraherent, satis, quantum potui, stilo corripui, et me quoque ab huiusmodi falsa

15 suspicione purgavi, ut debui. Sed quoniam, dum nostris minime parco, nonnullis de vestris nimium, in quibus non decet, videor assentire, pauca quae et vobis displicere cognovi, et omnibus bonis vitanda esse non dubito, necessarium reor subiungere: quae quidem, etsi fieri videntur in Ordine, absit tamen ut sint de Ordine. Nullus quippe ordo quippiam recipit inordinatum;

20 quod vero inordinatum est, ordo non est. Unde non adversum Ordinem, sed pro Ordine disputare putandus ero, si non Ordinem in hominibus, sed hominum vitia reprehendo. Et quidem diligentibus Ordinem in hac re molestum me fore non timeo: quinimmo gratum procul dubio accepturi sunt, si persequimur quod et ipsi oderunt. Si quibus vero displicuerit, ipsi se

25 manifestant, quia Ordinem non diligunt, cuius utique corruptionem, id est vitia, damnari nolunt. Ipsis itaque illud Gregorianum respondeo: MELIUS EST UT SCANDALUM ORIATUR, QUAM VERITAS RELINQUATUR.

HUCUSQUE CONTRA DETRACTORES.

⁶1 Cor 15, 46 (Vg: spiritale est sed, spiritale) ⁷Gen 29, 23 ⁹Ps 80, 3
²⁶cf. S. Gregorius Magnus, In Ezech. I, VII, 5, PL 76, 842.

¹concedis: concedit *St*, concedas *KM* dispensatorie: dispensatione *Td* ¹¹et²: etiam C ¹¹illa: *ab hinc usque ad num. 31 deest textus in K*, FINIT EPISTOLA *add Sc* ²²Ordinem: non tantum *add* P ²⁸HUCUSQUE . . . DETRACTORES *om* P, HUCUSQUE SERMO HABITUS EST CONTRA CISTERCIENSIUM DETRACTIONES *A*

But if you concede to some extent that the Rule can be changed by dispensation, both you and he follow the Rule, although differently—you more strictly, but he perhaps more discreetly. I do not mean by this that these exterior things should be neglected or that he who has not employed himself in these matters may soon become spiritual for this reason. Rather, spiritual things, although better, may be acquired or obtained either with difficulty or not at all, unless through those external things: as is written, "It is not the spiritual which is first, but that which pertains to the physical, and then the spiritual." Jacob did not deserve to obtain the desired embraces of Rachel, except by first knowing Lia. And as is said in the psalm, "Begin the song and play the drum," which is to say, begin spiritual things, but first give attention to physical things. Indeed, the best man is he who performs discreetly and harmoniously both the one and the other.

15. However, this letter must be finished if it is to remain a letter. I have censured with my pen as much as I was able our own people about whom, Father, you have complained that they detract from your Order, and have also cleared myself of false suspicions as I was obliged. But since I do not in the least spare our own people, I seem to agree unduly with a number of things concerning your people which are improper. And so I believe it necessary to add these few things which I know are displeasing to you and which, I have no doubt, are avoided by all good men. Even if these things appear to take place within the Order, far be it that they should be of the Order. For there is no Order which allows any disorder, in that when there is disorder there is no order. Thus, if I do not rebuke the Order in respect to its men, but rather the faults of men, I will be regarded as arguing not against the Order, but for the Order. I do not fear that I will be a nuisance in this affair to those who love the Order. Indeed, they are going to be grateful if we pursue that which they themselves dislike. If this will have displeased some, they themselves show that they do not love the Order, whose corruption, that is its faults, they refuse to condemn. And so to them I reply in the words of Gregory, "It is better that a scandal should arise, than that the truth should be abandoned." [Up to here has been against detractors.]

Incipit contra superfluitates

VIII. 16. Dicitur, et veraciter creditur, sanctos Patres illam vitam instituisse et, ut in ea plures salvarentur, usque ad infirmos Regulae temperasse rigorem, non Regulam destruxisse. Absit autem ut credam tantas eos, quan
5 tas video in plerisque monasteriis, vanitates ac superfluitates praecepisse vel concessisse. Miror etenim unde inter monachos tanta intemperantia in comessationibus et potationibus, in vestimentis et lectisterniis, et equitaturis, et construendis aedificiis inolescere potuit, quatenus ubi haec studiosius, voluptuosius atque effusius fiunt, ibi ordo melius teneri dicatur, ibi maior putetur
10 religio. Ecce enim parcitas putatur avaritia, sobrietas austeritas creditur, silentium tristitia reputatur. Econtra remissio discretio dicitur, effusio liberalitas, loquacitas affabilitas, cachinnatio iucunditas, mollities vestimentorum et equorum fastus honestas, lectorum superfluus cultus munditia, cumque haec alterutrum impendimus, caritas appellatur. Ista caritas destruit carita
15 tem, haec discretio discretionem confundit. Talis misericordia crudelitate plena est, qua videlicet ita corpori servitur, ut anima iuguletur. Quae etenim caritas est, carnem diligere et negligere spiritum, quaeve discretio, totum dare corpori et animae nihil? Qualis vero misericordia, ancillam reficere et dominam interficere? Nemo pro huiusmodi misericordia speret se
20 consequi misericordiam, quae misericordibus promittitur in Evangelio, Veritatis ore dicentis: Beati misericordes, quoniam ipsi misericordiam consequentur; sed certissime potius poenam exspectet, quam tali, ut ita dicam, impio misericordi sanctus Iob magis prophetando quam affectando imprecatur: Non sit, inquiens, in recordatione, sed conteratur quasi lignum infruc
25 tuosum. Dignae plane retributionis causam mox subinfert satis idoneam, dicens: Pavit enim sterilem et quae non parit, et viduae bene non fecit.

[21]Mt 5, 7 [24]Iob 24, 20 [26]Iob 24, 21 (Vg: sterilem quae)

[1]Incipit. . . superfluitates: *om* P, De superfluitatibus *Sc* T, Hic incipit contra Cluniacensium superfluitates *A* [3]et ut: ~ *L*, usque *F* temperasse: temperassent *FL* [4]destruxisse: destruxissent *FL* [8]potuit: vel coepit *add St int lin* [18]Qualis vero: Qualisve *FL* [19]Nemo: *ab hinc usque ad* iam fere, p. 96, l. 15, *om* P

[Here begin the chapters against excesses]

VIII. 16. It is said and rightly believed that that way of life was instituted by the holy Fathers and that they did not destroy the Rule even when they modified its rigor on account of the weak so that more people might be saved. Far be it, however, that I believe that they recommended or allowed the many things that I see in very many monasteries—foolish things and excesses. In fact, I am amazed that such intemperance in matters of food, drink, clothing, bedding, retinue, and the construction of buildings is possible to grow among monks to the extent that wherever these things are the more diligently, joyfully, and even extravagantly done, there the better is order said to be kept, there the greater is religious life thought to be. For moderation is thought to be miserliness, sobriety is believed to be austerity, silence is considered gloom. Conversely, laxity is called discretion, prodigality liberality, loquacity affability, guffawing agreeableness, luxury in clothing and horses legitimate respectability, and excess in bedding concern for cleanliness. And when we waste these things on one another, it is called love. But that kind of love destroys love. This type of discretion confounds discretion. Such mercy is full of cruelty, in as much as it so serves the body that the soul is slain. For what love is it to love the flesh and to neglect the spirit, or what discretion to give everything to the body and nothing to the soul? Indeed, what sort of mercy is it to feed the maid and to kill the mistress?

In return for this type of mercy, let no one hope to receive for himself that mercy which is promised to the merciful in the Gospel, with the mouth of truth saying, "Blessed are the merciful, for they will receive mercy." But rather let him certainly expect a punishment—if I may say so—such as that which holy Job called down on the impiously merciful (foretelling rather than causing), saying, "Let him not be remembered, rather let him be cut down like the wood of a barren tree." A little further on he adds a case clearly worthy of suitable retribution, saying, "He feeds the barren, childless woman and does no good to the widow."

17. Inordinata profecto atque irrationabilis misericordia est, sterilis et infructuosae carnis, quae, iuxta Domini verbum, NON PRODEST QUIDQUAM et, secundum Apostolum, REGNUM DEI NON POSSIDEBIT, adimplendis invigilare desideriis, et de animae cura Sapientis saluberrimum non curare consilium, admonentis atque dicentis: MISERERE ANIMAE TUAE, PLACENS DEO. Bona misericordia, misereri animae tuae, nec potest non mereri misericordiam, qua fit ut placeas Deo. Alias autem non est misericordia, sicut iam dixi, sed crudelitas; non est caritas, sed iniquitas; non est discretio, sed confusio, sterilem quae non parit pascere, id est, inutilis carnis concupiscentiis inservire, et viduae nil boni facere, animae videlicet excolendis virtutibus nullam operam dare. Quae utique, licet interim Sponso sit viduata caelesti, sensus tamen de Spiritu Sancto concipere et parere non desinit immortales, qui videlicet incorruptibilis caelestisque hereditatis valeant esse capaces, sed si pium habeant studiosumque cultorem.

18. Sub hac tamen abusione iam fere ubique sic pro ordine tenentur, fere iam ita ab omnibus sine querela atque irreprehensibiliter observantur, quamquam dissimiliter. Nonnulli quippe his omnibus tamquam non utentes utuntur, et ideo aut cum nulla offensa, aut cum minima. Aliquanti quippe haec agunt ex simplicitate, aliquanti ex caritate, aliquanti ex necessitate: quidam namque simpliciter ista tenent, quoniam sic eis praecipitur, parati aliter agere, si aliter praeciperetur; quidam autem, ne discorditer ab eis vivant cum quibus habitant, sectantes in his non suam libidinem, sed aliorum pacem; alii vero, quia resistere non valent multitudini contradicentium, qui haec utique tamquam pro ordine libera voce defendunt; et quoties isti aliqua, prout ratio dictat, restringere vel mutare incipiunt, illi mox tota eis auctoritate resistunt.

IX. 19. Quis in principio, cum Ordo coepit monasticus, ad tantam crederet monachos inertiam devenire? O quantum distamus ab his, qui in diebus Antonii exstitere monachi! Siquidem illi cum se invicem per tempus

[2]Io 6, 64 [3]1 Cor 15, 50 (Vg: possidere non possunt) [5]Eccli 30, 24
[8]Iob 24, 21 [12]Lc 1, 31, 35 [16]Lc 1, 6 etc. [17]1 Cor 7, 31

[6]mereri misericordiam: misereri misericordia *Sc* [9]inservire: deservire *Ct*
[15]iam fere ubique: Iam tamen ubique fere P tenentur: tenetur *Cl*[1]*D* [16]observantur: observatur *Cl*[1]*D* [25]prout: eis *add* P

17. It is assuredly a disorderly and even irrational mercy of sterile and barren flesh—which, according to the word of the Lord, "profits nothing" and, according to the Apostle, "will not possess the kingdom of God"—to look for the fulfillment of desires and not to concern oneself with the most beneficial advice of the sage about the care of the soul, of which he warns saying, "To have mercy on your soul is pleasing to God." Good mercy, to be merciful to your own soul, cannot help but merit mercy in as much as it makes you pleasing to God. Otherwise, it is not mercy, as I have just said, but cruelty, it is not love but iniquity, it is not discretion but confusion to feed the barren, childless woman—that is, to serve the useless concupiscence of the flesh—and to do no good to the widow—namely to devote no attention to cultivating the virtues of the soul. Meanwhile, the soul is deprived of the divine bridegroom, but reason does not cease conceiving by the Holy Spirit and bearing immortal things which can have a capacity for the incorruptible and divine inheritance if they have a devoted and diligent cultivator.

18. Despite this abuse, these things are now almost everywhere held to be in order and thus are now almost regarded without complaint and even as undeserving of censure, although in different ways. Of course, a number of people engage in all these things just as if they were not doing so, and for this reason either with no offense or with very little. Some do these things out of simplicity, some out of love, and some out of necessity. Certain people follow these ways simply because they are ordered and are ready to do otherwise if they would be told otherwise. Others seek in them not their own pleasure, but the peace of others, so that they might not live in discord with those with whom they dwell. Still others because they do not wish to offer resistance to the multitude of those who oppose them, those who with a loud voice defend these things as if they were in order. And whenever the former begin to restrict or change anything as reason prescribes, the latter resist them with all their authority.

IX. 19. Who in the beginning, when the monastic Order began, would have thought that monks would have come to such a lack of spirit? How far we are from those who were monks in the days of Anthony! When they visited one another out

ex caritate reviserent, tanta ab invicem aviditate panem animarum percipie-
bant, ut, corporis cibum penitus obliti, diem plerumque totum ieiunis ven-
tribus, sed non mentibus transigerent. Et hic erat rectus ordo, quando di-
gniori parti prius inserviebatur; haec summa discretio, cum amplius sumebat
5 quae maior erat; haec denique vera caritas, ubi animae, quarum caritate
Christus mortuus est, tanta sollicitudine refocillabantur. Nobis autem con-
venientibus in unum, ut verbis Apostoli utar, IAM NON EST DOMINICAM CE-
NAM MANDUCARE. Panem quippe caelestem nemo qui requirat, nemo qui
tribuat. Nihil de Scripturis, nihil de salute agitur animarum; sed nugae, et
10 risus, et verba proferuntur in ventum. Inter prandendum quantum fauces
dapibus, tantum aures pascuntur rumoribus, quibus totus intentus, modum
nescias in edendo.

DE COMMESSATIONE

20. Interim autem fercula ferculis apponuntur, et pro solis carnibus, a
15 quibus abstinetur, grandia piscium corpora duplicantur. Cumque prioribus
fueris satiatus, si secundos attigeris, videberis tibi necdum gustasse pisces.
Tanta quippe accuratione et arte coquorum cuncta apparantur, quatenus,
quatuor aut quinque ferculis devoratis, prima non impediant novissima, nec
satietas minuat appetitum. Palatum quippe, dum novellis seducitur condi-
20 mentis, paulatim disuescere cognita, et ad succos extraneos, veluti adhuc
ieiunum, avide renovatur in desideria. Venter quidem, dum nescit, onera-
tur; sed varietas tollit fastidium. Quia enim puras, ut eas natura creavit,
epulas fastidimus, dum alia aliis multifarie permiscentur, et spretis naturali-
bus, quos Deus indidit rebus, quibusdam adulterinis gula provocatur sapori-
25 bus, transitur nimirum meta necessitatis, sed necdum delectatio superatur.

[6]1 Cor 11, 20 [25]Rom 1, 27

[1]ex caritate: *om FL* [7]utar: loquar *FL* [15]DE COMMESSATIONE: *om* P, C, INCIPIT
praemittit B, DE VICTU ET POTU *Sc (ubi* POTO *pro* POTO) [15]grandia: grandium *St*
[16]pisces: priores *FL* [19]satietas minuat: satiant *FL* [20]et: consuevit *add Cl int*
lin rec m [21]renovatur: revocatur *Td* [22]puras: putas *FL* eas natura:
Deus eas *FL* [23]alia aliis: allis alia *A*, alias aliis *T*

of love, they took the bread of the soul from each other with such avidity that on many occasions they passed the entire day with empty stomachs, but not spirits, having completely forgotten the food of the body. This was right order, when that which was more important was served first. This was the highest discretion, when that which was greater was taken up to a greater degree. Finally, this was real love, when souls, for the love of whom Christ died, were tended with such great solicitude. However, when we come together, "It is not to eat the Lord's supper," if I may use the words of the Apostle. There is no one who would ask for the heavenly bread and no one who would give it. Nothing dealing with the Scriptures, nothing concerning the salvation of souls takes place; but idle talk and laughter fill the air. During meals, just as gullets are feasted with food, so ears are feasted with gossip so engrossing that you know no moderation in eating.

[On meals]

20. Meanwhile, however, course after course is served and in the place of a single one of meat, which is abstained from, there are two great courses of fish. And when you have been sated by the first, if you touch the second, it will seem to you that you have not even tasted fish yet. The reason is that they are all prepared with such care and skill by the cooks that, four or five courses having been devoured, the first does not impede the last and satiety does not impair the appetite. For the palate, as long as it is enticed by novel seasonings, gradually loses its attraction to the familiar and is hungrily restored in its desire by foreign spices as if it had fasted until now. The stomach, as long as it is unfamiliar with [these new seasonings and spices], is overloaded, but variety removes any weariness. This is because as long as one thing and another are blended together in many different ways, we treat unadulterated food—as nature has made it—with disdain and, having scorned the natural qualities which God has bestowed on these things, the appetite is roused by certain adulterated flavors: the limit of necessity is of course passed by, but the capacity for pleasure is not yet exhausted.

Quis enim dicere sufficit, quot modis, ut cetera taceam, sola ova versantur et vexantur, quanto studio evertuntur, subvertuntur, liquantur, durantur, diminuuntur, et nunc quidem frixa, nunc assa, nunc farsa, nunc mixtim, nunc singillatim apponuntur? Ut quid autem haec omnia, nisi ut soli fastidio
5 consulatur? Ipsa deinde qualitas rerum talis deforis apparere curatur, ut non minus aspectus quam gustus delectetur, et cum iam stomachus crebris ructibus repletum se indicet, necdum tamen curiositas satiatur. Sed dum oculi coloribus, palatum saporibus illiciuntur, infelix stomachus, cui nec colores lucent, nec sapores demulcent, dum omnia suscipere cogitur, oppressus ma-
10 gis obruitur quam reficitur.

DE POTATIONE

21. Iam vero de aquae potu quid dicam, quando ne ullo quidem pacto vinum aquatum admittitur? Omnes nimirum, ex quo monachi sumus, infirmos stomachos habemus, et tam necessarium Apostoli de utendo vino consi-
15 lium merito non negligimus, MODICO tamen, quod ille praemisit, nescio cur praetermisso. Et utinam vel solo, cum etiam purum est, contenti essemus! Pudet dicere, sed magis pudeat actitari; et, si pudet audiri, non pudeat emendari. Videas uno in prandio ter vel quater semiplenum calicem reportari, quatenus diversis vinis magis odoratis quam potatis, nec tam haustis
20 quam attactis, sagaci probatione et celeri cognitione unum tandem e pluribus, quod fortius sit, eligatur. Quale est autem illud, quod nonnulla monasteria ex more observare dicuntur, in magnis videlicet festis vina delibuta

[14] 1 Tim 5, 23

[1] enim: igitur *FL* [2] et vexantur: *om FL* [3] nunc frixa . . . nunc mixtim: *om St*
[3] frixa: nunc mollia *add F* [5] curatur: conatur *St* [6] delectetur: delectet *FL, A* [12] DE POTATIONE: *om* P, C, ITEM DE POTU *Sc* [13] aquatum: aquaticum *FL* [16] vel solo . . . purum est: cum parum vel solo etiam *FL* [16] purum: parum *St* [17–18] sed magis . . . emendari: quod nisi ego oculis probassem, referenti vix crederem P (oculis *om FL*) [17] pudet: pudeat *Ct, C* [18] semiplenum calicem: ~ P [19–21] diversis vinis . . . Quale est autem: diversa vina dum potando probantur ac probando potantur, tandem de multis quod melius est eligatur. Quale autem est P (ac probando potantur *om Td*) [21] eligatur: DE PIMENTO ET ALIIS POTIBUS *add Sc*

Who can say in how many ways that eggs alone (I won't mention the rest) are beat and buffeted, with how much care they are turned one way and then another, cooked soft, hard, and scrambled? How they are served now fried, now baked, now stuffed, now mixed with other things, and now separately? What is the point of all this, except that lack of appetite alone is looked after? The properties of these foods are prepared to show their appearance in such a way that their sight is no less pleasing than their taste. Although the stomach proclaims itself filled by repeated belching, curiosity is not yet satisfied. But while the eyes are enticed by the colors and the palate by the taste, the unfortunate stomach—which neither sees the colors nor is allured by the tastes—is forced to receive it all and, having been smothered, is more overwhelmed than refreshed.

[On drinking]

21. What can I say about the drinking of water, when watered wine is by no means tolerated? All of us, since we are monks, suffer from bad stomachs, and so we naturally do not neglect that unavoidable advice of the Apostle concerning the use of wine. However, I do not know why the expression "a little" with which he prefaced it is overlooked. If only we were content with wine by itself, even though it is unmixed. This is shameful to say, but it should be even more shameful that it is done. And if it is shameful to be heard about, let it not be shameful to be corrected. You may see in one meal three or four half-filled cups carried back and forth so that from among the different wines—more by the bouquet than by the taste, and not so much by drinking as by the texture—the one which is stronger may at last be chosen from the others by acute examination and quick recognition.

And what kind of practice is it which in a number of monasteries they are said to observe by custom when they are in assembly on the major feasts, namely,

melle, pigmentorum respersa pulveribus, in conventu bibere? Numquid et hoc fieri dicemus propter infirmitatem stomachi? Ego vero ad nihil aliud valere video, nisi ut vel amplius bibatur, vel delectabilius. Sed cum venae vino fuerint ingurgitatae, toto in capite palpitantes, sic surgenti a mensa
5 quid aliud libet, nisi dormire? Si autem ad vigilias indigestum surgere cogis, non cantum, sed planctum potius extorquebis. 22. Cum vero ad lectum devenero, requisitus incommodum plango, non crapulae peccatum, sed quod manducare non queo.

DE HIS QUI, INFIRMITATE NON EXSPECTATA,
10 IN DOMO INFIRMORUM PAUSARE CONSUEVERUNT

Ridiculum vero est, si tamen verum est, quod relatum est mihi a pluribus, qui hoc se pro certo scire dicebant: reticendum esse non arbitror. Aiunt enim incolumes ac validos iuvenes conventum solere deserere, in domo se infirmorum, qui infirmi non sunt, collocare, carnium esu, qui vix
15 aegrotis dumtaxat et omnino debilibus ex Regulae discretione pro virium reparatione conceditur, non quidem corporis infirmantis ruinas reficere pro incommodo sed carnis luxuriantis curam perficere in desiderio. Rogo quae est haec securitas, inter frendentium undique hostium fulgurantes hastas et circumvolantia spicula, tamquam finito iam bello et triumphato adversario,
20 proicere arma, et aut prandiis incubare longioribus, aut nudum molli volutari in lectulo? Quid hoc ignaviae est, o boni milites? Sociis in sanguine et caede versantibus, vos aut cibos diligitis delicatos, aut somnos capitis matutinos? Aliis, inquam, nocte et die cura pervigili festinantibus redimere

[2]1 Tim 5, 23 [16]conceditur: Reg. S. Bened., c. 36, 9 [18]Nah 3, 3
[21]Mt 23, 30 [22]Esth 9, 18 [23]Eph 5, 16

[2]fieri: *om FL* vero: autem *F,* id *add LStTd* [5]libet: mihi *add* P
[8]non queo: nequeo *BScT* [9–10]DE HIS . . . CONSUEVERUNT: *om* P, C, DE SANIS ET IUVE-
NIBUS IN DOMO INFIRMORUM POSITIS *Sc,* DE SIMULATA INFIRMITATE *T* [11]Ridiculum:
ab hinc usque ad Sic Macarius, p. 100, l. 14, *om* P [11]est[2]: *om* C [19]spicula: et
add CtM

drinking wine steeped with honey and sprinkled with ground spices? Surely we do not claim that this is done because of bad stomachs? I take it to serve no other purpose than that either more or better wine is drunk. But when the blood vessels pounding throughout one's head are gorged with wine, what else appeals to one rising from the table except to sleep? And if you force a person with indigestion to rise for vigils, you will wring not a chant but rather a groan from him. 22. When I have gone to bed, in need I lament my misfortune—not the sin of drunkenness, but because I am unable to eat.

[On those who while not expecting to be sick, have become accustomed to rest in the infirmary]

It is actually laughable, if indeed it is true, what has been reported to me by many people who have said that they know it for certain. It is a matter on which I think I should not be silent. For they say that healthy and even robust young men make a habit of deserting the community to put themselves, men who are not sick, in the infirmary in order to eat meat—which according to the discretion of the Rule is hardly conceded even to those who are sick and very weak for the recovery of their strength—not to restore the ruins of a body weakened because of illness, but to care for the self-indulgent flesh in its desires.

What kind of security is this, I ask—when among the gleaming spears of the teeth-gnashing enemy and the arrows flying around on all sides—to throw down one's weapons as if the war were already over and the enemy vanquished, and to rest over longer meals or to roll about defenseless on a soft couch? What faintheartedness is this, good soldiers? While your comrades are whirling about in the blood and gore, you are enjoying a delicate meal or taking your early morning

tempus, quoniam dies mali sunt, vos e contrario et longas noctes dormitando consumitis, et dies fabulando ducitis otiosos? An dicitis: Pax, et non est pax? Cur vel non verecundamini ad exprobrationem apostolicae indignationis? Nondum enim, ait, restitistis usque ad sanguinem. Immo iam ad eiusdem terribilis valde comminationis tonitruum cur non expergiscimini? Cum dixerint, inquit: Pax et securitas, tunc repentinus eis superveniet interitus, sicut dolor in utero habentis, et non effugient. Delicata nimis medicina est, prius alligari quam vulnerari, membrum non percussum plangere, et necdum suscepto ictu admovere manum, fovere unguento ubi non dolet, emplastrum adhibere ubi caesura non est.

23. Ad discernendum deinde inter sanos et male habentes, baculos in manibus gestare iubentur aegrotantes, plane necessarios, ut quam pallor in vultu maciesque non indicat, baculus sustentans mentiatur invaletudinem. Ridendas an lugendas dixerim huiuscemodi ineptias? Sic Macarius vixit? Sic Basilius docuit? Sic Antonius instituit? Sic Patres in Aegypto conversati sunt? Sic denique sancti Odo, Maiolus, Odilo, Hugo, quos se sui utique Ordinis principes et praeceptores habere gloriantur, aut tenuerunt, aut teneri censuerunt? Sed hi omnes, si sancti, immo quia sancti fuerunt, a sancto Apostolo non dissenserunt, qui nimirum ita loquitur: Habentes victum et vestitum, his contenti sumus. Nobis autem est pro victu satietas, nec vestitum appetimus, sed ornatum.

²Ez 13, 10 ⁴Hebr 12, 4 (Vg: usque ad sang. restitistis) ⁶1 Thess 5, 3 (Vg: cum enim dixerint, utero habenti) ¹¹Mc 2, 17 ¹⁹1 Tim 6, 8 (Vg: Habentes autem alimenta et quibus tegamur, simus)

¹⁵in: de P ¹⁵⁻¹⁶conversati: versati *Cl*¹ *Clac ut vid* ¹⁶⁻¹⁷sui utique: ~ P ¹⁸censuerunt: statuerunt P ¹⁸⁻¹⁹Sed hi . . . ita loquitur: Si sancti fuerunt, ab Apostolo non dissenserunt, qui utique dicit P ²⁰vestitum: vestimentum *FL* sumus: simus *FL, A* ²⁰est: *om Td* ²¹vestitum: vestimentum *FL, A*

sleep. While the others are quick to gain the time night and day with ever-watchful concern since the days are evil, you, on the contrary, waste the long nights in sleep and spend your leisurely days chatting. Do you not say, "Peace, when there is no peace"? Or why aren't you ashamed at the reproach of the indignant Apostle who said, "You have not yet resisted to the point of shedding blood"? Why don't you rouse yourselves to the thunder of his intensely terrible threat? As he says, "When people say there is peace and security, then sudden destruction will come upon them as labor upon a woman with child, and there will be no escape."

It is an unduly self-indulgent treatment to be bandaged before being wounded, to bewail a limb which has not yet been struck, to rub oneself from a blow not yet received, to treat a spot with ointment that does not ache, or to apply plaster where there is no cut. 23. To distinguish between the healthy and the sick, the sick are ordered to carry staffs in their hands and these are quite necessary, for, since a pallor of the face or a thinness of the body may not indicate something, the supporting staff must give the impression of infirmity. Should I have referred to this kind of absurdity as deserving of laughter—or of tears?

Did Macarius live this way? Did Basil teach this way? Did Anthony decree this way? Did the Fathers in Egypt act in this way? Indeed, did the saints Odo, Maiolus, Odilo, or Hugh—whom they especially pride themselves on having as the founders and teachers of their Order—did they follow this way or recommend that it be followed? But if, or rather, because all these men were holy, they did not disagree with the Apostle who said, "Having food and clothing, we are content." Yet for us there is satiety instead of food, and we do not seek clothing but personal adornment.

DE VESTITU SUPERFLUO VEL SUPERBO

X. 24. Quaeritur ad induendum, non quod utilius, sed quod subtilius invenitur; non quod repellat frigus, sed quod superbire compellat; non denique, iuxta Regulam, quod vilius comparari potest, sed quod venustius, immo vanius ostentari. Heu me miserum qualemcumque monachum! Cur adhuc vivo videre ad id devenisse Ordinem nostrum, Ordinem scilicet qui primus fuit in Ecclesia, immo a quo coepit Ecclesia, quo nullus in terra similior angelicis ordinibus, nullus vicinior ei quae in caelis est Ierusalem mater nostra, sive ob decorem castitatis, sive propter caritatis ardorem, cuius Apostoli institutores, cuius hi, quos Paulus tam saepe sanctos appellat, inchoatores exstiterunt? Et quidem inter illos cum nihil quod suum esset quispiam retinuisset, DIVIDEBATUR, ut scriptum est, SINGULIS PROUT CUIQUE OPUS ERAT, non igitur quod quisque pueriliter gestire poterat. Sane ubi tantum quod opus erat accipiebatur, ibi procul dubio nihil otiosum admittebatur, quanto magis nihil curiosum, quanto magis nihil superbum. QUOD OPUS, inquit, ERAT: hoc est, quantum ad indumenta, quod et nuditatem tegeret, et frigus repelleret. Putasne ibi cuiquam galabrunum aut isembrunum quaerebatur ad induendum, cuiquam mula ducentorum solidorum parabatur ad equitandum? Putasne, inquam, cuiuspiam ibi lectulum opertorium cattinum aut discolor barricanus operiebat, ubi SINGULIS DIVIDEBATUR tantum PROUT CUIQUE OPUS ERAT? Non illic arbitror valde curatum fuisse de pretio, de colore, de cultu vestimentorum, ubi tam indefessum inerat studium in concordia morum, animorum cohaerentia profectuque virtutum: MULTITUDINIS, inquit, CREDENTIUM ERAT COR UNUM, ET ANIMA UNA.

[4]potest: Reg. S. Bened., c. 55, 7 [8]Apoc 21, 2; Gal 4, 26 [10]Rom 1, 7; 15, 25 etc. [11]Act 4, 32 [12]Act 4, 35 (Vg: dividebatur autem sing.) [23]Act 4, 32 (Vg: multitudinis autem)

[1]DE VESTITU . . . SUPERBRO: *om* P, C, DE INDUMENTO *Sc* [3]invenitur: inveniatur *M Sc* [4-5]venustius immo: *om* P [7]a quo: unde P [9]ardorem: decorem *A* [10]appellat: cognominat *St*, commemorat *B* [16]tegeret: tegerent *CtM* [17]repelleret: repellerent *CtM* [19]inquam: *om* F, unquam *StTd* opertorium: coopertorium *FTdL* [20]barricanus: barracanus F, baracanus L [20]tantum: *om* FL [21]Non illic arbitror: Quis ibi putet P [22]tam indef. in. stud.: tanta cura et (tantum *add* FL) studium inerat P [23]morum: *om* P cohaerentia: *om* P [24]inquit: autem FL

[On excessive or prideful clothing]

X. 24. It is not that which is the more practical which is sought to be worn, but that which is found to be the more refined. Not that which may keep out the cold, but that which may appeal to pride. And not that which—according to the Rule— can be more cheaply bought, but that which can be shown off more attractively, or rather more vainly. Oh, miserable monk that I am! Why have I lived so long as to see our Order come to this, that Order which was the first in the Church, or rather by which the Church began, of which there is none on earth more like the angelic Orders, none closer to the heavenly Jerusalem, our mother, whether because of the beauty of its chastity or because of the ardor of its love, of which the Apostles were the founders, and of which those whom Paul so often called saints were the inaugurators. Since there was nothing among them which anyone kept in his own possession—as was written, "distribution was made to each according to his need"—no one could childishly desire anything.

Obviously, where only that which was needed was allowed, nothing superfluous was sanctioned there, how much less anything curious, how much less anything sumptuous. He said, "According to his need." As far as clothing is concerned, this means that which both covers nakedness and keeps out the cold. Do you think that silk or satin was sought for anyone there to wear, or that a mule worth two hundred gold pieces was bought for any of them to ride? Do you think, I say, that anyone's bed was covered by a catskin coverlet or multicolored bedspread there, where "Distribution was made to each according to his need"? I do not think that there was much concern about the price, color, or style of clothing in a place where there was such tireless zeal in the harmony of practices, in the unanimity of minds, and in the progress of virtues: "The whole group," he says, "of believers was of one heart and one soul."

25. Ubi nunc illud unanimitatis exercitium? Fusi sumus exterius et, de regno Dei, quod intra nos est, relictis veris ac perennibus bonis, foris quaerimus vanam consolationem de vanitatibus et insaniis falsis, ac iam religionis antiquae non solum virtutem amisimus, sed nec speciem retinemus. Ecce
5 enim ipse habitus noster, quod et dolens dico, qui humilitatis esse solebat insigne, a monachis nostri temporis in signum gestatur superbiae. Vix iam in nostris provinciis invenimus, quo vestiri dignemur. Miles et monachus ex eodem panno partiuntur sibi cucullam et chlamydem. Quivis de saeculo, quantumlibet honoratus, etiam si Rex, etiam si Imperator ille fuerit, non
10 tamen nostra horrebit indumenta, si suo sibi modo praeparata fuerint et aptata.

26. «Ceterum in habitu», inquis, «non est religio, sed in corde.» Bene. At tu quando cucullam empturus lustras urbes, fora circuis, percurris nundinas, domos scrutaris negotiatorum, cunctam evertis singulorum supellecti-
15 lem, ingentes explicas cumulos pannorum, attrectas digitis, admoves oculis, solis opponis radio, quidquid grossum, quidquid pallidum occurrerit, respuis; si quid autem sui puritate ac nitore placuerit, illud mox quantolibet pretio satagis tibi retinere: rogo te, ex corde facis hoc, an simpliciter? Cum denique contra Regulam, non quod vilius occurrerit, sed studiosissime quae-
20 ris quod, quia rarius invenitur, pretiosius emitur, ignorans facis hoc, an ex industria? Ex cordis thesauro sine dubio procedit quidquid foris apparet vitiorum. Vanum cor vanitatis notam ingerit corpori, et exterior superfluitas interioris vanitatis indicium est. Mollia indumenta animi mollitiem indicant. Non tanto curaretur corporis cultis, nisi prius neglecta fuisset mens inculta
25 virtutibus.

²Lc 17, 21 ³Ps 39, 5 ¹⁹vilius: Reg. S. Bened., c. 55, 7 ²¹Lc 6, 45
²²Ps 5, 10

¹⁻²de regno . . . bonis: et relictis veris bonis de regno Dei quod intra nos est P
³consolationem: et *add* Ct, C, Dpc ¹²Bene: *om* FL ¹³cucullam: tibi *add* P
¹⁴scrutaris: perscrutaris FL evertis: subvertis FL, Sc ¹⁶radio: radiis St
¹⁸tibi: *om* P simpliciter: ex simplicitate FL ¹⁹⁻²⁰quaeris: quod subtilius *add* St

25. Where is that practice of unanimity now? We are externally slack and—concerning the kingdom of God which is within us in true remnants and continuous blessings—we seek empty consolation outside ourselves in false vanities and insanities. Not only have we lost sight of the virtue of the old religious life, we have not even held on to its semblance. Even our habit itself, and I say this with sadness, which used to be a symbol of humility, is worn by the monks of our time as a sign of pride. We hardly find in our own region that which we consider worthy to be worn. The knight and the monk divide the same bolt of cloth between them for both cowl and cape. No one these days, however high, even if he were a king or an emperor, would appear unsightly in our clothes if only they were prepared and tailored for him in his own way.

26. "However," you say, "religion is not in the habit, but in the heart." Very well. But when you are about to buy a cowl you scour the cities, make the rounds of the markets, and quickly run through the fairs. You scrutinize the shops, rummaging through all the merchandise of every single one. You unroll many bolts of cloth, examining them with both fingers and eyes, and holding them up to the sunlight—when anything coarse or dull occurs, you disdainfully reject it. Yet if something is pleasing in its purity and brilliance, you run about to keep from losing it no matter what the price is. I ask you, do you do this from the heart or with simplicity? When, contrary to the Rule, you so energetically search out something not because it occurs more cheaply but because it is come across more rarely and so is purchased with greater expense, do you do this ignorantly or on purpose? Any shortcoming which appears on the outside undoubtedly proceeds from the treasury of the heart. The empty heart forces on the body the mark of its own emptiness, and exterior excess is an indication of interior emptiness. Soft garments reveal a softness of the soul. The adornment of the body would not be worried about so much if it were not that the soul had been previously neglected, unadorned with virtues.

De incuria praelatorum

XI. 27. Miror autem, cum Regula dicat ad magistrum respicere quidquid a discipulis delinquitur, et Dominus per Prophetam sanguinem in peccato morientium de manu pastorum requirendum esse minetur, quomodo
5 abbates nostri talia fieri patiantur, nisi forte, si audeam dicere, nemo fidenter reprehendit, in quo se esse irreprehensibilem non confidit. Siquidem humanitatis est omnium, in quo sibi quisque indulget, aliis non vehementer irasci. Dicam, dicam; praesumptuosus dicar, sed verum dicam. Quomodo lux mundi obtenebrata est? Quomodo sal terrae infatuatum est? Quorum nobis
10 vita via vitae debuit esse, dum exemplum in suis actibus ostendunt superbiae, caeci facti sunt duces caecorum.

De fastu equitandi

Quod enim, ut cetera taceam, specimen humilitatis est, cum tanta pompa et equitatu incedere, tantis hominum crinitorum stipari obsequiis, quate
15 nus duobus episcopis unius abbatis sufficiat multitudo? Mentior, si non vidi abbatem sexaginta equos, et eo amplius, in suo ducere comitatu. Dicas, si videas transeuntes, non patres esse monasteriorum, sed dominos castellorum, non rectores animarum, sed principes provinciarum. Tum deinde gestari iubentur mappulae, scyphi, bacini, candelabra, et manticae suffarcinatae, non
20 stramentis, sed ornamentis lectulorum. Vix denique quatuor leucis a sua

[3]delinquitur: Reg. S. Bened., c. 36, 10 Ez 3, 18 [8]Mt 5, 14 [9]Mt 5, 13
[10]Ps 15, 10 [11]Mt 15, 14

[1]De inc. prael.: *om* P, C, De abbate *Sc* [3]delinquitur: relinquitur *L*
[4]esse: *om* C [5]audeam: audeo P [6]reprehendit: in alio *add FL* [10]ostendunt: ostenditur *FL* [12]De fastu eq.: *om* P, C [15]multitudo: comitatus *St*
[16]sexaginta: septuaginta *FL* [19]scyphi, bac., cand.: candelabra, scyphi, bacini P
[20]lectulorum: lectorum *FL*

[On the negligence of prelates]

XI. 27. Furthermore, when the Rule prescribes to the master that he be mindful of whatever is lacking in those under his direction, and the Lord warns through the prophet that the blood of those dying in sin will be required from the hand of the pastor, I am surprised at the extent to which our abbots allow such things to happen. But perhaps, if I dare say so, no one boldly censures that of which he himself is not confident of being blameless. So it is with all human nature, one does not get very angry with others for that in which one himself indulges.

I will speak, I will speak; I may be called presumptuous, but I will speak the truth! How could the light of the world be made dark? How could the salt of the earth lose its flavor? Their life ought to be a path of life to us, while instead they offer an example of pride in their actions. The leaders of the blind have been made blind.

[On the pomp of riding]

As to the rest I will remain silent, but how is it a model of humility to travel with so much pomp and so many mounted men, to be surrounded with so many long-haired servants that the retinue of a single abbot would be sufficient for two bishops? If I am not mistaken, I have seen an abbot leading sixty horses and more in his train. If you saw them passing by, you would say that they were not the spiritual fathers of monasteries, but the lords of castles, not the keepers of souls, but the princes of some region. On these occasions napkins, cups, basins, candlesticks, and bags stuffed not with bedding but with embellishments for the bed are ordered to be

quispiam domo recedit, nisi cum tota supellectili sua, tamquam sit vel iturus
ad exercitum, vel transiturus per desertum, ubi non valeant inveniri necessa-
ria. Annon posset eodem vasculo et aqua manibus vergi, et vinum bibi?
Annon posset ardens lucere lucerna, nisi in tuo quod portas candelabro, et
5 hoc aureo vel argenteo? Annon posset dormiri, nisi super varium stratum
aut sub peregrino coopertorio? Annon unus aliquis minister posset et iu-
mentum ligare, et ad mensam servire, et lectulum praeparare? Nunc ergo
tantae multitudini garsionum ac iumentorum, cur, vel ad solatium mali, no-
biscum necessaria non ferimus, quatenus hospites non gravemus?

10 DE PICTURIS ET SCULPTURIS, AURO ET ARGENTO
IN MONASTERIIS

XII. 28. Sed haec parva sunt; veniam ad maiora, sed ideo visa minora,
quia usitatiora. Omitto oratoriorum immensas altitudines, immoderatas lon-
gitudines, supervacuas latitudines, sumptuosas depolitiones, curiosas depic-
tiones, quae dum in se orantium retorquent aspectum, impediunt et affectum,
15 et mihi quodammodo repraesentant antiquum ritum Iudaeorum. Sed esto,
fiant haec ad honorem Dei. Illud autem interrogo monachus monachos, quod
in gentilibus gentilis arguebat: DICITE, ait ille, PONTIFICES, IN SANCTO QUID
FACIT AURUM?

Ego autem dico: «Dicite pauperes»,—non enim attendo versum, sed
20 sensum—, «dicite», inquam, «pauperes, si tamen pauperes, in sancto quid
facit aurum?» Et quidem alia causa est episcoporum, alia monachorum. Sci-
mus namque quod illi, sapientibus et insipientibus debitores cum sint, carna-
lis populi devotionem, quia spiritualibus non possunt, corporalibus excitant

[4]Io 5, 35 [17]Persius, Sat., II, 69 [22]Rom 1, 14

[1]sit: *om Td* [4-5]lucere . . . dormiri: *om St* lucere: haerere P in: *om* P
[6]peregrino: silvestri P, *A Dpc int lin,* vel silvestri *add Ct,* silvestri vel peregrino *Sc*
[6-7]iumentum: iumenta *FLSt* [7]lectulum: lectum *FL* [9]hospites: hospitem *FL*
[10]DE PICTURIS . . . IN MONAST.: *om* P, C, DE PICTIS MONASTERIIS *Sc,* DE PICTURIS MONASTERII *T*
[11]Sed: Si *BT* ideo: non *add FL* [13]latitudines: amplitudines *FL* depoli-
tiones: politiones *St* [14]dum: *om St*

carried about. A man can scarcely go four leagues from his home unless with all his furnishings, as if he were going to go to war or to cross through a desert where the necessities of life are not to be found. Cannot water be poured on one's hands and wine be drunk from the same vessel? Cannot a burning light shine except in your own candlestick which you have brought along, and this of gold or silver? Cannot one sleep except on a multicolored mattress or under an imported coverlet? Cannot the same servant tie up the animal, serve at table, and prepare the bed? Why do we not at any rate carry with us the essentials to relieve the trouble of such a great crowd of servants and animals so that we do not burden our hosts?

[On paintings and sculptures and silver and gold in monasteries]

XII. 28. But these are small things; I am coming to things of greater importance, but which seem smaller, because they are more common. I will overlook the immense heights of the places of prayer, their immoderate lengths, their superfluous widths, the costly refinements, and painstaking representations which deflect the attention while they are in them of those who pray and thus hinder their devotion. To me they somehow represent the ancient rite of the Jews. But so be it, let these things be made for the honor of God.

However, as a monk, I put to monks the same question that a pagan used to criticize other pagans: "Tell me, priests," he said, "what is gold doing in the holy place?" I, however, say, "Tell me, poor men"—for I am not concerned with the verse, but with the sense—I say, "Tell me, poor men, if indeed you are poor men, what is gold doing in the holy place?" For certainly bishops have one kind of business, and monks another. We know that since they are responsible for both the wise and the foolish, they stimulate the devotion of a carnal people with material

ornamentis. Nos vero qui iam de populo exivimus, qui mundi quaeque pretiosa ac speciosa pro Christo reliquimus, qui omnia pulchre lucentia, canore mulcentia, suave olentia, dulce sapientia, tactu placentia, cuncta denique oblectamenta corporea arbitrati sumus ut stercora, ut Christum lucri
5 faciamus, quorum, quaeso, in his devotionem excitare intendimus? Quem, inquam, ex his fructum requirimus: stultorum admirationem, an simplicium oblationem? An quoniam commixti sumus inter gentes, forte didicimus opera eorum, et servimus adhuc sculptilibus eorum?

Et ut aperte loquar, an hoc totum facit avaritia, quae est idolorum ser
10 vitus, et non requirimus fructum, sed datum? Si quaeris: «Quomodo?» «Miro», inquam, «modo». Tali quadam arte spargitur aes, ut multiplicetur. Expenditur ut augeatur, et effusio copiam parit. Ipso quippe visu sumptuosarum, sed mirandarum vanitatum, accenduntur homines magis ad offerendum quam ad orandum. Sic opes opibus hauriuntur, sic pecunia pecuniam
15 trahit, quia nescio quo pacto, ubi amplius divitiarum cernitur, ibi offertur libentius. Auro tectis reliquiis signantur oculi, et loculi aperiuntur. Ostenditur pulcherrima forma Sancti vel Sanctae alicuius, et eo creditur sanctior, quo coloratior. Currunt homines ad osculandum, invitantur ad donandum, et magis mirantur pulchra, quam venerantur sacra. Ponuntur dehinc in ec
20 clesia gemmatae, non coronae, sed rotae, circumsaeptae lampadibus, sed non minus fulgentes insertis lapidibus. Cernimus et pro candelabris arbores quasdam erectas, multo aeris pondere, miro artificis opere fabricatas, nec magis coruscantes superpositis lucernis, quam suis gemmis. Quid, putas, in his omnibus quaeritur? Paenitentium compunctio, an intuentium admiratio? O
25 vanitas vanitatum, sed non vanior quam insanior! Fulget ecclesia parietibus, et in pauperibus eget. Suos lapides induit auro, et suos filios nudos deserit.

¹Mt 19, 27 ⁴Phil 3, 8 ⁶Rom 6, 21 ⁷Ps 105, 35–36 ⁹Eph 5, 5; Col 3, 5 ²⁵Eccle 1, 2

⁴⁻⁵lucrifaciamus: lucrifaceremus *St* ⁶inquam: iam *FL* ⁷oblationem: oblectationem *T* ⁸eorum¹: ipsorum *FL* et servimus . . . eorum: *om FL* ⁹quae: quod *CtDSc, C* ¹⁴ad orandum: ad adorandum *F, BT*, adorandum *L* ¹⁶signantur: saginantur *M* ¹⁷sanctior: sacratior *FL* ¹⁸donandum: dandum *St* ¹⁹venerantur: venerentur *T, C* ¹⁹sacra: De gemmis et coronis *add Sc* ²¹lapidibus: De candelabris *add Sc* ²¹et: *om A, C* ²²miro: multo *Td* ²⁵Fulg. eccles. par.: In parietibus ecclesia fulget *FL*

ornaments because they cannot do so with spiritual ones. But we who have withdrawn from the people, we who have left behind all that is precious and beautiful in this world for the sake of Christ, we who regard as dung all things shining in beauty, soothing in sound, agreeable in fragrance, sweet in taste, pleasant in touch—in short, all material pleasures—in order that we may win Christ, whose devotion, I ask, do we strive to excite in all this? What interest do we seek from these things: the astonishment of fools or the offerings of the simple? Or is it that since we have been mingled with the gentiles, perhaps we have also adopted their ways and even serve their idols?

But so that I might speak plainly, does not avarice, which is the service of idols, cause all this, and do we seek not the interest, but the principal? If you ask, "In what way?" I say, "In an amazing way." Money is sown with such skill that it may be multiplied. It is expended so that it may be increased, and pouring it out produces abundance. The reason is that the very sight of these costly but wonderful illusions inflames men more to give than to pray. In this way wealth is derived from wealth, in this way money attracts money, because by I know not what law, wherever the more riches are seen, there the more willingly are offerings made. Eyes are fixed on relics covered with gold and purses are opened. The thoroughly beautiful image of some male or female saint is exhibited and that saint is believed to be the more holy the more highly colored the image is. People rush to kiss it, they are invited to donate, and they admire the beautiful more than they venerate the sacred. Then jewelled, not crowns, but wheels are placed in the church, encircled with lights, but shining no less brightly with mounted precious stones. And instead of candlesticks we see set up what might be called trees, devised with a great amount of bronze in an extraordinary achievement of craftsmanship, and which gleam no more through their lights on top than through their gems. What do you think is being sought in all this? The compunction of penitents, or the astonishment of those who gaze at it? O vanity of vanities, but no more vain than insane! The Church is radiant in its

De sumptibus egenorum servitur oculis divitum. Inveniunt curiosi quo delectentur, et non inveniunt miseri quo sustententur. Ut quid saltem Sanctorum imagines non reveremur, quibus utique ipsum, quod pedibus conculcatur, scatet pavimentum? Saepe spuitur in ore Angeli, saepe alicuius Sancto-
5 rum facies calcibus tunditur transeuntium. Et si non sacris imaginibus, cur vel non parcitur pulchris coloribus? Cur decoras quod mox foedandum est? Cur depingis quod necesse est conculcari? Quid ibi valent venustae formae, ubi pulvere maculantur assiduo? Denique quid haec ad pauperes, ad monachos, ad spirituales viros? Nisi forte et hic adversus memoratum iam Poe-
10 tae versiculum propheticus ille respondeatur: Domine, dilexi decorem domus tuae et locum habitationis gloriae tuae. Assentio: patiamur et haec fieri in ecclesia, quia etsi noxia sunt vanis et avaris, non tamen simplicibus et devotis.

29. Ceterum in claustris, coram legentibus fratribus, quid facit illa ridi-
15 cula monstruositas, mira quaedam deformis formositas ac formosa deformitas? Quid ibi immundae simiae? Quid feri leones? Quid monstruosi centauri? Quid semihomines? Quid maculosae tigrides? Quid milites pugnantes? Quid venatores tubicinantes? Videas sub uno capite multa corpora, et rursus in uno corpore capita multa. Cernitur hinc in quadrupede cauda serpentis,
20 illinc in pisce caput quadrupedis. Ibi bestia praefert equum, capram trahens retro dimidiam; hic cornutum animal equum gestat posterius. Tam multa denique, tamque mira diversarum formarum apparet ubique varietas, ut magis legere libeat in marmoribus, quam in codicibus, totumque diem occupare singula ista mirando, quam in lege Dei meditando. Proh Deo! si non pudet
25 ineptiarum, cur vel non piget expensarum?

30. Multa quidem et alia suggerebat addenda larga materia; sed avellit

⁹memoratum: supra p. 104, 17 ¹⁰Ps 25, 8 ²⁴Ps 1, 2

¹quo: unde P ²sustententur: De picto pavimento *add Sc* ⁴⁻⁵Sanctorum: Sancti *F*, Sancto *L* ⁷conculcari: maculari *Td* ibi: tibi *Td* ⁹memoratum iam: ~ *P* ¹⁰ille: sermo *add St* ¹¹Assentio: Assentior *FLSt* ¹¹⁻¹²fieri in ecclesia: in eccl. fieri *LStTd* ¹³devotis: De sculptura claustrorum *add Sc*, De claustris sculptis et pictis *add T* ¹⁵ac: et *Ct*, *C* ¹⁹capita multa: ~ *FLSt*, *AB* ²⁰trahens: *om FL* ²³legere libeat: ~ *FLTd* ²⁴Deo: dolor *StTd* ²⁶addenda: *om FL*

walls and destitute in its poor. It dresses its stones in gold and it abandons its children naked. It serves the eyes of the rich at the expense of the poor. The curious find that which may delight them, but those in need do not find that which should sustain them.

Why is it that we do not at least show respect for the images of the saints, which the very pavement which one tramples underfoot gushes forth? Frequently people spit on the countenance of an angel. Often the face of one of the saints is pounded by the heels of those passing by. And if one does not spare the sacred images, why does one not at any rate spare the beautiful colors? Why do you decorate what is soon to be disfigured? Why do you depict what is inevitably to be trod upon? What good are these graceful forms there, where they are constantly marred by dirt? Finally, what are these things to poor men, to monks, to spiritual men? Unless perhaps at this point the words of the poet may be countered by the saying of the prophet, "Lord, I have loved the beauty of your house and the place where your glory dwells." I agree, let us put up with these things which are found in the church, since even if they are harmful to the shallow and avaricious, they are not to the simple and devout.

29. But apart from this, in the cloisters, before the eyes of the brothers while they read—what is that ridiculous monstrosity doing, an amazing kind of deformed beauty and yet a beautiful deformity? What are the filthy apes doing there? The fierce lions? The monstrous centaurs? The creatures, part man and part beast? The striped tigers? The fighting soldiers? The hunters blowing horns? You may see many bodies under one head, and conversely many heads on one body. On one side the tail of a serpent is seen on a quadruped, on the other side the head of a quadruped is on the body of a fish. Over there an animal has a horse for the front half and a goat for the back; here a creature which is horned in front is equine behind. In short, everywhere so plentiful and astonishing a variety of contradictory forms is seen that one would rather read in the marble than in books, and spend the whole day wondering at every single one of them than in meditating on the law of God. Good God! If one is not ashamed of the absurdity, why is one not at least troubled at the expense?

30. In any event, this broad subject has suggested many other things deserving

me et propria satis anxia occupatio, et tua, frater Ogere, nimis festina discessio, qui videlicet nec morari diutius acquiescis, nec abire tamen vis absque recenti opusculo. Facio itaque quod vis: et te dimitto, et sermonem brevio, praesertim quia utiliora sunt pauca in pace, quam multa cum scandalo. Et
5 utinam haec pauca scripserim sine scandalo! Enimvero vitia carpens, scio me offendere vitiosos. Potest tamen fieri, volente Deo, aliquibus quos me timeo exasperasse, potius placiturum esse, sed si desinant esse vitiosi: si videlicet et districtiores desinant esse detractores, et remissiores amputent superfluitates; si sic quisque bonum teneat quod tenet, ut alium aliud tenentem non iudi-
10 cet; si qui accepit iam esse bonus, non invideat melioribus, et qui sibi videtur agere melius, bonum non spernat alterius; si qui districtius vivere possunt, eos qui non possunt nec aspernentur, nec aemulentur, et qui non possunt, eos qui possunt sic mirentur, ut temere non imitentur. Sicut enim non licet his, qui maius aliquid forte voverunt, ad id quod minus est descen-
15 dere, ne apostatentur, sic non omnibus expedit de bonis minoribus ad maiora transire, ne praecipitentur.

DE MONACHIS EX ALIIS ORDINIBUS ET MONASTERIIS AD NOS VENIENTIBUS ET POSTEA RECEDENTIBUS

31. Scio quippe nonnullos de aliis et congregationibus et institutionibus
20 ad nostrum Ordinem pervolasse, pulsasse, intrasse, qui hoc quidem agendo, et suis scandala reliquerunt, et nobis nihilominus attulerunt, dum quantum illos sua temeraria discessione, tantum nos turbarunt sua misera conversatione. Et quoniam superbe spreverunt quod tenebant et temere praesumpserunt

[1]Ogere: cf. supra, p. 63 et 73 [9]2 Thess 2, 7 [11]Rom 14, 3

[1]Ogere: Ogeri P, C *(Clpc)* [2]morari diutius: ∼ *FL* vis: *om* P, *AT*
[3]brevio: abbrevio *Td* [7]placiturum: placitum *FL* [9]aliud: *om FL* [10]qui[1]:
quis P, *DT Cl*[1] [13]temere: *om* P non: *om FL* [17-18]DE MONACHIS . . . RECEDEN-
TIBUS: *om* P, C, DE MONACHIS AD ORDINEM CISTERCIENSIUM EUNTIBUS *Sc* [19]quippe: *om*
FLSt, K [21]scandala: scandalum *St*

to be added. But my own sufficiently worrisome preoccupations tear me away, Brother Oger, as does your imminent departure which you will not agree to delay any longer—yet neither are you willing to depart without this recent work. And so I will do what you wish. I will let you go and cut short my discourse, particularly since a few words in peace are more beneficial than many with scandal. And how I hope that I have written these few words without scandal! To be sure, in criticizing these faults, I am aware that I give offense to those who are in fault. Yet it can happen, God willing, that some of those whom I am afraid to anger, I will please instead, but only if they cease from being in fault—that is, if those who are stricter cease from being detractors, and those who are laxer cut away the excesses; if each one follows what he holds to be good in such a way that he not judge another who follows another way; if he who is admittedly good not be jealous of those who are better, and he who seems to himself to be better not scorn the good of others; if those who can live more strictly would neither spurn nor imitate those who cannot, and those who cannot would admire those who can, but not imitate them rashly. For just as it is not permitted to those who have vowed something greater to relapse into that which is less for fear that they apostatize, so it is not expedient for all to pass from lesser to greater goods.

[On monks who come to us from other Orders and monasteries and afterwards leave]

31. I know a number of men from both other communities and other observances who have flown to our Order, knocked, and entered and who, in doing this, have both left scandal behind them and brought it to us since they have disturbed us just as much by their wretched behavior as they have disturbed those whom they had left by their rash defection. And because they disdainfully scorned that which

quod non valebant, digno Deus exitu eorum tandem patefecit ignaviam, quia
et impudenter deseruerunt quod imprudenter arripuerant, et turpiter redie-
runt ad id quod leviter deseruerant. Cum enim claustra nostra sui potius
Ordinis impatientia quam desiderio nostri expetierint, ostendunt quod sunt,
5 dum a vobis ad nos, a nobis ad vos instabili levitate pervolantes, et nobis, et
vobis, et omnibus bonis scandalum faciunt. Quamquam ergo nonnullos eo-
rum noverimus, qui et fortiter, Deo auctore, coeperunt et, ipso protectore,
fortius perseverant, securius est tamen ut perseveremus in bono quod coepi-
mus, quam quod incipiamus ubi non perseveremus, et hoc pariter omnes
10 studeamus, quo, secundum Apostoli consilium, omnia nostra in caritate fiant.
Haec est nostra de vestro et nostro Ordine sententia; haec nostris, haec non
de vobis, sed vobis me solere dicere, nullus melius mihi testis erit quam vos,
et si quis me novit sicut vos. Quae in vestris laudabilia sunt, laudo et prae-
dico; si quae reprehendenda sunt, ut emendentur, vobis et aliis amicis meis
15 suadere soleo. Hoc non est detractio, sed attractio. Quod ut nobis a vobis
semper fiat, omnino precor et supplico. Valete.

[2] 2 Mach 9, 2 [10] 1 Cor 16, 14

[1-2] quia et: ~ *FL*, quia *Td, T* [2] imprudenter: impudenter *St* et [2]: etiam *FL*
[3-4] claustra . . . impatientia: Ordinem nostrum impatientia sui Ordinis potius P [4] quod:
quid *FL* [6] faciunt: *bic desinit textus in K* [7] noverimus: novimus *FL* Deo auctore:
om P [7] ipso protectore: *om* P [8] perseverant: perseveraverunt *FL* [9] quod: ut
P, *Ct* [11] vestro et nostro: nostro et vestro P, *ABFT* [11] nostris: et vestris *add FL*
[11-12] nostris . . . sed: de nostris et de vestris *Clpc*, de nostris et de vobis *Cl*[1], de nostris et
de vobis sed D [13] solere dicere: ~ *StTd* melius mihi: ~ C mihi: *om FL*
[14] quae: qua *StTd, Cl*[1] reprehendenda: reprehensibilia *St, Sc* [15] Hoc: Haec F
[15] nobis a: a nobis et *FL* [16] Valete: *om FL*

they were following and thoughtlessly presumed that for which they were not strong enough, God exposed their faint-heartedness in the end through their appropriate departure since they have both shamelessly deserted that which they had carelessly adopted and have dishonorably returned to that which they had lightly abandoned. For when they seek out our cloisters more from impatience with their own Order than from a desire for ours, they show of what they are made. Flying with unstable fickleness from you to us, and from us to you, they create a scandal to us and to you and to all good men. Therefore, although we may have known a number of those who have both begun vigorously, since God prompted them, and have continued more vigorously, since God also protected them, it is nevertheless safer that we should persevere in the good which we have begun than embark on something in which we might not persevere. And we should all apply ourselves in this so that, according to the advice of the Apostle, everything we do may be done in love.

This is our opinion concerning your Order and ours. It is what I am accustomed to say to our people and to—not about—yours. No one will be a better witness for me than you unless he has known me as you have. Those things which are praiseworthy in your people I praise and proclaim. If certain things deserve to be criticized, I make a practice of urging you and my other friends that they be corrected. This is not detraction, but a drawing together. I ask and beg that it may always be done in every respect by you for us. Goodbye.

SIGLORUM DECLARATIO

P Prima recensio

F Parisinus, Bibl. nat., lat. 564, f. 71–87ᵛ, olim abbatiae Fiscamnensis,
 O. S. B.

L Londinensis, Lambethani, 431, f. 166–171ᵛ, olim prioratus Lanthoniensis,
 can. reg.

Sg Carolopolitanus 186, f. non num., olim abbatiae Signiacensis, O. Cist., de
 linea Claraevallis.

St Coloniensis, Archivi historici, W. 4°. 186, f. 18ᵛ–29ᵛ, olim abbatiae
 Steinfeldensis, O. Praem.

Td Remensis 446, f. 113–116ᵇⁱˢ, olim abbatiae Sancti Theoderici, O. S. B.

S Secunda recensio

A Duacensis 372 I, f. 156–160ᵛ, olim abbatiae Aquicinctinae, O. S. B.

B Londinensis, Mus. Brit, Royal 8 F XV, f. 65–70, olim abbatiae
 Bellalandensis, O. Cist., de linea Claraevallis.

D Brugensis, Bibl. civit., 131, f. 37–55, olim abbatiae Dunensis, O. Cist., de
 linea Claraevallis.

M Berolinensis, Theol. lat. fol. 699, f. 26ᵛ–40, olim abbatiae Maceriensis, O.
 Cist., de linea Firmitatis.

Sc Sanctae Crucis, O. Cist., de linea Morimundi, 256, f. 49–62ᵛ.

K Claustroneoburgensis, can. reg., 805, f. 53ᵛ–58ᵛ.

Ct Divionensis 658, f. 66–73, olim abbatiae Cisterciensis.

T Monacensis, Lat. 18646, f. 57–67, olim abbatiae Tegernseensis, O. S. B.

C Recensio Claraevallensis

Cl Trecensis 426, f. 22–39ᵛ, olim abbatiae Claraevallensis.

Cl¹ Trecensis 799, f. 19–33ᵛ, olim abbatiae Claraevallensis.

Art Historical Commentary
on the Apologia*

81:1. APOLOGIA AD GUILLELMUM ABBATEM. On the title of this treatise, see the introduction to this appendix.

81:2. VENERABILI PATRI GUILLELMO. See Appendix 1, "The Origin of the *Apologia*," for William's role in the instigation and writing of the *Apologia*, as well as to what degree he is responsible for the "things of greater importance."

81:3. INUTILIS SERVUS. By the use of this epithet, Bernard conveyed to the uninitiated from the very outset that he considered the work which was to follow to be a duty imposed upon him by another, and one to which he acquiesced by virtue of his moral responsibility (Lk 17:10, "So you also, when you have done all that is commanded you, say, 'We are unworthy servants; we have only done what was our duty'"). But to the those familiar with Peter the Venerable's Letter 28, the implications may have been more involved; see Appendix 1, "The *Apologia* and the 'Pressing New Situation'." Cf. also *Carta Caritatis Prior* 1, p.91.

81:5–83:21. USQUE MODO . . . IN AURE LOCUTUS SUM. These first three chapters, I believe, constitute the preface (*praefatiuncula*) sought by Oger and William and discussed by Bernard in Letters 88:3 and 85:4, v.7:234, 222–223. See Appendix 1, "Bernard's Letter 88 to Oger and Letter 85 to William."

81:5. USQUE MODO SI QUA ME SCRIPTITARE IUSSISTIS. If Bernard has already stated that the burden of this treatise had been imposed upon him by another, he now makes it clear that it was actually at the request of a "Benedictine" that the *Apologia* was being written. That is, he wanted to convey the idea that it was not the result of Cistercian desires or schemes, but rather that the views expressed in it had a broad base of support outside of Cistercian monasticism.

William, in fact, was the immediate cause of Bernard's writing the *Apologia* as Letter 84[bis] indicates. However, it is unlikely that he was seen by Bernard as acting alone in this matter, or even that he was the first to

*See p.231; page and line numbers refer to Leclercq and Rochais' edition as followed here.

make such a request: and so the expression, "Until now"; see Appendix 1, "The Origin of the *Apologia*."

81:6–7. PRAESUMEREM QUOD NESCIEBAM. Such protestations of inability were standard form, with numerous examples existing in Bernard's writings (see, for example Letters 89:2, 398, v.7:236, v.8:377–379; *De Gradibus Humilitatis*, preface, v.3:16; *De Diligendo Deo*, preface, v.3:119; *De Gratia et Libero Arbitrio*, preface, v.3:165; *De Laude Novae Militiae*, preface, v.3:213; *De Praecepto*, preface, v.3:254).

81:7. NUNC VERO, NOVA URGENTE CAUSA. The pressing new situation that Bernard talks about seems to be a general threat of division within monasticism; see Letter 84bis, v.7:219 for his avowed purpose in writing the *Apologia* as the removal of scandal from the kingdom of God, and his discussions on unity within the Church in *Apologia* 5–9; on the actual causes themselves see Appendix 1 in general, but especially the subsection "The *Apologia* and the 'Pressing New Situation'." Bernard was not entirely removed from some of these causes of potential division. His acceptance of illegally transferring monks and canons gets special emphasis in the *Apologia* (*Apologia* 4, 31) and undoubtedly stirred much discontent among those institutions which were losing members (see Letters 3, 7:18–19, 32, 33, 34, 83:2 and perhaps 65, 66, 67, 68, and 396 for Bernard's views on the subject prior to the publication of the *Apologia*). Indeed, if my hypothesis that *Apologia* 1–3 constitutes the preface sought by William and Oger is correct, then the treatise as Bernard first wrote it began with *Apologia* 4, and so gave greater emphasis to the denial by Bernard that he was trying to actively influence monks to leave their orders for his. It also seems that the desire to show that he was not the only one open to accusation in the area of questionable recruitment was a major factor in the sudden publication of his letter criticizing Cluny to his nephew Robert who had been—in his opinion—prompted to criticize him (Bernard Letter 1:2, v.7:2).

81:9–11. QUOMODO NAMQUE SILENTER AUDIRE . . . DICIMUR IUDICARE MUNDUM. See the introduction to this Appendix for a discussion of Bernard's handling of this reference to Jerome, Letter 17:2. Bernard's decision to place this relatively obvious reference to Jerome and to Jerome's part in a monastic controversy in the preface—a decision which must have involved some reflection on his part if the preface was indeed added only after the preliminary draft—foreshadows a near constant tempo of allusions to Jerome, especially Jerome's great letters on the regular life such as Letters 22, 52, and 58 among others.

81:11. IUDICARE MUNDUM . . . ORDINI VESTRO DEROGARE. Bernard is making a distinction between alleged detraction of the world, in this case

probably the secular Church, and monasticism, finding the latter more serious. In fact, this is so much the case that he goes on to devote nine chapters to monastic (and ultimately Church) unity and six against detractors of traditional monasticism, while never returning to the subject of "the world" as indicated here. Monastic unity was a very important concept to Bernard, despite his willingness to participate in polemics, and it is this— not simply rhetorical advantage, although that too is a factor—which accounts for both of the series of chapters just mentioned. In a sermon to his own Cistercian monks, Bernard refers to "the double temptation with which religious are often spurred on through diabolical incitements to either strive after the glory of bishops or to rashly condemn their excesses;" *Super Cantica* 12:9, v.1:66.

I capitalize "order" in the translation whenever it refers to the meaning of "a religious brotherhood" so that the contrasting word play with the meaning of "correctly living according to a rule of life" will be clear. However, Bernard is referring more often than not to the monastic "order" in general or to a large, constitutionally unrelated segment of it—rather than to any specific, constitutionalized "Order."

81:12. GLORIOSISSIMO ORDINI VESTRO. This is the first indication of any formal statement on to whom the *Apologia* was meant to be seen as directly addressed, setting aside its nominal addressee, William. The term *ordo* as used in this specific case refers neither to the broad trifunctional or ternary senses as discussed by Georges Duby in *The Three Orders* and to which Bernard subscribes in Gregory the Great's ternary form in *Apologia* 5, nor to the narrowly defined sense of a particular monastic corporation inherent in the term "Benedictine Order," as it has been used since the fifteenth and sixteenth centuries. Actually, Bernard uses the word *ordo* in a number of different senses in the *Apologia*. In chapter 6, he uses it in conjunction with the categories of canons regular and laypeople to indicate the ternary social classes, including that of monks. In *Apologia* 19 and 24, it is used as a synonym of monasticism as a whole, independent of society. And "order" signifies the opposite of "disorder" in *Apologia* 10, 11, and 15. But far more commonly, it simply means a certain segment of monasticism, which segment being suggested by context (*Apologia* 4, 5, 7, 8, 10, 11, 15, 31). With respect to its use in *Apologia* 1, and therefore with respect to that "order" to which Bernard is primarily justifying himself and to which the *Apologia* is therefore primarily—although by no means exclusively—addressed, *ordo* obviously encompasses at least that segment of monasticism with which William was identified: traditional non-Cluniac Benedictines (at the time of the writing of the *Apologia*, William was abbot of Saint-Thierry, a Benedictine monastery which followed Cluniac customs, al-

though it had no official affiliation with the abbey of Cluny; William himself had been professed at Saint-Nicaise, which at that time followed the customs of Chaise-Dieu; see Ceglar 1971:63–64).

But Bernard's Letter 84^bis and *Apologia* 7 indicate that he expects his readers to take *ordo* to mean more than just non-Cluniac Benedictines. In Letter 84^bis, v.7:219, Bernard writes that he understands William to ask that he defend himself and those with whom he is associated from the charge of being detractors of the Cluniac Order (*detractoribus Cluniacensis Ordinis*). Yet in the *Apologia*, Bernard broaches his denial of any derogatory comments simply with the expression *Ordini vestro derogare*. Likewise, *Apologia* 4—in all probability the first chapter of the preliminary draft and so Bernard's initial treatment of the subject—is characterized by very heavy usage of the expression *ordo ille* or some similar term. However, in *Apologia* 6 Bernard introduces the term "Cluniacs" (*Cluniacenses*) in conjunction with "Cistercians" in mention of the monastic *ordo* as part of the Church. And in *Apologia* 7 he again mentions "Cluniacs" and Cistercians in a polarized manner, going on to describe the "Cluniacs" as *Ordinem illum* (the word "Cluniac" is never used again in the *Apologia*, although it has been interpolated in almost every translation and close paraphrase from Mabillon up to the present). Thus, Bernard expected his readers to see the *Apologia* as formally directed at William's "Order," an order which was understood to have loosely combined the various elements of traditional Benedictine monasticism, including Cluny, but without any special emphasis on Cluny. That Bernard's use of the word *Cluniacenses* in the *Apologia* or the phrase *Cluniacensis Ordo* in his reiteration of William's request in Letter 84^bis should lead one to infer that the treatise is specifically addressed primarily to the abbey of Cluny or even to its dependents cannot be supported either by the evidence of the *Apologia* or by current usage of the term. In fact, during the twelfth century the word "Cluniac" was commonly used to mean "traditional, non-Cistercian Benedictines." See the section "Cluny, the Cluniacs, and the Non-Cluniac Traditional Benedictines" for a brief discussion of this. It should not be forgotten that the formal address of the *Apologia* to all traditional, non-Cistercian Benedictines in no way precludes a very conscious, larger audience on Bernard's part. On this, see "The New Ascetic Orders and the Cistercians."

81:13. SANCTIS, QUI IN EO LAUDABILITER VIVUNT. The rhetorical logic of this and a number of other similar statements in the *Apologia* in no way diminishes Bernard's sincerity. See the section "Cluny, the Cluniacs, and the Non-Cluniac Traditional Benedictines."

81:14. MUNDI LUMINARIBUS. While it is not necessary to look for specific individuals behind this expression, at the time of the writing of the

Apologia Bernard was on the verge of making known to Abbot Suger of Saint-Denis his dissatisfaction with certain aspects of the latter's conduct; see Letter 78, v.7:201–210.

81:17–19. SI HOC ITA EST . . . SICUT OVES OCCISIONIS? Cf. the similar use of Psalm 43:22 (Rom 8:36) in Bernard, Letter 1:4, v.7:4; Jerome, Letter 130:7, v.174; and Benedict of Nursia, *Regula* 7.

81:19. PHARISAICA IACTANTIA. This is not just a rhetorical device to catch Bernard's traditional Benedictine readers off guard, although it also serves that function. He put forth the accusation again to his own Cistercians in *Apologia* 12 and took up the subject in general a number of times (for example, *Super Cantica* 7:7, 23:16, v.1:35, 149; *De Gradibus Humilitatis* 17, v.3:29; *De Diversis* 122, v.6pt.1:399); for the relation of this to Peter the Venerable's Letter 28, see Appendix 1, "The *Apologia* and the 'Pressing New Situation;'" cf. Jerome, Letter 52:13, v.2:188. He also applied this expression to the traditional Benedictines in their turn; see Letters 34:2, 91:4, v.7:91, 240 (to which Matthew of Albano may have responded in his letter to the Benedictine abbots who had gathered at the chapter of Reims, 1131; *Epistola*, p.323, 328). Cf. Gregory the Great, *Moralia* 15:7, p.752.

81:20–82:2. TANTA IN NOSTRO VICTU . . . VIGILIIS IUGIS EXERCITATIO. This listing of qualities for which Bernard felt the Cistercians were well-known is significant when compared to the fields of criticism undertaken by him against excesses in the *Apologia*. Of the former, only food and clothing—infractions potentially involving voluntary poverty—are given any real attention (although manual labor might arguably come under the heading of poverty, its statutory necessity was not universally upheld; see Peter the Venerable, Letter 28, p.70–71; Matthew of Albano, *Epistola*, p.329–330; the *Riposte*, p.316; and the anonymous *Tractatus Abbatis Cuiusdam*, p.85–88). The theme of Judaic formalism is again taken up in reference to monastic art in *Apologia* 28.

82:4. UT VIDEAMUR AB HOMINIBUS . . . RECEPERUNT MERCEDEM SUAM. For this reference to Matthew 6:2–5 cf. Jerome, Letters 23:2, 52:13, v.2:9, 188.

82:9–10. STUDEO NON ESSE VEL POTIUS NON VIDERI SICUT CETERI HOMINUM. Cf. Jerome, Letter 82:6, v.4:117–118, "magis esse voluerim aliquid, quam videri." Note the typical freedom with literary references, in this case a transposition of the original intention at Bernard's own expense. Cf. also Jerome, Letters 58:7, 125:7, v.3:82, v.7:118–119.

82:10–11. MINUS TAMEN ACCEPTURUS . . . QUAM QUILIBET HOMINUM. Bernard believed this to be the case despite the practice of extreme aus-

terities, because the monastic vow required more than was demanded from other people, because it was absolutely binding, and because a literal adherance to the Rule was not its most important aspect. It is this attitude which accounts for his placing the "things of greater importance" above literal infractions of the Benedictine Rule.

82:11–15. SICCINE ERGO NON INVENIEBATUR . . . AD LUCTUM TRANSIREMUS? Cf. Benedict of Nursia, *Regula* 5 (Mt 7:13–14).

82:18–19. SALTEM ABUNDANTES IN SAECULO . . . DIVITIAS. Cf. Jerome, Letter 118:6, v.6:96.

82:22. PAUPERIBUS SUPERBIS. Bernard is critical here of those members of his own party who are not poor in spirit (Mt 5:3). He takes up the problem of material poverty elsewhere in the *Apologia*, but especially in *Apologia* 28–29, where he even questions whether the excessive art programs of certain monasteries allows the monks there to retain the title of *pauperes Christi*.

83:5–7. NUMQUID NON HABET . . . ARROGANTIA SE COARCTAT. Cf. Jerome, Letter 22:39, v:1:156.

83:16–21. SED PROPTER ILLOS . . . IN AURE LOCUTUS SUM. A reference both to an unguarded moment on Bernard's part while speaking in public and to "private" conversations between himself and William.

83:22–89:22. QUIS UMQUAM ME ADVERSUS ORDINEM ILLUM . . . QUI MAGIS OPERANTUR. *Apologia* 4–9 comprises the apologia or justification proper, that is, it contains Bernard's formal denial of the accusations against himself and a statement of position on the primary doctrinal issue involved in those accusations, the question of diversity and unity within the Church, essentially as it relates to its monastic wing, coming out in favor of a differentiated unity. This is where his defense of his own actions begins in earnest and the first of many times that he uses the word "order" without any modifiers to describe that segment of monasticism which he was accused of attacking. The way in which Bernard presents this is of special interest because it contains an inference to what he saw as the real source of the dispute.

The section begins with a disavowal by Bernard that he has denigrated William's "Order" either in public or in private combined with a statement of praise of the "Order" (cf. Letter 84[bis], v.7:219). After this, he argues that he has never encouraged monks from other orders to enter his, he claims that he has both prevented some from doing this and turned back others, implying that William himself is among the former. He then very cleverly turns this argument around, suggesting that since he is innocent on that

score, the suspicion in which he is held must be the result, rather, of the fact that he belongs to a different order. While this permits him to go on and implicate the traditional Benedictines in the divisiveness with which he and the new orders are accused, and so to discuss the problems of diversity and unity within the Church in an abstract manner, it also reveals what he sees as the root of the problem of the controversy: the competition engendered with the appearance of the new orders and the concomitant threat to traditional monasticism. But one need not look to Bernard alone for support for this view. This was also the opinion of Peter the Venerable, the abbot of Cluny, who was even more explicit about the successful emergence of the new ascetic orders, seeing it as the ultimate cause of the friction between both parties; Letter 111, p.291.

As the probable beginning of the no longer extant preliminary draft of the *Apologia*, the force and meaning of *Apologia* 4 originally had far greater impact. For a later example of Bernard's views on variety within monasticism which confirms this earlier one and so puts its rhetorical value in proper perspective, see *De Praecepto* 47–49, v.3:285–287; the subject comes up somewhat in Bernard's debate with Peter of Pisa before Roger of Sicily: Arnold of Bonneval, *Vita Prima* 2:45, *PL* 185:294.

83:22–23, 84:7–8, 84:8–9. VEL CORAM AUDIVIT DISPUTANTEM, VEL CLAM SUSURRANTEM . . . ET PUBLICUM IN CAPITULIS, ET PRIVATUM IN CAMERIS . . . VEL CLAM, VEL PALAM. Again, repeated references to certain discussions Bernard had had and which had now become the object of discussion themselves. See 81:7 NUNC VERO, NOVA URGENTE CAUSA; and 83:16–21 SED PROPTER ILLOS . . . IN AURE LOCUTUS SUM.

83:26. A PATRIBUS INSTITUTUS. See 100:16 ODO, MAIOLUS, ODILO, HUGO.

84:1. ANIMABUS SALVANDIS NON MEDIOCRITER IDONEUS. Bernard is discussing Benedictine monasticism in general. Cf. Letter 1:11, v.7:8–9 where he stops short of calling into question Cluny's suitability to the salvation of souls, but which would still be at too great of a variance with this statement, written only a few months later.

84:11–17. ANNON POTIUS MULTOS CUPIENTES VENIRE REPRESSI . . . AC NE SUAS DESERERENT CATHEDRAS EFFECIT? The fact that the scope of these particular incidents is limited to non-Cluniac houses is significant (Saint Nicholas was non-Cluniac and one of the abbots referred to is generally believed to be William himself); cf. Bernard, Letters 84, 86:2, v.7:218, 224; William of Saint-Thierry, *Vita Prima* 1:33, *PL* 185:246. Since the problem of Bernard's position toward accepting questionable transfers seems to have been an impetus to the *Apologia* (see Appendix 1), the idea that that trea-

tise was directed primarily toward Cluny and only generally toward non-Cluniac monasticism cannot be maintained.

84:17. CUR IGITUR ORDINEM DAMNARE PUTOR VEL DICOR. Cf. Jerome, Letter 49:5, v.2:124.

84:19. DE QUO ET MIHI ORATIONES TAM SOLLICITE REQUIRO, TAM DE-VOTE SUSCIPIO? Cf. Bernard, Letters 147:2, 387, 389, v.7:351, 356, 357.

84:20–21. AN FORTE QUIA IUXTA ALIUM ORDINEM CONVERSARI VIDEOR, PROPTEREA SUSPECTUS HINC HABEOR? For the significance of this sentence, see the comments under 83:22–89:22 QUIS UMQUAM ME . . . QUI MAGIS OPERANTUR.

84:22–23. ERGO ET CONTINENTES, ET CONIUGES INVICEM SE DAMNARE PUTENTUR. See Bernard, *De Praecepto* 48, v.3:286 for the use of a similar argument in a discussion on monastic integrity.

84:24. REGULARES CLERICI. This is not the only time that Bernard mentions canons regular in the *Apologia* (see *Apologia* 6). In light of the canon regular Oger's very active participation in the writing of the *Apologia*—indeed, perhaps even providing the initial impetus—and the fact that of only five extant copies of the first redaction one is at a collegial church, it seems that the body of canons regular, as a crucial element of the extreme establishment reformers, was understood at the time of the writing of the *Apologia* to be a part of the latter's audience. The negative apposition of monks and canons regular by Bernard would have been immediately recognized as absurd because of his extremely active and supportive relations at that time with canons regular, especially the Premonstratensians. See the section "The New Ascetic Orders."

85:10–87:7. NON SUM TAM HEBES . . . ET DISPONIT OMNIA SUAVITER. Note Jerome, Letter 15:1, v.1:46 on the theme of the robe of Christ as a symbol of the Church.

85:13. ID EST PULCHERRIMA VARIETATE DISTINCTA. While such a statement need not be seen as necessarily indicative of Bernard's views on art, the concept of variety as a component of artistic attraction is put forth in *Apologia* 29. See 106:21–22 TAM MULTA . . . VARIETAS.

86:12. TUNICAM . . . INCONSUTILEM, ET DESUPER CONTEXTAM PER TOTUM. This allegory was often used by Bernard on matters of the most serious nature, such as schism. See Bernard, Letters 334, 336, v.8:273, 275 in reference to Abelard; Arnold of Bonneval, *Vita Prima* 2:45, PL 185: 294 in reference to Anacletus II; and Bernard, Letter 219, v.8:80–82 in reference to schismatic affair of the election of the bishop of Bourges.

87:1, 87:18−19. SIVE CLUNIACENSES, SIVE CISTERCIENSES . . . CISTER-
CIENSIS SUM: DAMNO IGITUR CLUNIACENSES? The word "Cluniacs" (*Clu-niacenses*) as used here refers to all traditional Benedictines and not to
monks of the Congregation of Cluny or to the monastery of Cluny alone,
or even to them in particular. Although it has long been recognized that the
word had this meaning after the rise of the Cistercians in the twelfth cen-
tury, this knowledge has never been directly applied to the meaning of the
Apologia. See the section "Cluny, the Cluniacs, and the Non-Cluniac Tra-
ditional Benedictines" and Appendix 1, "The Origin of the *Apologia*."

87:17−18. ORDINATE IN ME CARITATEM, UT ETSI UNA IN CARITATE, DI-
VISA TAMEN SIT IN ORDINATIONE. On this as relating to the previous refer-
ence in *Apologia* 5 (85:20−24, "quidem quosdam apostolos. . . . ") from 1
Corinthians 12:28, see Bernard, *Super Cantica* 49:5−6, v.2:75−77.

87:18−19. QUID ERGO? CISTERCIENSIS SUM: DAMNO IGITUR CLUNIA-
CENSES? ABSIT. See 87:1 SIVE CLUNIACENSES . . . CISTERCIENSES. Cf. Ber-
nard, Letter 7:19, v.7:45, "Quid inquis? Omnes ergo damnas qui similiter
non faciunt? Non."

90:2−94:11. UNDE NUNC MIHI CONVENIENDI SUNT QUIDAM DE ORDINE
NOSTRO . . . QUI DISCRETE ET CONGRUE ET HAEC OPERATUR, ET ILLA. The
five chapters of *Apologia* 10−14 are concerned with Bernard's condemna-
tion of the detraction of William's "Order" by members of Bernard's Cis-
tercian Order. In the process, a number of secondary issues are taken up,
such as discretion in the Rule (esp. *Apologia* 12, 13, 14) and the physical
versus the spiritual (*Apologia* 12, 13, and 14). Despite the credibility this
section adds to the criticisms of the excess of the traditional Benedictines to
follow, it in no way can be seen as solely a rhetorical device. Not only did
Bernard often condemn the vice of detraction which he felt was "more cruel
than the lance which pierced the side of Christ" (*De Diversis* 17:4−5,
v.6pt.1:152−154; *De Consideratione* 2:21−22, v.3:429−430) and which
he thought was fostered by putting too much confidence in fasting, manual
labor, and so on (*In Psalmum 'Qui Habitat'* 1:1, v.4:385−386), but he also
took up this subject and some of the others in this section in sermons to his
own monks of Clairvaux, including pride in work (*De Diversis* 47,
v.6pt.1:267), discretion and the Rule (*De Praecepto* 48, v.3:286; *In Cir-
cumcisione* 3:11, v.4:290−291), and overconcern with outward form (*In
Quadragesima* 2:3, v.4:361), to name a few.

90:8. QUI ETSI ORDINATE VIVENTES . . . UBI NULLUS ORDO. The literary
device of order and disorder was used elsewhere by Bernard only for the
most grave matters, such as the affair of Arnold of Morimond (Letter 6:2,

v.7:30; written December 1124 or early 1125) or that of Abelard, the monk without order (Letter 193, v.8:44). See also 94:19 NULLUS QUIPPE ORDO . . . ORDO NON EST.

90:16. PRIMO QUID AD VOS DE ALIENIS SERVIS? Jerome uses this passage from Romans 14:4 in one of his famous works on the ascetic life; Letter 22:37, v.1:153.

90:24–91:1. hypocrita, inquit, eice primum trabem de oculo tuo . . . de oculo fratris tui. This reference to Matthew 7:3–5 (Lk 6:41–42) was also a favorite one of Jerome's; Letters 45:4, 52:17, 117:4, v.2:98, 191–192, v.6:80; and cf. Benedict of Nursia, *Regula* 2.

91:23. PATRIBUS. See 100:16–18. SIC DENIQUE . . . TENERI CENSUERUNT?

91:23. QUAE MAIORA SUNT REGULAE. While this is not an allusion to the "things of greater importance" of *Apologia* 28–29 (104:11), it does exemplify in the same language that it is not a literal observance of the Rule—or general religious practice—that matters, but rather the spiritual intentions and attainments for which the Rule is a vehicle.

92:7. REPLETI DEINDE VENTREM FABA. Cf. Jerome, Letter 45:5, v.2:98.

92:13–16. SED ET SATIUS EST . . . VINI POTATOR APPELLATUS SIT. Both of these Biblical references may be found in Jerome's writings; cf. Letters 22:8, 52:11, 107:8, v.1:118, v.2:187, v.5:153; *Adversus Jovinianum* 2:5, 15, 17, *PL* 23:304, 323, 324.

93:10. MINIMA. Cf. *parva* in *Apologia* 28 (104:11).

94:3. DISCRETIUS. Cf. Benedict of Nursia, *Regula* 64.

94:12–27. IAM VERO, UT EPISTOLA REMANEAT . . . QUAM VERITAS RELINQUATUR. *Apologia* 15 forms the transition between the section on detraction (*Apologia* 10–14) and that on excess (*Apologia* 16–29). The opening expression was a favorite one of Bernard's, see Letters 7:18, 78:13, v.7:44, 210; *De Praecepto*, preface (twice), 61, v.3:253–254, 294; *De Conversione* 31, v.4:108. Cf. Jerome, Letters 3:6, 108:27, 109:4, v.1:15, v.5:196, 206.

94:17. OMNIBUS BONIS. Cf. Jerome's use of *omnibus bonis* in his famous tract on the monastic life, Letter 125:6, v.7:118.

94:19–20. NULLUS QUIPPE ORDO . . . ORDO NON EST. See also 90:8 QUI ETSI . . . UBI NULLUS ORDO.

94:22–24. ET QUIDEM DILIGENTIBUS ORDINEM . . . QUOD ET IPSI ODERUNT. This is not simply rhetorical, but rather is an allusion to the con-

siderable new reform movement within traditional monasticism which made itself felt in such manifestations as the chapters of Reims (1131) and Soissons (1132).

95:2–104:9. DICITUR, ET VERACITER CREDITUR . . . QUATENUS HOSPITES NON GRAVEMUS? *Apologia* 16–27 constitutes the "small things" mentioned in *Apologia* 28 (104:11). Together with the "things of greater importance" in *Apologia* 28–29, they make up the section against excess.

Of the twelve chapters of the "small things," fully one third are devoted not to the condemnation of specific excesses, but rather to what amounts to a challenge to the traditional justifications of monastic excess (*Apologia* 16–19) culminating in a comparison between traditional and ancient monasticism which both the traditional and new ascetic orders claimed as their model.

Of the chapters dealing with explicit examples of excess, only one is concerned with general monastic overindulgence in eating (*Apologia* 20), one with drinking (*Apologia* 21), one and the part of another were added in the second redaction about healthy monks who abuse infirmary dietary privileges (*Apologia* 22–23), and three take up the topic of excess in clothing and buying of clothing, with a short digression on bedding (*Apologia* 24–26). The relatively small amount of attention devoted to the various excesses of dining on the one hand and the relatively large amount of attention devoted to the single excess of clothing on the other may be explained by the impetus behind each excess. Bernard felt that the sin of gluttony was of less consequence than the sin of pride with which, as a monastic vice, he was much concerned; see *De Gradibus Humilitatis* 14, 25, 26, v.3:26–27, 35–36. (The fact that the chapters on infirmary abuse were not part of Bernard's first redaction indicates an absence of primacy in relation to his conception of contemporary monastic excess.)

The section on excess concludes with a chapter directed toward those individuals most personally responsible for the excess of their own monks as well as for their own far greater excesses, the abbots (*Apologia* 27).

What unites all these themes is the element of external observance. According to Bernard's own admission, it was possible for monks to live with little or no fault among these excesses by rising above them. In the end, while vices such as pride could enter into it, the infractions as stated by Bernard are ultimately related to questions of observance rather than morality in the immediate sense.

95:2–3. SANCTOS PATRES ILLAM VITAM INSTITUISSE. See 100:16–18. SIC DENIQUE . . . TENERI CENSUERUNT? This statement in conjunction with the following passage suggests that Bernard did not see moderate art

as in conflict with the monasticism of the "Fathers," and that, according to this statement, he did not object to the use of moderate art by traditional monasticism.

95:6–8. INTER MONACHOS TANTA INTEMPERANTIA IN COMESSATIONIBUS ET POTATIONIBUS, IN VESTIMENTIS ET LECTISTERNIIS, ET EQUITATURIS, ET CONSTRUENDIS AEDIFICIIS. Food, drink, clothing, bedding, equipage, and the construction of buildings: this list of excesses initiates the section on excess—immediately following Bernard's opening disclaimer of any reproach to the Fathers—providing the unavoidable implication that at that point of writing this was how the outline for the rest of the *Apologia* stood in Bernard's conception of that treatise. See Appendix 1, "Bernard's Letter 84^bis to William."

95:7. EQUITATURIS. Translated as "retinue," both the Latin root and the exposition in *Apologia* 27 make it plain that Bernard is concerned with the habit of certain abbots of travelling in state complete with horses, lay retainers, livery, and so on.

95:8–10. QUATENUS UBI HAEC STUDIOSIUS . . . IBI MAIOR PUTETUR RELIGIO. Bernard is referring to the attitude that saw material success as the result of spiritual success. The most notable positive exponent of this view was Suger of Saint-Denis. See the section "The Relation Between Material and Spiritual Prosperity."

95:10–14. ECCE ENIM PARCITAS PUTATUR AVARITIA . . . CUMQUE HAEC ALTERUTRUM IMPENDIMUS, CARITAS APPELLATUR. Cf. Bernard, Letter 1:4, v.7:4, which supports my hypothesis that it was that letter which gave the original idea of the *Apologia* to Oger and William and that it is to this style of writing that Bernard refers in Letter 84^bis, v.7:219.

95:19–96:15. NEMO PRO HUIUSMODI MISERICORDIA . . . SUB HAC TAMEN ABUSIONE. This discussion on true mercy was added only in the second redaction, apparently at the suggestion of William and/or Oger.

96:17–26. NONNULLI QUIPPE HIS OMNIBUS . . . EIS AUCTORITATE RESISTUNT. This use of 1 Corinthians 7:31 may refer to those within traditional monasticism who were open to the idea of reform. For this traditional position toward material things, in which Bernard is in agreement, see Gregory the Great, *Moralia* 8:45, p.416–417. This same reference to 1 Corinthians 7:31 comes up in William of Saint-Thierry's condemnation of monastic art; *Ad Fratres* 152, p.262–264.

96:25–26. ILLI MOX TOTA EIS AUCTORITATE RESISTUNT. Cf. Benedict of Nursia, *Regula* 3.

96:28–97:6. O QUANTUM DISTAMUS AB HIS . . . TANTA SOLLICITUDINE REFOCILLABANTUR. A reference to the contrasting example of Anthony and Paul the Hermit; Jerome, *Vita S. Pauli* 11, PL 23:26.

97:10–12. INTER PRANDENDUM . . . MODUM NESCIAS IN EDENDO. Cf. Benedict of Nursia, *Regula* 4, 6, 38; and Gregory the Great, *Moralia* 1:11, p.29–30.

97:14–98:10. INTERIM AUTEM . . . OPPRESSUS MAGIS OBRUITUR QUAM REFICITUR. Bernard's criticisms of culinary excess have a long history in ecclesiastical, especially monastic, writings. Jerome was quick to criticize such excess, especially in his ascetic writings; cf. Jerome, Letters 22:9–11, 22:17, 45:5, 52:5–6, (with certain similarities to the *Apologia*), 52:12, 58:6, 66:8, 69:8–9, (with certain similarities to the *Apologia*), 107:8–10, 108:17, 117:7, v.1:119–122, 125–127, v.2:98–99, 178–181, 187–188, v.3:80–81, 174, 205–207, v.5:152–155, 180, v.6:83; *Adversus Jovinianum* 2:8, 10–12, PL 23:311–315 (ch.8 seems to be the source for Peter the Venerable's passage against excessive care in monastic dining, Letter 161, p.389–390; ch.10 and 12 share certain similarities to the *Apologia*); cf. also Peter Damian, *De Perfecta* 6, PL 145:726; Serlo of Bayeux, *Invectio*, p.256–257; and Benedict of Nursia, *Regula* 1, 4, 39, 40. On the alteration of the natural flavor of food, cf. Bernard, Letter 1:11, v.7:9; this theme of the alteration of nature is taken up in the passage on capital sculptures in *Apologia* 29. See also Leclercq 1965:41–42 on the normalcy of eating habits at Cluny, including that of spices; and 1970b:17–21 for the particular genre of this passage; see Montalembert 1868:v.5:217 on monastic excess along these lines in ninth-century England. The Cistercians too had problems regulating the use of spices among their monasteries; Statute 63, p.27. And, according to Orderic Vitalis (*The Ecclesiastical History* 8:26, v.4:312), Payen Bolotin's satirical poem against "false hermits," including their eating habits, very much encompassed the Cistercians; *De Falsis Heremitis*, p.82–83. Suger's biographer, William of Saint-Denis, was careful to point out not just Suger's restraint in matters of food and drink, but that he followed traditional Benedictine moderation in his avoidance of extremes in either direction; *Vita Sugerii* 2:6, p.388–389. With regard to the novelty of dishes as stimulating the appetite, see Notker the Stammerer, *Gesta Karoli* 2:8, 1:18, p.751, 738.

97:22–24. QUIA ENIM PURAS, UT EAS NATURA CREAVIT . . . ET SPRETIS NATURALIBUS, QUOS DEUS INDIDIT REBUS. This abhorrence of the tendency to alter the natural taste of things resurfaces in *Apologia* 29 where it is the desire to alter the natural appearance that Bernard takes up with equally great vehemence in regard to hybrids.

98:5–10. IPSA DEINDE QUALITAS . . . OPPRESSUS MAGIS OBRUITUR QUAM REFICITUR. As with art, it is the appeal to curiosity and the senses that is the basis of Bernard's criticisms here, not outright gluttony.

98:12–99:8. IAM VERO DE AQUAE POTU . . . MANDUCARE NON QUEO. Like the abuse of food and the abuse of art, the abuse of drink also has a long literary tradition. For examples of Jerome's criticism of excess in this area, see Jerome, Letters 22:8–9 (including criticism of spiced wine), 22:17, 52:11, 107:8, 117:7, v.1:118–120, 126, v.2:187, v.5:153, v.6:83; *Adversus Jovinianum* 2:5–6, 13–15, PL 23:304–307, 316–323. Serlo of Bayeux, *Invectio*, p.256.

98:17–18. SED MAGIS PUDEAT . . . NON PUDEAT EMENDARI. The first redaction reads, "It is shameful to discuss that which, unless I had seen it with my own eyes, I would hardly have thought repeatable." It seems that this statement, like the following, was considered too harsh to retain.

98:19–21. DIVERSIS VINIS . . . QUALE EST AUTEM. The first redaction reads, " . . . the different wines are judged by drinking and drunk by judging, and finally that which is the best among the many is chosen. What kind of practice is. . . . "

99:5. SI AUTEM AD VIGILIAS INDEGESTUM SURGERE COGIS. Cf. Jerome, Letter 22:17, v.1:126.

99:11–100:14. RIDICULUM VERO EST . . . HUIUSCEMODI INEPTIAS? This entire section was added only in the second redaction, apparently as the result of conversations on the general subject of traditional Benedictine monasticism, possibly with William and/or Oger. On the pallor of the face as indicative of abstinence, Gregory the Great, *Moralia* 8:9, p.386. On the use of staffs by the sick at Cluny, cf. Ulrich, *Consuetudines Cluniacenses* 3:27, PL 149:769.

99:17–23. ROGO QUAE EST HAEC SECURITAS . . . SOMNOS CAPITIS MATUTINOS? Cf. Bernard, Letter 1:13, v.7:10–11; Jerome, Letters 14:2, 14:4, 22:17, 22:39–40, v.1:34–35, 37, 126, 157–158.

100:14–16. SIC MACARIUS VIXIT . . . SIC PATRES IN AEGYPTO CONVERSATI SUNT? On the use of these Fathers in a number of the authors cited in this work see Leclercq 1957b:93–94.

100:16–18. SIC DENIQUE SANCTI ODO, MAIOLUS . . . TENERI CENSUERUNT? The association of Odo, Maiolus, Odilo, and Hugh—all highly respected monastic reformers—with the great representatives of early Christian monasticism is a very diplomatic recognition of those whom traditional Western monasticism in the early twelfth century saw as their founders, after Benedict and Maur, regardless of Idung's rather sour com-

ment that the Fathers of the "Cluniac Order" were unknown; Idung, *Dialogus* 1:38, p.390. The reference to these abbots of Cluny as "founders and teachers of their Order" refers to traditional Benedictine monasticism as a whole and not the actual Congregation of Cluny. Odo was seen by at least some misinformed monks as the author of the Benedictine Rule; Maiolus, who reportedly refused an offer of the papacy, was the most contemplative of the Cluniac abbots and a great miracle worker; Odilo wrote a long monastic work, the *Collationes*, using the same title as one of the most famous of all monastic writings, Cassian's *Conlationes*; Hugh, who had quite recently been canonized, had acquired such power and prestige that he could be said—even if by his enemies—to have claimed the title *abbas abbatum*, abbot of abbots. All of these men were regarded as saints. It would have been improper, even if he had wanted to, for Bernard to include any living abbots of Cluny in this list. It is significant that Hugh should have been so included, despite the rhetorical advantage, since his great artistic undertaking of Cluny III should just have been reaching its highpoint around this time. Contemporary support of the good repuation of Cluny and its abbots is too large to cite here.

100:19–20. HABENTES VICTUM ET VESTITUM, HIS CONTENTI SUMUS. This reference to 1 Timothy 6:8 was used a number of times by Jerome, especially in his works on the ascetic life; cf. Letters 52:5, 66:8, 130:14, v.2:178, v.3:174, v.7:186.

101:2–102:25. QUAERITUR AD INDUENDUM . . . NEGLECTA FUISSET MENS INCULTA VIRTUTIBUS. Again, the criticism of sartorial excess was a constant in reform writings, along with that of food, drink, and art. Criticisms of this sort by Jerome are too numerous to list and occur in all of his works on the ascetic life—likewise, the subject is taken up often by Bernard. Cf. Benedict of Nursia, *Regula* 55 on proper monastic clothing.

101:12–13. DIVIDEBATUR, UT SCRIPTUM EST . . . CUIQUE OPUS ERAT. This reference to Acts 4:35 was also used by Jerome in one of his ascetical works which criticized excessive art; Jerome, Letter 130:14, v.7:184–185; cf. Benedict of Nursia, *Regula* 34, 55.

101:17. GALABRUNUM AUT ISEMBRUNUM. I follow here Casey's translation (1970:60); see Postan's note on these terms, given by both Casey and Knowles 1956:20.

101:18–19. CUIQUAM MULA . . . AD EQUITANDUM? Bernard is referring to the excess of certain abbatial retinues; cf. *Apologia* 27.

101:20. BARRICANUS. Cf. 101:17. GALABRUNUM AUT ISEMBRUNUM. Cf. Benedict of Nursia, *Regula* 55 on bedding; and Caesarius of Arles, *Regula*

ad Virgines 42, *PL* 67:1116, Letter 2, *PL* 67:1133; and even Cistercian legislation itself, Statute 41, p.23. The poor quality of Benedict of Aniane's bedding was pointed out by Ardo, *Vita Benedicti Anianensis* 7, p.202. William of Saint-Denis repeatedly drew attention to Suger's traditional Benedictine moderation in bedding, which was neither too luxurious nor too ascetic (with regard to the latter, so as to avoid any appearance of pretense); *Vita Sugerii* 2:6, 10, p.389–390, 393.

102:3. VANITATIBUS ET INSANIIS. Cf. *Apologia* 28, "sed non vanior quam insanior" (105:25).

102:8–11. QUIVIS DE SAECULO . . . FUERINT ET APTATA. The implication of a certain proximity to the secular world is continued in *Apologia* 27 and 28. Cf. the movement against the gradual spread of secular clothing among monks and nuns in England; Montalembert 1868:v.5:214–215.

103:13–104:9. QUOD ENIM, UT CETERA TACEAM . . . HOSPITES NON GRAVEMUS? Although Suger may have been foremost in Bernard's mind in regard to this excess (cf. Letter 78:3, v.7:203; also, the distance mentioned of four leagues is certainly reminiscent of the distance from Saint-Denis to Paris), criticism of excessive retinues has a long history of its own. It was also a subject taken up quite often by Bernard, especially in regard to the secular Church. Cf. Letters 42:4, 6–7, v.7:104–106 for its most striking appearance outside of the *Apologia* itself and one considerably more serious; and Letter 538, v.8:504–505, also on episcopal excess. See Letter 2:11, v.7:21–22 on secular canons. *Super Cantica* 33:15, v.1:244; *De Laude Novae Militiae* 3:8, v.3:216, 220–221 takes up criticism of this excess as it applies to knights. For papal retinue, *De Consideratione* 4:5–6, v.3:452–453. The apostolic model of the monk and bishop, Malachy, was repeatedly praised by Bernard for his rejection of the use of not just excessive retinue, but of any horse whatsoever, *Vita S. Malachiae* 17, 44, v.3:326, 349–350. According to Bernard, Christ himself avoided excessive retinue, *In Ramis Palmarum* 2:3, v.5:48.

See Jerome, Letter 3:6, v.1:15–16 for early criticism of this particular excess. Gregory the Great praised the humble mount and harness of Abbot Equitius, *Dialogorum Libri* 1:4:10, v.1:46. Abbot Odilo of Cluny was severely criticized by Adalbero of Laon (*Carmen*, *PL* 141:775–778) and praised by his own biographer (Jotsaldus, *Vita Odilonis* 1:11, *PL* 142:906) for indulgence and abstention respectively. Abbot Maiolus of Cluny was also associated with this excess in a passage criticizing the use of the precedent of Maiolus for such infractions of custom and law, "But is Maiolus really to outweigh Christ?" John of Fécamp, *Tuae Quidem*, p.201–202. Cluniac law forbade the abbot to be accompanied by armed men (*Constitu-*

tiones Hirsaugienses 2:12, *PL* 150:1051). Abelard, *Regula*, p.282, warned of this problem. And even the Cistercians were forced to impose legal restrictions on the retinues of their abbots. Statute 42, p.23. See Sumption 1975:127 for references to the criticism of the use of horses by priests by Martin of Tours and the rejection of the use of a horse by Hilary of Arles on a trip to Rome. Apparently, such rejection on pilgrimage was quite common and so pointed up the luxury of that use by monks even more, monks being perpetually on pilgrimage. See Sumption 1975:123 for references to two different bishops, Ealdred of Worcester (1059) and Bishop Gunther of Bamberg (1064) whose excessive retinue on pilgrimage was criticized; the latter was said to have been thought by the citizens of Constantinople to have been a king disguised as a bishop so as to avoid being taken prisoner by Islamic forces. Cf. also William of Saint-Thierry, *Super Cantica* 194, p.384. Ironically, Bernard himself was supposedly once questioned on the lavish trappings of the mule he had ridden from Clairvaux to Chartreuse, to which he answered that he had not even noticed the animal during the entire trip and that it nevertheless was lent to him by a Cluniac; Geoffrey of Clairvaux, *Vita Prima* 3:4, *PL* 185:305.

Bernard's reference to the abbot as a model of humility refers to Benedict of Nursia, *Regula* 2, where the abbot is exhorted to govern his monks' behavior more by actions than by words.

103:13–14. TANTA POMPA. The identical term was used to describe the reception of Bernard's cousin Robert at Cluny; Bernard, Letter 1:5, v.7:5. It is those of this world who rejoice in pomp (*pompis*); Bernard, *De Diversis* 1:8, v.6pt.1:79. It was to the pomp (*fastum*) of Suger's retinue that Bernard objected most strongly, Letter 78:3, v.7:203.

103:14. EQUITATU. More than just the elements of a retinue, mounted men comprise one indication of the social involvement of monasticism. The subject was also criticized by Bernard in relation to both the episcopacy and the papacy; *De Consideratione* 4:5–6, v.3:452–543; *Vita S. Malachiae* 44, v.3:349–350. Cf. Suger, *De Administratione* (Lecoy) 12, p.172 on Suger and his activities with "mounted men."

103:14. HOMINUM CRINITORUM STIPARI OBSEQUIIS. "Long-haired servants" are another indication of social involvement, this time a less belligerent one, but perhaps more degenerate in Bernard's view; cf. *De Consideratione* 4:21, v.3:464–465 where it is said that the pope and bishops should not associate with such types, let alone monks; cf. also *De Laude Novae Militiae* 3, 7, v.3:216, 220. Bernard praised Malachy for keeping no servants of either sex and for taking his turn to wait table as bishop; *Vita S. Malachiae* 18, 43, v.3:328, 348–349. It seems that it was one such "long-

haired servant" that Suger made advocate of Toury, which he had just re-
covered by force with his "mounted men"; Suger, *De Administratione* 12,
p.172–173. Cf. Jerome, Letters 52:5, 54:13, 66:8, 117:6, v.2:179, v.3:35,
174, v.6:82.

103:14–15. QUATENUS DUOBUS EPISCOPIS UNIUS ABBATIS SUFFICIAT
MULTITUDO? This is a thinly veiled reference to the infringement by mo-
nasticism on the rights and duties of the episcopacy, a reference which car-
ried great moral force within monasticism in the current controversy and
which undoubtedly also served to bring outside pressure to bear on the tra-
ditional faction. The acquisition by a number of abbots, most notably Hugh
and Pons of Cluny, of the right to wear episcopal insignia on certain feasts
was the most overt example of this infringement. But Cluny was by no
means alone in this practice, a practice which included the Cistercians; cf.
Bernard, Letter 42:36, v.7:130; Hunt 1968:51; Leclercq 1970:127.

The statement was also probably meant to be doubly condemning of
monastic excess, given the well-known history of episcopal excess. Cf. John
of Fécamp's criticism of abbots as having become richer than bishops; *Tuae
Quidem*, p.202.

103:18. PRINCIPES PROVINCIARUM. Cf. Adalbero of Laon's use of the
term *militiae princeps* to describe *rex Oydelo* of Cluny; *Carmen*, PL
141:775–778. Cf. also Jerome, Letter 52:7, v.2:182 , *princeps pastorum*.

104:3–7. ANNON POSSET EODEM VASCULO . . . ET LECTULUM PRAEPA-
RARE? Both the spirit and the rhetoric of this passage seem to refer to the
authority of Clement of Alexandria's rejection of excess in personal posses-
sions; *Paedagogus* 2:3:37, v.108:80–81.

104:5–6. SUPER VARIUM STRATUM AUT SUB PEREGRINO COOPERTORIO.
Cf. the reference to Suger's "nice" bedding in William of Saint-Denis, *Vita
Sugerii* 2, p.393.

104:11–106:25. SED HAEC PARVA SUNT . . . CUR VEL NON PIGET EXPEN-
SARUM? *Apologia* 28–29: the "things of greater importance." Bernard
himself divided his criticisms of monastic excess into two main categories,
the "small things" and the "things of greater importance." The "small
things" are almost exclusively concerned with matters which to one de-
gree or another involve infractions of external observance. The "things of
greater importance," on the other hand, are concerned with a moral excess,
an excess which, in the threat it posed to the basic principles of monas-
tic life, put them above certain infractions of the Benedictine Rule. See
95:2–104:9 DICITUR . . . for a brief discussion of the "small things."

A dichotomy exists in the "things of greater importance." Chapter 28,
which is almost 4½ times longer than chapter 29, is concerned primarily

although not exclusively with the question of the relation between art and the layperson in the monastery. Chapter 29—a great part of which is taken up with the detailing of examples of excessive art, much of it with an aim toward rhetorical effect—deals with art which was presumably intended for monks alone.

Aside from this, *Apologia* 28 is the crucial chapter for the laying out of Bernard's position—not personal views—on monasticism and art. He opens with a rapid-fire litany of objections to art in the monastery including excess, cost, distraction, and ritualism; he defuses one of the traditional justifications for excessive art, goes on to formulate more narrowly monastic objections, and proclaims his orthodoxy all in the space of a few well-written lines. After further monastic objections, he delivers a succinct and penetrating critique of the economic aspect, contrasts it with the social reality in regard to another traditional justification, offers some "common sense" observations and another specifically monastic objection, again takes on a traditional justification, and finally closes by appearing to make a concession, only to turn the argument around to his advantage for his discussion of art which was presumably intended for the monk alone (*Apologia* 29).

Bernard did not take up the "things of greater importance" as individual issues or infractions. Rather, they are woven into his overall, rhetorically very attractive, presentation. Indeed, it is Bernard's rhetoric which has made this passage justly famous, so much so that in modern times, at least, his rhetoric has tended to obscure the content which his contemporaries must have seen quite clearly.

104:11. HAEC PARVA SUNT; VENIAM AD MAIORA, SED IDEO VISA MINORA, QUIA USITATIORA. Despite the undeniably polemical facet to the *Apologia*, Bernard's work is first and foremost a monastic treatise. That this should be the case is plain enough from the content alone. But Bernard consciously used another factor to further drive this point home.

Bernard was above all a monk, an orthodox monk. It was not enough for him merely to keep to the accepted teaching on art in the Latin Church in his criticisms, he also felt he had to be clearly seen as being firmly and incontrovertibly in the soundest possible monastic tradition on the subject. This was why he so openly—but quite loosely—based himself to such a large degree on Jerome's letters on religious life, among other sources. However, in terms of content alone, the really exceptional aspect of the *Apologia* was not simply its chapters on art, but rather Bernard's stinging critique of the economic role of art and the fact that he put these "things of greater importance" above certain outright infractions of the Rule. While he could turn to Jerome as a tradition for a number of his "things of greater

importance"—and, more importantly, as a tradition for indignation against excessive art in general—even Jerome as an authority could not literarily justify his treating the misuse of art in the monastery as above the Rule in some circumstances. For this, Bernard turned to possibly the most important monastic text in the West after the Gregory the Great's *Vita* of Saint Benedict and the Benedictine Rule itself, John Cassian's *Conlationes* (on the importance of these writings, see Leclercq 1974:13).

Recommended for regular monastic reading by both Benedict (*Regula* 42 and 73) and Cassiodorus, the *Conlationes*, like the *Apologia*, is not concerned with art, but with the spiritual advancement of the soul. Unlike the *Apologia*, however, the subject of art is never formally taken up. Only in one passage can it even be said to make a statement along these lines. The fact that this is the only passage in Cassian which directly applies to art increases the significance of its being chosen by Bernard as an authority. (Cassian, *Conlationes* 10:2–5, p.286–291, on Anthropomorphism is ambiguous as to whether an actual physical image, in contrast to a mental image, is being discussed. Although the case could be argued either way, the probability is that the image of the old monk was mental, with the implication being that while properly instructed Christians had no need of effigies, the ignorant might: precisely Bernard's argument. The few other passages which in their disdain for the material refer to art or architecture are either allegorical or too removed from the artistic aspect to be taken as statements on the subject; cf. Cassian, *Institutiones* preface, p.3–4; *Conlationes* 23:5, p.646). Cassian's almost ubiquitous presence in monastic libraries and Western monasticism's general interest in him, an interest which was renewed with the tenth-century reform movement, also increases the significance of Bernard's choice, culminating for our purposes in the heavy influence of Cassian on the Cistercian way of life (Lackner 1972:387–388; Bouyer 1958:6–7).

In a section devoted to prayer (*Conlationes* 9:5–6, p.254–257), Cassian notes that some monks who have removed themselves from the world (cf. *Apologia* 28) eat and drink to excess (cf. *Apologia* 20–21) as if it were harmless or even useful (cf. *Apologia* 16), going on to criticize any excess in food and clothing (cf. *Apologia* 24–26). He finishes this discussion of excess with a condemnation of the danger to spiritual men (cf. *Apologia* 28) of secular ambition as it can come about through a superfluity in size and ornamentation of architecture. Continually referring to secular ambition, he explains how this can happen with architecture by saying that "These things—which seem to be small things (*haec quae parva videntur*) and insignificant, and which we see are indiscriminately permitted by those of our profession—oppress the soul by their nature more than those larger things

(*maiora*) which usually inebriate the senses of secular men." Those things which seem to be small things, Cassian goes on to say, distract the monk from God, keeping his attention on worldly impurities.

Bernard rewrote Cassian as Cassian meant to be understood: those things which distract one from God are more to be feared than those things which are traditionally considered to be standard occasions of sin. Thus he reverses Cassian's terminology, but not his logic, in distinguishing the "small things" and the "things of greater importance." Where Bernard moves away from Cassian is in assigning faults such as excess in food and drink to "small things" and restricting the "things of greater importance" exclusively to excess in matters concerning the use of art. This is the innovation of Bernard. But the authority of Cassian as a monastic Father remained and was used by Bernard to justify both the selective condemnation of monastic art and the extreme weight he gave to the subject in setting it above certain major infractions of the Rule. Yet, in typical Bernardine fashion, Bernard felt himself in no way compelled to slavishly follow Cassian on the question of art. Thus, while he continued the themes of secularity and distraction from prayer in regard to the monk, he almost immediately dropped the subject of architecture and took up other forms of art instead.

For a few examples of Bernard's attitude that infractions of the physical observances of the Rule did indeed comprise the "small things," see Bernard, *De Praecepto* 3–12, 16, 25, v.3:256–262, 264, 271; Letters 7:4, 142:2, v.7:34, 341. In *Apologia* 12, Bernard called the spiritual regulations the more important things (*maiora*) of the Rule. In *Apologia* 19 he used the term "*quae maior*" to indicate the spiritual.

On the connotations in legal terminology of small things and things which are more important, see Augustine, *De Doctrina Christiana* 4:35, p.141–142.

104:11–12. SED IDEO VISA MINORA, QUIA USITATIORA. Bernard notes how it is the very ubiquity of excessive art that makes it seem as if it did not pose a significant threat to monasticism. The implication is that this excess is common among respectable monasteries, monasteries whose respectability lends an air of respectability to the aesthetics of excess through association with it. This mute testimony to the good standing of those who engaged in artistic excess reveals one of the key factors in its widespread acceptance, within both monasticism and the secular Church.

104:12–15. OMITTO ORATORIORUM . . . RITUM IUDAEORUM. It is true, as Leclercq (1970:13, 22–23) and others have said, that this is an example of what medieval rhetoric called "*praeteritio*" (paraleipsis, or a declaration that one will not take up a certain subject, followed by one's doing just that).

However, this is the case only in so far as the areas which are declared not to be under discussion are discussed in this passage alone. In fact, Bernard never does go on to say anything more about the "things overlooked." There seem to be several reasons for this.

The main reason that architecture was even mentioned is a combination of the efficiency with which the reference to Cassian satisfied William's probable initial request, reinforced Bernard's argument with unimpeachable authority, made the transition from physical excess to moral excess, and led to the subject of other artistic abuse while giving the appearance of making a concession in regard to his indignation at architectural excess (on this last point see 104:15 SED ESTO . . . HONOREM DEI).

But the reason why Bernard dropped the subject is more interesting than why he took it up. In the first place, *Apologia* 28–29 represents Bernard's public position on art—not his personal views. These two chapters call for the rectification of a condition endemic to monasticism, not positively by a set of standards which it might present, but negatively by what it condemns. Throughout the *Apologia*, Bernard maintained that different customs and different degrees of austerity were allowable. He in no way tried to force Cistercian standards on the whole of monasticism, he only asked that it live up to the essential points of the vows its members had taken. Thus, it is a mistake to necessarily see *Apologia* 28–29 in terms of documented Cistercian regulations on art. Not only was Bernard in no way obliged to demand extremes from the established and wealthy monasteries of traditional Benedictine monasticism, the evidence of *Apologia* 28–29 shows that he had priorities and felt that to ask for a lot on what was secondary would be to lessen the effective force of what he wanted to say on what was primary. The size of churches was to Bernard—as far as traditional monasticism was concerned—secondary in terms of moral excess. In fact, it seems that architecture was not necessarily regarded by Bernard in the same light as the other arts at all.

Furthermore, contrary to the widespread opinion that it was because of Cluny that architecture is mentioned in the *Apologia*, it seems rather that it may have been in part because of Cluny that the subject was dropped. Despite my belief that the tendency to associate these few words on architecture with the third abbey church of Cluny was not as strong for contemporaries of Bernard as it has been for art historians since then (according to figures given in Conant 1968:141 and 1972:7, Cluny was not the largest church in Christendom at the time of the writing of the *Apologia*, even aside from Saint Peter's), the possibility remains that Bernard may have dropped the subject at the outset of *Apologia* 28–29 as a signal to his readers that he was not singling out that monastery for special attention. Such

an attitude would be entirely consistent with the previous reference to Odo, Maiolus, Odilo, and Hugh—the latter being the abbot under whom Cluny III was conceived and begun. Perhaps the 1125 vault collapse of Cluny III may have been part of this: it was obvious what he was getting at and to say more would have made him look vicious and petty. In any event, Bernard's position on architecture is consistent with that of Augustine as expressed in Possidius, *Vita S. Augustini* 24, *PL* 32:54.

104:12. ORATORIORUM. Bernard is doing more here than distinguishing between the monastic and the secular church building. As he later uses the word *ecclesia* twice in this chapter, his choice of *oratorium* here suggests that he was trying to make a special point. We know that Bernard did at times use *ecclesia* to describe monastic churches, even when speaking to monks (for example, in his first sermon on the Feast of the Dedication of the Church; *In Dedicatione Ecclesiae* 1:1, v.5:370), while at other times he used *oratorium* (as in *De Praecepto* 55, v.3:289; or *Vita S. Malachiae* 61, 63, 74, v.3:365, 368, 378). In *Apologia* 28, the word *ecclesia* is used first to indicate both the church building and the Church as an institution (see 105:25−106:2. FULGET ECCLESIA . . . QUO SUSTENTENTUR), and second simply to make a distinction between different parts of the monastery (106:12 "Assentio: patiamur et haec fieri in ecclesia"). Bernard chose to use *oratorium* here for its monastic implications. *Oratorium* could variously mean a chapel, an abbey church, or any church which was not a parish church. By using *oratorium* in his criticism of excessive architecture, Bernard was drawing an implicit contrast between the "immense heights, immoderate lengths, and superflous widths" mentioned and the humility proper to a monastic church as a place of prayer. He was also explicitly and sharply contrasting the use of the word as it appears in the Benedictine Rule where *oratorium* and not *ecclesia* is exclusively used to describe the monastic church no less than twenty-six times. The most significant of these occurrences appear in ch.52, "De Oratorio Monasterii," where Benedict repeatedly states that the oratory is a place of prayer, and that no one is to be distracted from prayer in that place. This is just the point that Bernard makes when he mentions the *oratorium*: that artistic factors of monastic churches combined to distract those in them from prayer. As a selection from the Rule was read daily in most monasteries, it is reasonable to assume that such a contrast would have been both conscious on the part of Bernard and immediately recognizable on the part of his readers.

Oratoriorum literally translates as "oratories." I translate it here as "places of prayer" in order to convey Bernard's word play and to avoid the currently more common meaning of "chapels."

104:12–13. IMMENSAS ALTITUDINES, IMMODERATAS LONGITUDINES, SUPERVACUAS LATITUDINES. This typically Bernardine allusion to Exodus 37:1 and 3 Kings 6:2, 20 serves to set the trap, so to speak, for the comparison with Judaic formalism at the end of the sentence. See 104:15 ET MIHI . . . RITUM IUDAEORUM. The modifiers, especially *immoderatas* and *supervacuas* were carefully chosen to convey the idea of excess, that which went beyond any reasonable need. It is possible, despite the unfavorable comparison, that Bernard also wanted to contrast the modest dimensions of the divinely commanded Ark of the Covenant, and even the Temple, to the extravagant size of monastic churches.

104:13. SUMPTUOSAS DEPOLITIONES. The word *depolitio* refers to something which is finished or perfect. As Bernard uses it, in immediate succession to a string of descriptions of architectural excess, it seems to have been meant to cover architectural decoration in the broadest sense: structural articulation and painted details, non-figural floor designs, sculpted vegetal work, and so on (Albert Blaise, *Lexicon Latinitatis Medii Aevi*, is of the same opinion concerning *depolitio*, whose definition as architecural decoration he exemplifies with this very passage from *Apologia* 28). Although not as attention-grabbing as other forms of art to be discussed, he felt such refinements were part of the larger distractive whole. By means of these "extras," these things which are not necessary to the structure of a building but which are found in formal architecture of every age, Bernard indirectly introduces the issue of cost—a subject of some importance in *Apologia* 28–29. Cf. Aelred of Rievaulx's rejection of *impolito lapide* in his criticism of art as a distraction to the monk; *De Speculo Caritatis* 2:70, p.99.

104:13–14. CURIOSAS DEPICTIONES. These representations, which Bernard explicitly condones, refer to one of the most noticeable omissions in *Apologia* 28–29: images of Christ, the Virgin, Biblical scenes, and so on. Close analysis of the rest of *Apologia* 28–29 indicates that Bernard does not actively condemn large-scale religious works, such as architectural sculpture (as distinct from the specific areas of criticism in *Apologia* 29), wall painting, stained glass windows, and—as the evidence suggests—sculpted capitals of overtly religious themes. Although he does view these subjects as distracting, he declares his tolerance of them for various reasons; see 104:15–16. SED ESTO . . . HONOREM DEI. Aside, from distraction, the phrase also mentions for the first time the question of excess in craftsmanship, a concept which underlies several of the "things of greater importance."

104:14. QUAE DUM IN SE ORANTIUM RETORQUENT ASPECTUM, IMPEDIUNT ET AFFECTUM. Thus, at the very beginning, Bernard takes up the issue

of distraction, seeing it as the outcome of the "things overlooked," but not to such a degree of offense as to merit the proscription of these things. Rather, the "things overlooked" represent the traditional but moderate monastic allowance of architectural decoration and specifically religious art. The problem of distraction is one which continues throughout the *Apologia*.

104:15. ET MIHI QUODAMMODO REPRAESENTANT ANTIQUUM RITUM IUDAEORUM. In speaking of the Judaic "rite," Bernard focuses on what was seen as Judaic ritualism, avoiding the artistic precedent of God's commands to Moses and Solomon. Although the criticism of Judaism as ritualistic is as old as Christianity itself, the force of Bernard's statement lies in the affront that it makes to monasticism, whose members, as Bernard later says, are spiritual men. For Bernard to describe monastic art alone—that is, without any of the earlier "small things"—as reminiscent of the Judaic rites implies, in his opinion, a serious misconception at the most basic level. According to Bernard, whose views are entirely traditional and Pauline, Judaism had abandoned the spirit for the letter (*Super Cantica* 14:2, 14:8, 58:7, v.1:76–77, 81, v.2:131–132; cf. William of Saint-Thierry, *Ad Romanos* 11:3–7, *PL* 180:659). Its form of worship was "crude" and its understanding darkened (*Super Cantica* 60:3, v.2:143). Indeed, it confused the veil which covered the mystery for the mystery itself: an accusation which has strong parallels in his later criticism of the equation between excessive art and holiness (*Super Cantica* 73:2, v.2:234). The beauty of the first Temple in Jerusalem consisted of perishable art works, but the beauty of the contemporary temple lies in the religious fervor of its occupants, the Knights Templar, whose pure hearts are far more delightful than shining marble or gilded paneling. To be sure, the voluntary poverty of that military order shows more honor to God's Temple than the ancient Judaic rites (*De Laude Novae Militiae* 9, v.3:222).

See Jerome, Letter 52:10, v.2:185–186 on the Judaic precedent, ritualism, and the rejection of gold. Cf. the comment of Nicholas of Clairvaux, at one time the personal secretary of Bernard, to whom to leave the traditional Benedictine monastery of Montiéramey for Cîteaux was to forsake the "Old Testament and shadow of the Cluniacs" and to flee to the purity of the Cistercians; Nicholas of Clairvaux, Letter 8, *PL* 196:1603. On the other hand, what the Middle Ages saw as Judaic formalism was ascribed to the Cistercians themselves; Orderic Vitalis, *The Ecclesiastical History* 8:26, v.4:322; and in a much less flattering sense, Walter Map, *De Nugis Curialium*, 1:25, p.86–88, 102–112.

As I have said, the real force of the reference to Judaic rites lies not simply in its charge of ritualism but in that such a charge was being made to

monks. But Bernard is quick to give the appearance of concession on the points of comparison for a reason other than its harshness. Despite the fact that the pro-art position had been sarcastically compared before in the West to Judaic practice (*Libri Carolini* 1:20, p.45–48), this particular comparison was more commonly used by those who would eventually be branded as heretics, for example, Claudius of Turin in the ninth century. But the fact that Bernard himself abhors the idea that heretics should regard churches as synagogues (Letter 241:1, v.8:125) gives a sense of the seriousness with which he intended this comment.

104:15–16. SED ESTO, FIANT HAEC AD HONOREM DEI. This is the first of several traditional, non-doctrinal justifications of excessive art which Bernard takes up in *Apologia* 28. The justification of art for the honor of God was certainly the most firmly entrenched of these, having roots which reached back to the Biblical, pagan, and early Christian past. Along more contemporary lines, Suger of Saint-Denis' *De Administratione* and *De Consecratione* provide the most thorough development of this attitude.

When Bernard acquiesces in those areas of art mentioned in the previous sentence, he does so not only with tangible rhetorical advantage, but also with a resistance pushed to the limit. Thus the opening of his next sentence reads, "However, as a monk, I put to monks . . . " as if to draw a limit to reasonable indulgence. The subject of the proper honor to God is taken up in a number of sermons he probably delivered to monks, one of which is specifically concerned with performing acts of sacrifice for the eyes of men rather than for God. In these sermons, Bernard presents the opinion that piety is the worship of God and that it is in the heart that one honors God. Yet, curiosity is the natural enemy of piety and can destroy piety if one is negligent (*De Diversis* 14:2, 125:3, v.6pt.1:135, 406). Thus what Bernard objects to in these areas (besides the excess, especially in cost) is their distractive potential which, in effect, can lessen the proper honor due to God. However, unlike the "things of greater importance" to come, these things which he would "overlook" do not necessarily involve moral excess. That is, they do not involve moral excess if the intentions behind them are pure in seeking the honor of God, the benefit of those around one, or good conscience (*De Diversis* 122, v.6pt.1:399). The intentions behind the "things of greater importance," as Bernard immediately tries to show, were most definitely not pure in the three latter categories.

And so Bernard makes a distinction between an acceptable level of art and an unacceptable level. What defines the line between the two is the intention with which art is advocated both in terms of the advocate's own good and that of those around him. It is significant for modern readers to appreciate that Bernard is vague to the point of obscurity on what was ac-

ceptable: that is, he is not presenting a position on what is to be allowed, but rather on what is not to be allowed. His concern is excess, not a theory of art as some scholars have tried to put forth. Furthermore, in so making this distinction, Bernard is able to open his extremely harsh criticism of excessive art, the harshest criticism in the entire *Apologia*, with a concession to the tradition of glorifying the house of God—a tradition he could not hope to overcome—thereby giving the impression that while he accepts the traditional postulate, the areas of discussion which follow do not enter into that postulate.

104:16–18. ILLUD AUTEM INTERROGO MONACHUS MONACHOS . . . IN SANCTO QUID FACIT AURUM? In this key sentence of *Apologia* 28, Bernard sets forth his main limits of criticism both in terms of whom he was concerned with and what he was concerned with.

"As a monk, I put to monks . . . " clearly limits the topic under discussion to monastic circles: Bernard goes on to deal with the question of art and the layperson in the monastery, but only in reference to monasticism's role. The monastic profession was, to Bernard, man's highest calling. To him, to err as a monk was far graver than to err as a layperson. It seems that, to Bernard, the very word itself carried a special force of dignity. For him first to compare monastic practices with Judaic ones, and then to shame his monastic readers by citing the example of a pagan more moral than themselves was harsh criticism indeed from one who said, "Let the pagan who lives without God [Ephesians 2:12] and the Jew who received earthly promises strive for [earthly riches]"; *In Festivitate Omnium Sanctorum* 1:7, v.5:332.

The "what" that Bernard was concerned with is embodied, more clearly than in any other thing, in gold. That is, he was not concerned so much with the possession of gold by monks, or even with its use by monks, but rather with the excessive display of gold and materials like gold in monastic churches in order to elicit certain specific reactions from lay visitors. In sharp contrast to the contemporary wealth of monasticism—according to William of Saint-Thierry, the greater part of the world was owned by monks (*Super Cantica* 194, p.384)—the traditional monastic position on gold was one of rejection. This is nowhere more clearly seen than in the *Vitae Patrum* and related writings which were of primary influence on the Cistercians. Bernard was no different in this respect. Criticism of the misuse of gold is quite common in his writings, with his general opinion being that use was good, misuse bad, solicitude worse, and use for profit disgraceful (*De Consideratione* 2:10, v.3:417–418). It is this latter category that Bernard has taken up here.

The quote from Persius, *Satires* 2:69 shows up in William of Malmes-

bury's *Gesta Regum* 337, v.2:384 (*PL* 179:1290), written shortly after the *Apologia*, in reference to the early Cistercians. Its appearance there is obviously the result of the influence of Bernard's treatise, despite William's relatively conservative views on the subject of religious art. The passage from Persius is also found slightly later in a very interesting account about Odo of Cambrai in the *De Restauracione* 66, *PL* 180:90 by Hermannus of Saint-Martin, again undoubtedly as a result of Bernard's work. Bernard himself later used it repeatedly in his Letter 42, often called the *De Moribus et Officio Episcoporum Tractatus*. In its original source, Persius Flaccus (d.62 A.D.) ridiculed the popular conception of prayer, satirizing those who prayed for exterior things, rather than virtue. The similarities with the *Apologia* thus extend beyond the mere borrowing of an apt phrase by Bernard. Cf. Jerome, Letter 58:7, v.3:81–82.

The term *quid facit* here marks the first part of Bernard's dichotomy on art—that is, art and the reception of the layperson in the monastery—and reappears in *Apologia* 29 to mark the second part—art which was ostensibly intended for the monk alone.

104:19–21. EGO AUTEM DICO: "DICITE PAUPERES,"—NON ENIM ATTENDO VERSUM, SED SENSUM—"DICITE," INQUAM, "PAUPERES, SI TAMEN PAUPERES, IN SANCTO QUID FACIT AURUM?" After negatively comparing the practices of some members of traditional monasticism first to Judaic ritualism and then to an example of pagan morality, Bernard delivered the hardest blow of all: a rhetorical questioning of that segment of monasticism's adherence to the fundamental monastic tenet of voluntary poverty. The implementation of the ideal of voluntary poverty had become, by the time of the *Apologia*, perhaps the central issue in the monastic controversy. Indeed, Leclercq even calls the controversy a "crisis of prosperity" (see Leclercq 1971 for an internal approach to the problem, i.e., one in which the crisis is discussed more in spiritual terms without reference to politics or power groups outside monasticism; for an external approach, one which interprets the crisis in broad social and political terms, see Cantor 1960). At the monastery of Cluny, for example, the subject of poverty was regularly called into question by many. John of Fécamp criticized the absence of poverty at Cluny under Maiolus, Adalbero of Laon under Odilo, Peter Damian under Hugh, Bernard under Pons and Peter (Letter 1), and the author of the *Vita Amedaei* under one of Peter's successors. Yet life at Cluny on the moral level was never—to my knowledge—impugned. The important thing to recognize is that traditional monasticism did claim to practice voluntary poverty, despite the glaring contrast between its way of life and that of the new ascetic orders.

What brought the vow of poverty into the realm of the "things of greater importance" was the particular way in which it was being violated. That is, it was not just a simple case of the possession of personal property or corporal laxity such as one finds condemned so often in the Desert Fathers and in the Benedictine Rule. Bernard was, rather, concerned with what he saw as a conscious and communal effort at the accumulation of material wealth by means of the sacred economy. He saw this as taking place at the expense of the faithful and to the detriment of real spirituality on the part of both monk and layperson. The significance of the issue of voluntary poverty is repeatedly driven home by means of an unusual emphasis on the subject through statement and restatement of the question, repetition of the word *"pauperes,"* the rare use of the first person personal pronoun, drawing attention to the change of meter from *pontifices* to *pauperes* (cf. Letter 398:3, v.8:378), and even the actual expression of doubt as to whether or not these monks were in fact "poor men."

It is in this moral sense that Bernard uses voluntary poverty to foreshadow three of his "things of importance": art to attract donations in both the subheadings of the monastic investment and the liturgical artwork, and art as opposed to the care of the poor.

104:21. ET QUIDEM ALIA CAUSA EST EPISCOPORUM, ALIA MONACHORUM. Bernard devotes only two sentences to the subject of secular religious art in *Apologia* 28–29. In each of them, he refers to the authority of one of the four great Doctors of the Church in such a way as to make manifest his orthodoxy concerning the acceptability of secular religious art on the one hand, and the inacceptability of excessive monastic art on the other: his aim being to discuss the latter, not the former.

In this, the first of those sentences, his main purpose is to disassociate completely the monastic order from the secular Church with respect to what he is about to say concerning excessive art. To do this, Bernard has relied upon the authority of Jerome as put forth in Jerome's Letter 58, one of the sources for Bernard's criticism of excessive art and a work which, like the *Apologia*, discusses standards of the regular life while criticizing excessive art for monks and citing both Persius (*Satires* 3:30) and a pagan whose actions were more moral than those of Christians. Cf. Jerome, Letter 14:8, v.1:41, "Sed alia . . . monachi causa est, alia clericorum"; and Letter 58:4, v.3:78, "Quod loquor, non de episcopis . . . quorum aliud officium est, sed de monacho." In typically Bernardine fashion, he has extracted the essence of his chosen authority and rephrased it to suit his own requirements—in this case, putting a somewhat greater emphasis on the polarization of the episcopacy and monasticism. Cf. Jerome, Letters 107:10, 125:8, v.5:155,

v.7:121. Hugues de Fouilloi raised the same argument as Bernard in regard to excessive monastic art; *De Claustro Animae* 2:4, PL 176:1053. Matthew of Albano acknowledged this argument in his defense of monastic art but did not attempt in any effective way to refute it; *Epistola*, p.331–332. See also the next comment.

104:21–105:1. SCIMUS NAMQUE QUOD ILLI . . . CORPORALIBUS EXCITANT ORNAMENTIS. In this second of the two sentences which make mention of secular religious art, Bernard is at pains to declare his acceptance of the orthodox position in the West on that form of art as put forth by Gregory the Great—that is, after he has already stated that it does not necessarily apply to monks.

In what was to become offical Church doctrine on the question of religious imagery, Gregory distinguished in two letters between the adoration of images and the use of images to instruct the illiterate as to what should be adored (*Registrum* 9:209 and 11:10, p.768, 873–876; I use the *Corpus Christianorum* numbering here, PL 77 numbering is bk.9:105 and 11:13). While in his second letter he did mention that art could be used as a spiritual aid as well, he never mentioned the popular conception of art for the honor of God.

Bernard acknowledged Gregory's widespread authority on the subject of art as briefly as possible. He did this only as far as secular religious art was concerned, taking Gregory quite literally that the purpose of religious art was for the illiterate or "foolish." (Bernard chose to ignore a letter of Gregory's to a certain hermit in which Gregory advocated the use of art to raise spiritual awareness, but which, however, is a spurious work from the eighth century; Gregory the Great, Appendix 10, p.1104–1111; traditional numbering, bk.9:52.) Thus, having stated his orthodoxy, he was free to return to his argument that excessive art was inappropriate to the monk without fear of appearing to sympathize with one of the marginal tenets common to so many contemporary heresies. It should be emphasized that it is only along these lines that Bernard raises the question of secular religious art and that he is in no way actively promoting it.

And so, following Gregory the Great, the function of art was to teach and to raise the spiritual awareness of the illiterate. This is what Bernard refers to by "stimulating the devotion of a carnal people with material ornaments." Yet it was not the place of the monk to do this. As Bernard said in that letter to Oger in which I believe he first turned down Oger's request to write the *Apologia* (Letter 89:2, v.7:236), "the duty of the monk is not to teach, but to mourn" (a reference to Jerome's *Contra Vigilantium* 15, PL 23:352, or 367 in the 1845 ed.). On the stimulation of the devotion of the monk, see Bernard, *In Epiphania* 3:1, v.4:304.

A secondary pressure is also rhetorically brought into play here, that of the controversy between the episcopacy and some segments of monasticism over pastoral care. The reference here and in *Apologia* 27 to the retinues of certain abbots as being enough for two bishops are very thinly veiled references to the infringement on the rights and duties of the secular Church by some monasteries. In this sense, Bernard was also contrasting the practices of traditional monasticism with the policies of the new ascetic orders, many of which made a rejection of pastoral duties and a recognition of episcopal rights over monks an important part of their claim to monastic purity. On Bernard's claim to limit himself to the business of the monk, see Letters 2:8, 61, v.7:19, 154.

The reference to the wise and the foolish (Rom 1:14) was a favorite of Bernard's. According to William of Saint-Thierry, signs were needed not for the wise, but for the foolish; *Ad Romanos* 1:14, *PL* 180:556.

105:1–2. NOS VERO QUI IAM DE POPULO EXIVIMUS, QUI MUNDI QUAE-QUE PRETIOSA AC SPECIOSA PRO CHRISTO RELIQUIMUS. Bernard is referring to another of the great points of contention in the monastic controversy of that time. After voluntary poverty, the issue of seclusion was certainly one of the prime areas of friction between the old and the new monasticism and, along with material wealth, one of the major factors contributing to the artistic situation so criticized by Bernard. In raising the point here, Bernard is implicitly drawing attention to the irony that, although these monks have left the world, they have brought the world with them into the monastery and that, although they renounced the possession of personal property, they live amid the trappings of great wealth. This general contradiction has been discussed by Bernard elsewhere, for example, *In Laudibus Virginis* 4:10, v.4:55–56. On the reference to Matthew 19:27 see Benedict of Nursia, *Regula* 4.

105:2–5. QUI OMNIA . . . UT CHRISTUM LUCRIFACIAMUS. Bernard brings up here the traditional conception of the monastic life as a rejection of the things of the senses. He believes that the senses are the opposite of the spirit and that, when they exert themselves, the eye of the spirit becomes shrouded in darkness (*De Consideratione* 5:2, v.3:468). They are less quick and penetrating than the mind (*De Diligendo Deo* 20, v.3:136). The most important of the senses is the sense of sight (*De Diversis* 10:3–4, v.6pt.1:123; *III Sententiae* 73, v.6pt.2:110–111). But sight can become a slave to curiosity and so come to resist the divine will (*De Conversione* 10, v.3:83). It is impossible for one so enslaved to perceive the spirit of God (*In Nativitate* 3:3, v.4:259; a reference to 1 Cor 2:14), and such a person will eventually dissociate himself from his fellow monks (*Dominica VI post Pentecosten* 1:3, v.5:208). Obviously, in Bernard's view, the dangers en-

gendered by excessive art when taken to the extreme can negate the spiritual benefits of monastic life.

Although Bernard's reference to Philippians 3:8 ("All things . . . I regard as dung, in order that I may win Christ") is indisputable, there is an interesting parallel in Jerome's Letter 52:10, v.2:185 immediately following Jerome's criticism of excessive art, "We will consider riches as dirt" (*divitias lutum putabimus*)." This passage of Jerome's was repeated in Gratian, *Decretum* causa 12:2:71 (col.711). See also Cassian, *Conlationes* 24:23, p.699, for use of Philippians 3:8 in reference to a rejection of the "pomp of this world." Bernard provides a rather close reverse parallel to his string of bodily delights in Letter 114:1, v.7:292. For the rejection of gold and silver as dung, see Bernard, *In Psalmum 'Qui Habitat'* 17:6, v.4:490, and in reference to monastic conversion, see Bernard, Letter 109:1, v.7:281. For other parallels in regard to the senses, see Augustine, *Confessiones* 10:35:54, p.184; and Hugh of Saint-Victor, *Didascalicon* 7:13, *PL* 176:821. Hugh of Saint-Victor wrote that the senses aid in spiritual understanding; *In Hierarchiam* 2, *PL* 175:950.

105:5. QUORUM, QUAESO, IN HIS DEVOTIONEM EXCITARE INTENDIMUS? Bernard, in this rhetorical question which is actually an answer to his inquiry about the function of gold in the holy place, comes out and suggests that the purpose of excessive art in the monastery is for lay reception. The implication is that since monks have left the things of the world behind and that since they use spiritual rather than material ornaments to excite their own piety, then they could only be trying to excite the "piety" of laypeople. He draws attention to this contradiction by the use of an interrogative intensifier. See the next comment.

105:5–7. QUEM, INQUAM, EX HIS FRUCTUM REQUIRIMUS: STULTORUM ADMIRATIONEM, AN SIMPLICIUM OBLATIONEM? Bernard continues with another rhetorical question which, like the previous one, is intensified by the use of an interrogative. His use of the word *fructum* is a foreshadowing of the phrase *non fructum, sed datum* two sentences further on. It has been translated as "interest" here to correspond to that important phrase. Previous translations of "profit" or "purpose" convey its meaning when limited to this sentence alone.

Bernard's question implies recognition of a conscious effort on the part of the predatory monk to extract something from the layperson through the use of art. The answers he loosely offers define the goal and the target of that effort. On the one hand, he asks if the intent of excessive art in the monastery is to evoke the astonishment of fools; on the other, if it is to elicit the offerings of the simple. Although it is wrong to insist on any one specific literary source for Bernard's use of these words, Proverbs 17:24

provides an apt association of the fool and curiosity: "A man of understanding sets his face toward wisdom, but the eyes of a fool are on the ends of the earth." Bernard, too, is concerned with the curiosity of the fool. But not for the sake of the fool. He is opposed to the instillment of awe by the monk through the use of art. For a monk to wish to astonish a fool would be foolishness in itself. Likewise, to solicit the offerings of the simple replaces with avarice the wisdom that a spiritual man should have—or, as Bernard said shortly after the *Apologia* was written, true wisdom is the rejection of filthy lucre and the refusal to serve idols (Letter 24, v.7:76). The common denominator of the apposition of the fool and the simple is the absence of any true religious spirit. Together, they comprise the least desirable elements of the lay pilgrimage.

105:7–8. AN QUONIAM COMMIXTI SUMUS . . . SERVIMUS ADHUC SCULPTILIBUS EORUM? The opposition between the old and the new monastic reform movements is never far below the surface in Bernard's critique of monastic art. He again takes up here, but far more explicitly, the subject of the increased opening up of the monastery to lay visitors. Unlike the traditional Benedictines whose reform especially involved the restoration of the regular life in older monasteries around which settlements had grown up, the new monastic orders, such as the Cistercians, actively sought out secluded locations far removed from secular distraction. Although many of the Cistercian monasteries were later to resettle nearer population centers for economic reasons (see Lekai 1978), the implication at the time of the *Apologia* was that the practice of geographical seclusion was closely in keeping with the spirit of primitive monasticism. Even more to the point, Bernard was objecting to the active encouragement of the pilgrimage—as distinct from the injunction of the Rule to welcome visitors (Benedict of Nursia, *Regula* 53). This is what he means by being "mingled with the gentiles." The seclusion and flight from the world that was so basic to monasticism had been worn away by an attrition no less lucrative than it was contaminating.

The gentiles are the lay people. And although Bernard successfully links Psalm 105:35–36 with Ephesians 5:5 (and Col 3:5) to explain idols as avarice, it seems that a more literal interpretation of *sculptilibus* as a carved liturgical artwork was quite intentional. Furthermore, the distinct possibility exists that what may have suggested the use of Psalm 105:35–36 was Gregory the Great's admonition to Bishop Serenus of Marseille (*Registrum* 11:10, p.874; *PL* 77, 11:13) that since he lived *inter gentes*, he should have been aware that the function of art was to instruct and to spiritually uplift. Cf. Jeremiah 10:1–4.

105:9–10. ET UT APERTE LOQUAR . . . NON REQUIRIMUS FRUCTUM, SED DATUM? As if Bernard had not been speaking plainly enough, this transition sentence announces the beginning of his "gloves-off" discussion of excessive monastic art—in particular of the monastic investment in art. Very effectively tying the Old Testament conception of idolatry (Ps 105:35–36), which was seen as the submission of oneself to the material, and the New Testament conception, which involved the submission of oneself to anything that comes between one and God (Eph 5:5 and to a lesser degree Col 3:5), he explains the service of idols as avarice, using the authority of Paul. Elsewhere, Bernard describes this type of service to idols as a sign of a degenerate soul and as ingratitude to God himself; *In Psalmum 'Qui Habitat'* 14:5, v.4:471–472; Letter 24, v.7:76. See Jerome, Letter 22:32, v.1:148 where Colossians 3:5 is related to excessive art in a tract on the ascetic life; cf. also Jerome, Letter 130:14, v.7:184.

His reference to Philippians 4:17 ("Non quia quaero datum, sed requiro fructum") is, in purely monastic terms, more scathing still. Bernard has taken up the financial language of Paul and applied it to the financial affairs—as he himself calls the monastic investment in art—of his fellow monks. *Datum*, as used by Paul and Bernard, has the meaning of "principal" or "capital investment." *Fructum* correspondingly signifies the interest accruing from such an investment. Whereas Paul said that he was not interested in the investment which the people of Philippi made in giving him financial support but rather in the interest that was accruing to their spiritual account, Bernard hurls an accusation of just the opposite at certain segments of contemporary monasticism. They were not interested in any spiritual profits from their investment in art, on the contrary, they were interested in the financial aspect alone. Such a charge against monks was a challenge to their claims of apostolicity. Once again, the moral questions of Bernard's are consistently put forth in terms of monastic tradition, ideals, or practice. Cf. Bernard, *Super Cantica* 62:8, v.2:160, "Do you ask whom I call impure? He who rates piety as profit, he who seeks not the interest, but the principal"; and Bernard, *De Consideratione* 4:12, v.3:458; Letter 1:8, v.7:7.

105:10–16. SI QUAERIS: "QUOMODO?" . . . IBI OFFERTUR LIBENTIUS. The main thrust of Bernard's critique of certain monasteries' investment in art for the sake of financial returns takes the form of a series of statements and restatements on how this was brought about. None of the other "things of greater importance" is driven home with such force as this. Bernard first says no less than three times that money is paid out so that a greater amount may be realized. The tone is one of irony, that the expenditure of one's resources actually increases those resources. (Cf. the strikingly close conceit of money breeding money by Aristotle, *Politics* 1:10,

p.28–29.) He then declares that this comes about through the tendency of lavish art to encourage donations. Twice more he repeats his accusatory observation, this time reversing the sense of an outflow to one of money as a magnet for more money. Then, once more, he identifies the operative factor as the force of excessive art. The general conclusion is that the more a place is decorated, the greater can be that place's expectations of financial returns. In the process, Bernard briefly raises the subjects of art as a distraction to the layperson and the cost of art.

The word *divitiarum* translates both as "expensive ornaments" and as "riches" or "wealth." Given the general topic and the previous references to *opes* and *pecunia*, it seems that Bernard intended to imply both meanings.

105:12. EFFUSIO. Cf. Bernard, Letter 42:7, v.7:106 for a conceptually similar use of this word—in this case, more precisely defined as a pouring out of the bare necessities of the poor.

105:13. VANITATUM. See 105:24–25 O VANITAS . . . INSANIOR. Cf. Letter 42:7, v.7:106 where the same word is used to describe episcopal excess, in both cases carrying the meaning of the spiritual emptiness of the luxurious object, whether artwork or craftwork.

105:15. QUO PACTO. Possibly a reminiscence of Persius, *Satire* 2:46, *pactum* implies the participation of two parties in a certain undertaking: an agreement, a set of terms. It has been translated here as "law" rather than in the idiomatic sense of "how" or "in what way" because the terms Bernard talks about are those of cause and effect. They operate beyond the realm of the conscious agreement of both parties, depending upon the elicitation of a natural reaction from the viewer as a regular occurrence.

105:16–17. AURO TECTIS RELIQUIIS . . . VEL SANCTAE ALICUIUS. The difficulty with this important passage is to determine exactly what Bernard means by *forma sancti vel sanctae*. In his entire discussion of excessive art and the reception of the layperson in the monastery, he mentions only five specific examples of artworks as objectionable—his objections were not limited to these works, but they are the main indicators of at least one element of what it was that Bernard found objectionable in excessive art.

Special attention is paid to the *auro tectae reliquiae* and the *forma sancti vel sanctae*. They are set apart from the other examples of artworks by the the fact that it is these to which he most directly attributes a remunerative power and by the emphasis placed on them as a result of their position as the first of any specific artworks listed. The phrases share a common meaning, immediately following as they do Bernard's main formulation of art to attract donations, and coming before *dehinc* of 105:19 which gives a certain

amount of distance between these works and those which follow. Just as *auro tectae reliquiae* or reliquaries attract donations, so people are asked to give when at the *forma sancti*. And just as reliquaries are kissed, so is the *forma sancti*. But most telling is Bernard's comment that the *forma sancti* is sacred and worthy of veneration. The *forma sancti vel sanctae* was meant, therefore, to refer to the statue reliquaries which had such force of attraction over people. The statue reliquary of Saint Foi from Conques (Fig. 5) is one among the many examples of what Bernard had in mind. Upon first seeing this reliquary statue, Bernard of Angers—later a devotee of the saint—was tempted to compare it to an image of "Venus or Diana," actually describing a similar reliquary statue as an "idol." He also noted that the custom was to include important relics of the saint in the statue, which would have been the ostensible justification for ritual osculation; Bernard of Angers, *Liber Miraculorum* 1:13, p.46–48. (There is probably no connection between Bernard's *forma sancti vel sanctae* and the *aut imaginem masculi vel feminae* of Dt 4:16, a paraphrase of the Second Commandment.)

But it was not the reliquary per se to which Bernard was objecting. It is also probable that he included in this criticism similar artworks which he felt exceeded the proper limits of material and craftsmanship and which did not bear relics. His principal objection was not so much to the extravagant ornamentation of reliquaries as such, but rather, as *signantur oculi, et loculi aperiuntur* implies, to the dual function of lavishly decorated artworks as a means of extracting donations from the faithful and as a distraction from the truly spiritual. The reliquary or some other suitable liturgical centerpiece receives priority position here because of its potentially greater impact and as the primary means of attracting pilgrims to monasteries, but this is the case only for the reasons indicated. (Bernard is known to have followed the traditional position on relics, to have had relics at Clairvaux, to have participated in the rage of obtaining relics from the East, and even to have been buried with relics.)

The phrase *signantur oculi, et loculi aperiuntur* does not translate literally, being a pun on the fact that it is usually money bags that are "sealed" (*signantur*) and eyes that are opened, although now it is the reverse.

105:17–19. ET EO CREDITUR SANCTIOR . . . QUAM VENERANTUR SACRA. At some shrines, the indulgence for the pilgrimage undertaken was so arranged as to be associated with the offering made there, and some even claimed that a pilgrimage without an offering was not efficacious (Sumption 1975:160). Such a parallel between the act of worship and the request for money at the time of worship seems to be the point of Bernard's word play, *ad osculandum, invitantur ad donandum*.

"Color" apparently refers not only to the application of paint or enamel,

but also to the accumulation of precious stones, cameos, and so on; see Bernard, Letter 42:7, v.7:106–107 for a stinging denunciation of episcopal luxury in which beautiful colors and excessive materials are explicitly associated. While excessive color, along with excessive material, does contribute to the overall sense of *praesentia*, the straightforward Cistercian objection to the use of multiple colors (as in manuscipts, for example) is more closely related to the premise of art as a spiritual distraction rather than to that of the equation between excessive art and holiness; cf. Statutes 10, 80, 12, p.15, 31, 61.

Bernard's description of people "running" to kiss the *forma sancti* may refer to the practice of the pilgrims racing to be the first into a holy place when the doors were opened in the belief that greater blessings might accrue (based on Jn 5:1–9; Labande 1966:284). See Suger, *De Consecratione* 2, p.86–88 for a similar but positive and very real account of this great rush to kiss the reliquaries.

105:19–23. PONUNTUR DEHINC IN ECCLESIA . . . QUAM SUIS GEMMIS. After having begun his criticism of specific artworks with objects central to the liturgy, to the housing of relics, and to the primary purpose under discussion of the artistic reception of the layperson in the monastic church, Bernard moves on to the more peripheral works of liturgical art: *coronae*, or large hanging chandeliers in the form of a crown, and large, floor-standing candelabra. Although peripheral, these *vasa non sacra* (Joseph Braun's term; Braun 1932:2) are not inconsiderable in that Bernard sees them as part of the same effort toward a program in which the entire environment combines to create a certain emotional response on the part of the visitor as indicated by the sentence immediately following the discussion of all of these artworks, "What do you think is being sought in all this?" Although not mentioned by Bernard, the chanting, bell ringing, incense, and alternate movement and immobility of the liturgy would also have joined with the varied visual effects of art—especially with the aid of candle, oil lamp, and sunlight—in a sensory saturation of the holy place.

As with the reliquaries, Bernard criticized *coronae* and candelabra for their excess in material (bronze and jewels) and craftsmanship. But he also singled them out for special condemnation for their sheer size, something which Hugh of Saint-Victor described as a common factor in the perception of beauty; *Didascalicon* 7:9, PL 172:819. The comments here are not overtly critical of traditional, small liturgical artworks such as *Exordium Parvum* 17 mentions or Statute 10 prohibits. Likewise, in contrast to the earlier custom of hanging crowns in churches, gigantic, as Bernard says, "wheels" were being employed. There is no exaggeration in either of these statements. Indeed, such candelabra were the size of trees, being so large that far from

standing on the altar they had to be placed on the floor (the practice of plac-
ing candlesticks on the altar rather than on the floor began to take hold in
the mid-twelfth century). The *corona* of Cluny was so large that Peter the
Venerable actually felt it was necessary, primarily for budgetary reasons,
to cut back on the number of candles burned in it and the frequency with
which this was done; Statute 52, p.82.

Size was only the most salient point among several of these liturgical
objects' own particular means of distraction. Peter's statute also specifically
notes in positive terms the immense power of the *corona* to impress, a
power he did not want to see diminished through overuse. In fact, the dis-
tractive power of jewels, particularly under flickering candles, seems to be a
serious source of distraction to Bernard (on the distractive qualities of lights
in church, see an example given by Gregory of Tours, *Historia Francorum*
2:7, p.69–70). Cf. also Aelred of Rievaulx's rejection of candles in conjunc-
tion with liturgical art; *De Speculo Caritatis* 2:70, p.99. A glance at
Lehmann-Brockhaus 1955 and 1971 or von Schlosser 1896 and 1974 show
how common both of these items were, and how often they were noted for
the same qualities named by Bernard but in positive terms. Two notable
monastic examples of this were the great candelabra of Benedict of Aniane
and of Cluny; Bloch 1961:87, 89, 134, 183; see Bloch 1961 on large, floor-
standing candelabra in general.

By singling out *coronae* and candelabra, Bernard shrewdly sidestepped
the problem of relating his views to the acceptable and even mandatory use
of precious material in conjunction with those liturgical artworks which
came into direct contact with the Eucharist. This passage also carries con-
notations of Judaic precedent in general, and perhaps Jeremiah 52:20 in par-
ticular (*Non erat pondus aeris omnium vasorum horum*). For a discussion
of the probable reference to Ovid and the obviation of the natural in the
excessive artwork, see the section "Bernard's Categories of Excess." On the
extreme unlikelihood that this passage refers to any specific works of art,
see the section "Cluny, the Cluniacs, and the Non-Cluniac Traditional
Benedictines."

Cf. Bernard's "nec magis coruscantes superpositis lucernis, quam suis
gemmis" with Honorius Augustodunensis' justification of *coronae* in
Gemma Animae 1:141, *PL* 172:588, "lucernae eius bonis actibus lucentes.
. . . Gemmae in corona coruscantes sunt." There is probably no connection
intended between Bernard's *artificis opere* and the *opus artificis* and *opus
artificum* of Jeremiah 10:9.

105:23–24. QUID, PUTAS . . . INTUENTIUM ADMIRATIO? At the end of
his classic statement on religious art, Gregory the Great concluded that the
stimulation of compunction (*ardorem compunctionis*; *Registrum* 11:10,

p.875; 11:13 in *PL* 77) was one of its primary functions. It is this that Bernard refers to here, not questioning the authority of Gregory, but rather questioning the sincerity of those who justified their actions by his authority. According to Bernard, no compunction is being prompted by this type of excessive liturgical art which dazzles rather than instructs. Quite the contrary, he believes that it hinders compunction through the distraction it engenders, serving only curiosity. Prayer from the heart, which he saw as a part of confession and as the layperson's primary duty of penitence in the world, was impossible (*De Diversis* 91:1, v.6pt.1:341). In this sense he is drawing attention to the failure of monastic art as part of the penitential system of the pilgrimage in that it impeded rather than expedited contrition. Indeed, according to Bernard's contemporary, Hugh of Saint-Victor, the attainment of real compunction involves the elimination of all earthly things; *De Arca Noe Morali* 3:6, *PL* 176:652.

105:24–25. O VANITAS VANITATUM, SED NON VANIOR QUAM INSANIOR. In this transition between the passage on art to attract donations and the passage on art as opposed to the care of the poor, Bernard expresses the futility of the one, and the absurdity of the other. *Vanitas vanitatum* (Ec 1:2) is the pre-eminent Biblical phrase for emptiness, an emptiness or futility Bernard ascribes to both parties involved in the pseudo-spiritual transaction of the previous passage in which excessive art acts as the medium. He has not used this phrase lightly. In his *Sententiae* he describes the "vanity of vanities" as sin (*III Sententiae* 115, v.6pt.2:208), elsewhere referring to it as "nothingness" (*De Conversione* 14, v.4:88). Yet, Bernard goes on to to say that this was no more empty or futile—referring to art to attract donations—than it was insane. *Insanus* relates to the following idea of art as opposed to the care of the poor. Its dual meaning connotes both madness and extravagance, the madness which justified excessive architecture while those within were in need, and the extravagance of that excess itself.

The play on *vanior* and *insanior* may have been suggested to Bernard by Psalm 39:5: "Blessed is the man whose hope is in the name of the Lord, and who has not turned his attention to false vanities and insanities (*vanitates et insanias*)." This passage was discussed in its monastic context by Bernard in *In Psalmum 'Qui Habitat'* 15:6, v.4:480. Elsewhere, Bernard states that those who are at peace with God are not concerned with earthly habitation, like those who are insane (*in insaniam versi*) and delight in their bonds (*In Vigilia Nativitatis* 2:2, v.4:204–205).

105:25–106:2. FULGET ECCLESIA PARIETIBUS . . . NON INVENIUNT MISERI QUO SUSTENTENTUR. As with much of the section on art to attract donations, the section on art as opposed to the care of the poor uses statement

and restatement to drive home its point. No less than four times in immediate succession does Bernard contrast the misuse of art with the resultant neglect of the poor. This takes the form of two denunciations of the self-glorification by the Church, followed by two more of its catering to the idle curiosity of the rich. At the base of this is not just a simple defense of the poor against practices that Bernard felt were inequitable, but rather an attack on the manipulation of the sacred economy by elements of the Church, and on the traditional social justification of excessive art which claimed that expenditure on art was the equivalent of almsgiving. Indeed, coming after the section on art to attract donations, the contradiction between these passages functions as a counterpoint to the claim which attempted to justify the situation it had helped bring about. See Jerome, Letter 22:32, v.1:147–148 on the contradiction of expenditure on excessive art while Christ in the poor dies at one's door.

In typically Bernardine fashion, he has based this passage on the monk Jerome's writings on the religious life, but without slavish imitation. As always, it is the intention which is of importance to Bernard. It is enough if the source can be recognized for the sake of its authority both for the force of the argument and for the reinforcement of Bernard's alignment with Church teaching. In Letters 58:7 and 52:10, v.3:81–82, v.2:185 (which seems to have been the basis for the later Letter 130:14, v.7:185–186; cf. also Letter 128:5, v.7:153), Jerome criticizes the adornment of the walls and other parts of the church with gold, jewels, and so on. He rejects the precedent of Judaic liturgical objects, yet never mentions the narrative art in which his friend Paulinus of Nola took such delight (cf. Jerome, Letter 58:7, v.3:81–82; Paulinus of Nola, *Carmina* 27:511–606, p.285–289; Paulinus, Letter 32:10–17, p.286–293; on the texts of Paulinus see Goldschmidt 1940; cf. also 3 Kg 6:20–22). He is indignant that this should be the case while the poor are in need, even saying that it was the property of the poor which paid for this. But Bernard goes further than Jerome. He makes a word play on *ecclesia*, using it first in the sense of the church building whose walls are radiant, and then in the sense of the Church as an institution whose members have been neglected. (Such a word play would have been quite clear to his readers; cf. Honorius Augustodunensis, *Gemma Animae* 1:129, PL 172:586.) He goes on to say that the Church has chosen to dress its unfeeling stone in gold, and dress its needy members in nothing (cf. *Apologia* 12 on some monks' attitudes toward their own souls: "suis vestibus anima nuda deseritur"). To Bernard, it is living stones which make up the house of the Lord (*In Commemoratione S. Michaelis* 1:4, v.5:296; based on 1 Pet 2:5). At Clairvaux, it was not the poor who were naked (*filos nudos; Apologia* 28) but the walls of the church (*nudos parietes;* Arnold of Bonneval, *Vita Prima* 2:6, PL 185:272).

He concludes with the charge that the Church actively catered to the curiosity of the wealthy pilgrim at the expense of the poor, a practice which was not only against all Christian teaching, but which also would have been immediately recognized by Bernard's monastic audience as contrary to ch.53 of the Benedictine Rule, despite the facts of life as described by Hugh of Saint-Victor, "In this world, the poor give to the rich" (*De Sacramentis* 2:13:7, *PL* 176:533). It should be noted that while he does raise the subject of lay curiosity, it is in an essentially different way than his treatment of monastic curiosity.

Bernard's approach to this subject is, actually, somewhat moderate for Bernard: cf. the excoriating Letter 42:4–7, v.7:104–107 for his handling of episcopal excess and the poor, a letter which is in part based on portions of the *Apologia* and which draws an interesting contrast in its complaints between the physical death of the plundered poor and the spiritual death of the arrogant rich.

106:2–8. UT QUID SALTEM SANCTORUM . . . UBI PULVERE MACULANTUR ASSIDUO? After having dealt with the question of excessive art and its justification on a number of different and very high levels, Bernard now takes up a somewhat more pragmatic approach to broaden his appeal. It is his turn to appeal to tradition, the tradition of showing simple respect for sacred images. And under that aegis he takes up the criticism of the absurdity of excessive art as manifested in decorated floors.

He begins by questioning the lack of respect shown to sacred images by subjecting them to the physical abuse inherent in decorated floors. He repeatedly draws attention to the maltreatment of the images, only gradually changing the strain to the absurdity of decorating the floor at all. Undoubtedly, the expense of this form of decoration is an undercurrent here. But aside from the general absurdity of such a situation where art is made only to be destroyed (cf. Jerome, *Vita S. Pauli* 17, *PL* 23:29–30), Bernard also seems to be concerned with the total and conscious ornamentation of the church environment with eye-catching artworks. He has already discussed artworks hanging from the ceiling, on the altar, and standing on the floor: now it seems that even the floor is decorated. And not just decorated: it virtually gushes forth imagery. It is not merely excessive material or merely excessive craftsmanship that Bernard is concerned with, it is also the physical scope of artworks. As much as excess in the two former areas, excess in quantity is a significant element in the sensory saturation of the holy place, and it is on these grounds that Bernard objects to decorated floors. In this first mention of images aside from the *forma sancti*, there is really no question about what images should or should not be included in floor decoration. The point is, rather, whether floors should even be decorated at all,

even with "beautiful colors," because of the excess, absurdity, expense, and lack of respect involved (see Bernard, Letter 42:7, v.7:106 on this non-aesthetic objection to beautiful colors). It is only on these grounds that he raises the subject of monks putting their concern for the material above the respect that should be shown for the saints, and so tries to shame them. See *In Laude Novae Militiae* 9, v.3:222 where Bernard contrasts the "beautiful colors" of the ritualistic Judaic precedent with the preferable virtue of the Christian ideal. There is no question but that Bernard would have vehemently disapproved of the later Cistercian decorated pavements of the twelfth century, and that it was largely the personal authority of Bernard and the atmosphere he was so instrumental in engendering that postponed this form of decoration, if only temporarily.

Cf. Bernard's "quod pedibus conculcatur, scatet pavimentum" with Honorius Augustodunensis, *Gemma Animae* 1:134, *PL* 172:586, "Pavimentum, quod pedibus calcatur."

106:3. IMAGINES. For a definintion of the use of *imago* as it relates to the finer points of artistic controversy in the West, see *Libri Carolini* 1:8, p.25.

106:4. SPUITUR. Complaints about spitting in church were not uncommon in the Middle Ages. Cassian, whom Bernard had read, was so refined as to consider it a form of distraction from prayer; *Institutiones* 2:10, p.25–26. William of Malmesbury, *De Antiquitate* 18, p.66, notes that only a few of the very boldest dared spit on the decorated pavement of the old church of Glastonbury because of the extreme holiness of the exceptional amount of relics contained there. Amalar of Trier observed with a certain amount of disapproval that some priests spit while at the altar; Amalar of Trier, Letter 11, p.264.

106:8. DENIQUE QUID HAEC . . . AD SPIRITUALES VIROS? This important sentence is rhetorically the ultimate question in the previous string of questions. It is distinguished from them by *denique* and logically connected to the following sentence by *nisi forte*. It is, in effect, the moral conclusion to *Apologia* 28, as distinguished from the formal conclusion at the very end of the chapter. Bernard goes on to neutralize as far as possible Psalm 25:8, a justification for lavishly decorating the church, and then gives the formal conclusion to *Apologia* 28. But the latter is a rhetorical device and transitional, and the former is a hypothetical response to the primary, moral conclusion.

The inclusion of *pauperes* refers this sentence to the actual beginning of the "things of greater importance," where Bernard substituted *pauperes* for *pontifices* in Persius's quote. As a conclusion it is interrogatively phrased so

that the answer might be provided by the audience as it reads. What is significant about this moral conclusion are the purely monastic terms in which it is couched: poor men, monks, and spiritual men are all synonyms for each other. If any distinction may be made between them, it is that as poor men they have abandoned their vow of voluntary poverty for luxury and avarice; as monks they have actively violated monastic seclusion in their quest for riches; and as spiritual men they have embraced the material, primarily in respect to temporal concerns, but also in the sense of art as a stimulation to spiritual devotion. As a conclusion to *Apologia* 28, his real concern is revealed not in the abuse of the layperson by the monk as much as the self-abuse of the monk using art and the layperson as the medium.

106:9–11. NISI FORTE ET HIC ADVERSUS . . . LOCUM HABITATIONIS GLORIAE TUAE. Rhetorically appearing as an answer to the previous sentence—the interrogative and moral conclusion of *Apologia* 28—this sentence actually functions as the anticipated hypothetical answer to the effective opening of the discussion of the "things of greater importance," "Tell me, priests . . . [or rather] poor men, what is gold doing in the holy place?" The basis of this hypothetical answer is Psalm 25:8, perhaps the most cited justification for excessive art (as well as for moderate artistic embellishment) of the Middle Ages and a central player in the controversy over monastic art in the first half of the twelfth century. In contrast to the justification of art as similar to almsgiving, Bernard can only neutralize this justification which he could never hope to actually overcome. He does this by giving the appearance of grudging consent, thus offering no point of opposition to the time honored and divinely inspired authority to rally against, yet in reality dismissing it through the same lack of attention and the Parthian shot of the next sentence.

106:11–13. ASSENTIO: PATIAMUR ET HAEC FIERI . . . NON TAMEN SIMPLICIBUS ET DEVOTIS. This sentence consummates the strategy of the previous one, striking a hard blow after the disarming *assentio* (cf. Letter 1:1, v.7:1–2). Feigning agreement, or at least acquiescence, Bernard yields nothing. In fact, his supposed concession both blasts his opposition in the present sentence and is used to turn the argument against them in *Apologia* 29. By pretending to agree on the existence of certain forms of art in the church on the basis of traditional justifications, he sets up a rhetorical device whereby if one is willing to take Psalm 25:8 literally and agree that it justifies the decoration of the house of God or the church building, then one must apply it literally and exclude the embellishment of claustral buildings—the ostensible subject of the next chapter.

As to the result of tolerating such a state of affairs in the church, Ber-

nard declares that it will harm only the shallow and avaricious—presumably the insincere pilgrim and the predatory monk. The simple layperson and devout monk will not be harmed, but then, neither the simple layperson nor the devout monk would be proponents of excessive art. Note that "shallow (*vanis*)" shares the same root with the earlier "wonderful illusions (*mirandarum vanitatum*)," "vanity of vanities (*vanitas vanitatum*)," and "no more vain than insane (*non vanior quam insanior*)" : both the art and the viewer share a mutual emptiness, a theme which runs throughout this chapter.

And so ending on this ambiguous note, the transition to *Apologia* 29 drops any implications of lay application and turns the discussion to the alternate heart of the monastery, the cloister.

106:14–25. CETERUM IN CLAUSTRIS . . . NON PIGET EXPENSARUM? *Apologia* 29: the "things of greater importance." As mentioned, a dichotomy exists in Bernard's chapters on art. The emphasis in *Apologia* 28 is on the question of the relation between art and the layperson in the monastery. *Apologia* 29 is generally concerned with art which was presumably intended for the monk alone. However, this did not represent a formal, theoretical distinction in Bernard's mind which, because of the exclusively monastic purpose of the treatise, might be seen as giving greater weight to the more purely monastic problems. Indeed, everything leads to the conclusion that it was the "things of greater importance" as they appear in *Apologia* 28 that most offended him. Rather, the distinction follows Bernard's train of rhetorical logic on the one hand, and a progression from the external to the internal on the other.

The structure of *Apologia* 29 is quite straightforward. After distinguishing between art within the church and art elsewhere in the monastery, Bernard enumerates a list of fourteen examples of excessive art as they might be found in capital sculpture. These comprise the three general categories of monstrous and hybrid forms, animals, and the worldly pursuits of men. (An almost identical list of distractions from monastic meditation is found in Walter Daniel's account of Bernard's friend, Aelred of Rievaulx, "flies, winged beasts, beasts of the earth, men"; *Vita Ailredi* 11, p.20. On the question of Bernard and any symbolic significance to this type of art, see the section, "The Excesses and Limits of Art as a Distraction to the Monk.") These three general categories take up the greater part of the chapter—that is, the greater part of that space which Bernard chose to devote to monastic art outside the church—providing powerful rhetorical effect. He concludes with two inherently monastic arguments against such artistic forms, noting immediately following in *Apologia* 30 that he is under pressure to bring his treatise to an end.

106:14. CETERUM IN CLAUSTRIS, CORAM LEGENTIBUS FRATRIBUS. The transition from chapter 28 to chapter 29 makes it clear that the subject under discussion is being examined as it applies to churches only and that, while that situation is at best questionable in monastic churches on the basis of traditional justifications, it is by extension completely unacceptable elsewhere (rhetorically speaking, that is: the evidence suggests that Bernard was more concerned with the excesses of *Apologia* 28 than with those of *Apologia* 29). The *ceterum* with which Chapter 29 opens indicates that the subject of excess in churches has been left behind and that this rhetorically unacceptable situation is being taken up. What Bernard chose to exemplify the unacceptable with was excessive art in the cloister and the disturbance of the reading that went on there.

For reasons given in the section "The Capitals of the Cloister of Moissac," I feel that "cloisters" should not be seen as a specific example but as a quintessential example. That is, Bernard is not objecting to excessive cloister sculpture, he is objecting to—primarily—the element of distraction in various art forms which can be said to have no tradition of justification either to honor God, instruct the illiterate, aid the poor, or act as the equivalent of almsgiving. These art forms were ostensibly for internal consumption only. The cloister rather than some other art form was chosen because of the highly charged connotations of the cloister as the spiritual center, if one may use the term, of monasticism. Indeed, it was virtually synonymous with monasticism itself. Far more than an architectural form or even a place of certain prescribed religious practices, to Bernard the cloister was the source of virtue, the place of spiritual struggle, the house of God and gate of heaven (based on Gen 28:17), a place of divine business and "holy avarice," the desert (*eremus*), the claustral paradise. To be sure, in one of his parables he has Christ ask a monk where he acquired certain virtues, to which the monk responded, "In the monastery, in the cloister, in claustral discipline. There is their place of business." Cf. *De Diversis* 42:4, v.6pt.1:258; *I Sententiae* 18, v.6pt.2:13; *III Sententiae* 29, 91, v.6pt.2:84, 140–141; *Parabolae* 7, v.6pt.2:302. Cf. Honorius Augustodunensis, *Gemma Animae* 1:149, *PL* 172:590, "Porro claustrum praesefert paradisum."

But Bernard's concern was never art per se, it was the abuses caused by art. Thus, more important than the location or even the form of the art were the problems raised by it. In *Apologia* 29, this is portrayed as reading. The cloister was the typical place to read. As used by Bernard, reading does not refer to the narrow sense of the word, but to reading as a spiritual exercise: the process of reading, understanding, and meditating (cf. William of Saint-Thierry, *Ad Fratres* 120–124, 171–172, p.238–240, 280). Even so, it is wrong to apply Bernard's criticisms strictly to reading alone, in whatever

form. Like the cloister, he has chosen this merely as the foremost but not unique example to convey the criticism of spiritual distraction through non-spiritual imagery. These excesses suggest that the "thing of greater importance" of art as a distraction to the monk was meant to be seen as limited neither to reading nor to capital sculpture. Cf. the narrower view of Caesarius of Arles, Letter 2, *PL* 67:1133.

106:14. QUID FACIT. The interpretation of *quid facit* by some authors as indicating an absence of an awareness on the part of Bernard of any meaning in the monstrous forms mentioned by him is wrong. Bernard is interrogatively stating that such artistic forms have no place in monastic life, and therefore in the monastery—let alone in an area used for spiritual reading. He is repeating the *quid facit* from Persius in *Apologia* 28, here indicating the second part of the dichotomy of his discussion on art.

106:14–15. ILLA RIDICULA MONSTRUOSITAS . . . AC FORMOSA DEFORMITAS? Bernard chose to begin his list of examples with this antithetically composed and conceived form. When seen in relation to his other examples, it seems that this represents the archetypal monster of his concept of the contradiction of nature inherent in certain artistic forms. Their deformity consists in the disparity of their parts; their beauty in the skill of the artist in reconciling that disparity. But to a lesser degree, the question of antithesis and contradiction applies to all of his examples. To Bernard, the beauty of this world is everywhere found in conjunction with that which is not beautiful; *In Festivitate S. Martini* 5, v.5:402. Cf. Jerome, Letter 125:18, v.7:130.

There is no satisfactory translation for Bernard's use of *deformis/deformitas* here. As used by him, it implies both the opposite of *formositas/formosa*, that is, ugliness, and also the misshapenness of the hybrids which follow. According to Hugh of Saint-Victor, it is an excess of "*deformitas*" that defines a "monster"; *De Sacramentis* 2:17:14, *PL* 176:602–603. He also notes that while some things are admired for their beauty, others are admired because they are absurd or because they are monstrous and ridiculous; *Didascalicon* 7:9, 7:11, *PL* 176:819, 820.

106:16–17. QUID IBI IMMUNDAE SIMIAE . . . QUID MACULOSAE TIGRIDES? This series of descriptions comprise Bernard's category of animals and that part of the category of monstrous and hybrid forms which could be called "traditional hybrids," at least in name.

The common denominator of the epithets of the animals is their description of characteristics for which they were particularly well-known. As such, the implication is that they were chosen as typifying the class of non-mythical animals, rather than some trait such as ferocity or impurity. Therefore, it is their simple appeal to curiosity that Bernard objects to here.

106:17. SEMIHOMINES. Literally, "half-men." This encompasses not only the traditional satyr, but also the welter of semi-human creatures found in medieval art.

106:17. MACULOSAE. *Maculosus* can mean "spotted" or "variegated" as well as "striped." "Striped" has been chosen here because the contemporary reader thinks of tigers as striped. However, the spotted "tigers" of medieval bestiary illustrations show that in fact either term could have been meant by *maculosae.*

106:17–18. QUID MILITES PUGNANTES? QUID VENATORES TUBICINANTES? These two descriptions constitute the only examples of Bernard's category of the worldly pursuits of men. Their characteristics are violence or the threat of violence, but their appeal to Bernard's audience must have been, at least in part, the nostalgic one of former noblemen. As to the reference to hunters blowing horns, hunting at this time was prohibited to clerics (whose standards were far looser than those of monks); for contemporary witnesses, Burchard of Worms, *Decretum* 2:214, *PL* 140:661; and Gratian, *Decretum* dist.34:2, 3 (col.126). A distinction began to be made around the time of the *Apologia* between "noisy" hunting (*venatio clamorosa*, as with horses, hawks, and dogs for sport) and "quiet" hunting (*venatio quieta*, as with the use of snares for sustenance).

106:18–21. VIDEAS SUB UNO CAPITE . . . EQUUM GESTAT POSTERIUS. As the major part of that category to which Bernard devoted most of his attention and therefore presumably felt was most distractive, this series of descriptions of hybrid forms takes on great importance for the formulation of a theory of what, in part, constituted artistic distraction to him.

The predominant feature of these hybrids is their inherent contradiction of nature. The hybridity detailed by Bernard is not a succession of attentive descriptions of artworks as they really existed, but rather a generic exposition on hybridity. The types joined to one another generally constitute the major biological classes and orders as they were understood in the Middle Ages. Reptiles, mammals, fish, and solid- and cloven-hoofed animals (solid-ungulates and artiodactyl ungulates) are joined together. The basic physiological law of one head, one body is defied. The attraction caused by this contradiction is compounded by the beauty created by the artist in resolving the contradiction. The resultant contradiction is all the more distractive for the paradox.

There are a number of parallels with this text which are of some interest but which, however, seem to bear no direct relation; see Origen, *In Exodum Homiliae* 8:3, *PG* 12:353 which was translated early on into Latin by Rufinus; Horace, *Ars Poetica* 1–5; and *Libri Carolini* 3:23, p.152, which is surprisingly close to the language of *Apologia* 29. On a possible indirect

relation between Bernard and Horace, see Gage 1973:359–360. In strong contrast to this violation of the spirituality of the cloister, see *De Diversis* 42:4, v.6pt.1:258 where, in the identical rapid tempo used here, Bernard describes the ideal cloister—complete with the antithetical pairing found in this passage.

106:21–22. TAM MULTA DENIQUE . . . APPARET UBIQUE VARIETAS. This is a significant indicator of what constituted a distraction to Bernard. Subject matter alone does not give a complete picture of his objections. He also found excessive quantity and variety, traditional monastic offenses, to be contributing factors. The variety of the capitals of Saint-Trond was highly praised shortly after Bernard's time; Mortet 1929:12.

Diversarum formarum has been translated as "contradictory forms" both on the basis of the primary meaning of the word and because any meaning such as "different" or "diverse" is ruled out by *varietas*.

106:22–24. UT MAGIS LEGERE LIBEAT . . . QUAM IN LEGE DEI MEDITANDO. Cf. Statute 20, p.17, for Cistercian legislation—in all likelihood framed by Bernard—forbidding virtually all sculpture and painting on the grounds of their distraction from meditation (*meditatio*). While the wealth of others lies in such objects as jewelled vessels and so on, the wealth of the ascetic is to meditate on the law of God; Jerome, Letter 30:13, v.2:34–35.

The play on reading in the marble rather than in books is an ironic reference to Gregory the Great (*Registrum* 9:209, 11:10, p.768, 874; bk.9:105 and 11:13 in *PL* 77) where the illiterate are described as being unable to read in books, and so only then are forced to read in the walls.

106:24–25. PROH DEO . . . NON PIGET EXPENSARUM? In this concluding sentence to *Apologia* 29 (it is not a conclusion to the entire discussion of art), Bernard summarizes his opposition to distractive art: the presence of such art in a place of spiritual men is an absurdity, as is the cost for those who claim to be "poor men."

106:26. LARGA MATERIA. Unfortunately, Bernard is somewhat ambiguous as to what "this broad subject" is. Is it the subject that he has been dealing with for fourteen chapters, namely monastic excess in general, or is it the subject at hand, that he described as the most important of all, the "things of greater importance"? Since Bernard had taken up so many distinct infractions, it seems that the use of the singular here (*larga materia*) would suggest art. If so, Oger's impatience at such a crucial point supports my theory that the "things of greater importance" as they finally emerged are wholly the product of Bernard's conception of the current monastic situation. Unfortunately, none of Bernard's later writings give a decent idea as to what these "other things deserving to be added" might be.

107:1. FRATER OGERE. Oger's name was pointedly worked into this treatise by Bernard. The reason for this, I believe, was that Oger was the original impetus to this work, not William of Saint-Thierry. It is also used here to indicate support from the new ascetic, and especially collegial, orders for the tenets put forth in the *Apologia*. For my reasons for this, see the section "The New Ascetic Orders" and Appendix 1, "The Origin of the *Apologia*."

107:3. OPUSCULO. This is the same word used by Bernard in Letter 88:3, v.7:234 to describe the *Apologia*.

107:19–20. SCIO QUIPPE NONNULLOS . . . PERVOLASSE, PULSASSE, INTRASSE. Bernard is making a point of his adherance to the Benedictine Rule; cf. Benedict of Nursia, *Regula* 58.

108:14. VOBIS ET ALIIS AMICIS MEIS. Bernard refers here to an undefined group of non-denominational, activist, establishment reformers: they come from every wing of the Church and can in no way be associated with any particular group, such as the Cistercians; cf. Bernard, Letters 84[bis], 88:3, 85:4, v.7:219, 234, 223.

108:15. HOC NON EST DETRACTIO, SED ATTRACTIO. The implication is that the *Apologia* was not meant to be a divisive attack on one segment of monasticism, but rather a pan-monastic treatise on the state of monasticism as a whole.

BIBLIOGRAPHY

Bernardine Bibliographies

Leopold Janauschek, *Bibliographia Bernardina* (Vienna 1891; reprint Hildesheim 1959) [editions and bibliography up to 1890].

Jean de la Croix Bouton, *Bibliographie bernardine* (Paris 1958) [editions and bibliography from 1891 to 1957].

Eugène Manning, "Bibliographie bernardine, 1957–1970," *Documentation cistercienne* 6 (1972) [editions and bibliography from 1957 to 1970].

Unpublished Manuscripts

Dijon 12–15: Bible of Stephen Harding, Dijon, Bibliothèque publique, ms 12–15.

Dijon 30: Psalter of Robert of Molesme, Dijon, Bibliothèque publique, ms 30.

Dijon 135: Letters of Jerome, Dijon, Bibliothèque publique, ms 135.

Dijon 141: Augustine, *De Trinitate*, Dijon, Bibliothèque publique, ms 141.

Dijon 168–170, 173: Gregory the Great, *Moralia in Job*, Dijon, Bibliothèque publique, ms 168–170, 173.

Dijon 641–642: Legendary of Cîteaux, Dijon, Bibliothèque publique, ms 641–642.

Troyes 27 (1–5): Great Bible of Clairvaux, Troyes, Bibliothèque municipale, ms 27.

Paris 8 (1 and 2): Second Bible of Saint-Martial, Paris, Bibliothèque nationale, ms lat. 8:pts.1 and 2.

Published Primary Sources

References in the text to primary sources first cite the traditional numbering system when one occurs, and then the page of the modern edition used. For example, Bernard, *Super Cantica* 23:16, v.1:149 refers to sermon 23, chapter 16 of Bernard of Clairvaux's *Sermones Super Cantica*, with the passage in question being found in volume 1, on page 149 of *Sancti Bernardi Opera* edited by Jean Leclercq. When dual systems of traditional numeration exist, reference is always made to the more precise of the two.

All Biblical quotations are from the Vulgate, *Biblia Sacra: Iuxta Vulgatam Versionem*, ed. Robert Weber, 2 v. (Stuttgart 1983).

AA SS: *Acta Sanctorum* (Antwerp 1643f.).

Abelard, *Historia*: *Historia Calamitatum*, ed. J. Monfrin (Paris 1959).

Abelard, Letter: "The Personal Letters Between Abelard and Heloise," ed. J. T. Muckle, *Mediaeval Studies* 15 (1953) 47–94.

Abelard, *Regula*: *Institutio seu Regula Sanctimonialium*, ed. T. P. McLaughlin, *Mediaeval Studies* 18 (1956) 241–292.

Adalbero of Laon, *Carmen*: *Carmen ad Robertum Regem Francorum*, PL 141: 771–786.

Aelred of Rievaulx, *De Institutione*: *De Institutione Inclusarum*, ed. C. H. Talbot, *Opera Omnia*, Corpus Christianorum: Continuatio Mediaevalis 1 (Turnhout 1971) 637–682.

Aelred of Rievaulx, *De Speculo Caritatis*: *De Speculo Caritatis*, ed. C. H. Talbot, *Aelredi Rievallensis Opera Omnia*, Corpus Christianorum: Continuatio Mediaevalis 1 (Turnhout 1971) 3–161.

Aelred of Rievaulx, *De Spiritali Amicitia*: *De Spiritali Amicitia*, ed. C. H. Talbot, *Aelredi Rievallensis Opera Omnia*, Corpus Christianorum: Continuatio Mediaevalis 1 (Turnhout 1971) 287–350.

Aelred of Rievaulx, *Sermo*: *Sermones de Tempore et de Sanctis*, PL 195:209–360.

Aelred of Rievaulx, *Sermones*: *Sermones Inediti B. Aelredi Abbatis Rievallensis*, ed. C. H. Talbot (Rome 1952).

Agobard of Lyons, *De Picturis*: *De Picturis et Imaginibus*, ed. L. Van Acker, Corpus Christianorum: Continuatio Mediaevalis 52 (Turnhout 1981) 149–181 [previously ascribed to Claudius of Turin].

Alexander Neckam, *De Naturis Rerum*: *De Naturis Rerum*, ed. Mortet 1929: 179–180.

Amalar of Trier, *Letter*: *Amalarii Epistolae*, MGH, Epist, v.5:240–274.

Ambrose, *De Officiis*: *De Officiis Libri Tres*, ed. I. G. Krabinger, Sancti Ambrosii Episcopi Mediolanensis Opera 13 (Milan 1977).

Andrew of Fleury, *Vita Gauzlini*: *Vie de Gauzlin, abbé de Fleury: Vita Gauzlini Abbatis Floriacensis Monasterii*, ed. and trans. Robert Bautier, Sources d'histoire médiévale 2 (Paris 1969).

Annales Rodenses: *Annales Rodenses*, ed. Simon Ernst, *Histoire du Limbourg*, v.7 (Liège 1837–1852).

Apophthegmata: *Apophthegmata Patrum*, PG 65:71–440.

Ardo, *Vita Benedicti Anianensis*: *Vita Benedicti Abbatis Anianensis et Indensis Auctore Ardone*, MGH, SS, v.15:pt.1:198–220.

Aristotle, *On Virtues and Vices*: *On Virtues and Vices*, trans. H. Rackham, *The Athenian Constitution, The Eudemian Ethics, On Virtues and Vices* (Cambridge 1935) 488–503.

Aristotle, *Politics*: *The Politics of Aristotle*, trans. Ernest Barker (Oxford 1948).

Arnold of Bonneval, *Vita Prima*: see *Vita Prima*.

Athanasius, *Vita Antonii*: *Vita di Antonio*, ed. G.J. Bartelink (Milan 1974).

Augustine, *Confessiones*: *Confessionum Libri XIII*, ed. Lucas Verheijen, Corpus Christianorum: Series Latina 27 (Turnhout 1981).

Augustine, *De Diversis Quaestionibus*: *De Diversis Quaestionibus Octoginta Tribus*, ed. Almut Mutzenbecher, Corpus Christianorum: Series Latina 44A (Turnhout 1975).

Augustine, *De Doctrina Christiana*: *De Doctrina Christiana*, in *Aurelii Augustini Opera* part 4:1, ed. J. Martin, Corpus Christianorum: Series Latina 32 (Turnhout 1962) 1–167.

Augustine, *De Moribus*: *De Moribus Ecclesiae Catholicae et de Moribus Manichaeorum*, PL 32:1309–1378.

Augustine, *De Ordine*: *De Ordine*, in *Aurelii Augustini Opera* part 2:2, ed. William Green, Corpus Christianorum: Series Latina 29 (Turnhout 1970) 87–137.

Augustine, *De Trinitate*: *De Trinitate*, ed. W.J. Mountain, Corpus Christianorum: Series Latina 50 (Turnhout 1968).

Augustine, *De Vera Religione*: *De Vera Religione*, ed. Klaus-Detlef Daur, Corpus Christianorum: Series Latina 32 (Turnhout 1962) 187–260.

Augustine, *Enarrationes in Psalmos*: *Enarrationes in Psalmos*, ed. E. Dekkers and J. Fraipont, 3 v., Corpus Christianorum: Series Latina 38–40 (Turnhout 1956).

Augustine, Letter: *S. Aureli Augustini Hipponiensis Episcopi Epistulae*, ed. A. Goldbacher, Corpus Scriptorum Ecclesiasticorum Latinorum 34, 44, 57, 58 (Vienna 1895–1923).

Augustine, *In Joannis Evangelium*: *In Joannis Evangelium*, ed. R. Willems, Corpus Christianorum: Series Latina 36 (Turnhout 1954).

Augustine, *Soliloquia*: *Soliloquia*, PL 32:869–904.

Basil the Great, *De Spiritu Sancto*: *De Spiritu Sancto*, PG 32:67–218.

Basil the Great, *Regulae Fusius*: *Regulae Fusius Tractatae*, PG 31:889–1052.

Basil the Great, *Regulae Brevius*: *Regulae Brevius Tractatae*, PG 31:1051–1306.

Bede, *Vita Abbatum*: *Vita Beatorum Abbatum Benedicti, Ceolfridi, Eosterwini, Sigfridi atque Hwaetberhti*, ed. Charles Plummer, *Venerabilis Baedae Opera Historica* (Oxford 1896, reprint 1975) 364–387.

Benedict of Nursia, *Regula*: *S. Benedicti Regula Monachorum*, ed. Benno Linderbauer (Metten 1922).

Bernard of Angers, *Liber Miraculorum*: *Liber Miraculorum Sancte Fidis*, ed. A. Bouillet, Collection de textes pour servir à l'étude et à l'enseignement de l'histoire 21 (Paris 1897).

Bernard [of Clairvaux]: *Sancti Bernardi Opera*, ed. Jean Leclercq and H.M. Rochais, 8 v. (Rome 1957–1977).

Bernard the Monk, *Itinerarium*: *Bernardi Itinerarium*, PL 121:569–574.

Bestiary: *The Bestiary: A Book of Beasts*, trans. T.H. White (New York 1960).

Bruel 1876: A. Bruel and A. Bernard, *Recueil des chartes de l'abbaye de Cluny*, Collection de documents inédits sur l'histoire de France 18, 6 v. (Paris 1876–1903).

Burchard of Worms, *Decretum*: *Decretorum Liber*, PL 140:537-1058.

Caesarius of Arles, Letter: *Epistolae*, PL 67:1125–1140.

Caesarius of Arles, *Regula ad Virgines*: *Regula ad Virgines*, PL 67:1103–1121.

Caesarius of Heisterbach, *Dialogus Miraculorum*: *Dialogus Miraculorum*, ed. Joseph Strange, 2 v. (Cologne 1851).

Candidus, *Vita Eigilis*: *Candidi Vita Eigilis Abbatis Fuldensis*, MGH, SS, v.15:pt.1:221–233.

Canivez 1933: *Statuta Capitulorum Generalium Ordinis Cisterciensis*, ed. Joseph-Marie Canivez, v.1 (Louvain 1933).

cap: the *capitula* from the *Exordium Cistercii*, *Summa Cartae Caritatis et Capitula*, ed. Jean de la Croix Bouton and Jean Baptiste Van Damme, *Les plus anciens textes de Cîteaux* (Achel 1974) 121–125.

Capitula de Canonicis: *Capitula de Canonicis*, ed. William Dugdale, *Monasticon*

Anglicanum, new ed. by John Caley, v.6 (London 1846) *xxvii-*xxxvi, between p.945–946.

Cartulaires de Molesme: *Cartulaires de l'abbaye de Molesme*, ed. Jacques Laurent, 2 v. (Paris 1907–1911).

Carta Caritatis Prior: *Carta Caritatis Prior*, ed. Jean de la Croix Bouton and Jean Baptiste Van Damme, *Les plus anciens textes de Cîteaux* (Achel 1974) 87–102.

Cassian, *Conlationes*: *Iohannis Cassiani Conlationes XXIIII*, ed. Michael Petschenig, Corpus Scriptorum Ecclesiasticorum Latinorum 13:2 (Vienna 1886).

Cassian, *Institutiones*: *Iohannis Cassiani de Institutis Coenobiorum Libri XII*, ed. Michael Petschenig, Corpus Scriptorum Ecclesiasticorum Latinorum 17 (Vienna 1888) 1–231.

Cassiodorus, *Expositio Psalmorum*: *Expositio Psalmorum*, ed. M. Adriaen, Corpus Christianorum: Series Latina 97 (Turnhout 1958).

Censura Doctorum: *Censura Doctorum Parisiensium*, PL 178:109–112.

Charlemagne, *Capitularium*: *Karoli Magni Capitularia*, MGH, Leg 2, Capitularia, v.1:44–186.

Chronicon S. Benigni: *Chronicon S. Benigni Divionensis*, ed. L. Chomton, *Histoire de l'église Saint-Bénigne de Dijon* (Dijon 1900).

Chrysostom, *Homiliae in Matthaeum*: *Homiliae XC in Matthaeum*, PG 57, 58:471–794.

Clement of Alexandria, *Paedagogus*: *Le Pédagogue*, trans. Claude Mondésert, Sources chrétiennes 70, 108, 158 (Paris 1960–1970).

Codex Calixtinus: *Liber Sancti Jacobi: Codex Calixtinus*, ed. Walter Muir Whitehill, 3 v. (Santiago de Compostela 1944).

Codex Sahidique S21: Codex Sahidique S21, trans. L.Th. Lefort, *Les vies coptes de saint Pachôme* (Louvain 1943).

Conrad of Eberbach, *Exordium Magnum*: *Exordium Magnum Cisterciense*, ed. Bruno Griesser (Rome 1961).

Constitutiones Hirsaugienses: *Constitutiones Hirsaugienses*, ed. M. Hergott, *Vetus Disciplina Monistica* (Paris 1726).

Concilium Parisiense: *Concilium Parisiense A. 825*: MGH, Leg 3, Concilia, v.2:pt.2:473–551.

Epistolae Variorum: *Epistolae Variorum Carolo Magno Regnante Scriptae*, MGH, Epist, v.4:494–567.

Erigena, *De Divisione Naturae*: *De Divisione Naturae*, PL 122:441-1022.

Ermenricus, *Ad Grimaldum*: *Ermenrici Elwangensis Epistola ad Grimaldum Abbatem*, MGH, Epist, v.5:534–580.

Exordium Cistercii: *Exordium Cistercii*, ed. Jean de la Croix Bouton and Jean Baptiste Van Damme, *Les plus anciens textes de Cîteaux* (Achel 1974) 110–116.

Exordium Parvum: *Exordium Parvum*, ed. Jean de la Croix Bouton and Jean Baptiste Van Damme, *Les plus anciens textes de Cîteaux* (Achel 1974) 51–86.

The First Greek Life of Pachomius: *The First Greek Life of Pachomius*, trans. Armand Veilleux, *Pachomian Koinonia*, v.1, Cistercian Studies Series 45 (Kalamazoo, MI 1980) 297–423.

Gaufridus Grossus, *Vita B. Bernardi Tironiensis*: *Vita B. Bernardi Tironiensis*, PL 172:1367–1446.

Geoffrey of Clairvaux, *Vita Prima*: see *Vita Prima*.

Gilbert Crispin, *Disputatio*: *Disputatio Iudei et Christiani*, ed. A.S. Abulafia, *The Works of Gilbert Crispin, Abbot of Westminster*, Auctores Britannici Medii Aevi 8, (London 1986).

Gilbert of Hoyland, *Tractatus*: *Tractatus Ascetici*, PL 184:251–290.

Gilo, *Vita S. Hugonis*: *Vita Sancti Hugonis*, ed. A. L'Huillier, *Vie de saint Hugues* (Solesmes 1888) 574–618.

Giraldus Cambrensis, *Itinerarium Kambriae*: *Itinerarium Kambriae*, ed. James Dimock, *Giraldi Cambrensis Opera* v.6, Rolls Series 21 (London 1868) 1–152.

Glossa Ordinaria: *Glossa Ordinaria*, PL 113–114.

Gratian, *Decretum*: *Concordantia Discordantium Canonum*, ed. A. Friedberg, *Corpus Iuris Canonici*, v.1 (Leipzig 1879).

Gregory of Tours, *Historia Francorum*: *Historia Francorum*, MGH, SS Mer, v.1.

Gregory the Great, *Dialogorum Libri*: *Dialogorum Gregorii Papae Libri Quatuor*, ed. Adalbert de Vogüé, *Dialogues* (Paris 1979).

Gregory the Great, *Moralia*: *Moralia in Iob*, ed. M. Adriaen, Corpus Christianorum: Series Latina 143–143B (Turnhout 1979–1985).

Gregory the Great, *Registrum*: *Registrum Epistularum Libri*, ed. Dag Norberg, Corpus Christianorum: Series Latina 140–140A (Turnhout 1982).

Guibert de Nogent, *De Vita Sua*: *De Vita Sua, sive Monodiae*, ed. and trans. Edmond-René Labande, *Autobiographie*, Les classiques de l'histoire de France au Moyen Age 34 (Paris 1984).

Guibert de Nogent, *Gesta Dei per Francos*: *Gesta Dei per Francos*, PL 156:679–834.

Guigues de Châtel, *Consuetudines Carthusienses*: *Consuetudines Carthusienses*, PL 153:631–760.

Hadrian I, Letter: *Epistola Adriani Papae ad Beatum Carolum Regem de Imaginibus*, PL 98:1247–1292.

Hélinand de Froidmont, *Sermo*: *Sermones*, PL 212:481–720.

Hermannus of Saint-Martin, *De Restauracione*: *De Restauracione Abbatiae S. Martini Toracensis*, PL 180:39–130.

Hilary of Arles, *Vita S. Honorati*: *Sermo de Vita S. Honorati*, PL 50:1249–1272.

Hildebert de Lavardin, *Par Tibi, Roma*, ed. Percy Schramm, *Kaiser, Rom und Renovatio* (Darmstadt 1984) 300–304.

Hildebert de Lavardin, *Vita S. Hugonis*: *Vita Sanctissimi Patris Hugonis*, ed. Martin Marrier and André Duchesne, *Bibliotheca Cluniacensis* (Paris 1614) 413–438 [also *PL* 159:857–892].

Historia Monachorum: *Historia Monachorum in Aegypto*, PL 21:387–462.

Historia SS. Chrysanti et Dariae: *Historia Translationis Reliquiarum SS. Martyrum Chrysanti et Dariae*, PL 121:673–682.

Historica Narratio: *Historica Narratio*, AA SS, March, v.3:138–142.

Honorius Augustodunensis, *Elucidarium*: *L'Elucidarium et les lucidaires*, ed. Yves Lefèvre (Paris 1954).

Honorius Augustodunensis, *Gemma Animae*: *Gemma Animae*, PL 172:541–738.

Honorius Augustodunensis, *Sermo Generalis*: *Sermo Generalis*, PL 172:861–870.

Hugh of Flavigny, *Chronicon*: *Chronicon Hugonis*, MGH, SS, v.8:280–503.

Hugh of Saint-Victor, *De Arca Noe Morali*: *De Arca Noe Morali*, PL 176:617–680.

Hugh of Saint-Victor, *De Arca Noe Mystica*: *De Arca Noe Mystica*, PL 176:681–704.

Hugh of Saint-Victor, *De Arrha Animae*: *Soliloquium de Arrha Animae*, PL 176:951–970.

Hugh of Saint-Victor, *De Sacramentis*: *De Sacramentis*, PL 176:183–618.

Hugh of Saint-Victor, *Didascalicon*: *Didascalicon*, PL 176:739–838.

Hugh of Saint-Victor, *In Hierarchiam*: *In Hierarchiam Coelestem*, PL 175: 923-1154.

Hugue de Fouilloi, *De Claustro Animae*: *De Claustro Animae*, PL 176:1017–1184.

Idung of Prüfening, *Dialogus*: *Dialogus Duorum Monachorum*, ed. R. Huygens, *Studi Medievali* 13:1 (1972) 375–470.

Institutiones ad Moniales: *Institutiones ad Moniales*, ed. William Dugdale, *Monasticon Anglicanum*, new ed. by John Caley, v.6 (London 1846) *xliv-*lii, between p.946–947.

Ivo of Chartres, *Decretum*: *Decretum*, PL 161:47–1022.

Jerome, *Adversus Jovinianum*: *Adversus Jovinianum Libri Duo*, PL 23:211–352.

Jerome, *Contra Vigilantium*: *Liber Contra Vigilantium*, PL 23:353–368.

Jerome, *De Nativitate*: *Homilia de Nativitate Domini*, ed. G. Morin, *S. Hieronymi Presbyteri Opera*, Corpus Christianorum: Series Latina 78 (Turnhout 1958) 524–529.

Jerome, Letter: *Saint Jérôme: Lettres*, ed. Jérôme Labourt, Collection des Universités de France, 8 v. (Paris 1949–1963).

Jerome, *In Johannem*: *Homilia in Johannem Evangelistam (1:1–14)*, ed. G. Morin, *S. Hieronymi Presbyteri Opera*, Corpus Christianorum: Series Latina 78 (Turnhout 1958) 517–523.

Jerome, *Vita S. Hilarionis*: *Vita S. Hilarionis*, PL 23:29–54.

Jerome, *Vita S. Pauli*: *Vita S. Pauli Primi Eremitae*, PL 23:17–30.

John of Damascus, *De Imaginibus*: *Pro Sacris Imaginibus Orationes Tres*, PG 94:1231–1420.

John of Fécamp, *Tuae Quidem*: *Tuae Quidem*, ed. Jean Leclercq and Jean-Paul Bonnes, *Un maître de la vie spirituelle au XIe siècle: Jean de Fécamp* (Paris 1946) 198–204.

John of Salerno, *Vita S. Odonis*: *Vita S. Odonis*, PL 133:43–86.

John of Salisbury, *Historia Pontificalis*: *The Historia Pontificalis of John of Salisbury*, ed. and trans. Marjorie Chibnall (Oxford 1986).

John the Hermit, *Vita Quarta*: *Vita Quarta Sancti Bernardi Abbatis*, PL 185:531–550.

Jotsaldus, *Vita S. Odilonis*: *De Vita et Virtutibus Sancti Odilonis Abbatis*, PL 142:895–940.

Lecoy 1867: see Suger (Lecoy).

Lehmann-Brockhaus 1955: Otto Lehmann-Brockhaus, *Lateinische Schriftquellen zur Kunst in England, Wales und Schottland vom Jahre 901 bis zum Jahre 1307*, 5 v. (Munich 1955–1960).

Lehmann-Brockhaus 1971: Otto Lehmann-Brockhaus, *Schriftquellen zur Kunstgeschichte des 11. und 12. Jahrhunderts für Deutschland, Lothringen und Italien*, 2 v. (Berlin 1938; reprint New York 1971).

Leo of Ostia, *Chronica*: *Chronica Monasterii Casinensis*, MGH, SS, v.7:551–844.

Libellus de Diversis Ordinibus: *Libellus de Diversis Ordinibus et Professionibus*

Qui Sunt in Aecclesia, ed. and trans. Giles Constable and B. Smith (Oxford 1972).

Liber Pontificalis: *Liber Pontificalis*, ed. Louis Duchesne, *Le Liber Pontificalis*, rev. ed. (Paris 1955–1957).

Liber S. Gileberti: *Liber Sancti Gileberti*, ed. and trans. Raymonde Foreville and Gillian Keir, *The Book of St Gilbert* (Oxford 1987).

Libri Carolini: *Libri Carolini* or *Capitulare de Imaginibus*, MGH, Leg 3, Concilia 2, v.2:pt.2, suppl., p.1–228.

Lupus of Ferrières, Letter: *Servati Lupi Epistulae*, ed. Peter K. Marshall (Leipzig 1984).

Matthew of Albano, *Epistola*: *Epistola Matthaei Albanensis Episcopi*, ed. Stanislaus Ceglar, "Guillaume de Saint-Thierry et son rôle directeur aux premiers chapitres des abbés Bénédictins: Reims 1131 et Soissons 1132," *Saint-Thierry: une abbaye du VIe au XXe siècle*, Actes du Colloque international d'histoire monastique (Saint-Thierry 1979) 320–333.

Les miracles de Rocamadour: *Les miracles de Notre-Dame de Roc-Amadour au XIIe siècle*, ed. Edmond Albe (Paris 1907).

Miracula S. Benedicti: *Les miracles de saint Benoît*, ed. Eugène de Certain, Société de l'histoire de France (Paris 1858).

Miracula S. Hugonis: *Miraculorum Quorundam Sancti Hugonis Relatio*, ed. M. Marrier and A. Duchesne, *Bibliotheca Cluniacensis* (Paris 1614) 447–462.

MGH: *Monumenta Germaniae Historica* (Hanover 1826f.).

Mortet 1911: Victor Mortet, *Recueil de textes relatifs à l'histoire de l'architecture: XIe–XIIe siècles* (Paris 1911).

Mortet 1929: Victor Mortet and Paul Deschamps, *Recueil de textes relatifs à l'histoire de l'architecture: XIIe-XIIIe siècles* (Paris 1929).

Nicholas of Clairvaux, Letter: *Epistolae*, PL 196:1593–1654.

Nilus of Sinai, Letter: *Epistolae*, PG 79:81–582.

Notker the Stammerer, *Gesta Karoli*: *Monachi Sangallensis de Gestis Karoli Imperatoris*, MGH, SS, v.2:726–763.

Odo of Cluny, *Collationes*: *Collationum Libri Tres*, PL 133:517–638.

Odo of Deuil, *De Profectione*: *De Profectione Ludovici VII in Orientem*, ed. and trans. Virginia Gingerick Berry, Records of Civilization, Sources and Studies 42 (New York 1948).

Ordéric Vitalis, *The Ecclesiastical History*: *The Ecclesiastical History of Orderic Vitalis*, ed. and trans. Marjorie Chibnall, 6 v. (Oxford 1969–1978).

Origen, *Contra Celsum*: *Contra Celsum Libri Octo*, PG 11:637–1710.

Origen, *In Exodum Homilia*: *In Exodum Homilia*, PG 12:297–396.

Pachomius, *Instituta*: *Praecepta et Instituta*, ed. Amand Boon, *Pachomiana Latina* (Louvain 1932).

Palladius, *Dialogus*: *Dialogus Historicus*, PG 47:5–82.

Palladius, *Historia Lausiaca*: *Historia Lausiaca*, PL 73:1085–1234.

Paralipomena: *Paralipomena*, trans. Armand Veilleux, *Pachomian Koinonia*, v.2, Cistercian Studies Series 46 (Kalamazoo, MI 1981) 19–70.

Paulinus, *Vita S. Ambrosii*: *Vita Sancti Ambrosii*, PL 14:27–46.

Paulinus of Nola, *Carmina*: *Sancti Pontii Meropii Paulini Nolani Carmina*, ed. W. Hartel, Corpus Scriptorum Ecclesiasticorum Latinorum 30 (Vienna 1894).

Paulinus of Nola, Letter: *Sancti Pontii Meropii Paulini Nolani Epistulae,* ed. W. Hartel, Corpus Scriptorum Ecclesiasticorum Latinorum 29 (Vienna 1894).

Payen Bolotin, *De Falsis Heremitis: De Falsis Heremitis Qui Vagando Discurrunt,* ed. Jean Leclercq, "Le poème de Payen Bolotin contre les faux ermites," *Revue Bénédictine* 68 (1958) 77–84.

Peter Damian, *De Institutis: De Institutis Ordinis Eremitarum,* PL 145:335–364.

Peter Damian, Letter: *Epistolae,* PL 144:205–498.

Peter Damian, *De Perfecta: De Perfecta Monachi Informatione,* PL 145:721–732.

Peter Damian, *Vita S. Odilonis: Vita Sancti Odilonis,* PL 144:925–944.

Peter the Cantor, *Verbum Abbreviatum: Verbum Abbreviatum,* PL 205:23–554.

Peter the Venerable, *De Miraculis: De Miraculis Libri Duo,* ed. M. Marrier and A. Duchesne, *Bibliotheca Cluniacensis* (Paris 1614) 1247–1338; also *PL* 189:1023f.

Peter the Venerable, Letter: *The Letters of Peter the Venerable,* ed. Giles Constable, 2 v. (Cambridge, MA 1967).

Peter the Venerable, Statute: *Statuta Petri Venerabilis,* ed. Giles Constable, *Consuetudines Benedictinae Variae,* Corpus Consuetudinum Monasticarum 6 (Siegburg 1975) 19–106.

PG: Patrologia Graeco-Latina, ed. J.P. Migne, 162 v. (Paris 1857–1866).

Pictor in Carmine: Pictor in Carmine, ed. M.R. James, "Pictor in Carmine," *Archaeologia* 94 (1951) 142–143.

PL: Patrologia Latina, ed. J.P. Migne, 221 v. (Paris 1844–1864).

Plato, *Republic: The Republic,* ed. and trans. Paul Shorey, 2v. (Cambridge, MA 1935).

Pontificale: Le pontifical romano-germanique du dixième siècle, ed. Cyrille Vogel and Reinhard Elze, Studi e Testi 226–227, 269, 3 v. (Vatican City 1963–1972).

Possidius, *Vita S. Augustini: Vita Sancti Augustini,* PL 32:33–66.

Prudentius, *Peristephanon: Peristephanon Liber,* ed. J. Bergman, *Aurelii Prudentii Clementis Carmina,* Corpus Scriptorum Ecclesiasticorum Latinorum 61 (Vienna 1926) 289–431.

Pseudo-Dionysius, *De Caelesti Hierarchia: De Caelesti Hierarchia,* PL 122: 1037–1070.

Pseudo-Dionysius, *De Divinis Nominibus: De Divinis Nominibus,* PL 122: 1111–1172.

Pseudo-Fulbert, Letter: ed. F. Behrends, "Two Spurious Letters in the Fulbert Collection," *Revue Bénédictine* 80 (1970) 253–275.

Regino of Prüm, *De Synodalibus: De Synodalibus Causis et Disciplinis Ecclesiasticis,* ed. F.G. Wasserschleben (Leipzig 1840).

Responsio: Responsio Abbatum (Suessione, 1132), ed. Stanislaus Ceglar, "Guillaume de Saint-Thierry et son rôle directeur aux premiers chapitres des abbés Bénédictins: Reims 1131 et Soissons 1132," *Saint-Thierry: une abbaye du VIe au XXe siècle,* Actes du Colloque international d'histoire monastique (Saint-Thierry 1979) 334–350.

Riposte: Riposte, ed. André Wilmart, "Une riposte de l'ancien monachisme au manifeste de saint Bernard," *Revue Bénédictine* 46 (1934) 309–344.

Robert de Torigny, *De Immutatione: De Immutatione Ordinis Monachorum,* PL 202:1309–1320.

Rodulfus Glaber, *Historia: Les cinq livres de ses histoires,* ed. Maurice Prou, Collection de textes pour servir à l'étude à l'enseignement de l'histoire 1 (Paris 1886).

Rupert of Deutz, *De Officiis: Liber de Divinis Officiis,* ed. Rabanus Haacke, Corpus Christianorum: Continuatio Mediaevalis 7 (Turnhout 1967).

Rupert of Deutz, *De Trinitate: In Exodum: De Sancta Trinitate et Operibus Eius: In Exodum Commentariorum,* ed. Hrabanus Haacke, Corpus Christianorum: Continuatio Mediaevalis 22 (Turnhout 1972) 581–802.

von Schlosser 1896: Julius von Schlosser, *Quellenbuch zur Kunstgeschichte des Mittelalters* (Vienna 1896).

von Schlosser 1974: Julius von Schlosser, *Schriftquellen zur Geschichte der Karolingischen Kunst* (Vienna 1892; reprint Hildesheim 1974).

Scripta de Fratribus: Scripta de Fratribus, ed. William Dugdale, *Monasticon Anglicanum,* new ed. by John Caley, v.6 (London 1846) *xxxvi–*xliv, between p.945–946.

Serlo of Bayeux, *Invectio: Invectio in Militem Qui Causa Paupertatis . . . Adeptus Est,* ed. A. Boutemy, "Deux poémes inconnus de Serlon de Bayeux et une copie nouvelle de son poéme contre les moines de Caen," *Le Moyen Age* 48 (1938) 255–257.

Smaragdus, *Via Regia: Via Regia,* PL 102:931–970.

Sozomen, *Historia Ecclesiastica: Historia Ecclesiastica,* PG 67:843-1630.

Statute: the *Statuta Capitulorum Generalium Ordinis Cisterciensis* traditionally but wrongly ascribed to the year 1134, in *Statuta Capitulorum Generalium Ordinis Cisterciensis,* ed. Joseph-Marie Canivez, v.1 (Louvain 1933) 12–32.

Statuts de Prémontré XIIe siècle: Les Statuts de Prémontré: réformés sur les ordres de Grégoire IX et d'Innocent IV au XIIIe siècle, ed. Pl.F. Lefèvre, Bibliothèque de la revue d'histoire ecclèsiastique 23 (Louvain 1946).

Statuts de Prémontré XIIIe siècle: Les Statuts de Prémontré: au milieu du XIIe siècle, ed. Pl.F. Lefèvre, Bibliotheca Analectorum Praemonstratensium 12 (Averbode 1978).

Stephen of Muret, *Regula: Regula Sancti Stephani Grandmontensis,* PL 204: 1135–1162.

Suetonius, *De Vita Caesarum: De Vita Caesarum Libri VIII,* ed. Maximilian Ihm, *C. Suetoni Tranquilli Opera,* v.1 (Stuttgart 1908).

Suger (of Saint-Denis), *De Administratione: De Rebus in Administratione Sua Gestis,* ed. Erwin Panofsky, *Abbot Suger,* 2nd ed. (Princeton 1979) 40–80.

Suger, *De Administratione* (Lecoy): *De Rebus in Administratione Sua Gestis,* ed. A. Lecoy de la Marche, *Oeuvres complètes de Suger,* Société de l'histoire de France 139 (Paris 1867) 151–209.

Suger, *De Consecratione: De Consecratione Ecclesiae Sancti Dionysii,* ed. Erwin Panofsky, *Abbot Suger,* 2nd ed. (Princeton 1979) 82–120.

Suger (Lecoy): *Oeuvres complètes de Suger,* ed. Albert Lecoy de la Marche, Société de l'histoire de France 139 (Paris 1867).

Suger, *Ordinatio: Ordinatio A.D. MCXL vel MCXLI Confirmata,* ed. Erwin Panofsky, *Abbot Suger,* 2nd ed. (Princeton 1979) 122–136.

Suger, *Vita Ludovici: Vita Ludovici Grossi Regis,* ed. A. Lecoy de la Marche, Société de l'histoire de France 139 (Paris 1867) 1–149.

Summa Cartae Caritatis: Summa Cartae Caritatis, ed. Jean de la Croix Bouton

and Jean Baptiste Van Damme, *Les plus anciens textes de Cîteaux* (Achel 1974) 117–121.

Theofrid of Echternach, *Flores: Flores Epitaphii Sanctorum*, PL 157:317–404.

Theophilus, *De Diversis Artibus: De Diversis Artibus*, ed. and trans. C.R. Dodwell, *Theophilus: The Various Arts* (London 1961).

Thomas de Froidmont, *De Modo Vivendi: Liber de Modo Bene Vivendi*, PL 184:1199–1306.

Thomas of Burton, *Chronica: Chronica Monasterii de Melsa*, ed. Edward Bond, Rolls Series 42:3 (London 1868).

Tractatus Abbatis Cuiusdam: Tractatus Abbatis Cuiusdam, ed. Jean Leclercq, "Nouvelle réponse de l'ancien monachisme aux critiques des Cisterciens," *Revue Bénédictine* 67 (1957) 83–93.

Ulrich, *Consuetudines Cluniacenses: Consuetudines Cluniacenses*, PL 149: 635–778.

Usus Conversorum: Usus Conversorum, ed. Hugues Séjalon, *Nomasticon Cisterciense*, new ed. (Solesmes 1892) 234–241.

Verba Seniorum: Verba Seniorum, PL 73:851–1024.

Vita Amedaei: Vita Amedaei, ed. Anselme Dimier, "Un témoin tardif peu connu du conflit entre cisterciens et clunisiens," in Constable 1956:91–94.

Vita Lanfranci: Vita Lanfranci, PL 150:29–58.

Vita Pachomii: La vie latine de saint Pachôme, ed. H. Van Cranenburgh, Subsidia Hagiographica 46 (Brussels 1969).

Vita Prima: Sancti Bernardi Vita Prima, PL 185:225–466.

Vita Richardi: Vita Richardi Abbatis S. Vitoni Virdunensis, MGH, SS, v.11: 280–290.

Vita S. Caesarii: Vita S. Caesarii Episcopi, PL 67:1001–1042.

Vita Theoderici: Vita Theoderici Abbatis Andaginensis, MGH, SS, v.12:36–57.

Vitruvius, *De Architectura: Vitruvii de Architectura Libri Decem*, ed. Curt Fensterbusch (Darmstadt 1976).

Walafrid Strabo, *De Exordiis: Libellus de Exordiis et Incrementis Rerum Ecclesiasticarum*, MGH, Leg 2, Cap Reg Franc 2, p.473–516.

Walter of Châtillon, *Dilatatur Inpii: Dilatatur Inpii Regnum Pharaonis*, ed. Karl Strecker, *Moralisch-satirische Gedichte Walters von Châtillon* (Heidelberg 1929) 105–109.

Walter Daniel, *Vita Ailredi: The Life of Ailred of Rievaulx*, ed. and trans. F.M. Powicke (London 1950).

Walter Map, *De Nugis Curialium: De Nugis Curialium*, ed. M.R. James, rev.ed. (Oxford 1983).

William of Malmesbury, *De Antiquitate: De Antiquitate Glastonie Ecclesie*, ed. and trans. John Scott, *The Early History of Glastonbury* (Woodbridge, Suffolk 1981).

William of Malmesbury, *Gesta Pontificum: De Gestis Pontificum Anglorum*, ed. N.E Hamilton, Rolls Series 52 (London 1870; reprint 1964).

William of Malmesbury, *Gesta Regum: De Gestis Regum Anglorum*, ed. William Stubbs, 2 v., Rolls Series 90 (London 1887).

William of Saint-Denis, *Vita Sugerii: Vita Sugerii*, ed. A. Lecoy de la Marche, *Oeuvres complètes de Suger*, Société de l'histoire de France 139 (Paris 1867) 375–411.

William of Saint-Thierry, *Ad Fratres*: *Epistola Domni Willemi ad Fratres de Monte Dei*, ed. Jean Déchanet, *Lettre aux frères du Mont-Dieu*, Sources chrétiennes 223 (Paris 1975).

William of Saint-Thierry, *Ad Romanos*: *Expositio in Epistolam ad Romanos*, PL 180:547–694.

William of Saint-Thierry, *De Natura Corporis*: *De Natura Corporis et Animae*, PL 180:695–726.

William of Saint-Thierry, *Meditativae Orationes*: *Meditativae Orationes*, ed. Jacques Hourlier, *Oraisons méditatives*, Sources chrétiennes 324 (Paris 1985).

William of Saint-Thierry, *Speculum Fidei*: *Speculum Fidei*, PL 180:365–398.

William of Saint-Thierry, *Super Cantica*: *Super Cantica Canticorum*, ed. Jean Déchanet, *Exposeé sur le cantique des cantiques*, Sources chrétiennes 82 (Paris 1962).

William of Saint-Thierry, *Vita Prima*: see *Vita Prima*.

Secondary Literature

Agus 1947: Irving Agus, *Rabbi Meir of Rothenburg*, 2 v. (Philadelphia 1947).

d'Arbois de Jubainville 1858: Henri d'Arbois de Jubainville, *Etudes sur l'état intérieur des abbayes cisterciennes, et principalement de Clairvaux, au XIIe et au XIIIe siècle* (Paris 1858).

Armand 1944: Anna-Marie Armand, *Saint Bernard et le renouveau de l'iconographie au XIIe siècle* (Paris 1944).

Aubert 1947: Marcel Aubert, *L'architecture cistercienne en France*, 2nd ed., 2 v. (Paris 1947).

Bautier 1969: Robert Bautier, ed. and trans., *Vie de Gauzlin, abbé de Fleury*, Sources d'histoire médiévale 2 (Paris 1969).

Baxandall 1980: Michael Baxandall, *The Limewood Sculptors of Renaissance Germany* (New Haven 1980).

Bédier 1921: Joseph Bédier, *Les légendes épiques: recherches sur la formation des chansons de geste*, 2nd ed., 4 v. (Paris 1921).

Benton 1986: John F. Benton, "Suger's Life and Personality," in Gerson 1986:3–15.

Berlière 1900: Ursmer Berlière, "Les origines de Cîteaux et l'ordre bénédictine au XIIe siècle," *Revue d'histoire ecclésiastique* 1 (1900) 448–471; 2 (1901) 253–290.

Bevan 1940: Edwyn Bevan, *Holy Images* (London 1940).

Bloch 1961: Peter Bloch, "Siebenarmige Leuchter in christlichen Kirchen," *Wallraf-Richartz-Jahrbuch* 23 (1961) 55–190.

Bony 1986: Jean Bony, "What Possible Sources for the Chevet of Saint-Denis?" in Gerson 1986:131–142.

Bouton 1953: Jean de la Croix Bouton, "Bernard et l'ordre de Cluny," *Bernard de Clairvaux* (Paris 1953) 193–217.

Bouton 1953b: Jean de la Croix Bouton, "Bernard et les monastères bénédictins non clunisiens," *Bernard de Clairvaux* (Paris 1953) 219–249.

Bouyer 1958: Louis Bouyer, *The Cistercian Heritage* (Westminster, MD 1958).

Branner 1965: Robert Branner, *St. Louis and the Court Style in Gothic Architecture* (London 1965).

Braun 1907: Joseph Braun, *Die liturgische Gewandung im Occident und Orient* (Freiburg im Breisgau 1907).

Braun 1932: Joseph Braun, *Das christliche Altargerät in seinem Sein und in seiner Entwicklung* (Munich 1932).

Bredero 1956: Adriaan Bredero, "The Controversy Between Peter the Venerable and Saint Bernard of Clairvaux," in Constable 1956:53–71.

Bredero 1961: Adriaan Bredero, "Etudes sur la 'Vita Prima' de Saint Bernard," *Analecta Sacri Ordinis Cisterciensis* 17 (1961) 3–72, 215–260; 18 (1962) 3–59.

Bredero 1971: Adriaan Bredero, "Cluny et Cîteaux au XIIe siècle: les origines de la controverse," *Studi Medievali* ser.3:12 (1971) 135–175.

Brown 1982: Peter Brown, *The Cult of the Saints: Its Rise and Function in Latin Christianity* (Chicago 1982).

Bruel 1876: see under *"Published Primary Sources."*

Cabrol 1929: Fernand Cabrol, "Cluny et Cîteaux: Saint Bernard et Pierre le Vénérable," *S. Bernard et son temps*, Association bourguignonne des sociétés savantes, Congrès de 1927, 2 v.(Dijon 1929) 19–28.

Cahn 1982: Walter Cahn, *Romanesque Bible Illumination* (Ithaca 1982).

Cahn 1984: Walter Cahn, "The *Rule* and the Book: Cistercian Book Illumination in Burgundy and Champagne," *Monasticism and the Arts*, ed. Timothy Verdon (Syracuse, NY 1984) 139–172.

Canivez 1933: see under *"Published Primary Sources."*

Cantor 1960: Norman Cantor, "The Crisis of Western Monasticism 1050–1130," *American Historical Review* 66 (1960) 47–67.

Capelle 1981: Ruth Capelle, "The Representation of Conflict on the Imposts of Moissac," *Viator* 12 (1981) 79–100.

Cartellieri 1898: Otto Cartellieri, *Abt Suger von Saint-Denis: 1081–1151* (Lübeck 1898).

Casey 1970: Michael Casey, trans., "St. Bernard's Apologia to Abbot William," *The Works of Bernard of Clairvaux: Treatises I*, Cistercian Fathers Series 1 (Spencer, MA 1970) 33–69.

Ceglar 1971: Stanley Ceglar, *William of Saint Thierry*, unpublished doctoral dissertation, Catholic University of America (Washington, DC 1971).

Ceglar 1979: Stanley Ceglar, "Guillaume de Saint-Thierry et son rôle directeur aux premier chapitres des abbés bénédictins: Reims 1131 et Soissons 1132," *Saint-Thierry: une abbaye du VIe au XXe siècle*, Actes du Colloque international d'histoire monastique (Saint-Thierry 1979) 299–350.

Chadwick 1958: Owen Chadwick, *Western Asceticism* (London 1958).

Colombás 1964: García Columbás, "The Ancient Concept of the Monastic Life," *Monastic Studies* 2 (1964) 65–117.

Conant 1968: Kenneth Conant, *Cluny: les églises et la maison du chef d'ordre* (Mâcon 1968).

Conant 1972: Kenneth Conant, "L'abside et le choeur de Cluny III," *Gazette des beaux-arts* 79 (1972) 5–12.

Constable 1956: Giles Constable, ed., *Petrus Venerabilis: 1156–1956*, Studia Anselmiana 40 (Rome 1956).

Constable 1956b: Giles Constable, "The Letter from Peter of St. John to Hato of Troyes," in Constable 1956:38–52.

Constable 1956c: Giles Constable, "The Vision of a Cistercian Novice," in Constable 1956:95–98.

Constable 1957: Giles Constable, "The Disputed Election at Langres in 1138," *Traditio* 13 (1957) 119–152.

Constable 1960: Giles Constable, "Cluniac Tithes and the Controversy between Gigny and Le Miroir," *Revue Bénédictine* 70 (1960) 591–624.

Constable 1964: Giles Constable, *Monastic Tithes from their Origins to the Twelfth Century*, Cambridge Studies in Medieval Life and Thought NS 10 (Cambridge 1964).

Constable 1966: Giles Constable, "The Treatise 'Horatur nos' and Accompanying Canonical Texts on the Performance of Pastoral Work by Monks," *Speculum Historiale: Festschrift Johannes Spörl* (Munich 1966) 567–577.

Constable 1967: Giles Constable, ed., *The Letters of Peter the Venerable*, 2 v. (Cambridge, MA 1967).

Constable 1971: Giles Constable, "Monastic Possession of Churches and 'Spiritualia' in the Age of Reform," *Il monachismo e la riforma ecclesiastica (1049–1122)*, Atti della quarta Settimana internazionale di studio, Mendola, 23–29 agosto 1968 = Miscellanea del Centro di Studi Medioevali 6 (Milan 1971) 304–331.

Constable 1972: Giles Constable and B. Smith, ed. and trans., *Libellus de Diversis Ordinibus et Professionibus Qui Sunt in Aecclesia* (Oxford 1972).

Constable 1973: Giles Constable, "'Famuli' and 'Conversi' at Cluny: a Note on Statute 24 of Peter the Venerable," *Revue Bénédictine* 83 (1973) 326–350.

Constable 1974: Giles Constable, "The Study of Monastic History Today," *Essays on the Reconstruction of Medieval History*, ed. Vaclav Mudroch (Montreal 1974) 21–51.

Constable 1975: Giles Constable, "The Monastic Policy of Peter the Venerable," *Pierre Abélard-Pierre le Vénérable*, Colloques internationaux du C.N.R.S. 546 (Paris 1975) 119–138.

Constable 1975b: Giles Constable, "The Statutes of Peter the Venerable," *Consuetudines Benedictinae Variae (Saec.XI-Saec.XIV)*, Corpus Consuetudinum Monasticarum 6 (Siegburg 1975) 21–25.

Constable 1976: Giles Constable, "Opposition to Pilgrimage in the Middle Ages," *Studia Gratiana* 19 = Mélanges G. Fransen, v.1 (1976) 125–146.

Constable 1976b: Giles Constable, "Monastic Legislation at Cluny in the Eleventh and Twelfth Centuries," *Proceedings of the Fourth International Congress of Medieval Canon Law*, Monumenta Iuris Canonici, Series C: Subsidia 5 (Vatican City 1976) 151–161.

Constable 1976c: Giles Constable, "Cluniac Administration and Administrators in the Twelfth Century," *Order and Innovation in the Twelfth Century: Essays in Honor of Joseph R. Strayer*, ed. William Jordan (Princeton 1976) 17–30, 417–424.

Constable 1977: Giles Constable, "Monachisme et pèlerinage au Moyen Age," *Revue Historique* 258 (1977) 3–27.

Constable 1977b: Giles Constable, "Monasticism, Lordship, and Society in the Twelfth Century Hesbaye: Five Documents on the Foundation of the Cluniac Priory of Bertrée," *Traditio* 33 (1977) 159–224.

Constable 1980: Giles Constable, *Cluniac Studies* (London 1980).

Constable 1986: Giles Constable, "Suger's Monastic Administration," in Gerson 1986:17–32.

Cothren 1982: Michael Cothren, "Cistercian Tile Mosaic Pavements in Yorkshire: Context and Sources," *Studies in Cistercian Art and Architecture* 1, Cistercian Studies Series 66 (Kalamazoo, MI 1982) 112–129.

Coulton 1910: George Coulton, *A Mediaeval Garner* (London 1910).

Cowdrey 1978: Herbert Cowdrey, "Pontius of Cluny," *Studi Gregoriani* 11 (1978) 181–268.

Dauphin 1946: H. Dauphin, *Le bienheureux Richard, abbé de Saint-Vanne de Verdun* (Louvain 1946).

Dereine 1948: Charles Dereine, "Odon de Tournai et la crise du cénobitisme au XIe siècle," *Revue du Moyen Age latin* 4 (1948) 137–154.

Dimier 1947: Anselme Dimier, "Architecture et spiritualité cisterciennes," *Revue du Moyen Age latin* 3 (1947) 255–274.

Dimier 1953b: Anselme Dimier, "Saint Bernard et le droit en matière de *transitus*," *Revue Mabillon* 43 (1953) 48–82.

Dimier 1956: Anselme Dimier, "Un témoin tardif peu connu du conflit entre cisterciens et clunisiens," in Constable 1956:81–94.

Dobiache-Rojdestvensky 1911: Olga Dobiache-Rojdestvensky, *La vie paroissiale en France au XIIIe siècle* (Paris 1911).

Duby 1952: Georges Duby, "Economie domaniale et économie monétaire: Le budget de l'abbaye de Cluny entre 1080 et 1155," *Annales* 7 (1952) 155–171.

Duby 1976: Georges Duby, *Saint Bernard, l'art cistercien* (Paris 1976).

Duby 1980: Georges Duby, *The Three Orders* (Chicago 1980).

Evans 1931: Joan Evans, *Monastic Life at Cluny 910-1157* (Oxford 1931).

Evans 1950: Joan Evans, *Cluniac Art of the Romanesque Period* (Cambridge 1950).

Fichtenau 1964: Heinrich Fichtenau, *The Carolingian Empire: The Age of Charlemagne* (New York, reprint 1964).

Foreville 1987: Raymonde Foreville and Gillian Keir, ed. and trans., *The Book of St. Gilbert* (Oxford 1987).

Forsyth 1986: Ilene H. Forsyth, review of Saulnier and Stratford 1984, *Speculum* 61 (1986) 457–460.

Fracheboud 1953: André Fracheboud, "Saint Bernard est-il seul dans sons attitude face aux oeuvres d'art?" *Collectanea Ordinis Cisterciensium Reformatorum* 15 (1953) 113–130.

Gaborit-Chopin 1969: Danielle Gaborit-Chopin, *La décoration des manuscrits à Saint-Martial de Limoges et en Limousin* (Paris 1969).

Gage 1973: John Gage, "Horatian Reminiscences in Two Twelfth-Century Art Critics," *Journal of the Warburg and Courtauld Institutes* 36 (1973) 359–360.

Gage 1982: John Gage, "Gothic Glass: Two Aspects of a Dionysian Aesthetic," *Art History* 5 (1982) 36–58.

de Gaiffier 1963: Baudouin de Gaiffier, "Pellegrinaggi e culto dei santi: Reflexions sur le thème du Congrès," *Pellegrinaggi e culto dei santi in Europa fino alla Ia crociata*, Convegni del Centro di studi sulla spiritualità medievale (Todi 1963) 9–35.

Geary 1978: Patrick Geary, *Furta Sacra: Thefts of Relics in the Central Middle Ages* (Princeton 1978).

Gerson 1986: ed. Paula Lieber Gerson, *Abbot Suger and Saint-Denis*, (New York 1986).

Gilson 1940: Etienne Gilson, *The Mystical Theology of Saint Bernard* (New York 1940).

Goldschmidt 1940: R.C. Goldschmidt, *Paulinus' Churches at Nola* (Amsterdam 1940).

Graham 1901: Rose Graham, *S. Gilbert of Sempringham and the Gilbertines* (London 1901).

Graham 1926: Rose Graham and A.W. Clapham, "The Order of Grandmont and its Houses in England," *Archaeologia* 75 (1926) 159–210.

Grégoire 1962: D.R. Grégoire, "Le *De claustro animae* est-il d'un clunisien?" *Studia monastica* 4 (1962) 193–195.

Grill 1959: L. Grill, "Der hl. Bernhard als bisher unerkannter Verfasser des *Exordium Cistercii* und der *Summa Cartae Caritatis*," *Cistercienserchronik* 66 (1959) 43–57.

Hallinger 1971: Kassius Hallinger, "The Spiritual Life of Cluny in the Early Days," in Hunt 1971:29–55.

Holdsworth 1986: Christopher Holdsworth, "The Chronology and Character of Early Cistercian Legislation on Art and Architecture," *Cistercian Art and Architecture*, ed. Christopher Norton (Cambridge 1986) 40–55.

Horn 1962: Walter Horn, "On the Author of the Plan of St. Gall and the Relation of the Plan to the Monastic Reform Movement," *Studien zum St. Galler Klosterplan*, ed. Johannes Duft (St. Gall 1962).

Horn 1973: Walter Horn, "On the Origins of the Medieval Cloister," *Gesta* 12 (1973) 13–52.

Horn 1974: Walter Horn, "New Theses about the Plan of St. Gall," *Die Abtei Reichenau*, ed. Helmut Maurer (Sigmaringen 1974) 407–476.

Horn 1979: Walter Horn, *The Plan of St. Gall*, 3 v. (Berkeley 1979).

Hunt 1968: Noreen Hunt, *Cluny Under Saint Hugh: 1049–1109* (Notre Dame 1968).

Hunt 1971: Noreen Hunt, ed., *Cluniac Monasticism in the Central Middle Ages* (London 1971).

James 1951: M.R. James, "Pictor in Carmine," *Archaeologia* 94 (1951) 141–166.

Janauschek 1959: see under *"Bernardine Bibliographies."*

King 1954: Archdale King, *Cîteaux and Her Elder Daughters* (London 1954).

Knowles 1955: David Knowles, *Cistercians and Cluniacs: The Controversy Between St. Bernard and Peter the Venerable* (Oxford 1955).

Knowles 1956: David Knowles, "The Reforming Decrees of Peter the Venerable," in Constable 1956:1–20.

Koch 1946: Konrad Koch, "Vollständiges Brevier aus der Schreibstube des Hl. Stephen," *Analecta Sacri Ordinis Cisterciensis* 2 (1946) 146–147.

Labande 1958: Edmond-René Labande, "Recherches sur les pèlerins dans l'Europe des XIe et XIIe siècles," *Cahiers de civilisation médiévale*, 1 (1958), 159–169, 339–347.

Labande 1966: Edmond-René Labande, "Elements d'une enquête sur les conditions de déplacement du pèlerin aux Xe–XIe siècles," *Pellegrinaggi e culto dei santi in Europa fino alla Ia crociata*, Convegni del Centro del studi sulla spiritualità medievale (Todi 1963) 95–111.

Lackner 1972: Bede Lackner, *The Eleventh-Century Background of Cîteaux*, Cistercian Studies Series 8 (Washington, DC 1972).

Lambert 1959: Elie Lambert, *Le pèlerinage de compostelle* (Paris 1959).

Lasko 1972: Peter Lasko, *Ars Sacra: 800-1200*, The Pelican History of Art (Harmondsworth 1972).

Lauer 1911: Philip Lauer, *Le palais de Latran* (Paris 1911).

Leclercq 1957: *Sancti Bernardi Opera*, ed. Jean Leclercq and H.M. Rochais, 8 v. (Rome 1957–1977).

Leclercq 1957b: Jean Leclercq, "Nouvelle réponse de l'ancien monachisme aux critiques des Cisterciens, *Revue Bénédictine* 67 (1957) 77–94.

Leclercq 1961: Jean Leclercq, "Monachism et pérégrination du IXe au XIIe siècle," *Studia Monastica* 3 (1961) 33–52.

Leclercq 1962: Jean Leclercq, *Recueil d'études sur saint Bernard et ses écrits*, 3 v. (Rome 1962–1969).

Leclercq 1963: Jean Leclercq, "L' 'Exordium Cistercii' et la 'Summa Cartae Caritatis' sont-ils de Saint Bernard?" *Revue Bénédictine* 73 (1963) 88–99.

Leclercq 1964: Jean Leclercq, *Aux sources de la spiritualité occidentale* (Paris 1964).

Leclercq 1965: Jean Leclercq, "Culte et pauvreté à Cluny," *La Maison-Dieu* 81 (1965) 33–50.

Leclercq 1968: Jean Leclercq, "Essais sur l'esthètique de saint Bernard," *Studi Medievali* ser.3:9 (1968) 688–728.

Leclercq 1970: Jean Leclercq, "The Intentions of the Founders of the Cistercian Order," *The Cistercian Spirit*, Cistercian Studies Series 3 (Spencer, MA 1970) 88–133.

Leclercq 1970b: Jean Leclercq, "Introduction," *The Works of Bernard of Clairvaux: Treatises I*, Cistercian Fathers Series 1 (Spencer, MA 1970) 3–30.

Leclercq 1971: Jean Leclercq, "The Monastic Crisis of the Eleventh and Twelfth Centuries," in Hunt 1971:217–237.

Leclercq 1974: Jean Leclercq, *The Love of Learning and the Desire for God: A Study of Monastic Culture*, 2nd rev. ed. (New York 1974).

Leclercq 1984: Jean Leclercq, "*Otium Monasticum* as a Context for Artistic Creativity," *Monasticism and the Arts*, ed. Timothy Verdon (Syracuse 1984) 63–80.

Lecoy 1867: see Suger (Lecoy) under "*Published Primary Sources.*"

Lehmann 1918: P. Lehmann, *Die Bistümer Konstanz und Chur*, Mittelalterliche Bibliothekskataloge Deutschlands und der Schweiz 1 (Munich 1918).

Lehmann-Brockhaus 1955: see under "*Published Primary Sources.*"

Lehmann-Brockhaus 1971: see under "*Published Primary Sources.*"

Lekai 1953: Louis Lekai, *The White Monks* (Okauchee, WI 1953).

Lekai 1978: Louis Lekai, "Ideals and Reality in Early Cistercian Life and Legislation," *Cistercian Ideals and Reality*, ed. John Sommerfeldt, Cistercian Studies Series 60 (Kalamazoo, MI 1978) 4–29.

Lopez 1952: Robert Lopez, "Economie et architecture médiévales: Cela aurait-il tué ceci?" *Annales* 7 (1952) 433–438.

López Ferreiro 1898: Antonio López Ferreiro, *Historia de la Santa A.M. iglesia de Santiago de Compostela*, 11 v. (Santiago 1898–1909).

Mabillon 1739: Jean Mabillon, *Annales Ordinis S. Benedicti* (Lucca 1739–1745).

Maines 1986: Clark Maines, "Good Works, Social Ties, and the Hope for Salvation: Abbot Suger and Saint-Denis," in Gerson 1986:77–94.

Mâle 1928: Emile Mâle, *L'art religieux du XIIe siècle en France*, 3rd ed. (Paris 1928).

Milis 1970: Louis Milis, *Constitutiones Canonicorum Regularium Ordinis Arroasiensis*, Corpus Christianorum: Continuatio Mediaevalis 20 (Turnhout 1970).

Montalembert 1861: Charles Montalembert, "Du vandalisme en France," *Oeuvres*, v.6 (Paris 1861) 7–77.

Montalembert 1868: Charles Montalembert, *Les moines d'Occident*, 3rd ed., 5 v. (Paris 1868).

Moore 1921: Herbert Moore, *The Dialogue of Palladius Concerning the Life of Chrysostom* (New York 1921).

Morghen 1971: Raffaello Morghen, "Monastic Reform and Cluniac Spirituality," in Hunt 1971:11–28.

Mortet 1911: see under *"Published Primary Sources."*

Mortet 1913: Victor Mortet, "Hugue de Fouilloi, Pierre le Chantre, Alexandre Neckam et les critiques dirigées au XIIe siècle contre le luxe des constructions," *Mélanges d'histoire offerts à M. Charles Bémont* (Paris 1913) 105–137.

Mortet 1929: see under *"Published Primary Sources."*

Müller 1957: Gregor Müller, *Esquisse historique de l'ordre de Cîteaux*, ed. and trans. Eugène Willems, 2 v. (Paris 1957).

Norton 1983: Christopher Norton, *"Varietates Pavimentorum.* Contribution à l'étude de l'art cistercien en France," *Cahiers archéologiques* 31 (1983) 69–113.

Norton 1986: Christopher Norton, ed., *Cistercian Art and Architecture* (Cambridge 1986).

Oursel 1926: Charles Oursel, *La miniature du XIIe siècle à l'abbaye de Cîteaux* (Dijon 1926).

Oursel 1929: Charles Oursel, "Saint Bernard, Fontenay et l'architecture cistercienne," *Annales de Bourgogne* 1 (1929) 84–89.

Oursel 1960: Charles Oursel, *Miniatures cisterciennes (1109–1134)* (Mâcon 1960).

Panofsky 1979: Erwin Panofsky, *Abbot Suger on the Abbey Church of Saint-Denis and its Art Treasure*, 2nd ed. (Princeton 1979).

Petit 1947: François Petit, *La spiritualité des Prémontrés aux XIIe et XIIIe siècles*, Etudes de théologie et d'histoire de la spiritualité 10 (Paris 1947).

Porcher 1959: Jean Porcher, *L'enluminure française* (Paris 1959).

Ringbom 1984: Sixten Ringbom, *Icon to Narrative: The Rise of the Dramatic Close-up in Fifteenth-Century Devotional Painting* (Doornspijk 1984).

Rudolph 1987: Conrad Rudolph, "The 'Principal Founders' and the Early Artistic Legislation of Cîteaux," *Studies in Cistercian Art and Architecture* 3, Cistercian Studies Series 89 (Kalamazoo, MI 1987) 1–45.

Rudolph 1988: Conrad Rudolph, "Bernard of Clairvaux's *Apologia* as a Description of Cluny and the Controversy Over Monastic Art," *Gesta* 27 (1988) 125–132.

Rudolph 1989: Conrad Rudolph, "The Scholarship on Bernard of Clairvaux's *Apologia,"* *Cîteaux: Commentarii Cistercienses* 40 (1989).

Rudolph 1990: Conrad Rudolph, *Artistic Change at Saint-Denis: Abbot Suger's Program and the Early Twelfth Century Controversy over Art* (Princeton 1990).

Russell 1965: Jeffrey Russell, *Dissent and Reform in the Early Middle Ages* (Berkeley 1965).
Russell 1981: Norman Russell, *The Lives of the Desert Fathers*, Cistercian Studies Series 34 (London 1981).
Sabbe 1928: E. Sabbe, "La réforme de Richard de Saint-Vanne, " *Revue belge de philologie et d'histoire* 7 (1928) 551–570.
Schapiro 1977: Meyer Schapiro, "On the Aesthetic Attitude in Romanesque Art," *Romanesque Art* (New York 1977) 1–27.
Schapiro 1977b: Meyer Schapiro, "The Romanesque Sculpture of Moissac," *Romanesque Art* (New York 1977) 131–264.
Schlink 1978: Wilhelm Schlink, *Saint-Bénigne in Dijon: zur Abteikirche Wilhelms von Volpiano (962-1031)* (Berlin 1978).
von Schlosser 1896: see under *"Published Primary Sources."*
von Schlosser 1974: see under *"Published Primary Sources."*
von Simson 1974: Otto von Simson, *The Gothic Cathedral*, 2nd ed., rev. (Princeton 1974).
Smith 1930: L.M. Smith, *Cluny in the Eleventh and Twelfth Centuries* (London 1930).
Starkie 1965: Walter Starkie, *The Road to Santiago* (Berkeley 1965).
Stratford 1981: Neil Stratford, "A Romanesque Marble Altar Frontal in Beaune and some Cîteaux Manuscripts," *The Vanishing Past: Studies of Medieval Art, Liturgy and Metrology Presented to Christopher Hohler*, ed. Alan Borg and Andrew Martindale (Oxford 1981) 223–239.
Stratford 1984: Lydwine Saulnier and Neil Stratford, *La sculpture oubliée de Vézelay: Catalogue du Musée lapidaire* (Geneva 1984).
Sumption 1975: Jonathan Sumption, *Pilgrimage: An Image of Mediaeval Religion* (London 1975).
Tellenbach 1964: Gerd Tellenbach, "La chute de l'abbé Pons de Cluny et sa signification historique," *Annales du Midi* 76 (1964) 355–362.
Vacandard 1884: Elphège Vacandard, "Saint Bernard et l'art chrétien," *Précis analytique des travaux de l'Académie de sciences, belles-lettres et arts de Rouen* 87 (1884) 215–244.
Vacandard 1902: Elphège Vacandard, *Vie de saint Bernard*, 3rd ed., 2 v. (Paris 1902).
de Valous 1970: Guy de Valous, *Le monachisme clunisien des origines au XVe siècle*, 2nd ed., 2 v. (Paris 1970).
Van Cranenburgh 1969: H. Van Cranenburgh, *La vie latine de saint Pachôme*, Subsidia Hagiographica 46 (Brussels 1969).
Van Damme 1966: Jean Baptiste Van Damme, *Les Trois Fondateurs de Cîteaux* (Westmalle 1966).
Van Damme 1972: Jean Baptiste Van Damme, "La 'Summa Cartae caritatis' source de Constitutions canoniales," *Cîteaux* 23 (1972) 5–54.
Van Damme 1974: Jean Baptiste Van Damme and Jean de la Croix Bouton, *Les plus anciens textes de Cîteaux*, Cîteaux-Commentarii Cistercienses: Studia et Documenta 2 (Achel 1974).
Van Damme 1982: Jean Baptiste Van Damme, "A la recherche de l'unique vérité sur Cîteaux et ses origines," *Cîteaux* 33 (1982) 304–332.
Van den Eynde 1969: Damien Van den Eynde, "Les premiers écrits de S. Bernard,"

Recueil d'études sur saint Bernard et ses écrits, ed. Jean Leclercq, v.3 (Rome 1969) 343–422.

Van Engen 1980: John Van Engen, "Theophilus Presbyter and Rupert of Deutz: The Manual Arts and Benedictine Theology," *Viator* 11 (1980) 147–163.

Van Engen 1983: John Van Engen, *Rupert of Deutz* (Berkeley 1983).

Vielliard 1963: Jeanne Vielliard, *Le Guide du Pèlerin de Saint-Jacques de Compostelle*, 3rd ed. (Mâcon 1963).

Vogel 1963: Cyrille Vogel, "Le pèlerinage penitentiel," *Pellegrinaggi e culto dei santi in Europa fino all Ia crociata*, Convegni del Centro di studi sulla spiritualità medievale (Todi 1963) 37–94.

Waddell 1982: Chrysogonus Waddell, "Prelude to a Feast of Freedom: Notes on the Roman Privilege *Desiderium Quod* of October 19, 1100," *Cîteaux* 33 (1980) 247–303.

Walliser 1969: Franz Walliser, *Cistercienser Buchkunst: Heiligenkreuzer Skriptorium in seinem ersten Jahrhundert (1133–1230)* (Heiligenkreuz-Vienna 1969).

Walther 1963: Hans Walther, *Lateinische Sprichwörter und Sentenzen des Mittelalters* (Göttingen 1963–1969).

Waquet 1929: Henri Waquet, ed., Suger, *Vie de Louis VI le Gros* (Paris 1929).

Warnke 1979: Martin Warnke, *Bau und Uberbau: Sociologie der mittelalterlichen Architektur nach den Schriftquellen*, 2nd ed. (Frankfurt am Main 1979).

de Warren 1953: Henri-Bernard de Warren, "Bernard et les premiers cisterciens face au problème de l'art," *Bernard de Clairvaux*, Commission d'histoire de l'ordre de Cîteaux 3, v.5 (Paris 1953) 487–534.

White 1958: Hayden White, "Pontius of Cluny, the *Curia Romana* and the End of Gregorianism in Rome," *Church History* 27 (1958) 195–219.

Williams 1938: Watkin Williams, "Peter the Venerable: A Letter to St. Bernard," *The Downside Review* 56 (1938) 344–353.

Wilmart 1917: André Wilmart, "L'ancienne Bibliothèque de Clairvaux," *Mémoires de la Société académique d'agriculture, des sciences, arts et belles-lettres du Départment de l'Aube* 81 [ser.3:54] (1917) 127–190.

Wilmart 1934: André Wilmart, "Une riposte de l'ancien monachisme au manifeste de St. Bernard," *Revue Bénédictine* 46 (1934) 296–344.

Wollasch 1971: Joachim Wollasch, "A Cluniac Necrology from the Time of Abbot Hugh," in Hunt 1971:143–190.

Zakar 1974: Polykarp Zakar, "Die Anfänge des Zisterzienserordens," *Analecta Sacri Ordinis Cisterciensis* 20 (1964) 103–138.

Zakin 1979: Helen Zakin, *French Cistercian Grisaille Glass* (New York 1979).

Zerbi 1972: Piero Zerbi, "Intorno allo scisma di Ponzio, abate de Cluny (1122–1126)," *Raccolta di studi storici in onore di Ottorino Bertolini*, 2 v. (Pisa 1972) 2:835–891.

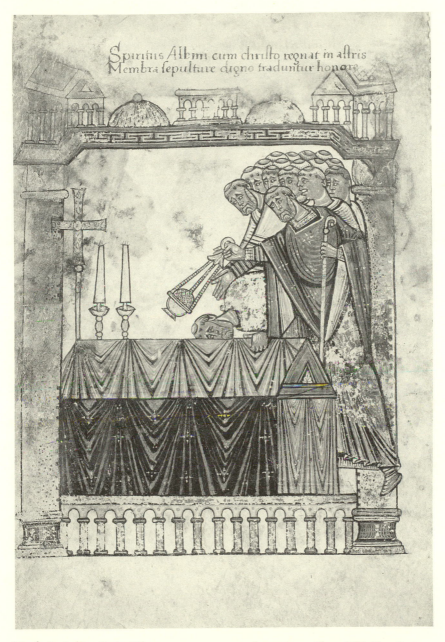

1. Vie de St Aubin. *Paris, Bib. nat., ms. nouv. acq. lat.1390:5v. Photo Bibl. Nat. Paris.*

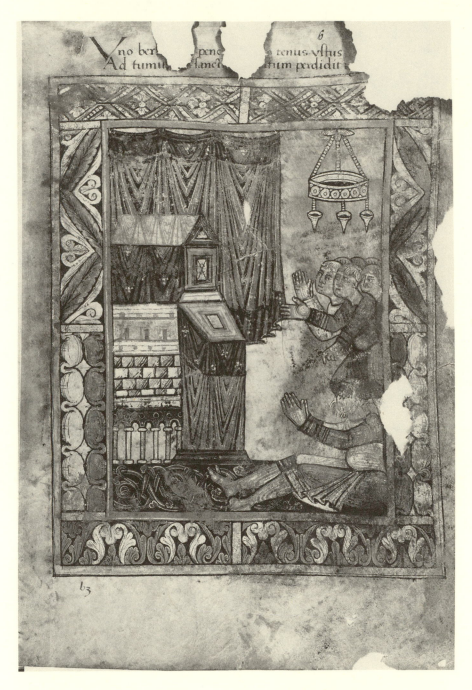

2. Vie de St Aubin. *Paris, Bib. nat., ms. nouv. acq. lat.1390:6. Photo Bibl. Nat. Paris.*

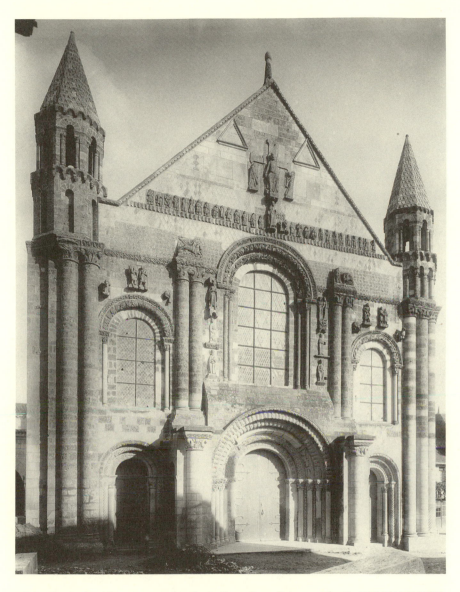

3. *Saint-Jouin-des-Marnes, west facade. Lefèvre-Pontalis/copyright © ARS N.Y./ARCH. PHOT. PARIS 1988.*

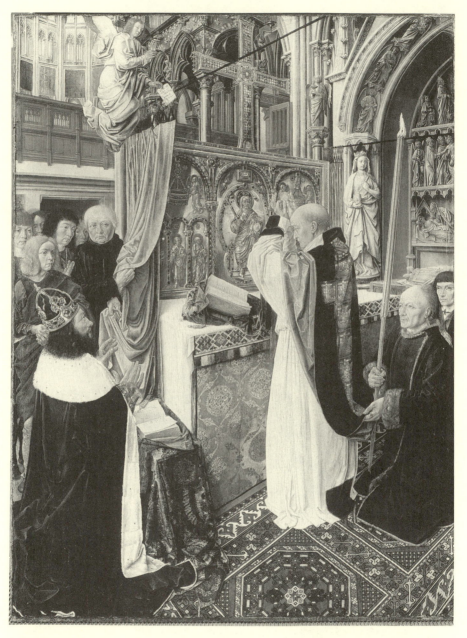

4. *Mass of St. Giles. Reproduced by courtesy of the Trustees, The National Gallery, London.*

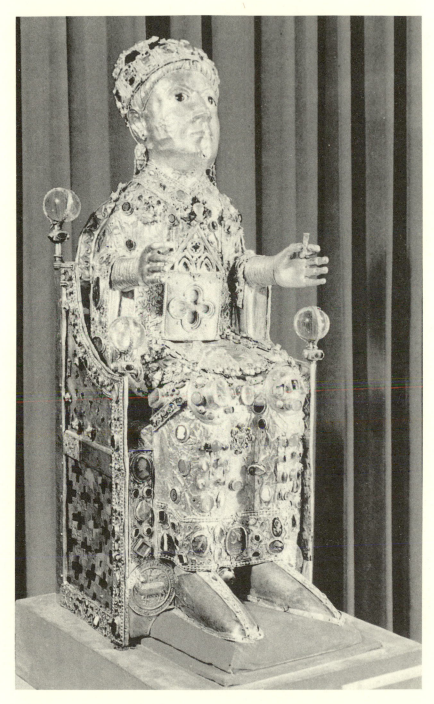

5. *Reliquary of St. Foi, Conques, Treasury of St.-Foi. Copyright Abbey Treasury, Conques.*

6. *Gospels of Bernward of Hildesheim. Hildesheim, Domschatz ms. 18:16v–17. Copyright © Hohe Domkirche Hildesheim.*

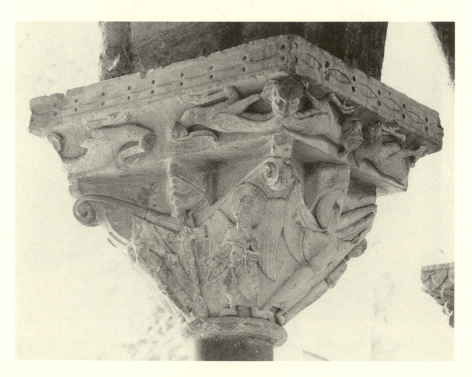

7. *Moissac, cloister impost 58. Photo James Austin.*

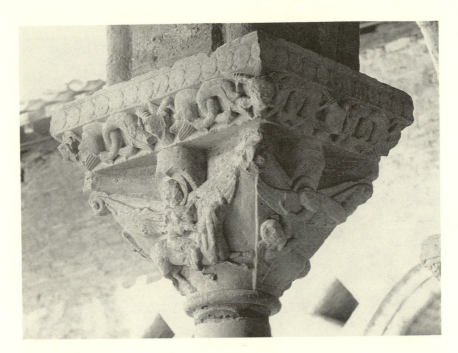

8. Moissac, cloister impost 15. Photo James Austin.

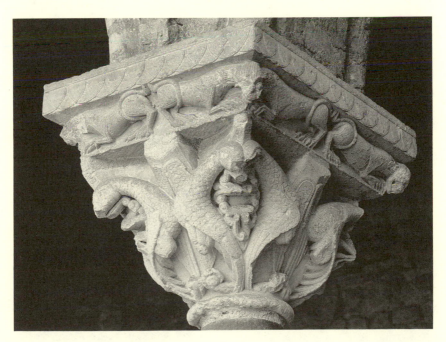

9. Moissac, cloister impost 60. Photo James Austin.

10. Moissac, cloister capital 28. Photo James Austin.

11. Moissac, cloister impost 2. Photo James Austin.

12. Moissac, cloister impost 24. Photo James Austin.

13. Moissac, cloister capital 49. Photo James Austin.

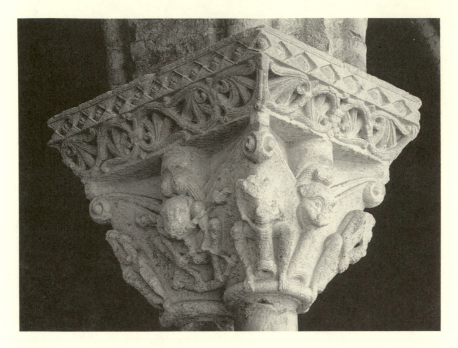

14. *Moissac, cloister capital 63. Photo James Austin.*

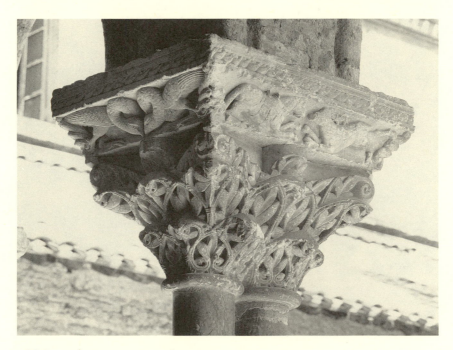

15. *Moissac, cloister impost 45. Photo James Austin.*

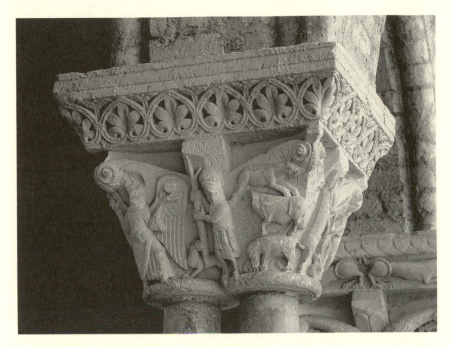

16. Moissac, cloister capital 61. Photo James Austin.

17. *Second Bible of Saint-Martial. Paris, Bib. nat., ms. lat.8:2:136v. Photo Bibl. Nat. Paris.*

magis in suo corpore oculū custodiunt. dū in
semet ipsis principalit humilitatē tuentur;

EXPL LIBER · XXX IIII;

INCIP LIB · XXXV;

VIA
ISTE

18. Moralia in Job. Dijon, Bib. pub. 173:174.

EXPL LIB · XXVII;
INCIP LIB · XXVIII;

PARS
VLTIMA;

OST

DĀPN A

REBVOR: POST FVSERA PIGNOR:
post uulnera corporis: post uer
ba male suadentis uxoris: post
contumeliosa dicta consolan
tium: post suscepta fortit ia
cula tot dolor: de tanta uir
tute constantie laudandus
auudice beat iob fuerat: sed
si ia depsenti scto eet euocan
dus. At post quā hic adhuc
duplicia recepturus e. post
quā saluti pristine restituitur:

19. *Moralia in Job. Dijon, Bib. pub. 173:103v.*

20. *Second Bible of Saint-Martial. Paris, Bib. nat., ms. lat.8:2:231. Photo Bibl. Nat. Paris.*

21. *Second Bible of Saint-Martial. Paris, Bib. nat., ms. lat.8:2:91. Photo Bibl. Nat. Paris.*

22. Second Bible of Saint-Martial. Paris, Bib. nat., ms. lat.8:1:171. Photo Bibl. Nat. Paris.

Text visible in the illuminated initial and column:

THAVM. SOPHYM. DE
monte effraym.
et nomen eius helchana filius
hieroboam filii helii filii thau
filii suph efurtheus. et habuit
duas uxores nomen uni anna.
et nomen secunde fenenni. fu-
eruntque fenenne filii. Anne
autem non erant liberi. Et as-
cendebat uir ille deciuitate sua
statutis diebus ut adoraret et
sacrificaret domino exercituum
in silo. Erant autem ibi duo
filii heli ofni et fines. sacer-
dotes domini. Venit ergo dies
et immolauit helchana.
deditque fenenne uxori
sue et cunctis filiis eius
et filiabus partes. Anne
autem dedit partem unam
tristis quia annam diligebat. Dominus autem

dicen
afflic
net
rum
uitta
eius
prea
anne
eius

A est
ei. V
quo
quit
ego
test
tu d
una
lous

T unc
tibi

V una
tuis
uult
tati
dom
suari
uxor

E t fac
na e
hel.
autem
laro
et an
uadi
et ap
ibi u

24. *Second Bible of Saint-Martial. Paris, Bib. nat., ms. lat.8:2:67v. Photo Bibl. Nat. Paris.*

25. *Second Bible of Saint-Martial. Paris, Bib. nat., ms. lat. 8:1:170v. Photo Bibl. Nat. Paris.*

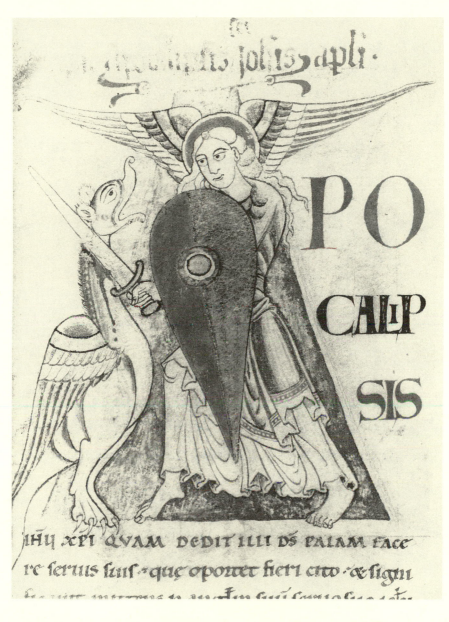

26. *Bible of Stephen Harding. Dijon, Bib. pub. 15:125.*

EXPLICIT LIB NONVS;

INCIPIT LIB DECIM;

VO

TIENS

IN HARENÆ

spectaculū fortis athleta descenderit.
hi qui imparis uirtutis existunt.
uicissim se eius expugnationi subi
ciunt·& uno uicto comm hunc ptiū
alter erigit·atq̃: hoc subacto aluis

27. *Moralia in Job. Dijon, Bib. pub. 169:88v.*

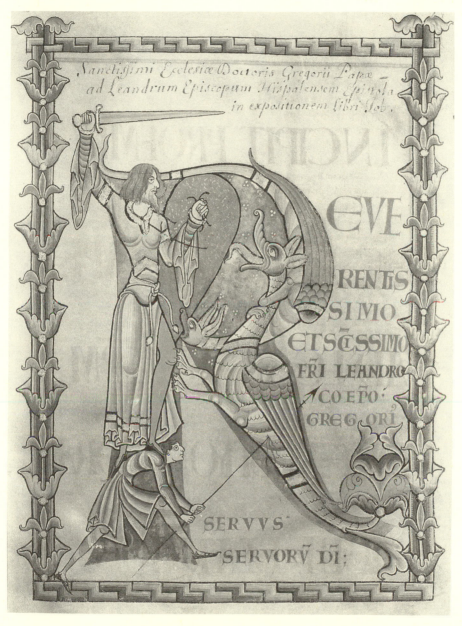

28. *Moralia in Job. Dijon, Bib. pub. 168:4v.*

29. *Bible of Stephen Harding. Dijon, Bib. pub. 14:128v.*

dattam ·ſpū feruentiore pꝛoferuntur;
EXPLICIT LIB VICESIM SECVND;
INCIP XXIII· PARS QNTA;

RE
FATI
ONEM
huiuſ opiſ toctenſ neceſſario repe
to. quocienſ hoc indiſtinctionē uo
luminū· locuttonſ mee pauſatione
ſuccido· ut cū legendi exordium
ſumtē. priuſ ipſa memorie lectio
niſ cauſa renouet· & tanto robuſti
ſurgat doctrine aedificiū· quanto
ex conſiderata cauſe origine ſtudioſi
ponti inure fundamtū· Beat ıob
dō ſoli ſibiꝗ· cognt intranquillitate adnıam
noticiā pducenduſ tactuſ ē· uerbere· ut odo
rē ſuarū uirtū tanto lati ſpargeret· quanto

30. *Moralia in Job. Dijon, Bib. pub. 173:56v.*

s extenuando ten
n sonent. hanc u
olus tendit minus
res in eccla seu
entes put uires
suis canticu bone
um & prudentes
tu sollerter mu
tta ptrahaut so
 laurunt. & quia
ident. ex ipso uir
posse conspiciuf.
rttate sumunt atq;
rt. trahere non de
f psecutiomb; pres
emptu considerat
entu format. q
ndo trahere non
luctu cythara mea
tu; A si apte fa
ee tempore palios
f uero more orga
u; Sed nunc in lu
flentu usue qa dume
dicationis cantu
p quosdã sca eccla
osdã in sinu ia exe
stephanus. iudes
ndo conat est. q
dã uideret ad
e fixis genib; ora
tias illi hoc pe
& parua & magna
are atq; organ

iuxta solius hyftorie textu tenent. ne si hec
ad indaganda mysteria trahim. uerttatem
fontasse opif uacuare uideamur;

EXP. LIB. XX.
INCIPIT. XXI.

NTELLECTVS

sacri eloquii inter textu & myste
rium tanta est libratione pensand.
ut utriusq; partis lance moderata
hunc neq; nimie discussioni pondus
deprimat. neq; rursus torpor incu
rie uacuu relinquat; Multe quip
pe eius sententie tanta allegoria
conceptione sunt grauide. ut qsqs
eas ad solam tenere hystoria nitit
earu notitia p sua incuriam puet;
Nonnulle uero ita exterioribz peep
tis inseruiunt. ut si quis eas subti
lius penetrare desiderat. intus quide
nil inueniat. sed hoc sibi etia quod
foris locuntur abscondat; Unde be
ne quoq; narratione hiftorica per
significatione dicitur; Tollens iacob
uirgas populeas uirides. & amigda
linas. & ex platanis. ex parte deco
ticauit eas. detractisq; corticibus in
his que expoliata fuerant candor
apparuit; Illa u que integra erat.
uiridia p manserunt. atq; in hunc
modu. color effectus e uarius; Ubi
& subditur; Posuitq; eas in canalib;

31. *Moralia in Job. Dijon, Bib. pub. 173:41.*

32. Second Bible of Saint-Martial. Paris, Bib. nat., ms. lat.8:1:1. Photo Bibl. Nat. Paris.

33. *Bible of Stephen Harding. Dijon, Bib. pub. 15:3v.*

partem aut amore labuntur aut odio;

EXPLICIT PROLOGVS·

INCIP̄ DANIEL PPHA·

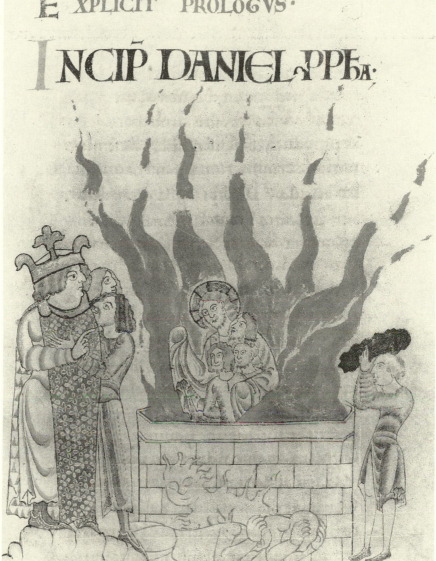

34. *Bible of Stephen Harding. Dijon, Bib. pub. 14:64.*

quencia... alii seta legis iudaice inducti. hos
reuocat apls ad ueram & euangelica sapienciam
scribens eis ab epheso p timotheu disciplm suu

EXPLICIT ARGVMENTVM;

INCP EPLA
PMA AD CRIN

AVL' VOCAT

apls xpi ihu p uoluntate di
& sostenes frater· eccle di que
est corinthi scificatis in xpo
ihu uocatis scis· cu omnib; qui inuocant nom
domini nri ihu xpi· in omni loco ipsoz & nro·
Gra uobis & pax a do patre nro· & dno ihu
xpo; Gras ago do meo semp p uobis in gra
di que data est uobis in xpo ihu· quia in om
nib; diuites facti estis in illo in omni uerbo
& in omni sciencia· & sicut testimoniu xpi con
firmatu est in uobis· ita ut nichil uob desit
in illa gra expectantib; reuelatione dni nri
ihu xpi· & qui & confirmabit uos usq̃ in fine
sine crimine· in die aduentus dni nri ihu xpi;
fidelis ds· p que uocati estis· in societate filii
ihu xpi dni nri; II.

Obsecro aute uos p nomen dni nri ihu xpi ut

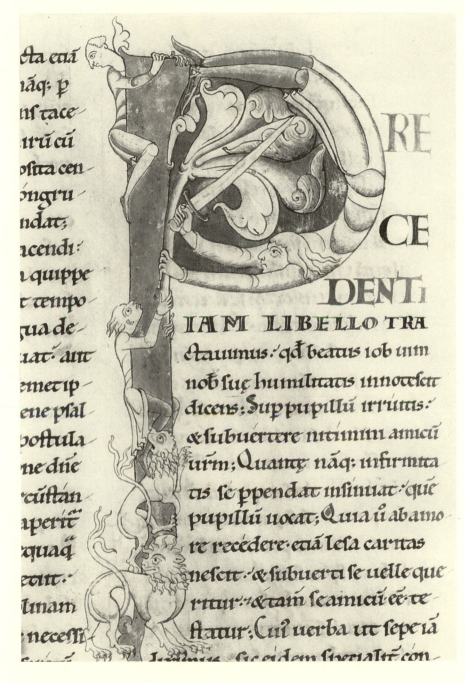

PRE
CE
DENTi
IAM LIBELLO TRA
ctauimus: qd beatus iob uim
nob suæ humilitatis innotesc
dicens: Sup pupillu irruitis:
& subuertere nitimini amicu
urm; Quantæ náq: infirmita
tis se ppendat insinuat: que
pupillu uocat; Quia u abamo
re recedere etiã lesa caritas
nescit: & subuerti se uelle que
rtur: & tam se amicu ee te
statur; Cui uerba ut sepe ia

36. Moralia in Job. Dijon, Bib. pub. 169:36v.

INDEX

Since there is such a large number of citations of primary sources in this study, reference to each one would make the index virtually useless. Therefore, reference is made only to those instances of relative importance—as opposed to cases of simple corroborative evidence or cross reference, especially as found in the commentary.